Women at the Siege, Peking 1900

On 20 June 1900, Baron von Ketteler, the German Minister, was assassinated in a Peking Street. By 4pm the first shots were fired into the legation quarter and the siege of foreigners by Boxers and imperial troops had begun.

Among the besieged were 148 women from America, Europe, Russia and Japan, and Maud, the Baron's American widow. What were their experiences and feelings? How did they cope with 79 children for two months, without enough to eat, often under fire? This book tells their story – of courage, grief, humour, friendship, ill-health and hard work – mostly through their own accounts. It identifies the women for the first time as individuals: missionary teachers and doctors, 'globe-trotters', and wives of diplomats, officials, railway engineers, merchants, bankers, and the owner of the Peking Hotel.

Most forgotten have been the hundreds of Chinese women refugees and their children, many badly injured and bereft. Their story contrasts with that of the Sisters of the Red Lantern who supported the Boxers with their magic in their struggle to rid China of foreigners. The Chinese ruler who loomed over these events, whether in charge or manipulated, was the Empress Dowager, Tz'u-hsi. Her relations with diplomatic wives allow fresh insights into what took place. They may well have affected later exchanges between China and the West.

Susanna Hoe has also written

Lady in the Chamber (Collins 1971)
God Save the Tsar (Michael Joseph/St Martins Press 1978)
The Man Who Gave His Company Away: A Biography of Ernest Bader, Founder of the Scott Bader Commonwealth (Heinemann 1978)
The Private Life of Old Hong Kong: Western Women in the British Colony 1841–1941 (Oxford University Press 1991)
Chinese Footprints: Exploring Women's History in China, Hong Kong and Macau (Roundhouse (Asia) 1996)
Stories for Eva: A Reader for Chinese Women Learning English (ed.) (The Hong Kong Language Fund 1997)
The Taking of Hong Kong: Charles and Clara Elliot in China Waters (with Derek Roebuck) (Curzon 1999)

Women at the Siege, Peking 1900

Susanna Hoe

HOLO BOOKS
THE WOMEN'S HISTORY PRESS
OXFORD

Published by The Women's History Press
A division of HOLO Books
Clarendon House
52 Cornmarket Oxford OX1 3HJ

British Library Cataloguing in Publication Data
A catalogue record for this book is available
from the British Library

ISBN 0–9537730–6–X

Designed, typeset and produced for
HOLO Books: The Women's History Press by
Chase Production Services,
Chadlington, OX7 3LN
Printed in the European Union

Dedicated to the memory of
Helen Hope Brazier Steedman
born Peking 17 December 1899, died Sussex 17 December 1999;
the last survivor of the Western women in Peking
20 June–14 August 1900

Contents

List of Illustrations

Preface

What used to be Legation Street is still two minutes walk from what is now best known as Tiananmen Square. I set out to find it in 1991. Of course, it was not the same as in 1900 – the buildings that existed then were mostly destroyed or too badly damaged to remain, and a bigger, grander legation area was rebuilt.

By 1991, diplomats had long since moved to a new embassy area, and the street that remained was dominated by the Supreme Court of the People's Republic of China. But if you were determined, you could make your way down an alley that had been part of the Russian, and then the Soviet, Legation and which led, behind that, to the British Legation. And you could get a clear echo from the past.

Since then, more redevelopment has taken place and there is really nothing left – just the odd building with porticoes that was once a foreign bank – the vestiges of the legations have been completely obliterated by new government buildings. But if you stand in what was Legation Street (behind today's Capital Hotel), under the beautiful Chinese scholar trees so typical of Beijing, and close your eyes, you can imagine.

You can throw your mind back to those 55 days from June to August 1900 when 149 foreign women and their 79 children were part of that strange phenomenon known as the Siege of Peking, or the Siege of the Legations – an incident of the Boxer Uprising.

The story of the siege has often been told, and some of the many first-hand accounts published have been by women. But the general descriptions and analyses by historians have barely used the women's accounts, and they have certainly not told the women's story. Even the men who were there hardly mention the women. For some they were a nuisance; they had to be protected and got in the way, though sometimes, of course, they were an inspiration to fight bravely.

I have managed to identify the majority of the 149 foreign women as individuals and provide an alphabetical list of biographical details. There were diplomatic and officials' wives, missionary doctors, teachers and wives, and visitors passing through (known as 'globe-trotters'). There were also wives (and one mother) of railway engineers, merchants and bankers, and the extraordinary American wife of a Swiss hotel keeper. Among the other nationalities were women from Australia, Austria, Belgium, Britain, Canada, France, Germany, Italy, Japan, Norway, Russia, Sweden and Switzerland.

There are half chapters, too, on the siege of the North Cathedral in Peking, and that of the linked siege of Tientsin.

Once the women became individuals for me, rather than a mass labelled either ladies or women, they began to assume another, and distinctive, dimension. But how could they speak? I discovered that not only were there a few published accounts by women, but many unpublished diaries and letters. I have, therefore, tried not only to tell the women's story, but also to tell it from their point of view, allowing them, as often as possible, to speak for themselves.

Sometimes they simply describe the minutiae of female making-do under impossible circumstances; sometimes they take the reader into their grief at the death of a loved one. There were also opportunities to show physical as well as moral courage. Sisterhood was important, too, and humour; and in the hothouse of the siege – sometimes under bombardment for several days at a time – there were love affairs and attacks on womanly virtue.

But the women also kept themselves informed enough to detail and analyse events more generally, so that what has also emerged from these accounts is a body of evidence that often begins to give answers where previously there were loose ends or even confusion.

It has been less easy to tell the story of the Chinese women involved, mainly Christian converts, including well over a hundred schoolgirls. But there are glimpses among the foreign accounts and it was possible to pan diligently for a paragraph or a line here and there that could be used to build up a picture of some poignancy, for the Chinese women's position was even more helpless than that of the foreigners. They had not only been forced to leave their homes but also escaped massacre, sometimes badly injured, and their conditions during the siege were even worse than those of their foreign sisters. Their story contrasts with that of the Sisters of the Red Lantern whose magic supported the Boxers in their struggle to rid China of foreigners.

Fortunately for the drama of the story, the Chinese ruler who loomed over events was also a woman. Indeed, developing relations between the Empress Dowager Tz'u-hsi and diplomatic wives both before and after the siege have allowed a fresh examination of the dynamics of what happened. What is more, account has not previously been taken of the possible continuing effect this interchange may have had on relations between China and the West.

Although Chinese women, particularly the Empress Dowager, play some part here, and some Japanese women were also besieged, it is essentially the Siege of Peking through the eyes and words of Western women. In recording their story, I have not put them under a late twentieth-century microscope in order to find them wanting. That would be invidious on my part for I was brought up in the colonies (Kenya) and I have recently spent fifteen years in post-colonial Papua New Guinea and colonial Hong Kong. For me the Western women are sisters previously without a voice, not specimens.

While it has been possible for me to develop some conception of what was wrong with nineteenth-century colonialism and imperialism, most of them

had not had that opportunity. But it would be patronising to suggest there was no awareness, and unmistakeable signs emerge of an increasing consciousness, both personal and ethical, of issues concerning gender, race, class, politics and war; after all, they stared them in the face, and there was plenty of time to talk to other women across a range of experience.

Mostly, I leave it to the reader to make judgements and draw conclusions regarding the failings and moral responsibility of these women, as well as their virtues.

Previous histories of the siege have been partial, lopsided even. I believe, therefore, that this new version does more than add to the growing and essential body of women's history; it should also allow a more rounded and, thus, a truer picture of those bizarre but influential events of 100 years ago.

Oxford, March 2000

Acknowledgements

How a researcher 'discovers' relatives and 'lost' papers is worth a book of its own. One of the greatest pleasures of this research has been the forging of friendships, often with granddaughters. The following have been unfailingly patient and helpful, some of them for many years, others just as the manuscript was completed (the besieged women and children are in brackets): Susan Ballance (Ada and Violet Tours); Kate Ker (Lucy Ker); Anna Farthing (Paula von Rosthorn); Christopher and Fay Hutton-Williams (Charlotte Brent); Charmian and Cyril Cannon (Ann Brewitt-Taylor); Dr Linda Koo (Tong Pao Yue, Mrs Wellington Koo); Janet Smith Rhodes and Dorothea Smith Coryell (Sara, Grace and Dorothea Goodrich); Jacquelyne Kenderdine, Robert and Martha Steedman and Alice Green (Helen Myers Brazier, Annie Myers, Daisy Brazier and Helen Hope Brazier). Helen Hope Brazier Steedman was 6 months old at the start of the siege; she was nearly 100 when I met her – a supreme moment in my research. She died on her hundredth birthday. I thank them all specially.

The following have some direct connection with the story, the material or place and deserve thanks: Peter Fleming's daughter Kate Grimond and his deceased son Nichol Fleming; Professor Howard Mel, present owner of Annie Chamot's house, Inverness, Marin County. During and following my visit to the house I was also helped by Diane Bessell, Missy Patterson, Mark Sheff and Professor Kevin Starr. Zhao Yuhong helped me first find Legation Street.

Without translation help from the German, Russian and Japanese my task would have been impossible. I imposed on the following who cannot be adequately thanked: Miss Irma Steinitz, Yongmi Schibel, Igor Radivilov, Kiyohiro Yamakawa. Catherine Phillips deserves special thanks for research in Detroit on Maud von Ketteler.

These institutions have provided material and given me permission to quote or use illustrations, for which I thank them (individuals named have been particularly helpful): Archivio Storico, Ministry for Foreign Affairs, Rome (Paula Busonero); (University of Birmingham Archives (Philippa Bassett); Bodleian Library (Peter Allmond, Valerie Bate); Boltzmann Institute for Research on China and Southeast Asia, Vienna (Professor Gerd Kaminski); Bon Secours Cottage Health Services (Jan Duster); British Library (Moira Goff, Graham Hutt, Andrew Prescott); British Museum (Philip Attwood); Burns and Oates (Paul Burns); Burton Historical Collection, Detroit Public Library; University of California, Berkeley (William M. Roberts); California State Library (John Gonzales); Cambridge University Library (Godfrey Waller); Council for World Mission (Dr S. Andrew Morton); City Hall Library, Hong Kong; Detroit Public Library (John Gibson); Federation of Red Cross and Red Crescent Societies

(Grant Mitchell); Foreign and Commonwealth Library (Peter Bursey, Linda Mind); Herbert Hoover Library (Dwight M. Miller, Cindy Worrell); The Royal Commission on Historical Manuscripts; Hoover Institution (Ronald M. Bulatoff); Houghton Library, Harvard University (Susan Halpert, Leslie A. Morris); *Illustrated London News* (Elaine Hart); Italian Institute, London (Maria di Angelo); Kent State University Press (John T. Hubbell); Matheson and Company (Jeremy Brown); Mitchell Library, State Library of New South Wales (Martin Beckett); John Murray (Deborah Gill); National Army Museum Reading Room; National Library of Scotland (Olive M. Geddes); Nissan Institute of Japanese Studies, Oxford (Yuki Kissick); Public Record Office, Kew; Queen's University, Belfast (Mary Kelly); Reading University Library; Rhodes House, Oxford; San Francisco History Centre, Public Library (Christine Moretta); School of African and Oriental Studies (Lesley Price, Rosemary Seton, Emily Tarrant); School of Slavonic and East European Studies (Martin McCauley, Jill Squire); Sotheby's, London (Edward Playfair); State Archives, Munster (Irmgard Pelster); State Archives, Vienna; United Church Board for World Ministries, the United Church of Christ in the USA; United Society for the Propagation of the Gospel (Catherine Wakeling); University of Hong Kong Library (Y.C. Wan, Special Collection); Yale Divinity School Library (Joan Duffy, Martha Lund Smalley). At least one permission has proved impossible to obtain, for which I apologise.

These friends and scholars provided help for which I am most grateful: Keith Arrowsmith, Roger Birchall, Helen Brooks, Phillip Bruce, Chris Chien, Dr Choi Chi-cheung, Heidi Christein, the late P.D. Coates, Professor Paul A. Cohen, Professor Olga Crisp, Lyse Doucet, Professor William J. Duiker, Christopher Eimer, Jane Elliot, Professor Neil Gold, Dr J.E. Hoare, Dr Sabine Jacobi, Dr Maria Jaschok, Mary Jay, Andrew Knowles, David Mahoney, Fida Moledina, Vivienne Monk, Professor Ian Nish, Diana Piggott, Diana and Michael Preston, Dr Rosemary Quested, Roberto Guicciardini Corsi Salviati, Dr Elizabeth Sinn, The Reverend Carl T. Smith, Peggy and Seagrave Sterling, Susan Stratigos, Jane Taylor, Marina Warner, Michael Wilson, Pauline Woodroffe.

I thank Dr John Cairns specially for his help with reproducing illustrations from the Tours' folio. Dr Christopher Munn has, as usual, given constant support and Yu Jing has helped in ways that defy thanks. There are moments in the writing and publishing process when encouragement is most needed; I thank particularly Dr James Cantlie, Staci Ford, Professor Peter Wesley-Smith and Dr Frances Wood. I thank Ray Addicott who has managed the production of this book with patience, flair and kindliness. My deepest thanks, as always, go to my partner in writing, publishing and life, Derek Roebuck.

Author's Note

Most of the accounts quoted in this work use terms of romanisation for Chinese words that are closer to the Wade-Giles system than to the modern Pinyin one. The Wade-Giles sytem is, therefore, followed in the main text as far as possible. There are exceptions: common names and terms that are better known to English readers in other forms; quotations are left in the original, sometimes with other appropriate transliterations in brackets.

As well as the problems of transliteration, both choosing a satisfactory system and coping with inconsistencies in different accounts, there is some inconsistency in the spelling of people's English language names. Lowry is an obvious example. Dr Emma Martin spells it Lowrie and I have taken the liberty of changing it in her text since there is already confusion enough with two Mrs Lowrys and two husbands in different places.

In 1900, women still called each other by their titles and surnames; sometimes, therefore, it has not been possible to find out a woman's first name. But today we readily use first names. Where they are available, I have tried to devise a compromise – using sometimes title and surname, sometimes first name and surname and sometimes just first name – which may appear anachronistic but is intended to bring the women closer.

This variation is also to help identify the many characters in the story, the number of which is an obvious problem. Theodora is striking enough, for example, for me to use it as a marker for Mrs Inglis, sometimes by itself. For the same reason I have used another trick, which I would normally avoid: I have used recurring adjectives or short descriptions of women in the way that journalists do to remind the reader of what they might have forgotten. 'pregnant Bessie Ewing' or, where possible, a more subtle reminder, is an obvious example. I often refer to Deaconess Jessie Ransome for the same reason – as well as to make clear her status. I nearly always use titles for the women doctors; it not only helps to identify them, but also makes clear that, while they were acting as nurses in the siege hospital, they were qualified doctors.

There were women of many nationalities; usually, unless they are English-language speakers, I have used the diplomatic French 'Mme', but not always. 'America' was used more commonly than 'the United States'.

Tz'u-hsi is referred to as both Empress Dowager and Dowager Empress in quotations; though my instinct was towards the latter, I have taken advice and, therefore, in the text, use the former. Her contemporaries also referred to her as the Empress, though the Emperor's wife more accurately had claim to that title.

In the Acknowledgements I have thanked those who have translated for me from German, Russian and Japanese. The mistakes or inelegancies in the French and Italian are mine and, sometimes, I have to confess, I have fiddled with my translators' careful work!

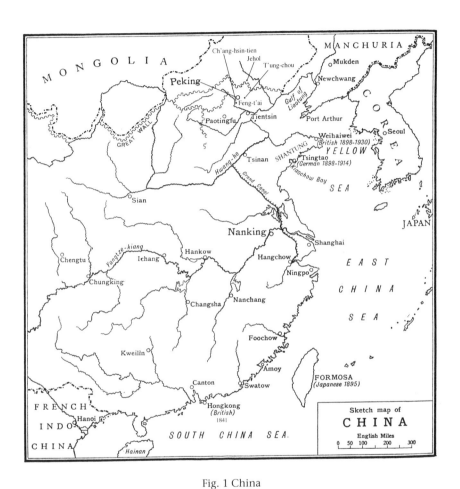

Fig. 1 China

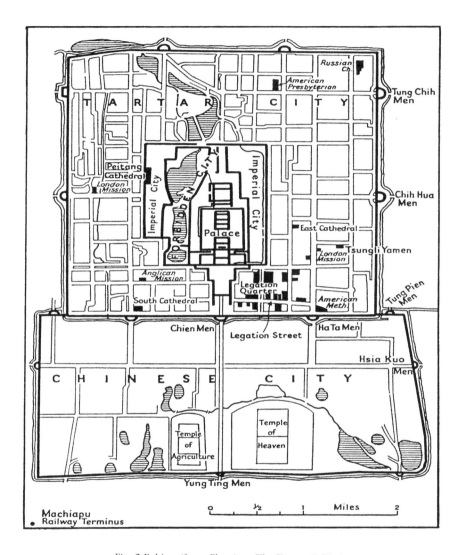

Fig. 2 Peking (from Fleming, *The Siege at Peking*)

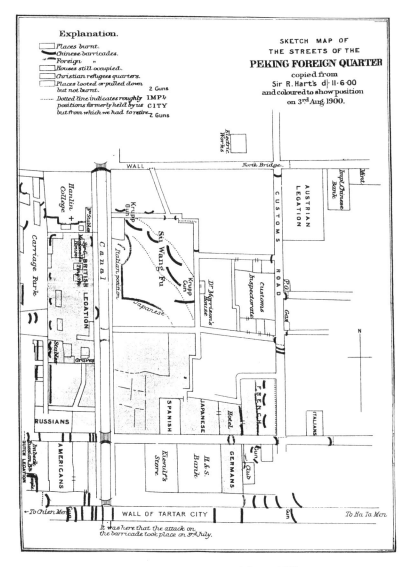

Fig. 3 Legation quarter, Peking, 1900
(from Oliphant's *Siege of the Legations in Peking*)

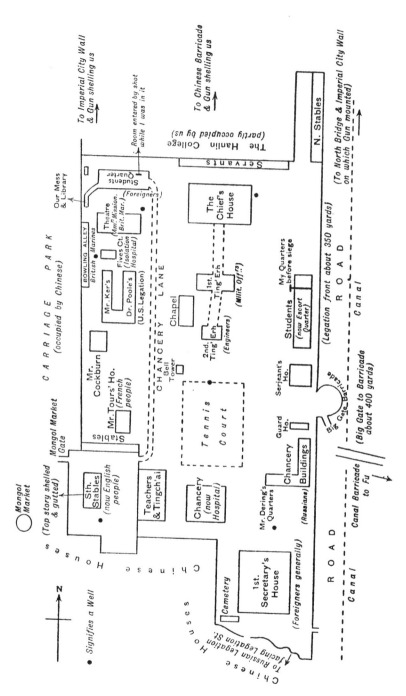

Fig. 4 British Legation, Peking, 7 July 1900
(from Hewlett's *Forty Years in China*)

Prologue: Meeting the Empress Dowager (1898)

'It is stated, and said to be true, the Empress Dowager had never seen a foreign lady,' wrote Sarah Pike Conger, wife of America's Minister to Peking, of December 1898, 'and that a foreign lady had never seen her'.[1] Indeed, the existence of the wives of the envoys had not even been acknowledged during the thirty-eight years that legations had been established at Peking.[2]

It was Lady MacDonald, the British Minister's wife, who had the idea of a meeting between the Empress Dowager Tz'u-hsi and women of the foreign legations, but it took two months of 'manoeuvring on the part of the Throne and the Diplomatic Corps' to bring it about.[3]

Sir Robert Hart, Inspector General of the foreign-run Chinese Maritime Customs and thirty years in China, gives a malicious but useful insight into these 'manoeuvrings' – at least on the diplomatic side – in a letter of 4 December:

> The ladies have not yet seen the Dowager Empress: first they were not ready the day HM wanted them to appear – then when the second appointed day came round they could not decide on one interpreter, each wanting her own (except Lady MacDonald) – then another difficulty came up as the Secs' wives and Ministers' daughters claimed to belong to the diplomatic corps and insisted on being received: and so the the visit is postponed *sine die* – another instance of the way international jealousies and individual crankiness shunt China on to a wrong line the moment she wants to get on the right one![4]

Sir Robert's tone may have been influenced by the fact that, although he had received from the Empress Dowager an award unprecedented for foreigners, he had, nevertheless, never met her. Forty-one-year-old Ethel MacDonald, who had been in Peking for two years and was doyenne of the diplomatic wives, gives a different slant in her account published in 1901:

1

The Empress was very curious to see us, but her Councillors objected strongly to this new and pro-foreign move, and tried in many ways to block our Audience by conceding as grudgingly as possible the stipulations made by our respective husbands that we should be received with every mark of respect. Some of the stipulations which we ladies insisted upon seemed exacting even to our husbands, and Prince Ching [the Emperor's Foreign Minister] said laughingly to mine at one of our meetings, that foreign wives seemed almost as difficult to please as Chinese. The negotiations lasted for about six weeks but we stood firm on all essential points and finally woman's curiosity proved stronger than man's opposition.[5]

Sir Claude MacDonald's dispatch after the event is the most revealing: it not only confirmed something of Robert Hart's analysis, it also showed how diplomatic Ethel MacDonald tended to be in print and suggests that what might be dismissed as petty jealousies among women had a deep undertow of international power politics. He wrote:

At the last moment Baroness Heyking, wife of the German Minister, who had shown much obstruction to all proposals, declared that she would not go without the Chinese Secretary of the German Legation as her interpreter, and Baron von Heyking wrote separately to the Tsungli Yamen [Chinese Foreign Office] to this effect. Her wish was acceded to.[6]

The differences on all sides were resolved, four European interpreters and two Chinese were chosen and, on 13 December at 10am, a mounted Chinese escort, sent by the Tsungli Yamen, went to each legation to escort the Ministers' wives to the British Legation. At 11am the party set out for the Winter Palace for an audience to celebrate Tz'u-hsi's sixty-fourth birthday. As Mrs Conger recounted, 'We formed quite a procession with our twelve chairs and sixty bearers.'[7]

After several formalities, the party of seven wives was ushered into the imperial presence: the twenty-seven-year-old Kuang-hsu Emperor and his aunt who was said to have ruled China in all but name since her husband's death in 1862.[8] Lady MacDonald noted that the Empress Dowager was 'watching our entrance with the keenest interest and no less keenly did we look at this formidable lady to whom is imputed such an iron will and unbending character'.[9]

Their first interchange came when the British Minister's wife read out a short address in English:

We rejoice that your Imperial Majesty has taken this first step towards a personal acquaintance with the ladies of Foreign nations. We venture to express the hope that your august example will be followed by the ladies of China, and that the peoples of the East and West will continue to draw nearer to each other in social intercourse. [10]

When the diplomatic wives had been presented to the Emperor, the Empress Dowager clasped the hands of each of them in hers and gave them presents, including a heavy gold and pearl ring.

At the banquet that followed, Lady MacDonald was placed next to Princess Ch'ing, 'a plain, elderly, shy woman', the wife of the Foreign Minister who sat separately, gravely smoking cigarettes and watching the party.[11] Then there was a further meeting with Tz'u-hsi at which she presented the young Empress

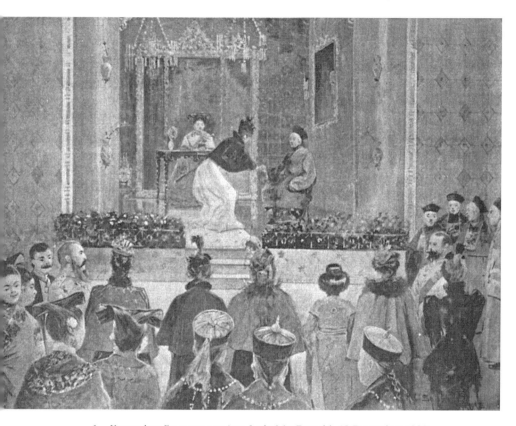

1 Kuang-hsu Emperor receives Lady MacDonald, 13 December 1898;
Empress Dowager above, other diplomatic wives below
(from *The Illustrated London News*, 18 March 1899)

to the foreign wives. Ethel MacDonald described her as 'a pretty wistful-faced little lady' who spoke not a word to anyone and quickly disappeared.[12] Sarah Conger wrote of the Empress Dowager that she was 'bright and happy and her face glowed with goodwill. There was no trace of cruelty to be seen.'[13] What is

more, 'She extended both hands towards each lady then, touching herself, said with much enthusiastic earnestness "one family; all one family".'

The visitors were led then to a theatrical performance which began to pall for Ethel MacDonald when she realised how cold and hungry she was. When they were taken to tea, although there were cakes and sweetmeats of all shapes and colours, the British woman noted, 'the cakes looked more appetising than they tasted ... I secretly longed for a cup of home tea and some humble bread and butter.'[14] In the final scene, the Empress Dowager returned for a third time to say goodbye and repeat her expression of unity.

Lady MacDonald starts her description of the diplomatic occasion with the memory that it was the 'bleakest, blackest, bitterest day ... that winter', but concludes that it was a 'memorable day'.[15] Fifty-five-year-old Sarah Conger, who had been in China since July, summed it up in the letter to her sister of 8 January 1899 as a 'wonderful dream-day'; they had been 'intoxicated with novelty and beauty'. 'Only think,' she continued, 'China, after centuries and

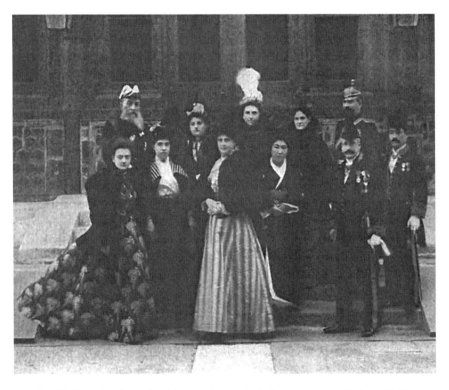

2 Diplomatic wives after 1898 Audience, including: Baroness Heyking (left),
Lady MacDonald (centre); (back row) Mme Pichon, Mme de Giers, Mrs Conger
(from *Letters from China*)

centuries of locked doors, has now set them ajar.'[16] The women returned to the British Legation and had a group photograph taken agreeing that 'It was a great day for China and the world.'

It was not only Mrs Conger and her diplomatic sisters who were impressed: her 'first boy' pronounced, 'Madame, much great thing come to you. Emperor come down from heaven. No foreign lady see him, few Chinese men. He came down from heaven. You very blessed.'[17]

1
Mrs Conger Tries to Understand China (1898–1900)

Tz'u-hsi's *coup d'état*

'23 September: ... This day the Empress Dowager resumed the reins of government. There are rumors that the Emperor is ill and that we shall soon hear of his death ...' wrote Mrs Conger in a diary contained within a letter home of 17 December 1898.[1] It is clear, therefore, that when the diplomatic wives met the Emperor, Empress and Empress Dowager on 13 December 1898 they did know about the *coup d'état* that had taken place three months earlier.

Sarah Conger had continued to follow the train of events:

26 September: There were six Chinese men beheaded at four o'clock this morning. These men are said to have been friends of the Emperor. Rumor says that the Emperor was planning to imprison and kill the Empress Dowager, that she heard of the plot, and that now she jointly rules with him by a compelled edict issued by himself ...

29 September: ... Many Chinese who are friends of Western customs and enterprise fled from the city, or hid away. The trouble seems to be that the Emperor and his advisers wish to adopt Western ideas, even to the discarding of long-time customs and cutting off the queue.

The rumours circulated not only in diplomatic circles; Bessie Ewing, sent with her husband to China in 1895 by the American Board of Commissioners for Foreign Missions (Congregational), wrote home from Peking in September 1898,

You have doubtless heard all the rumours that are current here. The young Emperor's plan for reform offended the Empress Dowager; she has made him a prisoner in a palace on a small island, and she continues to rule.[2]

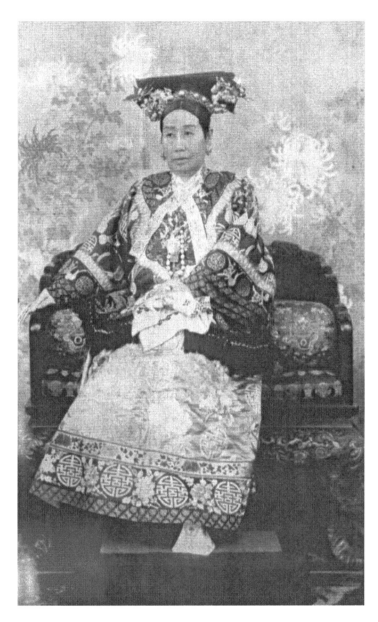

3 The Empress Dowager Tz'u-hsi
(from *Life and Times of the Emperors and Empresses*)

But, for all the knowledge available to foreigners, it was not possible then to appreciate the fuller story, nor the implications for the future; indeed, there is still uncertainty and contradiction over the facts even in more recent and informed accounts.[3]

The Empress Dowager, Tz'u-hsi, had started her original ascendancy as the concubine, or secondary consort, of the Hsien-feng Emperor of China between 1850 and 1861; she was his favourite and the mother of his only surviving son. Some accounts suggest that she even helped the Emperor with state papers, thus gaining access to the workings of Court and government. Hsien-feng died when their son was five and concubine mother and official empress became co-regents, Tz'u-hsi soon gaining supremacy. With her son's marriage, formal regency came to an end, but not her influence and by 1875 he, too, was dead.

Tz'u-hsi was responsible for the choice of her nephew (her step-sister's son) Kuang-hsu as successor. Although he came of age in 1887, she did not relinquish the regency until his marriage in 1889. Even then, she had chosen his wife, a cousin of his and a niece of hers, and continued to read State papers and appoint officials; moreover, the young woman she had chosen both disliked him and was in turn disliked by him. The Empress Hsiao-ting (later Lung-yu) has been unkindly described as 'severely buck-toothed, plain as a jackrabbit, and twice as thin', which hardly accords with Ethel MacDonald's perception of her as 'pretty' and 'wistful-faced' or, indeed, Sarah Conger's as 'beautiful'.[4] But then, Baroness von Ketteler, the German Minister's tall and lovely American wife, was to write of her in 1900, 'She is young, but plain, even for a Chinese.'[5] – contrasts which suggest that beauty is, indeed, in the eye of the beholder, and other impressions too. (See illustration on p. 343)

At the time of his marriage, a Chinese emperor was expected to take four secondary consorts; Tz'u-hsi chose two sisters – daughters of the Governor of Canton – for Kuang-hsu. One he disliked, the other, the more obviously pleasing Chen-fei, known to history as the Pearl Concubine, he loved. It was said that he was not able to fulfil the physical side of marriage but she was his best, and perhaps only, friend.

While physically weak and emotionally disturbed, Kuang-hsu was apparently intelligent and he came under the influence of a reforming party of whose members the best known to foreigners was the Cantonese K'ang Yu-wei. As a result, the Emperor, in the summer of 1898, began to institute a series of rapid reforms. In order to safeguard the issuing of the necessary edicts, he is said to have devised a scheme of temporarily isolating and restraining his aunt – a scheme which was probably distorted in the telling by those at Court wishing to manipulate the situation.

Whatever the truth of the Emperor's plan, the Empress Dowager believed there was a plot against her and left the Summer Palace, her place of semi-retirement, for the Forbidden City in Peking. Once again she took control. It is of these events that Sarah Conger and Bessie Ewing wrote.

Ostensibly the Emperor still ruled, but in reality he had no power and Tz'u-hsi was also persuaded that his successor should be chosen – a choice which moved a reactionary and influential Manchu family closer to the centre of power. Many sources suggest that the Emperor was imprisoned by his aunt on an island in the Forbidden City, but he was obviously wheeled out for public functions such as the audience with the legation wives: Ethel MacDonald noted, 'It was a pleasurable surprise to us all to find him taking part in the Audience, as we were told only the [Dowager] Empress was to receive us.'[6] And George Morrison, *The Times* (London) correspondent on the spot who was well, if often partisanly, informed, reports on 26 November that the Emperor was 'virtually' a prisoner within the palace, adding that 'the Empress presides over all meetings of the cabinet, sometimes seated beside the Emperor, sometimes by herself'.

Certainly the Emperor does appear to have been isolated from his favourite; the Pearl Concubine was separately confined – another outcome of Court manipulation; there is little doubt that the anti-reformers were now in the ascendancy. One story tells how on the fatal day of confrontation between the Emperor and his aunt, the Pearl Concubine knelt before Tz'u-hsi imploring her to spare the Emperor further reproaches: 'She actually dared to suggest that he was, after all, the lawful sovereign and that not even the Dowager Empress could set aside the Mandate of Heaven.'[7]

If the Emperor was deprived of his best friend, his wife, Tz'u-hsi's niece, with whom there was reciprocal animosity, was encouraged to stay close to him. And at least one source has it that fourteen eunuchs, the Emperor's personal attendants, were executed.[8] Many changes among high officials were made throughout the empire – often promoting Manchu; the implication was that the reformers were predominently Han Chinese and more concerned with the nation than the Manchu (Ch'ing) dynasty.

These events are more than background to the story of what was to follow nearly two years later because Westerners, as well as Western ideas, were strongly implicated in the Reform Movement of 1898 and its consequences.

The Emperor, circumscribed by his physical and mental constitution, Court life and the manipulators of power, channelled his energies into other areas, starting with Western mechanical toys and progressing to Western books and, thus, ideas. He not only began to learn English but also ordered books to be translated into Chinese. He read Shakespeare as well as the writings of missionaries to China. The latter had been free by law since 1860 to pursue their religious activities throughout China.

W.A.P. Martin wrote on international law, natural science and Christianity in both languages and was appointed president of the Imperial University set up in 1898 as part of the reforms which his writings fomented; and he and Arthur Smith – whose works were also translated – were still in Peking in 1900, together with Mrs Smith.

Such ideas were said by some to be inimical to the Empress Dowager or Old Buddha as she is often called; Der Ling, a later (1903) lady-in-waiting, was to write:

> Old Buddha had always hated foreigners. She had especially hated mission-aries who, she claimed, and righteously enough, had come to her country to reform it, despite the fact that there was probably plenty of opportunity for exercising their reformatory proclivities in their own country. Moreover, and facts were with her, the missionaries had caused untold suffering, much mis-understanding, in China.
>
> Naturally, then, she did not take kindly to the fact that there was a pos-sibility of Kwang Hsu becoming a Christian.[9]

During the Hundred Days of Reform and at the time of the September coup, the foreign legations were also implicated. Those six men whom Mrs Conger notes were beheaded had been in close touch with the Minister for Japan – a country deep in the process of reform through Western contact; the man foreigners saw as the leading reformist, K'ang Yu-wei, fled by way of Tientsin and was then helped to escape to Hong Kong by the British Consul in Shanghai and from there was given sanctuary in Japan; on the day of the coup itself, there was a rumour that the Emperor wished to take refuge in the Italian Legation, and another rumour had it that he had actually tried to gain admittance to the British Legation but been refused.[10]

Whatever the truth of the rumours, the British Minister, Sir Claude MacDonald, warned the Empress Dowager that he and his government would 'view with extreme disfavour' the execution of her nephew.[11] And, since there continued to be fears voiced that he had been put to death, the foreign Ministers insisted that one of their doctors should visit him – or, as MacDonald explained it to his government, he had suggested the idea gently as a way to calm unrest.[12] The Empress Dowager responded by issuing an edict asking for foreign doctors to visit the Emperor to see if they could detect the cause of his illness.[13]

More generally and longer term, since 1841 and the taking of Hong Kong and the forced opening up of five Chinese ports to foreign trade, the foreign powers had been nibbling away at the territorial integrity of China, and they were to continue to do so – a process which Claude MacDonald, who was a protag-onist, was to describe in 1914 as an 'unedifying scramble'.[14]

In 1858, Russia had seized territory north of the Amur River. Two years later, accusing China of violating the 1858 Treaty of Tientsin which followed another war, Britain and France took Peking, razing the Summer Palace in the process – an intrusion which led to the imposition of foreign legations in 1860. France then proceeded, over the next twenty-five years, to annex Annam and Cochin China; in 1886, Britain annexed Upper Burma and, in 1895, came the disastrous war against Japan. More recently, in 1897, Germany, taking the murder of two German missionaries as the pretext, took action which gave it a ninety-nine year

lease on Kiaochow Bay and the city of Tsingtao, only a hundred miles from Peking, and railway and mining concessions in Shantung. Russia leased Port Arthur in March 1898; France leased Kwangchowwan in the south in April, and Britain extended Hong Kong by leasing the New Territories in June, and signed the lease on Weihaiwei on 1 July.

Exposing Refined European Womanhood

Why then had the Empress Dowager agreed to receive the Ministers' wives that December? She was certainly subject to the severest public condemnation: from abroad, K'ang Yu-wei railed against her 'usurpation of the imperial power' and described her as the successor to 'those vile and licentious ancient Empresses Lu and Wu'.[15] He also accused her of earlier poisoning the Empresses of her husband and son. His open letter ended, 'If this could be clearly set forth in the Chinese and foreign newspapers and be published to the world, I verily believe ... some hero must surely arise to avenge our sovereign.'

Dr Mariam Headland, an American who attended the imperial princesses for some years before and after these events, speculates on reasons for the audience:

> It may have been to ascertain how the foreign governments would treat her who had been reported to have calmly ousted 'their great and good friend the Emperor,' to whom their ministers were accredited. Or it may have been that she hoped by this stroke of diplomacy to gain some measure of recognition as head of the government. She would at least see how she was regarded.[16]

The American traveller and writer Eliza Scidmore is less equivocal in *China, the Long Lived Empire* published two years later: 'When the diplomats came out of (their) trance they found that the audience of the foreign ladies, so thrust upon the Dowager Empress, was construed as an official recognition of the usurper.'[17]

While it is worth remembering that the Empress Dowager had responded positively to the idea of such a meeting some time before the hasty reform period or the coup, Western officials certainly had occasion to reassess their reading of her as a result. Lady MacDonald was to write, 'I should say the Dowager-Empress was a woman of some strength of character, certainly genial and kindly ... This is the opinion of all the ladies who accompanied me.'[18] And she 'particularly noticed that all her ladies and courtiers appeared quite at their ease in her presence, and talked to each other, perhaps in slightly lowered tones, but as if quite accustomed to her presence and in no way intimidated by her'.[19] More formally, her husband wrote in his dispatch that the audience marked

> Another step in the nearer relations of China and foreign nations. I venture to think that the affair will have a very good effect in giving the world a better opinion of the personality and character of the Empress Dowager. Her Majesty has been made the subject of virulent abuse in the press as an anti-

foreigner of the most rabid kind. Something has been done to counteract this impression.[20]

Given that the audience was rather more complicated than it appeared, it is hardly surprising that the foreign news editor should write from London to *The Times* correspondent in Peking, George Morrison:

> I am bound to say that nothing has yet happened to shake my belief that the downfall of the reformers has been detrimental to our [British] interests. Not even the reception of the ladies of the *corps Diplomatique*! I confess it went very much against my grain to have the incident dealt with as civilly as we [*The Times*] did last night. To begin with I feel very strongly about exposing the representatives of refined European womanhood to the ribald jests of Palace Eunuchs and the offensive curiosity of Chinese Mandarins, who will of course represent the ceremony as a great *kowtow* before the Empress and the Empress's party.[21]

In the report thus criticised by his colleague, Morrison had also written that the Empress Dowager embraced the foreign women in an 'outburst of womanly emotion', and that she playfully patted Lady MacDonald's cheek.[22] These touches were undoubtedly an attempt to neutralise the diplomatic event through gender stereotyping; but Ethel MacDonald was said to be most appealing by all who ever met her and if such an unlikely gesture really took place – it would not have been mentioned by either diplomatic wife who published an account – it provides an interesting foil to what was perhaps the least appreciative and most personal comment on the diplomatic women's audience.

Lord Charles Beresford had turned up in Peking in October 1898 and been taken into the British Legation as a guest. Beresford was a naval man, an aide de camp to Queen Victoria, and a Member of Parliament who, under the auspices of the Associated Chambers of Commerce, had come on a mission to regularise the prospects for British investment in China and offer the Chinese armed forces the benefit of British (mostly his) expertise. He later wrote about his visit and his erstwhile hosts to George Morrison – the repository of all gossip, the more critical the better:

> You know how amazingly well I got on with all the Chinese Viceroys, Mandarins and Officials, as well as with the traders of all nations. If Sir Claude MacDonald had interested himself in trying to get me an audience with the Emperor and Empress instead of thinking that it would redound to British welfare, if Lady MacDonald were to have an interview in place of the British Representative of trade and commerce, I believe something might have been managed.[23]

4 Sir Claude and Lady MacDonald (courtesy of Susan Ballance)

Beresford left China ten days after Lady MacDonald's audience; he was to spell out his feelings two years later. What was to happen in between may seem to underline only too clearly the lack of awareness of the Chinese political scene among the diplomatic community epitomised by the MacDonalds and Sarah Conger. And yet a question demands to be asked at this stage, a marker to be later explored: which of the potential meetings – with the diplomatic wives or Lord Charles Beresford – best justified the British Minister's efforts?

And whatever gaps there were in contemporary awareness, Sarah Conger's earlier letter about the coup contains some essential knowledge of what was going on in the countryside and then of its spread to the city:

> September 20: It seems wise to return to the city [from the cool Western hills] and stay there, as rumors of unrest are coming in from different parts of the country, and Mr Conger thinks it best to be at headquarters.

> September 30: Foreigners were attacked by a mob on their way from the railway station. Some of the Legation people and several missionaries were in trouble ... We soon learned of others who had been attacked ... The British, Russian, Japanese, French, German, Italian, Austrian and American Ministers asked their governments for legation guards and the requests were granted. The outbreaks are against foreigners in general. The mob cries: 'Foreign Devils' 'Kill!' 'Kill!'[24]

Claude MacDonald's telegraph to London reported that an unnamed Englishwoman was 'severely attacked with mud and stones'.[25] The suggestion that legation guards be brought in as a result was hotly contested in Peking and by the Chinese Minister to London since the implication that the Chinese government itself could not offer protection was an unacceptable slur.

The Italian Chargé d'Affaire's wife experienced a particularly frightening incident, and her husband was unyielding in his reaction. The Marchesa Salvago Raggi had been returning from visiting a nun attached to the main Roman Catholic Cathdral (Pei-t'ang) when her sedan chair was set upon by a crowd who wanted to beat the foreign woman up. In spite of the resistance of her bearers, the crowd succeeded in bringing the chair to a halt. The *mafoo* (grooms) following before and behind on horseback, dashed through the crowd and were able to force a passage, at the same time protecting Camilla Salvago from the blows.

The Marchese (then only a Second Secretary, though acting as Chargé) wrote to the Tsungli Yamen suggesting that 'Such incidents as this and the others should not occur in a city that claimed to be civilised.'[26] When a Yamen Secretary called on him to apologise, the Marchese protested that he was not sufficiently senior to be received. Even when a Minister called the following day, the row rumbled on with threats of marines from the *Marco Polo* anchored off Taku. Ironically, the more widespread disturbances and the Court's action

were not then directly connected but, by 1900, they were to become so. The clue to this progressive harnessing of events is provided again by Mrs Conger's diary of 6 October:

> The word has gone out to the common people that the Emperor is a friend to Western ideas, and is adopting them too rapidly, and that Western nations are coming in upon China to divide her among them. This has aroused the Chinese to drive all the foreigners from their country. The Empress Dowager is regarded as a strong character.[27]

From the Spring of 1898, gangs of youths had started congregating in the province of Shantung, so recently the scene of German territorial acquisition and now of railway and mining activity. Initially, the gangs indulged in frenzied rituals of chanting, signs in the dust, invoking of spirits and callisthenic exercises, or shadow boxing.

Soon, tales of invulnerability became common and literature began to circulate with sentiments such as:

> The scandalous conduct of Christians and barbarians is irritating our Gods and Geniuses, hence the scourges we are now suffering ... The iron roads and iron carriages [railways] are disturbing the terrestrial dragon and are destroying the earth's beneficial influences ... The missionaries extract the eyes, marrow and head of the dead in order to make medicaments ... As for the children received in orphanages, they are killed and their intestines used to change lead into silver and to make precious remedies.[28]

Some of this material was not new; when anti-foreign riots took place in Szechuan in 1895, the following was plastered over the walls of Chengtu:

> Notice is hereby given that at present 'foreign barbarians' are hiring evil characters to steal small children that they may extract oil for their use. I have a female servant named Li who has personally seen this done. I therefore exhort you good people not to allow your children to go out.[29]

In the countryside, missionaries and other foreigners were becoming increasingly aware, as time passed, of hostile developments. Alicia Little, wife of the British entrepreneur in China Archibald Little, and herself a keen observer and writer about the Chinese Empire and its mores, noted that 'There were four thousand [Chinese] Roman Catholic refugees in Chungking in the Summer of 1898. Not a few have been killed.'[30]

Lady MacDonald's Gilded Cage

But in Peking, among the diplomatic community, once the fallout from the *coup d'état* had subsided, life continued much as before: the foreign representatives jostled with each other in their dealings with the Foreign Ministry of the

Chinese government while socialising with their peers and their families and with visitors sometimes referred to as 'globe-trotters'.

The diplomatic women pursued the activities that made living in Peking more bearable. Sarah Conger describes summer visits to the legation temples (walled compounds) in the cool Western Hills, long early morning rides outside the Peking legation with her husband, and walks along the city wall – 44ft (15 metres) high, 34ft (11 metres) wide at the top – which ran just behind it; but a foreign woman had to be accompanied at least by a *mafoo* and might be accosted by disconcertingly persistent beggars. 'I am not afraid of the Chinese', Mrs Conger wrote firmly.[31]

There is an image of Ethel MacDonald (sometimes described as 'Lady Chief') remembered later by a student interpreter who arrived at about this time, which gives a rosy view of one aspect of her life:

> Behind the screening walls the British Legation rests in its own tranquillity. The red pillars of the ting'rhs [pavilions], the snowy lawns, the rambling old palace housing the minister and a modest staff. Inside the doors a sudden warmth, the warmth of forty fires, and the scent of Chinese winter blossoms. A hall of carved open panels backed with red brocade, and in the centre a round table laid for tea. At the head Lady MacDonald, dispensing cakes and honey after a choir practice in the chapel. All the homely grace of an English country house, with a hostess, a presiding genius, who seemed and proved adequate to every occasion.[32]

But Lady Blake, wife of Hong Kong's Governor, an equal with whom Ethel MacDonald could forget that she was a diplomat's wife, noted following her visit to Peking in the Spring of 1900:

> [She] spoke of the Legation as her 'gilded cage' and such indeed it seems. Anything more horrible as a place of residence than Pekin, I should say it would be difficult to find. The British Legation was in a street in which most of the embassies were situated. Once outside the walls the abominations of the city were in full force. The road was horrible, a mass of ruts, either ankle deep in dust or mud, according to the weather. It was bordered by a canal, which save for a foetid puddle here and there, was usually dry, and its bed served as a dumping ground for all adjacent nastiness.[33]

Women who had lived longer in China tended to be less critical: Alicia Little, who had known Chengtu and Shanghai well for some years, wrote of a visit to Peking at about this time, 'On returning from Peking I still thought it the most wonderful place I had ever visited.'[34] She does mention, though, that 'every whiff of air we breathed assured us we were in the pre-sanitary period'. And this atmosphere undoubtedly had its effect on the health of foreign residents; Bessie Ewing's husband wrote home somewhat contradictorily, though soothingly, in November 1898,

In spite of considerable sickness since she has been in China, and especially during the past year, when she had a prolonged tho not very serious seige with pleurisy, I think it is fair to say that on the whole her health has not deteriorated noticeably in these four years.[35]

Activists such as Alicia Little, who had established the anti-footbinding campaign in 1895, and missionaries like Bessie Ewing, knew something of what went on outside the gilded cage; more transient diplomatic wives, as often as they were able, broke out, sometimes to have brought home to them the position of Chinese women less privileged than themselves. In December 1898,

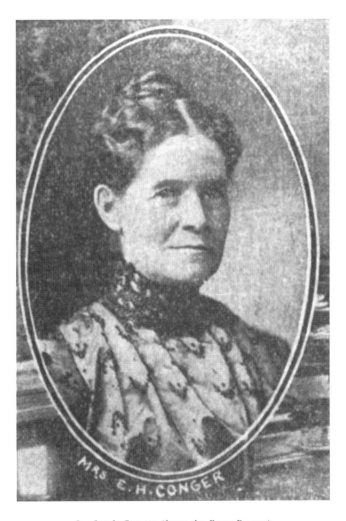

5 Sarah Conger (from the Fenn Papers)

Sarah Conger wrote home about a visit she had made to the Women's Winter Refuge – a home for aged, destitute women without relatives. She was accompanied by Mrs Mary Gamewell of the American Methodist Mission, who had been in Chungking during anti-foreign riots there in 1886.

Mrs Conger was vice-president, and Lady MacDonald president of the association that was responsible for the home; a German legation wife was secretary and Helen Brazier, whose husband worked for Robert Hart's Chinese Customs Service, was treasurer. They formed the finance committee which raised money for the home. On the executive committee which did the work of the association were representatives of most of the foreign religious missions in Peking; Frances Scott, wife of the Bishop of North China, was one of these.

Later that month, Sarah Conger and her daughter Laura and niece Mary Pierce visited a Methodist Mission Sunday School. The church was filled with seven hundred or so; in the classes boys and men were taught by Chinese Christian boys and men; the girls and women were taught by girls and women.

In June 1899, after months of careful negotiation, Sarah Conger was invited to meet the wife and other women relatives of Viceroy Li Hung-chang, who had been in charge of the Tsungli Yamen until dismissed by the Emperor at the height of his reforms the previous year, and the visit was later returned by Li's daughter and daughter-in-law; the Congers were told that these women had never before visited a foreign home.[36]

Mrs Conger, a Christian Scientist, has been painted as somewhat dour and eccentric and derided for her sanguine views on China and the Chinese but, in these ways, she was trying to understand what she called 'this strange, strange old country'.[37] In a letter written to a niece a week after the meeting with the Empress Dowager, she noted sympathetically and, in a sense in contradiction to the work of the missionaries that she supported, and that of her husband and his colleagues:

> The Chinese are not a warlike people; they wish to be let alone and have no desire to intermingle with other nations. They wish to live, to die, and to be buried in their own land and under their own Dragon flag. I will not write you about China's treaties with other nations, her opium war, and other earlier and later wars, her political career with its bright and cloudy days, and how she is treated by foreigners. You can read and reread of these things in many books. But I will try to portray for you in my letters what I see, and my impressions. Perhaps you can read between the lines and catch many ideas that I do not write.[38]

And two months later she wrote to a nephew in words which he had no need to interpret:

> I do not wonder that the Chinese hate the foreigner. The foreigner is frequently severe and exacting in this Empire which is not his own. He often

treats the Chinese as though they were dogs and had no rights whatever – no wonder that they growl and sometimes bite.[39]

Over the next eighteen months, the growling was to become louder and then came the time of biting. Sarah Conger, her daughter Laura and niece Mary Pierce, Ethel MacDonald and her daughters Ivy and Stella, Helen Brazier and her extended family, Bessie Ewing and her daughters Marion and Ellen, Mary Gamewell, Emma Smith, Maud von Ketteler, Camilla Salvago Raggi and Mesdames de Giers and Pichon were all to be involved. Frances Scott was to be stranded in Tientsin and besieged there.

2
Annie Chamot to the Rescue
(15–29 May 1900)

Dr Emma Martin Arrives in China

'There come the foreign devils, that's why we don't have any rain,' was the greeting Dr Emma Martin and her sister Lizzie received when they arrived in Tientsin on 15 May 1900.[1]

But the following day, as they travelled by train to Peking with fellow missionaries Mr and Mrs Walker, they gained a different impression of China. 'The Chinaman wanted to smoke,' wrote Emma in a letter home, 'almost all do – but he first asked Mr Walker if the ladies like smoke; he told them we did not so they went to another car acting much more courteous than many Americans'.[2]

The foreign-built railway line from Tientsin to Peking was relatively new – Lady MacDonald had been the first woman not to make the tedious journey mainly by river – and people by the wayside were both curious and apparently hostile. 'Whenever our train stopped,' Emma continued, 'a crowd of natives would gather round the windows and look in also say things about us and then laugh. We are not accustomed to being made fun of, nevertheless we are learning to go ahead and never mind.'

When they reached the Methodist Mission compound in Peking on 16 May, however, they could not mistake their welcome. Mrs Gamewell and Mrs Ed Lowry were there to greet them, and how Emma writes of her fellow woman doctor (who had been in China for fifteen years) in her diary shows an immediate bond: 'I had always thought of Dr Gloss as having dark eyes and black hair and was surprised to find the opposite. She seemed lively and energetic and practical and I was sure I would like her.'[3]

The following day, the newcomers started to learn Chinese, and on the 18th, when Mrs Gamewell and Dr Gloss went away, Dr George Lowry, who taught medicine at the university, took over Anna Gloss's clinic and had occasion to call for Emma Martin's help; now she was to begin to come to grips with the

6 Dr Emma E. Martin and Lizzie E. Martin (from *Siege Days*)

real China and the work she had come from Indiana (after five years' medical training) to do:

> A woman had been brought in who had attempted to commit suicide by cutting her throat. The skin was cut thro and the smaller blood vessels and her clothes were all bloody. She was on the table when I went in and her family about her. The old mother-in-law got down on her knees in front of me begging me to save the life of her daughter. The young woman lay there and said she did not want to get well that she would throw herself in the river if she did get well. The old mother-in-law wanted her to get well because if she died her spirit would come back and haunt her. Not because she loved the girl. The poor thing made no fuss but the tears just rolled down. I gave the anaesthetic while Dr George and Dr Tsou, his assistant, sewed the wound up. I said, 'Why don't you ask them how this happened', and he said that there's no use, you could not believe anything they tell you. Dr Tsou said bitterly, 'A pity it was not a bit deeper' and I thot – you awful man – but in the weeks to come when I knew more of the woes of heathenism I understood what he meant and would have thot so too had it not been for the hope that in some way she might hear the gospel. How my heart ached for her but I couldn't say a word to her.[4]

On their first Sunday in Peking, Mary Gamewell took the Martin sisters to the school to which she had taken the American Minister's wife Sarah Conger 18 months before, where Chinese Christian converts taught their fellows. But, whereas 6 months previously they had 12 to 1500 trying to attend when there was only room for 800, that day there were only 271. 'They are afraid to come because of the anti foreign feeling', noted Emma.[5]

Soon the thirty-year-old doctor began to yearn for exercise. She too discovered that you could only walk along the top of the city wall accompanied but the mission did have two ponies. Mrs Jewell, principal of the girls' school, liked to ride in the evening, and Dr Gloss in the morning. So Emma borrowed Anna Gloss's riding habit and set off with Dr George Lowry, passing through the nearby Hata Gate (Ha-ta-men) which led out of the Tartar city in which most of the foreign missionary compounds and legations were situated.

And now Emma Martin had an experience which began to prepare her for the weeks that were to follow; she recorded it in some detail in her diary:

> [We] were passing single file thro' the usual crowd of idlers and beggars, when an ugly scoundrel sprang up and seized my pony by the bits and frightened my pony (say nothing of myself) and he reared and plunged and would have run off if he could. I gave myself up for lost and in that moment the best I could hope for was a Chinese dungeon and Chinese food. The wretch put his hand out as if to pull me from my horse when another man rushed out and the world began to turn around, when a cool voice said at my elbow, 'Never mind him, Doctor, keep your seat' and I had my self possession again instantly.[6]

Dr Lowry set about the assailant with his riding crop, driving him off and reassuring Emma that the man was crazy – 'but I hardly think so', she noted. Then when it was all over she continued,

> I was so glad I did not scream. I did not say anything till we were on the stone bridge and then I laughed (hysterically) and remarked that it was quite an adventure and he said, 'Yes, such things relieve the monotony of living'. He said he hoped I was not frightened and I said no not much, but where would I have been if it had not been for his courage and wit – and he said I would not have been there in the first place ...

They continued their ride and Emma saw for herself the condition of Northern China and its people that summer:

> We rode out along the old canal bank where the green reeds grew and saw boats drawn by men walking along the shore and saw a large flock of Peking ducks and many shrines. The country away from the canal bank was dry and brown because of the long drought – no rain since last August. Everything green was covered with dust and the ground the color of ashes. The poor people had cut off the stubble and weeds close to the ground to use for fuel. The sheep we saw were poorly fed, the hogs scrawny and the camels lean, and lank, and half shed, the trees stunted and crooked and just everything seemed poverty stricken. Before we reached home Dr Lowry suggested that we not tell the ladies our adventure as they might be afraid to go out hereafter and that such a thing might never happen again.[7]

He offered to accompany her again any time she wished but, as it happens, it was to be Emma Martin's last trip outside the city for a while.

Deaconess Jessie Ransome is Overworked

Sister Jessie Ransome, a deaconess of the Church of England's North China Mission, was not a qualified doctor like Anna Gloss and Emma Martin, but she had received some nursing training and had growing medical experience; as she wrote home to England that same day, 26 May, 'I am busy with all sorts of jobs now, we are so dreadfully short handed I superintend the dispensary every day, among other things, and have to undertake all sorts of doctors' jobs.'[8]

Forty-three-year-old Jessie had been in Peking for four years, she and her younger sister Deaconess Edith (who had joined her in 1898) running St Faith's school for girls. One of the reasons for her overwork was that her colleague Marian Lambert, a trained nurse, was constantly called away from her missionary duties towards the Chinese by members of the foreign community who needed nursing. But Jessie was writing that day mainly to reassure:

> I am afraid you may be disquieted by many wild rumours about us at home. The country is no doubt disturbed but there are great exaggerations. We meanwhile go quietly on with our day's work and feel quite safe and happy in the protection which is above and around us. No real harm can happen, even if our lives were taken, and that does not seem at all likely. The poor people are in such terrible poverty, owing greatly to long continued drought, that they are rebellious for want of food more than any real hostility in very many cases, and if we had some rain they would probably go peaceably back to their fields.
>
> The greater number of our school girls have just gone to their homes for three months' holiday, and we only have a few little homeless waifs left. Edith is probably going to take them out to St Hilary's this week for a little country air and play. We have a trustworthy old Chinese widow who will take charge of them, so they will not weigh on her.

Polly Condit Smith's First Adventure

Not everyone was working that Saturday; a diplomatic party had set out for the Western Hills where the American Legation had its summer pagoda 'built on a most wonderful natural shelf of mountain side', as Polly Condit Smith described it.[9] Polly was a twenty-three-year-old globe-trotter – a rich young woman, niece of an American High Court judge, on a round-the-world tour – who had come from staying in Tokyo with her sister and diplomatic brother-in-law, to be the guest for a month of Harriet Squiers, wife of the Legation's First Secretary.[10]

The party consisted of Polly, Harriet (granddaughter of John Jacob Astor), her husband, their three sons, and one of their governesses, Mademoiselle. From their perch, Polly wrote, 'we could see the Dowager Empress's Summer Palace grounds spread out below us like a toy garden, with its wonderful landscape effects and its series of artificial waterways'.[11] Foreigners liked to repeat the suggestion that Tz'u-hsi had built the beautiful palace, a replacement for the one burnt down by the British and French in 1859, with the money intended for the navy – thus leading directly to China's defeat by Japan in 1895. They could also see, to the West, the Feng-t'ai station of the Peking–Paotingfu Railway, 'winding through the valley below like a piece of grey thread'. Herbert Squiers returned to the legation on Sunday; as he left, Polly noted,

> He tells us daily that the Boxers become more daring, but the diplomats and people in general put these things down to the usual spring riots which yearly seize Peking and are due to hunger and disease, prevalent among the poorer classes after a long, hard winter.[12]

As Squiers left, so Clara, the family's German governess, returned from shopping in Peking. Polly recorded that Clara had a slightly less optimistic story: '[She] tells us that all the natives she passed seemed to be armed, and that in all the temple enclosures companies of Chinese were being drilled.'[13]

On 28 May, as the women looked down from their eyrie, they saw that the 'railroad station at Feng-tai with its foreign settlement was burning'.[14] There was thick smoke, clearly discernable flames and the steel bridge had collapsed. Their own guard of twelve Chinese soldiers had also quietly melted away and the servants told the party that it was the Boxers who were responsible and that, having dealt with Feng-t'ai, 'the mob will surely sack this foreign-devil temple'.

As Polly wrote in what was the typical light touch of her character and 'siege' book:

> Our position now, to say the least, was critical. Not a foreign man on the place to protect us; a quantity of badly frightened Chinese servants to reassure; three children, their governesses, and ourselves to make plans for. We did what women always have to do – we waited.

It was *The Times* correspondent who was to come to the rescue of the women – a courageous move that gives an opportunity to put him in a context that up till now has only been hinted at.

The Australian George Morrison, six years in China, was to be regarded as one of the main heroes of the siege and his 30,000 word account of it in *The Times* over three days in October 1900 as a masterly work of reportage. It is not possible to discount his physical courage, nor even the moral stand he was to take with regard to the Chinese Christian refugees; but his gathering and use of information has since been questioned,[15] and anyone who reads his barely

legible diary must be shocked by his private attitudes – of racism, not so much against Chinese as against Jews, of misogyny, and of vindictive prurience; very few were safe. Two of those who were deceived by Morrison's gallant manner were Polly Condit Smith who praised him as a hero in her book, and Harriet Squiers who thought he was a friend.

Morrison had met Polly ten days earlier when he called on the American Legation on his usual round of the traps to gather information. That evening

7 Polly Condit Smith (from *Behind the Scenes in Peking*)

he described her to his diary as 'fat and gushing'.[16] Poor Polly, whom other accounts describe as 'beautiful', and who was certainly lively: five days later, seated next to him at a dinner party at Robert Hart's she could not restrain herself from saying coquettishly to Morrison that the 'IG [Inspector General] has just said to me "Have you observed to whom I have seated you next? That is the cleverest man in Peking."'[17] She had probably earned half her sobriquet – though others were much to appreciate her vivaciousness in the weeks to come.

On 29 May Morrison had been to burning Feng-t'ai on the hunt for a story and was on his way back to cable London with it when he remembered the American party in the Western Hills; he immediately turned his horse towards them and his arrival was much appreciated. As he studied how he was to defend the women, Herbert Squiers, and a Cossack he had borrowed from the Russian Legation, arrived and the forty Chinese servants rallied round. The party left at 6am the following morning and by 10.30 they had travelled unharmed in a cavalcade of cart, horse, and mule the fifteen miles to the American Legation.

Dr Lillie Saville Plays Tennis and Tends Silkworms

Thirty-one-year-old Lillie Saville – a qualified doctor, trained at the London School of Medicine for Women – had been in Peking for five years with the London Missionary Society (LMS) which had two compounds in the Tartar City, one in the West, the other in the East close to other foreigners.

Back at the West Compound on 25 May from the LMS annual conference in Tientsin, Lillie noted that the 28th was the feast day of the City god which was to be carried through the streets. 'The air had been thick with rumours for weeks past', she was to write. 'Christians were to be massacred, their homes pillaged, the Foreigners to be driven out or murdered. ...'[18] But, as Lillie realised, the best thing for everyone was to 'go on with the ordinary occupations of daily life'. Attendances at church and at the dispensary had fallen off, but there was still work and at 4 o'clock 'regulation tennis'.

Everything seemed so peaceful that she wondered how there could possibly be trouble; but she was alert: 'Was hearing rather quicker than usual?' she asked,

> Or was there really more noise? But that was natural when the City god was about to make his procession through the City. The day was hot and sultry, thunder was rolling in the distance, and ere long bright lightning flashes warned us of the coming storm; our pretence at light-heartedly playing tennis so as to help our Chinese Christians to keep calm, might with all fairness be given up. Then the thunder-clouds burst, and the heavens poured forth their waters. We knew the crowds must disperse; no Chinese mob, however evil-disposed, can stand heavy rain. We were saved for that day.[19]

In the midst of the storm came the first consignment of strawberries from the American Congregational mission (ABCFM) at T'ung-chou, twelve miles from the City. The American Board missionaries had made quite an industry of their strawberry growing and their order book was filled for the Summer though, as Lillie Saville asked herself, 'Shall we be able to stay here all the summer to receive them?' Then came a note from a friend in the East City four miles distant telling her that Feng-t'ai station had been burnt, and that they were cut off from Tientsin.

The following day, the implications of what was happening were brought home to Dr Saville most poignantly:

> ...I was sitting working with my teacher, when a small school-boy came in. In his hand he had my tray full of silkworms, and a small box of cocoons already spun. He had been custodian of my silkworms while I was absent on a visit to Tientsin shortly before, and had wished on my return to feed them still for me. He handed me the tray saying he wished to return home. 'Why?' I asked in surprise. 'I am going home.' 'Going home! what for?' 'Oh, the Boxers are coming. All the boys are afraid to stay; we all mean to go ...'[20]

The Bishop's Wife Tempted by Anxiety

But what could the missionaries do? Forty-seven-year-old Frances Scott was the wife of the Anglican Bishop of North China (a colleague of Deaconesses Jessie and Edith Ransome) who was away on a six-week tour of his diocese. She castigated herself in a letter home of the 28th: 'I do feel as one grows older, what a temptation anxiety is.'[21] Then she continued as bravely as she could:

> We are in a condition of dangerous excitement, and the crisis must come, and any day. The Ministers [diplomats] are worried to death. The massacre of Roman Christians has roused the French, and all are united in begging Foreign Guards. At present the Chinese government refuse, and troops would have to fight their way in. This is the natural result of the reactionary movement, and it must end in the break-up of China. But there may be bad times first. I hope my husband will be back now in a week's time. I want him badly. My house was burgled last night, and several valuable things stolen. My linen is partly gone. But these are trifles if we get through without an emeute [disturbance].

Deaconess Edith has Malaria

In the midst of all the wider happenings and fears, forty-two-year-old Edith Ransome had come down with malaria. On the evening of 28 May, the doctor ordered her 'to be put into a violent perspiration'.[22] Just then, a message came from the British Legation inviting them all to go into the compound, as no

one knew what might happen that night – particularly since news of the burning of Feng-t'ai station had just been received.

But the group of Anglican missionaries could not leave their people, even though, fortunately, there were only six schoolgirls left. It was decided that Mrs Scott, Nurse Lambert, and Edith should go; Jessie and their colleague the Reverend Roland Allen would stay. Indeed, Allen was later to write of the occasion, 'I kept one deaconess, who indeed would have refused to go, to look after the Chinese women and children who yet remained under our care'.[23] As Marian Lambert wrote to England the following day, 'We wrapped [Edith] in an eider-down etc. and put her into the cart, and Mrs Scott and I squeezed in as well, bringing with us a few valuables.'[24]

The Legation was full, including some LMS missionaries; indeed, so full was the MacDonalds' house that, as Edith later wrote,

'Lady MacDonald arranged for me and Miss Lambert to have Sir Claude's dressing room, so I was promptly put to bed there. Poor Sir Claude was in no end of a dilemma – stumbling into one room, he found one lady saying her prayers – not allowed to go into his dressing room, because I was there – 'Not a room without a woman in it!'[25]

Miss Smith Calms Things Down

In the East City, nearer to the foreign Community, Dr Saville's colleague, Georgina Smith, was in charge of the LMS girls' boarding school. Also attached to the Mission and based either in the East or West compound were two married couples – the Australians Mr and Mrs Howard Smith (with one baby) and Mr and Mrs Joseph Stonehouse (with a seven-year-old son and an ailing baby) – together with Miss Ethel Shilston.

On 28 May, forty-three-year-old Miss Smith put the Anglican account in context when she wrote with heavy irony and intense irritation:

Hearing of destruction of railway stations, I went off at 8.30 to see if I could gather any information as to what the very able Ministers of the various legations were doing now! And found they *were* at least awake to the *terrible* danger the city has been in and were telegraphing for guards. It has been the British and American Ministers' fault that guards have not come long ago. ... Whilst I was out – unfortunately – a notice was sent round by Sir Claude MacDonald telling [the British missionaries] they had all better go to the Legation for the moment. Mrs Smith and Mrs Stonehouse were naturally very startled and instantly packed up and started for the Legation. I arrived in the compound as the string of carts were leaving and was only just in time to save the poor converts from a terrible panic. They were all ready to fly they knew not where. We have about twenty refugees here besides the usual

residents of the compound and everybody's nerves are more or less strained. The Lord helped me to calm everyone down.[26]

Influences on the Empress Dowager

Poor Sir Claude was then, and has been since, much castigated for continuing with diplomatic words instead of taking positive (military) action. But he was in something of a bind: he was, after all, a diplomat, even though he had come to diplomacy as a soldier, and China was a sovereign state, even though the foreign powers had been undermining its territorial integrity for over fifty years.

Early in 1899, just before the MacDonalds went on Home leave (and for treatment in Germany for his heart condition) for a few months, Italy, left behind in the race for bits of China, had changed tack when a new representative was appointed. Martino demanded, and issued an ultimatum to that effect, a harbour for Italy. Li Hung-chang, whom Claude MacDonald called the 'Grand Old Man' of China, and whom all the diplomats, particularly the Russians, courted, came to see the British Minister, begging him to use his influence with his Italian colleague.

Claude MacDonald felt awkward – after all, Britain itself had just secured two new leases. The Italian government, learning of their representative's importunity, recalled him. MacDonald, aware of the effect that such a recall might have on the effectiveness of the diplomatic community, telegraphed the British ambassador to Rome to pre-empt the recall, but too late. By the time MacDonald returned from leave in the Autumn of 1899, much damage had been done from the foreigners' point of view.

First, in MacDonald's opinion, Italy's move and the apparent success in resisting it, had reinforced the hand of the reactionaries at Court; indeed, as MacDonald wrote in 1914, 'I venture to think [the incident] had much to do with the policy adopted by the so-called anti-foreign party during the Boxer troubles.'[27]

Another outcome was apparent immediately on MacDonald's return: 'encouraged by the success of their resistance to Italian demands, the Chinese Government "sat down" and indulged in a course of passive resistance, which was very trying; they opposed everything and everybody ...'[28] Thus, when an Anglican missionary, Sydney Brooks, a colleague of Jessie and Edith Ransome, was brutally murdered by Boxers on 31 December 1899, it was not as easy to get through to the authorities as it might previously have been.

But there was another element at work which was, in its way, to be more influential, and its importance was emphasised to both MacDonalds on 9 March, however unconscious an impression it made at the time.

The Empress Dowager had chosen an heir apparent to succeed the Emperor soon after the coup of Autumn 1898, but it was not until January 1900 that the change was formalised. Pu Ch'un, son of Prince Tuan, a relative of Tz'u-hsi,

was declared by the Emperor himself, because of his own limitations, to be his heir. Prince Tuan was said to have counted on his son replacing the Kuang-hsu Emperor pre-emptively, and regarded foreign interference as having prevented it – thus reinforcing his antipathy towards foreigners.

In spite of the 'passive resistance' with which Claude MacDonald had to contend in his own dealings with the Tsungli Yamen, the Empress Dowager was anxious, or amenable, to receive the diplomatic wives again, as she had in December 1898. Thus, on 9 March, Lady MacDonald, again the doyenne, led a party of diplomatic women to the Forbidden City.

This time, the obstreperous Baroness von Heyking had been replaced by Baroness von Ketteler, the American married to the new German Minister; there was also a new Japanese, Baroness Nishi, and a new Italian, the Marchesa Salvago Raggi (whose husband had returned, promoted to Minister in place of the too-keen Martino). The Russian Minister's wife, Mme de Giers had been in Peking since 1897 and Mme Pichon since early 1898 but this time the Frenchwoman was absent and her place taken by Baroness d'Anthouard, wife of the Chargé d'Affaires. Mrs Conger was on leave in the United States and would not be back until 5 April. Leaving aside the strict etiquette of the previous visit, the company had expanded to include relatives such as Miss Armstrong, sister of Ethel MacDonald, and Mlle de Giers.

If you depended only on the MacDonald account, you would have assumed that the Emperor was absent and made something of it but Maud von Ketteler noted in a letter home that he was 'also seated on the dais, but noticeably lower and nearer the steps than his aunt. He looked pale and very ill with big dark sad eyes, but he seemed to be greatly interested in it all.'[29] There was, however, a notable addition to the Chinese company: 'On this occasion,' as Ethel MacDonald was to write,

> we were presented to the heir apparent, son of the now famous Prince Tuan, a fat, sleek, cheerful looking boy of twelve or fourteen, who chatted with his gentlemen-in-waiting, and appeared quite at his ease in the society of foreign ladies.[30]

Baroness von Ketteler also notes that the new heir, who she judged to be fifteen, seemed very comfortable with the situation in which he found himself. Of the Empress Dowager, she was particularly impressed by her eyes, 'full of expression and keenness'. Tz'u-hsi was also 'entirely at her ease and very friendly', which accords with Lady MacDonald's remark that she was 'If possible, more friendly and genial with us than on our previous meeting.'[31]

On the earlier occasion, Lady MacDonald had not had her own interpreter; this time each diplomatic wife took her husband's Chinese Secretary. Henry Cockburn, though he had a brand new wife in China, had been there for twenty years; he was well-versed in its language, mores and political nuances. As Ethel MacDonald wrote of Cockburn,

Previous to our visit, his opinion of the Dowager-Empress was what I would call the generally accepted one. My husband had requested him to take a careful note of all that passed, especially with a view of endeavouring to arrive at some estimate of her true character. On his return he reported that all his previously conceived notions had been upset by what he had seen and heard, and he summed up her character in four words, 'amiability verging on weakness'![32]

In fifteen months, therefore, if we take Lady MacDonald's account, with its Henry Cockburn contribution, at face value, the Emperor had been joined at diplomatic functions by his heir apparent whose father was a known reactionary, and the strong and capable Empress Dowager, now in her mid-sixties, displayed 'amiability verging on weakness'. Indeed, wise after the event, Ethel MacDonald ended her piece:

It would seem then that this singular woman is either an accomplished actress, or that she is, what she certainly seems to be on the surface, a woman swayed hither and thither by the counsels of her advisers, of whom the vast majority are certainly phenomenally ignorant of anything outside the 'Middle Kingdom', and in addition arrogant and anti-foreign.[33]

The Empress Dowager's part in what was to follow will probably never be quite clear; certainly at the time those foreigners who kept accounts assumed that she was totally in charge – she was their *bête noire*.

The Congregational American missionary Ada Haven was to write as early as 21 January 1900, for example:

The next few weeks will decide whether the prophesied break up of China is to take place immediately, or whether the old Dowager will recover herself by one of those astute tricks with which she is in the habit of bamboozling foreigners.[34]

Her colleague Luella Miner wrote four days later, 'These are exciting times we are living in now and we are all waiting to see what will be the next coup of the old Dowager. It really seems as if her cup of iniquity were about full.'[35]

Theodora Inglis, an American Presbyterian, later wrote,

The winter of 1899–1900 had been decided upon by the Empress and Prince Tuan the Boxer leader for the denouement, but the wise Li Hung Chang, rashly admitted to their confidence, opposed the plan. He is reported to have said, 'Kill the foreigners if you will this winter when the rivers and ports are frozen up, but what will you do in the spring when the ice melts and the foreign fleets and armies come in.' The star villains ... were dissuaded for the moment, but upon the death of the Viceroy of Canton, the Empress Dowager seized the opportunity to be rid of her wisest counselor and appoint Li Hung Chang to the vacancy. Then she was free to carry out her nefarious schemes. ...[36]

While W.A.P. Martin, President of the newly-formed university, added a rousing climax: 'She has been compared to Elizabeth of England and Catherine of Russia, but, in my opinion for her the fitting prototype is Jezebel of Samaria who slaughtered the prophets of the Lord and rioted with the priests of Babel.'[37]

None of these comments is incompatible with that of Tz'u-hsi to her lady-in-waiting Der Ling in 1903:

> I never dreamt that the Boxer movement would end with such serious results for China. That is the only mistake I have made in my life. I should have issued an edict at once to stop the Boxers ... but both Prince Tuan and Duke Lan [his brother] told me that they firmly believed the Boxers were sent by Heaven to enable China to get rid of all undesirable and hated foreigners.[38]

And to show that the feeling between the Empress Dowager and missionaries was mutual, the passage continues, 'Of course [my advisers] meant mostly missionaries, and you know how I hate them and how very religious I am.'

Previous to the beginning of 1900, the Empress Dowager was aware that rebellion was in the air – but against whom? The declining Manchu Dynasty with its weak Emperor and his over-powerful aunt? Lady Blake, in Peking with her husband the Governor of Hong Kong between 5 and 11 May, following a conference in Shanghai about the home life of the women of China over which she had presided, easily picked up the vibrations:

> We were told that the people in Pekin are very discontented and disaffected towards the government, which they declare is no good. Food has become very dear, it has gone up fifty per cent and four or five times has the Emperor gone to pray for rain, but no rain has come. ... The Dowager Empress is said to be alarmed having received a telegram from Li Hung Chang warning her that ten thousand Reformers are going to Pekin ...[39]

Lady Blake had access to reasonable – albeit anti Tz'u-hsi and foreign – information. The vice-president of the Shanghai conference she had attended had been Alicia Little, the anti-footbinding campaigner for whose campaign Edith Blake had organised a meeting with Chinese women at Government House in Hong Kong in March. Just before that, Alicia Little had had a meeting about footbinding with Li Hung-chang in Canton. Slightly taken aback to be approached by a British woman campaigning for a reform she argued was essential to the modernisation of China, he had, nevertheless, inscribed her fan with some suitable words which she was henceforward to use to good effect. As she left his presence he grumbled, 'You know if you unbind the women's feet, you'll make them so strong, and the men so strong too, that they will overturn the dynasty.'[40]

Alicia Little, who was later to write a biography of the viceroy, pronounced as a result of that interview:

The idea could not help crossing my mind how Tse Hsi must regret that he is no longer her right hand man, and that something or someone ever came between them. For with that imposing personality beside the throne the Dowager Empress must surely have felt a cheerier as well as a safer woman.

The part of Li Hung-chang in all that was to follow was to be somewhat ambiguous; he is accused both of being a Russian stooge and of manipulating the Boxer uprising for his own ends. Whatever his relations with the Empress Dowager and the strings he was pulling, her newly powerful advisers had the means to clarify the current situation for her – hence the significance of the banners displayed over the smouldering ruins of the station at Feng-t'ai: 'Support the Dynasty and Exterminate the Foreigner.' Or, as the doggerel writers would have it:

> Their men are all immoral;
> Their women truly vile.
> For the Devil it's mother–son sex
> That serves as breeding style.
>
> No rain comes from Heaven,
> The Earth is parched and dry.
> And all because the churches
> Have bottled up the sky.
>
> When at last all the Foreign Devils
> Are expelled to the very last man,
> The great Qing [Ch'ing], united, together,
> Will bring peace to this our land.[41]

Lady MacDonald Keeps a Stiff Upper Lip

The burning of Feng-ta'i was the turning-point for all parties. In the weeks leading up to it, diplomatic life had gone on inevitably, at least for the British Legation, as before. Some time in March, or earlier, Sir Claude MacDonald had been rather ill with pneumonia. Morrison, who was away for some months until 4 April, notes in his diary that day, 'After lunch down to see Sir Claude. He looks very worn and fragile can only go out in chair not riding.' On the 16th he noted, 'Sir Claude somewhat better but I think alarmingly ill.'

Lady Blake noted that they carefully did not plan to stay at the Legation because they knew MacDonald was ill. In spite of that, Ethel MacDonald insisted that the gubernatorial visitors move from the Peking Hotel (where they admitted they were not happy) into the Legation; there they found the Minister better but obviously still suffering. On top of that, three-year-old Stella

MacDonald (born in Peking) was just recovering (and out of quarantine) from scarlet fever.

Ethel MacDonald was a strong woman, apparently able to take anything that life threw at her; she is described thus by one of the smitten young interpreters in the Legation:

> Through every scene, grave and gay the figure of Lady MacDonald stands out clear and unchanging. The beautiful face, the gracious manner, the racy humour, the immense force of character, of course, and of kindness ... [42]

But there was a memory that must have darkened every family crisis of health: she had watched her first husband and their two children die of cholera in India where he was a civil servant.

And then, to cap it all, there was the Boer War. The British had been besieged in Ladysmith for eight days until 28 February that year; in May, the outcome of the humiliating war between the imperial power and a handful of Boer farmers in South Africa was still in the balance. Mafeking was besieged for seven long months – the siege not lifted until 15 May. The British government had other things on its mind than dispatches from China about a murdered missionary and Chinese peasants muttering strange incantations.

Most of the information about Boxer activities came from the French; most of the victims were the majority Roman Catholic converts in the countryside. Georgina Smith of the Protestant LMS, almost the only woman whom George Morrison had any time for, probably because she was able to stare him down, gathered information and tried to filter it through to the Legation in the way she thought most likely to succeed. Morrison wrote in his diary on 23 May:

> Miss Smith of LMS writes official dispatches to Mrs Tours [wife of the Legation accountant] about the course of the Boxers. The official character of the letter is interrupted to give room for a flattering notice of the bonny baby [Violet, aged fifteen months] of Mrs Tours.

But the British Minister's hands were tied so tight by diplomatic convention and his country's policy that even after the siege British women from outside the diplomatic community – in this case possibly one who had had occasion to talk to Miss Smith – felt bound to make such public pronouncements as: 'We know that diplomatic bodies are rather averse from receiving expressions of opinion from either mercantile sources, the press, or the missionaries.'[43] And she remarked on the 'infatuation with which the Peking foreigners persisted in regarding [Boxer outrages] as a huge joke'.

Holding their heads high, the MacDonalds gave their usual grand reception to celebrate Queen Victoria's eighty-first birthday on 24 May. Morrison noted that he congratulated Sir Claude on receiving his GCMG in the birthday honours; it was modestly brushed aside: 'When I heard it he and I nearly

tumbled out of the chair Ethel said [;] she thought he had got it because he had had the pneumonia.'

Otherwise, Morrison's diary account was typical:

> Dined with the British legation, 59 in all. Each lady takes in 2 men though Mrs Bredon and Juliet strongly objected to do so the former insisting upon the syphilitic Simson. Lady Mac took me and the IG [Robert Hart] very pleasant. Gushing Miss Myers and Miss Brazier giddy things were there.

The new characters Morrison introduces are all relevant to the siege story. Mrs Bredon was married to Sir Robert Hart's deputy, also Robert, brother of Hart's sister. Lily Bredon was an American who, throughout his diary, Morrison claims is the mistress of Bertram Lenox Simpson – also of the Imperial Customs and better known as the writer Putnam Weale. Morrison refers to Simpson (whom he insists on calling Simson) often as a Hebrew, and usually syphilitic, who has infected Lily Bredon.[44] Juliet, according to Morrison, is Lily's daughter but not her husband's.

Annie Myers and Daisy Brazier are sisters-in-law – Miss Brazier the sister of (James) Russell Brazier of the Imperial Customs, for whom Morrison

8 Annie Myers (courtesy of the family)

has no time, Miss Myers, the sister of Mrs Brazier. Annie Myers and Helen Myers Brazier had been born and brought up in China, two of the three much admired and accomplished daughters of William and Alice Myers of Formosa. Earlier, Morrison had described twenty-five-year-old Annie Myers (whose diary is somewhat less rebarbative than his) as 'flabby' as well as 'gushing'.[45] He was not averse, however, to making use of the good-natured young women to help him in cataloguing his library. Twenty-six-year-old Helen Brazier herself, who had had her second (surviving) child in December 1899, is one of the few women

9 Helen Brazier (née Myers) (courtesy of the family)

Morrison finds attractive. He refers to her on separate occasions as a 'perennial favourite' and 'squeezable'.[46]

There would be little point in mentioning these petty and sometimes unedifying extracts from Morrison's diary except that people, apparently even medical professionals, fed him the gossip and it illustrates the undertow of foreign society in Peking in 1900 – a society that was soon to be confined together for fifty-five days.

Putnam Weale, alias Bertram Lenox Simpson, describes that Birthday evening too, but he mentions none of the same guests – let alone Morrison whom he tends rather to admire than otherwise. He is more concerned with the French Minister, M. Stéphen Pichon, whom he does not admire but whom he acknowledges has the best intelligence service in the diplomatic community, through the Roman Catholic Church headed by Bishop Favier. He goes on to say, 'The French Minister was irate and raised his fat hands above his fat person, took a discreet look around him, and then hinted that it was this legation, the British legation, which stopped the marines from coming.'[47]

With the burning of Feng-t'ai station, Sir Claude realised he had cause to act; what is more, on 27 May the British Foreign Office had telegraphed their Minister in Peking releasing him from his diplomatic strait-jacket 'if the lives of Europeans were in danger'.[48] The following day, the Ministers agreed a concerted plan of action; but on 29 May the British and American Ministers were still arguing with the Tsungli Yamen about the need to bring to Peking foreign marines from ships moored (provocatively) off the Taku Forts at Tientsin. The Chinese were adamant that it was not necessary, and refused to give their permission.

Annie Myers, in the Inspectorate Compound, wrote meanwhile, on 28 May, 'All the ladies are to hold themselves in readiness to go over to the MacDonalds in case of need for concentrating forces in one place.' And they were advised not to go riding for a day or two.

Annie Chamot Saddles Up

On 28 May, M. Parrot, a Belgian engineer on the railway line under construction between Peking and Hankow, had found that he could not get back to Ch'ang-hsin-tien, the station sixteen miles south-west of Peking where his family and other Europeans connected with the railway were living. The line was destroyed, and stations were on fire. Rumours abounded that the settlement was surrounded by Boxers.

Parrot had to live through that night but he was helped to do so by the support he was promised. Diplomats might be unwilling, or unable, to act, and missionaries might be preoccupied with the fate of their Christian converts, but there was another foreign community in Peking – the commercial one – and the most enterprising of its members were the Swiss Auguste Chamot and his wife who is variously described as 'courageous', 'plucky little', 'brave', 'heroic', 'fearless', 'valiant' and 'gallant'.[49]

In the limited post-siege material about the Chamots, mostly concentrating on Auguste, is one line that leaps out: 'Annie was a good shot, having been taught, it is said, by her father in the basement of their San Francisco home.'[50] Immediately you wonder what San Francisco was like in the 1890s when

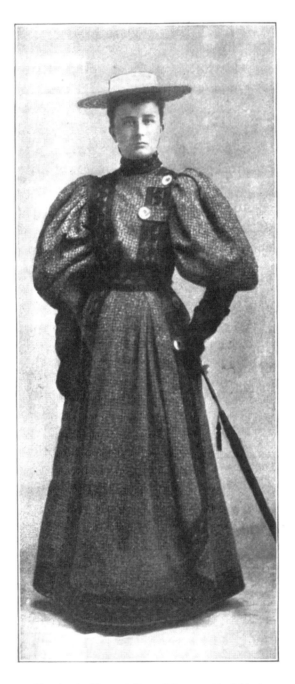

10 Annie Chamot (from *Beleaguered in Peking*)

prosperous property developers like Eugene McCarthy not only taught their daughters to shoot, but had shooting ranges in the basements of their houses.

In 1893–94, Annie Elizabeth McCarthy was on a round-the-world tour with her mother, Harriet. They stopped in Peking and stayed at the Peking Hotel, owned by a Swiss family. A young brother-in-law, the dashing Auguste, worked there. The couple kept in touch, and in 1895 he travelled to San Francisco to marry Annie and take her back to Peking.

By 1900, Auguste Chamot not only owned the hotel but he spoke good Chinese and knew his way – metaphorically and physically – round the byways of the city. Annie, it is clear, kept pace with him; they acted together. On the morning of 29 May, therefore, when M. Parrot, Auguste Chamot and four other men set off on horseback to Ch'ang-hsin-tien, there was no question of leaving twenty-nine-year-old Annie behind; and she carried a hunting rifle.

En route, the party nearly ran into two to three hundred Boxers who had just come from burning another station, and continued their journey on foot leading their horses. At Ch'ang-hsin-tien, the station was already in flames but the engineers were still managing to hold the hundred or more Boxers at bay. According to Chamot, some years later, he made his way towards the man who seemed to be the Boxer leader, a young prince whom he knew by sight. Acting instinctively, he reached down from his saddle, grabbed the man by the hair and dragged him up and across his pommel, placing his revolver against his temple.[51]

Thus, Chamot claims, he secured carts and horses and the right to leave with thirteen engineers, nine wives and seven children. The houses the rescued Belgians left behind were immediately pillaged and torched.

The American Presbyterian missionary Theodora Inglis noted,

> That afternoon a little cavalcade of armed men, worn with fatigue and excitement, carts containing frightened women with their babies and divers boxes and bundles, appeared in Peking streets and made their way to Chamot's hotel.[52]

Back at the hotel, Chamot allowed the prince to slide to the ground and then did what he afterwards much regretted – he slapped his hostage across the face. The Belgian families, settled into the hotel, became then one of the responsibilities of the Chamots throughout the siege.

But as Mrs Inglis, mother of a one-year-old daughter, Elizabeth, finished her account, 'The news of this episode came early to our ears and we felt that unless more help came our situation would indeed be desperate.' And Theodora Inglis had every reason to be fearful.

3
Dr Saville and the Marines
(30 May–9 June)

The Marines Arrive from Taku

'We will give you until six o'clock tomorrow for a favourable answer', Sarah Conger quoted the Ministers as informing the Tsungli Yamen on Wednesday 30 May.[1] 'If it does not come, we will bring the guards anyway.' As a diplomat's wife, Mrs Conger felt the need to explain in her letter-diary to her sister that day,

> These Ministers were very sure of their point, for none of them wish to get into a war with China. Our surroundings do not warrant it; we have been in no condition to bring the situation to a climax, nor are we now, but there are many warships at Ta Ku.

It was learnt much later that the Grand Council met that evening, that the proposal was put to attack the legations and massacre the inmates, and that such an attack was only ruled out by the efforts of Prince Ch'ing and General Jung-lu, Tz'u-hsi's relative and lifelong adviser.[2]

Whatever the truth of the claim, the Tsungli Yamen gave Sir Claude MacDonald permission at 2am that night to send for an international contingent of marines from off Tientsin eighty miles away. A telegraph was sent immediately. Putnam Weale wrote: 'Of course Peking is safe, that goes without saying; but merely because there are foolish women and children, some nondescripts, and a good many missionaries we will order a few guards.'[3]

Not everyone was anxious: earlier on Wednesday evening, Polly Condit Smith noted,

> We dined at Sir R. Hart's, and danced until twelve. He has two bands, brass and string, of Chinese musicians whom he has taught. The Secretary of the German Legation took me out to dinner – von Below, a most soldierly-looking person.[4]

Putnam Weale's account was not published until 1906 and it has been described not only as unreliable but even as fiction. That was the device, together with a *nom de plume*, he chose to enable him to go against the grain of the more straightforward male accounts that preceded his. But he was there and, whatever his contrivances, his attitudes are unmistakeable; I am prepared to let his fantasies speak for themselves within the framework of others' accounts. His impression of events is among those that act as a foil for the often unpublished and mostly neglected women's stories upon which I largely draw.[5]

Weale is concerned with poking fun at, undermining where possible, the conventional male view by his emphasis on diplomatic, military, missionary and moral failings (though he extols the joys of volunteer fighting). Women, whatever their race or status, are portrayed as objects, and in this his account is by no means unique. He seems unaware of the flesh and blood concerns of wives, mothers, teachers, doctors, those with responsibility for others at the personal and enduring level. Polly Condit Smith sometimes seems to give his dismissive slant support, but she was unusual: she was footloose and fancy free and she, too, was writing for effect, in her case consciously to amuse or provide frissons; she was influenced by her informants, and also publishing some years after events, making it easier to be wise. The well-springs of these two accounts, like those of many others, have to be borne in mind, and the factual contradictions they often raise juggled with.[6]

Typical of the concerns Weale disparaged and in which Polly had no direct involvement, were those exercising the mind of Frances Scott, the Bishop's wife. 'Mrs Scott was seized with a brilliant idea', her husband's colleague Roland Allen later wrote:

> As the [railway] line was said to be open, we might send the Shih family to Tientsin until the troubles were over. ... In two hours the whole of that family and most of the women and children who remained in the deaconess's charge were on their way to the station in little parties of two or three. These all got safely away and so were preserved, and the way was open for the deaconess [Jessie] to leave the compound, which she would certainly have refused to do if she had been compelled to leave her charges behind to the mercy of the Boxers. [7]

The international contingent of marines arrived in the middle of the evening of Thursday 31 May. Much has been made of the rivalry connected with both the defence and then the relief of the besieged and it is apparent even with the arrival of these troops: a few hours' delay is blamed on the British trying to bring 100 instead of the 75 the Russians were bringing.[8] And Polly Condit Smith was to write,

> When this polyglot contingent landed at the station in Peking there was great excitement to which nationality should lead. Captain McCalla, who

had come up with fifty marines hurried his men at the double-quick to get it, and our troops were the first to march up Legation Street.[9]

And Mrs Conger was to note that 'Fifty-six American marines ... started in ahead, closely followed by the Russians.'[10]

There had been a potential problem: the City gates closed at 7pm each evening; how could the new arrivals get in? The French contingent found themselves at Ma-chia-pu, one hour's march from their legation, and there, as Captain Darcy recorded, M. Chamot, proprietor of the Peking Hotel, came to put himself at the service of the Colonel as guide and interpreter; and, he added, 'Mme Chamot was also there. She was the first European woman we saw and both of them were on horseback and armed with carbines.'[11]

But the gates were left specially open, after all, and the troops passed safely through a crowd some said of between fifty and sixty thousand.[12] Sir Claude MacDonald was optimistic about the effect of the foreign troops' arrival, suggesting that the crowd's 'demeanour changed suddenly from truculence to something approaching humility'.[13] Even in retrospect, MacDonald seems oblivious of how much the insistence on bringing the troops, and their arrival, increased the potential for anti-foreign feeling, particularly on the part of the Court where it most mattered at this time.

At the French Legation, Darcy presented himself to M. et Mme Pichon who had just come back from a dinner party. Putnam Weale was at the party and described how:

> The political situation was represented in all its gravity by the presence of the Minister and his spouse. The former has always been pessimistic, and so we had Boxers for soup, Boxers for *entrées*, and Boxers to the end The Minister was, indeed, very talkative and gesticulative; his wife was sad and sighed constantly – *elle poussait des soupirs tristes* – at the lurid spectacle her husband's words conjured up.[14]

Darcy was not thrilled with the officers' quarters which appear to have been in the Peking Hotel next door to the French Legation. They included a not-very-clean sitting room used by everyone, including the hotel guests, 'and there,' as he put it somewhat critically, 'official information was discussed even by the women'.[15]

The Austro-Hungarian (Austrian) and German members of the international contingent failed to arrive that evening, but the arrival of the main body of a few hundred men seemed to provide a breathing space. Deaconess Jessie Ransome wrote on 1 June, 'We had a quiet night and can look back on yesterday's anxiety as a closed chapter I think.'[16] As for the Christian converts:

> Our people have behaved so well, given no trouble. The women and children and the school have behaved like real 'bricks'. The Christians have done one very knowing thing, which would never have struck me, I think, that is,

pawned all their best clothes and anything they set value on, so that the greater part of their property has been converted into pawn tickets, which are easily portable.[17]

Mrs Conger, meanwhile, wrote that same day:

> Everything seems more quiet in the city, but the bands of Boxers are reported to be active in the interior. Missionaries are still writing their suggestions and making earnest requests and appeals. They urge Mr Conger to make the Chinese officials act more quickly and protect them and their native converts.[18]

But, as she explained to her sister: 'The Chinese converts to Christianity are Chinese subjects, and the Chinese government has the right to protect or punish them according to its law, and they do not come under the right or power of other governments.'

The following day, Saturday 2 June, Mrs Scott made her way from the British Legation where she had been taking refuge and left on the train for Tientsin. There she was due to meet her husband after his tour of his diocese, to be a godmother at a Christening on Sunday, and to lay a foundation stone on Monday. She was to write on Sunday, 'Let me begin at the happy meeting of my husband and me after seven weeks yesterday. He got in by boat just as I arrived by train from Peking – luckily I did not know of his perils till they were past, nor he of mine.'[19]

Frances Scott was the last named European woman to get out of Peking by train and, although she was to go through the siege of Tientsin, the fact that she and her husband had that time together was, as events were to turn out, to be of some consolation.

And Deaconess Jessie Ransome had spoken too soon of Friday's quiet. On Saturday 2 June, she wrote: 'More bad news! One of our Christians has come ... saying that the Boxers have burnt the houses of the Christians in his village and killed his wife.'[20] And, as the day progressed, so rumours began to circulate of the murder of one of her British colleagues and the disappearance of another, fifty miles away from Peking. There was also a report that a party of foreign engineers employed on the railway line south of Paotingfu had been attacked when trying to escape by river to Tientsin. Of the party of thirty, one of them a pregnant woman, eight men and one woman were said to be missing.[21]

The murder of one of the missionaries was confirmed the following day and, that same day, Sunday 3rd, the 35 Austrian and 50 German marines arrived from Tientsin; the foreign marines now consisted of 389 men and 18 officers.[22]

Of the French marines who had arrived on 31 May, thirty were now sent over to Bishop Favier and his Roman Catholic Cathedral, the Pei-t'ang – increasingly crammed with Chinese refugees – and eleven Italians were dispatched to

protect the Sisters of Charity of the Jen-tse-t'ang whose premises were attached to the Pei-t'ang and two of whose members were Italian.

That day, too, by what many agreed was a strange decision, Ethel MacDonald's sister, Miss Armstrong, left for the British 'Summer Legation' in the Western Hills with the MacDonalds' daughters, Ivy, aged five, and Stella, the three-year-old who had recently had scarlet fever; they were accompanied by ten marines. Polly Condit Smith was sympathetic: she wrote, 'The heat is becoming insufferable, and the children of the diplomatic corps are showing the bad effects of this enforced confinement.'[23] And it was not as if Miss Armstrong (known to

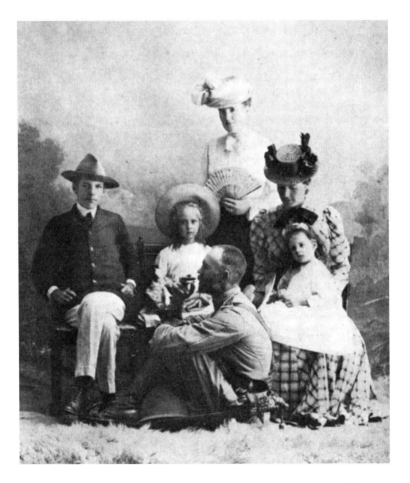

11 Miss Armstrong sitting with Stella (on lap) and Ivy MacDonald and Fargo Squiers; Polly Condit Smith standing (just post-siege with rescuer) (from *Behind the Scenes in Peking*)

her intimates as Arkie) was nervous; Morrison had noted in his diary on 19 May, 'Cockburn says ... Miss Armstrong does not fear the Boxers. She is laying in a stock of bricks and will give them a warm bombardment.'

Dr Martin Misses the Train to Tientsin

On 5 June, it was confirmed that the British missionary previously kidnapped had, soon afterwards, been treacherously murdered, and plans began to be laid and attempts made to get foreign women away from Peking to Tientsin by train.

In the American Methodist Mission compound, some colleagues had come up from Tientsin for a conference by mistake – not realising the gravity of the situation; now they suggested that Emma and Lizzie Martin, at least, travel back and stay with them. Dr Emma Martin had noted the previous day that the Empress Dowager seemed at last to be taking action – though was she not perhaps taking Boxers in through the front door (to punish them) and letting them out the back way? 'We did not know if this was true,' she wrote in her diary on the 4th,

> but we began to think that possibly she was in sympathy with them. We heard too that Prince Ch'ing, a pro foreigner, had had a quarrel with the soldiers and Prince Tuan and the latter had declared himself a boxer. We fear the soldiers would join the boxers if they dared.[24]

By action she was probably referring (writing in retrospect) to the incident reported on 7 June when General Nieh encouraged his foreign-drilled imperial troops to fire on some Boxers burning a station; but thereafter Nieh was ordered to retreat and leave the Boxers alone. As Mrs Conger wrote at that time, 'It also seems that the Government is afraid of the Boxers. The army, too, seems to be afraid of them.'[25]

On Tuesday morning, 5 June, the Martins tried to get hold of transport to take them to the station. They managed to procure one cart and, much squeezed in, set off with an armed male escort on horseback – the mission's riding ponies. Eventually they reached the station. As Emma tells it,

> In a little while Mrs Woodward and daughter of Chicago who were guests of the Congers were brought in, rather escorted in by 3 U.S. Marines and the 2nd Sec. We were glad to see them with the guns for they were going all the way to Tientsin with us. We waited for 5 hours for the train that never came – a 5 hours I shall never forget. ... The wires were cut and we did not know what was the matter and about 3 Dr George [Lowry] said we had better not wait longer (I found out afterwards that with his knowledge of Chinese he saw the crowd was getting dangerous and if we wished to get back home we must go at once). So we all started away again with heavy hearts thro the

rabble of hooting, jeering Chinese ... I expected every minute that we would be stoned.[26]

Outside the station they met the Walkers who, thinking the Martins had gone, decided they would try too. Seeing the sorry little party, they turned around and everyone 'wearily betook our way homeward over the long hot dusty road every moment fraught with danger'.

Mrs S.M. Woodward, in an interview when she and her daughter Ione finally arrived safely home, said that they were at the station from 7 o'clock in the morning until 11 o'clock at night. She added that they were surrounded by a 'howling mob' at the station, but that 'none of the Chinese offered to do us bodily harm'.[27] A fellow guest at the American Legation, the artist Cecile Payen, noted that 'Mrs Woodward had started out with a loaded pistol, prepared to use it in case of emergency.'[28]

That same day, 5 June, the MacDonald girls were hastily brought back from the hills; Mrs Conger was getting ready to send her rather nervy daughter Laura, and niece Mary Pierce, to Japan with Cecile Payen; and the following day, Polly Condit Smith was also preparing to leave for Japan, and her sister there, with Mrs Brent. 'Everyone feels that this is the time to leave Peking', Polly wrote, 'Everyone, at least, who is not bound to remain to protect interests they have in charge.'[29]

Sixty-year-old Charlotte Brent was the mother of Arthur D. Brent who worked for the Hongkong and Shanghai Bank in Peking – he was the banker son of a banker. His father, also Arthur, and mother had lived for many years in Japan and all four of their children had been born in Yokohama between 1874 and 1883, but after the family's return to England, Mrs Brent's health had deteriorated. We have some short biographical details written later by Arthur Brent senior to thank for an insight into the background of one of the older women who was to go through the siege:

> In 1899 we were having a very good year when my dear wife became very unwell, it being a critical time in a woman's life, and her nerves all out of order. She was recommended a thorough change, so we thought the best thing would be for her to start off on a voyage to the Far East to see our son AD [in Peking] and visit our friends in Japan. She had, indeed, been happy with her son for 3 months, until now ...[30]

But Polly Condit Smith and Charlotte Brent were thwarted, too, in their efforts to get away. Polly received a message via Sir Robert Hart saying that even if the train were eventually to get through to Tientsin, his agents had informed him that 'there were rioters and Boxers at several stations prepared to stone the passenger coaches'.[31] He urged her not to make the trip. On the 7th, Polly wrote:

> When we complain to the Yamen about the trains running no longer from Peking to Tientsin, as many ladies and children wish to leave, they smile

and say 'they regret the present state of affairs, but in a few days all will be in working order again'.[32]

Polly added that William Pethick, an American who had been Li Hung-chang's secretary for twenty-five years, 'thinks they are not allowing the trains to leave Tientsin because they don't want any more foreign troops to come to Peking'.

On 6 June, after visiting the Imperial Customs compound which was at one of the extremities of the legation area, Morrison noted in his diary,

> Mrs [Bredon] crying Simson [her lover] supporting her and Juliet in the arms of Lauru [her fiancé, a French member of the Imperial Customs]. Go to the Braziers. Then the IG [Robert Hart] came in painfully nervous and shaken. It was not [now?] necessary for the two girls Annie [Myers] and Daisy [Brazier] to go to the legation and the two [Brazier] children. Lady Mac had just written 'send 'em along'.

Annie Myers' diary does, to a certain extent confirm Morrison's; noting that 'a rising was most probable tonight', she continues,

> Therefore Sir Robert was collecting all the Customs people at his house and we were to go over there. On Russ's [Brazier's] return ... we found he had heard the same from Mrs Bredon who had called him in when he was passing ... and whom he found in a great fright over it, Mr Bredon having gone to Tallieu's [store] to verify the rumour. Helen [Brazier, her sister] wrote round to Lady MacDonald asking if the children, Daisy and I might go round to the Legation ... where there were guards (neither Daisy nor I knew of the decision) – she and Russ to take their chance at Sir Roberts. Dr Morrison came in while we were at dinner ... to say that Mr Bredon had found the rumour had been exaggerated by transmission.

So they stayed where they were.

In England that Wednesday, Queen Victoria, after studying dispatches which had taken two months to arrive from China, telegraphed Lord Salisbury, the Foreign Secretary, 'Situation looks very serious. Trust at all events we shall display no apathy.'[33]

Mrs Goodrich is Forced to Leave T'ung-chou

Meanwhile, in T'ung-chou, where the American missionaries grew strawberries, the Congregational Foreign Board had been holding its annual conference. Thirty-year-old Bessie Ewing had left Peking to attend it on 26 May with her two children, five-year-old Marion and nineteen-month Ellen; she seems just to have become aware that she was pregnant, though she never spells it out. Her husband Charles was to follow later. Mrs Goodrich was there, mother of three children, Mrs Chapin, Mrs Ingram and Mrs Tewksbury, each with two

children, Mrs Arthur Smith, and five unmarried women missionaries – Mary Andrews, Abbie Chapin, Luella Miner and the Misses Wyckoff, Grace and Gertrude from Tientsin.

They were all aware of what had happened at Feng-t'ai station because some Boxers from T'ung-chou had gone over to join in and then return. They had heard, too, of the rescue of the Belgians from Ch'ang-hsin-tien. The afternoon when they learned that, as Sara Goodrich tells us in her diary,

> The Congregational Association was held, while the ladies of the Mission listened to Miss Gertrude Wyckoff read a fine paper on the relative importance of supported and self-supported station classes for women.[34]

In general forums, women missionaries were not given respect: they were not allowed to vote, nor were they expected to speak.[35]

On 5 June, Luella Miner noted in her diary that they were enjoying the strawberries grown on the college's industrial farm, 'which are just in their prime'. And that same day, most of the visitors returned to Peking. Charles Ewing had come down briefly but then gone back to the capital to look after refugees and not been able to return to get his wife and family, but Bessie set off and describes her fears:

> The rest were all to go in carts, but Ellen and I had to go in a sedan chair, and could not go by the same route. The bearers I knew, and they were good, trusty men, but I must confess I was afraid to start on that fifteen mile ride with only my baby and four Chinese for company. The bearers were given very positive orders to keep with the carts, but in many places that is almost impossible. As soon as we were fairly on the way I felt all right as though there would be no trouble, and everything was as quiet as possible. [36]

From the start, the missionaries in T'ung-chou were in close communication with the Taotai – City Magistrate – with whom they had good relations and who had undertaken that sixty soldiers should defend the college and sixty the compound, but by Thursday 7 June he said he could no longer protect them – the situation in the city was getting out of hand – and a telegram was sent to Minister Conger asking him to provide an escort to bring the missionaries into Peking.

Thirty-nine-year-old Luella Miner, who had been in China for thirteen years, taught in Chinese at the Mission's educational centre. She talks, on 7 June, of their 'utter helplessness to protect our Christians' and of 'this compulsory desertion'. 'If we could only stay,' she continued, 'as the missionaries in Turkey did during the Armenian massacre, to uphold and comfort, to nurse the wounded and feed the hungry'.

They started to do a little desultory packing. Sara Boardman Clapp had come to China a single missionary, but married twice-widowed Chauncey Goodrich from T'ung-chou in 1880; she wrote now:

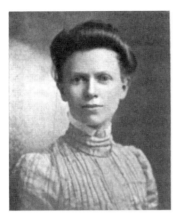

12a Bessie G. Ewing

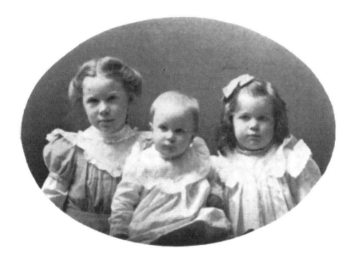

12b Marion and Ellen Ewing with baby brother
(b. December 1900) (from *Siege Days*)

It was not easy to leave behind the loved treasures of years among them some willow ware china preserved in the family for several generations, a parchment issued by the U.S. Government to your great grandfather because of a patent, and bearing the names of John Adams, Joseph Jefferson, and John E. Wirt, the genuineness being testified to by the U.S. seal. There was your grandmother's sampler made when a little girl in the early part of 1800, and many other things. Bedding and necessary clothing were all we attempted taking besides a few stores.[37]

At 11pm that evening, the missionary Dr Ament arrived from Peking with sixteen carts but no marines. Mrs Conger explains why he came unescorted:

> Mr Conger thought it would only enrage the Boxers to see foreign soldiers. He feared that the small guard would be in danger of being overcome and that the missionaries would be captured. This would give courage to the Boxers, and would make them more troublesome. It would weaken the guard here; and, too, if he did this for Tung-chow, other missions could ask the same. It would be impossible to give to all.[38]

Sara Goodrich strikes a poignant note when she writes of her own reaction:

> We prepared a supper for the marines we expected and also lunch for the journey. No marines arrived however – instead Dr Ament with a cartridge belt and fifteen carts. Arriving about 11pm, he alone sat down to the long table prepared for a dozen marines. Our cook ... had stayed by and made hot biscuits for a large company. Strawberries were on the table also.[39]

Luella Miner reports how the single women staying in the same house then passed a sleepless night,

> except Miss Andrews who fell asleep from sheer exhaustion. She and Miss Chapin had had a heart rending afternoon counselling the poor Chinese women in the city where to flee for places of safety, giving them money, comforting and encouraging.

Miss Andrews was leaving the work of thirty years. But even she did not have much time to sleep because the party left at 3.30am on Friday 8 June. Eight-year-old Dorothea and Grace Goodrich (eleven) rode with their father, while five-year-old Carrington rode with his mother who wrote fiercely: 'As I left the hall I noticed a donkey whip hanging on the rack. I carried that all the way to Peking, determined if I died for it I would use it on anyone who touched my little lad.'[40] This image of Sara Goodrich is a good introduction for she has been described as 'very aggressive and outspoken' and 'concerned about living today rather than going to heaven'.[41]

In the end, there were twenty carts, and the missionaries, nine women, seven children, and four men, were able to take a hundred or so converts, many of them students, with them. They arrived safely in Peking and went straight to the main Methodist compound where, at a meeting of American Methodists the previous day, it had been agreed that all American missionaries able to reach Peking should come together to be defended, together with the Chinese schoolgirls who could not be dispersed and thus were particularly their responsibility.

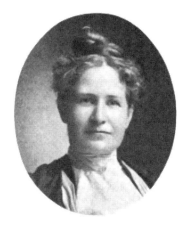

13 Sara Goodrich

13b Carrington, Grace and Dorothea Goodrich (from *Siege Days*)

The Schoolgirls Find Refuge in Peking

Of those in Peking itself, the Martin sisters and their colleagues had the least distance to travel; they lived just across the alley. They had earlier made contingency plans which Emma recorded:

> Mrs Jewell has had the back gates barricaded she suggested that we have handy some weapon of defence. Dr Gloss took one half of her obstetrical forceps. Mrs Jewell is the only one of us with a revolver and that is only a no. 22. We have it arranged so if there is trouble near at the given signal we are to run across the alley into the parent board compound. There are several

of the brethren there armed with revolvers. How I wish I had a rifle and knew how to use one – I think I could shoot to kill too It's strange how some of my ideas about firearms have changed since I left [home].[42]

That Friday the Methodist women had spent the day moving their trunks and stores across the alley. But there was another problem; there were not only Mrs Jewell's hundred or so schoolgirls. Mrs Jewell, though, once she had got her own girls organised, did not neglect those of the Congregational Foreign Board Mission. Ada Haven, fifty-year-old principal of the Congregational Bridgman

14 Ada Haven (from *Siege Days*)

school, wrote of her gratitude towards Mrs Jewell, Dr Gloss, and Miss Gilman concerning the treatment of the thirty or so girls that she had not felt able to send home; she then described their journey and arrival:

> It was expressly desired that we should not come very late, or very early (before dark), or in a great body, so as to attract notice. So, as soon as it was dark our six carts took our little band to the Methodist place. Our girls were very collected and calm, quite content to go anywhere or do anything as long as they kept with the foreigners. Arrived at the Methodist Mission, we were told to go to the church. We found the Methodist girls already there – eighty or ninety of them. As soon as we could, we got settled for the night, spreading down our quilts between the rows of seats. We could not sleep on the seats for they were like opera chairs, with their wood bottoms and back, so we threw up the hinged seats and spread ourselves between the rows, feet to feet, or head to head, a continuous line of bodies in each row.[43]

One of the schoolgirls – an orphan whose adoption by a Chinese Christian family had been organised by the missionaries – was later to be interviewed and her account written up by Ada Haven's colleague Luella Miner from T'ung-chou; the girl tells a straightforward story:

> It was almost dark when twenty of my schoolmates who had not been able to get to their homes came over from the boarding-school. What a strange gathering of homeless ones! Many of them did not know whether their dear ones in distant places were dead or alive. They gathered in the large, beautiful church, and as we sat together in the evening twilight we wondered what the coming days held for us. The girls were all Christians, and even the little ones did not cry.[44]

Presbyterian and mother Theodora Inglis had different preoccupations. She tells us how, as she sat that morning writing a letter to her mother, the old gatekeeper came and handed her a letter. It was an invitation to come and take refuge – an invitation approved by Mr Conger and containing instructions 'as to the bedding, food, canned stores and cooking utensils we should take with us'.[45]

Earlier in the week, Theodora Inglis had made a little chamois leather bag for her trinkets and been laughed at by her neighbour Mrs Fenn. 'I expect to throw all my things into a sheet,' thirty-five-year-old Alice Fenn explained, 'or go without them if the worst comes'.

It was Mr and Mrs Fenn's wedding anniversary that Friday, 8 June, and Theodora Inglis gave them a Japanese screen; taking it from her, Alice Fenn mocked, 'I believe the Boxers will get it yet.'[46]

Theodora packed everything carefully into a stone isolation room belonging to the hospital where her husband John practised, remarking, 'Well, if they

15 Theodora Inglis (from *Siege Days*)

do burn the place down, they can't burn more than the window sash in the stone room.'

That day, she walked around the partially denuded rooms 'opening this drawer, gazing absent-mindedly on its disturbed contents, pausing in front of this or that object, deciding for it and then rejecting it, then beginnning all over again'.[47]

That evening, dinner barely over, the Inglises and the Fenns received another message to hurry – everyone must be gathered in that night, immediate trouble was expected. But it was not as easy as that, as Theodora explains:

> There were few Chinese about the place, but I had to say goodbye to the baby's nurse, old Wang Nai Nai [Nanny Wang].
> 'Will you not come with me', I pleaded.
> 'No,' she said, 'my son and grandson are in the imperial army and they say that I must not go – that I must stay with my heathen daughter where I shall be safe', and she wrung her hands nervously.
> 'Oh, you must leave Peking,' she continued, 'leave and go to Shanghai'.

'Shanghai?' I repeated. 'How can we go to Shanghai? It is a thousand miles down the sea and the railroad to the coast destroyed.'

'Oh, you must go', she insisted. 'You are foreigners, you can surely make some plan, you must go to save that baby.'

It is needless to say that Wang Nai Nai, like many of her countrymen, had great faith in the power of foreigners. The old woman was very dear to me because of her devoted love to the baby and my heart was sad as I clambered into the cart which was to carry us to the Methodist Mission. Wang Nai Nai hugged and kissed the baby and weeping, put her into my arms. Back of me in the cart were packed some granite iron pots, stew pans and various other kitchen utensils. In front, beside the carter, my husband sat, revolver in hand.[48]

It was an unpleasant journey, dangerous even, and it was fortunate that the moonlight glinted on John Inglis' revolver. At 10 o'clock they reached the mission; but,

> We could not reach the gate for the dozens of carts already there – trunks, boxes and bedding were being unloaded, carters screamed and shouted to help along the general confusion With some difficulty, I extracted my feet from the pots and kettles, stretched my cramped and stiffened elbows, handed out the baby, and crawled from the uncomfortable Chinese cart. Pushing our way along, we approached the gate and there the blessed sight of a US marine met us.[49]

She was 'afraid to venture her voice', so instead held out her hand in silent greeting.

Congregational Bessie Ewing, with two children and her pregnancy to take account of, spent a similar day:

> It all seemed so strange to be packing up to leave our home. I tried to take as few things as possible, expecting that we should have to run to the Legation at the last. So we packed only our two extension bags with a change of under-clothing around, a warm outer suit apiece and two or three thin suits. We piled everything into one cart; the children's two mattresses on the bottom, the two bags at the back. I curled up in front with Ellen in my lap; the small spaces held two hand bags and cooking dishes for Ellen's food. Marion was on the outside with the driver, and Charles walked by the side to be near and to see that nothing fell out. In this way we left our home after ten o'clock ... Ellen had been asleep four hours, but Marion did not get any rest until about midnight.[50]

At the Mission, the welcome was mixed, as Bessie recorded:

> We were sent to Mr Gamewell's house into an empty room. They had just cleaned out ready to go home to America. With the two mattresses and a Brussels carpet that Mrs Gamewell brought out for us, we lay down for a few

hours. Charles had expected to return home ... but the Methodists protested, saying it was not fair to leave us all here for others to protect in case of attack. Although we did not think it likely the 'Boxers' would come, this argument had force and so Charles stayed. By half past five this morning he was up and had started for our home for more things.

Dr Saville Talks to Sir Claude MacDonald

Bessie Ewing hints at a more deep-seated difficulty which British Dr Lillie Saville tactfully omits from her slender published account; she glosses over the fact that the London Missionary Society (LMS) was also invited into the American Methodist Mission, and the implications of that invitation, when she writes of that night:

> It was about nine o'clock. The large Compound of the Methodist Episcopal Mission [MEM] was full of hurrying figures. Confusion there was none, in spite of the fact that the lane was filling quickly with carts bringing refugees from all the American Missions in the City. All had been suddenly called in since the afternoon. The Tungchow staff had arrived earlier in the day. Then Chinese refugees sought admission; a lame man carried on another's back, he must not be refused; our West City Bible woman with her old blind mother-in-law and baby girl – little Glory; a small West City school-boy came with pleading voice, 'Taifu, where can I sleep tonight?' Then our Mission Christians had to be identified in the dark in the Church, women and children huddled together in a corner in that huge building, but no sign of panic, no murmur of any sort was heard.[51]

Then she adds, 'The American marines had already arrived as a guard, and stood still and silent at their posts.' With that remark, the cryptic ones in the accounts of some of the American women begin to raise questions about what might have gone on behind the scenes, for Dr Emma Martin writes, 'Thirty of the London Mission refugees came to us that night when we were over-crowded already and none of the English were there to help guard.'[52] And Sara Goodrich, whose party had brought 100 converts from T'ung-chou: 'No British guards sent. Promised and then refused. The British minister was waited on by Americans and the Legation sent rifles, otherwise Mr Conger refused to have Miss Smith and the refugees from the London Mission remain.'[53]

That there was no animosity towards Georgina Smith herself is clear, for Theodora Inglis noted, 'The English missionaries were already in the British legation, all save plucky little Miss Smith who stayed on at the London Mission compound with a band of native Christians who had fled to the city from country districts.'[54]

There was, in fact, something of a saga, and Lillie Saville tells London how it unfolded in her long and detailed, feverish even, letter of 9 September.[55] She

starts by explaining the lead-up to 8 June, how her colleague Mr Stonehouse had constantly asked the British Legation for a guard, how his family had gone from the West LMS compound to the East, and thence to the Legation. Requests for protection were repeated on 7 June, and a refusal had finally come at 4pm. An hour or so later, Miss Shilston and Lillie Saville left for the East compound. On the morning of the 8th, the united LMS missionaries still hoped to protect the East compound and their native Christians in it, though Mrs Stonehouse, the children, and Miss Shilston went again to sleep at the Legation.

The LMS missionaries knew, though, that discussions had also taken place to safeguard all Protestant Christians together. And on the afternoon of the 8th, two American missionaries came to the East compound and told Dr Saville, 'You ought to be in the [American] Methodist Mission.' The invitation included those native Christians in their compound who had 'no sort of home in the city'.

Mr and Mrs Howard Smith, Miss Georgina Smith, and Dr Saville met and decided that Mr Smith should immediately escort his wife and baby to the British Legation. (Just before this time, Mrs Smith must have disbanded the girls' school she ran. As her husband later explained, 'the responsibility of providing for and protecting so many young girls was more than anyone could undertake at such a time.')[56]

Dr Saville now sent a note to get Mr Stonehouse, and another colleague, Mr Biggin, from the isolated West compound, together with their West City preacher with his wife, baby and mother. They now had a good many country refugees, a few West City boys and others in the compound who it was agreed should not be 'scattered'. Each was given a ticket stating 'LMS Christian – please admit'. And after dusk they were sent out in their twos and threes.

At about this time, a circular letter was sent out from the Americans, as Lillie Saville explains,

> offering to take in our Christians if the British Minister would help with a guard and our missionaries help to defend. As Miss Smith and I had already started [sending] the women and children there was nothing to be done – but soon one or two came back saying they had been refused admission. ... Miss Smith and I consulted together and agreed that she should stay there and manage affairs, and I would go to the Methodist Mission to try and arrange matters, and if necessary, go on to the Legation.

At the Methodist Mission, the stipulation about British marines and LMS missionary help was repeated; their deputation offering refuge without this point being resolved had been premature. 'I begged them just for that night to keep the women and children', Dr Saville continued in her letter to London. 'And I promised that we would get a clear understanding in the morning.' They agreed, on condition that she should go to see Sir Claude MacDonald and secure the guard. Lillie was careful not to criticise the Americans who had 120 school-

girls, their own Christians, 70 missionaries (men and women), their families, and at that time only 10 or so marines.

Late that night, Dr Saville went to see Claude MacDonald. 'He assented rather readily to the guard', she remembers. She thought the number was ten to twelve. They had had a joke, possibly leading to a misunderstanding on Claude MacDonald's part, about the need for the LMS missionary men to help guard the Methodist Mission – a problem compounded by the fact that the LMS men concerned were not then contactable in one place. But two notes – one to the LMS missionaries in the distant West compound, the other to the American Methodist Mission (addressed to Mrs Jewell) were approved by MacDonald and sent off immediately by legation courier, while Lillie decided, given that it was now midnight, to stay at the Legation.

On the morning of Saturday 9, Lillie Saville and Ethel Shilston met up early with their colleagues and agreed to join forces with the Americans. 'Miss Smith and I then consulted', Dr Saville continues,

> As to which of us should go – they would not wish an extra lady on their hands to protect, but we felt one must take charge of the [Chinese] women. We had not more than two or three West City women so Miss Smith and I agreed that as she knew the women, and was far more competent and experienced than I, she should have charge of them, and I go to the Legation.

But later that day, Dr Saville learnt that the guard had been refused 'and that the American Miss[ion]. was very indignant'. Miss Smith, meanwhile, after spending the night of 9 June at the British Legation with Dr Saville, moved to the Methodist Mission.

What Dr Saville later worked out must have happened was that on the morning of Saturday 9 June, MacDonald had told his military officer, Captain Strouts, what he had agreed and the captain, who was much against dividing his guard, had gone immediately to the American Mission to assess the situation 'And found there wasn't a single Britisher there.' Dr Saville deduced, 'as they had come to Peking not to defend Americans or native Christians, therefore Captain Strouts refused to send British marines'.

In a letter written on Monday 11 June, American Congregational missionary Bessie Ewing brings us up to date on what was happening on Saturday 9 in the Methodist Mission:

> At a general meeting it was decided to sift out the Chinese as there were too many for the health of all. Therefore, any who had homes in the city not on Mission property were asked to leave. About one hundred were thus sent away. This of course was a very hard thing to do but it seemed the wisest course and nearly everyone thinks there will probably be no general uprising in the city.[57]

Unaware of most of what had taken place, she then sums up the situation on Monday with regard to the British:

> We have about fifty London Mission converts with our refugees and two Englishmen with them, also one English woman. In view of this, the British Minister ... sent ten rifles with ammunition to help us out with defending.

Mrs Conger was too diplomatic, or too concerned with building up her storeroom to feed her expanding household, to give more than the bare details on 9 June:

> Our Captain Hall, with ten more American marines, went to join the other guards at the Methodist mission. The British sent to the Methodist mission ten guns and two men, as there were people there from the London mission to be protected. They are now quite well fortified, as they have over fifty rifles.[58]

Doughty Miss Smith, as always, sailed through it all:

> The kind American friends have opened their hearts and their compound to us. And there are between 100 and 150 LMS refugees here. They have comfortable quarters and everything is done that can be done for their health and safety. I am in charge of the refugees (ours) and Mr Biggin helps, as a guard.[59]

If it is not inappropriate to put down a romantic marker here; Miss Smith continues about her future husband: 'The friends here speak very highly of Mr Biggin, of his unselfishness and devotion to duty and his good training as a volunteer.'

As for Lillie Saville, she had taken no more part in the matter and did not see MacDonald again for more than a week; by then much had changed, for that weekend of the misunderstanding between the British doctor and the British Minister was the beginning of the period known later as the 'semi-siege'.

4
Mrs Gamewell Offers to Help Captain Hall (9–12 June)

Dr Saville Waits for More Marines

'Lady MacDonald called today', wrote Mrs Conger on Saturday 9 June. 'She was calm but was anxious to get her children to Japan.'[1] In the American Methodist compound that first weekend of the semi-siege, the seventy American missionaries, and Miss Georgina Smith of the LMS, had a certain sense of security and purpose as they prepared to protect themselves, their children, their schoolgirls, and other Chinese Christian refugees. In the wider legation area, the situation was more fluid.

In the British Legation, the Anglicans, Deaconess Jessie and Edith Ransome, Nurse Marian Lambert, their medical assistant Miss Hung and two Chinese Christian children were in two rooms with enough food for eight days. They and the LMS had handed over their mission properties to the Chinese authorities for safekeeping. As Jessie Ransome explained:

> Today there seems to be a general feeling that an attack is expected tonight, though why I cannot make out. Orders have been issued that *all* British subjects must come into the Legation except a certain number who are intending to defend the customs.[2]

The men were to stay at the Customs compound at the northern fringe of the legation area but not, of course, the women. Young Nigel Oliphant, a former soldier working temporarily for the Imperial Chinese Bank, took brief refuge in the British Legation where his brother David worked in the Chancery, together with his British boss Mr Houston and Mrs Houston; he wrote in his diary for that day in a style which was later to become tempered by personal tragedy: 'Sir Robert has sent all the customs ladies in here tonight after bidding them a most affecting and gloomy farewell which frightened them all fearfully.'[3]

For the diplomatic women in the compound, however, the Customs women were a question of logistics. Sisters-in-law Daisy Brazier and Annie Myers went to stay with Ada Tours and her husband, the Legation accountant, and their baby Violet; Lucy Ker, wife of the Assistant Chinese Secretary William Pollock Ker, took Helen Brazier and her children Willie (six) and Helen (six months). Lily Bredon and her grown-up daughter Juliet, and Ann Brewitt-Taylor had a room in Lady MacDonald's house.[4]

It was not quite as easy as it seemed; when Mrs Ker offered to have the Brazier children for a day or two, 'Amah seems so opposed to the idea,' Annie Myers had noted on 7 June, 'and gets so huffy at the thought of moving that, just now, when there seems the chance of servants leaving one in the lurch, Helen hardly knows if she can manage it, much as it would ease her and Russ's anxiety'.

And, on 8 June, Annie had observed, when Sir Robert Hart wanted all the Customs women to leave by train at an hour's notice, as soon as it became feasible, 'We were all *wild* at the thought of it but comforted ourselves with the thought that it would be some days before the trains could run again.' Then they heard that the bridge had been destroyed and Annie added 'So that put the kybosh on our leaving before the fun is over!'

Twenty-one-year-old British student interpreter Walter Townsend, in China since September 1899, captures the situation perfectly:

I believe that all the ladies are to be sent off as soon as possible, which will be a relief, as we will then be able to enjoy ourselves freely without having to think of them. I bet some of them will kick like fun at having to go.[5]

One of them would have been thirty-two-year-old Lucy Ker to whom Townsend lent his revolver on the 9th and whom Morrison also described as 'very gushing'. As Townsend also wrote home, 'Our Legation ladies are A1, just as plucky as possible.'

Of other British women, Charlotte Brent, who had been staying with her Hongkong and Shanghai Bank son Arthur in the Spanish Legation, came over to the British Legation for the night. And Mrs S.M. Russell and her husband (who taught mathematics and astronomy at the Imperial University) moved to an empty house in Legation Street near the French compound.

Mme A.T. Piry, wife of the French secretary of the Chinese Postal Service (also under Sir Robert Hart), and her four children and their governess, Mme Pons, had been picked up by Captain Darcy's men two days earlier and taken to the French Legation where Mesdames Pichon, Berteaux, Morisse and Saussine stayed for the moment – as did the other diplomatic wives in their respective legations. Contingency plans were already in place, though; as Jessie Ransome noted on Sunday, 'The Russians and Americans who adjoin us are to come in here if hard pressed, as we are most defensible.'[6]

And the situation was unsettled; Ada Tours observed that, 'The Dowager Empress returned from the hills in a vile temper and says the foreigners shall be exterminated.'[7] Roland Allen, Jessie Ransome's colleague, suggests that Tz'u-hsi's 'incontinent' return from the Summer Palace to the Forbidden City was because 'she had heard spirits in the night crying "Kill! kill!" though who was to be killed did not appear'.[8] It was said that her bodyguard for the journey was 'the retrograde Mahomedan rabble of [General] Tung Fu-hsiang who had long been a menace to foreigners in the province'.[9]

On the streets, apparently, the Chinese were asking if the Empress Dowager's return would make any difference. Some said that calm would be restored, disturbance being a crime of lèse-majesté; others that she was no longer mistress of the revolution and that she was taking refuge in the Forbidden City because she no longer felt safe out at the Summer Palace.

It was hardly surprising that opinion was hostile among foreigners: Ada Tours recorded on the 9th that 'The racecourse was burnt early this morning, so the Boxers are getting bolder and nearer.' Jessie Ransome elaborated on that incident with a certain asperity:

> Some of the Legation students riding out saw them, and rode in at once to report. Two who were riding a little later, however, were nearly caught in an ambush by the roadside; but they were armed with revolvers, which they fired with some effect, and escaped. They had no business to have ridden out, as they had been informed of the danger; but, like most British boys, their valour was greater than their discretion. Now, Sir Claude has forbidden any one to ride out of the city at all.[10]

The fact that the British Legation students fired on the Boxers is said to have contributed to the foreigners' difficulties.

For Chinese women in the city, the situation was more immediate. George Morrison noted in his diary that day:

> My boy's 'Mamma's sister', wife's sister's husband's sister, came in both crying. [General] Tung Fu-hsiang's soldiers were making house to house visitation asking 'how many Catholics are here?' meaning that there was to be a massacre. These reports are rife but untrue.

The following afternoon, Sunday 10 June, Anglican Jessie Ransome and Miss Hung went over to the western part of the city 'to see and try to comfort the poor women who were left'. Edith Ransome wrote to their Bishop's wife, Frances Scott, stranded in Tientsin: 'They found a very sad, terrified little company gathered at Lin's house, his wife and daughter, Mrs Yang, Mrs Lin and Mrs Chi. Poor things, the long strain is telling on their nerves.'[11]

But Jessie herself confided an even more affecting and politically charged story to her diary:

I found them all together in one house, with the door barred, weeping, and in a complete state of panic and terror. Two of them have been hiding in heathen houses, but yesterday houses of several people who had sheltered Christians were burned, so they dared keep them no longer, and they have crept back home. Poor things! they clung to me so, and some implored me to take them back here with me, and oh it is hard to refuse them; and yet what can we do? To stay with them would do no good, and make it even more dangerous for them, as without a foreigner they have a chance of escaping in the crowd, and to bring them here is impossible. The Minister could not take them. The Legation is already more than packed, and I have Miss Hung and the two children here only as the greatest favour, and with injunctions to keep them out of sight, lest other Missions should want to bring their refugees in.[12]

The political aspect of her story is bitterly confirmed by a letter that Mr Stonehouse of the LMS later wrote to London:

On Saturday night I saw Sir C MacDonald and he refused protection to our converts in any form. A shameless thing. Our converts said, 'we are to be massacred by our people; because we are converts neither your government nor ours will protect us, we are in a pitiable case.'... Two little girls came in one night, one thirteen years old and the other 4, they had seen their mother and elder sister speared in the street, and these two after four days wandering found their way here. I took them to the [American] Methodist Mission as no converts were allowed in the British Legation except under special circumstances. The missionaries and their converts are a despised race in the Legation.[13]

But all was not bleak that Sunday, as his colleague, Lillie Saville, the petite and determined doctor who had brushed up against Sir Claude on the same subject on Friday night, trumpeted:

'*The Allied Troops under Admiral Seymour left Tientsin today*!' Such was the news that flew round the British Legation ... An hour later our telegraphic communication with the outside world was cut off. But what mattered that? The troops would be up by tomorrow's train. Certainly the line was broken in places, so we would allow them twenty-four hours instead of three to make the journey. Carts came filing into the Legation to fetch the baggage from the station, five miles distant, tomorrow. Never mind, though fifty carters and their mules were quartered round the house in which we were living, the men lying about on the verandahs, smoking and gambling late into the night, tomorrow they would be gone.[14]

At the behest of the legation Ministers, 2000 armed men of eight nationalities had left Tientsin by train that day for Peking. As Sarah Conger, always able to

provide the diplomatic detail explained, 'There was no permission from here to let them come; the Viceroy at Tientsin granted it.'[15] It was not so much the general situation as a small incident at the British Legation the day before that prompted the call for reinforcements.

A regular, and friendly disposed visitor from the Tsungli Yamen called on Sir Claude and when the Minister remarked bluntly that he had heard that the present anti-foreign government was bent on the massacre of foreigners, the visitor's reaction was so marked that MacDonald felt the need to report to his fellows, and they to act.[16] It was comforting, therefore that the troops were coming, but Ada Tours observed of the 10th, 'the customs ladies returned to their homes in the morning and their husbands brought them back at night'.

During Sunday night, more damage was wreaked on foreign property: news reached the legations at 8am on Monday 11 June that in the Western hills the British Summer Legation – recently restored and redecorated at considerable cost – had been sacked and burnt by Boxers after Chinese soldiers sent to guard the premises left their posts during the night. Student interpreters felt particularly for the Minister's wife: 'Poor Lady MacDonald's new things from home, and old "lovey" odds and ends all gone.' wrote Meyrick Hewlett, while his fellow, Lancelot Giles, added, "Lady MacDonald is very wrath about it, as many of her priceless treasures (those of sentimental value) were out there.'[17]

What was rather worse, as far as Annie Myers was concerned, the gatekeeper had led his family to safety in a nearby temple but 'It was the rendez-vous of the Boxers', and his wife and children were killed. And the same band also destroyed the nearby LMS sanitorium and what Deaconess Jessie Ransome described as 'our dear little home at S. Hilary's'.[18]

Later in the day, each legation sent several carts to the station to meet the troops arriving from Tientsin – but no train appeared and they returned empty to the legations. Mrs Conger described her feelings:

> We should like to know where our troops are and what the outer world is doing. It seems that day by day we are narrowed into closer quarters; little by little connection with the world beyond Peking has been cut off. Now we stand isolated; both telegraph lines are gone; the railroad is gone. No Legation mail pouch; there is but little mail, and that is brought by couriers.[19]

But worse was to come; later still that day, the Japanese Chancellor, Sugiyama Akira, set out for the station to see what was going on. At first he was stoned on his way there; then, on his way back, he was dragged from his cart by the troops of General Tung Fu-hsiang and killed, his body badly mutilated – Polly Condit Smith describes him as having been 'disembowelled and cut to pieces'.[20] The Japanese Second Secretary, Narahara Nobumasa, who had a wife and two children in their legation, tried unsuccessfully to retrieve his colleague's body from the Tsungli Yamen. I have been unable to discover if the murdered man

was married, let alone had a wife, now a widow, in Peking. From that moment, the Japanese regarded diplomatic relations with the Chinese as severed.

Sarah Conger describes other diplomatic developments:

> Two members of the Tsung Li Yamen came and asked Mr Conger to stop his troops and not let them enter the city. They begged the Ministers to turn their troops back. They said it would be much easier for Prince Ch'ing [President of the Tsungli Yamen]. Mr Conger said, 'No; we cannot turn them back. They must come to protect our people. You fail to do it. We are your friends, and are going to help you to protect your people. We ask nothing but protection.' One of these officials said, 'Other nations do not allow troops thus to enter their domain.'
>
> The questions were asked, 'When your people are representing you in foreign countries are they stoned on their way to the station, insulted and struck on the streets? Is their property burned?' The reply was, 'No.'[21]

Word soon reached the legations that Prince Ch'ing had been arrested. Rumours about the Tsungli Yamen were to proliferate; Jessie Ransome noted that, 'Prince Ch'ing who was rather favourable to us, has been turned out of the Tsungli Yamen, and replaced by Prince Tuan who is pro-Boxer; and now there is a report that Prince Ch'ing has been killed, but it is not authenticated.'[22] However, her sister Edith repeated the rumour in her letter that day to Mrs Scott in Tientsin.[23]

By Tuesday 12 June, the reinforcements still had not arrived and it was very hot that day – 103 degrees in the shade. The Russo-Chinese Bank sent its women to the British Legation, including Mme Pokotilova, wife of the director. Teachers of those learning Chinese left for two or three days vacation, and many of the legation servants left too. But the student interpreter Hewlett noted that 'the position of the "boys' was very hard all this time, as many are RCs and it did seem hard for them to leave their wives and children and not go home, yet many stuck to us'.[24]

Four officials from the Tsungli Yamen called on the various legations that day. At the American Legation, they presented the compliments of the Empress Dowager to Mr Conger and his wife before, as Sarah Conger described it, they 'requested that the soldiers be kept in the Legation compounds and not in the streets'.[25] And she added anxiously that nothing had been heard from the troops in spite of many messengers being sent out. So she did the only thing over which she had any control: 'I have bought more supplies,' she wrote, 'flour, rice, meal, beans and coal. It seems that we may have need of them.' At the French legation, the Empress's best wishes were conveyed to Mme Pichon; there were also new assurances of peace and the news that the Tsungli Yamen had formally permitted the entry of reinforcements.[26]

In Tientsin, Bishop and Mrs Scott, keeping tenuously in touch by courier with their people in Peking – unable to return home in spite of every effort –

noted that 'Sir Claude intends (D[eo] V[olente]) to get all English women and children out of Peking under a guard as soon as the rail is repaired. Deaconess Jessie and Miss Lambert will, I think, remain to nurse in case of hostilities.'[27]

But it was not to be; as Dr Lillie Saville continued her account, noting that the railway line must have needed more repair than expected,

> The carters returned to the shelter of the verandahs, and another night's gambling. But tomorrow did not bring them, nor yet another tomorrow, and though hope died slowly, it died at last. The carters were ordered off, and the night brought peace from them, – but they had gone because they were no longer needed. No troops could reach us by the line.[28]

Dr Martin Wishes She Was a Man

In the Methodist Mission compound – thirty acres including barricaded streets and alleys – the women were similarly informed and similarly at a loss and anxious. On Sunday 10th, the Foreign Board missionaries from T'ung-chou heard that all their properties there – church, college, houses and, therefore, their work of decades – had been ransacked and burnt, apparently 'by the imperial troops placed there to guard them'.[29] Luella Miner confided to her diary on the 11th her anguish at the loss of her 'fine geological collection over which I spent so much time and my microscope slides'.

But one of the other women in the compound recorded, 'I wish I could tell you how brave the Tung-chou people are about the loss of their homes and property. Miss Andrews and Miss Chapin were so busy getting Chinese refugees settled that they came away with nothing but a bundle of clothes. Others were able to bring trunks.'[30] While Ada Haven, in charge of the Congregational schoolgirls, added, 'I have not seen a tear on the face of anyone since I came in, except a poor school girl whose father had been murdered by Boxers in Tungchou.'[31]

That first day of settling down, Saturday 9 June, had not been easy for her girls:

> The sun waked us early in the chapel, spite of the fact that the novelty of the situation had not been very conducive to sleep the night before. It was with some difficulty that those of the girls who woke early could be restrained from their accustomed use of their tongues. But the quietness on the other side of the church, where the Methodist girls had spread themselves, was a good example. On looking around, one could see most of the girls sitting cross-legged on the floor between the rows of seats, each one combing the hair of a girl who sat in front of her, yet busy only with hands – tongues entirely quiet, and even hands quiet as regards sound. So my girls and myself followed the good example. But when the 6 o'clock bell sounded, presto –

what a change! Every girl on her feet, folding her quilt, her tongue busy enough to make up for lost time.[32]

Ada Haven could not avoid being conscious of more important aspects of relations; as she put it, 'We felt very deeply the kindness and generosity of our Methodist friends in ... giving our Congregational girls a better place than remained to give to their own refugee families.'[33]

Miss Haven was talking in particular of Mrs Jewell – head teacher and matron of the Methodist girls – whom Presbyterian Theodora Inglis describes as 'clear grit through and through'.[34] But as Theodora also noted, Charlotte Jewell was 'secretly anxious concerning the many helpless girls upon her hands'. There was some consolation for, not only were her girls brave, they also managed to retain their sense of humour:

> She was touched one day by the girls coming to her and saying, 'You are not to worry about us any more Mrs Jewell, we have asked God to protect us and if he does, well and good, if not, we are Christians and will die for the faith which you have brought us.'
>
> And then one little girl said to another, 'Oh, if we should die, how many jewels, Jew Tai Tai (Mrs Jewell) will have in her crown up in heaven.'

Dr Emma Martin catches up with another aspect of Mrs Jewell (who had become a missionary when she was widowed), while confirming traits within herself with which she has already begun to acquaint us:

> I never lost my courage once and went to sleep with my revolver beside me. Mrs Jewell had gotten a larger one to defend the schoolgirls and she had given me her old one so I carried it now with the cartridges in Lizzie's chatlain bag suspended from my belt. Three things I would like to know about it: how much noise will it make? How far will it shoot and would it kill a boxer? I don't expect to use it unless I come face to face with one. I told Lizzie I would take care of her now that she could stay right behind me and she said she was very sure she would not want to be in front of me.[35]

But of her medical expertise Dr Martin was more confident and that was certainly in demand from the first morning:

> It was found that a little girl had slept in the church that night who was in the 'scabby' stage of small pox. I was horrified and supposed, of course they would fumigate the church but no one seemed alarmed, they are so accustomed to it, she was sent away for the sake of the marines and nothing more was said about it. Two other cases have been sent out as well as a scarlet fever family and some measles. There are eight of us medical missionaries here on the sanitary committee to look after the health of three or four hundred Chinese. About 70 fall to my lot to inspect twice daily for contagious diseases.[36]

It must have been quite nerve-wracking for American mothers; of the thirty-four women, eight had young children with them. Emma Martin and her colleagues obviously did not manage to keep the medical news from them for, in her diary the following day, Theodora Inglis noted, 'A Swedish missionary from north China [Mr Bok] came in carrying in his arms a child broken out with the small pox. Soon after, several came down with scarlet fever and then there were other cases of small pox and dysentery.'[37] She could not afford to panic and, from Sunday when there was consolidation of where women and children slept, there were other concerns which she describes:

> We soon had the beautiful church transformed into a fort. Inside, at night, there slept on the rostrum eight foreign mothers and twelve children. On the church floor slept the teachers and nearly 200 school girls; in the lecture room nearly the same number of native women with babies. There was a baby and often several crying every hour of the night. Happy was the mother whose babe was a sound sleeper and did not add to the general disturbance.[38]

And the mortification of one poor mother – American or Chinese is not clear – must have been immense following the incident Ada Haven describes on 11 June:

> Among the articles provided were 500 or more eggs – great tubfuls. But alas for those eggs! A toddling baby sat down in one of those tubs one day by accident. ... It was a bad thing for that baby, and still worse for those eggs, for not all the King's horses nor all the Dowager's Boxers could pick those precious Humpty Dumpties up again.[39]

Theodora Inglis had a marvellous moment that Monday: 'When we were at our early dinner,' she wrote:

> I saw a familiar old figure stalk by the side window. Rushing to the door, I beheld my old Wang Nai Nai, her face all aglow and her eyes gazing around for the baby.
> 'Oh, Wang Nai Nai,' I cried, 'You did come, I had given you up. Oh, why did you decide to come?'
> 'Why did I come?' she repeated in her gruff old voice that I learned to love so well. 'Why did I come? I came because I wanted to see my baby. Do you think that I would have come had my heart not cried day and night for my baby? Didn't my son who is in the army say not to come, that the soldiers and Boxers would kill me, and didn't my daughter say not to come for I would surely die if I did, and didn't I listen to them for three days and then told them I was coming anyway, that if they killed me, I could die once only and had to die sometime anyway, and, – where is that baby?' She broke off, and when she found her she hugged her, kissed her, sniffed her pink little

cheeks and said, 'Oh, such a sweet baby, old Wang Nai Nai's baby. No one else can have this little lamb but old Wang Nai Nai.'

And then the baby dimpled, laughed and cried, 'Nai Nai, Nai,' and the faithful old soul felt repaid for coming.[40]

Bessie Ewing, with two children, and newly pregnant, was not so lucky (then, at least). 'I get pretty tired each day as the baby's nurse did not come with me', she wrote, and continued:

> I was surprised that she did not come for I thought nothing would persuade her to leave Ellen. But the moment I spoke of leaving home and said she could do as she pleased, she spoke up quickly, 'Enough, hire a cart and get away.' It seems she had agreed with two other women that if there was any serious trouble they would all stick together. So we gave her wages for the full month and a little extra and left her. But after trying for four days, without success, to get carts to take them out of the city, she sent word to me on Monday asking if she might come back to me. I was getting along very well and curing Ellen of some bad habits, and it seemed as though the sleeping and feeding of another would trouble others so much. I knew the woman was comfortable at our place [the American Board Peking compound], and there seemed no immediate danger, therefore I sent back word that she need not come unless as a refugee with the other Christians ... [41]

And Bessie had more on her hands than her own two children: Martha, a Chinese girl whom she had adopted and placed with her Chinese Biblewoman – for her own good [she] must grow up a Chinese girl with the Chinese.'[42] Bessie explains the new position:

> I have the use of Dr Lowry's kitchen to prepare food for Ellen and also for our orphan girl Martha. She, with her little sister and the old lady who looks after them, came here the same night we did. Martha has been very poorly since the warm weather came on. Her cough is bad, she cannot sleep and can only be tempted to eat. The refugees have only millet, rice and cornmeal cakes and these not well cooked, so I prepare for Martha [food] twice a day and take it to her. Dr Lowry's cook buys vegetables and eggs for me to give her and I can sometimes get her a little bread and jelly or fresh fruit.[43]

Then, just in case she should have any time to spare, Bessie Ewing recorded how on Sunday evening the men asked for cartridge belts, 'So we bought strong blue Chinese cloth and set to work to make belts for the cartridges as fast as possible, not knowing but that they would be needed [that] night. But all was quiet and we think the troops from Tientsin must come soon.'[44]

Bessie finishes that account with a remark which, taken in conjunction with other stories, had interesting resonances for the American women: 'I fear when they do come that the ladies and children will be sent to Tientsin, and most

of us do not wish to go. But just here we are glad we are Americans, for no one will *order* us away. Our minister can only *advise*.'

At about this time, fifty-two-year-old Methodist Mary Porter Gamewell happened upon Captain Hall of the US marines. She had been in China since 1871 – as an unmarried twenty-three-year-old she had come out to a new school for girls in Peking dedicated to the unbinding of feet. Frank D. Gamewell, a civil engineer, arrived at the Mission in 1881, and they were married the following year.

In 1884, Mary Gamewell accompanied her husband to Chungking, in the interior; they were there during the riots of 1886 and first she held back a mob

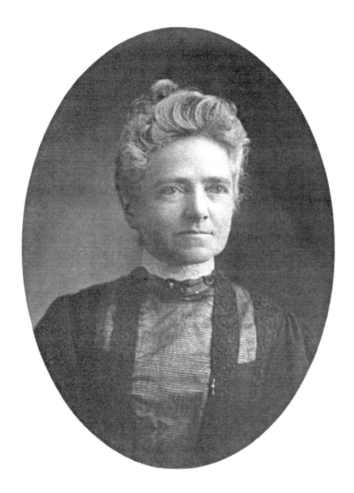

16 Mary Gamewell (from *Mary Porter Gamewell*)

with an unloaded gun, resulting in one of her fingers being almost severed, then she was a prisoner in the magistrate's yamen. Soon thereafter, Frank Gamewell was reappointed to Peking, to teach at the university, while Mary was put in charge of a training school for Bible women. In her work she travelled hundreds of miles under all conditions through North China.

The Gamewells were packed and ready to go on leave when the troubles of May 1900 started. Now, this mature and experienced woman told the captain in charge of the twenty-strong marine force that 'I should be glad to serve in case of attack anywhere and in any capacity that he might suggest.'[45]

The Captain 'heard her through' and he then replied, 'The most helpful thing a woman can do in a fight is to keep out of the way.' Mary Gamewell meditated for a moment on these 'rather strange words' and then thought perhaps the Captain had had second thoughts for he spoke again, unsmiling: 'There is one thing you can do. When the firing starts you can take charge of the hysterical women and try to keep them quiet.'

Mary Gamewell went on her way and 'repeated the captain's saying to my comrades over whose hysterical performances I was thus appointed to preside, and watched the serious faces of those brave women break into a smile that went around at the captain's expense'.[46] She could not help adding, however, that 'every heart was warm for the captain and his handful of brave men who stood between us and peril'.

Dr Edna Terry of the (Methodist) Women's Foreign Mission, who had arrived by mistake from Tientsin on 30 May for a conference, must have been one of those women for she noted on 10 June, 'All the gentlemen and some of the ladies are armed; but the captain says the place of women is under the seats in the chapel if anything happens. That put a damper on the martial spirit of some of our brave women.'[47]

And Dr Emma Martin, too, for she wrote home:

> I'm tired of being a girl – I wish I was a man and could carry a gun and keep guard. I'm dying to climb up on top of the church to look around – some fellow sits up there with a field glass all the time. The Captain said ... if we were attacked and had to go to the church he 'would like for the women to be under the seats'. *Imagine it.*[48]

In fact, whatever Captain Hall's views, Mary Gamewell reported a change in perception of the women's use:

> In accordance with the new plan, women sentinels took turns day and night at watches of two hours each, on certain verandas, and chairs were provided for these sentinels. When an attack seemed probable, a soldier would warn a watcher on a particular veranda, and she would warn the watchers on other verandas, who in turn would inform the various assemblies in various parts

of the premises; then all would take their appointed places in the general movement to the church.[49]

Chinese women, no matter their status in the outside world, had functions to fulfil, though traditional attitudes of protection extended to them in a slightly different guise. Theodora Inglis, describing civil engineer Frank Gamewell's fortification of the compound, talks of

> Young Chinese matrons and even old grandmothers [helping] in carrying bricks, one or two at a time as their strength permitted. I overheard a marine at a gatehouse say, 'Boys, I hate to see old women carrying bricks.' And in this remark, he showed American spirit. But the old woman said, 'It is all I can do and if carrying bricks helps any, I will do it.'[50]

Miss Georgina Smith – the only British woman there – may or may not have been aware of what was going on with respect to American mores when she wrote later to London, 'The captain speaks highly of the women who neither cry nor get excited when danger seems right upon us and we all have to make a quick march to the chapel.'[51]

But then Miss Smith had concerns of her own. She told London how, if she could have got away to her mission compound during the time it was deserted,

> I think I would have tried to bury the hospital drugs and instruments and the fire engine or I would have sent the latter away here. But a great many people were nervous about anyone being in the vacated compound for fear the Boxers should come upon us suddenly and my colleagues were so annoyed with me for going there after it had been handed over to the care of the Tsungli Yamen ... that I decided to stay away for the sake of peace!

While Georgina Smith was trying to assert her independence and exercise her initiative, Drs Emma Martin and Anna Gloss were having less trouble – for their hospital was only across an alley. Emma Martin wrote:

> We were over in the hospital today, collecting dressings and drugs and instruments that might be useful in case of a siege and Dr Gloss remarked 'It's rather gruesome work, isn't it?' and I agreed. It is hard to tell just what one ought to take and what leave in case of hasty flight or in case of siege, and we know now that it will be one or the other at best or death. It is strange how things, beautiful costly things lose their market value when one stands face to face with death. So we sadly survey our possessions and try to select what we think will be most useful to us or will keep life in us the longest if we should be besieged.[52]

There was still time to save possessions of all kinds, and Bessie Ewing's husband, Charles, was determined to do so; he went to their house several times on Monday and Tuesday and Bessie was pretty pleased with his haul:

He packed and sent down here practically all our clothing, also my good table linen, sheets and pillow cases, best silver and church communion service and our small gold clock. My silver pudding dish was the only large silver piece Charles sent. Our double mattress was brought down for one of the officers and the bedding was brought with it, but not my best quilt that Auntie Ellen pieced for me. Charles did not have time to pack Mamma's tea-set ... On the last trip Charles brought down all the deeds to our mission property both in Peking and in our out-stations and also brought all the account books, Mission, Press and personal. These had been in the Press safe and Charles sent the books to our Legation to be placed in the safe there. He saved the book of Marion's baby pictures, the record books of the two children, a small album containing pictures of Mamma and of us four children, several of Marion's best picture books, a few playthings and my Chinese primer, over which I have spent so much time and thought.[53]

The 'officer' – perhaps Captain Hall – was undoubtedly delighted with the double mattress, but what the marines really wanted were new summer uniforms; they had left their ships off Taku without notice and, therefore, without the necessary warm weather clothing. Mary Gamewell describes how

The women took a collection among the missionaries, and while it was yet possible to make purchases at the shops they procured enough navy-blue drilling and brass buttons to outfit the twenty soldiers with lightweight suits. We had no experience in making men's clothes, and thought it possible that the soldiers might object to any fit we might make, but we hoped for the best, and after consulting the captain as to the regularity of the proposed proceeding – for we were under military rule those days – we entered upon the undertaking. We ripped a suit of Mr Gamewell's for a pattern. Then one of our number cut coats and another cut trousers. To be sure, the soldiers were tall and short, heavy and slight, but the pattern was medium, and there was to be a basting and fitting of each suit. While two cut, many basted. Then in capacity of a fitter I took the garments to the soldiers' headquarters, and pinned and fitted until every suit was adjusted. ... We found that the soldier boys, sweltering in heavy uniform, were not half so anxious about the fit of the lightweight suits as they were eager to be clothed with the same.[54]

Mary may not have had her tongue in her cheek when she added:

Concerning one point only were these brave soldier boys particular, and that was that there should be no hint of flare where the trousers met the feet, for the soldiers of the marine corps were anxious that no extra width of trousers should cause them to be mistaken for sailors.[55]

Dr Martin was obviously excused sewing, for she noted of Sunday, 'Some of the sisters made cartridge belts ... The ladies are making the marines summer

suits.'[56] For a moment, they could forget the gravity of their situation, but there was general concern in the compound at the lack of news from Paotingfu, due west from Tientsin, in Shansi Province, which they knew was menaced by Boxers. There eleven American and five British missionaries – women, men and their children – were holding out.[57]

Before ever they were to hear news from Paotingfu, came the night of 13 June in Peking – sometimes known as the Chinese St Bartholomew.

5
Wen Te Avoids Sisters of the Red Lantern (13–17 June)

Annie Chamot Gets in the Way

'Baron von Ketteler, the German Minister, considered some Boxer who walked down Legation street was impertinent to him', wrote Polly Condit Smith on Wednesday 13 June.[1] As she reported the story, forty-seven-year-old von Ketteler chased the man up the street as far as the Russian Bank, 'where he finally captured him'. Not content with taking the man prisoner, 'He was beating him over the head with his walking-stick even before the fellow stopped, and the crowd that collected was enormous.'

But the story was not the same in everyone's diaries: Mrs Russell, the professor of mathematics' wife who since Saturday had moved to a house in Legation Street, reported that two Boxers were 'riding in a cart down Legation Street waving naked swords'.[2] According to her, the Chinese authorities 'asked that [the captured man] be given up for punishment, but Baron von Ketteler replied he would be given up on the arrival of the police force'.

A.D. Brent, the Hongkong and Shanghai Bank man who was based in the Spanish Legation with his mother Charlotte, added that in the cart was also 'a woman apparently bound hand and foot'.[3] As several foreigners gave chase, so the Boxers fled, one of them escaping, the other taken to the German Legation and afterwards handed over to the Chinese authorities.

Deaconess Jessie Ransome gives yet another version:

The Germans captured a Boxer, who had been one of the three swaggering about in Legation Street in all their war-paint and with drawn swords. Unfortunately, the one they caught was only a boy of about seventeen or eighteen, but still capable enough of doing a great deal of mischief. The German Minister attacked him with a stick, in what seems to us an undignified manner rather! He was taken into the German Legation, and the Chinese authorities informed, but the Germans refused to give him up.[4]

Jessie's colleague Roland Allen added a further refinement: 'It is said that the German Minister refused to give the man up to the yamen authorties, insisting that he should be executed on the bridge the following day.'[5] Nigel Oliphant of the Imperial Chinese Bank described von Ketteler as 'so excited that he nearly killed the poor wretch, who was only a boy of sixteen ...'[6] Annie Myers talked of von Ketteler 'beating a tattoo on his head with his stick until he was requested to desist by Captain Myers [no relation] for fear he should kill him'.

The variety of detail to be found among those reports suggests the difficul-ties of interpeting or recreating what really happened; but it also shows that people's perceptions, false or distorted as they may have been, have their own validity – for that is what they thought happened, and what, often, they reacted to. Sometimes, of course, although a diary entry has a specific date, it was written later during a period of catching up, and may have come under other influences. Annie Myers was overtly aware of the dangers of misreporting; she wrote of an occasion three days later:

> I learned another story about it, which shows how much everything must be verified to be really believed! It seems, according to the second version of the story, which I got from one of the party and therefore must be the right one ...[7]

But what those cool, supposedly factual accounts of 13 June leave out is reaction among the non-participating foreigners – except for Jessie Ransome who, as often, is judgemental about style of behaviour. The incident led to immediate repercussions only in the American Legation where there were by now twenty-nine foreign women and children sheltering; Mary Bainbridge, wife of the Second Secretary wrote:

> All the women and children in our Legation came running up to my rooms, they thought an attack was being made on us, for Dr Coltman came running into the compound with glaring eyes and calling to the top of his voice, 'an attack, an attack', and they all thought their doom was sealed and wanted to get to a safe place, if one could be found.[8]

Even the calmest became involved; American artist Cecile Payen noted,

> At about eleven o'clock this morning, when I was painting on a portrait, Dr Coltman came rushing in, calling to us that the street was full of Boxers and an attack was made on the legation. The call to arms was given.[9]

Annie Myers noted in her diary that night that Dr Coltman had told Captain Myers that '*500 Boxers* were coming up the street.'

But this incident suggests almost the only sense of panic among women either that day or on any of those that followed, and it is noteworthy that Dr Coltman should be involved. He was not only doctor to the American Legation, but also a journalist on the side; he also appears to have fed gossip – gained

from his medical practice – to George Morrison of *The Times*. And yet Morrison was to repay his reputation poorly in the days to come – depicting him as a coward. All Coltman wrote himself of 13 June in his published account that is relevant was: 'Events have been too exciting to allow of one sitting down quietly to write.'[10]

Our interest in Coltman stems from the fact that he had a wife and six children (probably all born in China) with him; he tells us later that he and his family had been invited to move into the American Legation from their house in the vulnerable extreme east of the legation quarter, just by the Ha-ta-men. What were his wife's feelings about his behaviour – and how did she cope with his panic and trying to keep six children calm? Almost the only image we have of her is conveyed by Cecile Payen the night the Coltmans moved into the Legation (8 June). Those already there were 'dancing and singing among ourselves ... Poor little woman, as she entered the house with her sleeping baby in her arms, how disgusted she looked to see us amusing ourselves!'[11]

We also need to start thinking of the feelings and reactions of Baroness von Ketteler, for her husband now began to get the bit between his teeth where the Boxers were concerned, and defending the legation quarter and its inhabitants from them.

Maud von Ketteler was a twenty-nine-year-old American, born Matilda Ledyard, the daughter of a Detroit railway magnate. Her mother had died in 1895. Before I found the portrait overleaf of Maud, I already thought of her as Lady Blake saw her at a dinner party in May: 'a tall fair woman, gracefully dressed in white satin carrying a fan of ostrich feathers'.[12]

Maud Ledyard had met Clemens von Ketteler when he was Secretary at the German Legation in Washington and married him in 1897. She went with him to Mexico when he took up his appointment as Minister there that year. Diplomatic life would not have felt new to her; not only had her family been diplomats for two generations but, through family contacts, she was well travelled in Europe. Peking was rather different. A secondary German account which gives no source suggests that Legation Street was so dusty and unpleasant that she felt she had been transferred to a small town in the mid-west of the United States; she longed for elegant and busy New York.[13]

While that rings true enough, Maud's first-hand account of the journey by sedan chair to the second diplomatic women's audience with the Empress Dowager on 9 March that year is likely to be a better reflection of her views:

> What I have come to regard as the strongest characteristics of the Chinese race are their love of dirt, and their curiosity and their incessant noisiness ... Men, children, even women lined the entire way, and peered and leered into the little windows of our chairs, all exchanging criticism of us which may or may not have been flattering for all we knew. Added to their jabbering, were the incessant directions and discussions of the chair-bearers and I am sure

that one could not go to any other Court in the world in a less dignified, but more interesting manner.[14]

For Maud's husband, on the other hand, China was completely familiar. Baron von Ketteler came from an old Roman Catholic family from Westphalia, and was the nephew of an archbishop. He had been a lieutenant in the Prussian army, and then transferred to the consular service, initially as interpreter in the German Legation in Peking, and then as Secretary. Between 1880 and 1890,

17 Maud von Ketteler (courtesy of Bon Secours Cottage Health Services)

his Chinese had become fluent and he distinguished himself for bravery when the foreign settlement in Canton was attacked during riots in 1888; with the assistance of a few German residents, he defended a house in which women and children had taken refuge and was, as a result, decorated by both the German and Chinese governments.

His relations with China seemed cemented when, in 1890, during his leave in Germany, Li Hung-chang, China's senior minister, visited Europe to discuss, among other matters, military technology, and von Ketteler was deputed to show him round armaments factories such as Krupp. Having risen in Germany's diplomatic service thereafter, he was appointed Minister to China in 1899. By experience, his seemed a good – better than most – appointment; but by temperament, and because of German policy towards China, he was unlikely to put up with what he considered nonsense and the implications of his independent and impetuous behaviour were to be far-reaching; on 13 June, they may even have contributed to the night's events.

From now on, a part, at least, of my imagination concentrates on the reactions of Maud von Ketteler whose brother had been killed in an American military action in the Philippines barely six months previously, bringing a grief which led her to write to a future sister-in-law, 'I know from my own personal experience that it is *sorrow* not *happiness* that forges the closest bond.'[15] Did she ever say to her husband, 'Should you have, my dear?' And if she did, how did he react?

Later that Wednesday afternoon, a party of German and Italian marines raided a nearby temple, but the thirty or so Boxers there escaped, leaving behind their red girdles and swords which were carried off as trophies. During the course of the afternoon, the French shot two Boxers. Legation street itself had been packed with milling Chinese; they were at sixes and sevens because the previous morning 'bloody hands' had appeared on walls in several parts of the city which suggested that something was about to happen. The Boxers were working on the superstitious fears of the people.

In the early evening Boxers started pouring through the Ha-ta-men, the gate just to the south-east of the legation quarters, between it and the American Methodist compound. Polly Condit Smith explained how the captains of the American, British and Russian troops

> seized this opportunity to make a kind of rush down and up Legation Street, placing the Maxim-gun ready to use if necessary, and in this way completely cleared it of Chinese from the Dutch Legation down to the Italian. They had wanted to take this step for some time, deeming it has now become necessary to take real measures for our defence.[16]

Barriers were now placed at either end of the street.

Jessie Ransome recorded what happened next from within the British Legation: 'At 7.30 we suddenly saw a great column of smoke to the East, and

then, in about half an hour, a volley of shots in Legation Street, and a lot of soldiers tore up the stairs into our rooms.'[17]

In the American Legation, on the opposite side of the street and up against the city wall, Mary Bainbridge told how, 'At seven in the evening the Captain told the ladies that when the alarm was given, no matter what hour of the day or night it might be, we were to fly across to the Russian Legation. At 8pm two marines were sent up to our quarters to watch for boxers or soldiers who might fire on us from the wall.' From the Russian Legation you could get comparatively easily to the British Legation behind it.

The Spanish Legation was on Legation Street but across the canal from the Russians and British. Charlotte Brent, who was staying there with her son A.D., noted that 'There were various alarms in the afternoon and we had to rush to the [British] Legation with AD about 5.30 ... stayed the night at the Cockburns but, returned next day to the Spanish Legation.'

At the Chinese Imperial Bank residence next to the Austrian Legation out on a limb at the north end of Customs Street, Mr and Mrs M.H. Houston were having dinner when they received a message from the British Legation to come quickly. They had married two months previously in Hong Kong and the dining room was full of wedding presents. Mrs Houston just gathered up the table cloth with its silver cutlery and they left immediately.

A report that Boxers were on their way towards the legation quarter had brought out foreign troops in different places to look after the interests of particular legations; with them came the volunteers. Captain Darcy of the French marines later reported that 'M. and Mme Chamot were at the head of a number of volunteers armed with carbines and hunting rifles which crossed the French and Italian lines in Legation street and went to meet the Boxers.'[18]

The volunteers fired a dozen or so shots which sent the Boxers on their way – five were killed, including a lad of fifteen who had flaunted his chest, believing himself to be invulnerable. The group of volunteers went on towards the Ha-ta-men; there, while Annie Chamot 'kept seven or eight Chinese covered with her carbine, M. Chamot locked the gate and took away the key'.

The volunteers of all nationalities were to prove invaluable in the days and weeks to come, but military discipline had to be maintained; Captain Darcy explained that 'while admiring the courage of the volunteers, I felt obliged to suggest that I felt they had been imprudent. I told them that our marines were there to protect them, not to be protected by them.'[19] What was more, the Italian Minister and his captain 'asked me to add that in future they should not put themselves between the Italian marines and the enemy either'.

For the professionals, the whole thing had been a bit of a debacle, although, as they were called out, Annie Myers had overheard one British marine saying to a comrade, 'Hurray, lads, sport at last!'; for the volunteers, among whom was Putnam Weale, 'It was like a good drink of strong wine.'[20] But what did Annie Chamot feel? I have been unable to find out – she appears to have left

nothing written – but that image of her covering a group of Chinese men with her carbine, defending her husband as he locked the city gate, is striking; it squares with the one of her on horseback with a rifle slung over her shoulder, riding to save the Belgians at Ch'ang-hsin-tien, but it is at variance with the posed photograph of her on p.38.

After the little *entretien* of Wednesday night, Captain Darcy sent four men to the Customs compound (known as the Inspectorate) opposite the Austrian Legation to get Mme Piry and her four children and their governess, and Mrs Bredon and Juliet. To the east, the Chinese Imperial Bank quarters were burnt down and the Houstons lost their wedding presents, though the bank itself only had its front windows smashed that night because a member of staff had the presence of mind to suggest that it was a Chinese institution.[21]

At the Austrian Legation itself, there were only Dr von Rosthorn, the Chargé d'Affaires, and his wife Paula, and some Austrian marines, but the Boxers were seen off with a gun known as the 'carpet knocker' because of the noise it made.[22] But George Morrison remarked disparagingly in his October account in *The Times* that when they went out expecting to find piles of bodies, there were none because the gun had been aimed wide of the mark.[23] Morrison was convinced that this fiasco helped to promote Boxer belief in their invulnerability.

Nigel Oliphant adds to Morrison's criticism with his suggestion that the Austrians had only 'succeeded in cutting all the electric wires which stretched across the road to their north'.[24] Whether these remarks are a manifestation of already-existing bad blood between the British and Austrians, or that Austrian incompetence that night contributed to future disagreement, is unclear, but Paula von Rosthorn's behaviour and memories were to be affected by soured relations. Later, the electric light plant was destroyed but, strangely, no one was to mention the lack of electricity.[25]

And, whatever their failures, the Austrians did try, as Polly Condit Smith noted, to rescue 'a Chinese woman who was being burned to death very near their Legation wall'.[26] Polly's account suggests that she was successfully saved, others are less convinced.[27]

After 9 June, when many women spent the night in the British Legation, most Customs and university families previously living in their own scattered houses, had moved into the Inspectorate compound, leaving their houses empty. Now, the Brewitt-Taylors' house was burnt to the ground. What was deemed particularly striking was that there had been no attempt to loot, even though their possessions were packed in boxes as they were about to move south for the Imperial Customs and were only waiting for the railway line to be reopened. The Russells' house in the university compound was also destroyed.

But what happened in the strongly protected legation quarter was as nothing compared with what was happening outside; well might Jessie Ransome write

that night, tucked up in Lady MacDonald's ballroom, 'We long to know what has happened in the West City, where our compound is.'[28]

The Fate of Ellen Ewing's Nanny

That night the Boxers went on the rampage through the City and set fire to any building connected with Christianity and foreigners that they could reach, from the Tung-t'ang, the Roman Catholic East Cathedral, to the homes of Christian converts. They slaughtered the Christians as they went.

The accounts of the burning of the Tung-t'ang (to the north of the legation quarter) are limited and confusing, but Putnam Weale seems to have been in the vicinity with other volunteers. He describes how

> A Frenchman stumbled with a muttered oath, and, bending down, jumped back with a cry of alarm. At his feet lay a native woman trussed tightly with ropes, with her body already half-charred and reeking with kerosene, but still alive and moaning faintly. The Boxers, inhuman brutes, had caught her, set fire to her, and then flung her on the road to light their way. She was the first victim of their rage we had yet come across. That made us feel like savages.[29]

Though a rescue party was sent to the area of the smouldering cathedral after midnight, several hundred Roman Catholics had disappeared. In the early hours of the morning, refugees began to emerge. Putnam Weale describes how one gatekeeper had lost everything: 'His wife, six children, his father and mother, and a number of relatives had all beeen burned alive – thirteen in all. They had been driven into the flames with spears.'[30]

Dr Lillie Saville had watched from the upper verandah of the First Secretary's house in the British Legation compound 'columns of smoke followed by huge blazes all over the city. We knew our homes, schools and hospitals were being destroyed', she wrote. 'We heard, moreover, the yells of the mob – *kill – kill – kill!*'[31] Later Lillie Saville was able to piece together the story of Wen Te, a West City day scholar whose father was one of the helpers in the Blind School Mission.

Earlier in June, the thirty blind boys and eight girls had been moved from their compound in the West City to a more secluded spot near the foreigners in the East. Twelve-year-old Wen Te's mother, elder sister, and baby brother were put with them. That Wednesday night,

> The mob had rushed into the Compound where the Blind were, and fired the buildings. All had run out together and tried to escape, but became separated; she had heard that all the blind girls had been driven back on to the flames. She and her mother and sister had fled westwards, towards their old home, but had been recognized. Mother and elder sister were cut to pieces, the baby

stripped, most of her clothes taken, and then – wonderful to relate, she was allowed to go. But where? For five days that child wandered about the City, avoiding the big streets, creeping along the narrowest lanes, always with the baby, aged two on her back. She had no cash to buy food, and was afraid to beg. A Buddhist priest had met her, given her a few cash and a small charm, advising her to keep it, and shew it when questioned. The streets were full of Boxers – men with red caps, red girdles and ankle ties, they went about in gangs crying *kill*! *kill*! Yes, she had seen many people burnt, others speared, others cut to pieces. She had been the round of all the Missions, and seen their smouldering ruins. Our West City Compound, she said, was just a 'wilderness – an empty place', even the big trees gone. ... A kind-hearted British marine allowed the girl to rest and take some food in his improvised sentry shed, and later on in the day, the poor little woman was taken to the friendly shelter of the Methodist Mission.[32]

In that compound – almost the only foreign mission to survive that night – Mrs Goodrich was to add to Lillie Saville and Wen Te's story; she tells of what happened to some blind girls who 'were taken to the Ping Tzu Men and urged to confess that the foreigners took out their eyes. They bravely refused to lie and confessed the Master. Some were killed, and some fled.'[33] Stories about missionaries depriving Chinese of their eyes (and other body parts such as vaginas) for their own nefarious purposes were rife at this time and used to stir up hatred.

It did not seem throughout the whole long night that the American Methodist compound would survive. Dr Emma Martin describes how

In the evening there was a great excitement on the wall near the Hatamen and the refugees in our compound were frightened and fled across to the other side while we were at supper and we all left the table to see what the commotion and shouting meant for we thought surely it was the boxers and Mrs J[ewell] got the girls in line ready to cross over and it was only a few minutes till our street and about a block away was in flames. We thought our place would be next and the Captain ordered us, women and children, in to the church and such a scene: mothers with their little ones, gray haired missionaries running about with a gun in one hand and a bundle in the other of bedding tied up in a rag – bundles of every description, we had water bottles and food supplies and refugees all piled in together any way, every one on the run. Lizzie and I had no children to look after so we left our bundle and went outside to see what was going on.[34]

The schoolgirl whose account Luella Miner used at some length, told her version:

We heard the cry, Fire! Fire! and someone came to the door saying, 'The Boxers are coming!' No one screamed or ran. We rose quietly from our knees, and the missionaries who were leading the meeting told us to be ready to

march into the church, but not to start until the order came. We stepped outdoors and saw smoke rising not far away. The Boxers had set fire to a little chapel near our compound. ... Soon some missionary ladies came to lead the women and children into the church. Not one in that long procession filing into the dark church looked frightened. I didn't feel as if any danger was near; it just seemed strange, that was all.[35]

The Martin sisters went outside and talked to the sentry about the crowd collecting in the alley but the marines set off and made a bayonet charge which dispersed it. Then they watched the fires over the city for a while, knowing well the implications: 'How bad the folks felt when they saw the smoke going up from their homes where many had spent the best part of their lives.'[36]

They tried to find a quiet place to sleep but ended up with all the other women. 'I suppose no tongue or pen could picture the scenes in that Church', wrote Emma Martin.

Up on the rostrum with the organ were groceries, eggs, canned goods, surgical supplies, water bottles, hymn books and sleeping children. Then there were I suppose 3 or 400 Chinese scattered around among the foreigners and their bedding under and between the seats as well as in the aisles, sobbing and crying and praying until our hearts were wrung with pity. Near the door our trunks were piled up where they could easily be used to barricade the door. They were ticketed to all parts of the world ... reminding one of a great baggage car.

At nine o'clock, when the cry came, 'They are firing the foreign compounds!' Theodora Inglis behaved apparently out of character: 'Crawling up onto a ladder,' she later wrote,

I beheld the sky to the north and east lighted as by one illumination. Five great fires rushing upward, mingled their smoke and flames with the clouds, burning as it were, great holes in the darkness whose upper edges overlapped and ran together in flames. We could hear nothing of the uproar that we knew must accompany the burning. No clamor or cry in the streets near to us. ... The fires continued to blaze for hours. All night we watched and waited for the return of the mob.[37]

It seems strange that she was not in the church with the other mothers but now she tells how,

Leaving Wang Nai Nai with our little Elizabeth, I went at twelve o'clock with a friend to make coffee for the weary men who were standing or walking guard sixteen hours out of twenty four. ... Three times nightly, we served it and every morning when I wakened at dawn I could see good Mrs [Arthur] Smith [Emma] giving the marines and others great bowls of steaming coffee. 'Never was so well treated on duty before,' remarked a soldier.[38]

But as Theodora continues, she had not even had breakfast that Thursday when she heard a commotion at the gate and cries of

> 'My wife, my wife, oh, my children – my wife!' and there on the gate bench sat our native pastor Wang, his huge frame shaken with sobs, dirty, unkempt and his garments torn. He had escaped from the mob with his two small children, but his wife and two daughters had been separated from him in the rush of the onslaught and we learned later were killed. ... This arrival of the early morning was repeated at intervals throughout the day but not half so often as we wished.

But it was even more harrowing and personal for Bessie Ewing who had told Ellen's nanny that she should only come to the compound as a refugee; now she had to add to her account:

> She did not come and now it is too late. Oh! I have felt so badly that I did not say 'come' but we thought we were doing the best thing at the time. ... The Christians who lived near had to run for their lives and our woman must have been among their numbers. Some have reached us but we have heard nothing from her. Ellen cries for her a good deal and clings to me all the time.[39]

One Hour More She Be All Finee

Two Roman Catholic cathedrals were still standing once the Eastern one was destroyed, the Pei-t'ang (North Cathedral) which was full of refugees and defended by Italian and French marines, and the Nan-t'ang, or South Cathedral, to the West of the legation quarter. Auguste Chamot now received news via his staff that this was in danger, so he put together a rescue party of those staying at the Peking Hotel and Annie, of course, and set off on a mercy dash in the early hours of Thursday 14 very conscious that the French priest had died in the conflagration of the East Cathedral. They arrived in time and, making two journeys, escorted to the safety of the hotel the French priest and three colleagues, together with five (or eleven) French Sisters of Charity and twenty Chinese nuns of the Order of Josephine. Soon after their final departure, the 278-year-old cathedral went up in flames.

George Morrison who, surprisingly, does not have private comments in his diary about Annie Chamot does, however, give her the credit in his later articles that some recorders omit – for example her presence on the expedition to the South Cathedral. But he does also note in his diary for the 14th, 'Visit British and yarn with Cockburn [the Chinese Secretary] especially concerning the feats of Chamot who with his wife both acted with great courage and resolution.' Some time later, one of the Chinese nuns was to talk of 'a plucky little American woman with a rifle' who had come to their rescue.[40]

Marines were not sent to the cathedral that day, for fear of weakening the defences of the legation quarter; in the evening, German marines on the wall, which ran behind their legation as well, were ordered by Baron von Ketteler to fire down on a group of Boxers going through their rituals on the other side. Ten or so Boxers were killed – a useful attack on their invulnerability, some thought.

All through that evening there was a great deal of shouting '*sha! sha!*' (kill, kill) by the crowds of reassembled Boxers trying in vain to get through both the Ha-ta-men and Ch'ien-men. One American woman writing it up afterwards suggested that 'this killing [by the Germans] may have something to do with the demonstration'.[41]

Sound carried easily that night, for the demonstration was easily heard in her new house in Legation Street by Mrs Russell who describes how: 'We spent the night in much anxiety, disturbed by distant cannonading. The howls of the people outside the city gates were fearful to hear. Their cry was "kill, Kill! Burn, burn!" It seemed as if all hell were let loose.'[42]

In the American Legation, one of the women, listening to the clamour with her Chinese servant, asked, 'Boy, have you no fear?' There were said to be tears in his voice as he replied, 'I fear for you, Madame!'[43] A.D. Brent, trying to protect his mother Charlotte, noted impersonally, 'It must have tried the nerves of the women tremendously.'[44] He is not necessarily speaking of his mother whose diary shows no sign of panic. Putnam Weale also records, 'Our women were frozen with horror.'[45] He may well have been talking about his alleged mistress Lily Bredon whose courage George Morrison has already attacked. But he added, 'the very sailors and marines muttered that this was not to be war, but an Inferno of Dante with fresh horrors'.

Dr Emma Martin in the American Methodist compound near the Ha-ta-men managed to put things in perspective: she heard it all, and was told there must be at least 50,000 voices to make such a noise, but 'Lizzie and I laid down and slept till morning for no one took the trouble to tell us what they said for which we were glad.'[46]

Mrs Russell had started that day's account by noting that they spent it quietly at home, and then went over to the French Legation after dinner. There they heard the news of the burning of the South Cathedral 'in which it is said there were 400 women and children. What their fate is we do not know.'[47]

By Friday 15, various groups within the legation quarter were determined to do something about potential refugees. British student interpreter Hewlett rather pointedly (and slightly inaccurately, though there was no French or Italian contingent as such) remarks that it was the non-Catholic countries who sent their men out.[48] But Jessie Ransome appears to put a contrary spin on her account when she writes of her activities that day:

I went with Mr Allen to one of the foreign stores within the lines of defence to try and buy some more tinned provisions, lime-juice, etc. We went round the lines, which include most of the Legations ... We met two cartloads of poor wounded Christians coming into the lines, and when we got home we heard that about two hundred more had been put into a large compound opposite the Legation. Edith and I went over to see if any of ours were there, but they were all Roman Catholics.[49]

Without the complementary diary entry of Ada Tours, the reader would be left somewhat at a loss regarding the humanity of the deaconess; but Ada wrote on the 15th:

In the afternoon more refugees were brought in by 4 American marines – 2 leading the way and 2 bringing up the rear. They met with no difficulties. Some of the women were fearfully hacked about and later the Sisters of Mercy [Charity] and Sisters Jessie and Edith went and attended to their wounds. The French legation commandeered an ox and 2 sheep and many bags of rice for the refugees and Mrs Ker and Mrs Cockburn made bottles of tea which were taken over to them, also provisions and mats.

Mary Bainbridge, from her vantage point in the American Legation which the sad trails of refugees had to pass, wrote of the day:

This forenoon 22 marines went out to rescue the inmates at the Nan-Tang. The Boxers had set fire to the building after tying some of the most helpless women and children to posts, trees or their beds, and torturing them in the most brutal manner. These barbarians are most wonderfully brave where there is no one but women and children. The boys shot 62 boxers, and brought all the refugees back with them who were not dead or dying.

An old Amah of Mrs Squiers who had gone out there on Sunday to Communion, intending to return on Monday, but was unable to get back, came in with the others. Her youngest son was one of the Priests and was among the number who was burned to death. I went down to see the old lady, and she told me that in 'one hour more she be all finee'.

I have had a few things in a hand bag, my umbrella and hat near the doorway ready to fly at a moment's warning, since the 10th. This afternoon a number of German, English and Americans went out and shot 40 more of these brutes. I was out near the gateway when our boys came in. Following behind some distance were about a hundred or more refugees hobbling along as best they could, all bruised and bleeding from their wounds. One young girl who was being led by her companions was blind, her eyes had been dug out of her head; another had a wound on the back of her head and the brain exposed to view. They all sat down on the walk in the shade to rest and got a cool drink. The Army Surgeon dressed their wounds. ... And yet there was not a murmur.[50]

The significance of the women 'hobbling' may not be immediately obvious – many of the women and young girls had bound feet which, though Mary Bainbridge does not spell it out because it was obvious to her, made them particularly vulnerable.

It is not clear which 'army surgeon' Mrs Bainbridge is referring to; Dr Robert Coltman, the American Legation doctor, writes of how

> I have just finished dressing the wounded head of a little girl ten years of age, who, in spite of a sword cut four inches long in the back of her head and two fractures of the outer table of the skull, walked all the way back here, leading a little sister of eight and a brother of four. As she patiently endured the stitching of the wound, she described to me the murder of her father and mother and the looting of her home. ... how long before we are all murdered we cannot say.[51]

Polly Condit Smith was at the same time writing lines such as 'so far, things are not as bad as that [the last terrible act]'.[52] Her attitude suggests how temperament rather than gender were likely to get one through the days ahead; indeed, it is quite clear that Polly is going to sail through almost unscathed, compared with those she gently mocks in her notes for the same day – the 16th:

> Things got so bad that our bugler played the 'call to arms' four different times which is the signal here for all women and children and all non-fighting men to appear at the big gate of the Legation, and within five minutes from that time Captain Myers will decide what must be done – whether the marines will escort us over to the Russian or British Legation. After each of these alarms, however, it was decided not to send us quite yet. At the last alarm they kept us waiting, all huddled together like sheep, for an hour. And such an hour as it was – the constant reports of Mauser rifles, the absolute lack of knowing what was happening!
>
> But for one moment I was obliged to forget the terror of it all and look at the humorous side. Mrs Squiers was holding her youngest boy, a baby of four, in her arms, busy in quieting him. Her other boys, Bard and Herbert, were there, too, rather subdued, and last, but not least, our little cortège was completed by the arrival of the French and German governesses, each of them arguing violently in her respective mother-tongue. Mademoiselle is a large woman of ample proportions in wrong places, and she had her bosom filled with recommendation papers, which she fingered nervously – they were all she was saving in the way of valuables. Clara, the German governess, had forgotten what her valuables were, and looked quite distraught with fear. She had a French clock in each hand, and was telling me in broken English, German and Chinese how afraid and terrified she was. I said to her, 'Gehen Sie mit mir,' and she clutched my arm most painfully for the next half-hour.[53]

Mrs Conger carefully does not mention her daughter Laura at this time, but we learn later that she was of a nervous disposition – how she handled the weeks to come was to scotch any attempt at generalisation.

Polly Condit Smith was to use her sense of fun to lighten many a tense occasion, and her humorous descriptions can be used to the same effect. I am aware that readers may question my use of apparently endless details of horror – and I was tempted to go for a more impressionistic effect. But my lack of reticence has two reasons: first, the foreign community was not imagining the danger it faced, if the treatment of the Christian converts was anything to go by; it is fashionable in some quarters to downplay the fears and trials of the siege of Peking. Second, it must have been quite stunning for previously sheltered women to experience the sights of those three days, from 14–16 June; Polly Condit Smith can certainly have seen nothing before like her description of the 16th:

> ... such a lot of poor, wretched people I hope never to see again. Half starved, covered with soot and ashes from the fires, women carrying on their breasts horribly sick and diseased babies, and in one case a woman held a dead baby. One man of about fifty years old carried on his shoulders his old mother, who must have been every day of ninety years. She looked so withered and wrinkled, one had to think of the burning of Troy and Aeneas. A great many of these people were terribly wounded – great spear-thrusts that made jagged wounds, scalp-cuts and gashes on the throat where the victim had been left for dead.[54]

Cecile Payen, watching the same or similar arrivals, saw a man of sixty or so with his crippled mother on his back and wrote, 'This completely broke me down.'[55]

It does seem, at least from anecdotal evidence, that women were particularly vulnerable, and probably targets because of that. And a contemporary, non-Christian Chinese account records a weeping woman on the 16th complaining:

> At first they said they were going to kill the foreigners, but up till now not a single foreigner has been hurt. The ones killed have all been Chinese who were worshippers of things foreign. What is more, not a single man has been hurt. The only ones killed have been women and children.[56]

Sisters of the Red Lantern

For the traumatised Chinese women refugees 'who never uttered a cry or moved even when the surgeons were operating on them' there was rather more going on than met the eye of spectators such as Polly Condit Smith. It is from an almost secondary source that we get a glimpse into a subject that is discussed in little detail in Western accounts of the siege and the Boxer uprising.

Henry Savage Landor, a British adventurer-writer who was to arrive with the relief forces, obviously got this information concerning the burning of the Southern Cathedral and the rescue operations from George Morrison, a mate from previous adventures. *The Times* correspondent modestly (as always in both articles and diary) omits his own bravery; he does not mention that he was a promoter of and participant in much of the rescue work – though only one account notes that on this particular occasion Morrison himself was not, as is usually suggested by others, the instigator; W.A.P. Martin (American President of the university) wrote: '... He went at the instance of Mrs Squiers ... [who] is a woman of large heart and long purse, whose feet were never weary in looking out the abodes of the poor and needy.'[57] Martin was taking refuge with the Squiers at the time so was undoubtedly biased in Harriet's favour, but he probably heard the conversation when she raised the matter with Morrison.

Landor described how in the Cathedral area,

> A woman was being murdered by a Boxer, but a bullet from Morrison's revolver saved her. Some poor girls of twelve or thirteen were carried away by force to join the infamous society of the Red Lamp; others, to avoid dishonour and disfigurement, sat outside their houses waiting patiently to be killed. Women and children, gashed and mutilated in the most horrible manner, lay about everywhere.[58]

The student interpreter Hewlett may not have known what he was implying when he recorded, 'Many girls of 13 or so, have sat to be killed, and disfigured their faces with mud and filth to avoid being carried off.'[59] W.A.P. Martin, a Sinologist, usefully introduces us to the Sisters of the Red Lantern when he writes,

> A special branch [of the Boxers] was created for the young women of the province – a feature the more remarkable on account of the jealousy with which Chinese women are ordinarily kept in seclusion, one of their war-songs commences thus:
>
> > We, the brothers of the Long Sword, will lead the van;
> > Our sisters of the Red Lantern will bring up the rear guard.
> > Together, we will attack the barbarians,
> > And drive them into the sea.[60]

The Sisters of the Red Lanterns Shining Society (Hung Teng Chou) were particularly associated with the burning of places of Christian worship, where there were often women taking refuge, and of Christian homes. Fire was the most potent magic of the Boxers, but sometimes there was a mistake or failure and that was blamed on the pollution of women. The magic of the Red Lantern Sisters, usually aged between twelve and eighteen, was particularly useful, therefore, and particularly powerful in spite of, or because of, their own pollution. They could both point out, through their magic, where Christians

lived, and overcome potential failure caused by pollution. Later beseigers of the Pei-t'ang were to say, 'We have to wait for the Red Lantern Shining before we can advance. The Red Lanterns are all girls and young women, so they do not fear "dirty things".'[61]

A Chinese source, recording events of 15 June, spells out in more detail the nature and significance of women's pollution. Some Boxers, having gone through their rituals at their altar, set out on their mission of arson with flaming torches. Along their route was a shop selling reed mats. The wife of the pagan Kono-on, the shop's proprietor, was pregnant; as the procession of Boxers passed, she came out to see it but her presence was unlucky for them: because of her, their magic was destroyed. In revenge, the Boxers set fire to the shop and the whole family perished in the flames. Ten Boxers were injured.[62] On later days, women would be warned not to be on the street.

This informant picks up on the significance of the women refugees within the Pei-t'ang: the cathedral was 'too big to burn but, in addition, there were many women in there and that was likely to destroy the magic'. To protect themselves from the Boxers, it is said that Europeans and Christians cut open the bellies of pregnant women. Hence the importance of the Sisters of the Red Lantern.

In addition, the magical force of the Red Lanterns, dressed all in red and carrying red lanterns and fans, allowed them to fly through the air. A sight of that had been vouchsafed on 3 June to the Reverend Roland Allen. At ten o'clock that night, the carter attached to the Anglican compound rushed in to

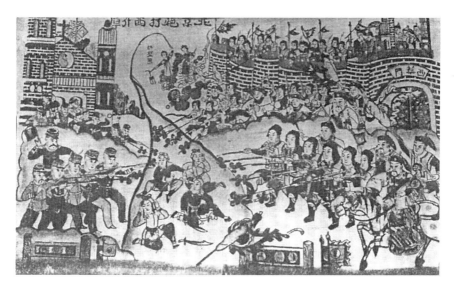

18 Sisters of the Red Lantern (centre) in attack on the Pei-t'ang
(from V.M. Alexeev, *Kitayskaya Narodnaya Kartina*)

tell the missionaries that they must go outside to see 'a Red Lantern Light'.[63] They were shown 'a wonderfully bright planet in the West, very large and brilliant', which the carter averred was a 'spirit girl bearing a lamp'. It was said to move up and down and was 'a portent of awful woe to come'.

The American missionary Sinologist Arthur Smith (husband of Emma) has an explanation for the natural phenomenon: during the weeks when riots and fighting were most violent, towards evening hundreds of 'ignorant, credulous people' would watch the sunset. 'The impression upon the retina caused by gazing at its disc, causing a round red spot to appear whenever the eye should turn, was pronounced the magic of the 'Red Lantern', and excited cries of 'There are two!' 'I see three!' 'There are a great many in the north!' would fill the air. Then, when the evening clouds gave back the sunset glow, this common sight took on the aspect of the supernatural, and the people would whisper to each other 'Truly the power of the Red Lantern is very great! With it we must conquer the foreigners!'[64]

More mundane, and not surprisingly, the Sisters were also thought to have cared for wounded Boxers, sewed and cleaned. Mention is made, too, of the Cooking Pan Lanterns who fed Boxer troops with pans which, it is said, were magically replenished after every meal. There is even some evidence of direct participation in battle.[65] It is unclear if there is any significance in the fact that the most prominent Red Lantern leader, the Holy Mother, Lotus Huang of Tientsin (originally Lin Hei-erh) was said to be a young prostitute. I can find no suggestion that the Sisters were used for sex by the Boxers; and, indeed, evidence is lacking that rape was used as a weapon of terror of war by them either against Chinese Christian women or foreign women (unlike the later foreign military campaign of retribution). Two commentators (1963 and 1978) on the Boxer phenomenon suggest that they were forbidden contact with women, like the Taiping rebels before them, and enjoined to obey the conventional moral law.[66]

Another commentator (1987) goes so far as to suggest that 'some young women also found an opportunity to escape the confines of Confucian patriarchy and join in mysterious and no doubt exciting activities with their peers, outside of the home'.[67] But a later (1997) historian, exploring possible twentieth-century myths surrounding the activities and attributes of the Red Lanterns, suggests that, 'It isn't clear ... that the real [ones] ever saw themselves as rebelling against the Confucian social order that hobbled Chinese women at the end of the 19th century.'[68]

According to a feminist writer on China, the Red Lanterns had unbound feet which, while practical, and perhaps even ideological, is rather contradictory as a Chinese woman informant reports that, 'for a woman to have natural feet was then a sure sign of being connected with foreigners'.[69]

Whatever the reality for Red Lanterns at the time, it is easy to imagine the emotions of young Christian women, often girls, confronted, under terrifying

and confused circumstances, with the options of fire, mutilation, death, and becoming a Red Lantern – the antithesis of their Christian (often Roman Catholic) faith. With this in mind, Putnam Weale's description of one of these rescue parties (though not the actions of the male protagonist) suggests a painful lack of understanding:

> Some of the girls seemed quite paralysed with fear; others were apparently temporarily bereft and kept on shrieking with a persistence that was maddening. A young French sailor who did not look more than seventeen, and was splashed all over with blood from having fallen in one of the worst places, kept striking them two and three at a time, and cursing them in fluent Breton, in the hope of bringing them to reason. *Eh bien, mes belles! Vous ne finissez pas,*' he ended despairingly, and rushed off again to see whether he could find any more.[70]

The compound to which the refugees were eventually taken was to become known as the Fu (Palace or Park) – short for Su-wang-fu, the palace just across the canal from the British Legation belonging to Prince Su, which was commandeered politely but firmly not only because it was needed for the refugees but also because it was essential to the defence of the legation quarter and Prince Su was considered a reactionary (he was a member of the Manchu imperial family). Prince Su himself very quickly saw the implications of staying among the foreigners and Polly Condit Smith noted that he vacated his fine palace and large grounds without much hesitation 'leaving all of his treasure and half of his harem'.[71] The compound was put in charge of Japanese and Italian marines under Colonel Shiba, the Japanese military attaché.

By the 16th there were 1500 or so Roman Catholic refugees there, many in a pitiful condition of wounding, burning, trauma and grief – most of them without recorded names. Among them were the elderly mother and nephew of Ch'ing-ch'ang, recently Minister to France and still apparently there, a former student of W.A.P. Martin. Mme Ch'ing was, like all the others, on foot and destitute; the nephew was badly burnt following the looting and burning of the family palace in the legation area and nearly every other member of the family had been murdered – a Roman Catholic Manchu family going back several generations.[72]

On Saturday 16th, having burnt nearly every building connected with Christianity, the Boxers turned their attention to anything commercial connected with foreigners – large swathes of mercantile streets went up in flames, mostly by mistake (including the famous booksellers' street, Liu-li-chang) and the fire eventually caught hold of the imperial gate, the Ch'ien-men, with its towering wooden pillars. Jessie Ransome described how

> ... the flames leapt up these and then rushed into the building, and it seemed simply clothed in fire. It was a wonderful sight, not only as a spectacle, but

for the thought that there was a mob of ruffians, butchering, pillaging, burning, even to the Emperor's own special gate of the capital of the kingdom, and not a finger raised to suppress them except by our foreign soldiers, who try to keep them out of the lines of defence at least.[73]

Ada Tours recorded, 'About noon we were told there was a fire at the Chien Men. We went up to the stables to Sister Jessie's room to see.' The artist Cecile Payen wrote,

It was a never-to-be-forgotten scene. We watched it from a point of vantage, spellbound at the sight. Never a pyrotechnic display could even suggest a tithe of the magnificent spectacle. The flames licked the sky until the vault of heaven seemed a writhing, seething volcano that even the people of Tien Tsin must see.[74]

By the end of that day, the destruction of foreign property in Peking – except that in the now carefully defined legation quarter and the American Methodist compound – was complete. Mrs Gamewell itemised the properties:

All the mission premises, of which there were seven besides the Methodist, every street chapel, two Catholic cathedrals with their orphanages and hospitals, all the houses occupied by those in the employment of the Imperial Customs Service [except the Inspectorate itself], the homes of the professors of the Imperial University and the Imperial College, the post office, the telegraph office, the electric light plant, the Imperial Chinese Bank, the Russian bank and all shops containing anything foreign, were consumed.[75]

Another American woman added, 'Up to the present time there have been twenty-six places burned, even to foreign cemeteries, and then they began burning shops where anything foreign was sold, like cloth, even to flour shops, where the flour was ground with foreign machinery.'[76]

On the 16th, too, the Belgian Minister and staff (no women are mentioned) had to abandon their legation in the north, beyond the others, and move into the Austrian one. Paula von Rosthorn now found herself, with no help in the legation except for one 'coolie', looking after four refugees in addition to the five Austrian officers already there (who had been much taken by the generosity of her welcome two weeks earlier). Mrs Mears, wife of the Customs Inspectorate's handyman, helped her with provisions.

As a result of the Boxer prisoners being brought into the British Legation, servants there panicked for, with their magical powers 'they could set fire to the place by *breathing*!' Annie Myers added on 14 June, 'Helen's amah tried three times to escape ... but fortunately Helen was there each time to prevent her and also it is impossible for Chinese to pass out of the gate without a written passport. The old dame was going to try to get out on the pass belonging to Mrs Ker's amah.' By the 16th, the women were doing much of their own housework.

Blaming the Empress Dowager

Of course, there was only one person to blame: 'We began to realise that the Empress had no intention of putting down the Boxers,' Theodora Inglis wrote, 'but that she was furthering a union between them and the imperial troops'.[77] Firmly, Theodora elaborated when she wrote about the events of Wednesday 13th:

> The city magistrates had refused to give the native Christians any protection; in fact, had closed up the doors of their offices and stole away purposely to avoid the prayers and importunities of the persecuted ones. The streets were full of special police who that night, by imperial sanction, kept booths where the Boxer and soldier weary with their bloody work, came for hot tea to refresh them for further efforts. We learned also that Her Majesty's imperial soldiers stood waiting with carts along the great streets and any fugitive fleeing for his life was caught, thrown into the cart and held a prisoner to be delivered into Boxer hands. If no Boxer arrived the soldiers themselves frequently dispatched their victims. ...[78]

The Empress Dowager is said to have watched the destruction of the Nan-t'ang and revelled in it, but the account on which the contention is based, which for many years was regarded as unique Chinese insider information, has now been discredited; it suggested:

> Major Domo Li Lien-ying [the chief eunuch] told him that the Old Buddha had watched the conflagrations from the hillock to the west of the Southern Lake, and had plainly seen the destruction of the French Church. Li Lien-ying had told her that the foreigners had first fired on the crowd inside the Ha Ta Gate, and that this had enraged the patriotic braves who had retaliated by slaughtering the converts. ... She is amazed at the Boxers' courage, and Kang I [an anti-foreign adviser] believes that she is about to give her consent to a general attack upon the Legations. Nevertheless, Li Lien-ying has warned him that exaggerated praise of the Boxers arouses her suspicions and that, with the exception of Jung Lu, all the Grand Councillors are afraid to advise her. Her Majesty is moving into the Palace of Peaceful Longevity in the Forbidden City, as all these alarms and excursions disturb her sleep at the Lake Palace. ... [79]

I quote the account because it may not have a basis in fact but it is certainly the image of Tz'u-hsi conveyed for many years by Western historians. And the Englishman, Edmund Backhouse, who concocted the Chinese account central to the influential biography, was at least one of the besieged; whatever his motives, he was inevitably part of the prevailing mind-set among foreigners, many of whom would have assumed the accuracy of his claims because of their own experience. In that passage, he may have been making a link between 'foreigners had fired first on the crowd inside the Ha-Ta Men' and the incident

that took place in the early evening of Thursday 14th when Baron von Ketteler ordered the German marines to fire from the city wall.

What has always been a mystery is that, on that same day, there was a report in the *North China Daily News* that one of the foreign Ministers in Peking had been murdered – that could have been a delayed reporting of the Japanese Chancellor's murder on the 11th; but on the 16th the story appeared in the international press naming the diplomat as Baron von Ketteler. These reports did not reach those most intimately concerned, cut off as they were in the legation quarter. Where the press report originated from is not known; as for the false insider diary, one theory is that it was concocted by Backhouse at the end of the siege to rehabilitate Jung-lu in the eyes of foreigners.

If that so-called first-hand account of the Empress Dowager's reaction is of no factual value, it is worth looking at that of Dr Headland, as told by her husband – though neither of them was in Peking during the siege and no doubt informants had their own agendas. Concerning the Council meeting of 16 June, Headland wrote,

> One of the princesses [later] told Mrs Headland that before coming to a decision the Empress Dowager called the hereditary and imperial princes into the palace to consult with them as to what they would better do. She met them all face to face, the Emperor and Prince Tuan standing near the throne. She explained to them the ravages of the foreigners, how they were gradually taking one piece after another of Chinese territory. 'And now,' she continued, 'we have these patriotic braves who claim to be impervious to swords and bullets; what shall we do? Shall we cast in our lot with their millions and drive all these foreigners out of China or not?'
>
> Prince Tuan, as father of the heir-apparent, uneducated, superstitious and ignorant of all foreign affairs, then spoke. He said:
>
> 'I have seen the Boxers drilling, I have heard their incantations, and I believe that they will be able to effect this much desired end. They will either kill the foreigners or drive them out of the country and no more will dare to come, and thus we will be rid of them.'[80]

Other princes had their say, but none, except Prince Ch'ing, was prepared to speak out after Prince Tuan had spoken. The Empress Dowager asserted that she was impressed by the magical powers of the Boxers; it transpired that Prince Tuan had earlier persuaded her to receive a troupe of them in the palace and they had successfully gone through their rituals.[81]

But how does this marry with the spin Tz'u-hsi put on events when she let her hair down to her lady-in-waiting, Der Ling, in 1903? Unfortunately, it is not possible to date what she describes, but it would have been about this time:

> Matters became worse day by day and Yung Lu was the only one against the Boxers, but what could one man accomplish against so many? One day Prince

Tuan and Duke Lan came and asked me to issue an Edict ordering the Boxers to kill all the Legation people first and then all remaining foreigners. I was very angry and refused to issue this Edict. After we had talked a very long time, Prince Tuan said that this must be done without delay, for the Boxers were getting ready to fire on the Legations and would do so the very next day. I was furious and ordered several of the eunuchs to drive him out, and he said as he was going out: 'If you refuse to issue that Edict, I will do it for you whether you are willing or not,' and he did.[82]

Everyone then and later was rewriting history. The day after the Council meeting of Saturday 16 June, it is said that a document purporting to come from the foreign Powers – presumably via their representatives in Peking – was received. It laid down impossible and provocative demands such as that revenues and the conduct of military affairs should be handed over to the foreign Ministers (to counter corruption) and that the Emperor should be restored to his throne. This document is also said to have been a forgery from another, probably Chinese, stable – possibly Prince Tuan who presented it to a further Council meeting of Sunday 17, possibly the venerable Li Hung-chang.[83] Whatever its provenance, its effect upon Tz'u-hsi and her advisers was to further enrage them against foreigners.

As the foreign troops under Admiral Seymour approached Peking, Tz'u-hsi could hardly forget the day forty years earlier when she and the Emperor had fled the advance of foreign armies on the capital, a flight that had led to the death of the Emperor in exile in Jehol, and an occupation that had resulted in destruction and further foreign undermining of Chinese territorial integrity.

But Robert Hart, who had followed the Empress Dowager's actions and reactions for over thirty years, is much more pragmatic on her behalf; he later reconstructed the scene of the Council meeting to his own satisfaction:

> The Empress Dowager had probably said to the Prince [Tuan], 'You and your party pull one way, Prince Ching and his another – what am I to do between you? You, however, are the father of the future Emperor, and have your son's interests to take care of; you are also a head of the Boxers and chief of the Peking Field Force, and ought therefore to know what can and cannot be done. I therefore appoint you to the Yamen: do what you consider most expedient, and take care that the throne of your ancestors descends untarnished to your son, and their Empire undiminished! Yours is the power – yours the responsibility – and yours the chief interests!'[84]

That Sunday, 17 June, when Tz'u-hsi felt most threatened by the foreigners at Tientsin and those advancing upon Peking, von Ketteler chose once more to act. An attempt was made later to smoothe things over – Sir Claude MacDonald and Henry Cockburn talked to a Chinese officer – but Mrs Tewksbury, a Congregational missionary in the American Methodist compound, was perhaps more prescient than she knew when she recorded in her diary the following day:

... a most unfortunate thing occurred, which we feared would bring immediate trouble on our heads. As some Chinese soldiers [not Boxers] were passing the Austrian Legation, the Germans threw stones at them, and immediately the Chinese fired, and for a while they had a lively time. Nine Chinese were killed. They feared a serious attack at that time, and we all regret their lack of tact and wisdom in precipitating such a thing.[85]

This incident, and adverse reaction to von Ketteler's tactics, were much discussed in the foreign community at the time and Claude MacDonald even sent him a tactful note suggesting he restrain himself, even in the face of provocation, at least until Seymour's troops arrived. But another story received less attention. On Saturday 16th, while the Grand Council was in session, and while internationally von Ketteler's alleged death was causing a stir, the Mayor of Peking, a mandarin close to Prince Tuan, called upon the German Minister to seek yet again the release of the young Boxer hostage he had taken on the 13th. Von Ketteler refused; what is more, he could not comply because 'during a fit of fury [he] had shot him'.[86]

So far the von Ketteler incident of 13 June has only been described here from Western points of view, but the story apparently doing the rounds of the Chinese community at the time adds an essential ingredient to what followed. A French study of the siege, incorporating extracts from several French protagonists, includes the diary of a member of the 'Peking bourgeoisie'; this informant wrote on 13 June:

> Several Boxers were seized by Europeans in the legation quarter. In vain were they fired upon with guns, struck with sabres, there was no way of killing them. They were as gods, invulnerable. So the Europeans took a child, doused him with petrol and tried to burn him; that was also in vain; the young Boxer was fireproof.
> The same day, the Boxers set the Tung-tang Cathedral on fire ...[87]

In spite of all the foregoing, known and unknown at the time, a message appeared in the *Imperial Gazette* on Sunday 17th as follows:

> If amongst the families or staffs in the Legations there are any desiring to proceed temporarily to Tientsin, they should properly receive ... protection on the way. But at the ... moment railway communication is interrupted, and if they were to hurriedly proceed by road it would be difficult to insure their safety. They should, therefore, remain quietly where they are until the railway is repaired when the circumstances can be further examined and steps taken as required.[88]

This message, which looks as if it expressed well-intentioned concern on the part of Tz'u-hsi, was to prove a hostage to fortune.

6
The Widowing of Baroness von Ketteler (18–20 June)

Tz'u-hsi Sends a Message to Lady MacDonald

'We had a call from two or three of the Foreign Office last night', continued Mrs Tewksbury in her diary entry for 18 June.[1] In view of Yamen calls that were to take place on the Monday, the visit to the American Methodist Mission of Sunday 17th is both bizarre and unremarked upon in reconstructions of those days.

Grace Tewksbury is unspecific about who 'we' were, and who the officials were, but she may have been there herself for she continues:

> [They] stayed talking for an hour and a half. We told them to tell the Empress we had heard enough of their promised protection (the errand of these officials purporting to be the promise direct from the throne to protect us), and now proposed to protect ourselves, giving them to understand something was going to happen when our soldiers got here.

The Tewksburys were members of the Congregational group who had fled T'ung-chou before dawn on 8 June, and whose property had since been destroyed, in spite of it being left in the safekeeping of the local Yamen. Elwood Tewksbury was among those who had, by dint of temperament and experience, become a leader within the newly constituted mission community – for example, on 15 June, four of them, Tewksbury, Theodora Inglis' husband John, Bessie Ewing's husband Charles, and Dr James Ingram (whose wife and two daughters were with him), armed with guns, had gone to the Ha-ta-men in the evening and taken the key (an iron bar two feet long) away, so as to prevent the Boxers entering the Tartar City. At dawn they had returned to the gate and opened it and, thereafter, repeated the dawn–dusk performance, in spite of Chinese requests to return the key. The American missionaries all thought it was a 'great joke', according to Dr Emma Martin but, as they found out later,

the Chinese had a duplicate key, anyway, and the missionary behaviour 'only irritated' them.[2]

Whatever prompted the mandarin visit to the Methodist Mission on Sunday – and it may have had something to do with the *Imperial Gazette* report of that day about the dangers of the journey to Tientsin – it surely had some bearing on what happened the following day when three members of the Tsungli Yamen called upon the British Minister, Sir Claude MacDonald.

Neither the Chinese authorities nor the foreign diplomats knew on Monday 18th that the 2000 troops under Admiral Seymour sent to Peking to protect the foreign legations had finally had to turn back to Tientsin because they could not sufficiently protect themselves from attack while they tried to repair the railway line destroyed in front of and behind them. News that imperial troops and Boxers under the dreaded General Tung Fu-hsiang had driven back the international force not far from Peking had been received in the legation quarter on Sunday, but not been believed.

Neither side knew then that on that same Sunday, 17 June, the foreign naval authorities at Taku had taken the Chinese forts by force. By an unhappy coincidence, while one ultimatum to the Court was false, another delivered by the French Consul to the Viceroy of Tientsin on 16 June, that the Taku Forts be surrendered, was genuine.

So, on the Monday morning the Chinese Court thought that foreign troops were on their way to Peking, and they may have known that an ultimatum concerning the Taku Forts had been received in Tientsin; they certainly knew about the other, false, ultimatum.

Of the three mandarins who called, two were well-known to Sir Claude; indeed, he calls them 'old friends'; the third was unknown but his appearance and manners were 'exceedingly prepossessing'.[3] Sir Claude noted, in his account of the meeting published in 1914, that 'it was evident that he came as specially representing the Empress Dowager, to convey to her the result of our interview'.

That they came from the Empress Dowager, not even formally from the Emperor, is noteworthy, but there was more to it than that for, after compliments had been delivered, their spokesman 'said that the deputation had come direct from Her Majesty with a special message to Lady MacDonald'. Tz'u-hsi wished to express regret that

> Owing to the misdeeds of the local banditti and Boxers, who had rendered the surrounding country unsafe, the members of the British Legation, especially the ladies, had been unable to go out to their summer residences in the western hills. This would, however, soon be rectified and the Boxers dealt with as they deserved.

The most likely explanation for this woman-to-woman message is that it was a more-than-ever two-faced diplomatic nothing to introduce what was then the burden of the discussion; I have already noted two other occasions when

greetings came from the Empress to diplomatic women. But this was more than a greeting and I prefer not to dismiss it so lightly; I believe that Tz'u-hsi was genuinely trying to convey a wish to a woman whom she had met twice (in an unprecedented manner), and got on with, that things could be different.

I'm not talking about a bosom friendship but Ethel MacDonald wrote of her second visit, in March 1900, that the Empress Dowager was, 'if possible, more friendly and genial with us than on our previous visit',[4] and Baroness von Ketteler noticed that she distinguished 'at once those whom she had seen last year'.[5] They certainly all had some laughs as they inspected each other's clothes and jewellery, their hostess generally behaving 'with the naive curiosity of a mere woman'.[6] Perhaps Tz'u-hsi thought that Ethel MacDonald could influence her husband; perhaps she just wanted to communicate at this most confused and confusing time.

The visitors went on to ask the British Government's intentions towards the Manchu Dynasty and with regard to China generally – they seemed particularly anxious to learn of any annexation policy. Sir Claude informed them that his last instructions from his government had been to maintain the 'friendliest relations' and that he was sure Britain had no intention of 'interfering with the Dynasty in any way'.[7] His assurances were received 'with evident satisfaction' by the two Han Chinese members of the deputation who said to their Manchu colleague 'Now you have it from the Minister himself.' His assurances would be 'conveyed to the Empress'. When asked if he could speak for the other Ministers, Sir Claude demurred and suggested they should be approached personally, and that is what then happened.

At the American Legation, Mrs Conger noted that the visitors came – at 10 o'clock in the evening – from both the Emperor and Empress Dowager, and they seemed to follow a different tack from the one at the British Legation, being more concerned that the troops who were on their way should camp outside the city gates. But Sarah Conger noted that 'Mr Conger most positively said, "No: they will come to the Legation, and if they are not enough, plenty more will come."'[8] The visitors apparently replied, 'We know the foreign soldiers are far better than ours.'

The Empress Dowager Feels Betrayed

The following day, Tuesday 19 June, there was a calm of sorts. Dr Emma Martin recorded that in the American missionary compound a Chinese wedding took place – 'a school boy and girl, so he could take care of her better'.[9] She added that there were also two births and the death of a baby. She was glad still to be alive. (The day before, young Wen Te, Dr Lillie Saville's protégée, ended her awful journey from massacre to the Methodist Mission – 'stripped of all but two thin cotton garments, and a naked baby on her back'.)[10]

In the British Legation, Annie Myers wrote of mundane enough matters:

All day most quiet. So much so that after tiffin the two Oliphants took Daisy and me round to the customs to get some things from our boxes. We had to go through Sir Robert's gate as all the others were closed and barricaded up. On our return Russ [Daisy's brother] joined our party and we five went on the wall as far as the chien men, where we collected some green tiles as trophies.

The visit to the ruined gate coincided with one by Jessie Ransome and initiates a pattern which I am dubbing 'siege tourism'. Sister Jessie recorded,

I have just come in from an expedition on to the wall to see the remains of the Ch'ien Men and the devastation outside it. Mr Allen took Miss Lambert and me. In spite of yesterday's heavy rain, the ruins are still smoking in many places, and the destruction is terrible – acres of shops and houses levelled with the ground, or mere shells left standing. We were much excited by seeing four men, whom we took to be Boxers, got up in red turbans, etc. They were down below us in the street, and stared hard at us, but disappeared into the crowd.[11]

Roland Allen noted more the friendly and peaceable attitude of the troops they met (as opposed to Boxers), and added that, '[we poked] about amidst the ruins for tiles as mementoes of that great sight. We were joined there by other parties of ladies and men, who, though they carried revolvers, never supposed for an instant that they would have occasion to use them.'[12]

On the return of the 'tourists' to the legation, they realised that something had happened: at 4 o'clock on Tuesday 19 June, each of the eleven Legations and the Inspectorate of Customs, out of the blue, received the following message, as recorded by Sarah Conger:

We learn that foreign troops are to fire upon our forts near Tientsin, hence we break off all diplomatic relations with your Government and ask you to leave Peking in twenty-four hours. No further protection will be given by us.[13]

Mrs Conger's version seems at variance with that of Mrs Brent who was in a bungalow in the legation of the doyen of Ministers, Señor Cologan of Spain. In an interview Charlotte Brent gave later, the journalist reported:

The members of the diplomatic body all held their consultations at the Spanish Legation and the very last formal meeting of the Ministers took place almost under Mrs Brent's window. This was on the occasion of the receipt of the ultimatum of the Tsungli Yamen which was to the effect that the Taku forts having been taken by the Allies, China was at war with the Western world and that in accordance, therefore, with diplomatic etiquette all the Ministers must leave within twenty four hours.[14]

This brings into question the chronology of who knew what when – never possible to clarify quite satisfactorily. But if we take it that by 19 June the Empress Dowager had sent a special emissary to the British Minister, to be assured of his good faith, only for her to learn subsequently of the taking of the Taku Forts the day before the emissary called – whatever MacDonald knew then – it must have seemed like a double betrayal. (It was later learned that all three members of the Chinese mission to the legations were beheaded.)

What seems likely is that the Chinese talked in their note to the Ministers of an ultimatum – rather than a consummated act – because they did not choose to recognise that the forts had actually been taken; while rumours may have seeped into the legation quarter about an ultimatum, even the taking of the forts, they could not be acknowledged because the Ministers were the representatives of their countries and they had neither authorised nor wished for such an action – one which put them in a most awkward position.[15]

Of course, the Ministers in Peking had little idea of what was happening in Tientsin (eighty miles away), how bad the situation there was, how active the Boxers were. They did not know, for example, that only part of the group of engineers and their wives from Paotingfu, one of them pregnant, had staggered into Tientsin on the 3rd after an appalling journey under constant attack from Boxers, that the others were still missing but the worst feared, that large bands of Boxers had taken control of the native city on the 15th and that they ran through the city shouting 'kill, kill'.

Nothing had been heard in Tientsin from Admiral Seymour for over a week; rumours of von Ketteler's murder had reached them but they were unable to contact Peking; and they saw the Chinese laying mines in the mouth of the Peiho and the railway seized near Taku. The only information about Tientsin that the diaries in Peking record is of the destruction of the Roman Catholic Cathedral – which had been destroyed in anti-foreign riots thirty years earlier and recently rebuilt. Deaconess Jessie Ransome noted on 18 June, 'No news of the troops yet. But bad news from Tientsin by a courier who managed to get in this morning ...'[16]

That courier came from her Bishop and Mrs Scott; and it is to Frances Scott's letter from Tientsin of the same date, to an unknown correspondent (not in Peking or not received then in Peking), that we owe details of what was happening there, and an explanation:

> I must write you a line during the bombardment of Tientsin. If you could see the collection of dirty, unkempt refugees who are now in this place, the Gordon Hall, you would be amused. You know we took the Taku forts yesterday, between 1 and 4am. We only suggested to the Chinese that it was better we should hold them for the present, and then they began to fire, so it will always be an open question which began the war. However, it was

quite time we held those forts, and we took them quite easily in the rear – all the nations, so it is not a British victory!

It was no use playing with the Boxers any longer, and we had to come to the real root of the mischief somehow. But that fact meant *war*. So it is not really surprising that yesterday afternoon at three o'clock, shells began whizzing about our heads at Tientsin.[17]

The Ministers in Peking being sure of neither where Seymour was, nor what was happening in Tientsin, were now in an impossible position and, given that they were at variance with each other at the best of times, it was not an easy meeting and went on for some time.

There were foreign women and children to think of – were they more likely to be murdered on the way to Tientsin, the route which the Chinese Court had solicitously told them only on the 17th was too dangerous to think about travelling, or in Peking? Was it not totally inappropriate to receive their passports from the Tsungli Yamen and be put out on their ear? They had had nothing to do with what may or may not have happened at the Taku Forts. As for the Chinese converts who had taken refuge in the Fu, the Methodist Mission, and the Pei-t'ang, could they be taken into account? Could you avoid the fact that they would obviously be massacred the moment the foreigners left?

In the end, the diplomats sent a letter to the Tsungli Yamen asking for further and better particulars about transport and protection, suggesting that it was impossible to move out within twenty-four hours, and asking for a meeting of clarification with Prince Ch'ing and Prince Tuan the following morning.

Some Women Start to Pack

Since everyone was to be wise after the event about their intentions towards leaving, it is worth looking at the words and activities of the women. Dr Lillie Saville of the LMS, with her ambivalent relations with the British Minister (she had had another brush with him on the 17th), was likely to be among the least informed. She wrote for publication after the event:

> That evening handbags were in readiness in case the Ministers should decide that tomorrow all must leave. It would have to be a very hasty flight if four hundred and more men, women and children were to be outside the city walls in twenty four hours, and there surely was not one who did not feel that escort to Tientsin by Imperial Troops meant massacre when once we were in the open.[18]

Deaconess Jessie Ransome, who kept a diary that was later published, and had a room in the MacDonalds' quarters, recorded, 'Sir Claude has just told me that in his opinion we must stay here, and sink or swim with the ship, and *hope* for reinforcements – but where are they?'[19] Ada Tours' unadorned diary, never

meant for publication, confirms the unambiguous British stand: 'I put a few things together for the journey in case we have to go, although before we went to bed Sir Claude said he had no intention of moving a yard'. But Lucy Ker, Canadian wife of the British Second Chinese Secretary, in China since 1897, and Peking barely a year, seems to have been closest to events. MacDonald sent her husband to ask her reaction as a woman to the proposed journey; she replied: 'Remember Cawnpore' and that decided it for him.[20] It was only forty-three years since British women and children had been massacred there when a British garrison in India surrendered on the promise of safe conduct. An anonymous British woman was later to note that Claude MacDonald 'as a child had been through the Indian Mutiny'.[21]

In the American Legation, Mrs Conger wrote, in a letter of 7 July, 'It was out of the question to go; to leave our fortifications here and go across the country was sure death.'[22] The wife of her husband's Second Secretary, Mary Bainbridge, noted, 'It was not a very happy night, for any of us, for it was utterly impossible to get away. The trains had been destroyed, the carts all taken to the outer city and we saw nothing but death staring us in the face.' But the British clergyman Roland Allen suggests that 'in the American Legation people were up all night packing in preparation for a speedy departure'.[23]

And Polly Condit Smith, also writing in the American Legation, and attached to the First Secretary, writes a much fuller, more revealing story:

> We women were packing the tiny amount of hand-luggage we were to be allowed to take with us, wondering whether to fill the small bag with a warm coat, to protect us on this indefinite journey to the coast, or to take six fresh blouses. Our hearts were wrung as to what to do, and while we were arranging and worrying about these trivial details the great diplomatic question was at white-heat.
>
> The Ministers were moving about from one Legation to another, arguing, talking – always talking. The strong men felt we must not leave Peking until our own foreign soldiers arrived to escort us, but the weak men felt in despair as to which course to vote for. They did not like the idea of leaving either, but, oh dear, what a breach of diplomacy to receive their passports and then to decline to go! The strong, who knew, were so few, and the weak, who feared to disobey the Tsung-li Yamen were so many, that it looked very much as if we were all to start out to our deaths the following morning.[24]

Then there were the non-diplomats whose spokesperson was *The Times* correspondent George Morrison. According to Polly, they were strongly in favour of waiting for the troops to arrive and regarded any cowardly plan to leave as leading inevitably to the death of all concerned, including the Chinese Christians.

Captain Darcy of the French marines records what was happening in the French Legation and it is difficult to know if one should accept his account at

face value, or did he have distorted preconceptions about French women? But he is clear that 'At five o'clock the general opinion was that we should be leaving the following morning.'[25] He continues,

> The courtyard of the French Legation was full, as if by magic, with carts that had come from who knows where. It had been agreed that nothing should be taken but essentials; however, at the wish of the women, huge trunks were dragged from attics and outhouses. The demands of coquetry never lose their rights, even under the gravest circumstances. Can one possibly go to Tientsin without several changes of outfit?

For those trunks, carts would be needed, and for them horses. 'Husbands' went to look for vehicles and Auguste Chamot, armed with a rifle to the end of which he had tied a large kitchen knife to make a bayonet, set off with engineers and coolies (not necessarily with Annie) for the stables of the mandarin who had boasted that he intended to line his sedan chair 'with the hides of foreign devils and fill his harem with their women'.[26] Chamot came back 'driving ten or so superb beasts'.[27]

In the Japanese Legation, the women were altogether more practical; this is almost the only time Colonel Shiba mentions his countrywomen when he writes:

> Baroness Nishi [the Minister's wife] is not at all well. But all the women are composed. Mrs Ishii [First Secretary], Mrs Narahara [Second Secretary], Mrs Nakagawa [surgeon], and Mrs Ogawa [Peking Power Company] seem particularly determined and stayed up all night making food parcels for everyone – a much-admired gesture.[28]

Putnam Weale summed up by praising the calmness of the women in comparison to the 'distraught' older men but this was doubtless to reflect badly on the men rather than well on the women.[29] A few pages later, putting a name to generalisations, and slightly contradicting himself, he added, 'In the French Legation [M. Pichon] has been receiving such tearful instructions from his wife during the last three weeks that it is a wonder he has any backbone at all.'[30]

Over in the American Mission compound, the situation hardly lent itself to much composure – they had their refugees to think of, and it was clear to the missionaries that the Americans planned to leave. Sara Goodrich, already preoccupied by her young son Carrington's dysentery, expressed the dilemma most pithily:

> The horror of forsaking our Chinese who had trusted in us seemed unbearable. Better to die with them than to leave them, and seem even to turn our backs on duty. It was the hardest experience of my life.[31]

Theodora Inglis seemed under a different impression regarding the refugees:

The order included permission for hundreds of native Christians to accompany us and contained directions as to amount of food and baggage that we should take with us. It was six o'clock in the evening when all this information reached us ... In it we recognized our death sentence. A committee waited upon our US minister to debate with him the advisability of our departure, but he could not change the ministerial decision.[32]

Meanwhile, in the German Legation, Baron von Ketteler, much more experienced in China than the other Ministers, speaking Chinese, temperamentally impatient, and belonging to a tradition whereby the German Legation approached the Tsungli Yamen separately, wrote his own letter to them requesting a meeting for 9am on the morrow.[33] He carefully did not ask for a reply which he would have to wait for.

Maud von Ketteler was later to confirm to Morrison what he said he already knew, that 'he alone of all the Ministers was opposed to the pusillanimous and yet suicidal decision come to by all his colleagues, Sir Claude MacDonald among them, to leave Peking'.[34] This does not square with MacDonald's own account nor, more tellingly, with the artless ones of British women.

Sir Claude ends his account of opposition to leaving – with its detailed argument – with the remark that, six years later, when he was ambassador to Tokyo, he talked to a son of Prince Ch'ing who was passing through Japan. 'He told me', wrote MacDonald in 1914,

> that all the members of the pro-foreign party were immensely relieved when we remained in our legations, for the Empress and the so-called patriotic party were so infuriated with the attack on the Taku forts, that it would have been quite impossible for his father, or Jung-lu, to protect us on our journey to Tientsin.[35]

Baroness von Ketteler Advises her Husband

Most people in the legation quarter had gone to bed late, had slept little, and were up early. A meeting of the diplomats convened at 7am in the French Legation to wait for a reply from the Tsungli Yamen. M. Pichon suggests that at this session they sent a second dispatch but Arthur von Rosthorn, the Austrian Chargé, who had worked in China since 1883, tells how, having continued to try and design a solution to the problem that faced them following the break-up of the Ministerial meeting, he had returned in the middle of the night to talk to Claude MacDonald, and proposed a further communication. In this, the foreign powers, who had previously been unaware of the ultimatum concerning the Taku forts, would offer, given the means to communicate, to promote the return of Admiral Seymour and his force to Tientsin. Von Rosthorn says he was later told that this second note was dispatched at 2am.[36]

Now the diplomats half expected to proceed to a meeting, as they had requested, at 9am. But no reply was received. There was some desultory discussion about all setting out in a body for the Tsungli Yamen. Finally Clemens von Ketteler took the initiative; indeed, Claude MacDonald suggested in a dispatch that, excited as he was, he 'banged his fist on the table'.[37] He declared that he had an appointment and he intended to keep it, adding, 'I will go and sit there till they do come, if I have to sit there all night.'

The dangers were pointed out to him but he replied that he had sent his Secretary, M. Cordes, there the previous day, and he had come back safely. 'That being the case,' suggested M. de Giers, the Russian Minister, 'why not send your Secretary now?'[38]

Sir Claude MacDonald, who was sitting next to the German Minister, recorded that he thought for a moment and replied, 'A good idea, I will do so.' He left the room and the meeting broke up.

Perhaps only Maud von Ketteler knew what happened next. On 30 August she was to discuss the matter with George Morrison when they dined at the Squiers' house, and Morrison tells us a few days later in his diary that she was ready to be debriefed on the subject by William Pethick.[39]

If ever that interview took place, it has not been possible to find a record of it. Pethick himself died soon afterwards (in 1901); his file in the Morrison papers in Sydney does not contain it and I have also tried to find it among Maud's own papers in Detroit, and in Germany.[40]

Whatever prompted him, von Ketteler decided, anyway, to keep his appointment at the Tsungli Yamen. He believed it would be discourteous not to, having requested a meeting and stipulated a time; also, he 'did not intend to allow the Chinese Government to say he broke an appointment through fear'.[41] All that remains of his wife's intervention is in Morrison's later diary entry: 'Ketteler was armed with a small revolver in a leather case. His wife induced him to take it.'[42]

We can probably assume that Maud saw him into his green and red official sedan chair – unless she had tried hard to dissuade him from going and refused, therefore, to see him leave. He not only had his revolver with him, but a book, in case he was kept waiting. Putnam Weale saw him leave, 'smoking and leaning his arms on the front bar of his sedan, for all the world as if he was going on a picnic'.[43] His Secretary, Cordes, was behind him in another sedan chair and they had only two Chinese outriders, legation *mafoos*. An armed guard was ready to accompany him, but he decided against taking it, according to the story Cordes told Morrison later, 'because the passage through the streets of armed foreign soldiers might arouse excitement, but mainly because the Tsungli Yamen knew [he] was coming and would therefore ensure him the protection due to a foreign envoy'.[44] Cordes also stated that he and the Minister were unarmed. Just after 8am, the party turned the corner out of Legation Street.

The Schoolgirls Read Mrs Jewell's Face

Over at the American Mission, south of the Tsungli Yamen, they had passed the night even less happily, and first thing in the morning they, too, had a meeting to decide what to do, particularly concerning their refugees. As for the Chinese Christians themselves, they were not at all sure what was going on, but the signs were not promising. One of the Chinese schoolgirls remembered what happened after Mrs Jewell and Miss Haven had led them back from the church, where they had spent the night on the floor, across the barricaded street to their schoolhouse for their morning meal:

> I noted that all the missionaries whom we met that morning had white, anxious faces. All our teachers except one were absent for an hour, and we heard that they were attending a prayer meeting across the street. The lady who usually sat from eight to ten on a veranda near our schoolhouse, ready to give us warning if it was necessary to flee back to the church, that morning paced restlessly up and down the walk with bowed head and frequent glances at the city wall, now swarming with soldiers. But no one told us of the fearful crisis which had come to the missionaries; that they had been ordered the night before to leave us and flee to Tientsin with all the other foreigners in Peking. They were moving heaven and earth to revoke this decision; but the hope of changing the plans of those in authority failed them at last. I shall never forget Mrs Jewell's face when she returned from that prayer meeting to tell us about the situation ...[45]

Theodora Inglis describes the meeting of missionaries in moving detail:

> A few women furtively wiped away tears that could not be repressed. A young woman standing near me pressed her face against the mud-brick wall and stood rigid as a statue. The speaker's voice was trembling and at times he hesitated for words so long that we could guess at the struggle in his heart. The only thing that kept us up as a body, was the continuous howling of a healthy infant in its mother's arms, but the meeting was not cheering and we separated to look over our effects and to pack up the small amount of clothing and provision which we were to be allowed to take with us. What a hopeless task! I leaned my forehead against the open lid of my large trunk and endeavored to think. All about me in the church vestibule, were people pulling and tugging at their trunks. These were piled storeys high and the resultant confusion was nerve destroying.[46]

Dr Emma Martin, who had only been in Peking since May, and with few immediate responsibilities, noted of the packing ordeal:

> We were told to get our hand baggage ready to start hastily so we fell to rummaging our trunks again. Lizzie and I took out our photos and looked at the dear faces sadly but as we could neither eat them or wear them we

knew we must leave them behind. We took our family pictures out of the frames and cut the margins off so they wouldn't take up much space and got a few other little things. While going thro the tray of my trunk I accidently upturned a handsome manly face of an old school friend who had once been much to me and I thought 'I must take that' and then I changed my mind and left him with many of my things more precious, to the boxers and turned resolutely away. I left my trunks unlocked and told anyone to help themselves to anything they wanted. Lizzie, the soul of order, locked her steamer trunk and put the key in her pocket.[47]

Sara Goodrich, with three children, one of them ill, reported how her husband had written a letter to the American Minister on behalf of the Chinese. Then came the meeting at which they were told that they had to leave with just over one hundred carts to transport them. The guards were insufficient to guard 'too long a train, but we might take a personal servant with us and a trunk (servants to walk)'.[48] She began getting together a few stores and fewer clothes, agonising the while, 'I was bound to take my woman and Kao Wen Lin's family instead of clothes, if possible.' But there came a moment when everything changed, for she writes, 'Suddenly word came of the death of the German Minister.'

Mrs Conger and Lady MacDonald Look After the Baroness

'I looked up, the packing had ceased', wrote Theodora Inglis.[49] She picks up the story for, by chance, those in the American Mission knew first more exactly what had happened:

Each one stared dumbly at his neighbour. In that moment we could scarcely formulate the question 'how?' Then a voice cried, 'Mr Cordez, the German interpreter is here just inside the gate, badly wounded.' Immediately J [her husband, John] went to help in dressing his wound.

It seemed that Mr Cordez was accompanying Baron von Ketteler to the Tsungli Yamen where he meant to protest in person against the order to leave the city. When half way there, they were met by Yamen runners who asked them to send back their guard of German soldiers promising that they could safely proceed without them. Unsuspicious of treachery, Baron von Ketteler, a man of great courage, did as requested. They had proceeded some distance farther and were almost at the Yamen when the Chinese Imperial troops stationed along the street, fired upon them. The sedan chair bearers dropped their burdens. Mr Cordez, though wounded in the leg, rushed forward, looked into the minister's chair, and saw his chief apparently dead, a ghastly wound through his head. Then Mr C turned and fled. Several shots followed him, but he ran down a side street to the east and going on some distance, his wound bleeding at every step, he fell fainting at our north east

barricade. He was picked up and borne inside our walls and a message sent in haste to the German and American Legations.

Because Cordes's own statement, given later to George Morrison and published by him in *The Times*, is slightly different from the story that quickly spread through the American Mission, presumably from the interpreter's lips as he was being treated, it is worth comparing them. He told how the Minister's party had passed through the arch of honour near the Belgian Legation (which had had to be abandoned four days earlier) and was close to the police station on the left. 'I was watching a cart with some lance-bearers passing before the Minister's chair,' he continued,

> when suddenly I saw a sight that made my heart stand still. The Minister's chair was three paces in front of me. I saw a banner soldier, apparently a Manchu, in full uniform with a mandarin's hat with a button and blue feather, step forward, present his rifle within a yard of the chair window, level it at the Minister's head and fire. I shouted in terror, 'Halt'. At the same moment the shot rang out. The chairs were thrown down. I sprang to my feet. A shot struck me in the lower part of my body. Others were fired at me. I saw the Minister's chair still standing, but there was no movement. One moment's hesitation would have been fatal. I ran, wounded as I was, 50 paces to the north, and turned down the street to the east, a lively rifle fire following me. Looking back I saw the Minister's chair still standing. There was no sign of life.[50]

In one account, Cordes actually looked inside the Minister's chair and saw him apparently dead there; in the other, he assumed his death as he fled because there was no sign of movement within his enclosed chair. There was one person to whom this ambivalence was to matter enormously.

Through all this reconstruction of von Ketteler's assassination, my questions are, unavoidably, where was Maud? How did she hear? Who told her? Who looked after her?

One of the *mafoo* outriders thundered back to the German Legation, distraught, within a quarter of an hour of her husband's departure; he was immediately surrounded by anxious German marines. They, of course, did not know about Cordes, but a posse of fifteen under their commander, Count Soden, who had earlier started out to accompany their Minister, went to recover his body. They were fired on from all sides and were forced to retire without achieving their aim.

It is not clear if they thought, before they set off, to tell the Baroness what had happened; did she not hear the noise of the horse's hooves and yelling and rush out? Again there are contradictory reports. At first glance, Polly Condit Smith's seems the most likely:

Baroness von Ketteler, half crazed, wandered wildly about the most exposed and dangerous part of the German Legation. It was only by Lady Macdonald's telling her that probably her husband's body was at the British legation that she was able to get her there, it being necessary, of course, for her to be put somewhere safe from bullet-fire, where women could be with her and do what little they could.[51]

The only problem with this moving and dramatic account is that, for there to have been bullet-fire, Maud von Ketteler would have had to be left for six hours by herself with the news of her husband's death, and that is patently not what happened.

Theodora Inglis' account seems to provide a clue when she talks of 'a message was sent in haste to the German and American Legations'.[52] They were almost next door to each other on the same side of Legation Street. The message to the Americans was obviously crucial, for Sarah Conger writes in her letter home of 7 July: 'It devolved upon me to bear the word to Baron Von Ketteler's American wife. While I was with her the order came to go at once to the British Legation. I helped her to pack a few things and we went together. Lady MacDonald took her in charge.'[53] Cecile Payen confirms this version and, surprisingly, adds, 'We have only met [the Baroness] once, when she called on one of Mrs Conger's Thursday afternoons. ... None of us had met the Baron.'[54]

Ada Tours saw the incident from the British Legation vantage point; she wrote in her diary that evening:

On coming in we found Mrs Brent in the Tingirh [pavilion] in great consternation, having been bustled round by her son. She seemed greatly agitated and on enquiry told us that Baron von Ketteler had been shot. ...The poor Baroness was brought here, Lady MacDonald having to break the news to her.

Annie Myers, her room-mate, writes much the same. This version does not really contradict the American accounts which must be taken at face value; indeed, Morrison writes in his diary, 'Mrs Conger broke the news gracefully to the Baroness who later supported came to our legation a pitiful sight.' Sarah seems to have stayed with Maud for some time because she continued her account, 'I returned to the American Legation at about three o'clock.'[55] I suspect that both she and Ethel MacDonald took turns sitting with the new widow, until they felt they could leave her, that she wished to be left alone, the British woman having given her a room in her house. Only one (later) account mentions what must have caused a yo-yo of emotions for Maud in the weeks to come: 'she hoped to the last that the Baron was merely a prisoner and still alive'.[56]

One thing was now certain, no one was going anywhere out of the legation quarter. Sarah Conger wrote of her return to the American Legation, that she

'found our people were moving to the British Legation'.[57] Dr Lillie Saville, who perhaps should have been called to Maud von Ketteler, confirms what had happened and how quickly:

> About 11 o'clock an exhausted-looking man jumped from a cart to our verandah, and working might and main began to pile up cases of stores, tinned meats, fruit, milk; he could scarcely spare a moment to tell us that the German Minister had been shot by Imperial Troops on his way to the Tsung Li-Yamen, and that all thought of leaving the City must be abandoned; and the British Legation was to be the refuge of all women and children and non-combatants.[58]

Finally, at 2pm, a reply came from the Tsungli Yamen to the diplomatic note of the night before saying that the countryside between Peking and Tientsin was dangerous, being overrun with Boxers, and asking that Ministers should not leave, especially as railway communications were interrupted. It also advised against visits to the Tsungli Yamen as that route was not safe either.[59]

A rather different message was sent to the German Legation suggesting that two Germans had been proceeding along Ha-ta-men Street, and one of them had fired at the crowd. The Chinese had retaliated and he had been killed. Now the Tsungli Yamen demanded to know his name.[60]

This note has always seemed the final brutality, but an article entitled 'The Homecoming of Baroness von Ketteler' in the *Detroit News* of September 1900 contains this claim: 'It is said that at the moment of his death, the baron pulled his revolvers and fired point blank at his assailant.'[61] It is unsourced and seems unlikely physically according to Cordes's account, but it is in character and, whereas accounts say that von Ketteler was unarmed, we know that his wife had persuaded him to take a revolver.

Whatever had motivated Clemens von Ketteler then and earlier, his last action (to go to the Tsungli Yamen) and the assassination that resulted from it were recognised to have saved everyone from a similar fate on the road to Tientsin.

Later, people were to start analysing events and Lady Blake was to write to George Morrison from Hong Kong on 7 December in terms which, had they been used on 20 June, would have seemed unnecessarily cruel; she had just been reading Morrison's account of the assassination and subsequent events in *The Times* and suggested:

> Do you not think that Baron von Ketteler having shot the Boxer in the German legation and making the German guard fire on the Boxers going through their incantations in the Chinese City (Baron von Ketteler seeing their proceedings from the tops of the wall) had a good deal to say to his murder? I was given to understand Baron von Ketteler had done this before the siege of the legations began.[62]

Lady Blake's theory and, indeed, the record of von Ketteler's behaviour during the previous week, strongly imply that he was blameworthy, even that the Chinese were, unsurprisingly, out to get him, that he was their number one *bête noire*. Annie Myers, with her access to MacDonald and Morrison, suggests in addition that 'There is great animosity towards him personally amongst the Chinese as he has always taken a prominent part whenever home truths were told the Yamen.'[63] But there are two contradictory glimpses of relations between von Ketteler and the Chinese, quite apart from the Chinese decoration that he had been awarded in 1888, and the escort in Germany he had provided for Li Hung-chang in 1890.

On the announcement of his assassination, Mrs Russell, wife of the mathematics professor at the university, wrote that 'He was most popular with the Chinese, so now we know for a certainty that the massacre of all foreigners is determined upon.'[64] Secondly, when his body was eventually retrieved after the siege, it was found to have been put in a safe place by a Chinese friend – undoubtedly an act of great courage and friendship; indeed, Hsu Yung-i, also one of those who had visited the legations on 18 June, was executed in mid-August for being anti-Boxer, anti-war, and pro-foreigner.

Some German sources add another spin to the von Ketteler story. The account of his manservant who was with him for many years, though not apparently in Peking, suggests that the taking of the Taku Forts was the result of the German Minister's murder. This source correctly cites the 20th as the date of the murder, while the forts were taken on the 17th.[65] But, by a strange coincidence, much later German reports, originating in von Ketteler's home town of Munster and kept in the same archives, give the date of his death as 16 June, the date of that strangely prescient but premature report, which was certainly known about at that time in Tientsin.[66]

For the time being, all that Maud von Ketteler had to hold on to – in the moments when she acknowledged that he was dead – was that her husband had sacrificed himself to save the rest of them; indeed, the inscription on his eventual grave was to read, 'He gave his life for his friends.'[67] Mrs Gamewell shows how the women felt at the time when she notes, 'Our hearts yearned the more over her because we realized that we had profited by that which brought sore grief to her.'[68]

There is a quite horrible irony now in how Maud von Ketteler ended her letter home after her audience with the Empress Dowager in March 1900 – only three months earlier:

It had been in every way a memorable day, and while one cannot think that this significant step in advance, in the conservative life of a Chinese woman, will affect in any great degree the political or social conditions of China, it nevertheless brings with it possibilities and certainly consequences which

one cannot ignore. Among the latter and not the least reassuring is the effect such a proceeding has upon the common people. For them to see the wives of the 'Foreign Devils' being received with all honors by the great Empress, who is perhaps more feared than loved, makes for the safety and respectful treatment of every foreigner in the North.[69]

7
Lady MacDonald at Home
(20–21 June)

Miss Haven Looks After her Girls

'Mrs Jewell and others would not have gone and left the schoolgirls and Christians behind', wrote Dr Emma Martin of that Wednesday morning when they learned that the German Minister had been assassinated.[1] So it was just as well that the American Minister finally gave way to his missionaries' entreaties: 'Bring them,' his wife reported him as responding, 'I do not know how they will be fed, but it is sure death to them if they are left behind. Bring them.'[2]

During the period of hiatus at the Methodist Mission, after they had heard of the ultimatum to leave for Tientsin, but before the order came to move to the legation quarter, the missionary women responsible for the schoolgirls began to make arrangements to scatter them into the streets with money to tide them over.

In other parts of the Mission compound, American mothers were at sixes and sevens as they received conflicting instructions; 'It was hard to pack for flight', pregnant Bessie Ewing explained, then her anxieties as a mother naturally dictated her actions:

> I could not do much except to attend to Ellen. Her morning lunch is at ten and not knowing when or how she would get another meal I felt this one was important. She went right to sleep after eating and then I had time to do a little, but everything was so uncertain, and still we thought we should certainly get our trunks, that I had not the heart to pick out much. The day before Charles had packed everything very carefully in view of a possible journey to America. Our small extension bag I filled with necessary articles for myself and the children and Charles got out his clothes, just one change of underclothing.[3]

Then came the order from Captain Hall, 'Take hand baggage only, and march to the US Legation', Theodora Inglis recorded. She too was a mother:

> Then it was that we stopped just long enough to make a bundle of some clothing and food for the children. The men hurriedly got provisions together and planned for the departure of the native Christians. We ourselves tied up a mattress with some sheets and pillows inside, managed also to take a steamer trunk and boxes of milk. The two latter articles, our cook Chang Su and one of our hospital boys carried over for us. We had barely assembled out under the big mission trees, in fact I was busy counting the children to see if they were all there, when Captain Hall called out, 'Forward March!'[4]

Dr Emma Martin and her sister Lizzie had less incentive to be organised:

> Of course we had taken more things than we could carry. We had on so many skirts and it was so hot. Fortunately we got a Chinaman to carry our telescope [bag] and a bundle. Dr Terry asked if we were taking any bedding and I said 'No, how could we?' And she said 'Of course they will have no bedding for us, you could carry a pillow at least.' So I ran upstairs and seized a pillow in a lace trimmed case and as I started, I saw my old comfortable shoes that I had taken off that morning and changed for a heavy new pair lest we have to walk to Tientsin and my old ones were so thin but says I to myself, 'These will be handy to have,' so I grabbed them up and put them in my pillowcase and then I saw Lizzie's and I rammed them in too: Then I start to run on out for they said to hurry and I saw our gay colored cretonne laundry bag with its pink gathering string, hanging on the door knob the one Mother had made last thing and I snatched it up and stuffed it all in there thinking its just the thing and who cares for looks today.[5]

And so they set off, 800 people, out of the fortress organised by Mary Gamewell's husband in which they had protected themselves for eleven days of semi-siege. Eight German marines marched in advance, four of them at a time carrying their late Minister's Secretary, Heinrich Cordes, on a stretcher; then two by two the women missionaries carrying their children, with their husbands either side carrying rifles and, on either side of this phalanx, the American marines.

Bessie Ewing explains how her Congregational 'sisters' took account of her vulnerable state:

> I did not carry anything as the two children were enough for me to look after. I took hold of a hat that was in the trunk but Charles said, 'No, wear your big sun hat.' Mine was badly torn so I put on Marion's thinking thus to save her hat and feeling sure of getting mine later. Miss [Nellie] Russell and Miss [Elizabeth] Sheffield took turns with me in carrying Ellen, a walk of about a mile while I carried their things.[6]

Theodora Inglis had only one, smaller child to manage, but her account of the 'march' shows that it was gruelling enough, at least for her:

> The sun burned furiously and we soon grew warm and fatigued. The baby, however, surveyed the strange scene with the greatest interest. Her little cheeks under her white bonnet grew rosier still and her blue eyes brighter as a new world opened to her baby vision. She made no comment, however, except a little crow and an upward jump now and then to emphasise her observations. She was plump and heavy so we all three took our turns carrying her, Wang Nai Nai, J, and I, though to do it her father shifted the gun to his other shoulder and I carried the umbrella over all.[7]

That happy account of little Elizabeth will later attain particular poignancy.

At the gate before they left, Captain Hall had counted all the missionaries to make sure that none was missing; one was, Ada Haven. As one of her Congregational schoolgirls recorded:

> She would not leave her twenty girls to take that journey alone, and had crept in among us unobserved. When she led us out into the street, the missionary women and children, guarded by American marines, had already filed out. We followed, circling about Miss Haven, lest the marines discover her and force her to go ahead with the others. After we schoolgirls had passed the barricade close by our gate, word was given for the hundreds of Chinese men, women, and children to follow us. On we went into the great street, almost deserted now. ... We had to pass within a stone's throw of that gate tower crowded with hundreds of [Chinese] soldiers, their rifles glittering in the sun. ... We could hear their rude laughter as they called to their comrades to look at us, and one shouted out, 'See that crowd of erh mao-tzu [secondary hairy ones]. Of what use is their running all over creation? Wherever they go, it is only a question of days when they will all be killed.'[8]

They had a mile to walk and Mary Gamewell looked around her; she did not dwell on what was happening, as she might have done for, as newcomer Dr Emma Martin observed, 'It seemed like a large funeral as we went from our comfortable homes leaving our worldy possessions behind and the beautiful church and school buildings where some of them had given the best of their lives.'[9] This had been a familiar street to her Methodist colleague Mary Gamewell for a long time, but it was different today:

> On ordinary days this great street was filled with a jostling noisy crowd, wherein mingled top-heavy wheelbarrows, pushed and balanced by straining men, and dragged by men, mules, or donkeys, freight carts and passenger carts, each with its shouting driver and cracking whip, slow-moving camel trains, pacing mules with jingling bells and elegant riders, and dodging, darting, more or less imperiled pedestrians; but on this day, except for the

soldiers and our procession the streets were deserted and a great hush seemed to have settled upon the city, as if in awe of the enormity of the crime committed, or holding its breath for an expected explosion.[10]

The only British woman among them, Miss Georgina Smith, later remembered:

> The city wall and gate, which almost cast its shadow on the road which we crossed, so near was it, was crowded with armed Chinese soldiers watching us in grim silence, rejoicing to think that, as they imagined, we were walking into a death-trap. They thought that at any moment the Empress Dowager's orders to open the attack upon us would be given.[11]

Eight-year-old-Dorothea Goodrich was usefully distracted. She had taken her dog Dinger when they fled T'ung-chou. 'When we were ordered to leave the Methodist Mission,' she later wrote,

> I took Dinger in my arms, but mamma said I must carry a pillow and tins of milk and jam and leave Dinger there. I could not bear to have the Boxers take our nice little dog, so I begged mamma to let me take Dinger too. Papa said I could try it. We marched two by two to the Legation, the soldiers guarding us. Dinger was restless and wanted to get down, but I held him tight.[12]

At the barricade into Legation Street they were stopped by French marines, a testing time for the Chinese schoolgirl recording the event. Her friend noted, 'How glad we were to welcome some missionaries who had come over from the British Legation to help and encourage us.'[13]

One of them was Miss Smith's colleague Dr Lillie Saville for she describes that arrival and how the refugees were taken to the recently vacated princely palace where 1500 Roman Catholic converts were already sheltering:

> Planks across the Canal formed a foot-bridge from the British Legation to the gate of the Fu. Entering this, one came upon a long avenue of goodly trees, and in their shade, massed in sections according to their Missions, sat our weary friends. Here in a retired corner were the patient schoolgirls, still perfectly modest in manner, and without the slightest sign of panic in spite of such trying experiences for Chinese girls. From another group sprang forward an old friend; an ugly red burn on her neck gave proof that she had fallen into Boxer hands, who would have burnt her head off, had not their attention been diverted. She escaped and found her way through the lines. But these poor people had waited through the burning hours of a June day – could nothing be done to refesh them? There was no chance of providing a meal that day, but at any rate we could give them a cup of cold water. A couple of bedroom cans came from the Legation and some cups were soon on hand ... long thirsty hours had that crowd waited, and yet there was no scrambling, no clamour, only everywhere the kindest consideration for others

first, and always a word of thanks for the cooling draught. From the outside avenue the people were gradually moved into the buildings round the courtyards.... In the huge reception hall one found a group of schoolgirls with their teacher – a tall, beautiful refined American girl – seated in their midst on the floor. She was talking quietly with them. I hurried away – her 'talk' with her girls at such a time, and in such a place, seemed too sacred for a stranger to intrude.[14]

While most of the seventy American missionaries had peeled off from the Chinese refugees, it is clear that several women had not. The young American teacher could be Miss Sheffield of the Congregationalists (who had helped Bessie Ewing carry Ellen) working with her fifty-year-old colleague Ada Haven; or she could be one of those working with Charlotte Jewell and her bigger group of Methodist girls.

Mrs Squiers Serves Lunch

Some of the Americans had particular friends in the Legation but, as Mary Bainbridge recorded, she tried to make them all feel welcome:

It was a pitiable sight to look upon them as they came marching in homeless and forlorn, their possessions all gone. As I stood in the doorway of the office building watching them as they came along, my heart seemed to almost stop beating. I never had witnessed such a scene before. I shook hands with each as they drew near, those I had not seen before as well as the ones I had become acquainted with. I could not speak, my heart was too full for utterance. As Mrs [Ed] Lowry came along alone (for her husband was caught in Tientsin and could not get back) my heart went out for her, she looked so forlorn, she pressed my hand warmly and neither of us spoke a word, but walked away silently to a quiet corner in the compound where we were alone.

Theodora Inglis remembers it all with gratitude:

Kind Mrs Bainbridge, whom so many of us have reason to remember gratefully, was not long in lighting her little oil stove and her rooms became the baby headquarters. Mrs Squiers was already rushing here and there inviting the tired and hungry, and we were all that, to partake of the generous hospitality with which it was seasoned.[15]

Sara Goodrich, three children in tow, seconds her warm memories: 'Arrived at the U.S. Legation, we went to the office, and soon Mrs Squiers served us to tea, scrambled eggs made in her chafing dish, sardines, etc. It was a picnic dinner served in her gracious manner.'[16] Polly Condit Smith was there, of course, and adds colour to the story and details to Harriet Squiers' hospitality:

Mrs Squiers arranged a luncheon for everybody – men, women and children; and, although she knows her food-supplies may possibly run short for her own large family, she opened her storeroom, containing staple groceries and many crates of condensed milk and cream, and urged these women to take, individually or collectively, literally as much as they could carry of the articles they most need to tide them over until the troops arrive. These women had all had a taste of siege life, and already knew what it was to see their children show the lack of proper food; and they consequently availed themselves fully of Mrs Squiers's more than generous offer. It was a happy 'mothers' congress'

19 Harriet Squiers (from *Behind the Scenes in Peking*)

that denuded those storeroom shelves, and then this missionary convoy was taken over to the British Legation, and Lady Macdonald gave them the chapel for their lodging.[17]

Lady MacDonald Sorts Out Accommodation

As hundreds of people flooded into the three-acre British Legation, with its fifteen-foot-high wall, someone had to be responsible for organising their accommodation; Polly Condit Smith gave a clue of whose shoulders this fell upon when she wrote, 'Lady MacDonald gave them the chapel for their lodging.' The British Minister's wife explains:

> My husband who, with Captain Strouts, was busy organising the defence of the Legation, deputed to me the task of finding house room for all. My only chance of doing this was to turn many of our own staff out of their houses and take them in ourselves; thus, in a few hours I managed to pack twenty-five Russians into the Second Secretary's house, eighteen or more French into the accountant's, twenty-five Americans into the doctor's, forty of the Imperial Maritime Customs in one set of students' quarters, some stray foreigners into the second students' quarters, thirty to forty American missionaries in the chapel, the bulk of the Japanese Legation in a small three-roomed bungalow, many English missionaries into the First Secretary's house, while the refugees from the hotel and the shop people were domiciled in the second large reception hall.
>
> The first hall was reserved exclusively for the Legation Staff and officers, who lived and slept here throughout the entire siege ...[18]

And Ethel MacDonald had to superintend these arrangements without letting Maud von Ketteler sense that she was distracted.

The allocators showed particular sensitivity then, and later, towards women with special needs. Theodora Inglis noted of that day, 'Through the kindness of Lady MacDonald and her sister Miss Armstrong, our little family was given a private room belonging to Mr Warren, a young Legation student.'[19] And Dr Emma Martin writes,

> Lady MacDonald came over to see Mrs Ed Lowry and she said she would find her a place, so she had the students vacate two rooms in their quarters and nine of us M[ethodist] E[piscopalian] ladies, Mrs Jewell, Gamewell, Dr Gloss, [and Terry], [Miss] Gilman and ourselves went there to sleep.[20]

Annie Myers explains how some of the displaced Legation staff, at least, were accommodated: 'Daisy and I helped the Tours to move over into the MacDonalds' house where two rooms opening out of each other by an arched doorway (Miss Armstrong's suite in fact) have been given up to Mrs Tours, Violet, Daisy and me.'

Not everything worked out immediately; Sara Goodrich was to note that, 'In a large pavilion just east of our chapel, the Catholic sisters, the priests, the Chinese nuns, Mrs Squiers' refugees, and Italians found a refuge.'[21] But it seems they were initially overlooked, for there is a touching account of their disorientation. Deaconess Jessie Ransome noted that,

> All the long afternoon a doleful company of poor French Sisters were sitting out of doors, as no place could be found for them. They had fled away in the night before their house was burnt, and they had not a single thing, literally nothing, and they were as helpless as little children. At last one of the ladies from the French Legation managed to stuff them in somewhere.'[22]

But the open-sided pavilions – the *T'ing-erh* – were soon sorted out; Theodora Inglis records:

> Young Jesuit Priests in long black robes walked nervously about and a white haired father in Chinese garments [Padre d'Addosio], sat in one of the big pavilions sipping his wine; white-capped sad-eyed nuns clustered about on the broad pavilion steps telling their beads or striving to cheer their frightened converts. The French and Belgian engineers were preparing to keep house in the pavilion itself and were pounding and opening their boxes and barrels. Hundreds of native Christians sat helplessly about on the ground waiting for orders; Diplomats, army officers and missionaries were all talking and working together. Each woman was trying to find her belongings; children hopped about under the big trees, babies, wide eyed in wonderment or waiting, carts rumbled through little lanes, attended by screaming carters; ponies neighed; dogs barked and roosters crowed. The officers were calling to their men and the marines rushed about, obeying their commanders. Add to all this, one thousand tongues wagging in seventeen different languages.[23]

Jessie Ransome adds to her own experience and account:

> The Norwegians have got our room, and Mrs C[ockburn] has most kindly given us her dining-room, where we three women camp out quite luxuriously; and Mr Allen and Mr Norris sleep in a verandah. The Japanese settlement is most interesting, the dear little babies looking so exactly like Japanese dolls that one no longer can think the toys unlike living children. All the shops round have been cleared into the Legation, and a flock of sheep and some cows have also been brought in, and there are lots of ponies, so we shall not starve.[24]

And Polly Condit Smith had been listening to gossip, I suspect from George Morrison via Harriet Squiers, when she declared:

> There are so many women in our United States Legation that the British have assigned us the doctor's bungalow. Dr Poole is the compound surgeon, and

we are living in comparative comfort compared to the people of other
Legations. Politics seem to enter into the distribution of the Legation houses
that are assigned to the heads of each Legation, and after a Minister is given
one, he proceeds to arrange his people as comfortably as he can. Our house
has not many rooms, but they are large, whereas the Russian Minister has
been given the second secretary's house, which is in bad repair, and is
anything but commodious. Sir R. Hart, as Chief of Customs, has one of the
inferior houses, which is unfortunate, as his Customs officials are very
numerous; but then, from time immemorial, the British Minister has never
loved the Customs people's great power in having control of the huge
revenues of China.[25]

The Russians were distinctly *persona non grata*, it being clear to everyone that
they had attempted to be in cahoots with the Chinese for some years, the better
to get their hands on Manchuria and otherwise extend their sphere of influence
– indeed, the de Giers were to find themselves somewhat ostracised.[26]

Mrs Conger got back to the American Legation from looking after Baroness
von Ketteler at about 3 o'clock 'and found that our people were moving to the

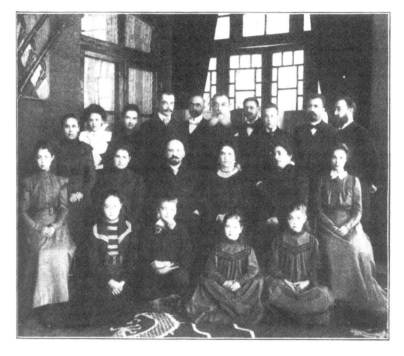

20 Russian Minister and staff of Legation and their families
(from *Beleaguered in Peking*)

British Legation. Everybody was busy, busy.'[27] Mrs Squiers and Mrs Bainbridge had coped in her absence more than adequately with the American missionaries, and now everyone was settling into their allotted places in the British Legation. Indeed, so in control were the missionaries feeling that some of the men, accompanied by converts, made the journey back to the Methodist compound, left guarded by Chinese police, to retrieve supplies and possessions. Bessie Ewing, the prospective mother, who must have been feeling distinctly jaded by now, recorded gains in a way that reflected that:

> The looters had been at work and had opened everything that was not fast locked, but a good deal was saved. As neither of our trunks were locked (one lock being broken and the other having the key bent) we lost all. There were great quantities of goods scattered all over the church and these our Chinese gathered up into sheets and quilts as best they could. We had discarded quite a large pile in repacking, thinking the articles selected would do the Chinese refugees more good than they would us, but many of these old things were brought over. Nothing ever appeared from our trunks or big box. About all we gained from the scatterings were my very old winter coat, Charles' old overcoat, one white suit and an extra pair of white trousers, a flannel underskirt, a torn shirt waist, a crocheted sack of Ellen's, a few soiled clothes, my silver pudding dish without the cover, our gold clock and some bedding.[28]

And that is how Lizzie Martin, the orderly sister who had properly packed her trunk and pocketed the key, came to see it once again. Even Emma benefited: 'I found in it my white and my black sateen waists. I have my black skirt and my brown serge suit and my mackintosh came.'[29]

Frau von Rosthorn Leaves Home

Over in the Austrian Legation, which was rather more exposed than many of the others, plans were not moving in quite the same direction. The American Legation doctor, Robert Coltman, hints at a muddle caused perhaps by too much concern for diplomatic niceties – the fact that Dr von Rosthorn at the Austrian Legation was not a minister, but a mere chargé d'affaires. According to Coltman, 'no notice was given to Dr von Rosthorn of the ministers' new decision not to leave'.[30] As a result, he and his wife, Paula, left their legation with their marine detachment and arrived at the French Legation at 3 o'clock, as if setting out for Tientsin. There M. Pichon showed von Rosthorn the latest correspondence with the Tsungli Yamen, promising the diplomats protection in Peking, and the von Rosthorns returned to their legation.

If that is what happened, it is not hard to imagine the feelings of the von Rosthorns and Captain von Thomann who, it transpired, was the most senior

among the professional defenders. But Robert Hart, Inspector General of Customs, picks up the story without mentioning this apparent insensitivity and confusion. As far as Hart was concerned, the Austrian Legation and the Inspectorate, opposite each other at the top of Customs Street, were to be mutually supportive; but Hart suddenly learnt that the Austrians could not hold their position and would abandon it and retire to the French Legation at 2pm. 'This upset previous plans,' he reported,

> and forced the customs, almost without preparations, to desert the Inspectorate which they had hoped to continue to occupy and so at 3pm Austrians and customs were marching together down the street to the French and British Legations. Thus the ... line of defence along Chang-an Street had virtually been given up without a blow.[31]

These two accounts do not easily mesh but, whatever did happen, it did not bode well for future relations. Annie Myers, keeping her diary in the British Legation, confounds the discrepancies still further by noting:

> [During] dinner Mme von Rosthorn came in. The Austrians have had to abandon their Legation and seek refuge through Sir Robert's garden, over his walls and on to the French Legation, where they still are, Mme von Rosthorn alone coming here. She had brought a tiny bag with her containing practically nothing, so I had to lend her a brush and comb and nightgown and tucked her into the bed I was going to occupy, as she was tired out and wished to retire earlier than we did. She told us that one of their marines had been wounded by a bullet.

Ada Tours, sharing the same room, made an almost identical diary entry, but she added, 'She had packed for the proposed flight when of course provisions would have been more important than clothes.' Taking that into account, and adding it to Coltman's suggestion that they had earlier returned to their legation, would not Paula von Rosthorn have repacked for possible retreat into another legation and subsequent siege? The Austrian contingency plan had always been to fall back on the French Legation because they had no citizens of their own to protect.

As far as Hart's account is concerned, if one of the Austrian marines had been wounded, presumably during or just before the flight, the Austrians had not 'abandoned' their legation between two and three o'clock; they could not have done so until much nearer 4pm. The original twenty-four-hour ultimatum had been due to expire at 4pm on Wednesday 20th, and everyone had that deadline in mind no matter what the Chinese had said during the day about protecting them. Among the women, Deaconess Jessie Ransome most neatly records the moment of truth:

Just at five minutes to four by our time we heard firing begin at the Austrian lines, and it continued pretty sharply at intervals all round till about nine. The bullets whizzed about gaily. I never before have been under fire, nor understood what the 'whistle' of a bullet meant, but I do now. I was obliged to go across the compound to find a place for Miss Hung and the children to sleep, and I was just coming out of a house when a bullet struck a pillar of the verandah in front of me.[32]

Jessie Ransome's account suggests that the Austrians must have abandoned their legation some time between four, when we know that the ultimatum expired and the firing started, and nine o'clock, and Annie and Ada said that they were having dinner in the British Legation when Paula von Rosthorn arrived.

Captain Darcy was, of course, at the French Legation; more diplomatic than Robert Coltman, he nevertheless gives us some useful facts:

At 2pm the Austrians left their legation and came to ours. Believing the departure for Tientsin would not be long delayed, they brought only arms and ammunition. The retreat of Austria involved that of the Customs who could neither logically nor materially withstand the first shock of an attack. ... Their people took refuge in the British Legation ... At 4pm, the Austrians wished to reoccupy their legation but the sound of firing from Chinese soldiers stopped them in their tracks, and they returned for good to our position.[33]

Darcy adds that at 8pm the Chinese tried to set fire to the Austrian Legation but they were prevented by fire from all sides from the French, Austrians, English and Japanese. The French commander's account implies that a failure to keep the Austrian Chargé informed – prompting them to set off, as if for Tientsin – was more to blame for the loss of the Austrian Legation and the Customs Inspectorate than the lack of spine hinted at by Hart and others.[34]

In spite of Darcy's first-hand account, Dr Coltman insists that the Austrians returned to their legation, for he adds:

The Austrian Legation being entirely exposed, and untenable against any serious attack, it had been understood that the *chargé d'affaires* and the detachment were to retreat to the French legation. This was done under galling fire, but there was only one man wounded.[35]

If it was under fire, it was after 3.45, and if the fire was galling, there might be some excuse for abandoning the exposed legation. This may be an example, in view of the factions that were to develop among the besieged, of the massaging of history. Coltman would certainly have been on the side of the Austrians, being determinedly anti-Britain and its Minister. Claude MacDonald, whether he liked it or not, was one of the main protagonists in this factionalism.

Inevitably, therefore, Ethel MacDonald and Paula von Rosthorn are pitted against each other. Happily, it was only through their husbands' disagreement: for two such fine women to have quarrelled face to face would have been unedifying.

The British Minister does not mention the Austrians at this stage of his account; indeed, according to him, the first shots from the Chinese at 4pm 'struck the coping of the canal a few inches from where I stood'.[36] All that the French Minister, M. Pichon, will venture is that he and his wife, accompanied by Señor Cologan, the Spanish Minister, arrived to take refuge at the British Legation – and join the other French diplomatic families there – at 9pm. But the French relief commander's account makes it clear that Mme von Rosthorn came with them.[37]

And there the incident could rest, tantalisingly unresolved – history, after all, being in large part the story of those whose records survive.

Sixty years after the siege, the British traveller, writer, and historian, Peter Fleming, published *The Siege at Peking* (1959) – a reconstruction with hardly a woman in it but otherwise highly readable. On 24 November the following year, a letter left Vienna addressed to Fleming. 'Let me introduce myself first,' it read. 'I am Paula von Rosthorn and as I am 87 years of age, I take it that I am one of the few survivors of the siege of Peking in 1900 and as such can really appreciate your book.'[38]

I found this letter among Fleming's papers when I started to research this book, and Fleming's delighted reply asking the ghost from the past a couple of tactful questions. There was apparently no response from Vienna. A letter I wrote thirty years after Fleming to that address, hoping it might still be the von Rosthorn family house, also went unanswered. But a letter to the Austrian State Archives written more recently brought news of a book published in Vienna in 1989, whose English title is *If I Were Chinese, I would be a Boxer*, based to some degree on the papers of Paula and Arthur von Rosthorn.

In his nine-page account of the siege, Arthur does not discuss the events of the afternoon of the 20th June. The editors of the book note that Paula writes about the same things as her husband, but without his diplomatic reserve. Her temperament allows her to be more direct, her language more blunt; she brings events closer.[39] Her account of the siege covers fourteen pages, and she does write about the 20th.

But first, who were the von Rosthorns? One of the first things we learn is that Arthur von Rosthorn and Sir Robert Hart had known each other for seventeen years, ever since the younger man came out to work for the Chinese Imperial Customs in Shanghai. He was only twenty-one then and Robert Hart writes (the only time he mentions von Rosthorn in all his thirty-nine years of nearly 1500 recorded letters), 'What a nice looking youth von Rosthorn is and what a full head he has got: but what a staid old man he is in manners and talk.'[40]

In 1893, after ten years in China, von Rosthorn went home to Vienna and spent two years there, finishing his doctorate on the spread of Chinese power in south-west Asia up to the fourth century AD. In 1895, still in Vienna, he was appointed to the Austrian diplomatic service in China. It occurred to him then that he should have a wife, so he looked among his cousins and chose the one he though the 'cleanest' – the physical connotation of the German word is inescapable.[41] The couple were probably married in 1895 in Vienna where she was the daughter of the dentist Johann Pichler and his wife Jozia Kner. Paula was twenty-two, Arthur thirty-three. Then they left for Shanghai, where Dr von Rosthorn still had some responsibilities towards Robert Hart.[42]

In Shanghai, Paula, who was shy, found it difficult to make friends and was lonely and unhappy, and Arthur seems to have left her there for some months while he went ahead to Peking; the death of those senior to him in the Austrian hierarchy had catapulted him into the position of Chargé d'Affaires. But by the end of 1896, they were both in the capital and Paula obviously felt more at home in China; life began to look up. Von Rosthorn had been instructed to acquire some land and begin the construction of a legation; in April 1897, Baron von Czikann, the first Austrian Minister to Peking, arrived.

By 1899, Rose Villa was built, one of the few houses of more than one storey in Peking, and its most distinctive feature was the two large electric lanterns outside the front gates which Chinese citizens would flock to see switched on at night. While von Czikann was apparently more interested in his promotion than China, his junior had clear radical ideas about his host country. He made a point of sticking to the demands of protocol other diplomats mocked, and he worked on understanding the causes of China's increasing xenophobia. 'Just imagine what it would be like,' he suggested, 'if you forced Britain to give Cornwall to France'.[43] And, knowing his temperament, he was serious when he pronounced, 'If I were Chinese, I would be a Boxer.'[44]

In the spring of 1900, von Czikann went on leave, and von Rosthorn, aged thirty-eight, was once again Austrian Chargé. On the night of the 19th June, he had swallowed his diffidence about being 'Benjamin' among the Ministers, and drawn on his experience of China. His less impetuous nature than that of von Ketteler, the other experienced China hand among them, had prompted him to devise a stratagem to which the Chinese had at least sent a diplomatic reply.

Earlier that day, to reassure the Christian servants who had returned to the Legation after their flight on the 13th, Paula, who had always surrounded the Austrian compound with greenery, asked the gardener to plant new lettuces.

But there was more to the twenty-seven-year-old Austrian woman's sang froid than meets the eye. Dr Isaac Headland, husband of Dr Mariam (both of whom were on leave in the United States during the siege) later wrote an article called 'Heroes of the Siege of Peking' which started:

21 Arthur and Paula von Rosthorn at the Austrian Legation

(from *Ware Ich Chinese, so Ware Ich Boxer*)

Just before the outbreak in Peking began, Frau von Rosthorn ... started to return to her home, that her first babe might be born in the fatherland and with her own people about her. She is a beautiful little woman, who seemed too timid to live in the Chinese capital. As she was about to sail from Taku, she learned of the danger that confronted the foreigners in Peking. She insisted on being put shore and on going straight back to her husband's side.[45]

Now, we can leave Paula to tell her version of the events of the 20th:

It was not spoken about and I, as well as several others, believed that yesterday's decision [to go to Tientsin] still stood when we left our legation. [Captain] von Thomann had explained that, in the event of a military attack, it would be impossible to hold our legation, and it was decided to take our provisions to the French Legation for the time being. The rest of the morning was occupied with packing provisions. We only had one cart and it had to be used to transport the ammunition. Meanwhile, Arthur and von Thomann burned the legation code books page by page in the stove because there would be nowhere to keep them safe if we took them with us.

We left with sad hearts, each with a little bag on our backs which contained all our belongings. We felt much comforted when M. Pichon met us on the way saying, 'Go back, it's not so bad after all. A conciliatory letter has just arrived from the Tsungli Yamen in reply to our overnight one. The government still wants to protect us, or will make the necessary arrangements if we prefer to go to Tientsin. etc.'

He didn't have to persuade us further and we returned happily to our legation. But it was not five minutes before the first shots fell. The Chinese had kept accurately to the twenty four hour ultimatum. Our happiness had been of very short duration. I knew that we had to give up our house after all, but just as the Chinese started shooting, we suddenly remembered that I had to save something very important – our flag, the same one that we had made ourselves in 1898 for the Empress's birthday. It always hung over the altar during mass and the marines fired their salutes over it.

Quickly I dug it out – it was at the bottom of a large trunk. Then Arthur came looking for me because now we really did have to flee: from three sides bullets were clattering against the house. We ran out by the stable gate, then quickly across the street which was completely exposed and into Sir Robert Hart's compound, through his garden. The southern gate which led to a small alley was locked, but a ladder was leaning there. So, quickly, up the ladder, and without thinking too long, we jumped down from the eight foot high wall. Above us was the most frightening whistling.[46]

The only diversion that Coltman seems to have created, at least in my mind, is to imply that there was some disregard in the failure to tell the Austrians that there was to be no departure for Tientsin; more likely, it was taken as read,

and no one formally told anyone; contingency plans meant that most diplomats would make their way to the British Legation, while the Austrians would make theirs to the French.

On the face of it, Paula von Rosthorn is not critical of the British, at this stage; but the Austrian abandonment of their legation obviously did cause resentment in several quarters. Did Arthur von Rosthorn realise why Sir Robert Hart did not fall over himself when he turned up later having rescued the diaries of his former boss from the smouldering Inspectorate? It would be unreasonable to criticise the Austrians. They had already packed up their ammunition and the cart had either been left at the French Legation, or was now quickly hurried back there by the marines. Arthur himself lost his valuable collection of books on Chinese history and philosophy.[47]

Paula now took refuge in the British Legation, her husband staying with the Austrian and French marines at the French – minus its diplomats: she writes, 'During the five days that I spent in the English Legation, I only saw Arthur twice.'[48] Since several accounts suggest that she never left her husband's side, that she went straight to the French Legation and was the only diplomatic wife to stay (bravely) outside, this correction of hers is useful, and sets the scene for a later departure from the relative safety of the British Legation.

By coincidence, Baroness von Ketteler was also still alive in 1959 when Fleming published his book; he never even mentions her, but neither does Paula von Rosthorn. Paula, conceivably pregnant, was to go on to become a heroine of the siege.

The Widowing of Mrs James

An hour after the shooting started, the American missionary women looking after their converts in the Fu were advised to leave; the British Legation was likely to be attacked at any moment. One of the schoolgirls observed:

> I think they all started at once, except Miss Haven and Mrs Jewell, who staid back among their schoolgirls. A little later the missionaries came back for them, and I saw Miss Haven talking very earnestly. Though I could not understand what she was saying, I know that she was pleading to be allowed to stay with us. But they must have convinced her that it was not best, and soon she made her way across the wide street down which the bullets were already flying.[49]

One appreciates Miss Haven's behaviour all the better for knowing that this was supposed to have been the week leading up to her wedding day; but she had no idea where her future husband, widower Calvin Mateer, was, 'whether my good man is alive or dead'.[50]

The British doctor, Lillie Saville, also nearly left it too late to leave the Fu where she had been helping the LMS refugees to settle in. Suddenly she heard

an unfamiliar noise. 'What was that?' she later asked rhetorically, and answered herself, 'The short, sharp sound of a rifle shot, quickly followed by another and yet another.'[51] She was at once taken in hand by Professor Francis Huberty James of the Chinese University, the man who, with George Morrison, was responsible for making sure that the Chinese converts had a place of sanctuary. They had insisted on it as a principle with the diplomats, and then negotiated with Prince Su to secure a suitable place.

Now Huberty James said to Lillie Saville, 'You must leave at once; the other ladies are gone; the Chinese are firing on the bridge, you must cross the canal before it is too late.'

An hour or so later, for reasons which could only be surmised by those who watched horror-struck from the British Legation, Huberty James, who spoke Chinese and had been a missionary as well as a university teacher in China for some years, was seen on the bridge apparently making an attempt to communicate with the Chinese, to halt the catastrophic events that were now set in train. He seemed to be felled by deliberately aimed fire and was last seen through the gloaming crawling in the canal and then, probably, taken away by those who had shot him. It was not possible to go to his aid, and it was never known what his precise end was, but his supposed fate – either of immediate death or of later execution after torture – certainly confirmed that the siege had really started.

I have found only one person – Theodora Inglis – who thought about Huberty James's death beyond praise of the dead and the immediate danger of the besieged. 'I could not bear to think of the wife and children in the homeland,' she wrote, 'of whom the husband and father had always spoken with such pride and fondness'.[52] James's fellow missionaries were in touch with his widow after the siege, keeping her 'informed about all I can find out about the end of our good friend', as one of them wrote to Morrison.[53]

Miss Georgina Smith Queens It

It is not surprising that there were different impressions recorded about Wednesday night. Phlegmatic Dr Emma Martin, in the special quarters with eight other American women, wrote, 'There was more or less firing all night but we slept some anyway. A mule just outside kept braying and disturbing me.'[54] One of her companions, Dr Edna Terry, spelled out more clearly what Emma rather glides over: 'Eight or nine ladies slept that night upstairs on the floor of a small room in a building which was a target for the enemy. The house was fired on repeatedly during the night, and it was necessary for us to find a safer place.'[55]

From phlegmatic Emma Martin to Tacitean Edna Terry, the account moves to Mary Gamewell who clocks almost every minute of the night, including:

The rifle fire thickened, the shots snapped and hissed more constantly and seemingly at closer range. There was an attack on the north, and the Chinese rifles commanded the north window of our building. If our beds were not actually in the firing line, they were rather thrillingly near to it. It was not difficult then to understand why the occupants of the better protected rooms below preferred to be crowded there rather than have more freedom in these exposed rooms on the second floor. ... With the morning came an invitation from Lady MacDonald to better shelter in her ballroom. Several ladies had preceded us there but on its spacious floor there was room for all and in the ballroom we spent the remaining nights of the siege.[56]

Dr Martin woke with the lark, reporting, 'This morning dawned bright and clear and while nine of us were dressing in one room with all beds on the floor Mrs Gamewell related her experience of getting supper and how she lost her temper almost and I nearly hurt myself laughing.'[57] But then Emma Martin changed her tune: 'Our hearts are heavy this morning for they can see the smoke towering upward from the direction of our place [the recently abandoned Methodist compound] and I cannot bear to look at it.'

Theodora Inglis who, with her family, had been given young Mr Warren's room, was altogether more fed up:

The porch outside our windows was crowded with smoking, snoring Germans. Across the hall, eight or ten belonging to the Japanese Legation ate and slept. No chance of fresh air from without, for the Germans had barricaded the edge of the porch in nearly to the roof with their boxes and barrels of food stuffs, neither could we get any fresh air from the hallway which was full of undesirable articles. The Japanese servants, in order to make their own rooms inhabitable, pushed everything into the hall from dirty utensils to stale and rotting food. There was no other inlet for fresh air and we knew that while we slept we were drinking so much poison, poison inside, bullets outside, every inch of available house or porch room covered with a human body.[58]

Still it was better than the total lack of privacy of the Methodist Mission and, apart from a few nights of the heaviest firing, when she and baby Elizabeth were to join the other Americans in the chapel, they stayed there for three weeks.

There were six members of the Presbyterian Alliance Mission, some of whom had been stationed in Peking at what was known as Miss Douw's Mission: two of them, Matilda Douw and Amy Brown, were American; but Miss Gowans and Miss Rutherford were British subjects, and Janet McKillican and Grace Newton were Canadian.[59] The Mission was American for most siege purposes, but apparently British as regards accommodation. Miss Douw describes how they were put in the large two-storey house at the south-east corner of the British

Legation – sometimes known as the First Secretary's House, sometimes 'The Corner House'; she adds that

> In this house twenty-six foreigners were quartered. There were four bed rooms downstairs. A bank director and his wife [Mr and Mrs Houston] occupied one of these until it was needed as an annex to the hospital; when they moved into a smaller room in the same house. The family of Mr Stonehouse (L.M.S.) lived in another of these large rooms, while a third, not so large, was occupied by the single ladies of the London Mission, with the exception of Miss Smith, who arranged a cot for herself in the entry, curtaining it off with Chinese gauze of so gorgeous a hue that it was called by some 'the throne of the Queen of Sheba'.
>
> The second floor of this house, being too exposed for safety, the other lodgers, men without wives, had no other place open to them than the lower veranda. That was open, alas, too open! Here, on shutters, or in hammocks, these poor men sought repose, and a wash basin at the end of the veranda located the toilet room. As the rooms occupied by the ladies opened out with glass doors upon this veranda, and as we could keep the shutters closed but on one side, much of the time, these fellow-lodgers might have made it very disagreeable for us. That they did not, was owing to the fact that they were *gentlemen*; and the ladies never think of them without gratitude for their delicate consideration.[60]

Polly Condit Smith and Harriet Squiers, for all the Americans apparently had the best quarters, were hardly better pleased than the worst complainers by the time the first morning arrived:

> Mr Squiers has been assigned two rooms of this house ... they are situated at the back, opening directly on the filthy, dirty Chinese servants quarters. Mrs Squiers, and my maid, and I have the large room, which is practically the living-room for the family and mess of the First Secretary of Legation. Our trunks, with two silver chests, and all the many dozens of tins of food that we brought from our Legation, are banked all round, up against the walls. The big double mattress on which we sleep is rolled up in the daytime, and we use it for seats as well as the trunks. We have no furniture, as Dr Poole moved his bed to the hospital. ... Perhaps it is just as well, however, because we have great difficulty in finding a place big enough to spread our mattress out when night comes as our stores and trunks almost fill the room.
>
> The three children have their respective cribs which we were wise enough to bring over from our Legation. They are placed in the other room which looks out on the little avenue that runs through the compound. The air is much purer there than in our room, where we breathe the servants' air and gas which rises from a broken sewer. The French and German governesses are placed in the ends of small halls.[61]

The Death of Baby Imbeck

Only one account noticed the first death among the foreign besieged – one of the Imbecks' children died during that Wednesday night. Roland Allen puts it down to the hardships of the previous days without noting that the German merchant and his wife had had a particularly trying twenty-four hours. Their shop, Imbecks, and Kierulffs run by the Krugers, were just out of the area it had been decided to defend and they had had to abandon it the previous afternoon. And it later becomes only a statistic that, in fact, the Imbecks lost both their children during the siege, and the Krugers their only child. No one notes whether or not they shared accommodation and if there is anything to be made of that.

Mrs Bainbridge was to record the death of the second Imbeck child (who died on 5 July aged two): 'The German merchant where we used to take our meals when we first came to Peking, buried two within 10 days. The poor little things were simply wrapped up in a sheet and taken by one or two men to the German Legation to be buried.'[62]

It is impossible to know now if Maud von Ketteler found the strength, as the German Minister's widow, to console the two German women who lost their children. It cannot be ruled out. Certainly her own grief was intense. From that first morning, Mrs Gamewell went in search of her husband who, like many of the American men, had found a berth in one of the corridors of the MacDonalds' residence. 'At right angles to the outside wall of the corridor and opening into the little court around which Sir Claude's dwelling is built,' she wrote,

> was the room occupied by Baroness von Ketteler. I have seen her in the gray of early morning ... standing at her window, white and grief-stricken; and one day she caught her black robes about her and stepped toward me. We clasped hands. She is an American and looked only a girl. She was glad to take my hand because I also am an American. 'I am so alone,' she said.[63]

That Thursday afternoon, the 21st, the first full day of the siege, Harriet Squiers' fifteen-year-old stepson, Fargo, took it upon himself to set out in a cart with two 'coolies' to rescue the provisions in the two abandoned Western shops – Imbecks and Kierulffs. It had previously been decided to leave them to their fate, rather than to risk death through sniper fire.

On the way there, one of the coolies was, indeed, killed and young Fargo had to force the other to stay with him and load. He then whizzed back, getting the second coolie wounded in the process, and deposited his booty among his stepmother's stores. As Polly Condit Smith, a potential beneficiary, recorded:

> The [food] committee were about to order him to unload his desirable cargo with them, to be used for the good of the public, but upon hearing that the boy had ridden into the very jaws of death to procure these supplies, and

had dared what no man in the compound had dared to do, they told him he could have the disposition of them, for his rash valour he had well earned the lot.[64]

Quite an adventure, yes, but you wonder what Harriet Squiers had to say to him when he arrived home; her friend Polly gives a clue when she remarks, 'This boy saw what he thought he ought to do, and he did it; but what a terrible price might have been paid for these stores!' We might, indeed, remind Polly of the price that had been paid by his dragooned helpers; and what about the Imbecks and the Krugers? Somehow, through late twentieth-century, judgemental lenses, the effervescent Polly becomes a little less admirable! But, in any case, Polly does not tell the whole story, for Mrs Bainbridge noted that day that 'The two foreign merchants gave over their stores to be used for all and as soon as things could be brought it was done.'

Polly had noted earlier that day their arrangements for cooking:

> Mr Conger's large family, increased by several guests from Chicago, had their meals cooked on [Dr Poole's unsatisfactory] stove at certain hours. Our family … is also very large, and accordingly we find it necessary to have meals at other hours; then, again, the Second Secretary, Mr Bainbridge, arranges his *chow* at times during the day when it may be possible to cook something; and still again, Dr Coltman, with his wife and six children, who have a room in this bungalow, have a definite time for their mess.[65]

Throughout all these little domesticities, there was gunfire in the background. Deaconess Jessie Ransome noted, 'Firing began again just after 6am, and continued off and on all the morning; the afternoon was almost quiet, but at 4pm it began again very sharply from all sides as it seemed'.[66] And there were several ironies connected with the firing; Jessie Ransome begins to explain them:

> There seems to be a division among the Chinese soldiers – Prince Ch'ing's are apparently friendly on our east, while [General] Tung Fu Hsiang is attacking us furiously from the west. He has a cannon up on the wall, and fired on us for some time … but without effect.[67]

Apparently Prince Ch'ing's soldiers were firing at Boxers, but there was a further irony of which Jessie shows no awareness in her diary: while the previous day it had only been rifle fire aimed at the legations, now cannon fire had been introduced and Claude MacDonald spells out the make of cannon – Krupp. These field guns were undoubtedly purchased as a result of Li Hung-chang's visit to Germany in 1890 when Baron von Ketteler had escorted him round the armaments factories. Indeed, Cecile Payen was later to note, 'The guns that have been taken from the Chinese are of the same date and make as those our own German marines are using.'[68]

At 6 o'clock that evening, the firing of rifles and cannon was much heavier, and smoke and flames could be seen to the north. Mrs Houston would have been able to watch her husband's responsibility – the Imperial Bank of China – burn, Mrs Wyon the Imperial Mint that her husband had been hired to set up, and Mme von Rosthorn her husband's legation next door to the Bank, and with it her home and creation, Rose Villa.

8
Nurse Saville and Nurse Martin Serve (21 June)

The Lady Doctors Lay Aside Professional Etiquette

'Arrangements are now getting perfected', wrote Sara Goodrich on Thursday 21 June. She was not being unduly optimistic, just satisfied by practicality though with a trademark waspish tailpiece, as she explains:

> Men are being appointed on committees. Refugees are tearing down buildings. There are no fortifications here, and the English do not hustle like Americans. A general committee has been appointed, a sanitary committee, a committee on food suply, on water, on stores and on fortification. Aprons are provided for nurses in the hospitals and lady physicians. It is a terrible strain on our men, especially a few.[1]

It would be easy to make an issue of 'men ... being appointed on committees' but it was one of those inevitable aspects of society that had not begun to be reformed; indeed, even forty years later, after women had made great strides following their contributions in World War I, the similar committees set up in the internment camp at Stanley, Hong Kong, in 1942 had a determinedly all-male membership. Women made their contribution, on both occasions, outside the general committee structure.

Sara Goodrich talks about 'nurses and lady physicians', but it was not quite as straightforward as that. Deaconess Jessie Ransome, who kept a diary of the Siege Hospital, tells us how it was set up on Thursday afternoon – there was already Herr Cordes to be looked after and a wounded Russian – but the women were not appointed there as physicians. Jessie explains that, as Miss Lambert was the only 'fully trained and certified nurse ... she was immediately put in charge as matron, and some lady doctors of other Missions generously laid aside professional etiquette and worked under her as nurses'.[2]

Dr Emma Martin was to record, 'All the Med[ical] Mis[sionary] girls have volunteered for nursing.'[3] And she was obviously not averse to doing so, whatever criticisms she later started to level at how the hospital was run. And Dr Lillie Saville noted, in an article written later for medical professionals, 'The women doctors were asked to act as nurses, which we gladly did.'[4] And everyone who bothers to mention the work of the women in the siege hospital praises them for this unselfish devotion to duty.

In spite of their amenability, I could not initially stop my own hackles rising on their behalf. But Dr Saville explains a non-gender-specific practicality involved: 'To most of us, the experience of shot and shell wounds was new, and we had much to learn.'[5] Thus it made sense for Dr Wordsworth Poole of the British Legation, and Dr Carl Velde of the German, both doctors with military experience, to be in charge.

Dr Martin tells us how Drs Anna Gloss and Lillie Saville 'are to work during the day time for neither of them are very strong and I was so well and strong

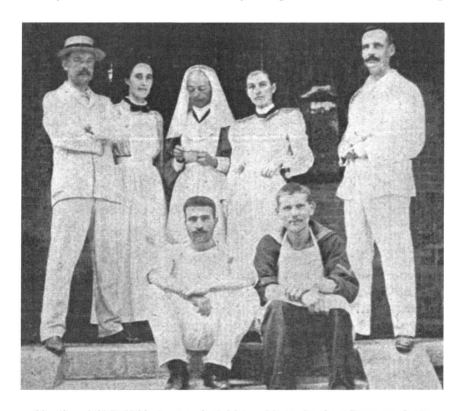

22 (from left) Dr Velde (in straw hat), Matron Marian Lambert, Deaconess Jessie Ransome, Dr Lillie Saville, Dr Poole, (sitting, right) Fuller (from *Black and White*, 20 October 1900)

that they put me on as night nurse with Dr [Eliza] Leonard'.[6] Lillie Saville, who does not of course mention her vulnerability, tells us how she and Dr Gloss divided the day between them and 'were fortunate in getting a good deal of the surgical work, dressings, operations, anaesthetics. ... the character of the wounds was not that of open warfare, for the fighting was all behind barricades. Consequently the proportion of head injuries was large.'[7] Dr Martin supports her contention by describing one of her first patients in her guise as nurse:

> A Russian was brought in shot [through] the chest. We put him on the operating table and took the bullet out of his back and just as we had him fixed up we saw six of the US Marines carrying one of our boys shot through the head. He was vomiting and a little stream of blood trickled along the path and onto the veranda. They put him on the table but he died that very minute and we could not help it. Oh the horrors of war. I felt like crying but there was no time or place for we found the Russian was having a hemorrhage so we brought him back and took the dressing off and packed the wound – he breathed in and out through the wound, making a most distressing noise – and put him back to bed.[8]

Dr Saville describes the general logistics and practical details of the hospital:

> [It] first occupied two rooms in the Chancery bungalow, but gradually, as the number of wounded grew, we had to take over more rooms, till finally we had an operating room with two tables, five wards, three beds for five patients in the hall, and a convalescent ward for officers and civilians in Lady Macdonald's house, and another for the marines elsewhere. Three American ladies superintended the kitchen and stores; these were beyond praise ...
>
> Owing to the difficulties of 'diverse tongues' the men were 'warded', wherever possible, by nationality; at any rate no man was in a room where he could not talk to some one. Italians and French were together, with a French sister in charge; Russians in another room, where they were most tenderly cared for by Madame de Giers herself – the Minister's wife – with them Germans were often put, one room was always full of the bright inter-esting little Japs. English and Americans naturally went together. There was one ward for officers and civilian volunteers, and here we nursed British, American, German, French, Italian, Austrian, Dutch, Australian and Russian. It was wonderful how our stores and supplies came in; beds and bedding, shirts and all that was necesary. They represented very much self-denial on the part of others and exhibited many expedients. The under pillows were made of straw from the packing of wine bottles, eiderdown quilts were cut up for soft pillows, a long piece of Chefoo silk, found in the Mongol market, made shirts, as did best damask linen and bright yellow cotton. 'Imperial' shirts these were called. There were very few bedsteads; mattresses were placed

on the floor, but every man did have a mattress from somewhere, also sheets and pillows.[9]

Jessie Ransome who, though not qualified, was experienced and an integral part of the nursing establishment, elaborates on the difficulties of securing linen:

> Sheets, etc, were a more serious difficulty, as the supply required was so large – frequent changes being absolutely necessary. Fortunately, more than one of the stores within the lines of defence, whose contents had been commandeered at the outset, produced large bales of calico, which was cut up and made into sheets, shirts, pillow-cases and aprons, as they were wanted, by Mrs Conger, the American Minister's wife, and the ladies in her house. But before these could be got ready many people gave us such linen as they could spare to go on with.[10]

Even Polly Condit Smith was impressed by the contribution to the hospital of Mme de Giers:

> The wife of the Russian Minister, ... a handsome woman with a great charm of manner, has been a veritable angel of mercy in the hospital. She has personally nursed most of the Russian patients, for while all Russians of education speak either French or German, and the hospital nurses understand their wants, to the poor sailors who can express themselves only in their own language, her nursing is a Godsend, and she is on duty with her suffering compatriots an incredible number of hours out of twenty four. A graduate trained nurse, working to make a record, could do no more than she is doing, and her physical strength, patience, and gentleness are a joy to witness.[11]

Mme de Giers' commitment was particularly important as lack of language could sometimes be a very real barrier. Dr Eliza Leonard (Presbyterian Mission) who worked in tandem at night with Dr Emma Martin, tells of an incident in the third person that should perhaps be told in the first:

> One of the first nights on duty, a nurse had charge of German and Russian patients in one room, in another of a German and an Italian. The latter were mortally wounded men, and really needed constant attention to keep them quiet and supply their demand for water. Great strong, brave men, with magnificent physiques, wounded to death! An Italian orderly was left on duty with his Italian brother, but a reclining steamer chair proved too tempting to the over-weary man, and in spite of his best efforts, sleep would descend upon him. The nurse's knowledge of Italian was nil till she caught the term for water, and her once slight knowledge of German had been largely lost in the acquisition of Chinese. The enemy kept up a very heavy firing that night, and it was with great difficulty that the two rooms could be cared for, as a call could scarcely be heard from one to the other. Shortly

after midnight, a sudden change came over the Italian, and the orderly was quickly roused, in the hope that he might take a last message and speak a word in a familiar tongue. Like a shot he was out of the room and the nurse was alone with two fast dying men, and unable to speak intelligibly with either. Just as the Italian passed away the orderly arrived breathless, with an Italian priest and a friend whom he had hastened to call when he saw the end so near. A short service was held, and at the close the friend looked up at the nurse and asked 'Finish?' and was answered, 'Yes, finish,' and the dead was borne from the room to be wrapped in the flag of his country for burial. Before the morning dawned the brave German lay wrapped in the German flag beside his Italian brother.[12]

The three American women in charge of the kitchen hospital were led by Abbie Chapin (Methodist from T'ung-chou) and everyone was full of praise for her; Lillie Saville describes her talents:

> Of course the hospital had the first claim to commissariat stores, but nowhere else was there such fragrant pony soup, such really eatable mule stew; and I think the officers and men often thought it was worth while to be slightly wounded to get a few days good feeding.[13]

Abbie Chapin was assisted by Miss Gowans of the (American Presbyterian) Christian and Missionary Alliance and her Methodist colleague Nellie Russell. Jessie Ransome adds another dietary element:

> Eggs were a great treat, and I am afraid were sometimes obtained by not entirely lawful methods. There were very few laying hens in the Legation, but of these a few belonged to some people inhabiting one of the houses near the hospital. One of our convalescents used to keep a sharp eye on these, watch where they went to lay, and as soon as the triumphant chuckle announcing an egg was heard, would dart off on his crutches to secure the prize and bring it in to be cooked for some sick comrade. For the most part, however, people were most generous in sending to the hospital the eggs they could ill spare themselves.[14]

I suspect that the chicken belonged to the Russians. A colleague (Miss Douw) of the two Presbyterian women working in the hospital (Miss Gowans and Miss Newton) noted in her siege account that the Russians, whose house was near that of both those women and the hospital, had their carts and mules in the open space in front and 'their chickens roosting in the trees, or on the top of carts, till all were eaten'.[15] Jessie ends her description of the virtues of the hospital's dietary department with another bouquet to the elderly Chinese cook who ungrudgingly 'did most of the actual kitchen work'.[16]

Medical supplies started well enough, but tailed off alarmingly, as Lillie Saville implies:

Those of us who had had to leave our homes at an hour's notice had of course very few drugs, and no dressings. The British Legation was poorly stocked, as Dr Poole had only just come out; fortunately Dr Velde had a large supply, all of the German army type – iodoform gauze tied up in little packets, very compressed, to be cut into strips, white muslin gauze squares, about 5 x 5, folded and compressed into another very small package. He also had a steriliser, which had to be used later when muslin curtains took the place of the white gauze, and bags of peat or saw dust that of wool. Instruments were always sterilized for operation.[17]

One of the most touching contributions to supplies is described by Jessie Ransome:

A great nightmare for some of us was the fear of breaking a clinical ther-mometer, with the knowledge always in our minds that it was impossible to replace it; and when a patient bit one or dropped it out of his mouth, we really felt inclined to shake him. We were reduced to two or three borrowed ones for some time before the relief, and at last only a single one survived, a very handsome one lent by the wife of the late German Minister. Fortunately for us, it registered in one minute, otherwise our whole time would have been occupied in taking temperatures.[18]

Apart from the professional women – the American doctors, Dr Saville, matron Lambert, nurse Ransome, the French nun and, one has to add, Mme de Giers, and Abbie Chapin's team – many women offered to help in whatever way they could. Regulars included Mrs Bailie, wife of the Professor of English at the university who, as Lillie Saville explained, 'has for some months been giving her services to the London Mission hospital';[19] Mrs Woodward (guest of Mrs Conger), Miss Sheffield (Methodist American Board), Mrs Houston (wife of the manager of the Imperial Bank of China), Ethel Shilston (LMS), Lucy Ker, Polly Condit Smith and Mrs Squiers. Every day, the sisters-in-law Annie Myers and Daisy Brazier, whom Morrison had a little earlier described as 'gushing' and 'giddy', filtered the water for the hospital with a hand pump filter. Dr Poole is said to have found Mme Pichon 'a great nuisance in the hospital'.[20]

Being a volunteer was not emotionally easy; Polly Condit Smith seems to be describing the wounded Russian who was one of Dr Martin's first patients when she writes of the helplessness of seeing death hovering before her untrained eyes:

I was at the hospital with Mrs Squiers this morning. Several men were brought in, and they all had to wait their turn to be operated on, and the two nurses were so busy assisting with the work in connection with the operation of the moment that nothing was done for a wounded Cossack who was laid on the floor. He was covered with blood, and it trickled down his chest and

formed into a pool all around him, his face an olive-green – the colour one sees in unskilfully painted pictures of death – so livid, I never believed even dying people could look that way. He lay there for some time, everyone in authority too busy except to tell me to do what I could for him, and keep the flies from bothering him until he should die, probably in twenty minutes. He was shot through the lungs.[21]

An even more vivid account from an untrained volunteer comes from Paula von Rosthorn, not only because she seems to be describing the same Russian at an even later stage but also for what it reveals of herself:

I often went to the hospital to see if I could help there. ... on one morning when I offered my services again, Dr Poole asked me to keep the flies off a wounded man and make sure that he didn't move. The poor devil, a Russian soldier, had had a shot through the lungs and seemed to suffer terribly. He was only half conscious and constantly tried to speak. But he could only whoop and after each attempt blood came out of his mouth. For half an hour, maybe, I stood by his bed, bent over him, fanned him to cool him, and tried to calm him. Then suddenly he threw himself violently on to his other side.

As a result, his dressing became dislodged, a big plaster that covered his whole back loosened and a stream of blood gushed from his wound, so that the whole bed was awash. I called the orderly and ran to look for a doctor. But as soon as I stepped outside, everything started to spin. I leaned against a tree, my knees buckled, and I fainted.

I had not slept at all during the night and when I went to the hospital, they brought in one wounded man after another. No one could tell me what was happening to those in the French Legation and I was so worried and physically agitated about Arthur that the most contradictory feelings ruled me. I even wished that he was slightly injured – for example, that he had received a flesh wound, because then he would come to the hospital and I could take care of him and he would be out of danger.

Then, again, I reproached myself for this and told myself that I should be grateful that nothing had happened to him up till now. And then, in addition, there came the sight of this poor dying man, my bent-over posture, and the warm smell of blood in the hot room, that was too much for my strength and my nerve gave way. But it was the first and last time. ...[22]

That episode is the only hint of a pregnancy. Cecile Payen also describes keeping the flies off the Russian. Thanks (chronologically) to Polly Condit Smith, Cecile Payen, Dr Emma Martin and Paula von Rosthorn, and probably Mme de Giers too, the man survived the siege. Lucy Ker describes taking over when Paula von Rosthorn fainted, holding a young German marine in her arms as he died.

I have been unable to find first-hand evidence to substantiate the following claim from an article in the *Detroit News* of 30 April 1973:

> As the casualties mounted and an improvised hospital in the Chancellery filled to overlowing, Maude [von Ketteler] found work to do that made her forget her own plight. She proved a tower of strength as a nurse and comforter of the wounded.
>
> The story of her efforts became such a legend that more than half a century later, when Hollywood made a film about the affair, the role of a fictional widowed baroness who became the Florence Nightingale of the siege was written into the script.[23]

Mrs Conger, known as the 'fairy godmother' in the hospital, sums up the women's general contribution to it:

> Our dining-room, sitting-room, reception room, and sleeping-room, all in one, is an active workshop through the day. Two sewing-machines are in constant use. Nothing was ready for the hospital, and as it is filling, increasing demands are made daily. With constant work, the supply has been sufficient. Lady physicians turn nurses; college teachers turn cooks; ladies turn servants for the sick and wounded. The true sister is not found wanting. Women serve in these capacities, as men must serve in other ways. There are sick children and adults to be cared for, and loving hands reach out to help them. The mounds in the open space to the south of us speak of heart-sorrows. The hour is most testing.[24]

A more personal summing-up is provided by Dr Emma Martin:

> I do love to do this hospital work, the poor fellows appreciate every little thing we do for them. They are so careful not to make us any more trouble than is necessary, sometimes doing without rather than ask us or waken their fellows. Yesterday Mrs Conger took me over to her house and we went thro a little trunk she had there to see if there was anything in it we could use for the hospital. She gave me a petticoat for myself and then so many nice towels and washrags and pillow cases. I was so pleased I just put my blue cotton apron over my face and cried then and there. Note: The only time I indulged during the siege and that was most ridiculous. Then she gave us many yards of toweling and table linen which we used for sheets and she and others made suits for the patients out of everything from silks to gay-colored cretonne. Mrs Conger asked me how long I had been in China and I said six weeks and that we had tried to get away the day Mrs Woodward [Mrs Conger's guest] did and she exclaimed 'What a good thing it was you did not get away.' She was thinking of the poor fellows in the hospital. That was a new way of looking at it – for I had only thot what a pity and after that I was glad I was there.[25]

Mrs Bainbridge Makes a Stand

The hospital was not the only place where women made themselves invaluable. However scathing newcomers to the British Legation were about the lack of advance fortification, once Claude MacDonald had asked Mary Gamewell's husband, Frank, to continue the good work he had started at the Methodist Mission, progress was swift, much praised and effective. One of the greatest and most immediate needs was sandbags. Mary Gamewell describes some of their functions:

> Bags were an important feature of the fortifications. Bags filled with earth were built into walls around exposed sentinel posts. Bags supplemented the height of walls. Bags filled the arches of the hospital veranda and protected other building. Bags protected men while they built walls important to the defense of the Legation. Bags were thrown into any breaches that were made in the defenses. Bags were in constant demand throughout all the days of the siege, and there were no days when someone was not making bags.[26]

Bessie Ewing's account is the best introduction to what immediately became a feminine industry and the practical quid pro quos that could result – she needed to look ahead to her later pregnancy, who knew how long the siege would last?

> We have two machines in the chapel that are buzzing away most of the time. At Mrs Conger's and other houses they are equally busy. The material that has gone into these sandbags would make a fortune. Most elegant silks and satins, beautiful figured goods, legation curtains and damask, fine bed spreads, woolen blankets of the soldiers, whole pieces of foreign cloth and large quantities of cotton cloth have been among the variety. Some of us exchanged strong cloth, such as sheets, pillow cases and bed spreads for thin silks, embroideries, and dress goods. I put in two large sheets and received six yards and a half of very fine black cashmere. Mrs Mateer will give me skirt lining and I was given enough odd pieces of legation chair covers for a waist lining. I have hooks and eyes from the same source. A beautiful piece of light blue grass cloth came in about ten yards but very narrow, and I made another exchange for that. Now Marion can have a nice dress.[27]

Theodora Inglis adds another dimension:

> From the foreign shops we brought in bolts of dry goods to be used for sand-bags. We later found several cloth and tailor shops belonging to the Chinese. The owners had fled, and we promptly used this also for sand-bags; damask, silks, satins, brocades, bed linen, Mrs Conger's and Lady MacDonald's beautiful portieres, all were made into bags. It would have been saddening to cut up all these exquisite silks and linens, had we not so fully appreciated our danger. As it was, we cut and slashed the fine fabrics,

often with smiles and jocular remarks, exceedingly thankful that we had the material for the bags.[28]

There were three sewing machines – also taken from the abandoned tailors' shops – in the chapel. Two of them were hand-operated and needed many hands to take turns; but there was more to making a sandbag than just zipping along; Ada Haven makes the story come alive:

> When we had made the first lot of sand-bags according to the size given us by Mr Gamewell, and were working away on more, a soldier came along and said: 'I don't like to risk my life behind such little bags as that. You will have to make them bigger.' So we acted on his advice. After this next lot was made and dispatched, a marine came along with an aggrieved look, saying: 'Those bags are terribly big. It breaks our back to take them up to the roofs of the houses. And it breaks the bags, too.' What should we do? While in this dilemma, wishing we had not lost the original measurement and longing for Mr Gamewell, he appeared around the corner on his wheel ... When he heard our dilemma he took pen and paper, wrote a few words, pinned them up in the vestibule of the chapel, saying, 'No matter who tells you to make them different, make them just according to these measurements,' and then, with a polite 'good morning', he instantly vanished.
>
> ... Sometimes when the need was most urgent, division of labor was carried to a fine point. One lady would measure off the stuff, another would cut, another fold, another feed into the machine, which, of course, was run by another, while another would cut the thread between the bags and lay them in piles. And so we worked all day. We used good whole stuff on the machines, sending the old garments, army blankets, etc. over to the Chinese girls and women to be done by hand. We were obliged to save the good spool cotton for ourselves also, sending to them skein silk. The girls also twisted stout silk out of masses of silk waste. At first we feared the gaudy coloring of much of the stuff would attract the fire of the enemy. So we tried having the gay sand-bags dyed black in an inky mixture of coal dust and water. But this proved far too laborious and was soon given up. As to the number of sand-bags made, it was variously estimated at forty to fifty thousand.[29]

Cecile Payen suggests that 'We six women [in the Conger household], with the aid of two machines have made at least 1,500 bags in three days.'[30] By the 27th they had made 3000. What is more, Mrs Conger even sacrificed 'the rolls of silk the Empress Dowager had presented her the year before'.[31] She was not the only Minister's wife thus engaged: Ethel MacDonald says that she gave up some rolls of silk given to her by the King of Korea and Theodora Inglis tells how not only Mrs Conger but also Lady MacDonald worked at her machine 'all day long'.[32] What was more, 'Little Madame Pichon ... with her bright "Bonjour Madame," ran back and forth in an incredibly short space of time,

calling for more goods to sew. ... The French women sewed with Mme Pichon and worked well.'[33]

An article in the *Michigan History Magazine* of January–February 1997 suggests that 'along with other women, Maude [von Ketteler] sewed sandbags, using velvets and satins from her own wedding trousseau.'[34] The touching detail may have come from Maud's family but the only connection apparent from the memoirs of others is this from Sarah Conger of 9 July:

> We are making more sandbags, as many of the first we made are bursting. ... These sandbags suggest to me the people who are working here side by side; people of all callings working together in one common cause. Here in this awful peril rank is little recognized, and much less claimed. A lady of title, position and wealth and in deepest sorrow, looked most appealingly in my face today and said, 'No title, no position, no money, can help us here – these things mock us.' She is right; each one stands for the good he can do.[35]

Polly Condit Smith tells us how the women could benefit, apart from keeping themselves healthily occupied under fire:

> A man comes rushing into where we are working, and tells whoever is in charge of filling the sandbags that a hundred, or as many as possible, must be taken to such and such a barricade, or it *cannot hold out*. We get snatches of the real state of affairs very often in this way.[36]

But all was not complete sweetness and light among the sandbags, as non-missionary Mary Bainbridge's story of a few days later reveals:

> A certain lady who claims to be a Faith cure and a fanatic on religion came along when several of us were sitting outside the chapel busy as bees, and said, 'Now ladies, let us lay aside our work and go inside to have a few prayers, I think it will strengthen the courage of our boys on the wall.' Some of them put down their work, but Mrs Lowry, Mrs Killey and myself sat there. I did not know their thoughts, neither did they know mine. Mrs [Arthur] Smith looked at us, then said, 'Come, aren't you going in?' I finally said to her that I could pray and sew at the same time and I would not give much for a person who could not, and that while bullets were flying over our heads by the thousand, that sand bags would be of more use just now in saving the lives of our boys on the wall in their awful position than prayers. So we three sat and sewed while the rest held a prayer meeting. Shells were exploding all about us. Cannons booming and shots could be heard on all sides. It seemed to me that it was wicked to waste one minute in anything that was not to help save the lives of the 20 or 30 brave Marines who were holding the wall and driving back thousands of Chinese soldiers. We have been expecting a relief from Tientsin for many weeks, but so far have heard nothing, if they do not come soon it seems as if we must give up.[37]

Mr Bainbridge was in charge of burying the American dead in the Russian Legation's cemetery. And, from the sublime to the ridiculous, Mrs Goodrich (mother of three) noted, as she sat cramped in the chapel, 'Just outside, noisy sewing machines were busy all day long making sand-bags, and within, the five babies, tortured by heat rash, mosquitoes and the thousands of flies, cried almost constantly.'[38]

The Missionary Mess

Day-to-day living in the various quarters had to be organised too, each entity managed more or less separately. Among the more complicated was the chapel occupied by the American missionaries; there the production and eating of meals was a logistical feat. Sara Goodrich tell us that the inhabitants of the chapel were divided up, for purely practical and not ideological purposes, into thirty-six Congregationalists who ate at 6.30am, 11.30am and 4.30pm, sixteen Presbyterians who ate next, and twenty Methodists who ate last. 'This made nine meals a day!' she exclaimed, adding, 'The cooking of food is attended with peculiar difficulty, the kitchen being on the other side of the court – which, by the way, is kept guarded by a man with a spear in his hand, for fear we should lose even this place – and cooking dishes, and dishes for the table being especially noticed by their absence.'[39]

The women in the chapel did, as Bessie Ewing explains, have their own internal management committee:

> The housekeeping arrangements are to a large extent in the hands of our committee. This consists of three ladies, one from each mission. They make out the menu each day and give the orders to the [Chinese] cooks. ... Everything in the way of food material has to be carefully measured out and all left-overs kept for the next meal. ... Two of our ladies act as housekeepers each day, making the tea and coffee on oil stoves, cutting and spreading bread, preparing dishes of butter, sugar and milk and serving the rest when all is ready. We each take a plate, cup, knife and fork and spoon and sit down wherever we can find room. Two others assist the housekeepers in waiting, and they are kept busy I can assure you. The housekeepers are changed each day. There are eight Chinese servants belonging to our whole party. They wash the dishes (nine times each day), bring the food from the kitchen which is on the opposite side of the court, draw water and do the hard work of cleaning the chapel and court.
>
> We Congregationalists have charge of cleaning [the chapel] every third day and the Presbyterians and Methodists attend to the other days. We also have care of the bath rooms and the court round the chapel. There are so many more of us that of course it is fair for us to do more of the cleaning. Most of the carpet has been taken up and put in the loft, but the church

cushions will be used as table seats for the children and to fill up the depressions in the settees so that our beds will be even. These cushions must be beaten, all the settees and everyone's baggage moved, and the floor all swept and mopped each day. There is not much chance for quiet.[40]

Mary Gamewell also describes this mopping process:

Tables and benches and bedding and bundles had to be piled so that one section might be cleaned. Then onto that spot things must be piled against while the mopping proceeded to yet another square of our floor, and so on until the whole was properly gone over. On days when the firing was worst, and we had orders to keep under cover, the children also were piled upon the tables while the housecleaning went on. On one such occasion, a child exclaimed in discouraged tone: 'Oh dear, when we are inside we are in the way, and when we are outside we get shot.'[41]

Mary Gamewell recounts that although there were general food supplies in common, there were separately – sometimes with their own additional supplies – the 'Missionary Mess ... the Customs Mess, the Soldiers' Mess, Lady MacDonald's Mess and various other messes, each of which was known by some descriptive name'.[42]

Daisy Brazier Manages

The next largest entity to the Missionary Mess was probably Lady MacDonald's. She was used to holding large dinner parties and receptions in the Minister's house and, as one account tells us, she was an 'admirable housekeeper, and always manages her household and servants herself'.[43] Indeed, on 28 April, George Morrison confides in his diary a mean little story about her servant problems – though he partly blames it on 'parsimonious Miss Armstrong'. Now, Ethel had to cater for forty people eating three meals daily – some thirty-odd sitting down at table.[44]

According to the short, anonymous account written by Annie Myers, Lady MacDonald delegated some aspects of her responsibilities:

After the other Legations had moved into the British, Miss Brazier moved to the MacDonalds. She was at once made house-keeper and had to cater for 34 people! By no means an easy task in piping times of peace – imagine what it was in siege times when 'half rations' was the order of the day, with hungry men coming in from veritable hard labour.[45]

In Annie Myers's unpublished diary of 21 June, she added that Ada Tours, their room-mate, helped Daisy. Lady MacDonald has a recurring line in self-deprecation when she writes,

I gave over the housekeeping, as too difficult a problem for my poor brain, to a young lady who was living in the house and very well did she carry out her work. It was a thankless task, for she had to endure good-natured grumbles at table when our menu was limited to one pony rissole, and a choice between jam and butter.[46]

Not much chance there for twenty-nine-year-old Daisy Brazier to be giddy. Polly Condit Smith adds a later tailpiece that puts everything in perspective:

[Lady MacDonald] is very sensible, and has only one dish. Nobody thinks of dressing for dinner, except the Marquis Salvago, and I think it shows things are truly far gone when English people dine, but do not dress.[47]

Annie Chamot Rides Shotgun

But perhaps the greatest hive of activity and contribution to the nutritional well-being of the besieged was the joint enterprise of Auguste and Annie Chamot in the Peking Hotel – known as the Swiss Legation – next door to the French Legation. Captain Darcy's account describes how in less than twenty-four hours Auguste succeeded in getting together enough mules, horses and wheat to feed 1200 Europeans and 3000 Christian Chinese for two months. 'He discovered millstones and transformed four rooms of the Peking Hotel into mills ... He was miller, baker, cook, builder of barricades, navvy, leader of coolies etc., all off his own bat, no one hesistated to go to him when they needed something.[48] Lieutenant Theodor Winterhalder, of the Austrian detachment, added to this panegyric of Auguste that Annie, a woman of 'extraordinary daring and energy ... was always by the side of her husband'.[49] She also did 'a thousand little jobs that no one knew about'.[50]

Polly Condit Smith gives a useful broad-brush picture of the Chamot activities:

There have naturally been numbers of people without stores of any kind, and people who, if they had stores, would have no place to cook them; so Chamot stepped forward and undertook to feed daily I don't know how many people. When we were first assembled in the British compound the confusion was something terrific, and he gave food to all those who had nothing, and later he made a permanent business arrangement to provide food for those who had no means of messing themselves. Among these are many Roman Catholic priests and twenty-five Roman Catholic Sisters, saved by himself and his wife from the Nan-t'ang just before it was burned, besides numerous families and detached individuals having no stores, who would have had a more serious time without his assistance.

These Sisters were fed by Mrs Squiers for many days before Chamot volunteered their care. Of course, the variety that he supplies is not wonderful,

but he gives them horse-meat, rice, occasionally some tinned vegetables, and a kind of coarse brown bread, made from an inferior flour, which he bakes himself. For so many people it is quite marvellous how he feeds them so regularly. He has a few coolies to help him at his hotel ... and there he personally superintends the cooking of two messes, one at twelve and one at six o'clock, and brings it up in a Chinese cart to the British compound, always at the risk of his own life from snipers.[51]

The fact that Polly does not mention Annie in regard to the provision and distribution of food may be lack of knowledge; but Polly knows more than most of what everyone is up to because of her access through the Squiers to George Morrison as a source of facts and gossip. There may have been some resistance among women to acknowledge the larger-than-life American woman; it may simply have been that, for women, the reckless adventurer image of her husband obscured her. Perhaps it had something to do with her being in trade. It is, however, thanks to the American missionary Matilda Douw that we have an account of the more dangerous part of the Chamot feeding enterprise which leaves little doubt about Annie's part in all aspects:

The bringing of grain and supplies from the foreign and Chinese stores is a most necessary work (albeit a dangerous one), and here we may note the constant passing of Mr Chamot's cart, protected by his American wife, gun in hand, taking bread and other provisions to those whom they fed. We may know this cart by the Belgian flag covering one side of it.[52]

Professor W.A.P. Martin noted that often as the Chamot bread cart crossed the bridge it was fired on and once the 'flag was shot away'.[53] Theodora Inglis supplies the climax to this story and gives an interesting insight to Annie when she relates:

Mrs Chamot would not allow her picture to be taken but I wish that we could have had one of them both one day as they drove into our camp. They sat in their Chinese cart and Mr Chamot held in his hand part of his rifle, shattered and broken by a shell that had struck it where it extended beyond the cart. It was the only time anyone ever saw Mr Chamot turn pale.[54]

But Annie's real fan was Dr Robert Coltman who made sure in his book that her part in the siege was not subsumed under that of her husband; he noted:

After some shells had burst into the baking room, and killed one and severely wounded another of the Chinese bakers, Mrs Chamot, rifle in hand, held the coolies to their work while her husband served with the guards.[55]

Daisy's Brother Manages the Laundry

Getting fed, being protected from bullets, shells and cannon balls, and treated when you were wounded or sick, were the three primary concerns of the

besieged, but there were a host of other more minor practicalities to be dealt with. Annie Myers tells how her brother-in-law, Russell Brazier, had his position as Chief Secretary of the Inspectorate of the Imperial Maritime Customs cut down to size by trying to solve a problem for all households:

> Afterwards the Chinese Christian refugees were turned on to the laundry work, Mr Brazier being manager. It was very funny; you made up your bundle, pinned your name and the number of articles on it, shouldered it – for if anything had to be carried you had of course to do it yourself – and walked down to the laundry, which was one of the Macdonalds' outhouses in the back quarter. There Mr Brazier was seated on a board placed on two inverted buckets, with a child's copybook in which he entered your name, told you the number you were on his list, and handed your bundle over to the head washerman. The next day or day after, you marched down again and received back your own, clean certainly – starched only towards the end when some had been discovered somewhere. Mr Brazier was 'at home' every afternoon there, where he held his Court, having to decide disputes between the washermen and Russians, Belgians, Germans, Swedes, French, and other unintelligible creatures who invariably spoke nothing but their own languages. ... However, they were always satisfied with him, and invariably went away grinning.[56]

It is not certain, in spite of what Annie says, how grateful the women were for this service. Sara Goodrich, who vies with Jessie Ransome for being judgemental, remarks, 'To speak quite frankly, the laundry work was not very good, but little attempt at ironing being made, as the force was insufficient and unskilled.'[57] Bessie Ewing added: 'Some of the Chinese college students are detailed for laundry work, but they are green hands. I am thankful to get my clothes through soap and water, although I cannot be sure they will be much cleaner when they come back than when they are sent. There is only starch enough for collars, and nothing else seems to be ironed.'[58]

Dr Edna Terry seemed to think that Russell Brazier made a difference:

> It was difficult to get washing done till one enterprising gentleman started a laundry. Lady MacDonald gave the use of her laundry for the general good. Still, persons with very limited wardrobes did not like to trust their scanty supply of clothing to the enterprise till an English gentleman was put in charge. Then order began to reign.[59]

Some women had more important things to worry about, as Polly Condit Smith suggests:

> Mrs Coltman, the mother of six lovely children, was speaking of the impossibilities of clean linen or having any washing done. 'But after all,' she said, 'what does it matter? If the troops come within ten days, my children can

wear what they are wearing; if Peking is not relieved within that time, we will all be dead.' She was not melodramatic, but spoke very quietly.[60]

Coping with six children under those conditions would rather have influenced your perspective. Looking after even one child during the siege was obviously a full-time job; it was not just their physical well-being: there were seventy-nine foreign children and they had to be kept out of mischief, as much when they were confined indoors because of bullets and shelling as when they were allowed outside. Playing Boxers was one of their favourite games, but there were times when mothers were at their wits' end and then it was noted that Polly Condit Smith 'rallied and entertained the children as her special job throughout the siege'.[61]

Polly herself wrote of the children's Boxer games that

> Their Chinese war-whoops of *sha sha*! (kill, kill!) is a creditable imitation of the real thing. It is very clever, and they are all very full of life. I help them to play, for it's a good thing that they don't realize what all this may mean, and we hope that relief will come before they lose their spirit and before they know.[62]

Dorothea Goodrich needed less entertaining for she had her dog Dinger. 'He slept at our feet on the floor all summer', she wrote. 'They said at the Legation if any dog was loose they would shoot it. I was so scared for fear Dinger would be shot. I was afraid, too, that some day there would not be even a scrap of food for Dinger ...'[63]

Many men put their lives at risk to protect the women and children; several others went out of their way to make life easier for the women in less important practical ways. On the first day, when all the women who were not already in the British Legation were moving in, the student interpreter Lancelot Giles wrote that

> All morning I was slaving away in the Braziers' house, bringing over all their food and drink and articles of value. It pleases Mrs Brazier to show much gratitude and all that; but it really was not much for me to do. In fact when the ultimatum was up, we had got everything fairly trim. All the windows had been sandbagged with loopholes for firing; a strong barricade had been built round our front gate. ...[64]

As the days passed, Ada Haven tells of another attempt, this time by a nameless 'knight':

> One of the gentlemen who had heard some of the ladies sighing for rain water to wash the smoke and cinders from their hair, took untold pains to have a great stone water jar brought over from a deserted Chinese house and then, to secure its being filled with rain water, had personally superintended it during a shower with the immediate effect of being wet to the skin himself,

but the permanent result was a great jar of nice rain water, labeled, that it might be respected by others, 'for the ladies in the chapel.'[65]

Elwood Tewkesbury, co-chairman of the general committee or, as it was also called, the Committee on Public Comfort, was equally ingenious, as Mary Gamewell describes:

> To keep out the bullets the chapel windows were partially filled with so-called sandbags. ... These bags also kept out much-needed air. One day the versatile chairman ... appeared with long screens, which he had taken from the British Legation theater. These he proceeded to suspend across the chapel, so as to swing free above our heads. Then he connected them by means of a rope and left a long end, by pulling on which we could set the whole five screens in motion. This arrangement was our 'punka'. A door in each end of the chapel open and the punka in motion we obtained a change of air.[66]

Many of these arrangements began to be implemented that first Thursday of the siege; in spite of the almost constant firing, in spite of the still lively optimism that the relief forces were about to arrive, the urges to organise, to regularise, to create a home, and to succour were irresistible. Which is just as well, for there was still much to face.

9
Frau von Rosthorn at the Barricades (22–29 June)

Paula von Rosthorn Starts to Fume

The Austrians blotted their copybook again first thing on Friday 22 June. Somehow, Captain von Thomann, who had taken command because of his seniority even though he was only a visitor to Peking, got wind – falsely as it turned out – that the American marines had been forced to evacuate their crucial legation. He gave the order for other marine detachments – the Japanese, French, Italian and German – to retire to the British Legation, implicitly for a last stand. Seeing what was happening, the Russian and American marines joined the stampede.

Their arrival caused both chaos and fury. An emergency meeting of Ministers was held at which the marines were ordered, each by their own Minister (including Dr von Rosthorn), to return immediately to their posts, von Thomann was unceremoniously dismissed, and Sir Claude MacDonald, a former army officer, was asked to take overall command. Fortunately, the Chinese had not realised what had happened, and nearly all the abandoned ground was retrieved except for the Italian Legation which was lost and, indeed, set on fire, forcing the Marchese Salvago Raggi to retreat into the British Legation (joining his family there), unable to save anything that had not already been evacuated. And, thereafter, the French Legation became more exposed. The Italian detachment was ordered to help the Japanese return to the Fu – where all the converts had apparently been left to their fate – and to stay with them there.

Paula von Rosthorn was to express some firm views in 1901 on this change in command:

The day after the unfortunate retreat by Thomann, Sir Claude sent a circular in which he explained that he had taken over command according to the wishes of his colleagues. This circular was signed [only] by Salvago [Italy], Giers [Russia] and Pichon [France]. Thomann, Darcy and [Captain] Graf von

Soden [Germany] did not recognise Sir Claude as their superior at all and from that there resulted a peculiar situation in which Sir Claude always gave orders which were simply ignored. Sir Claude wanted to lead the whole defence and was not informed about the situation at the various points of defence outside his own Legation because he himself never came over and did not even let his adjutant [Captain Strouts] give him reports. Therefore his orders were never in harmony with the needs of the moment.[1]

Arthur von Rosthorn himself, while approving what his wife wrote by adding a preface to it, simply notes in his own account that, while von Thomann had been elected by his peers, Sir Claude, 'who had given shelter to the ... Ministers had his guests give him command'.[2] George Morrison later wrote in *The Times*, 'Sir Claude MacDonald, at the urgent insistence of the French and Russian Ministers, subsequently confirmed by all their colleagues, assumed the chief command.'[3]

Putnam Weale, the maverick Customs man who was writing for his own amusement, 'relished' the scene as he saw it:

It was the British Minister who remained the most calm; perhaps he immediately understood that the game was now in his hands. But the other Ministers, I wish you could have seen them! They crowded round his British Excellency in an adoring trembling ring, and without subterfuge offered him the supreme command; that was exactly what we had been expecting.[4]

MacDonald, for his part, writes,

I was asked [by five Ministers and two Secretaries (Austria and Germany)], as having held combatant rank in the British army, to take general command of defence. This I at once consented to do ... I was throughout supported by the greatest loyalty and willingness by my colleagues and also by the commanders of the various detachments. ... On the other hand, such diplomatic training as I possessed was constantly brought into play in smoothing down the friction which took place between various nationalities, especially in the matter of supplying reinforcements to each other.[5]

Leaving aside the political overtones of Paula's judgement, it is worth noting that any orders issuing from the now centralised command under MacDonald were to be given through the Minister concerned to the marine detachment at his legation (from which he was, in all cases, absent – though Arthur von Rosthorn himself was with his marines at the French Legation). The unfortunate division which Paula von Rosthorn accurately describes was to undermine working and social relations among the besieged, to create separate camps, one inside the British Legation, the other centred on the French Legation (without its diplomatic staff). But ultimately, by chance rather than design, the different

strategies were not to work to the disadvantage of the besieged; indeed, I would like to suggest that the 'creative tension' was quite healthy.

Mrs Cockburn's Home is Ransacked

On that second day of the siege, however, there were plenty of other distractions – among them the organisational arrangements outlined in the last chapter. Then that afternoon the fire alarm was sounded in the British Legation. For some, it was just the first of a string of frightening attempts to attack the besieged by fire; Dr Emma Martin describes how

> Some Chinese started a great fire with kerosene just over the wall by one of the houses and angry flames went over so high the general alarm was rung and everone turned out to fight fire. English, Americans, Germans, Russians, Chinese and Japs. Methodists, Presbyterians, Greek and Roman Catholics and everyone turned out forming in double line to pass water: for which every kind of vessel was used from a chamber to a bath tub, all working for our lives. The men tearing down outbuildings and spreading wet blankets and quilts on the roof to keep it from catching fire. Women cheerfully sacrificed their last blanket to the awful fire god and we used the precious water not knowing how much there was in the well. ... While the excitement was running high an old Chinese nurse who was watching it jumped up and down crying out, 'Cut off their legs. Cut off their legs'. After they had the fire out of danger they went outside and burned still farther some of the buildings that were too close to us where snipers had been hiding.[6]

It seems likely, from what we know of her, that the 'old Chinese nurse' was little Elizabeth Inglis' Wang Nai Nai; but Theodora herself describes that fire and those that followed more generally and particularly conveys her anxiety for her husband with his 'blistered hands and almost total exhaustion'.[7] For Ada Tours, too, these fires were always to be a time of worrry: her husband B.G. was head of the fire committee and early on sprained his ankle; on 7 July, having volunteered to demolish a Chinese barricade by throwing sulphuric acid at it, he slipped and fell eighteen feet, covering his face and head with acid but emerging relatively unscathed.[8] It is not surprising, therefore, that Ada sometimes insisted on going on his rounds with him.

For some, particularly Elizabeth Cockburn, that fire and its results were of rather more personal concern. Deaconess Jessie Ransome, you may remember, had been occupying, with her sister Edith and Matron Lambert, the Cockburns' dining room, so she is best equipped to tell a more involved version of the story:

> The afternoon was pretty quiet till about 4.30 [then] there was an alarm of fire, and it was found that a Chinese house had been set on fire just outside the Legation, close to Mr Cockburn's house ... As the storeroom was at the

23 Ada and B.G. Tours (courtesy of Susan Ballance)

corner, we were told to clear out all our stores. Houses and walls were pulled down and water brought, and after an hour or two the fire was more or less under control, and the danger of its spreading in this direction seemed over. Meanwhile, however, great destruction had been wrought on this house by parties of would-be friends, who tore in, and in their panic simply cleared the house of everything, recklessly tearing down pictures and hangings and carrying all bodily out into the compound, while another army began to tear down the kitchen quarters. It was hopeless confusion. We were hours

getting things back and much was broken and lost. At last, about 8.30, we sat down to a dinner of ham and some bread, begged from various friends, and enjoyed it most thoroughly.[9]

I assume she means her little group sharing the dining room; it can hardly have been an enjoyable evening for Mrs Cockburn, though I notice Jessie sees it as her husband's house and does not stop to examine what must have been Elizabeth Cockburn's distress at having her home trashed. What only Lucy Ker mentions, by implication in a later unpublished letter, is that Elizabeth Cockburn was several months pregnant.[10]

It is noticeable, too, that young Nigel Oliphant writes in his diary, very much in passing and with surprise, 'Even the women turned out to pass buckets.'[11] But B.G. Tours writes clearly in his recollections, 'Our Brigade consisted of any volunteer of either sex who happened to be off military duty when a fire occurred.'[12]

Not only was Elizabeth Cockburn's house now a mess – leaving aside the many guests sheltering in every nook and cranny – but where once her garden had been was fast becoming a pit from which sandbags were filled.

Annie Myers Clears the Stables

No one slept much on the night of the 22nd; 'firing has been going on nearly the whole night,' Jessie Ransome wrote, 'and early this morning it has been very sharp, the bullets singing past this window.'[13]

Saturday 23 June was to be similar to the day before. Sara Goodrich, in a polished version of her account, more elaborate than her diary, describes events most effectively; I have cut her account somewhat, particularly the mystical overlay:

> Near noon, the bell in the bell tower again rang out an alarm of fire, which proved to be the burning of the famous Han Lin Library, directly north of us, some of the large halls being close to Sir Claude MacDonald's establishment.
>
> Nothing so proved to us the dire madness of the Chinese as this willingness to sacrifice, for the sake of destoying the foreigners, this library containing copies of all China's most modern and ancient classics, and the annals of their national life.
>
> With what blank dismay everyone turned his face toward those raging fires! The wind was high, blowing the flames right toward us, while Chinese soldiers in the third row of buildings were keeping up a steady rifle fire, hoping thus to prevent our putting out the fire.
>
> No time during the siege do I remember seeing our men carry such white, hopeless faces as during the hours of that fire. They would not talk, they would not look us in the eye, but their jaws were all set with that dogged

determination to fight – fight to the last. It seemed so hopeless as they passed up buckets of water or tore down buildings, for the flames gained upon them in spite of every effort.

Because of the rifle fire we ladies were not allowed to help pass back to the well (for refilling) the empty buckets, bath tubs, pitchers, basins etc, as the day before. Whenever anyone came from the fire and we asked how matters were going, there was only a shake of the head, while with downcast eyes the man passed on. We women could do nothing ... The general work must go on – the children must be diverted, and the sand bags we had just begun to make must be sewed. ...[14]

Luckily, however, or as some claimed through prayer, the wind changed direction. But all was not over, as Sara Goodrich continued:

About 4 o'clock another fire broke out. The indefatigable Miss Smith, of the London Mission, seized my arm, saying: 'Come, many of our missionaries are engaged on the fortifications elsewhere, and cannot leave. Let us go to the fire. Perhaps we can act as interpreters between the Chinese Christians and those who would direct them, and thus help to put out the fire.' We passed back of the British Minister's servant quarters, through the breach in the wall, into the very court of the Han Lin. There a great tree, thought to be about one hundred and fifty years old, was on fire, a huge branch hanging over the only building save one not being devoured by flames. Within this building were several large stone tablets upon which were carved the famous saying of a sage, and countless stereotyped blocks. These blocks were of teak, every character being exquisitely carved, and represented what was now left of China's library.

One could see at a glance that if this hall caught fire nothing would save Sir Claude's buildings, so it was determined to cut down the tree, and at the same time throw these priceless blocks upon the flames in the adjoining court. We could only view them now as inflammable material to be gotten rid of. It was here we ladies found ourselves useful in directing the bringing of ropes to drag the tree in its fall from the building rather than toward it. ...[15]

In her anonymous article, Annie Myers describes some of the other jobs that women could usefully do to help the firefighting that day:

By that time ... the hose was playing on the nearest Legation roof. All of [us] had to help to clear the neighbouring places of inflammable stuffs and I don't know how we did it; but huge packing cases were taken out all the way round the Macdonalds' house and plumped on the lawn.

You see, all the men were busy, cutting away, and generally doing fire drill. All the windows and doors of the outhouses were taken off, and so we women folk who were not in the line for passing buckets had to clear the stables! Fortunately, the horses had been placed outside the Legation in the

Fu after the fire near the south stables, [so] there was no fear of a stampede. All this time there was sniping going on ...[16]

In her unpublished diary, Annie notes that they were more careful about causing 'needless destruction' than they had been at the Cockburns' house the previous day.

Whenever you picture the firefighting scene with its women helpers as brave, Putnam Weale is there to cut the picture down to size: 'To see Madame so-and-so, a Ministerial wife handling these delectable items [chamber pots], and forced to labour hard, was worth a good many privations.'[17] He may have been referring to Mme Pichon who was known to be in the firefighting line.[18] All well and subversive, but he never once mentions the women working tirelessly in all kinds of menial jobs, for example in the hospital. Once, when the detail for cleaning failed to appear, Minister's wife Mme de Giers 'seized the mop herself and more than made good his place.'[19] And Sara Goodrich wrote on 26 June, 'Cleaned up the yard. Also cleaned up a men's and a ladies toilet room.'[20]

Nurse Martin on Duty

That night, Dr Emma Martin was on duty for the first time as a nurse. Just getting to the hospital was not easy:

> Dr Leonard said there was no use for us to be up at the same time as there was so little to do and for me to sleep till 1.30 and then come over and be on duty till 8am and I agreed. I woke up about one and the bullets were just whistling around so I waited a little in hopes they would stop for it was dark and I was afraid even without bullets. I felt I must go – so reminding myself that I was a soldier's daughter, I plucked up my courage and started across the court in the dark with the bullets whistling overhead – thro another part of Sir Claude's house, thro another open place and then along the chapel where the missionaries were sleeping – passing the bell tower then alongside the tennis court till I reached the stable corner. I was hurrying as fast as I could and keeping as near the shelter of the stable as I turned the corner a bullet came so very near me and I was almost there so I started to run ... [21]

Dr Eliza Leonard passed on to her the patient details, including a German bleeding to death from a liver wound:

> I sat there on the floor, for his mattress was on the floor, and fanned him and gave him water; he tried so hard to make me understand something but I could not. I could see by the dim flicker of the candle light that the red circles under him was growing wider and I could not help it tho I tried to make the dressings tighter. His breath grew shorter and he breathed his last at the first gray streak of dawn. I called the steward and we fixed him up a little and

putting his blanket all over him so let him lay there till daylight as there was no place else where we could put him. He looked like a large overgrown boy with light hair and blue eyes – somebody's darling.[22]

Then the Russian was brought in, as described in the last chapter, and all that day, Sunday 24 June, the various women in the hospital looked after him and other patients and others outside got on with making hospital supplies and sandbags.

Ada Haven Looks After her Girls

While that work was going on, Ada Haven, in the world beyond the British Legation, was rushing round looking after her schoolgirls; 'Soon after breakfast,' she wrote, 'word came that the Boxers had broken into the Su Wang Fu where our Christians were, and that a place must be made for our girls elsewhere'.[23] The Fu was very much a prime target – General Tung Fu-hsiang holding a particular grudge against the converts.

They had been more or less safe in the Fu, give or take their abandonment, about which they may or may not have been aware, on the 22nd; one of them describes their experience:

> Can you picture a hundred and twenty girls in that hall, with its lofty ceilings and painted shrines? There we lay down on the straw at night, happy if we had a quilt for a cover. There our food was brought to us twice a day. There, day after day, night after night, we heard the blast of trumpets calling to an attack, then thousands of rifles would pour out their deadly fire, thousands of voices, cruel with hate, would cry, 'kill! kill! kill!' Our hall had windows only on the south side, the direction from which fewest bullets came, and the thick brick walls were a perfect protection. We learned to lie down quietly and sleep while the bullets were speeding through the air like sleet. But we knew that between us and a terrible death there was only that compound wall, perhaps fifteen feet high, and a few score of Japanese and Italian soldiers ...
>
> Often the cry, 'Fire! Fire!' would burst on our ears; then we would hear the rush of feet as men ran to the rescue. If we stepped out we would see flames bursting up a few rods to the north or east, where the Boxers had set fire to buildings just outside our wall, or to one of our own gateways. Then the suffocating smoke would envelop us, the exultant cries of the Boxers would greet us.
>
> In a few days there came another sound which I had never heard before. It was the boom, boom, of cannon, the swift rush of shell through the air, the dash of hundreds of pieces of shrapnel on the roof. Later they learned to aim lower, and the exploding shell dashed through our roof with deafening din, scattering down plaster over our heads.[24]

Ada Haven continues the day of the enforced move of the whole community of the Fu, though the girls were her first concern. When she rushed off, without her hat, to the meeting-point, they were not there, so she took time to reconnoitre the best premises in an alley between the British and Russian Legations:

> Hearing firing from the wall, it seemed safer on the side of the lane nearer the English Legation. So I went into place after place, examining each, and getting my eye incidentally on many ropes and shovels and awnings, which afterwards came in conveniently in countermining and for sand bags. ... There really did not seem to be any best place ... [the stores] had evidently been deserted in hot haste, for all the means of living, as well as the stock of the store, were left behind. But everything was tumbled around in wildest confusion, probably the work of looters. What seemed almost sadder ... was the evidence of the deserted home. ...
>
> Finally a hat store was picked out as having several rooms in the rear, and also as furnishing something in the way of food. ...

At last the refugees show up and she quickly distinguishes her flock: 'It was such a strange, sad meeting, after the days of separation, but there was no time then for more than the nod of greeting that meant, 'So you are still alive, thank God!', she writes, and continues:

> Up the lane, almost filled with the debris of broken boxes and furniture from the looted shops, they picked their way as quickly as possible, so as to get out of the way of the soldiers who were passing back and forth, for an attack was on just around the corner. The zipping bullets overhead, too, made one hasten one's steps to get behind walls. Once behind them, however, and the next thing was to think of the more peaceful means of preserving life – how to get breakfast. ...
>
> ... They were left with instructions not to wantonly destroy. Others found a place in the family rooms at the back, rooms strewed with cast-off clothing. But, as the girls were hungry, the first thing was to seek the kitchen. Range, kettles, coal-balls, water, flour, all were there. The next thing was to start the fire. And the next was to step across the little court to the hat shop again, and make a little modification in the precept just laid down – not to destroy – to explain the moral term 'contraband of war', and get them to hunt up small wooden boxes among the rubbish, and split them for kindling. While the school woman was making a spark with her flint and steel, and the girls were stirring up the flour and water for their pancakes, a sound was heard above all the crackling of rifles – the tolling of the bell in the English Legation – the signal of attack; and in almost direct connection with this the quick ringing of the same bell – fire. Then we noticed what we had not thought of before, how close the rifle fire was to us, and the great columns of smoke that were rising nearer still.

Poor Ada had not chosen well and, with fire and bullets raging round them, she had to gather her flock together, not forgetting their made pancakes and the still uncooked mix, and set off again to join the other milling refugees. Then, delightfully incongruously, she is relieved by a colleague who says, 'I will stay with the girls now. You go to the English Legation for your dinner.' She returns after dinner: 'By that time the enemy had been driven out of Prince Su's palace, and the place was really considered safer, so the Christians were mustered back.'

Now the refugees had to be returned to the Fu, not so easy when there were great steps to be made from one level to another:

> What wonder that those poor women, some of them having children in their arms, others having little [bound] feet, needed help? So two or three of us stationed ourselves at the stumbling places and helped them down. Never in a single day, perhaps, did any of us take so many people by the hand – over a thousand women and children. We let the men shift for themselves, in accord with rules of Chinese etiquette; not because Chinamen are averse to getting women to use strength for them, but because it would be impossible to help them without touching their hands.

So ended that first Sunday, rather unlike what Ada Haven and her colleagues were used to.

Did the Empress Dowager Make a Gesture?

Mary Bainbridge describes best what happened on Monday 25 June:

> At 1am we were awakened by heavy firing and as we have done for many nights past, got up and put on our clothes. After an hour or so, the ladies retired without undressing and slept until daylight. All the men being on guard in different places. At 9am firing began again and has been somewhat lively ever since. Bullets are whizzing through the air from all quarters. 5 o'clock pm a proclamation was posted up at the bell tower saying Chinese had been ordered to stop firing on foreigners. The officials had sent a messenger from the Tsungli Yamen saying the Empress Dowager had given the order, but as we had lost all faith in Chinese powers no one believed it to be anything but false and went to work harder than before, making sand bags, building more barricades, digging trenches and all manner of things so that should the Chinese make an attack that night everything would be ready for their reception.
>
> One German and one Japanese were shot, and two Americans wounded during the day.
>
> Most of us went to bed rather earlier than usual in order to get a few hours sleep if possible. At 12.30 we got up in a great hurry, as the heaviest firing

we had ever heard was close around us. They came upon us like a thunder clap. The shots were quick and it seemed as though there were thousands of soldiers outside the compound. I did not go to bed as it seemed too awful. Mr B went on his watch at 1 o'clock and I thought I would sit here and write while he was out. 3am they began on us again and no one got any more rest all night. Sargent Fanning of our Marines was killed early this morning and one wounded.

The significance of the large placards with their Chinese characters advising the besieged that they should expect a message to resolve all difficulties, was never satisfactorily explained; it seems fairly clear that there was a moment when factions at Court briefly changed places, but there was no follow through. Sir Claude MacDonald remarked that 'The Dowager Empress, womanlike, had again changed her mind.'[25] An old *amah* apparently urged Henry Cockburn – MacDonald's adviser on matters Chinese – 'not to be deceived by the notice posted on the bridge'.[26]

Otherwise, Monday was a fairly typical early siege day.

Frau von Rosthorn Leaves Lady MacDonald's House

Paula von Rosthorn suggests in her 1901 account that she left the shelter of the British Legation on 25 June; Captain Darcy and Lieutenant Winterhalder's more formal accounts, kept within the French Legation, record that she arrived on the 26th. I suspect that the officers, with their disciplined notetaking, are more likely to be accurate as regards dates. Peter Fleming, in his careful reply of 10 January 1961 to Paula von Rosthorn's letter, wrote,

> What I wanted to ask you was the immediate cause of your leaving the British Legation. It is so long since I worked on the book that I cannot remember details, but I do know that one or two sources indicated that you and your husband were involved in some kind of 'incident', probably with a member of the British Legation staff, on about the second night of the siege, and I could not help being curious to know what was involved.[27]

Fleming did not feel that he had enough material on the matter to make it more than a footnote in his reconstruction. The only first-hand evidence I found, before Paula's account surfaced, was Polly Condit Smith's version, apparently written in her diary on 9 July. She is confusing dates and issues when she writes, and even misspelling a crucial name but, as we shall see, she obviously had some inside information:

> [Sir Claude MacDonald's] path is a thorny one ... most of the Legations are so jealous of this compound being the centre and last stronghold *par excellence*, that they are outrageously inconsiderate of all orders issued ... A small incident may be cited to show this horrid and prevalent spirit.

The French had put in an application with the Committee on Fortifications for picks and shovels to be sent to their Legation for important night barricade work. The missionary in charge of them at the British Legation failed to send them; either they were all in use on equally important work, or there was an oversight on his part. Having failed to receive them, Herr Von Rostand, the Austrian Chargé, who had joined the French in their compound, at twelve o'clock last night returned to the British Legation, where he and his wife were accepting Lady Macdonald's hospitality, and took upon himself to wake Sir Claude up, and insultingly shouted that Sir Claude was responsible, and he alone responsible; that the French Legation was not being properly defended, etc. (especially the etc.). Sir Claude said that he would discuss anything relative to the safety of the Legations at any time in the proper manner, but the way that Von Rostand spoke made it impossible for him to talk to him at all. The Von Rostands then took up their abode at the French Legation, which was natural more or less, as the Austrian soldiers are helping them.

A question going round the compound is: When the French and German Legations must be given up, where will the von Rostands go? The fact that one is a Minister or Chargé does not help to find one new quarters, as every room, hall-way, and closet, was long ago appropriated.[28]

Baron d'Anthouard, the French First Secretary, who 'missed' the siege but arrived with the relief force, is the only other involved person to mention the problem when he writes of 26 June, again inaccurately, but with some inside knowledge:

Serious disagreements arose among the Ministers [concerning the disposition of reinforcements]. It was thus that the Austrian Chargé d'Affaires ... after a very lively discussion with Sir Claude MacDonald, left the English Legation where he had retreated with his wife after the burning down of his legation, swearing to die rather than to return there.[29]

We need to step back now and, using Paula von Rosthorn's account with Darcy's, and bearing Polly and d'Anthouard's in mind, recreate a truer picture. The pettiness at some stages will seem almost unbelievable but all it really means, apart from the implicit international politics, is that people during the siege were under the sort of pressure and stress which inevitably broke through even the most diplomatic façade.

After Paula's account of the incident in the hospital where she fainted and realised how anxious she was about her husband, she continued:

'I recovered soon but I decided to put an end to this state of affairs and return to my people. On the afternoon of 25th, I went to the French Legation. Arthur was very surprised and told me I could only stay if all officers, the French as well as the Austrians, agreed. I took to pleading, promised on my

honour that I would never be nervous and would follow every order, that no one would need to worry about me. Darcy and von Thomann agreed and I happily went back to the British Legation to get my few possessions and tell my room companions of my decision. When I got back [to the French Legation] it was mealtime. How different it was there. One could feel nothing of the dreary atmosphere that pervaded 'England'. There was horsemeat, asparagus, truffles and lentils – only mineral water was short.[30]

Darcy writes of the 26th, 'Mme von Rosthorn left the British Legation and came to stay at the French Legation with us, that is to say, with her husband.'[31] Winterhalder describes her as 'carrying a heavy suitcase but nothing else'.[32] A secondary French account inaccurately suggests that von Rosthorn's 'young wife had refused to take refuge with the other wives in the British Legation but agreed to go to the French'.[33] This account, without giving a source, also provides a charming picture of Paula who, it should be remembered, had fled her own legation without any possessions:

She was wearing a strange sort of riding habit: a long pale skirt and white sailors' blouse, almost open showing a striped knitted top. A large black silk cravat contributed to the effect of a sailor. Her courage and her allure immediately ensured that she was a great success and the Austrian Chargé d'Affaires – in beige hunting suit, hair en brosse and a fine moustache – appeared the most enviable of husbands.

Paula was to continue to look original, even after she set up house in the French Legation:

Mme Pichon had offered to let me take from her leftover wardrobe what I could use but, actually, she had taken her simple summer dresses to 'England' and, then, she was a lady of greater circumference and so I looked rather comical in her things but, faute de mieux I did make use of her offer.[34]

Almost immediately, she began to busy herself in the kitchen, 'to bring a bit of variety to the menu. Instead of the eternal horse goulash, we now had horse steak à la mode and horse schnitzel.'[35] The food supplies at the French Legation were, as one might expect, of a superior kind. While bulk supplies had gone over to the British Legation with the French staff, as Darcy records,

Mme Pichon had left behind for us her tins of provisions ... Oh those truffles. On the pretext of not leaving them for the Chinese, we put them everywhere, with horse as entré, with mule as roast, with butter as desert.[36]

And Dr Matignon, who looked after those who defended the French and German Legations (linked by loopholed barricades) and the Chamots' Hotel, was even more ecstatic about Mme Pichon's 'gastronomic treasures':

Savoury petit pois, asparagus as long and fat as drumsticks, and truffles, and cèpes, and bonbons, and preserved fruits, and boxes of biscuits. Alas! within two or three days, these good things melted along with our hopes.[37]

At least there was some asparagus left when Paula arrived and the Minister had not neglected his guests either: 'We disposed of M. Pichon's entire cellar', Darcy wrote, 'On leaving, he had given us the mission of not abandoning to the Chinese his hundreds of bottles of excellent wine.'[38] – that was in addition to those that had been carried over to the British Legation which included two to three hundred bottles of champagne.

Now Paula was with them, things really looked up for the French and Austrian officers and the volunteers who had thrown in their lot with them. Darcy tells how on the 27th June,

> Our table was now presided over by Mme von Rosthorn. The presence in our midst of this young woman who came of her own accord to set us an example of gaiety and spirit filled us with courage; we looked to the future with more confidence. We laughed at the cowardice of our enemies and recognised that if we had had before us four or five hundred blacks instead of four or five hundred celestials, we would not have the pleasure of tasting the best Burgundy cru, while eating horse and truffles. It was an hour for hypotheses and each made their own. Mme von Rosthorn, in making a second relief column advance ten kilometres a day – that's not much – and while counting on her fingers, demonstrated to us that the international forces should at least have arrived at Tungchow by now. So, boy, another bottle of champagne![39]

In the middle of that riotous evening news was brought in that one of their comrades had been killed, for it was by no means a picnic at the French Legation, and this is where the trouble lay. Paula spells it out in her inimitable way:

> During the first weeks of the siege, Claude MacDonald's whole ambition was to concentrate all the forces in the English Legation, partly for reasons of personal safety but also out of national ambition because it would have flattered the English greatly if they alone had survived the siege and England could proclaim to the world, 'we alone have saved the community of foreigners'. Only much later, when the enemy pressed us ever harder and we heard nothing from the relief troops, he and the other Ministers began to realise that as long as the other legations were held they would act as buffers for 'England'. By taking the force of the direct attacks, to the benefit of the English Legation, the further away the outer defence limit was.[40]

With this attitude prevalent among the French and Austrians in the French Legation, a constant tussle took place, as is clear from Darcy's diary – though he records facts rather than attitudes. Orders would come from the headquar-

ters in the British Legation that marines from the French/Austrian position should be sent to such and such a position to reinforce it. They, with their views on the necessity of defending the French Legation to the bitter end, would refuse and even demand reinforcements of their own. This went on for some days; even the French Minister, from whom the orders directly came, was rebuffed.

But then, as Dr Matignon explains, they regarded Stéphen Pichon not so much as head of mission as 'comrade in misfortune'.[41] At least he came to see them, though never without 'his wretched hunting rifle, probably unloaded' which led to them nicknaming him, amid gales of laughter, 'Stéphen Mal-Armé'.

Paula tells us what happened next, and her story partly meshes with Polly Condit Smith's:

> Sir Claude was very embittered by this passive resistance and, since he assumed, not without reason, that Arthur was the leader of this opposition party, he honoured him with his special dislike and during one of their first encounters it came to a formal break for a trivial reason.
>
> Our [Austrian] detachment had spades with its field equipment. When one day the Germans needed spades for digging trenches, and the general officer approached us, Arthur offered to go to the English Legation where he had stored the spades, together with the provisions for our men.
>
> Sir Claude had taken away the spades, since he needed them, before my very eyes, but when Arthur now demanded them back, he completely denied knowing about them, and also refused to do anything about getting them back.
>
> Because of our trust in Sir Claude, we also lost all our supplies and, not only our own which Lady MacDonald had put in her storeroom and did not relinquish, but also the rice for our marines for sixty days. When these were taken into the English Legation, von Thomann had left a guard with them. This guard was later drafted according to MacDonald's dictates and the supplies were taken into the Minister's antechamber, in the absence of a secure room.
>
> When after some time, Lt Kollar went with us to have part of those supplies brought into the French Legation, several sacks of rice had disappeared and when we claimed them there was a heated exchange of words with the English Minister. During this exchange, he went to go into his room and noticed some flour lying on the floor that had been scattered during the lifting of a bag. He turned around and exclaimed vehemently at me, 'You know, if you dirty my room, you should clean it up – straight away.'
>
> 'What!' Arthur leapt to his feet as if stung by a viper. 'What are you suggesting? My wife is not here to sweep out your room.'

'I'm not saying your wife, particularly,' he replied sullenly. 'If you like, a coolie, or whoever,' and growling he quickly withdrew.

Arthur was so outraged that he swore never to set foot in the English Legation again, even if the ultimate should happen.[42]

When this all occurred is not clear (it may even have been two separate occasions), and it is obviously partial to the von Rosthorns' point of view – Polly Condit Smith having leaned towards MacDonald's. I much admire Paula and many of her admirable qualities are still to be revealed, but I have caught her out in a little inaccuracy. She also claimed that in the British Legation 'almost 40,000 sandbags were filled and although this was not nearly as exposed as [the French or German Legations] ... we could not get even one sandbag from them, however urgently we needed them'.[43] And yet, Captain Darcy tells, on 29 June, how Mme Berteaux, wife of the Chancellor of the French Legation, was actively interested in their defence and came over [from the British Legation] quite frequently 'to see what was happening ...'.[44] As a result, 'Mme Berteaux sent to Mme von Rosthorn seventy bags that the women had made in the British Legation. The coolies filled them with earth and brought them to us.[45] Apparently Paula even superintended the coolies. On 7 July, Darcy added, 'We asked for more bags from the British Legation ... Those which now arrived were of silk; at the Fu the Japanese had them in fur!'[46] And the same day Mrs Goodrich noted in her diary, 'The French Minister's wife asked for bags, as they had had a hard time there.'[47]

I also have a sneaking sympathy for MacDonald, undertaking what must have been a quite impossible task. There is, for example, an undated note from the Russian Minister, de Giers, that reads:

M. le Ministre –
I regret that I am unable to share your view that by giving a nursing orderly a rifle you tranform him into a soldier, or that a cavalryman with a cavalry carbine is worth two sailors with bayonets who have been trained in infantry fighting. Be that as it may, I shall be most obliged if you will send me the 15 men whom you were kind enough to promise me, together with coolies and whatever is necessary for burning down the Chinese houses. ... They have just brought in a sailor wounded in the head; this leaves me with 57.
With best wishes,
Giers.
Another man has been wounded; this leaves 56.[48]

The student interpreter Hewlett, who acted as one of MacDonald's ADCs and may, therefore, have been biased, was of the opinion that he possessed 'tact, cheerfulness, and a sense of what posts were in truth most threatened'.[49] And, as the volunteer Oliphant wrote somewhat bitterly, 'All the Legations try to make out that they are being the most severely attacked, but they never realise

that *we* have all the responsibility and anxiety of looking after *their* women and children.[50]

What is more, MacDonald was again unwell; on 28 June, George Morrison wrote in his diary, 'I saw Sir Claude. Looks very ill and worn – propped up in bed with pillows worried by such men as Pichon and sheep[?].' According to Jessie Ransome, it was dysentery.[51] And it was not as if he clung to power: Hewlett noted on 25 June, 'The Chief had to take to his bed, and affairs were carried on by the Italian Minister, a great pal of Sir Claude's ...'[52]

But I doubt if Sir Claude was entirely innocent in the von Rosthorn affair. One has to put with Paula's account Dr Lillie Saville's tussle with him over the marines for the American Mission. Sir Claude either had a poor grasp of facts and a memory to go with it or he had, at best, a tendency towards evasiveness.

Dr Saville had bumped into him again on 17 June and described the meeting in her later letter – I will not trouble to go over the old background; what she writes conveys the flavour:

> On the 17th I met Sir Claude in the compound. He was with the Reverend Frank Norris [of another British Mission] ... He stopped me and asked if I were still very angry with him. As I had never expressed any opinion, I was taken aback but replied somewhat to this effect – that I felt it was no time to be angry. We were all in too great danger, and each must do our duty as we saw rightly. He then said I had misled him ... I reminded him of ... but he did not remember – doubtless I did – he did not doubt my word – and thereupon he walked away.[53]

After the siege was over, they had occasion to meet again, on business of Miss Smith's. 'At the end he asked if I had forgiven him yet', Dr Saville writes.

> He said he had been very pained by a conversation in the compound. He remembered he had met me with someone else – he forgot whom – I reminded him ... And both had agreed afterwards that I knew how to talk straight to anyone. (My recollection of it is that I tried to say as little as possible.) I told him that I had understood him to say I had deceived him ... [etc. etc.]

So, in the saga between the von Rosthorns and MacDonald, we should perhaps simply be very understanding; there was, after all, a common enemy!

Paula von Rosthorn is Injured

Great play was made at the end of the siege about how well protected the foreign women had been, how no one had been harmed. Actually, there were several near misses, as Dr Martin has already suggested and sometimes, as the next chapter will show, the missiles came even closer. Paula von Rosthorn, insisting as she did on leaving the safety of the British Legation, and going to

the French Legation which was under constant and exposed fire, was putting herself at risk. The inevitable happened only two days after her arrival there, on Thursday 28 June.

Arthur von Rosthorn had been in the front line of the defence of the French Legation since he had given up his own on 22 June. Dr Matignon records him as saying to Darcy, 'Captain, please see me no longer as the representative of His Majesty the Emperor of Austria, but as a simple soldier who puts himself under your orders.'[54] The scholar diplomat had not for a moment held back, and his wife was determined to pay her way. And she was set an example by Annie Chamot, holed up in the Peking Hotel next door. Auguste Chamot's doctor was later to record that Annie

> Took part in combat with the other volunteers. Dressed in the uniform of a zouave which she had doubtless obtained from the little French garrison, stretched out on the ground with the other sentries, her rifle loaded and directed towards the enemy, she surveyed the barricades carefully and, if one of the assailants had the misfortune to show his head above the surrounding wall, she polished him off with one ball, without ever missing, thus arousing the admiration of her husband and all his comrades for being such an excellent shot.[55]

Winterhalder confirms that Annie took her place beside her husband at the barricades, while Sara Goodrich recounts how 'She held a post alone on the night of the fierce attack.'[56] Now Paula was to try to pull her weight in the field. On 27 June, Darcy wrote:

> Calm came with the night. As soon as darkness allowed, we worked on the blockhouse of the great gate, the Chinese [converts] carrying the material, the officers and the volunteers disposing of it. How could anyone remain inactive when a young woman was setting an example. Mme von Rosthorn moved those heavy and uneven bricks over several hours; she did not even stop when her hands, little used to this sort of activity, began to hurt a lot.[57]

Arthur von Rosthorn had the idea the following day of burning the Chinese barricade that was causing them so much trouble; and he himself climbed up onto the roof of the stables to carry out his plan; he tells the story best of what happened next:

> Paula handed me the straw soaked in petrol which I set on fire and threw over the wall until the [Chinese] barricade caught fire. As I threw one of them, a few sparks fell into the petrol barrel below, which exploded. With one leap, I jumped from the ladder and saw my wife burning on the ground and a marine trampling on her. I gave the good man who had saved her from the worst a shove so that he staggered back. Paula suffered burns on her face, her hands and her legs which took quite a long while to heal.[58]

Darcy describes how Dr Matignon led Paula away 'almost against her will and gave her first aid'.[59] She was not down long, however, for, as Darcy records,

> She was able to come to the table that evening, but her husband had to help her eat because her dressings stopped her using her hands. The heroine of the day was fêted and congratulated as she deserved. The evening was almost calm; also with the help of good wine our precious gaiety was retrieved.[60]

Paula von Rosthorn was soon to be back in harness again, giving the excuse to those who arrived in Peking after the siege, such as the French writer Pierre Loti, serving in the relief force, to sing her praises in their accounts; he wrote in *Les Derniers Jours de Pékin* (1902):

> There was, however, one woman with [those defending the French Legation]. Young and charming, this Austrian woman, who will have to be awarded the highest French award, alone in the midst of these men in distress, maintained her unfaltering gaiety intact. She looked after the wounded, prepared with her own hands meals for sick marines, and then went off carting bricks and sand for the barricades, or kept guard on top of a roof.[61]

One of those who helped create the legend was Dr Matignon who described Paula as the 'Good Fairy of the Defence'.[62] And her good humour and soothing hands were to be much needed: from 29 June, the French Legation and the Chamots' Peking Hotel were to be harder pressed than ever.

10
Who were the Heroines?
(24 June–16 July)

Miss Laura's Pony

'Today we have eaten pony for the first time', wrote Ada Tours on 29 June. 'Really it was quite good done up with rice and gravy.'[1] By the time Paula von Rosthorn reached the French Legation, they were already eating horsemeat; she took it as a matter of course and set to to improve its presentation. Two ponies had been shot during the night of the 24th by snipers and they were cut up and distributed. Jessie Ransome wrote on the 26th, 'This morning there was some very sharp fighting on the wall, but the afternoon has been ominously quiet till just now, and I dread what it might bring. We all had a very good supper, however, of stewed pony, and I feel more fortified to bear things.'[2]

A.D. Brent later wrote home about his mother, Charlotte,

> The Mother had some white bread sent her every day by Mrs Squiers which really saved her as she could not touch the coarse brown stuff. She ate the pony flesh though all the time – it got terribly monotonous after a time ... [Champagne and water] did a great deal to keep up the Mother.[3]

But the Americans seem to have been less well able to cope. 'We had beans and horsemeat last night for supper', wrote horsewoman Dr Emma Martin of the 25th, and continued:

> I had to pray for grace to eat it and keep it down. I reasoned it out that we did not know how long we would be there or how short of food we might be and I would have to come to it at last so I thot I had better begin on it at once so I did.[4]

Her Methodist colleague from T'ung-chou, Luella Miner, did even less well; she wrote in her diary on the 28th:

177

We have a new delicacy added to our bill of fare. We call it 'French roast beef'. This morning it was prepared in the form of a curry to eat with rice. After eating the limited amount of cornmeal mush allowed to each person, there was a break in the meal, and someone asked Miss Haven, who was helping to wait on the table, what was the reason for the delay and she replied, 'The horse is not yet curried.'

I started out this morning to eat my rice without anything to help it down, then I remembered how faint I got between meals yesterday and made an attempt at the French beef. I managed to get down a few mouthfuls. Then Miss Russell who was sitting beside me began to get seasick and it was too much for me. I ate the rest of my rice clear. My reason tells me that horse meat is much cleaner than pork, but it must be confessed that the Anglo-Saxon stomach is prejudiced against that noble animal.[5]

But soon the Americans were able to manage; Mrs Galt tells how, 'I eat it right along now, since I have gained control of my imagination.'[6] And Dr Eliza Leonard remarked on the 25th, 'All foolish notions were laid aside and the food was eaten.'[7] By 3 July, Dr Martin was an old hand; she recorded gamely, 'We had mule stew for dinner today and Miss [Mrs?] Smith remarked, "This mule is very nice today" (it was extra good) and some of us looked up in surprise and she said "Yes, I know it is mule, I saw the Chinese carry its head away in a basket." It almost upset me.'[8]

Soon it became a matter of course for the Americans too; Mary Gamewell puts it in the context of the rest of their diet, as well as showing how recipes, even for horseflesh, came to be swapped:

The ladies in the pantry developed great ingenuity in varying the bill of fare. One day there were three cans of tongue for our mess of seventy. The tongue was cut fine and mixed with brown rice ... There was on hand a quantity of flavoring extracts but no eggs and no milk. But there were a few raisins; so the raisins and a little extract and sugar were added to the left-over rice which was then served as pudding. A quantity of millet was brought in. Now millet when boiled is more adhesive than rice. We sometimes had millet porridge. Left-over rice and left-over millet porridge were mixed with water and salt; a very small portion of flour, from our one bag of white flour, was added to help hold the mixture together, and baking powder made it rise. This combination, cooked on griddles prepared with drippings from horsemeat or mulemeat, returned from the kitchen in the shape of griddle-cakes each the size of a tea-plate – very light, very brown, very beautiful, in fact, the most popular article of diet that graced our tables. The plates of cakes en route from kitchen to chapel passed in sight of the 'Customs' Mess'. Soon a lady of the Customs Mess called for our recipe for cakes! She said that her husband, seeing our cakes, had asked: 'Why can't we have good things to eat as well as the missionaries?'

That same little lady gave us points on cooking horsemeat: 'Cut in steaks, cover with hot water, and simmer for three hours; then brown in fat and add spice.' There was a big cauldron in one of the courts in which nearly half a carcass was boiled at once. The long-continued boiling necessary to cook so large pieces, seemed to take away the wild taste that the flesh otherwise had, and when finally our mess had orders which gave us a part of such boiled meat, it found more favor than any other form of cooked horseflesh.[9]

Mrs S.M. Russell and Mrs Mears ran the Customs' Mess; Dr Coltman wrote of them that 'All the Customs volunteers will ever remember [them] for their constant, untiring efforts to render palatable the daily ration of horse-meat and rice.'[10] Jessie Ransome ran the Cockburn Mess and Lucy Ker that of her household; she claimed that she and Jessie devised eight different ways of making the meat edible.

Mrs Squiers, however, had so ordered things that her tinned beef lasted rather longer than most; as Polly Condit Smith delicately put it on 29 June, 'When one's tins are gone one can eat horse-meat and rice.'[11]

But, of course, there was another side to eating horse, mule, or pony meat for some. The Reverend Roland Allen noted discreetly, 'One lady of my acquaintance never failed to ask, "Is it a white mule?" If the answer were "No," all went well.'[12] As we shall see on 14 August, that questioner was probably Ethel MacDonald. Annie Myers was fairly sure exactly which pony she and Ada Tours were eating on 29 June, and even which race she had watched 'Red Knight' win in 1896. But Mrs Conger best describes the problem:

Our mule is gone and our ponies are all gone but one, daughter Laura's. First of all Mr Conger's pony had to be eaten, as he hated foreigners as bitterly as do the Chinese ...

One morning very early the door into the hall quietly opened, then closed. After a few moments it opened again. I said, 'Is that you, Wang?'
He said, 'Butcher take Miss Laura's pony; I think more better he take mafoo pony.'
I replied, 'All right, Wang, you go and tell the butcher that we wish you to choose from our ponies.'
While our ponies were all turned in to the general supply, we were caring for them at the American Legation. Later I talked with Wang.
He said, 'Miss Laura's pony save to the last. I told mafoo lock stables, and told guard let no one get ponies.'
I said, 'Wang! Our ponies are common property now. We are just taking care of them. But you are right about Miss Laura's pony, and if he is not needed we will keep him for her; if needed, let him go too. It is all right.'[13]

(Laura's pony survived the siege; that of her cousin, Mary Pierce, was slaughtered the day before it ended.)

24 Laura Conger on her pony (from *Letters from China*)

Mrs Conger and Miss Condit Smith Differ

In fact, Miss Laura Conger had a surprising siege. 'Laura, dear girl, was physically weak', wrote her mother amidst the bullets and shells.[14] At the beginning of the siege, Sarah Conger must have dreaded the days to come because, as she continued:

> At first when the severe attacks came upon us she was almost frantic, and she grew weaker and weaker. It seemed as though the ravaging enemy could not be stayed. Their yells and howls could be heard mingled with their awful firing. ... I gave her one thought to ponder, which I think has been helpful to her. It is this: 'When you are becoming frightened, turn your thoughts to some blessing and give thanks to God with your whole heart.' Gradually she grew calmer, and for more than a week she has been getting stronger, eating more, sleeping more, and working all the time. She does not undress at night yet, but there are many who do not. She and Mary are two dear and helpful girls.
>
> Our boy Wang is always trying to prepare something delicate for 'Miss Laura.' One day, on our little square table with our allotted food, was a plate

with two small rice birds upon it. I asked Wang what they were and where they came from. 'For Miss Laura. I put rice on floor; small bird come. I shut door and window; catch bird. Cook make 'em Miss Laura'.

From her earlier state, Laura advanced so that her mother was able to add, 'Daughter Laura has full charge of the food supplies and looks carefully to the amount and quality of each meal.' And Sarah Conger was not being fanciful about her daughter's improved health and well-being; Professor W.A.P. Martin, who moved from Mrs Squiers' table to Mrs Conger's, observed the phenomenon:

> On the first shots Miss Conger, who was suffering from nervous prostration, threw herself into her father's arms and wept convulsively. At the next attack she bore the ordeal with perfect composure. As the siege went on, the daily fusillades appeared to act upon her nerves like a necessary tonic. She grew stronger from day to day, and at the end of the siege she seemed to have obtained a complete cure, a thing which she had sought in vain by an ocean voyage.[15]

Martin suggests that Laura Conger thrived on danger and adrenalin, and perhaps excitement in her life was creative; but I am more inclined to think that it was doing hard work, having it valued, and being given increasing responsibility that did the trick. She grew up during the siege.

Sarah Conger herself had many responsibilities apart from a nervous daughter and somebody else's child, her niece Mary Pierce. (It is not clear how old either young woman was; I suggest about twenty.) She had three guests whom she had brought with her that spring from the United States: Mrs and Miss Woodward, and Miss Cecile Payen. She had tried unsuccessfully to get them away before the semi-siege; now the danger in which she had placed them must have weighed heavily. Then there were her duties as first lady of the American Legation which she fulfilled mainly, as we have seen, by organising essential hospital supplies. And she was already fifty-seven years old, one of the older women living through the siege. This is all to set the scene for an incident which Polly Condit Smith describes and which has led to Sarah Conger being mocked. Polly wrote on Friday 23 June:

> This afternoon we were in Mrs Coltman's room, and her sweet baby was asleep in a funny, old-fashioned, high-backed crib. Although the sound of exploding bullets was to be heard outside the house, we were much startled to feel one – you can't see them, they come so fast – enter the room, hit the headpiece of the baby's crib, detaching it from the main part, and bury itself in the opposite wall. An inch lower and it would have cut through the baby's brain. His mother picked him up, and all of us flew into a room on the other side of the house, where we felt we would be free from shot, at any rate coming from that direction.

We were accompanied by the wife of the Chief, Mrs Conger, conspicuous for her concise manner, and an open follower of Mrs [Mary Baker] Eddy. She earnestly assured us that it was ourselves, and not the times, which were troublous and out of tune, and insisted that while there was an appearance of warlike hostilities, it was really in our own brains. Going further, she assured us that there was no bullet entering the room; it was again but our receptive minds which falsely led us to believe such to be the case. With these calming (!) admonitions she retired, and I can honestly say that we were more surprised by her extraordinary statement than we were by the very material bullet which had driven us from the room.[16]

Professor Martin would not have a word said against his hostess; he was to write protectively:

Had I been her brother I could not have been treated with more affection-ate kindness than I received at her hands and those of the Minister. Calm, resolute, hopeful, and, as Pope says, 'Mistress of herself, *though China fall*,' a devout Christian, too, though tinged with the idealism of Bishop Berkeley, Mrs Conger is one of the most admirable women it has been my privilege to know. I wished many a time that, like her, I could look on all those events as nothing more than a horrid nightmare, merely conjured up by a distem-pered imagination.[17]

As for her remark, I think it would have been easy enough under the circum-stances to say something that did not seem entirely appropriate to one's fellows. Most of the women developed their own strategies for coping and those of Sarah Conger and Polly Conduit Smith were poles apart, as another Polly anecdote, of 26 June, testifies:

After this fiendish attack had been in progress long enough for everyone to get up and dress, Mrs Conger came back to our room, and her manner was more than tragic when she saw me lying on my mattress on the floor, not even beginning to dress for what I suppose half the women in the compound believed to be the beginning of the final fight. She said, 'Do you wish to be found undressed when the end comes?' It flashed through my mind that it made very little difference whether I was massacred in a pink silk dressing-gown, that I had hanging over the back of a chair, or whether I was in a golf skirt and shirt waist that I was in the habit of wearing during the day hours of this charming picnic. So I told her that for some nights I had dressed myself and sat on the edge of the mattress wishing I was lying down again, only to be told, when daylight came, that the attack was over, when it was invariably too late for anything like sleep (which way of living is distinctly trying), and after a week of it, when one has so much to do in the day hours, I had come to the conclusion that, as it was absolutely of no benefit to anyone my being dressed during these attacks, I was going to stay in bed

unless something terrible happened, when I should don my dressing-gown and, with a pink bow of ribbon at my throat, await my massacre. This way of looking, or I should rather say of speaking, did not appeal to the Minister's wife, but I must say that at such terrible moments during the siege it is a great comfort to be frivolous. By making believe that one is not afraid one really lessens one's own fear. 'Assume a virtue if you have it not,' says our beloved Shakespeare. After Mrs Conger's visit on this same terrible, ear-deafening night came Clara, Mrs Squiers's German nursery governess, and she needed all sorts of assurances to convince her that a massacre was not in progress at that very moment.[18]

It is easy to imagine that, different as they were, and living on top of each other as they did, Sarah and Polly said things in each other's presence that, no doubt unconsciously, they knew would rile the other. (Sarah Conger does not mention Polly at all in her letters-diary.) But the account is typical and W.A.P. Martin had his Polly story, too:

During the first stage of the siege I noticed a handsome young lady, one of the guests from abroad, sitting for her portrait, while a lady artist, Miss Payen, with untrembling hand, transferred her pleasing features to canvas. I wondered at the composure of them both. Nor was my astonishment diminished when, in the evening, I overheard the same young lady saying to Captain Myers:

'Now, remember, should they overpower us, your first duty will be to shoot me.'[19]

One of the missionaries, Bessie McCoy, was later to tell another typically Polly story – one written to Peter Fleming by Bessie's brother before he had had a chance to read the book in the United States:

Among the Americans sheltered at the Embassy, she recalled in particular a young and beautiful girl ... of a rather frivolous nature. My sister Bess happened to be in one of the parlors of the Embassy on a day when it seemed as if the Boxers were about to break in at any moment. There was a tall pier-glass in the room and as the American girl passed by it she caught sight of herself in this mirror – and, so said my sister, the girl lifted her hand and blew a kiss to herself ...

Although she did not say so, my sister seemed to think that the girl's gesture showed a deplorable lack of propriety at such a time. But I, being no more than eighteen years old that year, had romantic notions. I confess I thought the girl's gesture was a brave and gallant gesture indeed.[20]

Romantic Inspiration

Polly was to be shot, lightheartedly and seriously, by more than one young man, including Captain Myers who was himself to be wounded on 3 July. And

it is clear that these siege romances were a means for those concerned to survive the pressure. An American who was a thirteen-year-old girl in 1900 and wrote to Peter Fleming in 1960, told how she shared a cabin with Polly from Japan to Europe after the siege:

> You speak of an unauthenticated story that in the last days of the siege when a break-through was expected at any moment certain men were appointed to shoot certain of the women when that moment arrived. I can only say that in sharing a cabin with Polly Condit Smith from Yokohama to Genoa a great deal of what she experienced rubbed off onto me, in spite of considerable glossing over in deference to my youth. I can vouch for the truth of this tale to the extent that Polly had the revolver with her and showed it to me, telling me that the young Russian, with whom I gathered she had something of a siege romance, had asked her if she wanted him to do it, or would she rather do it herself; then after it was all over, had given her the revolver as a souvenir. ...
>
> Some years later Captain Jack Myers told us how she had taken care of his wounded leg, had often given up her share of the hoarded rice and practically lived on cigarettes (of which the Russians had a good supply) how she had rallied and entertained the children as her special job throughout the siege. Evidently, her natural beauty, never-failing good-temper and resourcefulness, and unremitting hard work had impressed them all.[21]

The Russian was no doubt their commander, Captain von Rahden. Polly wrote of him that '[he] is frequently up all night, and when he is, he usually comes to us for breakfast, which we have at any time between 6.30 and 8 o'clock. ... A fresh table napkin we have procured from somewhere, and on the table we place some green leaves for decoration, and breakfast is announced.'[22] Polly provides a corrective on 16 July to a detail regarding her Russian admirer:

> It is discussed quietly by men that they will certainly kill their wives when that time comes. God grant it never may! Apropos of this, I have in my pocket a small pistol loaded with several cartridges, to use if the worst happens. A Belgian secretary stole it from the armoury for me – 'in case you need it, Mademoiselle.'[23]

The Belgian Legation had been abandoned as early as 16 June, sacked and destroyed on the 18th, and burned on the 21st. Its Secretary was M. Merghelynck who had other ways of trying to please Polly too; she wrote on 9 July, 'The other day he brought me five long Chinamen's queues, which he had cut off the heads of the Boxers he had killed, as a souvenir of a day's work.'[24]

But Polly was by no means the only young woman able to inspire through stirring the hearts of young men; Professor Martin wrote of Mrs Woodward's handsome daughter, Ione:

If she rendered any service besides the sewing of sand-bags, [she] did it chiefly by inspiring certain young men to heroic deeds. The mother having expressed to me a wish to have a Boxer's rifle for her museum, I whispered in the ear of young Bismarck, who the next day brought the desired weapon, and, laying it at her feet, said, 'This is the spoil of an enemy whom I shot this morning.'[25]

Anxious not to overlook Sarah Conger's 'fair niece' Mary Pierce, Professor Martin (seventy-three years old and a widower since 1895) added in a footnote that under her 'inspiration Dhuysberg, a young Dutchman, performed more than one exploit'.[26] And he summed it up, including the artist Cecile Payen and Mrs Woodward,

> These three ladies were a powerful reinforcement to the three ladies of the Conger family, and the six attracted not merely young men, but had frequent visits from such old men as Sir Robert Hart and the Spanish Minister, Mr Cologan, a hidalgo of Irish extraction. ... In a word, all our men were doubly brave because they had our women to encourage them.

Mrs Woodward, who went everywhere careless of danger with her camera, was known by the wounded American boys in the hospital as 'Mamma'.[27]

The inspiration was not just in personal deeds to please particular young women; several tell the story of 3 July, but Theodora Inglis will do it here, when a sortie was to be made by marines under the command of Captain Myers: 'He pointed to the British Legation and said,

> 'My men, yonder are nearly four hundred women and children. To save them and to save ourselves, we must keep this wall and force the Chinese back a little,' and pointing to the Chinese barricades which had encroached upon their territory, he added, 'We must take that barricade, are you willing to follow me?'[28]

They did, including the non-English-speaking Russians. Later, an American marine described to Mrs Goodrich what it had been like and confessed that though he was not a good man, he swore, and did not go to church much, 'I am willing to give my life for you women and children. It's tough up there [on the wall] with the rain pouring and the bullets flying, but I am willing to do it for you.'[29] And the student interpreter Hewlett explained:

> It is a lovely sensation to know you are sending a bullet at one of those brutes, and I was only sorry I was not using smokeless powder [so as] to watch him fall. You must think I am getting horrid, but one cannot daily see the babies in the Legation dying, their poor little faces getting that quiet and resigned look almost past fretting, without feeling bitter against these beasts of Chinese.[30]

His fellow student, Lancelot Giles, wrote ambiguously on 3 July, 'The worst of a siege like this is that there are so many women and children about the place.'[31] Hewlett had been rather less ambiguous following the racecourse incident before the siege, when Claude MacDonald had had to rein-in his trigger-happy young staff: 'I cannot ride or walk or carry firearms,' he wrote, 'so I am out of it, but I expect you are glad. It is hateful being classed with "women and children".'[32]

Looking for Vaseline

The romances hinted at above may have been platonic, rather in the nature of ladies and parfit knights. But there were others that were not necessarily inspirational or platonic. Theodora Inglis tantalisingly informs us that 'There were lovers and would be lovers, of course, and some were kept busy scolding about a soft young couple who did no work, and wondering if X would propose to Z before the siege was over.'[33]

Putnam Weale was more interested, however, in less platonic, romantic or inspirational relations between men and women. (You may or may not want to remember that, according to George Morrison, Putnam Weale was Lily Bredon's lover and, according to Dr Coltman, he was, togther with Juliet Bredon's fiancé, Lauru, counted as a member of the Bredon family during the siege.) In general, he never hesitated to depict the Russian marines as lazy and feckless, but on occasion they could be fired by a rather different sort of imperative, as he writes of 3 July:

> Some of them discovered that a large number of buxom Chinese schoolgirls from the American missions were lodged but a stone's throw from their barricades. The missionaries, fearing that some scandal might occur, had placed some elderly native Christians in charge of the schoolgirls, with the strictest orders to prevent any one from entering their retreat. This was effective for some time. One dark night, however, when the usual fusillade along the outer lines began, the sailors made tremendous preparations for an attack which they said was bound to reach them. At eleven o'clock they developed the threatened attack by emptying a warning rifle or two in the air. Then warming to their work, and with their dramatic Slav imaginations charmed with the *mise en scène*, they emptied all their rifles into the air. Then they started firing volley after volley that crashed horribly in the narrow lanes, retreating the while into the forbidden area. Fiercely fighting their imaginary foe they fell back slowly; and as soon as the elderly native converts had sufficiently realised the perils to which they were exposed, these cowardly males fled hurriedly through the passageways which have been cut into the British Legation. The sailors then placed their rifles against a wall and disappeared. Unfortunately for them a strong guard sent to investigate this

unexpected firing almost immediately appeared, and presently the sailors were rescued, some with much scratched faces. The girls, catlike, had known how to protect themselves![34]

Our schoolgirl informant does not mention this particular incident but she does recall that after the siege was over:

> We were between the British and Russian Legations, and the coarse-faced Cossacks had hardly filed into their legation, before some of them appeared in our yard, frightening us more than Boxers would have done. Notices posted on our gate failed to keep out these ruffians, so some of the missionaries staid with us constantly to protect us from these foreign soldiers.[35]

This rather ties in with the end of Putnam Weale's story of the earlier occasion, for he writes that:

> The next day there was a terrible scene, which everybody soon heard about. Baron von R[ahden], the Russian commander, on being acquainted with the facts of the affair, swore that his honour and the honour of Russia demanded that the culprits be shot. I shall never forget the absurd scene when R ..., who speaks the vilest English, demanded with terrible gestures that the ring-leaders be identified by the victims. It was pointed out that the affair had occurred when all was dark – that the whole post was implicated – that it was impossible to name any one man. Then R swore he would shoot the whole lot of them as a lesson; he would not tolerate such things. But the very next day, when a notice was posted on the bell-tower of the British Legation forbidding everyone under severe penalties to approach this delectable building, R ... had his *revanche à la Russe*, as he called it. Taking off his cap, and assuming a very polite air of doubt and perplexity, he inquired of the lady missionary committee which oversees the welfare of these girls, '*Pardon, mesdames*, he said purposely in French, '*Cette affiche est-ce seulement pour les civiles ou aussi pour les militaires!*'[Excuse me, Ladies, but is this notice only for civilians, or does it also apply to military personnel!][36]

However much Putnam Weale may have embroidered the story to improve his book, Dr Emma Martin confirms something of it, though she does not mention schoolgirls, when she writes on 10 July:

> Shortly after this Mr Hall came over to report that the Russians *again* [my italics] had been bothering the Chinese Christians, shooting at them, and the Russian commander said if the men could be identified they should be court martialled and shot. He looked very soldier like in his full uniform and Miss [Georgina] Smith went back with him because she had seen some of them.[37]

But it was not only the raw Cossacks who were unable to restrain themselves; ten days later, Putnam Weale had a story to tell of a patrol of Russian student

5 5 5

5 5 5 5

5 5 5 5 5

5 5 5 5 5

5 5 5 5 5

5 5 5 5 5

5 5 5 5 5

5 5 5 5 5

5 5 5 5 5

5 5 5 5 5

5 5 5 5 5

5 5 5 5 5

5 5 5 5 5

5 5 5 5 5

5 5 5 5 5

5 5 5 5 5

5 5 5 5 5

5 5 5 5 5

5 5 5 5 5

5 5 5 5 5

5 5 5 5 5

5 5 5 5 5

5 5 5 5 5

5 5 5 5 5

5 5 5 5 5

5 5 5 5 5

5 5 5 5 5

5 5 5 5 5

5 5 5 5 5

5 5 5 5 5

5 5 5 5 5

5 5 5 5 5

5 5 5 5 5

5 5 5 5 5

5 5 5 5 5

5 5 5 5 5

5 5 5 5 5

5 5 5 5 5

5 5 5 5 5

5 5 5 5 5

5 5 5 5 5

5 5 5 5 5

5 5 5 5 5

5 5 5 5 5

5 5 5 5 5

5 5 5 5 5

5 5 5 5 5

5 5 5 5 5

5 5 5 5 5

5 5 5 5 5

only one gave way to hysteric shrieks (she was not American); and it may be added, by way of off-set, that one man, a Norwegian, went stark mad.[40]

Some light relief is provided by a contrary view from a babe – a child who, when asked by a reporter after the siege whether any ladies had cried, replied, 'No, only one and she was a *Presbyterian*.'[41] The missionary reporting this added, '(Loyal little Congregational maiden)' And then quickly explained,

> That one had very good reason. She was a lady whose husband had been sent to a very perilous position, which meant almost certain death. And she had let him go most bravely, but after he was gone she went off by herself, where she thought no one would see her, to weep and pray. But children are everywhere, and one of them saw, and remembered, and told the reporter.

Theodora Inglis made another link, ending with what would become a dreadful irony: 'How we loved the children, they were our greatest care and yet a pleasure and encouragement. Everyone tried to keep up before the little ones and the only two women who had hysterics at any time, were childless.'[42]

Polly Condit Smith, who moved in the same circles as Professor Martin, does not entirely agree about the limited number of hysterics or the restraining effects of children; she, of course, had her perennial hysterical governesses to the Squiers children, so that on 16 July she wrote:

> Today I took the French governess her dinner, into which, I must admit, the cook had dashed the curry-powder rather too strongly. With this small *contretemps* as a starter, she seized my hands, and with heart-breaking sobs begged me to save her, as she knew, from the unusual taste of her food, that someone was trying to poison her. 'Mademoiselle, je ne demand que peu, simplement qu'on me retourne tout de suite en France.' [I'm not asking for much, just that I should be returned immediately to France.] ... She was hopelessly unbalanced with terror.[43]

But Polly also talked of 'women who have collapsed [who] simply spend their hours, day and night, behind the nearest closed door, and await each fresh attack to indulge in new hysterical scenes'.[44] That generalisation is not borne out by anyone else's account, unless it be George Morrison's earlier diary entry (of 6 June) about the Bredon women, Lily and Juliet, mother and daughter, against whom, with their attendant men, he waged a private vendetta. As he messed mainly with the Squiers, I suspect Polly's information may have come from him, and remember his 17 May opinion of her: 'fat and gushing'!

But this question of general hysteria and courage among women was to become a bone of contention after the siege. Charlotte Brent was faced with it by journalists when she reached Yokohama – 'Mention was made to Mrs Brent of the charges of cowardice brought against Japanese ladies by a certain Japanese paper.' As the report went on to say,

Mrs Brent indignantly repudiated these. Speaking of the Japanese generally she said: 'There were no people so appreciated and so held in respect as the Japanese. They were the smallest band – 24 originally – and perhaps another 25 who had been in Peking from the time of the war. Of these only five remained intact at the end of the siege, all the rest having been killed or wounded. The nurses said they had never attended patients so brave and courteous as the Japanese.[45]

This is not just an opportunity to praise, through the mouth of a woman, the behaviour in general of the Japanese during the siege – something on which everyone who was there agreed; that story about cowardly Japanese women managed to get twisted round the other way, leading Mary Gamewell to write:

It was reported in Japan, after the raising of the siege, that ladies of the Japanese Legation declared that during the attacks on the Legations the European ladies screamed and otherwise behaved very badly, but the Japanese ladies conducted themselves with great calmness and courage. When the report came to my ears there immediately arose in my mind a vision of that demure little lady of Japan, whom I met that first night of the siege we were under fire. She was not screaming, but neither were we. I never heard that any Japanese ladies screamed when under fire. Neither did I know of any European lady who was other than courageous.[46]

I suspect the story of a Japanese woman may have come from an interview that Cecile Payen gave on her arrival home. Discussing the second worst night of the siege, one of storm and bullets, she is said to have remarked, 'It is to the credit of the women that only one was hysterical that night. This was a Japanese or Russian woman who was in the pavilion surrounded by boxes instead of walls.'[47]

As for Charlotte Brent herself, her son wrote to a close friend after the siege, 'My dear old Mother bore up wonderfully with a fortitude that would have done credit to many a man.'[48] To his father a day later he was a little franker:

The dear old Mother, she has borne up splendidly throughout and been a wonderful example to many younger women – although the conduct of all women has been most admirable. One or two nights when the firing was very heavy she broke down a little but I think it was more on account of the actual danger to me during the night than fear of the worst.[49]

Annie Myers is even more protective of Charlotte Brent, and is of the Polly Condit Smith school of being massacred; she tells how, on 27 June, the alarm bell in the church tower rang its alert and everyone went to their posts:

Mrs Brent and Mrs Brewitt-Taylor, who had already retired, were told to dress again by Mr Gamewell and another missionary who had gone in and alarmed them, a very unnecessary thing to do, as, in any case this is the very last

25 Women and children of the Japanese Legation
(from *Black and White*, supplement, 20 October 1900)

stand should anything occur and one might as well be comfortably massacred in one's night gown and bed, as uncomfortably in one's hastily donned garment in the Hall! They both looked frightened nearly out of their wits, as was natural considering the fearful noise going on outside, and with the 'smatt-smatt' of bullets against the walls and houses and the inconsiderate way they had been roused from their slumbers.

Lady MacDonald obviously realised what was happening and wrote later:

At first, some of the panic stricken foreigners rang [the bell] for nothing, causing unnecessary pain to the already-taxed nerves of the women, so my husband took this duty on himself, and we were, therefore, less often brought face to face with what might spell 'the end'.[50]

The Marchesa Dresses Up

Charlotte Brent was completely out of her element, of course, and had started her trip to China under the weather, but even those more experienced in China had every excuse to be anxious and frightened. Take the Marchesa Salvago Raggi. Little is said in English-language accounts of either her or her husband, but there is one telling line in Polly Condit Smith's: 'The Marquis Salvago sits chatting with his wife, a very beautiful woman, in a *chaise longue* most of his time.'[51] Polly implies, and secondary accounts such as Fleming's pick it up, that the thirty-five-year-old Marchese (who did not speak English), like some other diplomats was a shirker during the siege.[52]

In exploring this suggestion, particularly as it affects the Marchesa, I remembered two things: one that she had been attacked by a raging crowd in her sedan chair in October 1898; second, that her house had recently been burnt down following the misjudged withdrawal on the 22nd. She might, therefore, need quite a bit of care from a solicitous husband to help her get through the nerve-wracking days. But a 1908 reconstruction of the siege by naval lieutenant Mario Valli prompts a different view.

The Italian couple, married since 1891, were experienced diplomats who obviously liked to present a distinctively stylish image. Giuseppe Salvaggo, as we already know, was the only man to continue dressing for dinner during the siege. Some diplomats and their guests brought over one dress case each to the British Legation as early as 15 June, and there would have been some chance to top up possessions on the morning of the 20th. Lady Blake gives a useful impression of Camilla Salvago in May:

[She] was a tall handsome and most charming woman. Her manner had all the charm for which those of her nationality are celebrated, and in conversation she was very agreeable. Her fine figure was shewn off to advantage by a very pretty white satin dress embroidered with silver spangles.[53]

And Theodora Inglis makes it clear that Camilla kept up her high standard. Discussing in her account the contributions of various diplomatic women, she came, without naming her, to the Marchesa who was,

> Useful (in her way). She lifted us from the sloughs of seriousness every evening by appearing before the public gaze in her beautiful Parisian toilettes. These she had remembered to bring with her into the British Legation while forgetting all her food supplies and other necessities.[54]

Annie Myers, perhaps with her tongue in her cheek, noted on 21 June, before the Italian Legation was destroyed, 'This morning we were all busy putting away the wines and aerated waters, the Salvagos brought with them, to a place of safety.'

But there is more to their self-image. Polly Condit Smith took a mental snapshot of them and the '*chaise longue*', and it was probably not exaggerated, but Valli mentions the hand-wringing of other diplomats – and observers and commentators implicate M. Pichon, the French diplomat (and his wife) in this – and then continues in what may well have been a first-hand remark: 'others more fortunate [in temperament or training] preserved, even in the most critical moments, an admirable calm'.[55]

As for the shirking, we know from the student interpreter Hewlett that Salvago took over when MacDonald was indisposed. Valli makes it clear that the Italian Minister was with his men on the fatal 22nd, and that when his marines were posted to the Fu, he was the Fu detachments' (Japanese and Italian) coordinator in the British Legation. The Fu, with its two thousand Christian converts and its position, was a crucial part of the defences and it was, more or less, held until the end. But the Italians were somewhat disparaged. Jessie Ransome wrote of 12 July, 'There was a tremendous fusillade on the Jap position in the Fu, and the Italians ran away and left the British barricade isolated and undefended, to the great disgust of our men.'[56]

Such stories were stirred by George Morrison who, at a 'lunch' given by Mrs Squiers on 11 July, which included Mrs Goodrich, expressed his lack of sanguineness over the Fu because, as she recorded in her diary, 'The Austrians and Italians guard so poorly their points. They go off to dinner, or go to sleep, as suits them. A shell strikes the wall adjoining and they flee.'[57] If there is any truth in these aspersions (which are contradicted by their comrades' behaviour at the siege of the Pei-t'ang, see Chapter 15), Salvago's job would have been all the more demanding and delicate, and Valli observed that he divided his time and efforts between his family and his work with the Fu.

His family was not only his wife but his small son Paris who was prone to dash off to pick up spent projectiles which he would bring back to his father to show how hot they were.[58] As for the Marchesa, with an energetic and inquisitive boy to keep safe as an occupation, she also had, as the only Italian diplomatic woman there, her inspirational role to play.

The story is told of how, on 3 July, Lieutenant Milano brought a message from his commander in the Fu to the Minister; Camilla sat him down beside her to rest while a reply was written, talked to him about his birthplace, his mother, and his fiancée – gave him 'a little haven in the gloom of the siege' – then sped him on his way back to his post.[59]

Unattached Polly Condit Smith is not unappreciative of what it must have been like for wives; she wrote on 29 June:

> In the case of the Legations who are still holding their own, it is very hard on the women whose husbands are still staying with the soldiers until they finally evacuate. These poor women naturally wonder, 'What is my husband doing? Is he dead, and when they evacuate will he be amongst the lucky number to retire to the British compound alive?'[60]

For two days, the Marchesa had fallen into that category; thereafter, there were Japanese Mesdames Narahara and Nakagawa, Mme Korsakova, wife of the Russian surgeon, and, often, Harriet Squiers; and well might they worry. On 26 June, Polly had been more inclusive: 'Women with husbands and children suffer horribly. They dread lest their children die of disease or by torture ... and fear for their husbands who may be killed during any attack.'[61] Ada Tours recorded on 29 June, 'Bertie's post is under the redoubt at the gate for which I am truly thankful'. Dr Gilbert Reid was shot in the leg on 5 July. His wife, when told, 'Could not believe they were not making light of the wound, to save her from too heavy a shock.'[62] When it comes to the courage of wives, I like the remark of the Reverend Courtenay Fenn on arrival safely in the United States: 'My wife bore up bravely through it all, even far better than I ever expected a woman to do.'[63]

While Cecile Payen noted, 'Sir Robert Hart has just been in to pay his daily call. Poor man, he says he goes about to see the ladies so as to keep up his cheer.'[64] No doubt he really meant to reassure them.

Men Running Scared

It was by no means only women who were scared. We can leave aside the story of the Norwegian missionary, Nestegard, mentioned by W.A.P. Martin; he ran amok over to the Chinese side and allowed himself to be debriefed by them on how they could best attack the foreigners (and was then allowed back unharmed). He had clearly lost his reason and was locked up for his own good, as well as everyone else's. (Among his papers was found a letter to the Russian Minister apologising for indecently exposing himself to Mme de Giers.)[65] Polly Condit Smith adds to her account of hysteria above, 'I can honestly say there are more men to the bad than women.'[66] but she does not name names.

In his diary, George Morrison is particularly scathing about Dr Robert Coltman (father of six) who was so generous to him with professional gossip;

and it was bomb-proof shelters that provided the peg for Morrison. On 27 June, Deaconess Jessie Ransome noted that 'All hands are now busy making a bomb-proof shelter, into which we may creep if there is a determined assault with the bomb shells.'[67] The need was not just because of what she wrote two days later: 'It is curious how used we get to going about with bullets whizzing about our heads; but I confess I do not like bomb-shells, there is something so 'skeary' about them, and the noise and flash are so bewildering.'[68] Polly Condit Smith explained how on 1 July there was a panic again among the marines that the wall had been evacuated which would

> enable the Chinese to mount their guns on this portion of it, directly commanding the British legation, and to fire down on us, and no one can say how long we could hold out against such an attack. In such an event we will put women and children into deep bomb-proofs that have been made for that purpose, which are covered with logs, sandbags, and dirt, and are shell-proof. These trenches we have made as near as possible like those used in the siege of Ladysmith.[69]

In spite of the danger, women were not quick to climb into the shelters – in fact, the American diplomat William Bainbridge suggests that they 'never had a single occupant' because of their courage.[70] But Morrison's siege gallows-humour Coltman story, mean as it is, gives another reason; he wrote on 4 July,

> Coltman is another depressant. With the sweat of his brow he dug a bomb-proof shelter but it has been remarked that the first shell falling upon it could bury all the occupants in a common mound. And with much callousness it was suggested that families should be separated another time so that all eggs might not be in the same basket and chance of losing all might be reduced.

On 8 July, he added for good measure:

> The most depressing man in the legation is Coltman. So convincing is he that all is lost and that our last hour is approaching that he has discontinued attending to sanitary work and has made his will leaving everything to his wife and children. I induced him, in order to cheer him, to make further provision – suppose his wife and children should be in the massacre.

And he later added, 'Coltman has resumed his courage now that danger is passed, has ceased drinking ...'[71] Coltman himself gives no sign in his published account of untoward behaviour, though it is not he who keeps the family diary; he explains, 'Being occupied daily with sanitary work and attendance on the sick, I was unable to keep much of a diary, so I instructed my son Robert, aged 16, to do so for me'.[72] Dr Coltman does, however, provide the setting for his son's record and in that he expresses an opinion that could apply to his supposed friend Morrison:

One of the most noticeable effects of siege-life has been to bring out into prominence all the mean and selfish characteristics of the individual, as well as the heroic and self-sacrificing. People who in times of peace pass for very nice, sociable individuals, with no particularly mean tendencies, when subjected to deprivation in the food-supply and their nerves become a bit shattered with the sound of whistling bullets, the shrieking of flying shells, or the dull thud followed by the crashing and grinding of solid shot, show up in their true bedrock character, and are meanness to the core.[73]

How Mrs Coltman coped with all this and six children (one a babe in arms) has to be left to the imagination. And who did Ethel MacDonald have in mind when she wrote, '...there was one man who wept incessantly on his brave little wife's shoulder and never gave us more than forty eight hours to live'?[74]

An example of a male diplomat less brave than might be expected was another beau of Polly Condit Smith, Claus von Below, the German Chargé since von Ketteler's assassination; she wrote on 5 July:

... notwithstanding his military physique, [he] seems to be developing into a man of moods instead of a man of action, and the story comes over from

26 Dr Robert Coltman jnr standing (right) behind his wife with their six children and his parents (post-siege) (from *Beleaguered in Peking*)

his quarters [in the German Legation] that during this last terrifying attack he was seized with the premonition that this was the end. He preferred to meet his doom by making his piano interpret his last feeling. The music from 'Valkyrie' that he drew from that instrument was marvellous. He played, regardless of time and place, in a soul agony, but was rudely awakened some hours later to be told that the attack was all over, and that for this time at least he was not to be massacred in a storm of music.[75]

The Siege of a Lifetime

Even Polly Condit Smith had her off days; on Sunday 1 July, she admitted: 'I have been quite under the weather, to use a civilized expression, and I assure you that things have got (not are getting) to such a state that to live and act and talk as one would do at home is quite out of place.'[76] I suspect that Polly is referring euphemistically to menstruating, and that raises questions about how women coped – something which, it being only 1900, none of them begins to elaborate on.

On 27 May, for example, as things hotted up, Mary Bainbridge wrote, 'Received a birthday present which made me rejoice for just four weeks, then it was taken away from me and my heart has ached ever since' – which I can only interpret as an early miscarriage. Bessie Ewing, as we know, was newly pregnant; Paula von Rosthorn may have been too. Mrs Bok and Elizabeth Cockburn were advanced, and Mrs Moore gave birth to a boy (to be nicknamed, at least, Siege Moore) on 24 June.[77] But there is no other hint about the exigencies of women's particular bodily functions. It would be interesting to know if, in such a comparatively short time, the menstruation cycles of the women living together began to coincide, or if others stopped menstruating altogether.

Childbirth and the menstruation of foreign women raises the question of their pollution and its possible repercussions on the Boxers' efforts to eliminate the besieged (its inherent power for the women and its undermining of the power of men). Childbirth was generally more polluting than menstruation (because of post-partum discharge) whether the woman was Chinese or foreign, but the Chinese were not impressed by how foreign women dealt with menstrual blood; a Chinese woman informant summed up the difference: 'It is better to use paper that can be thrown away than to use cloth that must be washed each month.'[78]

Whatever the psychology of this aspect of foreign women on the Boxers, the siege conditions certainly had a bearing on women's general health. Temper and spirits were affected – fear undoubtedly being a component part. Dr Emma Martin wrote on Wednesday 27 June:

Mrs Walker is quite ill today from loss of sleep and boils in the axilla. I fear I am a demoralized missionary. Spending many nights in the ball room ([dressed] every other night now) and much of my time in the billiard room (set aside for the night nurses) sewing on Sunday (sandbags), sitting up all night with young men (in the hospital) sometimes too busy and tired to comb my hair daily or read my bible and pray as I should.[79]

She even began to fret in the hospital; two days later she complained, 'We have an English Deaconess as Hospital Supt. and she goes around with her keys and scissors jingling from her belt with no more executive ability than a chicken.'[80] On 30 June, Deaconess Jessie Ransome wrote, 'Miss Lambert is not well, and off work today, which makes me a bit extra busy.'[81] Did Emma Martin confuse the two British women, or was Marian Lambert failing because she too was overstretched?

What Dr Nurse Martin needed was rest. The response of 'outspoken' Sara Goodrich, mother of three, to the nervous tension seems to have been to become especially judgemental of her sisters, particularly of her fellow Methodists with whom she mixed most and whom she knew best. She wrote on 7 July, 'Miss Haven seems to me very miserable. It appears like nervous prostration.'[82] The following day she noted:

Mrs Jewell sent three men to find a mill, so her girls could grind their wheat. They went beyond the new barricade, and her carter was killed. She is very sorry over it. It seemed an unnecessary waste of life.[83]

And, on 18 July, for good measure, she recorded: 'Mrs Tewksbury is miserable. She seemed to suffer more during the firing than the other ladies. I believe her bowel-trouble is largely due to nervousness.'[84]

Polly Condit Smith, without the family responsibility of many women, found more occupation worked best as a palliative, particularly since it was not only the wounded in hospital who needed looking after: 'dysentery has its grip on almost everybody here', she pronounced; and there was a home remedy:

The treatment is almost to stop eating and to drink rice-water in large quantities ... When the kitchen is comparatively free, Mrs Squiers, my maid, and I make gallons of rice-water, thick, nutritious but tasteless, which we bottle in quart-bottles and place to cool in our zinc-lined, cold-water-filled box. It is placed in a corner of our two-roomed quarters, and the constant stream of men coming and going to that box would lead an uninitiated observer to believe that at least a Hoffman House bar was hidden there and doing a steady business.[85]

No wonder Polly was so popular!

But in the end, perhaps, it was becoming accustomed that was the solution to coping; Bessie Ewing sounds like a typical wife and mother when she writes on 8 July:

These midnight attacks, though generally short, are much worse than in the day time. To be awakened out of a sound sleep by a storm of shot and shell is something terrible. Several times the big bell has been tolled as the signal of a general attack. This added to the cannonading of the enemy and the return fire from our men makes even me shudder. In the day time there is so much confusion that one does not always distinguish sounds, but when all else is quiet these sudden onslaughts are appalling. It seems as though we must surely be overcome and when a lull comes in the storm I dream of a Boxer sword poised over my neck. That first night of fierce firing I could not help asking myself if I was willing to die. I did not feel afraid to die but I would rather live longer. I feared most that Charles might be killed and I should be left alone with the children. ... Now even these night attacks have lost much of their terror. Of course I waken but often fall asleep again before the firing ceases.[86]

And Theodora Inglis emphasised another aspect – positive thinking:

It was said that there was not a woman pessimist on the ground but that we had four men of that persuasion. They were of English, German, French and American nationalities, 'blue pills' they were called. They were the only men who talked openly about their poisons and their pistols being in readiness for suicide and family slaughter in event of the worst. According to them, at dawn we were never going to live until night fall and at night, never until morning and so on ad infinitum. We should have been thankful that we did not have a whole box of these 'blue pills'.[87]

Polly Condit Smith made an aspect of flirtation out of the business of death at the hands of various young men rather than falling into Chinese hands; there is no doubt, though, that it was a real subject for discussion. And, bearing in mind what they had seen and heard of the treatment of Chinese Christian converts (and what was later to be learnt of the fate of foreign missionary women in the interior), it was not an issue to be dismissed out of hand.

Dr Emma Martin discussed it with Fuller, the steward from the *Orlando* who had come up with the British marines and worked as an orderly in the hospital. Fuller was much loved by everyone and he and Emma Martin, who were often on duty together, had a touching relationship. She wrote of 6 July:

That night the firing was so nearby Fuller could not sleep so he got up and dressed and we sat there in the dark talking and waiting. We talked about what one would be justified in doing should he find he was going to fall into the hands of the Chinese alive. I would not mind being shot but I did not

want to fall into their hands as a prisoner and I said so. He exclaimed, 'It shall not be, it shall not be, we will not let them.'[88]

The wife (not among the besieged) of Wilmot Russell, one of Claude MacDonald's ADCs, wrote on 1 June 1963 to Peter Fleming and described having tea in 1931 with Ethel MacDonald (by then a widow):

> Lady MacDonald also told us she had asked her husband to shoot her and the children if the Chinese got in. And then, afraid that he might not be near her at the time, she asked Dr Poole to give her poison – to which he replied that he would not as she might just poison her family as help arrived.
>
> However after the siege, she was nursing Dr Poole ... and she asked to get something out of his attaché case, found a letter addressed to herself, and on asking what it was he said, 'Oh that is the poison – I had it all ready for you.'[89]

And there were other ways of facing the end; Polly Condit Smith wrote on 16 July:

> Late yesterday afternoon the shooting seemed to cease temporarily as I was sitting with Baroness von Ketteler on one of the benches which bore witness that this Supply Department had been, before the siege, the Legation tennis-court, when a bullet whistled with startling clearness within half an inch of my ear, passing between the Baroness and myself. Knowing that the sniper who had spied us was taking a moment to re-aim or reload, I immediately dropped from the bench on to the ground to get out of his range, trying at the same time to pull Baroness von Ketteler with me. This I could not do, and it was some time before one of the Customs students who was working quite near us realized that we were the target for this new sniping, and forcibly led her back to the Legation. In her agony of mind I am sure a bullet to end her suffering would have been truly welcomed.[90]

Ambassadors' wives had a specific role. Stéphen Pichon never mentions his but a biographical panegyric to him at the end of his book observes:

> It is under such circumstances that the wife, or the Ambassadress, can best collaborate with her husband, giving him the benefit of her charm and her grace, and all the finesse of diplomacy, that science so eminently feminine.
>
> Mme Stéphen Pichon could not fail in this task, and those who knew her, those who remember this young woman, so gentle, so simple, so charming, cannot think without trembling of what could have been and what is perhaps still her agony – the agony of all those women and all those children. Men, after all, are men and when one represents one's country one is always, more or less, in a state of battle. And then in this life so short, where no man is master of his destiny, it is something special to have a fine death, to fall bravely for one's flag, for one's country, side by side with the representatives

of other nations, competing with them in heroism, solidarity and self abnegation.[91]

In the end, though, when we are talking about fear and bravery, it is Theodora Inglis who tells the best story, and it is George Morrison, so judgemental of others, so dismissive of women, who gives her the opportunity to tell it:

> Those who knew him personally, liked him. I met him the first time at Mrs Squiers. She had kindly invited several of us to lunch with her [on 11 July] and I remember listening for Dr Morrison's conversation – I had once read a most enjoyable book of his – but he was evidently considering weighty matters for, I think, that he uttered only three sentences during the hour and I departed disappointed. He was one of the lions in the Siege and he didn't roar.
>
> Everyone treated him well too – beautifully in fact – accepted his criticisms, with which he was not chary with proper meekness, and showered favors upon him. Indeed who would not so treat the man who is able to influence the foreign policy of the British Government. ...
>
> But most of us admired him immensely even when he said emphatically, 'You should appreciate your advantages – the privilege of indulging in a Siege, the like of which was never known in history.'[92]

Tracking the impressions of George Morrison through his diary with a jaundiced eye, I cannot help noticing that on 9 July, two days before this lunch, he was dining with the Cockburns and the Reverend Roland Allen who records: 'He was reminding us that we should probably only meet with one siege in a lifetime, and that it was just as well to have a good one whilst we were about it.'[93] Not a lion, but a peddler of aphorisms around the messes.

But, as Theodora Inglis responds,

> The advantages were not so patent to me then as they may be when I am a white haired grand-mother, then I dare say, I shall gather my little grand children about my knee and tell them of the wonderful Siege in Peking. ... And for fear I shall be tempted to boast, let me set down right here in indelible characters that I was not one of the heroines – had it been left to my choosing, I would never have sought a Siege in any shape or form. I was only a 'weak woman' with a baby and a husband and frightened badly at times for all three of us.[94]

There is not only one template for heroism then, it is clear. Paula von Rosthorn may have been the 'Good Fairy of the Defence' and Annie Chamot ridden shotgun under a hail of bullets to deliver bread, but Laura Conger also faced her fear and triumphed, and Theodora Inglis kept her sense of humour – at least for a while longer.

Ironically, on 16 July, the day that Maud von Ketteler refused to dive for cover, the outside world was informed of the massacre of the foreigners besieged in Peking. Thereafter a memorial service was planned for 23 July in St Paul's Cathedral in London, and only cancelled at the last moment. The *Daily Mail* reported:

> They died as we would have them die, fighting to the last for the helpless women and children who were to be butchered over their dead bodies. ... Of the ladies it is enough to say that in this awful hour they showed themselves worthy of their husbands. Their agony was long and cruel, but they have borne it nobly and it is done.[95]

Well might Ada Tours write in her diary four days earlier:

> Mother's Wedding Day! I wonder what news the papers give her of this part of the world. As the only news can go from Shanghai I fear it will be disconcerting for Shanghai even in times of peace always gives exaggerated reports. Poor Mother![96]

11
Loss – Mrs Inglis, Mrs Narahara and Mrs Li (4–24 July)

Bastille Day in the French Legation

'One day when Arthur was again lying on guard behind the wall, a bullet hit his loophole from very close by.'[1] Paula von Rosthorn is writing of an incident that occurred on 7 July, only ten days after her own injuries and only a week since the French had briefly retreated from their legation (1 July), and then retaken it.

Through the force of the impact of bullet on stone, 'some particles entered his left eye and injured his cornea', she continued. At first, after Dr Matignon had examined it, the injury did not seem serious – time would heal it. Von Rosthorn was in considerable pain, however, so Matignon gave Paula a small flask of cocaine from which she should drip a little into his eye. But, as Paula explains,

> Towards evening it got so bad that even the unhurt eye was completely blinded through the shock to the nerves, and the pain became so fierce that I injected him with cocaine three or four times during the course of the night. It was in every way a horrible night. The Chinese fired with guns and cannons without a break as if raving, shouted their eternal *sha*! *sha*! and, in addition, made a row with their trombones and gongs. Then the cocaine seemed to have a bad effect on Arthur's heart, causing severe constriction which was heightened by his feeling of helplessness because of his blindness.
>
> Towards morning I brought him out onto the veranda in front of our dining room and went for ten minutes, at the most, into the kitchen to cook a breakfast soup for the sick marines. When I came back, I found him in such a state of feverish exultation that he exclaimed, 'Oh, there you are, after all. I thought you had all abandoned the legation and left me behind.'[2]

This seems to be one of the most touching personal moments of the siege and it is compounded, for Paula at least, by what happened next. Von Thomann, the Austrian commander, has so far appeared as a somewhat shadowy figure but always apparently responsible for an avoidable setback; now Paula gives him another dimension:

> By chance Thomann came past and comforted us both so tenderly and knew how to calm Arthur down wonderfully. Soon after Thomann went to check with the guards to the East. Only five minutes later we heard that he was dead ... He was standing with Darcy and Winterhalder and talking about the possibility of a sortie to capture the cannon which was less than 150 feet away. He stepped up to the breach [in the wall] and at the same moment a shot sounded, a shell exploded in front of him and he was hit in the chest by a big explosion while a smaller one shattered his right arm. He said only, 'Oh! oh!' and fell dead into Darcy's arms.

At the end of her account of the funeral that same afternoon, Paula describes von Thomann as 'a noble man, a brave officer, a loving commander'.

For Paula, her husband's eye injury and von Thomann's death followed each other on the same day; in fact von Thomann appears by other accounts, including Darcy's, to have been killed and hastily buried on the 8th. This, together with Paula's view (and experience) of von Thomann underline yet again the precariousness of historical reconstruction and its dependence on the perceptions that survive on record. To compound this, Nigel Oliphant, keeping his diary in the British Legation, where his brother David had been killed three days earlier, continues to maintain the view of von Thomann as inept, even in the manner of his death: 'He went along a small lane in the German Legation in spite of all warnings and a shell caught him just as he was half way through and killed him on the spot.'[3]

George Morrison's diary account of von Thomann's funeral, instead of following the critical line taken by Oliphant, adds to the poignancy of the events merged in Paula's memory: 'Mrs von Rosthorn crying but bravely holding up her head, her hands all covered with burns; her husband standing there with his eye bandaged.'

The image of Paula herself is further burnished by Darcy's diary entry of 11 July:

> Mme von Rosthorn continues to move amongst us, her countenance so delicate, so soft, so full of laughter. If she is aware of the danger, she hides her feelings so well that it is impossible to read in her face the least trace of vexation or anxiety, except when her husband exposes himself to danger more than he should, which happens rather too often. She has a kindly word, a consideration, a willingness to help everyone, volunteers, officers, and marines; you can always be sure that she will be where she is needed.

But Mme von Rosthorn gives priority to our sick; she knows how to find condensed milk to prepare herself the bread and milk and drinks prescribed by Dr Matignon for those with dysentery. Marvellous mistress of the house, she prevents our last tins of food, kept back for the wounded, from being wasted. For all of us, she is the good fairy who will protect us until this fight is over.[4]

Paula, like many of the other women, rose to the challenge in a way that may have surprised even her; and she gained obvious satisfaction from her total commitment to the cause of the French Legation and those fighting there. Here is her description of her role:

Our supplies were now much reduced and we lived almost exclusively off horse goulash, bread, tea and rancid butter. At first we had been wasteful and now we paid the price. We suffered mostly from having no vegetables, potatoes or rice. Because of the bad nourishment, several of the men suffered from digestive problems and so it was a difficult trick to secure an adequate diet for them. Among the French marines there were several with dysentery for whom I had to care. From time to time I went to the English Legation and begged from different people there whom I knew had larger supplies such things as a packet of biscuits, some arrowroot flour or, and this was the most precious, a few tins of condensed milk.

Through thrifty use of these treasures, I could constantly supply my patients with the necessities and I had the great pleasure of seeing most of them soon recovered. And they were all so grateful for my efforts that it was really touching.[5]

Strangely, Paula does not describe what happened on 13 July. At about 6 o'clock in the evening, the climax of incessant Chinese attacks on the French Legation came with two mine explosions. Arthur von Rosthorn and Captain Darcy were standing side by side, together with some marines, when they were blown off their feet and buried under a pile of rubble; a second explosion threw them up into the air and free, covered with dust, dazed, bruised but almost completely uninjured (Darcy had a slight head wound). Two marines were killed though and several of those Chinese who had dug the tunnel and set the mines and who did not get out of the way quickly enough. Now, too, there was a terrific conflagration and the French and Austrians hurriedly took to the trench which they had dug earlier in the day.

Deaconess Jessie Ransome records a somewhat factual perception of the incident from the British Legation:

Fairly quiet till 6pm, when the Chinese made a determined attack on the French Legation. They had mined one of the houses, and had blown it up, and soon the whole place was in a blaze. The fire burnt all night, but in spite of it, the French succeeded in holding their position. The attack went on

furiously till eight; the alarm was rung, and every one was on the alert. The noise was so deafening that we had difficulty in making ourselves heard.[6]

But for Dr Emma Martin the appreciation of what was happening at the French Legation merged with her own experience in the hospital; she describes the mine explosions and then continues:

The soldier, French, who was shot thro the trachea and oesophagus was very bad last night and Dr M[ackey] had to sit by him all the time to keep the tube clean and I had all the rest to look after. When Fuller [the orderly] who is very tired was spreading down his little mattress in the operating room, I said 'how nice it is to see a bed with a sheet on it'. I had not slept on one for a month as we gave all ours for sandbags, and he said, 'Sister, won't you lay down there and sleep and let me take your watch?' But I wouldn't think of doing it for he was on duty night and day and then he said, 'Don't carry the bed pans, that's no work for you, Call me if they are wanted.' But I did not promise.

The firing was heavy between twelve and one; lurid flames lit up the sky toward the French Legation and I could hear it roar and crackle and snap. The dim moonlight now eclipsed by the firelight, the rattle of musketry, the howling Chinese outside and the dying men inside made things seemed weird and ghostly and unreal and like a horrible dream, a nightmare.

Dr Leonard came to relieve me about 2 and I was not sleepy but she insisted on me going. I hated, yes, I suppose I might as well admit, I was afraid to go through the long dark hall of Sir Claude's house where there were so many boxes and beds to stumble over all the way along. Fuller was awake and so I asked him if he would mind going over with me and he said he would with pleasure so he did. He is not at all like an Englishman.[7]

Darcy writes laconically of that evening of the 13th, 'Everyone went to eat at the Chamot Hotel [next door].'[8] There, as Morrison observed when he visited it the next day, the Chamots and others, including Mme d'Arc, wife of the assistant manager, were camped out in the corridor rather than using the bedrooms.[9] Morrison had written in his diary three days before (8 July):

Chamot's hotel has again received 91 shells in an hour yet work still goes on. Mules are grinding flour 1/4 Indian corn, 3/4 wheat in the ground floor rooms – four in all – making 450 pounds a day. He bakes 300 loaves a day sending 100 to the French and Austrians, 80 to the Russians, 60 to the French at the British Legation, 20 to the Russian Minister and the Russians at the British Legation ... he has large stores of wheat sufficient for several weeks.

And two days later, Nigel Oliphant recorded: 'The valiant Chamot and his wife and two friends went into the small police station next the hotel and could

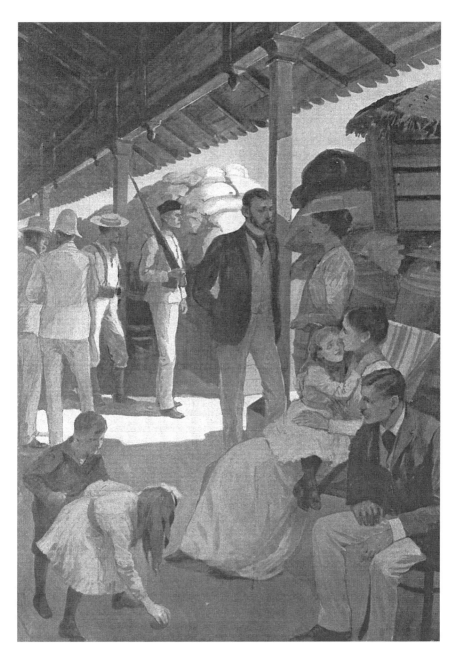

27 French Legation families in the Tours' house, British Legation. ('Very funny picture! I've never seen the Fr Legation people look so clean or respectable in my life!' – B.G. Tours (in pencil on his copy) (from *The Illustrated London News*, 20 October 1900)

plainly hear the Chinese shouting and officers trying to persuade their men to climb over the walls and kill the foreigners.'[10]

There was not now much left that was habitable in the French Legation; the house of Mme Saussine and her student interpreter husband had been set fire to on 7 July; on the 8th the house of Mme Morisse and her husband, the Chinese Secretary, had been demolished by cannon fire; the mine finished the job of destroying the Saussine's home and the fire that followed that of Mme Pichon and the Minister – M. Pichon mourned each room lost: 'my bedroom, my study ... all my personal possessions ...'[11] He waited in the British Legation for the 'final massacre'. It is a nice touch that Mrs Bainbridge believed it was M. Pichon (rather than the Austrian Chargé looking after his legation) who was injured on the 7th.[12]

As for Paula von Rosthorn, she wrote about 14 July,

> Since I did not want to claim a whole room to myself, I had to make the decision to move to the hotel. I was very saddened that I had to leave the French Legation and be once again separated from Arthur but I decided I would rather stay at the hotel than return to the English Legation. At this point Herr von Below came and offered me a room in the German Legation which I happily accepted.[13]

Arthur von Rosthorn was now homeless and seemed to revel in it; Paula remembered: 'Arthur stayed nowhere; he slept at night in a hammock next to Darcy and only when it rained did they retreat to a veranda.'

As for the German Legation, Darcy writes that Paula was now 'the Germans' hostess', so that evening, France's national day, 'it was she who presided over a charming reunion'.[14] Dr Matignon described how, 'Thanks to M. Chamot our genial and heaven-sent commissariat officer, we ate fresh veal and we had white bread.'[15]

Chamot's procuring of the veal almost created a diplomatic incident between the British and French because the calf and its mother belonged to the British and were carefully guarded. But Chamot had long coveted the calf and that morning, while visiting their legation to deliver rations to the refugees, he determined to give the defenders of the French Legation a veritable feast. First, he gave the two sentries a bottle of whisky to celebrate the French festival then, when they were asleep, he (and presumably Annie) tied the calf up and bundled it into his cart. 'It was child's play' for Chamot and an hour afterwards they were all enjoying its succulent flesh.

That was in spite of what the student interpreter Hewlett recorded of the 14th: 'Chinese bugles quite close in the S.W., followed by a fire in the German Legation, when the Chinese completely set fire to the Legation stables, and planted a flag there. The Germans attacked and captured the flag driving out the Chinese who were there.'[16]

Paula paints an interesting picture of the German Legation at this most trying time of the siege though it is noticeable that her whole account omits any mention of Maud von Ketteler, the former mistress of the legation, or Annie Chamot who offered her hospitality in the Peking Hotel on the night of the 13th and as long as she wanted to stay; or, indeed, Ethel MacDonald who looked after her for the first five days; Paula wrote:

Everyone when they entered the German Legation was surprised by the clean-liness and order that reigned there. There we could almost forget that we lived in a state of war. The gardener had to take care of the flowers and garden just as before, and the servants in the house had to do their work as usual. More than that, every time a grenade hit, which happened repeatedly in the Minister's house, the first thing was to call the trembling 'boy' to sweep up the pieces of wall and ceiling and get rid of the dust neatly so that you could only notice the holes that the shells had made when it rained. Then all the bowls and buckets were brought out and placed in position and the furniture and carpets were protected from the wet. It was a pleasant contrast, a return to order, at least in the house, because outside the racket did not stop all night.[17]

But, as always, Paula's main concern was her husband:

Arthur came to us every day around four or five in the morning when the flies did not let him sleep any more. I spent the greater part of the day over with him, just as before. I always had a superstitious feeling that nothing could happen to him while I was there, and therefore every separation was terrible for me, more so because he was so reckless that the officers often asked me to tell him that he should not so expose himself.[18]

American Independence Day

Celebrations among the Americans on their national day, 4 July, had been even more low-key than they were to be among the French ten days later; Mrs Conger wrote:

We did nothing to celebrate the Fourth, except to wear our little flags, attend to duties here, and send loving thoughts homeward. Mr Conger and I went over to the American Legation and got a silk flag and placed it over the graves of the six American marines. Many of the foreigners and all of the Diplomats called and congratulated us upon our Independence Day. They are always very prompt about those things. Mr Conger spends most of his time at the American legation consulting with the officers and encouraging them. This morning I made my rounds, then went off in a little nook by myself to read. ...[19]

It was hardly a time for celebration, though Mrs Squiers – called by many 'Lady Bountiful'[20] – made an effort for the children, throwing a party for them which was much appreciated – 'a pleasant change for the little folks', as Mrs Goodrich, mother of three, described it.[21] And that evening, Mrs Squiers gave a select dinner party at which she served 'tiny chickens' which her cook procured that morning from a nearby market at great risk to his life. The left-over chickens were kept and nurtured to feed the ailing babies.[22]

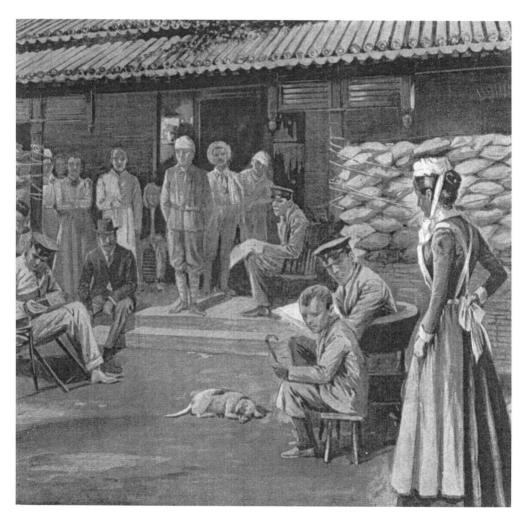

28 The Siege Hospital (from *The Illustrated London News*,
20 October 1900)

In the hospital, the occasion was to demoralise the wounded Americans, in spite of Dr Emma Martin's best efforts:

> July 4 – ... The boys seemed so blue this morning. As I went about helping them get washed, I tried to cheer up those with wounded arms telling them it was a good thing it was not their leg so when the troops came they could walk to Tientsin. ... Several of the boys wish they had been killed instead of wounded. We had scalloped oysters and green gage plums for supper and what a feast it was.[23]

Caring Nothing for Bullets and Shells

From 5 to 16 July, the British Legation was under continual fire. Nigel Oliphant rather gave a hostage to fortune when he wrote on 10 July that the women and children 'now walk and play about the compound and care nothing for the bullets and shells that are always crashing and whistling through the trees. They ought to be kept indoors, but are not, and luckily, so far, no woman or child has been hurt.'[24] The following day he, as a volunteer combatant, was wounded, though not too seriously.

But several non-combatants did have nasty moments even when they were not taking risks outside. Sara Goodrich noted a string of them in her diary: On 6 July she wrote, 'This morning, while sitting near the chapel door, a piece of shrapnell struck me above the left lung, but glanced off. It seemed like a wonderful deliverance that it was a spent piece.'[25] The following day: 'Today a great cannon ball went through Sir Claude's house roof, and came down in an adjoining room, smashing the glass on the table.'[26] (The table was set for dinner.) 'Another great ball struck Sir Claude's house in the early morning', she observed on the 10th,[27] and continued on 11 July:

> The last few days 38 cannon balls have been picked up in Sir Claude's house, court, or wall just behind it. But all have been aimed at his house. A ball struck an Italian patient in the hospital last night in the stomach. Luckily it was spent. He picked it up and threw it away. A ball also lodged in the roof of the first Secretary's house last night.[28]

That same day, Deaconess Jessie Ransome wrote, 'I had a narrow escape the other day, going to the hospital a piece of shell which fell within two yards of me, and which I picked up still quite hot, also a large cannon ball came into Mr C[ockburn]'s bedroom window but, fortunately no one was in the room. I heard the crash and ran in to see.'[29]

Nigel Oliphant had noted on 10 July: 'In the afternoon [the Chinese] mounted a small one-pounder behind Cockburn's house and then knocked a few holes in the roof and startled Mrs C by sending a shot into her bedroom. Luckily no damage was done.'[30] Jessie's colleague, Roland Allen, suggests that

there were two separate incidents, but Annie Myers confirms they shared a bedroom at this time, whatever the usual arrangements of the newly-marrieds; for some, and Jessie Ransome in particular, it was always the man's house. In any case, after the first incident, the women were moved over to the other side of the house, and moved back after the second incident; and, thereafter, the rain came through the shell holes.[31] On 14 July, a four-pound shell 'jumped' through the window where Lily Bredon and her daughter Juliet were sleeping, but fell harmlessly between them.[32]

Ada Tours records that on the 16th, 'Daisy [Brazier] got hit this evening but not seriously. She was walking in the compound when a shell burst overhead and fell – a piece striking her on the ankle bone and causing a good deal of pain for some hours.'[33] Strangely, Ada Tours does not mention a rather more serious incident recorded by Morrison in his diary two days before: 'One Chinese woman was shot today while crossing the barricades upon the legation redoubt and Tours' amah while in the yamen between our legation and the American.'[34] He obviously did not realise he had already made a note that day about the same shooting, in which he makes it clear that Ada Tours' amah was killed 'by the bursting of a shell'.

Ada Tours has a tendency, as we shall see again, to omit details that are too close to home; Sara Goodrich has no such qualms where her imagined readership is concerned. She records a similar story the same day which may well be the same incident: 'Three women went out at the great gate this morning, and presently two came running back. The other had had her brains blown away.'[35]

The chance to retaliate was at hand, as Mary Bainbridge explains on the 8th:

This afternoon some coolies saw the American gunner trying to rig up a big gun out of some old things which had been found, and after watching him for some time two of them started away and in a short time they returned bringing with them an old English gun which they found in a Chinese shop not far off. It was brought here in 1860. Our gunner looked at it with a smile, laid aside his other work and set himself to work fixing up the one which the coolies brought in. He had it mounted on an Italian carriage and with Russian shells which the Russians could not use [because they had left behind the gun in Tientsin]. The American gunner fired it over into the Imperial City about 5pm and it proved a great success, as the Chinese got up to 'look see' what had happened. They were picked off in great numbers. And we all rejoiced at their loss.

Dr Emma Martin adds some details to account for the fact that one of the machine's names was the 'International': 'They got the Russian ammunition and with a Jap. fuse and German fuse powder and Italian carriage and Amer. gunner made the thing work. Thanks to Yankee ingenuity.'[36] The mongrel's other names were 'Betsy' and the 'Empress Dowager' and, temporarily, at least,

she helped to lift morale, as Mrs Goodrich confirms: '"Our gun" at noon was taken outside the gate, and it has been knocking at the Imperial City (Huang Ch'eng) wall, making a big hole in it. Certainly the gun was a grand find.'[37] She noted without irony on the 12th that a captured Chinese reported that 'The Dowager Empress [not the cannon!] had forbidden the use of guns of large calibre against us, fearing the harm they might do to her loyal subjects and their homes'.[38]

Another American woman explained, 'We all claim [the International] you see for we are so glad to have it.'[39] But Jessie Ransome was not convinced of its efficacy; she noted: 'It seems to have only had the effect, however, of stirring up the enemy, for they have been shelling us vigorously; one shell hit the [Cockburn] house, and another burst close to the hospital.'[40] And Annie Myers reported Sir Claude MacDonald's explanation for calling the cannon the Empress Dowager: 'One never knows what it will do next as after each shot "she jumps up on end and dances round the room".'[41]

In the midst of all this public activity with bullet and shell, Dr Emma Martin had a private experience on 9 July the ramifications of which were to linger and spread; she recorded:

I had a horrible night at the hospital last night. A German who had been shot in the foot had lock jaw-tetanus and he fell to my lot to care for the way Dr Mackey and I divide our work. He was in a room with eight or ten other men and having convulsions, and according to order I gave him 'half a syringe full of morphine solution' which did not relieve him. It was awful to see him, so in half an hour Fuller advised me to give him another dose which I did and he soon became more quiet. I sat on a chair at the door where I could hear any noise he made and after a little while he was so quiet I went to look in at him and he was dead. While or just after I had given him his last dose of morphine I took the syringe back to the operating room to clean it and had to put in the 1% carbol., the solution Dr Poole often uses for his instruments and seems to think sufficient, and in handling it I nearly let the basin drop and in my effort to save it I stuck myself with the dirty syringe.

I squeezed out a drop of blood and went to the storeroom where Dr M and Fuller were eating their lunch and told them what I had done. He caught my hand and sucked the wound and I went back to my watch and the horribleness of what might befall me came over me so I had Dr M take one of her own little knives, which she happened to have with her, and make a deep cut and then put in Pure Carbol. acid. After that very soon we had the unpleasant task of getting the dead man out quietly so as not to waken the other men and we succeeded very well.[42]

Further public demoralisation came with the deaths. Mary Bainbridge wrote of 16 July, that at 2.30

We buried our American boy by the side of his six companions in the Russian compound. All the Legation ladies and many of the missionaries went over for the funeral. Mr B had already gone over to superintend the digging of the grave and we went over with Mr Conger. We gathered what flowers there were to be found and some green leaves to strew over the graves of all. It was the first one of our boys who had been buried when ladies could go. The rain was falling softly down on our umbrellas and the tears silently rolling down most of our faces. I stood at the foot of the grave and as I looked down upon the form of the poor boy lying on the cold ground dressed in his blue clothes and our American flag wrapped round his lifeless body, I thought of the poor mother at home whose heart would be sadly grieved did she but know how her boy had fallen in trying to save others.[43]

Polly Condit Smith noted that same day:

Last night young Warren, of the Customs, was carried through the compound on the way to the hospital, his face almost entirely shot off. I knew him quite well – had danced with him often; he was a charming fellow. He died at daybreak this morning.[44]

At much the same time, Captain Strouts (the British commander), Colonel Shiba (the Japanese), and George Morrison went to reconnoitre when disaster struck; Polly added to the same diary entry:

About 8.30 this morning, after our mess had been straightened up, I was *en route* for the hospital, carrying a pot of coffee to the doctors and nurses, when some soldiers passed me, carrying a rough litter bearing Captain Strouts, mortally wounded. It was especially shocking to me to see him thus, as he had breakfasted with us at seven o'clock, and had seemed tired from his constant work, but hopeful and in good spirits. His arm was hanging limp, the hands and fingers stiff with agony. It seemed but a moment before that I had passed him at breakfast a cup of black coffee, to receive which he had held out that strong, slim hand, with the signet-ring on the little finger, and now it was so changed. In less than two hours the hand was being held out, but in his death-throes.[45]

Dr Emma Martin, on duty in the hospital, takes up the story:

The darkest day of all the siege I think and others say so too. It was drizzling and everything was wet and sticky and dirty and smelled so bad and the flies were terrible. About 7 I stood on the hospital veranda and watched about 20 of the English marines pass by and go through a hole under the wall to cross the old canal almost into the Fu. In about an hour they carried in Dr Morrison ... with a flesh wound of the thigh. And almost at the same time Capt. Strouts with a shattered thigh, who died that morning of hemorrhage.

He was the best officer we had for Myers our Amer. Capt. was in bed and Capt. Halliday, their best Eng. officer but still they had Strouts who was a brave man. Now we have Hall and Wray left, the American and English Captains whom their men despise for cowardice and drink habits. We wonder why it is that the best and bravest are always taken. Fisher, another one of our marines was killed on the wall today, and still we wonder at this rate, how long we can hold out.

Capt. Strouts was buried this eve with honors. The funeral was beautiful, impressive, and sad. Just as they had removed the flag for they only have one to use for all, a shell passed over our heads so close with such a shriek that we all involuntarily ducked our heads. ... In walking back to the chapel I had said something about the sadness and hopelessness of our situation to Fuller and he had said cheerfully (although Abbie Chapin said he had broken down completely that day) 'Why if all the boys were killed, if only the women and children saved it would be all right.' [46]

George Morrison does not appear to mention in his diary the nursing care he received in the hospital; nor does he mention the nursing staff more generally in his three long, much-admired, post-siege articles. With Captain Strouts' death, Harriet Squiers' husband took over as second in command to Claude MacDonald.

Prince Ch'ing and Others

If the 16th was the darkest day, according to Emma Martin and the record of the three funerals, things were about to change. It is to Dr Martin, too, that it is best to turn for what was to precipitate the change. She had written on 11 July:

I slept in Sir Claude's smoking room last night oh, so soundly, though I was within 20 feet of his powder magazine which was soon moved to the cellar. Mosquitoes are dreadful. A rumour is abroad today that a great battle has been fought in which the Chinese were badly defeated, at Tientsin, I suppose now. Also that Prince Ching is fighting the two other Chinese armies and that the Russians say that the Chinese soldiers are leaving the city as fast as they can. Rather cheerful rumors on the whole.[47]

Her diary of 14 July continued, after the details about the French Legation:

Our messenger who went out four days ago came back today and said he had been captured before he got out of the city and taken to the temple and beaten, and then taken to Jung Lu. They got his letter away and read it and sent us word back, as that was the only way they could get a message to us, as we fired on every Chinaman who came near, that if we would come to the Yamen in groups of 11, unarmed they would protect us, that we had paid no

attention to their flag of truce and fired on their messenger which was all true. They said the [international relief] troops had been driven back by the Boxers, they started five weeks ago but they wished to preserve friendly relations and would protect us as above.

The letter closed as follows: 'This is the single way of preserving relations that we have been able to devise in the face of innumerable difficulties. If no reply is received by the time fixed even our affection will not enable us to help you. Compliments, Prince Ching and Others.' ...

Our reply declined their offer of protection and said they could communicate with us any time by a white flag. There was no official seal on their letter and we regard the whole thing as a ridiculous farce.[48]

The Ministers, for the first time for some time, had something diplomatic to discuss. Even Arthur von Rosthorn was present at the meeting; in his rather spare and diplomatic account of events, he records:

To participate in the deliberations of the diplomatic corps, I took my only collar, soiled by flies, from a nail behind the door and went to the British Legation. The relative quiet and fact of correspondence seemed to justify the view that there was a party at Court which did not agree with the violent line against foreigners. Our answer was designed to gain time.[49]

In spite of the fact that the whole foreign community, as well as the Ministers, was sceptical about the messages that continued to arrive from 'Prince Ch'ing and Others', some sort of truce did start on 17 July. Ada Tours' diary entry for that day reads:

Since the white flag appeared, there has certainly been less firing and we all feel different beings. We have hardly had a shot today and the rest to one's brain is immense. I think if they fire much more I shall be in a state bordering on imbecility and that when those wonderful troops do arrive I shall only be able to murmur the word 'sandbags' in an incoherent manner. Baby [Violet] is very seedy. I fear the atmosphere of dead horse and decaying Boxer is not exactly the sort of thing for children – added to hot weather and over-crowded quarters. All the children are seedy and looking dreadfully white but I am thankful that we have not had such desperately hot weather as yet. I do hope the troops will turn up soon and we can get away.

And now the irony of the truce was to hit the Inglis and Narahara families – just at a time when other people could start to relax a little, their agony was to reach its climax.

Mrs Inglis' Daughter

One of the other children whom Ada Tours is implicitly including in her account of their suffering was little Elizabeth Inglis who had been so perky on

the walk from the Methodist Mission to the British Legation on 20 June. Theodora Inglis had done her best to keep cheerful and optimistic but there were times when it was difficult, such as the nights she describes in the middle of July:

> Amid it all the clanging of our alarm bell, whistles blowing which was the Captain's signal for every man to be up who owned a revolver or a knife. Once he called 'every man to his post and those who have none, stand by their doors'. And not once but many times during that night my husband took his place in our little hall way while I could only creep across the floor in the darkness to where my baby lay. Often have I knelt over her with closed eyes listening, waiting for the sound of a struggle outside the door and the end of all things.
>
> Only once did my old Wang Nai Nai break down and in such a night as this. The attack was so bad up in our quarter that we had gone to the Chapel. As we crouched together near the little pulpit the old Chinese woman reached out and took the sleeping child from my arms and I heard her sobbing softly. The bullets were being poured in upon us and through the curtain of fire we could hear the demoniacal howls of the enemy and the shrieks of poor Nestagard ... One night I continued to sob and I could only say:
>
> 'Never mind Wang Nai Nai, never mind – don't cry it will be all right.'
>
> And she answered brokenly: 'I am not crying for us big folks – it is these little lambs like this one.'[50]

Straight after that part of her account, Theodora Inglis wrote, the connection being clear:

> About 14 July, our little Elizabeth, who had fallen ill, grew worse and Lady MacDonald moved her guests around and took us over into her main drawing room which was the highest and best located of any in the compound. Here every favor was showered upon us by our kind hostess and her sister, Miss Armstrong, and in the sad days that followed I could never tell of all their goodness – nor did I wish to. I have it all yet with that of my other friends deep, deep in my heart.

For nearly a week longer Theodora and John Inglis and Wang Nai Nai nursed their baby; Ethel MacDonald did everything she could to help; Theodora later wrote: 'We were given cradle carriage, mosquito netting, distilled and mineral water, daily, and Lady MacDonald even took her own three year old [Stella] off from cow's milk to let our baby try it for a change.'[51] But then the mother had to write: 'The change of room could not save the life of our child and on the evening of July twenty second, we laid her beside the brave Marines who had died defending her.'[52] Mary Bainbridge, who had been helping the Inglises

nurse their daughter, and hurried to be with them at the end, describes what Theodora Inglis could not bring herself to do:

> One of the missionary men made a little coffin of pine boards and the ladies covered it with white flannel and lined it with some white silk which [they] found. We found some little white flowers and with a few green leaves tied them with some satin ribbon Mrs Conger sent over. I put a little pink rose in her left hand and as we looked at the little form lying there so quietly, while bullets were flying over our heads outside, we could not but feel that it was all for the best. 'Just as the sun went down' we laid the little lamb beside the brave soldier boys who had given their lives trying to defend hers.[53]

Later, Theodora wrote how Ethel MacDonald came to her with tears in her eyes when she heard the news of Elizabeth's death. 'I know what it means to lose a child,' she said, 'for I lost two daughters within four days'.[54] And there was another memory that Theodora Inglis felt the need to record:

> Wang Nai Nai need not have wept, fearing massacre for her little lamb and mine. When God so kindly took her into his bosom, I knew not whether to grieve or to give thanks the future seemed so dark and uncertain and we knew that dangerous days and nights lay between us and any rescue. But I never think of Her that I do not think of old Wang Nai Nai who came upon us in the dusk that night after everything was over. The tears were streaming down her withered cheeks but taking me by the hand, she said bravely:
>
> 'Why so you weep Yin Tai Tai? Don't you know that your child has gone to God – Don't you know that Jesus loves Her – She is happy there?'
>
> Thus she spoke, old Wang Nai Nai, the weight of nearly seventy years upon her, and who in her youth, had cast her dead babies into the streets, thinking as other heathen mothers, that Death was the end of all things for children[55]

Now, too, as well as an unshakeable relationship with Wang Nai Nai, Theodora Inglis was to develop one with a Japanese woman whose existence had previously been unknown to her.

Mme Narahara and her Husband

On 6 April, George Morrison, who took an interest in the young Japanese Second Secretary, noted in his diary that Narahara had lived in Edinburgh for some years and had learned reasonable English which he had rather forgotten. Nevertheless, he was always 'amiable to us' (the British). Mme Narahara, Morrison noted, was the daughter of the Marquis Saigo, the Japanese Home Minister. Being Morrison, he later notes in his diary that the British Ambassador to Tokyo had told him that Mme Narahara was the 'illegitimate daughter of the Marquis Saigo'.[56]

On 15 August, Morrison was to elaborate on his description of Narahara: he was a 'brilliant Chinese scholar' and former 'Private secretary to Marquis Ito and was present at the peace negotiations in Shimonoseki in 1895. He was universally respected.' More topically, and ironically, he recorded on 26 June, 'Narahara came chuckling, "Yesterday a mandarin and some soldiers came near to our soldiers and we 'shooted' ten of them. How many have you *shooted*?" He shooted only five I think.'

Now poor Narahara Nobumasa was paying the price; he had been 'shooted' himself on 11 July – a compound fracture of the tibia. His case was described in all its unhappy detail in Dr Lillie Saville's post-siege article for professionals:

> The second case [of tetanus] was Mr N. of the Japanese Legation. In his case there was no wound of exit. On the second day it was found that flies had got under the upper layers of bandage and freely laid their eggs, and this although he had his wife's private nurse constantly with him to fan. The bandages were removed and the dressings underneath the splint found to be quite clean; the limb was carefully washed with creolin and the splint reapplied, and he was moved into another bed with fresh bedding. Odour from the wound was noticed next day, and though the dressings were frequently changed the discharge became most foul. On the ninth day it was decided to explore for the bullet. He did not take the chloroform well; breathing was irregular and peculiar in character; in fact I remarked it was as if he had diphtheritic diaphragmatic paralysis. The bullet was found, and a counteropening made for drainage. For the next two days he complained of being very tired, disinclined to talk and refused food; finally saying it was because his teeth would not bite. This was found to be the case, but there was no difficulty with swallowing. Gradually he developed slight tonic contractions; first of hands, then tirsmus, but never very marked. There were one or two attacks of opisthotonos just before death, which occurred four or five days after operation. He had *chloral hydrate*, gr.xxx, four-hourly as long as he could swallow and hypodermic injections of morphia.[57]

He died on 24 July and Mme Narahara watched him go through all that, as did Dr Emma Martin who gives a less academic, more frightening personal and professional view on 22 June:

> Last night when we went to the hospital we were informed that Mr Narahara, the wounded Jap. interpreter had the lock jaw just 11 days after the other case, from the time poor Meinharts died with it. We wonder who will be the next victim, perhaps myself. They were so careless about the bedding after the other case. Though he was on 3 different mattresses while he was sick none of them were burned. None of the sheets or bedlinen or under clothes are ever boiled, just washed out and hung up to dry. The sheets are stained and stiff sometimes from the blood and pus, and the towels are so bad I never

wipe my hands on them. They are so careless about giving hypodermics, putting it from one arm into another without cleaning it, ie Mr Poole does but we nurses [women doctors] are always careful. My end of the house was so quiet that night and I was so sleepy that Dr Mackey said for me to get into the steamer chair and take a nap and she would take my calls, bless her heart, so I did. When I awakened I had a peculiar ache, under my left ear at the angle of my jaw. It was so noticeable that I could not but wonder if I was taking the lockjaw, it was 12 days before that I had been exposed. ... The next day was Sunday and I slept none but prayed very much. I got no worse and after two days the feeling passed away.[58]

Sisters in Grief

It was an unhappy coincidence that Mrs Inglis' daughter and Mme Narahara's husband should have died so close in time to each other. Her grief attuned Theodora Inglis to others in the same position round her; it also made her sleepless which gave her more opportunity, as she wrote, to observe:

Often in the night I arose and stood at the big French window, gazing out into Lady MacDonald's private little courtyard. Sometimes a death-like silence prevailed but frequently I heard the stifled sobs of young Baroness von Ketteler. Night after night she lay on a steamer chair on her dark veranda just under our window, all alone, and I could always trace her shadowy form in its dead black garment even through the shadows. How I pitied the lonely wife ... Watching her I realized that there were things far worse than simple loss – what comfort to lay our dead reverently under the sod; to know where they lie, to plant the flowers of spring and sweet remembrance above their heads.[59]

Theodora continues:

Mrs Narahara also was a pathetic figure. Her husband ... had died from his wounds and left her with two little children. Before his death she spent long nights with him at the hospital, and after he died although we could see she suffered, she went about bravely and patiently as ever. We often talked together and I grew very fond of my little Japanese friend.

Charlotte Brent confirms that Mme Narahara 'nursed her wounded husband most devotedly'.[60] Another woman who befriended Mme Narahara was Mrs Edward Wyon. Her husband, whose extended family had been in the coin and medal business for generations, had already set up mints in Japan, Cairo, Brazil, Burma and Colombia when, in 1887, he was sent by his firm, Ralph Heaton and Sons of Birmingham, to set up China's first mint in Canton. He stayed on to supervise it and, not long before the siege, he had arrived in Peking to establish a central mint there. Some work had been completed by the beginning of the

troubles but had since been destroyed. Theodora Inglis wrote of Mrs Wyon and her husband, 'a fine old Englishman' (he was sixty-three):

> They had lived in the room adjoining ours before we moved to Lady MacDonald's. Then and afterwards we saw them almost daily and I used to wonder at their good courage for they were absolute strangers to every one assembled there. But they were brave as could be and so kind to everyone that we shall always remember them with pleasure and gratitude.[61]

Mrs Li Goes Missing

Many more babies were dying and being born in the Fu than in the British Legation – but no record was kept. Charlotte Brent's son, in his newspaper article of 16 October, suggested that 'the Chinese converts have lost over 100 children during the siege from various illnesses'.[62] And on 16 July, Luella Miner noted that four T'ung-chou children had died. On 28 July, Mrs Goodrich noted that seventy Roman Catholic children had died.[63]

As far as births are concerned, in her more personal post-siege account, Dr Lillie Saville describes visiting the Chinese converts; there she was greeted by a family she had known in happier times, one that was now fatherless. But life went on. Dr Saville records:

> The dear mother, Mrs Liu, now safe with her children in the premises we had secured for our Christians and ourselves, rose quietly and greeted me, enquiring kindly and anxiously after us all. And then, knowing intuitively I should want to see the baby that had never seen its father, and yet knowing I could not trust myself to ask, she led me to see the wee morsel of humanity.[64]

Later, when it was all over, they were to meet again, and Dr Saville added to her record of the 'mother's calmness': 'I saw Mrs Liu slip out. I followed her, and there she lay on her brick *k'ang*, dear woman, convulsed with grief – Oh such piteous grief! What could one say to comfort her?'

Babies were being born but there was increasingly little to eat in the Fu and, while the legations were under fierce attack, the Christian converts in the Fu were even more vulnerable because of the particular hatred they aroused – thus the attackers' determination to eliminate them. Mrs Goodrich noted of the Fu on 4 July, 'A little girl was hit in the leg by a shell. It severed both arteries. She died in the night.'[65] (According to Dr Emma Martin, she was one of the school-girls.)[66] And Sara Goodrich added on 6 July that she had heard that 'Chao nai-nai, our Bible woman, in the act of carrying cold water to a sick person was shot in the foot. How I long to go over and see the people in the Fu, but we are not allowed to do so.'[67]

Most of the Chinese men were doing heavy manual labour – whatever their social status had been in pre-siege days – strictly organised by the committees of American missionary men in the British Legation (who did not, however, shirk heavy or unpleasant work themselves). Mrs Conger was to tell an anecdote illustrative of one side of the story:

> The other day I said to a scholarly Chinese, 'Will you help to fill these sand bags?' He replied, 'I am no coolie.' Then I in turn said, 'I am no coolie either, but we must all work here and now. I will hold the bag and you come and shovel the sand.' I took a bag and a Russian-Greek priest stepped forward and filled it. He spoke no English and I no Russian, but we both understood the language of the situation. Other people rallied about us, and we soon stepped aside. Our work was finished. This scholarly Chinese was of the American Legation's staff helpers. As rank is so respected in China, and as the Chinese do not wish to degrade the ranks, this man, from his point of view, could not fill sand bags. Mr Conger talked with him, saying, 'Your life as well as ours is to be protected here, and you must do your part or we cannot feed you.' The man was in hiding three days. As our troops did not come, and he was near to starvation, he came to the front, willing to do what he could.[68]

In spite of the reluctance to allow the Christian converts into the legation quarter at the beginning of the siege, it was soon agreed that survival would be impossible without their contribution; nevertheless, there continued to be reservations. Mrs Conger recorded on 8 July:

> Many of the native refugees at the Fu are to be removed to buildings on Legation Street. There is some sickness in the Fu and it is feared that it might spread by having the coolies go back and forth. What should we do without the Chinese coolies? They are necessary and efficient workers in building barricades, digging ditches, putting out fires, and in doing all sorts of manual labor.[69]

But her reading of the situation is rather ambiguous – quite apart from her blanket use of the word 'coolie'; it appears that by the 8th the Chinese had managed to fire much of the Fu, making it essential to move some of the converts.[70]

Luella Miner's schoolgirl reporter had earlier moved with a Chinese family into the open pavilion in the British Legation that housed the Roman Catholic nuns, but a friend of hers later told her of conditions in the Fu:

> Fire after fire was started in the northern part of the palace, each one creeping nearer, until the afternoon before their flight, the fierce flames kindled in the great quadrangle just north of their hall. The smoke was blinding. There was a pandemonium of crackling flames, zipping bullets, screaming shells, and, worst of all, cries of 'Good! good!' from their enemies. The Japanese,

and the volunteers helping them, were making a stiff fight; but step by step they were being driven southward. So the same night that the girls took their flight, most of the Chinese families in the same quadrangle forsook the palace for small, damp buildings still further south.[71]

Bessie Ewing describes at least part of the move from the Methodist point of view on 9 July:

Last night about 100 Christians were brought over on this side and lodged in courts near the American Legation. These courts have been seized since we came into siege, and the residents sent away. Here our Christians are very comfortable, having small courts and houses by themselves. Each family is given its supply of food raw, and so can cook it to suit themselves. More families have come today, also all the school-girls. There were fierce fires all day yesterday, next the Chinese quarters across the canal, and it was thought best to remove the people before any imminent danger.[72]

Mrs Goodrich visited the Chinese Christians in their new quarters on the evening of the 9th and wrote:

Some were in very nice houses, others were more crowded. The 120 school girls were in a palatial residence. There are long mirrors, elegant clocks, priceless vases, while the smell from the numerous camphor wood chests makes the room fragrant. Gold fishes are in the kongs of every description. As I saw some of the Christians sitting under the grape vines, it made me think of the inheritance of the children of Israel in the land of Canaan, eating of vines that they had not planted. They wear clothes they did not make, and eat food they did not buy. Still it is a hounded life they live. I saw Chao Nai Nai, our Bible woman. She seems brave and patient.[73]

Miss Ada Haven, caring for the thirty Congregational girls, had practical reasons for visiting, as she rather shamefacedly explained:

Today I was commissioned to go and do some professional looting (foraging) for the hospital. The place where our girls were quartered was the home of a wealthy family who had left without time to remove their vast stores of clothing. The house seemed furnished with clocks and clothing, with an occasional cheval glass to reduplicate it all. The clocks we had stored in the long sideboard that we were obliged to clear off to make a sleeping place for the girls; some too in the beautiful brass-bound teak-wood ice-chest that stood in the middle of the room. It was meant to receive ice, but no food. Holes in the cover were to impart coolness to the room. (Why aren't we as civilized as that? We have stoves in the winter in our parlors, but not ice-boxes in the summer.) The clothing was stored in great wardrobes reaching to the ceiling – these and piles of trunks, of handsome dark wood, also reaching to the ceiling, lined the walls, while two or three immense camphor-

wood chests stood under the windows. All these were securely locked. But now, at command from headquarters, I, teacher in a Christian school, was to lead my flock in burglary. After a little lecture on the subject to them, I set to work with a good conscience, picking and breaking locks and going through everything.

How glad I was there there was no bric-a-brac lover on hand that day! I should not have been able to restrain the hunt to simply fans, cotton or linen garments, and piece goods suitable for hospital use or sand-bags. Oh, the furs! And, oh, oh, the embroidered silk and satin garments![74]

It was obviously the luck of the draw what accommodation you got; or, rather, who you had to do your reconnoitring and fight your corner for you. It seems, too, that it was mainly the smaller number of Protestants who were moved. The suggestion that the Protestant missionaries looked after their people, while the Roman Catholics did not, is not always discreetly expressed.[75]

On 10 August, when Emma Martin – who was not theologically partisan – was out and about, she went to the Fu, where the Catholic converts were still sheltered, and wrote that 'We saw many of the poor refugees, many of them half starved and nearly naked and so miserable. They were making their food out of a coarse grain, looked like dirt.'[76]

Even when the Chinese refugees had foreign supporters, and had been moved from the Fu, it did not always help; this time candid newcomer and American Dr Martin gives an essential but unconsciously ideological insight when she writes on 6 August of the Chinese doctor with whom she worked when she first arrived in Peking:

Dr Tsou, who went to Brooklyn for his medical education and to marry much against his will, and who is a mandarin, has been living down near the school girls with his family for a little time, is in great trouble. Two of his children have dysentery. One of them is in a semi-comatose condition with involuntary movements and both are too sick to make any resistance. Mrs Jewell and Mrs Gamewell were down to see them and they suggested calling me to see them as I had a few medicines, so he came for me. He had given up all hopes of their recovery. It did seem as if they were too far gone to save but we gave them some calomel and zinc sulph. carb. He had tried in vain to get the former somewhere but failed. The drugs the English have are too precious to waste on the Chinese. Both the children are making a good recovery and they are my life long friends, for they think that I saved them, but I didn't.[77]

But on 11 August she had to add:

Dr Tsou's little Mary died suddenly today. We had been caring for the children but while he was away his wife, or old mother-in-law gave it something it wanted. His heart is just broken. His wife is a nominal Christian

but amounts to little. The Methodists went down tonight and had a funeral in the rain.[78]

Even some of those (Protestant) Chinese who had been moved from the Fu had it less easy than others; our schoolgirl reporter describes the accommodation and the lives now led by some of her compatriots:

> Our friends across the street were not so favorably situated. Several women and girls were killed or wounded. The pestilential air, breeding swarms of flies, the brick floor on which they slept reeking with moisture, the coarse, distasteful food, made life very hard for the little children. Nearly every day a new grave was made, one mother losing two children during the sorrowful months, and there were few homes which death did not visit.[79]

Somewhere among all these women – probably in the Fu before some were moved – was a widow, Mrs Li, who had been taught by Miss Georgina Smith of the LMS – a factor which may have brought out her own courageous streak. She had with her five children and a blind mother. Throughout the siege, Chinese, usually men and boys, were used as messengers to the outside world – to take out news of the besieged and try to bring direct responses or indirect news back. The most important questions being – Where is the relief force? And when will it arrive?

Colonel Shiba was particularly in the habit of sending out messengers and one day he once again called for volunteers; Mrs Li responded. Her story was later to be told by Miss Smith to a colleague writing a short account of the siege for the LMS. Mrs Li set out, past the barricade, dressed as a beggar, with a basket over her arm and a letter carefully concealed. The story is then told how,

> Mrs Li succeeded in her errand and the message reached its destination, the Japanese were able to hold out to the last, and the great band of refugees were saved.
>
> But the Christian heroine never reached the palace [Fu] again. She is said to have returned to the barrier, but meanwhile the guard had been changed, and the soldiers did not recognize her. In the hurry and excitement of her departure no one had remembered to give her a passport to enable her to enter again the place of refuge.
>
> Finding she could not gain an entrance to the palace, she succeeded in making her way out of the city to her old home, about six miles from Peking. She reached the village without mishap, but the next day a neighbour betrayed her to the Boxers, telling them that she belonged to the hated 'Jesus sect', and she was at once put to death.
>
> Towards the end of the siege, Mrs Li's little son, a lad of thirteen years of age, became so distressed at finding she did not return, that he managed to get away from the Legation and started off for their village home 'to find mother'. He found their home in ruins and learned that his brave mother had

been cruelly murdered. The poor boy succeeded in making his way back to the Legation, where he and his sisters were cared for by missionaries.

'She was a large-hearted kindly woman always ready to do anybody a good turn', writes [Miss Smith] tenderly. 'All the world has heard of Colonel Shiba's heroic defence, and the brave part he played in warding off a general massacre. But the noble act of this lowly Christian woman is known to comparatively few'.[80]

No other source mentions Mrs Li, so it is as well that she should be commemorated here – together with the less noble and nameless Chinese women and children who suffered and died before, during and after those fifty-five days.

As for Colonel Shiba, his system of messengers did indeed pay off and, finally, the besieged began to learn what had happened in Tientsin; what had happened to Admiral Seymour (Admiral Seen No More as they called him) and why he had not arrived to relieve them; and when they might now expect to be saved.

12
Mrs Brent and Miss Tours Hang On (15 June–5 August)

Lou Henry Hoover Besieged in Tientsin

On 18 July, Colonel Shiba received word that a force of 2400 Japanese, 4000 Russians, 2000 British, 1500 French and Americans, and 300 Germans were to start for Peking within a couple of days. This is not in fact what happened, but it was good enough to raise spirits for the time being.

The besieged in Peking also heard for the first time that the Taku forts had been taken by the Allies on 17 June and that Tientsin City had been taken after severe fighting on 13 July, nearly a month later. What had been happening in between everyone wanted to know – a question which would not be fully answered for nearly another month.[1]

But it is time now for us to explore that question and see what Frances Scott, wife of the Bishop of North China, had been going through in Tientsin, together with one or two other women such as Lou Henry Hoover, wife of the future President of the United States.

It was, as we know, by chance that Frances Scott and her husband were not in Peking with their colleagues such as Jessie and Edith Ransome and Marian Lambert; they had tried their best to get back to their home up till the second week of June but such was the deterioration in conditions on the railway running between Peking and Tientsin that there was no possibility of travelling either way.

It was by chance, too, that Lou Henry Hoover and her husband Herbert Hoover, who had been working for a British mining company in North China since their marriage in the United States the previous year, were not there either. Though they had started off living in Peking, they had since moved to Tientsin but they had been in Peking in May (for Herbert's work) when Lou fell rather ill.

So far from home, and staying in a hotel (it must have been the Chamots'), Herbert Hoover took a decision: he scooped up his wife and carried her back to Tientsin where he was more confident of the medical care. In fact, Mrs Bainbridge's diary shows that she accompanied the Hoovers to Tientsin on 11 May to look after Lou, but was herself called back to Peking on 22 May to nurse her sick husband.[2]

While Frances Scott and the Bishop moved to Gordon Hall, a sort of Town Hall, when the Taku forts were taken by the Allies on 17 June and the bombardment by Chinese imperial forces started, the Hoovers moved in with Edward Drew, Tientsin Commissioner of Customs, and his wife Anna. The Drews had managed to send their four children away two days earlier, which was just as well because they now had rather a full house: twenty-six foreigners in all, including five women and nine children, and several Chinese staff, including those of the Hoovers.

Among these guests were two separate though related halves of couples in Peking: Ed Lowry and Mrs George Lowry and her three children. Mrs Lowry had gone from Peking on a short visit to Tsun-hua and when trouble came there it was impossible to rejoin her husband in Peking so, with her children and their amah, she had travelled two days and nights to Tientsin arriving there the day before the bombardment started. Herbert Hoover, in his rough draft about the siege of Tientsin, wrote about the Lowry families:

> One brave little lady with three babies lived in the same house, whose husband was in Peking, and she never showed anything but outward calm which comes upon nerves strained to the breaking point – and the gratitude of her eyes for every word of hope made it doubly pitiful. With her was a brother [in law] whose wife and family by strange circumstances were in Peking, and he pulled wool bales and built barricades with a soberness that said much. And there were many with their best in Peking, and all with dear friends there.[3]

Robert Hart, her husband's superior, had written of Anna Drew in 1889 when he appointed Edward Chief Secretary, 'If the missus can write as she can talk, you'll hear all about our doings.'[4] Certainly her diary, written eleven years later, gives useful access, from a woman's viewpoint, to the siege of Tientsin, as it records its several phases.

From 17–23 June, the foreign settlement and those Chinese with foreign connections were defended by 1000 or so Russian Cossacks who had arrived from Port Arthur on 12 June. And that week or so was rather grim though everyone agreed that they owed their lives to the Russians whom Anna Drew described as 'Great strong dirty fellows, looking as if they had grown into their heavy clothes.'[5] She went on to add that 'These were the men who defended us so bravely ... [and] many of their number were killed.' Frances Scott endorsed that when she wrote in a letter of 24 June, 'Russians have behaved splendidly,

indeed we owe our lives to them. This week the Cossacks fought like demons, and it will much hinder the future political animosities when we remember what we all owe them here in our time of need.'[6]

These views form a useful antidote to the anti-Russian feeling in Peking and the suggestions of collusion with the Chinese; Dr Matignon of the French Legation later wrote, for example:

The neighbouring legations, in particular those of Germany and America and the park defended by the Japanese came under fierce attack ... A singular fact: the Russian Legation, situated opposite the American one, was left completely undisturbed by the Chinese, and this protection for the Cossacks could not fail but to appear strange to us.[7]

Daniele Varè, an Italian diplomat who was to arrive in Peking in 1912, and later to write a biography of the Empress Dowager, suggested that it was generally believed (among foreigners) that the Boxer movement had been encouraged by Russian government agents. He pointed out, too, that while it had been agreed among Ministers before and after the siege that they should present a common front, it was known that M. de Giers had secret meetings with Manchu Princes. Varè describes how

'Once during the siege itself, when de Giers passed through the crowd of refugees, who were collected in the British compound, a voice from the crowd shouted after him, 'Qu'est ce qu'il fait, celui la, parmi nous? Qu'il s'en aille avec les Chinois. [What is that man doing among us. Let him be gone to the Chinese.]'[8]

Indeed, so high did feelings run, that on one occasion de Giers refused to attend a meeting in Claude MacDonald's house; he had to be persuaded by his French and Italian colleagues who went to fetch him and escort him through the crowd.

The anti-Russian feeling in Peking and the praise of ordinary Russian soldiers in Tientsin were to merge after both sieges when the Cossacks fed everyone's prejudices.

During this first week, the besieged in Tientsin had some intimation of what was happening to Admiral Seymour's force that had set off on Sunday 10 June on a journey to Peking which should have taken only a few hours. Unable to progress, on Monday and Tuesday they sent back for more supplies and then, as Anna Drew noted:

The weather had turned very hot, and knowing that many of the men had only the small caps as protection from the sun, I obtained permission ... to have some of the drill caps, with a curtain to protect the back of the neck, such as were used in South Africa, made to send up the line to them. I therefore sent a circular to all the ladies asking how many each would

undertake to make. We cut out more than four hundred – and on Wednesday sent off three hundred finished, but the next day our communication was completely cut off with them and the others could not be sent, and I never heard if the first lot were ever received.[9]

On 22 June a note got through from Robert Hart to Edward Drew dated 19 June and confirming that Seymour and his troops had not arrived in Peking. Then all went quiet and the besieged in Tientsin waited to hear from Seymour, or from the troops sent from Taku to relieve them.

During this time, the heroine of the Drew household seems to have been Lou Henry Hoover. Anna Drew described how a regular guard patrolled the grounds, Lou Hoover and another taking the 9–11pm watch: 'Mrs Hoover had a small rifle that she knew how to use very well – and she used to walk quietly all about the garden, down by the stables, and everywhere, in the darkness,

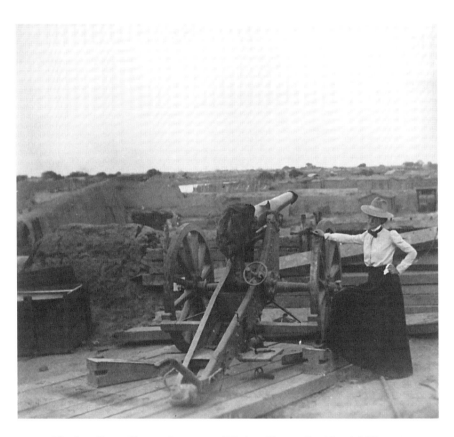

29 Lou Henry Hoover (courtesy of Herbert Hoover Presidential Library;
from the Lou Henry Hoover Collection)

seeing it all was as it should be.'[10] With this reminder of San Francisco-born Annie Chamot's prowess with the gun, it is worth noting that twenty-six-year-old Lou Henry had also been brought up in California. As well as a degree in geology from Stanford University, where she met her future husband, she had obviously come by other accomplishments.

Lou also worked in the hospital where there was one doctor. Of his staff, Herbert Hoover recorded:

> Little Miss Burgignone, the only trained nurse in North China, did not spare herself in the care of the wounded. Short of a surgeon and almost destitute of nurses, with a building devoid of hospital convenience, Tientsin had little to offer the poor fellows who fell in her defence. But what one little woman could do, did Miss B. It seemed impossible that she could continue her work with the few hours that she slept, with the bits of ... that she occasionally snatched at odd moments.[11]

As for his wife, Hoover wrote in his memoirs:

> Mrs Hoover volunteered at once and I saw little of her during the first period of the siege, except when she came home occasionally to eat or catch a little sleep. She became expert in riding her bicycle close to the walls to avoid stray bullets and shells although one day she had her tyre punctured by a bullet.[12]

Of all the nights, 20 June, by chance the first night of the siege in Peking, was the worst in Tientsin; Anna Drew wrote of it and those that followed:

> The attack was being pushed so vigorously, and the firing from the large gun that was called the 'Empress Dowager' so constant, that everyone felt that the situation was indeed desperate. The British Consulate had been hit twice, and so Mr Carles brought the whole family over to us ... with baskets of provisions and clothing – as it seemed more than likely that their house would go [during] the night. ... It was a very hard night – perpetual firing from the guns in the city and ones in return and constant sniping. The noise was incessant. A man, his wife and delicate little child, came in from their bungalow opposite and sat up all night in our hall ... We had the large gates from the vegetable garden on the Victoria Road kept open – in case there was a rush on the settlement – and we should have to go to the Gordon Hall. ... This was the night that James Watts started off with the Cossacks to ride to Taku to inform the Admirals of our critical condition and to hurry up our relief. ... Why troops had not been sent off at once to us, Sunday afternoon, when it was first known at Taku that we were being bombarded – I have never heard.
>
> ...We got through the night of the 20th and 21st safely. The Carles family went back to the Consulate after their breakfast and we all managed to struggle on for two days and a half more. I kept well employed all the time.

There was the boiling of all the drinking water and the milk to attend to which was sent off to the hospital, at the Club, by E.B.D. [her husband] and Mrs Hoover. The servants' rations of rice to give out and a constant demand for supplies at the hospital to be hunted up – old linen, mosquito nets, reading matter etc. All the outhouses on the premises were occupied by Chinese clerks and their families who had come to us for protection. Old Hui, the head of mafoos, home was full of E.B.D.'s Chinese writers family, and the green house had several families of native Christians.[13]

On 23 June a relief force of 10,000 – British, Americans and Russians – reached Tientsin from Taku. The men were not enough to lift the siege, but their presence brought much reassurance to the besieged, particularly as they also brought with them two fifteen pounders – a boon for the besieged who were contending with well-armed, foreign-trained imperial troops. The newcomers settled in, the officers using the Drew house as a base, 'ready for something to eat or drink'.[14]

Thus Anna Drew was kept abreast of developments, such as the discovery of a 'fine new Krupp gun – with plenty of ammunition and all set up ready for use'.[15] The implications were immediately clear, as Anna details:

Mr ... was dealing in arms for the Chinese and evidently this gun was all ready to hand over to them when the outbreak came. These Germans who had made so much money by selling arms to the Chinese had now the pleasure of witnessing their excellent quality and of being able to testify to the good marksmanship of the people they had taught to use them.

The night before the foreign relief arrived, a Chinese attached to Admiral Seymour's lost party had reached the settlement with a message that they were boxed-in three miles north of Tientsin and needed help; now help could be sent, and on 26 June Seymour arrived back where he had set off from; Anna Drew noted:

The Seymour party had been gone just sixteen days – and had had a very hard time. For thirteen days they had been cut off from all outside communication, 295 of the men had been killed and wounded, and they were a very sad looking set of men when we saw them returning that Tuesday morning.[16]

Not surprisingly, the Drew household was turned to for help, at least for some of the Americans; Anna records:

The servants, Mrs Hoover and the other ladies all set to work, and by the time the soldiers were settled inside the garden we were quite ready to give them their breakfast. The wounded were laid out on their stretchers all along on the front terrace under the matting, making a beautifully cool place for them – the other men were given the lawn and the large kongs full of water

near the greenhouse for their washing. We supplied them with plenty of soap, and they had a fine scrub. ... We had a good breakfast for every man, one hundred and ten, I believe in all. There was plenty of strong soup, tea and coffee, and boxes of American crackers – and enough milk for the wounded.[17]

Among Seymour's wounded was Captain John Jellicoe, a cousin of Mrs Scott's and later to become a distinguished British admiral in World War I; she now rallied to look after him. She wrote the following day:

I shall never forget to my dying day the long string of dusty, travelworn soldiers, who for a fortnight had been living on quarter rations, and fighting every day. Alas! the saddest part was the long line of stretchers with poor, motionless figures inside, which turned into the hospital gate. I was there waiting for cousin Jellicoe; the Admiral, with his never forgotten courtesy, had sent on a special messenger to prepare me for his arrival. ... He was shot through the lung five days ago, and at first thought to be killed, but most mercifully he took a turn for the better, and was quite on the mend when they brought him in. I soon made him comfortable, and then I did the same for some half dozen officers. The whole expedition had lost 203 in wounded and 59 killed.[18]

The Bishop added: 'All the ladies from the Town Hall [Gordon Hall] here and the houses round were rushing out with tea in buckets, and giving every poor famished man a good cup of hot tea; one poor fellow burst into tears, 'to think of having this to drink, after ditch water for days, and not much of that!''[19]

The Scotts had not had an easy time shut up in Gordon Hall. Miss Critall, one of four British women missionaries attached to Bishop Scott's Mission and based in Tientsin, wrote on 27 June, when they had just left Gordon Hall:

On the stage of the Hall encamped a large party of Americans; below, between twenty and thirty Japanese women and children; next to them, between fifteen and twenty of Warren's circus men and women and children. Next to this came ourselves – Bishop and Mrs Scott, Mr and Mrs Iliff, baby, and amah, our four selves, and six children.[20]

Anna Drew elaborates:

It must have been a terrible place if half the stories one heard were true. There were all kinds of people thrown together in the most promiscuous way. A circus company who got stranded in Tientsin and had to remain. Some of the members got intoxicated every night on looted champagne – were among the motley throng. The von Hanneker household went to the hall one evening intending to remain, as their house was considered unsafe – but they returned after two or three hours, deciding that they would prefer

to die decently at home if necessary, rather than remain in such a place under such dreadful conditions.[21]

Now the Scotts moved into the parsonage, the home of his colleague Geoffrey Iliff, his wife Florence, and baby daughter, together with Captain Jellicoe whom Frances Scott continued to nurse.

But they could not relax; not only was Tientsin still under fire from Chinese forces but, as Frances Scott wrote, 'All our anxieties are for Peking.'[22] On Friday 29 June a second message got through from Robert Hart in Peking; Anna Drew wrote,

> It was evident that they were in a bad way. We were still in great danger ourselves and were helpless to assist them. It was true that soldiers kept coming in to us, but it was considered impossible to make the march to Peking with less than fifty thousand men.[23]

Starting on 3 July, the women and children in Tientsin were evacuated; Frances Scott soon found herself comfortably installed on the *Centurion* (Captain Jellicoe's ship) in Taku Roads, from which she was transferred to a transport which took her southwards to the British enclave of Weihaiwei. From there she wrote on 9 July, 'I am waiting for a room to be vacant on shore at the primitive little hotel to join many grass widows whose husbands are at the front.'[24] Her colleagues were taken to Japan and they had rather a less easy time of it before they got there.[25]

Anna Drew left Tientsin on 5 July, without notice and against her inclinations; she would rather have stayed with Edward. When at Taku the women and their families were put on over-crowded transports without proper courtesy, care, or food; she managed to pull strings and was transferred to another vessel and better accommodation. Even so, she was on board in Taku Roads for a month before reaching Yokohama on 20 July where she was reunited with her four children and sailed the next day for San Francisco.

An account by a male contemporary observer had some bare essentials right when he wrote on 8 July:

> I grieve to say that there was fierce indignation among the Tientsin British residents over the scurvy treatment of their wives and children during the exodus. Other nationalities had their ladies at once taken off to their war ships and treated with all the generous consideration their misfortune demanded, but the British were transshipped and retransshipped into a rat-ridden cockroachy vessel, with execrable food, and utter and abominable absence of sanitary requirements. No officer came to see them, and until a strong protest was sent in, no other arrangements were made for their dispatch elsewhere.[26]

Lou Henry Hoover stayed in Tientsin because she was useful in the hospital and the Hoovers moved back to their house which was now deemed safe. It was, perhaps, safe from Chinese bombardment, being sturdy, but not from Russian looting which began soon after the Cossacks were no longer carrying the full load of the defence. One day, Lou Hoover was called from the hospital by one of her servants to be told that Russians were in her house. She jumped on her bicycle and charged home, arriving as the looters were leaving.

Confronted by an irate householder, they dropped what they were carrying most obviously, though their boots and breeches (according to one of Hoover's biographers) were bulging and they had ransacked the house, eaten everything in sight, and covered everything else with strawberry jam.

The Hoover's house was safe enough, though one evening when Lou had returned from the hospital and was playing solitaire, a shell exploded against a wall and blew out a door. It entered the mythology that Lou never even lifted her head. But the day of the first attack, Chinese with foreign connections and their families had moved into the foreign settlement into less substantial houses. Herbert Hoover, for example, had found a house in a nearby compound for Tong Shao-yi, the Director of Railways (and later prime minister in the Republican government).

A few evenings after Lou's display of sang-froid, the Hoovers heard several shells explode in the compound opposite and Herbert hurried over to find that Tong Shao-yi's house had received a direct hit. His wife and baby were dead, and another child injured. With the father, Hoover escorted the rest of the family over to his house, including a little girl, Tong Pao Yue, where they were looked after by Lou.[27]

More and more foreign troops had been arriving and, on 13 July, the Allies felt confident enough to attack the Chinese forces and Tientsin was finally relieved. Thus is explained why relief had not reached Peking; the relief of Tientsin also offers an explanation for why the Chinese started to attempt negotiations with the besieged in Peking on 14 July, culminating in a period of truce after the 17th.

But three days after the relief of Tientsin, the false news of a massacre in Peking was received, and somehow the urgency to send fresh troops along the route on which Seymour had come so unstuck lost its allure; and international political and territorial rivalry as regards China resurfaced. This uncertainty and delay must have been excruciating for the British surgeon William Myers, usually practising in Formosa but now attached to the military base hospital in Tientsin. He had two daughters in Peking – Annie Myers and Helen Brazier – and two grandchildren.[28]

Baroness d'Anthouard, stranded in Tientsin like so many others, with her husband the French Legation's First Secretary, had also been consumed with anxiety about the fate of her maid, 'an elderly woman who had taken care of her as a child. She was afraid that no one would look after her at the French

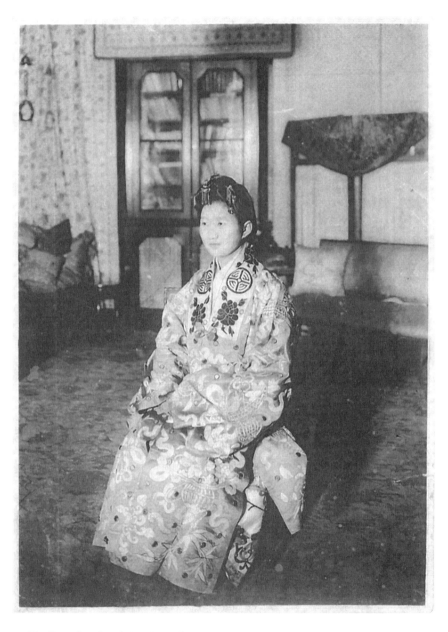

30 Tong Pao Yue (May Tong) (later Mrs Wellington Koo) (courtesy of the family)

Legation.'[29] What happened to the Baroness at the beginning of July is unclear, but her husband prepared to join the French contingent arriving from French Indo-China when finally they left to relieve Peking. Ed Lowry, having packed his sister-in-law off to Taku on her way to the United States, prepared to join the American contingent to rescue his wife.

By the end of July a force of 25,000 had been gathered at Tientsin and Taku. The British General Gaselee reached Tientsin on 27 July and he began to persuade his fellow commanders to make a move. After a five-hour conference on 3 August, it was resolved to set off on the 5th. In Peking they did not know that, and they were still waiting.

Mme Chamot Begs for Mercy

As it happens, Mlle Bergauer, whose fate so concerned Baroness d'Anthouard, was safely in the British Legation, as was later discovered with some surprise, according to Lieutenant Winterhalder. Indeed, she had unobtrusively taken over the running of the house in which the French diplomats were camped.[30] In the meantime, the defenders of the French Legation made good use of the Baroness's dining room, her 'boys', her chef and her cellar. They, particularly the men, had also made use of her wardrobe. Dr Matignon describes how most of them grew pretty disreputable in appearance but M. Merghelynck, Secretary of the Belgian Legation – who seems to have abandoned Polly Condit Smith for glory in the French Legation – could sometimes be seen wearing a shirt of the finest cambric, encrusted with lace, which belonged to the absent Baroness.[31]

Now that there was a truce, they could relax even further. On the 17th, Chamot had four flags bravely fluttering over his hotel, the American one, in honour of Annie, being the most conspicuous. On the 20th, the Empress Dowager sent two cartloads of provisions to the legations containing water melons, cucumbers and aubergines – which M. Pichon described as 'a gift of distinction in China'.[32] Darcy tells how they had 'happily' to pass in front of the Chamot hotel – 'that is to say they did not arrive at the British legation with a full load'.[33]

Paula von Rosthorn, without mentioning Chamot's light fingers, said severely that the present of food – including a sack of flour for each legation – was 'truly a mockery of our present situation'.[34] But the French–Austrian–Chamot–German camp were in the mood for fun. Darcy describes how that evening at 9pm he had just stretched out in his hammock and begun to sleep when he heard Arthur von Rosthorn calling him. Rather anxious, and without bothering to dress, he ran to the breach in the wall of the hotel from where the voice came, wondering what unpleasant news awaited him now. 'We have invented a new drink', said the Austrian. 'You must come and try it.'[35]

There in the grand salon of the hotel, Darcy found all the officers and members of the German Legation. Paula von Rosthorn, helped by Lieutenant von Soden, was filling champagne flutes with liquid. Paula takes up the story which had started earlier in the German Legation itself:

> We made very good punch from our water melons. The lid was cut off, the fruit was scooped out and the hole filled with Champagne and sugar. Then the whole thing was suspended in cold water. After dinner we took one such punch into the hotel where the former French–Austrian dinner group were gathered and together we emptied it very cheerfully and drank to a happy ending to this adventure.
>
> When the delectable drink was finished, together with Baron von Soden, always ready for a bit more fun, we carved eyes, nose and mouth with big teeth into the empty husk. Then we put the melon on a plate, with a burning candle inside, and carried it in triumph outside where we placed it on top of the barricade.
>
> The Chinese, who either sensed the derision or, superstitious, took it for a ghost, got terribly upset and the usual shouting and wild shooting started. Someone also made the suggestion that we place our fiery head on the wall facing towards 'England' but for that our courage failed us, because we were already notorious as 'frivolous people [in English]'. Our views were very different; we, for our part, found it unbearable in the English Legation. The hand-wringing and complaining and the endless sounds of the 'prayer meetings' of the missionaries drove us to despair.[36]

The Chinese were definitely trigger-happy during this supposed truce. Darcy tells how the day before, M. and Mme Saussine had come to visit the Legation. They walked with him to their barricade and the Chinese watched them approach and then suddenly one of them fired a rifle shot in their direction which 'happily did not hit anyone'.[37] And they hurried back to the shelter of their own walls.

That same day, the 19th, Darcy sent a Christian Chinese to reclaim the bodies of the French marines who had earlier been killed. But he did not come back. Later his wife came to ask for news and Darcy then records how on each day she returned. On 20 July, 'his wife, in tears, won't leave us'.[38] On the 21st, Darcy was sure that the husband had been killed but did not tell her so. On the 23rd, Jung-lu, whose troops were camped behind the the French Legation, replied to the French Minister's request made in writing that the marines' bodies had not been found and that he knew nothing about the Christian in question.[39] On the 29th, the woman was at the Legation again; she was, as Darcy said, 'Still coming to look for M. von Rosthorn who tries to console her. But, alas, we have no illusions about the fate of this unfortunate.'[40]

News of another body did, however, reach the German Legation at this time; Nigel Oliphant wrote on 19 July that the Tsungli Yamen, '… told the German

Chargé that the Emperor had wired the German Emperor his regret at von Ketteler's death "at the hands of brigands". They have the body at the Yamen and have prepared an elaborate coffin – not much consolation to the poor Baronin, who is still very much upset by the shock of her husband's death.'[41] It was at about this time that Theodora Inglis, suffering herself, sensed the grief of the woman in the room below her.

On 22 July, Darcy recounts how two Christian boys who had stolen provisions were arrested by French marines. Fortunately for them, 'they had their lives saved following the entreaties of Mme Chamot'.[42] But, as he explains, 'I had their queues cut off and had them caned. Their offence was all the more serious as provisions are becoming scarce. In the Fu the Christians are plucking leaves from the trees to feed themselves.'

The Empress Dowager's Melons

The women in the British Legation had the same ambivalent feeling towards the provisions sent by the Empress Dowager on more than one occasion as Paula von Rosthorn. Polly Condit Smith suggests that the offering did not come spontaneously, that Sir Claude MacDonald wrote to 'Prince Ch'ing and Others' that 'the ladies felt the need of ice, eggs, and fresh fruit'.[43] And Nigel Oliphant talks of the deliveries as 'in answer to our request for fruit etc ...'[44] MacDonald does not choose to confirm this and they are just as likely to have come as a result of the sortie outside on the 17th of the young French adventurer Pelliot who leapt the barricade and landed up having a friendly meeting with Jung-lu. Pumped about the food situation of the besieged, he informed the Chinese commander that all they lacked was ice and fruit, and he was sent back to his lines with his pockets full of peaches and watermelons.[45]

Certainly, there were, during the truce, several meetings between Ministers and Chinese representatives. One of MacDonald's ADCs, the student interpreter Hewlett, noticed, for example, on 18 July,

> An underling of the Yamen and five others came. They were made to sit outside the Big Gate barricade and discuss. They talked of opening a market, but Sir Claude was very haughty with them, as they were in no position to discuss with him.[46]

A market was, apparently, opened on the 20th of eggs, melons, cucumbers and other vegetables and very quickly sold out.

However the cartloads from the Empress Dowager were prompted, Charlotte Brent wrote on 28 July after the arrival of the second delivery:

> Yesterday a present of flour, ice, water melon etc. was accepted from the Empress much against the feeling of the general community. The edicts from

the Peking Gazette of last month [also now available] show that the Boxers have been paid and encouraged by the Empress and the Government.

Mary Bainbridge wrote with even less respect for persons on the same day:

Last evening three or four carts of vegetables, flour, and ice were sent here, whether to poison us or what, is the question in our minds. We understand the 'old Lady' and her crowd are preparing to leave the city. She might not have the opportunity to go if she waited until foreign troops arrive.

Mrs Russell's two entries, with a subtle addition to the second, suggest that a fair amount of discussion went on between the two deliveries about the ethics of accepting. On 20 July, after the first cartloads, she wrote, 'A present of vegetables came for the Ministers from the Yamen. Many disapprove most strongly of receiving paltry presents from people who have been trying their best to kill us.'[47] On the 27th, after the second delivery, she wrote:

The Empress is collecting carts and mules with a view to flight. A present of vegetables and flour came today from the Ministers for Foreign Affairs. The flour we do not intend to use, fearing it may be poisoned. The *majority of us* [my italics] strongly disapprove of taking presents from Chinese officials who have been treating us so badly.[48]

But Ada Haven gives a delightful example of the pull that dietary lack was able to exert when she writes on 26 July:

When watermelons came in the other day, sent by the crafty Foreign Office in the name of the Emperor, I would not take a bite. ... I stretched that same conscience of mine yesterday, however, when the watermelon rinds came on pickled. I regarded them as a gift of the housekeeping committee, for surely neither Foreign Office nor Emperor expected us to eat the rinds.[49]

And Dr Emma Martin threw her conscience to the winds. She wrote on 25 July when the short-lived truce had already been broken by the Chinese:

My birthday in such a place. Mrs Walker and Mrs Arthur Smith kissed me this morn and Mrs Jewell all wished me a happy birthday. Lizzie had made me a little case of pockets and put in it a new neck ribbon and a note wishing me a happy day. We had a bad night last night for sleep. We were bombarded about 2 and it was so hot I got up and struck a light and chased and killed several fleas and a centipede which we found in bed. Dr Mackey, Lizzie and I were all up at it. We chased them again at 3. At 7 we got up and dressed and I put on my seer suck waist and went to a breakfast of cornmeal mush, horse hash, brown bread and black, bitter coffee and 'samp' [coarse corn porridge] which I could not eat. Then I came over to our room and found Lizzie down on her knees washing the floor with a little rag (with the vain hope of getting rid of the fleas) and I helped her with that then we washed her hair and went

into the ball room to rest and read my Bible. Then we went to dinner and had bread and butter and horsemeat, too tough to eat, red rice, which has gone thro a ferment and has a musty taste, beans and oh, joy, bliss, watermelon sweet pickles.[50]

Polly Condit Smith, who does not appear to have entered into the ethical discussion, noted that the melons were unripe and that while fruit and vegetables had been sent 'they regretted they could not send us ice, because, if they attempted to do so, the Boxers, who like ice, would be sure to capture it'.[51] And those against accepting the food had at least a practical point, as one of the women suggested: 'Twice presents of fruit have come from the 'Emperor' (?) and we judge by a telegram that came to Sir Robert Hart that they have reported they were protecting and feeding us.'[52]

The discussion gathered pace and by 4 August, Ada Haven, who had admitted a few days earlier enjoying the rind pickle, was reporting:

Today the question came up whether we should beg the enemy to send water-melons, eggs (2,000), several sheep, a cow or two and a number of other articles per diem for the use of women and children, but was vigorously protested against by the ladies, who said if the men wished to ask for these themselves they must do so in their own names. Some among us even characterized such doings as dishonorable and unworthy. It was said in answer that this was to be merely palaver, just to talkee talkee with the Tsung Li Yamen ... and keep them busy till the troops came. Finally they chose another topic for debate, ...[53]

So much for democratic discussion: Charlotte Brent recorded on 12 August, 'Minister[s], against the desire of most of the community, have accepted offers of market supply.' Her son, A.D. Brent, in his diary later published anonymously, suggests that the women actually signed a petition against receiving food, while some of the men 'cannot bear to see their wives, mothers and sisters suffering from want of food'.[54] Of the foreigners, I believe only he had a mother there, and only Russell Brazier a sister (Daisy). But M. Pichon explains in his diary on 8 August that the request for food is a subterfuge to make the Chinese think the besieged are short of food, when in fact they have enough meat until the 20th, and enough rice and bread until the end of the month – and thus deter them from pressing home their advantage.[55]

Violet Tours Gets her Egg White

Perhaps Polly Condit Smith did enter the discussion about the acceptance of food in her own way; she wrote on 21 July:

People's larders are getting terribly empty, and the menu I quoted three weeks ago is now in the distant past. We live quite sparingly, and are hungry

most of the time. The chief comfort in our mess now are the Selzogene bottles that Mrs Squiers brought with us from our Legation, in which we daily make enough soda-water to last throughout the day.[56]

Fortunately, there had never been any shortage of water, there being seven wells in the British Legation grounds, five of them sweet.

Polly noted on 7 August, with or without a hint of irony:

I'm sure everyone is sorry for Lady MacDonald, with that enormous mess to keep going. The complaints that people actually have the impertinence to make at her table, loud enough for her to hear, got so bad that one day she rose from her chair and said: 'I give you the best I have; I can do nothing better; and, what is more, let me remind you that what is good enough for the British Minister to eat is more than good enough for anybody here.'[57]

In wondering who could possibly have told this story to Polly, it is worth noting that in the previous paragraph of her diary entry she writes: 'Today Baroness von Ketteler took a simple tiffin with Mrs Squiers. Her condition has been such that she has not had one night of natural sleep in the seven weeks since her husband's murder.' But, if you can picture Maud telling the story about Ethel MacDonald to Harriet and Polly, she was beginning to find pockets of enjoyment in life again!

As for Ethel MacDonald, she does not, of course, tell the story in her published article, but she does say that their 'excellent cook deserted' leaving a poor replacement whom she could only get to perform through threats, and she does write:

Some of the members of our mess were rather greedy, and their appetites out of all proportion to the fare provided, so they were carefully watched and gently reproved when inclined to take more than their share of a succulent pony curry. When this failed it was privately arranged that they were to be helped last, and, as there was never a chance of a second plateful for anyone, a check was, in this kindly manner, kept on their appetites. ... Since the siege I have been told by many members of our mess that they constantly went to bed hungry.[58]

There had been one important nutritional development as soon as the truce set in; Polly wrote on 21 July:

We have been trying to make a kind of market with the Chinese soldiers doing duty on the Chinese sentry lines, but although they would be very glad to pocket the big commission which they could get out of the transaction, they have not been allowed to do so by their officers, but they smuggle in eggs for us every morning at high prices (*bien entendu*), just enough for a very small supply for the hospital.[59]

The Austrian Lieutenant Winterhalder recorded a less commercial experience round at the French Legation which had Chinese forces posted just behind it and, indeed, in part of it:

> Mme Pichon with her husband and some other women from the French Legation came here to see what had happened to her house and was depressed to see that there were Chinese soldiers resting in the ruins. As she looked, a soldier came over and handed her a little melon and a peach. He made it clear that he wanted neither thanks nor payment and retreated hastily behind his barricade. Mme Pichon had never seen the man before, so the offer was obviously spontaneous, nor did he want any discussion, advantage, or thanks.[60]

But it was the eggs that were essential and, although they could not be relied on for either freshness or supply, they were a lifeline. Bessie Ewing wrote on 23 July that the Chinese soldiers were bringing eggs concealed on their bodies. 'Even with this precaution we know that several have been killed by their officers for thus helping the enemy. But what a Godsend they are to us. Ellen went almost wild over hers.'[61] Theodora Inglis elaborates on how the market worked:

> On 9 August, the Chinese began firing again. Every soldier and guard took up his gun and went back to his post. Brave Mr Brent of the Hong Kong and Shanghai Bank, closed up his market and rejoined the volunteer guard. Our market had been running during the truce for we had been able to get a few eggs from the Chinese peddlars. They sold to a committee of one at the barricades and the committee turned them over to Mr Brent who distributed them at the same hour that he gave out a cigar each day for the smokers.[62]

You would not guess from the siege writings of Charlotte Brent's son that he played a leading role in procuring essentials.

Eggs had become the main topic of conversation, so much so that some even managed to weave scandal around the subject; Putnam Weale suggested on 31 July that 'Everybody professes tremendous rage because a certain lady with blue-black hair is supposed to have used a whole dozen in the washing of her hair! She is one of those who have not been seen or heard of since the rifles began to speak.'[63]

That was tittle-tattle for those who were missing the fighting during the truce. Before the egg market existed, Alice Fenn, Theodora Inglis' erstwhile neighbour in the Presbyterian compound in Peking, wrote under the heading 'luxuries':

> At one time, I recall, when my baby [Martha, 20 months] could take no food at all, I felt that I must have the white of an egg to put in the water she drank. I pointed out to her father that one enterprising father had come in with an

egg in his pocket; and that if it were possible to loot one, we should thankfully use the only means that Providence allowed us of securing one. He did not much relish my suggestion, but when he returned again the egg was in his pocket. 'This is a diluted egg,' he said, 'the looted egg of a looted hen'...

We learned new values for things in those days. How carefully the yolk of that egg was saved for another child, not too sick to eat it. At times when I had mixed a little condensed milk for my baby and she was unable to take it, I would start out, cup in hand, to find some other child who needed it just then, that the precious food might not be wasted. There are several mothers who will not forget how more than once Mr Norris secured a chicken and Mrs Brazier made it into broth, which was most unselfishly divided into equal portions, that each sick child might have a share of it.[64]

Deaconess Jessie Ransome leads into a particular egg story with her observation that when her colleague Roland Allen was ill, 'we managed to get two or three fresh eggs, which we divided with a sick baby, she getting the whites, and he the yolks'.[65] Allen was so ill that he did not really remember what happened, but he later wrote, dated 18 July, 'I have been told that while I was ill, I used to share an egg with a sick baby.'[66]

That baby became identified, at least privately, during Fleming's research for his book, and his approach to Ada Tours' family. The baby, born Violet Tours, then Mrs Garnons William and nearly sixty years old, wrote to Fleming on 10 March 1958, apologising for the fact that her aunt had not kept some siege letters, and continuing:

Just by the way, on page 228 of Allen's book I am the baby he shared an egg with, he had the yoke and I had the white, as there was no baby food. My mother's description of rushing to the doctor, himself very ill, and hearing him say 'dead' are one of the more dramatic bits. However, it wasn't true, as it turned out! ...[67]

Through that lead, I tracked down Ada Tours' granddaughter, Susan Ballance, at the family home in Wales, and she not only gave me generous access to her grandmother's diary and scrap book but also elaborated on the egg and baby story, showing the importance of family oral history:

At some stage during the Siege my mother [Violet] was taken ill, and she was put outside her room as she had been pronounced dead. The wife of the French Ambassador passed down the corridor, found her, picked her up and insisted there was life in her after all. We were always told that it was she who found an egg to give Violet, which put her on the road to recovery, and decided that the Saving of the Baby was to be the Ladies' project for the Siege. Because of all this, Violet became known as 'The Siege Baby'.[68]

31 Madame Pichon (from *Le Siège de Pékin*)

Mme Pichon has had rather a bad press, particularly in English-language male accounts of the siege, I suspect because they liked to mock her husband. Hewlett wrote on 18 July, for example, 'Two or three days ago M. Pichon burnt all his diplomatic papers; Mme Pichon rushed about stamping on bits that blew away and burning them again – a fine scene.'[69] Neither was it so obvious which Mme Pichon's siege constituency was; but Theodora Inglis notes not only that she was 'lovable' but also that 'she never wearied in [her] attentions to the native Catholic Christians'.[70] Cecile Payen (of French extraction) confirms this when she writes, 'Mme de Giers and Mme Pichon ... take turns in looking after the sick and needy; the latter has all the Catholic refugees to look after'.[71]

32 Violet Tours and Murray Ker (courtesy of Susan Ballance)

It was at about this time that many foreign babies became ill and more than one died; Elizabeth Inglis died, as we have seen, on 22 July. In Ada Tours' diary, there are only cryptic remarks and a gap. On 17 July, she wrote, 'Baby is very seedy.' And, describing the conditions, noted that several others were too. There is then a gap until 24 July, when she notes the arrival of fruit from the Empress Dowager. The following day, she writes, 'Cooler and Baby rather better.' I suspect it was during that gap that they thought their baby, too, had died.

On 27 July, Ada Tours observed of the two-and-a-half-year-old baby of her husband's colleague William Ker and his wife Lucy (née Murray), 'Murray Ker is not well today and the doctors think he has scarlet fever.' On 7 August, she wrote, 'Think [my] Baby is picking up a bit but am deadly sick of the whole show.' On 10 August, it was: 'Murray Ker better and Baby Stonehouse very ill ... Baby seems a little brighter but is miserably thin and white.'

She also failed to record what happened on 7 August, but Ada Haven wrote:

Today in the early morning the little Bok baby (Swedish) died. Now in the evening about twilight, the funeral is to take place. It is to be at the chapel, so the Presbyterian and Methodist supper was hurried up so that the chapel might be free between supper and bedtime. I must go and attend it now.[72]

Mrs Arthur Smith noted that the Bok's baby, whom she calls Baby B, wore a dress of little Elizabeth Inglis, and that 'The sad parents followed the English service with some difficulty, but when the children gathered round the tiny grave and sang 'Bright Jewels' in Chinese, and the baby's sister sang, too, then we all seemed one.'[73] Ada Haven noted of the funeral that they buried the baby between Elizabeth Inglis and a soldier shot just inside the gate by a random ball, and that shots were fired over their heads during the ceremony, even though, on the whole, it was fairly quiet during those days.[74]

When Baby Bok died, not surprisingly Theodora Inglis summed up the tragic sequence, explaining that she was

the same child that had suffered with small pox in the Methodist Mission. We were all sorry for Poor Mrs Bok, expecting as she was, the early birth of another little one. Throughout the entire siege and under fire they had lived on an open porch, railed in with a few boxes and in that little enclosure the pretty baby died. It too was buried in our little cemetery in the British Legation. Poor Mr Imbeck's only two children and Mr Kruger's only one had been taken to the German Legation and laid beside the dead German soldiers. There was still another child waiting to be called, the beautiful baby boy of Mr and Mrs Ker of the British Legation; it lived, however, until a few days after the siege was lifted.[75]

Even when death did not occur in the end, most of the babies were seriously ill. The Stonehouse baby was still ill on 15 August when his father wrote home to headquarters.[76] His colleague Howard Smith had feared during the siege that 'we should lose our baby'.[77] Later, when asked for her memories of the siege, five-year-old Marion Ewing replied, 'In the siege Ellen [twenty-one months] was sick and nearly died.'[78] Ellen's trouble started with the fact that she was teething and her mother records the ups and downs that were exacerbated by their situation. But Bessie is equally solicitous of the other babies, writing on 12 July,

Poor little Miriam Ingram has some kind of skin disease. She was bitten on her face and then scratched it, and then the sores spread. Her face on one side is covered and more sores are coming on her body. The doctor gives her no hope of a cure until we get to a better place where the air is purer. ... Martha Fenn was very low with dysentery but is much better now.'[79]

But by 15 August Bessie was having to write of Ellen, 'The poor little thing has had a terrible sore on her shoulder, an eruption just like Miriam Ingram's. ... She is too weak to stand on her feet and wants petting all the time.'[80]

Of the seventy-nine foreign children besieged, six, all of them babies, died. Polly Condit Smith wrote following Baby Bok's death with some acuity, though perhaps lacking the necessary empathy with suffering or understanding of sisterhood, 'All mothers who have children or infants who are ill or weak seem fascinated by these pitiful funerals, and they all go to them.'[81]

Theodora Inglis was quick to observe, in the midst of her own grief, that Chinese children were dying at the rate of nearly two a day. But she has suggested that she is an optimist so, immediately after talking of Elizabeth's grave, she wrote of the baby who, slightly confusingly, was not Violet Tours:

> But our little Siege baby grew and flourished. I had heard its first cry amid a shower of bullets, one night when we had been but two weeks in the British Legation. The wail of the new born – how it startled us that dark night, but afterwards, when I saw his proud young mother, Mrs Moore, wheeling him about I concluded that her circumstances were happy after all. Dr Morrison advocated naming him 'Siege' but Dr [Arthur] Smith hoped if they did so, that it would not take twenty years to raise him.[82]

The Latest Diet

The discussion about the ethics of accepting food from the Chinese, and the way the women rallied round each other when their children were ill, were put into their pragmatic context by Nigel Oliphant when he wrote on 7 August:

> Another child [Baby Bok] died last night simply from lack of suitable fresh food, and more will certainly follow if the Ministers do not demand of the Yamen the means of procuring milk and eggs etc. If they refuse we are no worse off and it puts them all the more in the wrong. If you don't ask, and afterwards complain of the scarcity of food, the people at home will say, 'Oh we thought the Chinese government was supplying you; didn't you ask them for what you wanted?' And when we answer, 'No', we shall only be thought fools for our pains.[83]

According to Oliphant, a few days of prevarication began after the reqest was made. The student interpreter Lancelot Giles says on the 10th that it was for the starving converts in the Fu that the food was requested a few days previously.[84] On the 27th July, 'Prince Ch'ing and Others' had written suggesting that as Peking was now tranquil, they advised the foreigners to let the Christian converts leave and return home, thus saving themselves trouble.

As far as fruit and vegetables, milk and eggs for the foreigners was concerned, it was not just the infants who suffered from ill-health, though it was more

lethal because of their stage of development; grown women increasingly found it difficult to keep well as their systems rebelled against the diet, the nervous tension, the heat, the rain which had now set in, the insects and the pollution caused by unburied corpses and carcasses. Indeed, the truce itself, shortlived as it was, no doubt exacerbated the pressure on some over-stretched nervous systems. 'I was quite sick for one week,' wrote Bessie Ewing who was unable to make entries in her diary between 24 July and 14 August (just after her sixth wedding anniversary),

> and the doctor tried to keep me on liquid or low diet. The treatment cured me but left me very weak. The low diet would probably have been all right if there had been any material, but beef extract was about all that could be obtained. I had mutton broth twice and a very little white rice towards the last. ... When after two weeks of starvation I was allowed to go back to pony steak and coarse brown rice I felt much better. However I cannot eat the graham bread any more. In fact it is very painful now for me to eat at all as my mouth is filled with cankers.[85]

Just before she took to her bed, on 22 July, Bessie went to see Martha, the orphan girl whom she had taken charge of, and wrote, 'Now that [our Christians] are this side of the canal we are allowed to visit them. Poor Martha, she has changed fast and is evidently in the last stages of consumption. It makes me feel so bad not to be able to do more for her. The milk supply is getting so low that it is all reserved for the babies, and, of course, I cannot take any to Martha.'[86]

Bessie was still able to buy three eggs a day – they were reserved for children or the sick – and she took two over to Martha, 'feeling almost guilty in doing that. Now I have seen her I don't know as she will be able to eat even eggs.' She was right in her diagnosis: Martha died at the end of the first week of August: 'I was not able to attend the funeral. It made me very sad to think how little I had been able to brighten her last days.'[87]

Charlotte Brent, who had travelled from England for the sake of her health, noted on 30 July, 'Felt very weak during the day. Food getting so coarse and repugnant but must struggle through as now we hear the troops are only 17 miles away.' That was not true; they had not yet left Tientsin, but hope was a great encouragement.

On 2 August, Mary Bainbridge wrote,

> Was very sick in bed eight days, but Mrs Lowry has told me of all that has transpired during that time. I got so that I could not eat the horse meat any longer and it was that or starve, so I concluded starvation was as good as horsemeat. I found a little corn starch and with a little water and sugar (no eggs) the boy fixed it up and once or twice a day I had that. Chinese soldiers shot every one who went outside to look for eatables and so no one was

allowed to bring anything to us and here we are behind these walls like prisoners.

On 2 August, Cecile Payen recorded, 'I cannot eat horse-meat; I have tried it five times, but each time it has made me ill.'[88] She added on the 8th, 'On account of illness I have not been able to write in my journal since August 4.'

Those working in the hospital were under even more pressure; Dr Emma Martin wrote on 23 July when the previous night there had been a violent thunderstorm but little lessening of the heat:

> I had a horrible night with mosquitoes, sandflies and fleas, the worst I have had yet. It was so hot and we tumbled about on the floor and scratched and by 2 o'clock I was ready to cry from exhaustion. I dozed off once in a while toward morning but got up tireder than when I went to bed. Dr Gloss was not well and she asked me to take her place at the hospital in the daytime and ask Dr Terry to take mine at night. ...[89]

On 17 July, Jessie Ransome had recorded, 'Tomorrow I am going to take a day's rest, and Lady MacDonald has kindly asked me to go there and lie under a mosquito-net on a bed, which will be a treat after a month of sleeping on a table!'[90] Indeed, throughout the siege, women who found things were momentarily getting them down, would be invited over to Ethel MacDonald's to find a temporary haven. And on 10 August, Jessie Ransome noted that 'Lady Macdonald came down for several hours today to help with the typhoid patients, and relieve my hands a little.'[91] She noted on 6 August that Miss Lambert was in bed, and would probably be so for some days more; and on the 10th 'Miss Lambert has been away ... several days, knocked up by the heat and over-strain.'[92] While her colleague Roland Allen, whom she had been nursing, notes in a later recorded diary entry for 3–10 August:

> I cannot refrain from again insisting on the heroic labours of the nurses. Already Miss Lambert has been laid up for several days with sickness brought on by overwork, and Deaconess Ransome was on the verge of collapse; one or two of the others less well known to me were in no better case: yet they hold on. In the hospital there was none of the excitement, none of the vigorous labour in the open air which the more sturdy members of the defence enjoyed, only the dull routine, the strain of perpetual standing or stooping over sick-beds, the fearful sights and noisome smells of wounds and sickness. It was wonderful to me that they could persevere with such unfailing zeal, such patient devotion, at such a task, in such an atmosphere.[93]

And Ethel MacDonald was to remember,

> Towards the end of the siege, when many of our willing English and American lady nurses were breaking down from over-work, I took a few hours

duty every day in this improvised hospital. It was not till then that I realised the hard work and devotion of those good women.[94]

But whatever the effort, somehow they had to hang on; in spite of endless false rumours and keen disappointments, they had never given up hope that a relief force would arrive from Tientsin. On 3 August, the day of the conference in Tientsin which decided that the troops would after all leave, and do so on the 5th, Charlotte Brent noted, obviously sustained by the false knowledge, 'The general idea is that the troops will not arrive until Sunday next. These last days will be a great trial as provisions are getting short and the great delay has wearied us all.' The Chinese spy who had been providing such contrived reports as a useful source of income was unmasked that day. The troops had still to leave, and to fight their way to Peking.

A day or two later, the attacks of the besiegers closed in again; Claude MacDonald explains that the bullets were coming much lower 'and women and children were as much as possible kept indoors'.[95] They were informed by another spy that 'a new general had arrived from Shansi [Province] who had sworn to the Dowager Empress to take the legations in five days'.

Rumour had it that the Empress Dowager had been preparing for flight; according to Morrison, 200 carts had been assembled by 27 July, entering the Imperial palace via the gate immediately facing the Ch'ien-men. But she did not leave then.

13
Pokotilova – Inspiring as a Bugle's Blast (17 July–13 August)

Mrs Lowry Shares her Letter

'Communicate tidings bearer', came the apparently cryptic message in cypher to the United States Minister Edwin Conger from the State Department in Washington on 17 July (delivered by the Tsungli Yamen).[1] The besieged did not know that the day before news of their massacre had been blazoned across a newspaper in the outside world, but they did understand from it that Washington did not know their situation, and they did know that it was a real cable, because only Washington and Conger had access to that cypher.

Conger carefully replied, 'Surrounded and fired upon by Chinese for a month. If not relieved soon, massacre will follow.'[2] For all the false news before and after, there was now a bedrock of confidence that was to tide everyone over, the more so as messages were pinned up on the bell tower for all to read – I have taken those texts deliberately from Bessie Ewing's diary.

Mary Bainbridge recorded how on 2 August there was a message from the American Consul in Tientsin

> saying they never expected to see us again until they got Mr Conger's telegram in July saying we were alive. There was a telegram from London saying that they had seen Mr Conger's message to the [State] Department. It was the only thing they had been able to learn of anyone in Peking, only what the Chinese Minister [in London] had informed them. They had been led to believe that we were being well cared for by Chinese officials, that we were all comfortable and happy.

It was not all plain sailing, however; the messages began to flow freely and were sometimes exhilarating, but often they were obscure or ambivalent, none more so than that from the British Consul General in Tientsin which read, according to Polly Condit Smith's diary:

The rest of the British contingent, under General Gaselee, coming from Singapore, are expected on the 24th. Most of the Japanese troops are in Tient-tsin, and mobilized. The Russians are only landing at Taku. There are many Chinese troops between Tient-tsin and the coast. If you have plenty of food, and can hold out for a long time, the troops will save you. All foreign women and children have left Tient-tsin, and plenty of soldiers are on their way to your succour.[3]

Polly wrote that the only excuse for such a message was 'that he was afraid that the letter would fall into the hands of the Chinese'.[4] Sara Goodrich writes of the letter's reception:

No one can imagine the disgust which was shown on reading this letter. No other nationality could begin to say any worse things about sending such a message than the British themselves. To discover after seven weeks that troops still had not started to our relief seemed inconceivable. Shut up in Peking in ordinary circumstances in the summer is something all avoid. One cannot understand just why with Russia and Japan so near, that it takes so long, or at least why no explanation is made.[5]

Later messages were to come in from other consuls in Tientsin and Polly Condit Smith was to write in high dudgeon: 'They all take the attitude that the writers are pleased that we are not dead, then give us some trifling details about themselves in Tientsin and long, rambling accounts of what wonders they have gone through. Nine days [only] besieged!'[6]

When you know what was going on in Tientsin and that the decision to leave had not yet been taken by the Service commanders and how awkward that must have been for the consuls, you can better understand what Carles wrote, and I cannot help adding here what Anna Drew wrote of Mrs Carles – it was not as if they had been sitting on their hands in Tientsin:

Mrs Carles had been very brave – and they remained right at the Consulate, which was in a very exposed position, all the time – except the night they came to us. They had a very miserable little shelter under their veranda, and spent many days and nights there. She had far more anxiety than I because of the children – four little ones to care for.[7]

The only thing that added any consolation (by way of wry amusement) to the disappointment and confusion caused by the Carles message, was the news that the messenger who brought it had been given half a dollar to bring it by Carles 'and a Russian soldier took it from him at the barricade'.[8]

One of the highlights of the arriving messages was a letter from Ed Lowry in Tientsin to his wife in Peking; it was dated 30 July and arrived on 2 August. Mrs Lowry allowed that letter, too, to be read out loud and then posted on the bell tower for all to read. That it did the women good is confirmed:

One of the ladies had a letter from her husband, who has been in Tientsin all these weeks. How happy she is! Even if this had been no particularly good news, I feel as if my joy for her would be enough to set me up for a week.[9]

And Ada Haven, whose future husband was she knew not where, wrote, 'I cannot say I did not envy Mrs Ed. one wee bit for her letter.'[10]

Reading the letter, now, though, I find it rather confusing; perhaps not entirely surprising, there is nothing personal to his wife – he did not know who would read it – but Ed Lowry does not send in it a message to his brother George about his wife and three children; what is more, he mentions Boxers killing Christians at Tsun-hua, which is where Mrs George had set off to from Peking, and from there fled to Tientsin. He said that most of the women and children had now safely left Tientsin, but not that his sister-in-law was among them; by 30 July, having spent nearly a month on a transport in Taku Roads, the family was on its way to San Francisco. It must have left Dr George fairly frantic, unless there was another message which has left no trace.

Theodora Inglis' comment upon his brother's letter must have made it even more worrying to George Lowry:

> He mentioned many things but was silent concerning our friends at Pao Ting Fu. There were, of the Americans, Dr Taylor, Mr and Mrs Simcox and their three beautiful children, young Dr Hodge and his lovely wife, Misses Morrill and Gould and our good friend Mr Pitkin, also five others, British people. A Rumour crept in from Chinese sources that they had been killed on July the first, but this we could not and would not believe. Nevertheless the suspense of those last days almost over-shadowed our expectancy of relief.[11]

She would have to wait until 14 August for an answer to her unspoken question.

But there was often good news pinned up on the bell tower. Polly Condit Smith wrote of M. Pichon on 21 July that he 'had a very nice telegram sent him from France, saying: you are unanimously voted to have the Legion of Honor. Your mother sends her love and greeting, and 15,000 Frenchmen are on their way to your support.'[12] Actually, there were 800 French troops, but Pichon is rather winning when in his own diary he mentions the Legion of Honour and continues, 'They gave me – something which was particularly pleasant for me, and touched me more than the rest – news of my mother and that she is in good health.'[13] On 7 August, Robert Hart received a telegram from his wife – who had lived in England with their children for some years – congratulating him on being alive.

The bell tower had several other community functions; on Friday 27 July, Sara Goodrich noted,

> The next sensation was the appearance at the belltower of the man (a Chinese) who had cruelly beaten his wife the night before. He had a *cangue* on his neck, and on it were the words, 'This man beat his wife and hence is

33 Bell tower and messages; chapel, home to
American missionaries, in the background
(from *China in Convulsion*)

sentenced to wear the *cangue*.' The mother came and plead for him, weeping, 'his wife reviled her husband first!' The Chinese grinned not a little. Will they welcome a regime that forbids the husband right to abuse his wife if he so desires![14]

Cecile Payen interpreted some details differently: that the 'wife-beater' had a 'forced grin on his face' and that the family's complaint was that they, too, were being disgraced. She added that it was Mrs Squiers who had seized the 'coolie' and locked him up, that he was a Christian, and that he had also beaten his baby.[15]

Other functions were rather less didactic, more naturally entertaining, as Ada Haven wrote, allowing herself to become almost lyrical:

After it became too dark to copy edicts, gazettes, etc., one could amuse one's self looking down upon the crowd below, passing on the Boulevard. Here are some Chinese returning with their shovels, to exchange them for dinner-tickets. Here is a new group among those going to take an airing, some Japanese ladies and a toddling baby, looking like a bright flower blowing in the wind. We had supposed Japan was represented only by men. But this armistice brings the ladies and children out. Here, too, is the result of a notice we have just read on the bulletin, that after a certain date, now past, all dogs weighing over seven pounds will be shot if found running at large.

That is with a view to the benefit of the Christian Chinese, and to remove said dogs from the list of eaters to the list of eaten. The result is seen in a big, strong dog going about the compound leading a little European lady [Dorothea Goodrich and Dinger?] about by a string, and sometimes he leads her a chase, to be sure. Here is a little index of the length of time we have been in the siege, little baby 'Siege', going past wheeled in his carriage by his mamma. ...[16]

The fact that the Japanese women were now apparent – added to the bravery of their men at the Fu and when wounded in hospital and everyone's reliance on Colonel Shiba – was now to be turned to practical and political use. Soon, plastered over the bell tower, were designs for a siege medal. The one chosen – illustrated here – honours, on one side, the besieged women from Europe, America, and Japan.[17]

Pokotilova Sings the Marseillaise

Dr Emma Martin wrote on 27 July, 'We often sing these evenings around the bell tower when there are not too many bullets. Mr Hobart and [Mr] Verity and Mrs Woodward and Ione are very good singers. Sometimes its America and sometimes its God Save the Queen or the Russian national hymn and sometimes all the same evening.'[18] Mrs Gamewell elaborates:

34 Design for Peking siege
commemoration medal (from *Siege Days*)

Now with a bound the sweet possibilities of home and friends were brought near. We joined the singers, we sang 'America,' 'Star-Spangled Banner,' 'Battle Hymn of the Republic,' 'Marching through Georgia,' and 'Tramp, Tramp, Tramp, the Boys are Marching,' hoping intensely that they were marching our way right speedily. Having sung our own national airs, we tried 'The Marseillaise.' Then from over the way in the pavilion where the French [engineers and nuns] had their quarters there arose a clapping. British soldiers had drawn near. We sang with them 'God Save the Queen.' ... Again there was a clapping of hands. We sang 'Watch on the Rhine' with the Germans and their song was received with clapping. Then the ladies and gentlemen of the Russian Legation stood forth. They had a prima donna in their number, and they rendered grandly Russia's grand national hymn. And again a clapping of hands cheered the singers. ...[19]

Mr Fenn's 'Siege Song' – a parody on 'Tramp, Tramp, Tramp' – which gave such pleasure does not quite stand the test of time, but one verse at least is appropriate:

We've been kept in best of cheer, by the loyal ladies fair,
Who have worked with might and main to help the men.
Of the wounded and the sick they have taken the best care,
And have made a million sand bags lacking ten.[20]

But it was Mme Pokotilova, wife of the Director of the Russo-Chinese Bank, who was the real star. Polly Condit Smith, with her flair for getting names wrong, and with her access to George Morrison's gossip, wrote on 21 July:

The Russians seemed horribly worried about so many Japanese soldiers coming, but there are always rumours that the Russians have been keeping away from Tient-tsin so as not to join the allied Powers, and perhaps be forced to make some promises which they might regret later, and that they are doing some seizing of territory at the present on their own account on the plea of defending their railways. An Englishman here, being, of course, anti-Russian, insists that this nation is absolutely careless about its Minister or other Russian people trapped here, whether they live or not. If it is a question of making some coup for the aggrandizement of their country, they would not hesitate to sacrifice their people in Peking. One of the men in the Russian Legation is named Pompoff, and has a very pretty wife with a gorgeous voice, and as Russia is known to want Manchuria, he put it quite aptly in speaking of probable orders from St Petersburg: 'They will say, *Mon Dieu*, what is Madame Pompoff to Manchuria?'[21]

Mme Popova, wife of P.S. Popov, the Russian Legation's interpreter, was certainly there, together with five daughters, but Polly is clearly writing about

Mme Pokotilova; though she is not the only one to be confused about exactly who the Russian woman was.

Putnam Weale can start the story off; he wrote of 15 July:

> In the evening the missionaries now gather and sing hymns ... sometimes Madame P ..., the wife of the great Russian Bank Director, takes compassion, and gives an aria from some opera. She used to be a diva in the St Petersburg Opera House, they say, years ago, and her voice comes like a sweet dream in such surroundings. A week ago a strange thing happened when she was giving an impromptu concert. She was singing the Jewel Song from *Faust* so ringingly that the Chinese snipers must have heard it, for immediately they opened a heavy 'fire', which grew to a perfect tornado, and sent the listeners flying in terror. Perhaps the enemy thought it was a new war-cry, which meant their sudden damnation![22]

The best-informed about the Pokotilovs was, not surprisingly, George Morrison. This became particularly important when Dmitri Pokotilov was appointed Russian Ambassador to Peking in 1905, but those in the know had their eye on him from the start of his career in China, he was so obviously bright and forceful – he was also the nephew of Sergius Witte, the Russian Minister of Finance.

Pokotilov began his career at the Russian Legation in Peking in 1888 and was soon so well established that not only did he speak fluent Chinese (as well as English, French and German), but he was also said to be close to the Empress Dowager's all-powerful chief eunuch. He later joined the Russian financial administration and, by 1896, he was back in Peking as Director-General of the Manchurian Railway. In 1897, according to a Morrison contact, Pokotilov, Director of the Russo-Chinese Bank, 'Yesterday offered the Chinese Government 500,000 Berdan rifles at a price of 7 taels a piece ... the offer was accepted.'[23]

In April 1900, Morrison describes Pokotilov as 'A tall, swarthy man, handsome striking with very clear piercing black eyes.'[24] This is of significance because he was something of a Lothario. According to Morrison, he 'married a lady some years older than himself, with a beautiful voice, who had for some years been his mistress'.[25] The *Times* correspondent added, 'Both he and his wife have always been friendly to me.' It is not surprising, therefore, since loyalty to 'friends' was not Morrison's strong suit, that a year after he wrote that, in 1906, he should write (not in his private diary, but in a letter to a colleague): 'P... is at present in relation with a spare lady of his legation, his own wife, who was formerly a member of the oldest of all professions, being now at Peitai-ho.'[26]

This is all strongly at variance with a description of Pokotilova's antecedents written by Bessie Ewing's husband Charles on 17 February 1899:

> One of the ladies living at the Methodist Mission has been teaching English to a Russian lady, the wife of the gentleman in charge of the business of the

Russo-Chinese Bank. She finds the lady ... of great culture and intelligence. She was for some years a teacher in a college in St Petersburg, where her husband also taught for a long time.[27]

During the siege, according to Polly Condit Smith, Dmitri Pokotilov performed an essential function; she explained on 5 July:

> The president of the largest and most influential bank in Peking, besieged here with us, has received a wound which absolutely incapacitates him from active work. He can only hobble around on a crutch. He has volunteered to tend 'Miss Cow' and assist her to find the few blades of grass which are still to be had.[28]

It is this cow, I suspect, that was the mother of the calf liberated by Auguste Chamot, and 'Miss Cow' was, in turn, probably dispatched on 8 August; certainly, according to Mrs Goodrich, 'a cow was killed ... How nicely it tasted.'[29] By this time, Ethel MacDonald, confident that relief was at hand, and when horses were running low, would have seen the value to the ailing community of every morsel of the cow.

As for Mme Pokotilova, whatever her past, and her rather uncertain future with her husband (of whose philandering under her nose she only became aware when he died of a heart attack in Peking in 1908), she played an essential role in lifting morale during the dark days of the siege.[30] Mary Bainbridge's husband, in an appendix to her diary, tells how on one dreadful night of attack, a Russian lady began singing the 'Marseillaise'. 'Her voice rang out sweet and clear above the din of conflict, inspiring as a bugle's blast and soon the strains of that most martial air rose defiant among our entire line.'[31]

However integrated the Russians seemed through the communal singing, the de Giers are said to have moved back to the Russian Legation by 26 July, supposedly 'because they were uncomfortably crowded here',[32] but just as likely it was because of the political treatment of the Minister. The feelings of Edith Miller, governess to the de Giers children, have to be left to the imagination.

Siege Tourism

One of the other diversions during the gaps in the firing was Siege Tourism. Mrs Bainbridge noted on 18 July,

> Very quiet. We walked over to our Legation to see how things looked and see what had happened since we left it. Four weeks had passed since we all fled to the British Legation, and desolation was on every side. The gatehouse was badly shelled, trees cut down and lying in all directions, bullet holes everywhere. In our rooms I counted 66 bullet holes. The windows all broken, blinds hanging by one hinge, and one place in our bedroom where a shell

came through large enough for a man's body to get in, carpets and furniture ruined.

The same day, Mrs Goodrich wrote,

> This afternoon Miss Haven and I went into the Han Lin Yan, and saw the trench they are digging. They were countermining and had only gotten down six feet, when they struck an old concrete foundation. They found stone cannon balls under the roots of an old tree. The balls were used in an old Chinese catapult or had been made by the Jesuits. They must be over 150 years old. We also looked over the barricade and saw the Chinese sand-bags, but were sternly ordered to come down by Capt. Poole. Of course we might be shot and he would be responsible, but we did so want to see!![33]

Sarah Conger wrote on 1 August:

> Mr Conger took us upon the city wall. Without seeing it, no one can conceive what ingenious work has been put into the holding and strengthening of the position on the wall. It is marvellous! The deep ditches and high barricades silently give their protection. There are many loopholes through which our men can watch the manoeuvrings of the enemy. These holes are not the safest places in our besieged quarters. There is a dangerous one at the top of the ramp leading to the wall. For some time, our men could not detect the position of a troublesome sharpshooter. Finally they discovered a dark spot high up in a tree, and that spot at once fell.[34]

At the beginning of August, Theodora Inglis recounted:

> My husband and I walked over the Compound and went some places where we had not dared to go when there was sharp firing. We visited Fort Halliday, a barricade on the spot where Captain Halliday was wounded; Fort Oliphant out in the old Hanlin where [David] Oliphant and Warren fell, and Fort Strouts, the barricade at the front gate, so named in honour of the gallant officer.
>
> There was life and movement everywhere, even the convalescents were out, some sitting on benches, some limping about on crutches, and there were little groups of people scattered here and there all chattering busily. We went at last to the little cemetery in the South Corner and looked again at a little grave there, which two kindly British lads had bricked around and upon which young Fuller, the English Hospital Steward, had placed a beautiful cross in memory of his own little child that had been born and died in his absence.
>
> It was dusk when we turned back up the little lane. The Russians were chanting in their quarters, the British Marines rolling out jolly songs in their barracks and the Americans, led by Mrs Woodward, everybody's good friend, and the soldier's favorite, were gathered at the bell-tower, singing quaint

negro melodies. We did not pause long but passed them and went on farther towards our own quarters the sound growing fainter and fainter until as we stepped over and down into the little side court yard, the evening breeze bore to us a dying strain of Home Sweet Home.[35]

Sara Goodrich added to her impressions on 3 August:

Friday, I went on the city wall with Dr Ingram, Miss Russell and Miss Miner. We were protected by wall all the way. ... The city looked peaceful, only the great burned district west of us showed the great area occupied by foreigners and others burned over: Russian bank, Austrian Legation etc. The Imperial palaces looked serene from the wall. Oh! to see below those yellow tiles![36]

And on Saturday 4 August, Annie Myers shows us that sometimes Arthur von Rosthorn did venture socially into the British Legation:

Dr von Rosthorn, whom we met at the Belfry [bell tower] this afternoon, very kindly took Daisy and me through the tunnel to the French Legation, thence to the German and the Club and back over the South bridge and through a labyrinth of houses in the Mongol Market into this Legation by the hole in the South Wall. The French Legation is a sight to behold. Three parts of it are utterly destroyed and the remaining bit, portions of the d'Anthouards' and Berteaux' houses and chapel, is a perfect ruin. A long trench and breast work having been thrown up on one side and on the other a little barricade which is often under fire, so much so that people have to run between it and the next shelter.

Miss Mary Pierce is Chaperoned

In the calm of the relative truce, there were other imperatives than pure curiosity and the urge to walk freely; Mary Bainbridge wrote on 30 July, 'Saturday afternoon I chaperoned Miss Pierce and Mr Daysberg [Dhuysberg] over to look at the Japanese, French and German legations. They are all very much damaged.' It may well be that, bearing in mind Professor Martin's words about Mary Pierce inspiring Mr Dhuysberg to great deeds, we should now add Ada Haven's remark of 12 August: 'More than one romance is at present interesting those who love to watch and report such matters. There goes a Legation couple down the Boulevard behind me just this instant.'[37] And it is worth mentioning here that fifty-year-old Ada Haven met up with her own missing love, Calvin Mateer, after the siege, and, wasting little time, or making up for lost time, married him in September.

Romance was not the only relationship to flourish; The American Dr Emma Martin's friendship with the British hospital orderly Fuller – the steward from HMS *Orlando* – is, as you may have already noticed, one of the most attractive of the siege. She wrote on 20 July:

This morning before I came off duty, Fuller called to me, 'Here, Sister, let me give you something'. It was a leaf he had just torn off from his daily calendar with the following lines: 'The friends thou hast and their affection tried, grapple them to thy soul with hoops of steel'. I laughed and said 'Do you want this to be personal?' And he said 'I wish it might be'. And I said 'So it shall be'. He is the most unselfish man I think I ever met.[38]

Other women were able to make connections across gender, rank and race. Thirty-two-year-old Lucy Ker had seventeen marines camped outside her bedroom window and soon she was 'Mother' to them and her son Murray, with whom they played, 'Kid'; while Mary Bainbridge was to record on 18 August:

This evening Mr B. and myself went down to see our Marines. ... Before they left here some of them gave me some very nice little presents which I shall prize very highly, coming from the boys who fought so bravely for our lives for eight long weeks. I asked why they had given me such lovely things, and one, with tears in his eyes, said because you have treated us like white folks, and what you did for one was done for all.

Mrs Gamewell Gets Ready

Siege tourism came to an end; Ada Tours wrote on 6 August 'There was a sharp fusillade again at 2am quite like old times.' As the firing and shelling closed in upon them again, and as they believed that the relief force was this time really on the way, so other concerns came to the fore; Mary Gamewell writes:

During these last days, when there was no longer a demand for sand-bags, we could avail ourselves of the kind offer of one of the English Legation ladies [Elizabeth Cockburn] who put her library at the use of the missionaries, and I suppose of any who could read English. This was certainly most generous at a time when the only way anyone could be sure of finding any of his belongings was to keep them under his hand all the time. We had time also for another employment – to make ourselves some new clothes. Some of the stuff from the foreign stores proved too thin for sand-bags, but would make very pretty shirt waists, delicate satin stripe challies, and such material. They had been sent to the chapel weeks before by the storekeepers, with the request that they should be given to the ladies who most needed them. These were put away at the time. Who could tell whether we would ever need shirt waists? ... But now that the troops were almost here, we would make up those new shirt waists (for we sadly needed these too) and wear them first in honor of their arrival, making a gala-day of our welcome to them. And so it was that on this last afternoon of the siege, we found ourselves gathered where we had often with such feverish haste rushed

foward the sand-bags, sitting quietly doing our own sewing, while one of our number read aloud from one of these English books, about the Siege of Lucknow. We had often spoken of this remarkable siege before, wondering as we passed through certain experiences, whether these others had had similar trials or mercies. So now this gave us a chance to compare. As the one read, the others would often interrupt her, renaming the persons or the places of the story, as they seemed familiar – 'Why that is Major Conger or Sir Claude', or 'Call that Tungchou or Ch'ien Men'. Never was history so interesting.[39]

An anonymous American woman was to add:

I do not like to recall how I ironed the day before the troops came. I had been sick and was just up and able to get around. My knees trembled under me while standing, and two bullets struck the roof of a little house five or six feet from where I was standing, and sent the brick dust over my clean skirt and shirt waist. We had one iron for I don't know how many people to use, at least twenty-five. These ladies were waiting for me to get through so they could iron.

We began to expect the troops on the 13th, but doubted much whether we would be alive to welcome our rescuers, for, as the Chinese army fled before the allies, it fell back into Peking and vented its desperate spite upon us.[40]

This sweet vanity, and the effort that went into it – repeated throughout the compound, and by Paula von Rosthorn in the German Legation – was to exact a heavy price.

Last Days – For the Record

As the end of the siege drew near, with some more confident than others that the relief force this time really was approaching, so the diaries of those whose siege stories I have sometimes told thematically ask to be followed day by day:

Mrs Russell wrote on 6 August, 'Last night there was an attack [on us], and today a despatch came from the Yamen asking why we had fired on the Chinese troops.'[41] Polly Condit Smith added to that on the 7th: 'Last night there was a very severe attack, coming from all sides at once, and the firing continued for many hours. It is outrageous considering the letters we get every day from the Yamen declaring to us that they give orders to their soldiers daily that there must be no more shooting.'[42]

8 August – Ada Haven:

The reason why this day was an especial one as to the bill of fare was because, as had been announced on the bulletin for some days previously, a cow had been killed, and all the ladies and children among the foreigners were to have a portion. I think it was an especial forethought that made the market

committee pick out this day for the killing of Mrs Jewell's horse, knowing of course that she would not wish to eat horse meat on this particular day. Over seventy-five horses have been killed at the market (by Sir Claude's kitchen) since we went into the siege. They have naturally reserved the treasured pets and the race horses till the last. We shall soon be obliged to commence eating the racers unless the troops come quickly. ... In our mission, everyone, man, woman and child, received a portion. But I shall long remember the time we housekeepers, Mrs Smith and I, had in cutting the meat that night!

I wonder what would happen if, at this late date, I should confess that I got a little mixed between the various platters in the pantry that night? – the Con[gregational] beef for slicing, and that for making into stew for tomorrow, two similar platters for the Methodists, and then the platters of mule meat. I *tried* to keep them all distinct, and everybody enjoyed what they *thought* was the beef, and perhaps it was. ...

This same afternoon a number of gentlemen among us took the task of counting the Catholics in the Fu, for the purpose of trying to make some plan to keep them from starving. There turned out to be 1,295 women and children (men not counted). In the morning I had secured a very small portion of food they eat, as a specimen. (It did not deprive them as it was replaced by better.) It was black and in little cakes, with so much dirt in it that I immediately disposed of the bit I took in my mouth, and my mouth felt gritty for a long time. Another coarser kind contains much straw, oats, etc., and was filled with a stuffing of elm leaves.[43]

8 August – Polly Condit Smith:

Unless the troops come soon it is dreadful to think of the fate of the Chinese Christians in the Fu. Until now we have been able to give them a certain amount of food daily, but we can only spare this supply a few more days. These poor people will be forced to choose between leaving the Fu, with an almost certain chance of massacre, probably of torture, and staying where they are and dying of starvation.

No description of this place can give an idea of it as it exists today. To turn to Doré's engravings in Dante's 'Inferno' would help. Every tree in the Fu, and there are many, has been stripped of leaves by these starving people; the smaller branches pulled and the bark chewed off. Diseased or not, these wretched people have been forced to remain here all together, as there is no other place for them. Carrion crows and dogs are killed and dragged to the Fu by sentries whenever possible, and these ravenous creatures pull the flesh from their bones and eat it without a pretence of cooking. Every morning when the two horses are shot at the slaughter-house, for distribution to the messes, half of the inedible parts are eaten with relish by these starving people.

The heat is intense, the ground in the Fu is brown and hard, the children are naked, and the adults wear little, but one and all are enveloped with the agony of relentless, hideous starvation. The white rice which we have used in the compound has been finished, and we now use the yellow or uncleaned rice, which is very sandy and gritty, and which even the coolies in ordinary times would never think of using. It is made into curries or eaten plain, but one has to swallow it in spoonfuls without closing one's teeth on it, or it would be too much like chewing sand.

Today a letter came from the Yamen saying that Li Hung Chang had arrived in Shanghai, and that he would soon begin peace negotiations by telegraph with the Ministers in Peking. Not a word was mentioned about our leaving for Tien-tsin, nor an apology for the continued sniping at night, and the occasional attacks which make us realize the lie that we are being 'tenderly cared for and watched over by the Empress.'[44]

9 August – Mrs Conger:

Our food is getting low. ... Dog meat has been served to the Chinese today. Heretofore, horse meat has been given to them. For the coolies at the Fu a food has been made of slippery elm leaves, grains, and a little meat and its broth. We are all told to serve short rations. No messenger came to take messages to the Tsung Li Yamen. There has been considerable firing all day, but no battles. Sir Robert Hart brought me a poem written by himself, surely a choice gift in the siege. We look forward to his eleven o'clock visits with great pleasure. He never detains us in our work.[45]

10 August – Mrs Russell:

There was a bad attack last night from all directions. In the afternoon I went over to the Su Wang Fu, to one of the Japanese outposts, and was told a messenger had just arrived with a letter to Colonel Shiba from the Japanese General. It was written from Ho Hsi Wu, a place half-way between Tientsin and Peking. It stated that the Allies had defeated the Chinese in two big engagements, and that they hoped to reach Peking on the 14th or 15th. I ran back to the British Legation, and was the first to convey the good news. We are all so thankful and elated! Even some who had long faces all the time now began to relax a little.[46]

10 August – Jessie Ransome:

Great news today! A letter from General Gaselee at T'si T'sun, about eighty miles from here! I cannot tell you what the joy of hearing definite news like this is; the last few days of absolutely no information, even in the form of rumours, have been *most* trying, especially after having our hopes raised by the letter of the 30th from Tienstin.

General Gaselee's letter is dated August 8th, and is as follows: 'Strong force of allies advancing. Twice defeated enemy. Keep up your spirits.'[47]

10 August – Ada Tours:

A big fusillade – quite the biggest I have ever heard took place at 3am. The bullets positively rained upon the walls of our room – like heavy hail stones or a game of five. But we are so callous now that Daisy [Brazier] and I discussed the situation as if nothing were happening.

10 August – Mary Bainbridge:

The Chinese seem to be getting more desperate every hour. The 'Old Lady' has ordered two of the members of the Tsung-Li-Yamen beheaded, because they were inclined to be friendly to foreigners. We have had two or three attacks every night. Last night at dinner time they began at a furious rate and the British gave them a few greetings with 'Betsy' the International, and they very shortly retired for refreshments, tea and a smoke, and to cool their heated brows.

10 August – Dr Emma Martin:

This morning as I went to breakfast I looked over toward the butcher shop, which I seldom do, and there I saw our bay pony standing waiting to be shot. I turned away with such a sickening sensation and felt as though I would faint. I got to the church and sat down. A great lump came in my throat. It seemed wrong to kill the faithful horse and my mind went back to the time when we were in trouble at the city gate, when if either one of them had failed us it would have no doubt cost us our lives. ... They kill a horse, and sometimes two, every morning at 8. In a little while we are very likely to see the head go by, probably dragged along by two Chinese boys. It has the bloody wound where the bullet entered and the nose is making a trail in the dust as they drag it by the ears. In a little while two coolies will come along with a big basket in which is the intestines, hoofs and probably the hide with the tail hanging over the outside, and leaving an odor all the way along. Then each 'mess' sends their cook at once so the best pieces will not be gone, and it would probably look like steak if it could cool but as it is, warm, it is like red mush and must be put in the pot at once so the flies won't get to it. There is hardly a meal but what we find flies in the cooking. We never throw it away if we do, but cover it up on one side of our plates and eat the rest of it for another spoonful would be no better. We usually have very pleasant times while we eat and we all make the best of things if only to make the girls feel good who have the responsibility of getting it ready. That surely is the very hardest place to work and I would rather do anything else than that.[48]

10 August – Polly Condit Smith:

Such horrible dreams as one has now on going to sleep after a violent attack, and with the awful sounds accompanying such attacks still ringing in our ears! The shrill cries of 'Sha! sha! sha!' (Kill! kill! kill!) and the constant blowing of trumpets, is enough to account for our continued nightmares. While awake the brain can be somewhat controlled, but the real horror of our situation follows us even in our sleep. On awaking, one wishes one were asleep again, as the heat is something awful. The very worst weather of the year is upon us: the rain is almost incessant, and everything is sticky and muggy. Of course, this continual downpour is very hard on the soldiers, making everything a mass of mud, and the attacks keep them out in the wet for hours. The flies, mosquitoes, and fleas are pests that still continue.[49]

11 August – Sara Goodrich:

Mr Conger suggests that we need to be thinking where we will go when the troops come as the English Legation will need all its quarters and whatever it has taken into its boundaries for the accommodation of English troops. While I understand how this is so, still it seems to me cool when we mis-sionaries and our Chinese have all worked on their fortifications, have taken this Chinese treachery etc., etc., to be expected to yield it convenient or inconvenient. Our Christians are living in the houses which they desire for their troops. Like the two tribes and a half, they should first secure us our promised land, and then with good grace we will go and occupy it.[50]

11 August – Dr Emma Martin:

It has drizzled nearly all day. At the hospital this morning everything was damp and musty and sticky. The Frenchman was dying and Sawyer may die any hour. Poor fellow, shot through the pelvis at the very first and the wound infected and so full of pus with his mattress soiled and smells so badly, one hates to go near him. He is always asking for 'a drop of lime juice, please, nurse' or won't you do this or that but he is so miserable one cannot blame him. Some of the mattresses have rotted on the floor with the men on them. We have so much dysentery now we have had to go into another house.[51]

Sunday, 12 August Ada Haven at the service in the Russian chapel:

We recognised some of the faces we saw in the church, the priest who helped Mrs Conger fill the sand-bags, and worked with an axe on the burning tree in the Han Lin, the matrons whom we had seen serving as Red Cross nurses in the Russian ward of the hospital, and one slender strip of a boy [Constantine de Giers], whom we had seen passing in and out among the beds of the Russian patients, giving each a word of cheer, or himself sitting

on the floor beside some bed to read to a patient. He had struck me as looking thin when first I saw him there on his little errands of mercy. Now through his calico shirt one could see that he was worn almost to a skeleton. He was here also in his usual capacity – serving; acting as acolyte – lighting or extinguishing the lamps at appropriate times, and passing the communion.[52]

12 August – Miss Andrews:

The Chinese [converts] had had their meetings as usual, and Miss Evans had a meeting with one group of women. I wanted to meet another group, but it has been so fearfully hot that I thought I would wait until after tea. Later a fierce attack came just after tea, and the bullets were flying so everywhere that I delayed my meeting till the firing stopped. Then it was so far to the group I wanted to reach, and so many sick ones to see by the way, that I was finally obliged to give up my meeting as the darkness was already gathering. Just as I was starting back another terrible attack began and I was rather afraid to come back; but I could not know how long it would last, and dared not wait lest it be dark, so I rushed, and asked the Lord as I went to cover me with his hand, and he did. As soon as I got within the walls of the English Legation ... I went into the first house I came to, in which were Miss Douw and the ladies of her mission, and waited there until there was a lull in the firing. There have been five distinct attacks today, in one of which the French commander [not Captain Darcy] was killed.[53]

12 August – Dr Emma Martin:

Sunday, beautiful, clear and hot. I am in high spirits today ... as Mrs Gamewell said just now when she came in, with the bullets whistling overhead and a chorus of Chinese bugles just outside the wall, they say 1,000 Chinese soldiers went out of the Chin Men today on the double quick and we think probably the [foreign] troops are at Tung Jo [T'ung-chou]. We thot too we could hear distant cannonading. A note from Prince Ching and others says they would like to call there tomorrow at 11 and make peace with us. An edict of August 7th says Li Hung Chang has been commissioned to make peace with the Powers by cable on most any terms. It is almost as ridiculous as when they sent us word that they would stop firing if we would. Of course we agreed to it till they kept pushing their barricades too near us. They were so near that several times the soldiers on both sides would toss even bricks at one another.[54]

The Eve of Relief

13 August – Mary Gamewell:

This is the first day mentioned by the Japanese general as the date of possible arrival in Peking!

Persistent firing all [last] night. Almost no sleep until daylight. Some did not sleep then. A bullet came into our east door. Entering the northeast window, it struck at an angle the opposite wall and carried a patie of pulverized plaster back to the east wall, a few feet from the window at which it entered, and then struck the floor not far from the head of Mrs Brent's bed.

The rifle fire did more damage to fortifications than any heretofore directed against the English Legation. Rifles carry bullets that penetrate very thick walls. ... the din of musketry made it impossible for us who slept in the ballroom to hear what was going on at the west where the rush would come from if made at all.[55]

13 August – Polly Condit Smith:

An assurance came from the Yamen saying that we could have as much food as we wanted, and inviting us to send to them a list of what we desired, which we did, and they were to have sent the things yesterday by nine o'clock. Needless to say, they never appeared.

In the afternoon an official communication came from the Yamen saying in the most polite and abject Chinese that they would like a personal interview with the Ministers, to be held in the German Legation, as it was near their lines. This letter came late in the afternoon of yesterday, and the corps [diplomatique] was to sleep all night on it, and decide this morning what to reply. In the compound feeling ran very high; everyone is against it. People felt that to receive these lying tricksters, who are offering peace and compliment with one hand, and with the other writing orders to their army to exterminate us, would be most undignified.

Early this morning the Ministers decided to bid them come at eleven o'clock to-day, the 13th. So they wrote to that effect, and the answer came back saying they regretted, but that other affairs and engagements of importance kept them busy to-day, so they would not be able to come, but hoped to give themselves that pleasure later. They also said the terrible firing we kept up prevented them sending us the market supplies we desired.[56]

13 August – Theodora Inglis:

Late in the afternoon ... I was lying upon my mattress on the floor like Jessie at Lucknow. In this position I heard what seemed to be the roll of distant thunder. Mrs Lowry, sitting by me, heard it too, and said hopefully: 'Oh, perhaps it is the Relief troops'. But I smiled wearily and said: 'Oh, I can't believe that – we have thought them coming too often'.

Towards one o'clock on this last night, the firing diminished somewhat and exhausted I dropped asleep for the first time for several days. The next thing I remember, was sitting bolt upright and calling out: 'The troops are at the city gates.' And just at that instant through the open window, the

Spanish Minister shouted to Sir Claude MacDonald: 'It ees the troops, it ees the troops, I know it ees the foreign troops'. And so it was. Instantly with the hearing of these sounds, the Chinese were on us again. But between their heavy fusillades we heard the thunderous boom of heavy guns outside the city gates. Boom-boom-boom then the nearer reply from the Chinese on the wall striving to drive them back. But in vain; until long after dawn we listened joyfully, cheerfully, hysterically to the welcome roll of distant artillery and the click-click-click of the foreigners' sharp spoken machine gun. There was not much sleep after the first sound of the Allied guns. The whole Compound was at once full of life and movement in spite of the fact that the Chinese turned their heaviest artillery upon us, sending big shells, bursting into different houses and breaking off great limbs from the trees.[57]

13 August – Dr Edna Terry:

Some of the men who were convalescent were restlessly moving about. Others were too sick to notice what was going on. Mitchell, the fearless gunner who had manned the International, was brought in before midnight, wounded in the elbow, and placed on a bed on the floor. About midnight, above the roar and din of the musketry and artillery going on all about us we heard other sounds which we had not heard before. The trained ears of soldiers detected the sound of the machine guns of the troops who were coming up in advance, and we knew relief was near. While I was giving gruel to a typhoid fever patient, the other night nurse came in and said, 'The troops have come.' The news seemed too good to be true. There were wild demonstrations of joy in some parts of the Legation compound, but all was quiet in the hospital.[58]

14 August – Mrs Conger:

Volley upon volley from the enemy's smaller guns was fired, and the big guns on the city wall and on the Imperial City wall boomed their deadly shells into our midst. Strange work, surely, after the Tsung Li Yamen sent the foreign Ministers in a message last night, 'We have ordered that no firing shall go from our men during the night,' etc. This only shows their cruel treachery. It seemed that they wished to throw us off guard and destroy us. They knew that our allied troops were near the city wall. We have never been caught napping by their soothing words.[59]

14 August – Dr Emma Martin:

I went to bed last night at 7 just as it began to rain. Dr M[ackey] and I had been in the hospital the night before and had been so busy. The firing was heavy all night but we did not mind it so much as we were used to it and they seldom hit any one. I remembered afterward that we were in the kitchen shortly after midnight eating our lunch of bread, and jam and cold horse

liver and had our light hid under the table which was against the window so the light could not be seen from outside, and the noise from the guns was so great we could not hear one another speak in an ordinary tone of voice and we were both laughing as hard as we could at the very ridiculousness of it all. We were so tired, we ... went right to sleep and I have always been sorry we did, for so many interesting things happened that night that I missed entirely. No one slept hardly that night for the bombarding was greater than at any time previous. There were six desperate attacks and all our boys were out and all our guns. To add to the din, it thundered and lightninged and the report of the musketry was deafening. They could feel the flash of the guns and feel the boom of the cannon. ... Three times in the night Sir Claude's house was hit but it did not disturb me in the least. About three in the morning Bessie McCoy came in and awakened us by saying: the troops were outside the city gates and we asked her if she was sure and how did she know. She told us we could hear them. I could hear nothing but the guns near us and I was so tired I went to sleep again.[60]

15 August – Bessie Ewing:

I think I was the only grown person who slept any after eleven o'clock. I woke before then and realized the good news, but was too tired to get up. Several came to my bedside and asked me if I heard the firing. I sleepily answered, 'yes,' hoping they would soon quiet down but the talking only increased with much passing back and forth through the room. It did not seem as though I could have the children wakened, and I did need the rest so much for another day. When for the third time I was disturbed by 'Have you heard the good news?' I said yes but I don't see why you want to talk all night about it and wake up all the children. Finally I said 'Thank the Lord and go to sleep in peace.' I was so worn out as to have no more enthusiasm or sympathy than just that.[61]

14 August – Ada Tours:

Last night the fusillading was something terrific, surpassing a hundredfold all we have experienced before. It commenced at about 8 o'clock and was especially warm round our room ... A shot, or a shell, struck Lady MacDonald's bathroom bulging the bricks inwards making the plaster fly in all directions in the room, thence to the East wall of the Legation from which it rebounded on to the roof of Sir Claude's bedroom, making a tremendous hole through which it fell into the room. At bedtime the noise of falling bullets was something too awful so much so that we decided to move our camp into the big dining room. Accordingly Daisy went along and called the 'Boys' to move our bedding. She says she will never forget the passage through the corridors. The perfectly fiendish noise outside, with the constant, almost unceasing sound of the bullets hitting the walls of the house.

Eventually we were ensconced in the dining room, our mattresses on the table some mosquito nets pinned to the punkah.

At about two o'clock this morning big guns – real ones this time – were heard in the distance and also more distinctly a Gatling gun! Then we heard the deep bass of the doyen [the Spanish Minister] saying outside the Salvagos' window, 'Les troupes sont arrivées.' Lady MacDonald who was also up and about at the time, came in and visited our temporary camp.

14 August – Lady MacDonald:

At about 2am I heard the unmistakable rattle of Maxims. Almost afraid to believe my ears, I woke my husband who, worn out, had fallen asleep, and soon the compound was alive and mad with joy. In the brilliant moonlight men and women, in sketchiest attire, were running about laughing, crying, shaking hands, scarcely knowing what they were about. The only sad one amongst us was the unhappy widow of the German Minister, for whom my heart ached, for deliverance from death was a very mixed joy to her.[62]

14 August – Paula von Rosthorn:

At 2am none of us had closed an eye yet; we heard, during a short break [in the Chinese firing] the well-known tick tick ticking of a machine gun. The echo which reverberated through the many walls around us deceived us for a while as to the direction from which the sound came but when we realised it came from the South East and soon after we also heard the dull rumble of the heavy artillery, we were sure. The troops, the troops are here!! We were incredibly elated, rushed from one place to another where we believed we would hear the long-awaited sounds better, made bets on what time the first [sign of] our saviour would show up and were beside ourselves with joy. Just like us, our attackers had also heard the foreign artillery, the fire became weaker and weaker and sometimes stopped completely. We stayed up all night and every shot by the cannons outside the city gates filled us with satisfaction. We made many guesses about the strength of resistance which the Chinese would put up. Since we still assumed quite a lot of troops to be in Peking, we expected to wait another twenty four hours[63]

14 August – Mrs Russell:

Last night was the most dreadful, and at the same time the most joyous, night of all. The attack was hellish, bullets flying thick like hail, and shells continually booming overhead. Our Gatling gun, the Austrian and Italian Maxim guns, also the 'International' were going nearly all night, to prevent the Chinese from rushing the Legation. It seemed as though the Chinese were going to leave their covers at last and destroy us by mere force of numbers. We could hear their officers urging their soldiers on, telling them we were few in number and the soldiers replying, 'Pu hsing!' meaning, 'It

can't be done!' Twice the alarm-bell rang for the reserve to muster to repel a general attack.

At 2am, east and south-east, we heard a quick faint sound – tat, tat, tat! exactly like the distant echo of our own Maxim gun. We soon understood the meaning: our troops were not far off, likely at the city gates. Then came the faint sound of distant volley fire. We all ran round the compound regardless of the whistling bullets, rousing any that might be sleeping – though few could sleep that night – to tell the good news.[64]

14 August – Mary Bainbridge:

Last night was the worst of all. One German marine was killed, our gunner wounded, and one Frenchman, one Russian, one Japanese doctor was wounded also. A Russian was buried this forenoon who died in the hospital during the night.

Just after Mr Bainbridge had come in from his watch and gotten to sleep I heard away off in the distance heavy cannonading and firing which I knew was something I had never heard before, and the more I listened the more I was convinced that relief was very near. Shortly I heard Mr Conger's voice outside then all the ladies were out talking and laughing as I had not heard before in many long weeks. After an hour or so they all retired again and at 7am big guns were heard very near and we knew our troops were blowing down the wall to get into the city.

14
General Gaselee Kisses Dorothea Goodrich (14 August)

Dilly Dallying

'Danger seemed to be forgotten', wrote Theodora Inglis of the morning of Tuesday 14 August 1900. 'All the morning, people rushed here and there about the grounds, bullets whistling through the air and fragments of shells stripping the few leaves left off the green trees.'[1]

With her obviously later and slightly contrived description, Luella Miner now usefully lowers the tension of those hours which somehow had to be got through:

> Inside the British Legation the tides of life were flowing as usual. The Chinese millstones were grinding the wheat which had indeed been the staff of life to thousands of beleaguered foreigners and Christian Chinese; the butcher was dividing up the flesh of two horses; the men in charge of the fortifications still flew from place to place, superintending the Chinese workmen; soapsuds were still splashing in the laundry; the cobbler was trying to reconstruct the tattered fragments of a refugee American's only pair of shoes; the ladies had laid out the most respectable shirt-waists in their limited wardrobes to don in honour of the arrival of the troops.[2]

Not everything was so unchanging: according to Ada Tours (and an identical entry in Annie Myers' diary), 'The chloroform has just been finished in the hospital, so the operations have had to be performed without it today. A Russian was hit last night, looking through one of the loopholes on the wall; he was most plucky in hospital.'

Then, as Theodora Inglis noticed, towards noon everything went suddenly silent for an hour or two and 'we wondered if the Relief Column had turned back'.[3] Well might they have had an anxious moment, for the arrival of the international force before the walls of Peking did not go exactly according to

plan – there was too much at stake, not only in terms of rescuing the besieged but also of national honour. There was more than an element of truth in the diary contentions that day of Dr Emma Martin, Ada Tours, and Polly Condit Smith; Emma Martin wrote:

> It seems the reason in the first place why they were so long in coming, we got this out of Mr Brown who was an interpreter and guide for the British, was not because they were waiting for more men but because they could not agree as to who should have command. The Japs. having the most men had really a right to command and they did not want this so they dilly dallied around (as Mother would say) and finally the English hired the Japs to fight for them and they had a Council of all the powers.[4]

Ada Tours, deep in the heart of the British Legation, was given another slant:

> The delay in starting from Tientsin was occasioned entirely by the Russian General, who dallied about fixing the date of departure until he was told at last that the others would take matters into their own hands and start without him! Our men have been marching 20 miles a day to be in time, for they have all been expecting to find the worst had happened.

Polly Condit Smith picks up the story:

> It seems that the greater part of the allied armies had spent the night at Tungchou, and it had been absolutely settled by the commanders that the following night and morning hours were to be spent there, which would give time for scouts to go out and make reasonable reconnaissances; and that by early noon the main body of the allies should march on to Peking, each having a different city gate to take simultaneously. This plan was very nice and correct and military, but the Japanese and Russians, who had been eyeing each other distrustfully, could not stand it any longer, and throwing to the winds the pledge that they had given that day in conference, they both started their columns off double-quick before dawn for the capital. This breaking of their promise to the allies at the last moment, so to speak, rather mixed things up, but perhaps, after all, it was a relief to the others, because it then meant they were relieved, too, from any long concerted action, and they could begin to march straight for Peking, which they did.[5]

Emma Martin continues her account:

> When they reached Tung Jo they had planned to move on to Peking in four columns. The Japs and the Russians to the North gates and the Americans and English on the South. The two columns on the north had the shortest cut or the best roads and each was so afraid the other would beat they got to racing and were way ahead of the others. They attacked the gates on the N. first and fortunately for our men they took nearly all their men, ie the

Chinese, and massed them on that side thinking the foreign troops would all come in at the same gate. And while they were fighting on the north the English came in on the south and the Amer. on the east. The English did not have to fight at all while the Americans, although they got into Southern city first, had to take the Tung Pien Men by force and fight in ambush for a mile, losing several men.[6]

Even who suggested the troops should come in by the Water Gate – the outflow through the city wall from the filthy canal that ran past the British Legation – depends on the nationality of the diarist. But, as Mrs Russell encapsulates it: 'The British troops came up to the city much later, rushed in by the South-East gate of the Chinese city, ran along the outside moat, and into the Tartar city by the Water Gate, with the loss, I believe, of only one man.'[7]

The first member of the British contingent through the Water Gate was Henry Bathurst Vaughan, in command of the 7th Rajputs, but he did not immediately go any further, waiting for General Gaselee to catch up and come through and be formally greeted by Sir Claude MacDonald; Lucy Ker wrote, 'Major Vaughan, cousin of the Headmaster of Rugby, *really was* the first man to reach the gate [of the Legation] but sat himself down in a ditch to light his pipe.'[8] Vaughan himself recalled laconically:

> After we sat there some time, a young lady without a hat and carrying a fan in her hand offered to show us the way to the British Legation, a sentry there saying, 'You English? Very good,' as we passed him. We passed a cemetery and a girls school, who cheered us, and reached the lawn in front of the British Legation where we piled arms. The whole place was crowded with Europeans, cheering and waving their hats, and perfectly indifferent to the hail of bullets which were pattering against the roofs and upper parts of the walls around them.[9]

Unfortunately, our schoolgirl informant was not on the qui vive to see Vaughan and his men pass, though the girls had been told that morning that the night's bombardment presaged good news.

A Day of Wonderful Deliverance

There are many accounts contending to define the very moment of relief; there are even rivals for whom General Gaselee first kissed in greeting. Polly Condit Smith's is typical of the teller:

> At about half-past three I was debating with my maid whether I should or should not go over to the American Legation and take the cheerful bath which I had been indulging in each day lately owing to the half-armistice existing, the early afternoon hours were fairly safe ones in which to move about the lines, and I was about to start with bathing paraphernalia and the little maid, when my inner consciousness was struck by something unusual

happening out in the compound. I tingled all over, for my instinct had told me the troops had come.

Running to the old tennis-court, the only open space, I found everybody flying in the same direction. There were about two hundred Sikhs. They had entered Peking by the Water Gate ...

It was queer to see these great, fine-looking Indians, in khaki uniforms and huge picturesque red turbans, strutting around the compound, and as they entered right into our midst they all whooped a good English whoop. A little blond Englishwoman was so overcome at the relief really being here that she seized the first one she could get to and threw her arms around him and embraced him. The Sikh was dumbfounded at a *mem-sahib* apparently so far forgetting all caste. ...

At this wonderful moment the Chevalier de Melotte, Mrs Squiers, and myself, without a word spoken, flew with common consent to the point in our lines down Legation street where we knew we could see the entering columns. Cannons were booming in all directions, caused by the Powers trying to enter by the different gates, shells exploding and sniping everywhere. We took our stand at the bridge crossing the canal, from where we saw large quantities of soldiers, sometimes even cavalry, come through the Water Gate. We had scarcely caught from this rather exposed point a bird's-eye view of it all, when a squad of Sikhs passed us with an officer of high rank, who turned out to be General Gaselee, riding in the midst of them. He jumped off his horse on seeing us, and showing on every inch of him the wear and tear of an eighty-mile midsummer relief march, he took our hands, and with tears in his eyes said, 'Thank God, men, here are two women alive,' and he most reverently kissed Mrs Squiers on the forehead.[10]

Where does young Dorothea Goodrich's account fit into this? Being so brave and vulnerable, she should really be given the advantage when she tells her own story:

When the troops came to save us from the Boxers, the English general, who led all the soldiers from the different countries, was the first to enter the Legation with some Sikhs – great tall Indian soldiers with turbans around their heads. I was pretty white because I had been so hungry. When General Gaselee saw me, he stopped and asked me how old I was. When I told him eight years old, he stooped down and kissed me for the sake, he said, of his little girl at home.[11]

Dr Emma Martin saw that kiss and catches a reality of that moment of relief:

At about 2pm an American marine came running over and cried out, 'They've come, they've come'. And he ran back to see them again and everybody took up the word and passed it on. We all ran to the S. gate to see them come in for we knew they would have to come in at the water gate. And it was not

long till we saw some Shieks with turbans on their brown heads and then Sir Claude with Fuller and Gen. Gaselee. The latter lifted up a little girl near the gate and kissed her. No words of mine can do that scene justice. A shout went up from both sides. They kept on coming and they gave 3 cheers when they got to the hospital. The ladies laughed and cried and waved their kerchiefs and danced, and I wanted to cry and felt as if it would be such a relief to do so but I couldn't. I had my self control screwed up so tight I feared I never could let go. And I didn't until I had been in Japan a month.[12]

Whoever General Gaselee kissed first, and however moving the moment, there was national honour too. Jessie Ransome wrote:

About noon I went up to Lady Macdonald's to get a little rest on her bed, where I could be sure of quiet, and I slept till nearly two o'clock, and was just in the midst of dressing when I heard a cheer, which increased in volume every minute. I rushed to the window, and was just in time to see our British general and his staff, and a company of Sikhs come up the T'ing erhs. I got out into the hall and there found them all shaking hands and greeting one another. It *was* a moment to remember, and so good that it was our own dear British contingent who had the honour of being first; and all the greater credit to them as they had started last, and only had one day to get over the fatigue of their journey from India.[13]

Ada Tours was equally proud: 'The British were the first to be in after all! They entered at the south of the Legation, one Seikh rushed ahead of the others and danced a regular pas seul all round the lawn, brandishing his sword!' Lucy Ker makes that image even more picturesque:

The first man through the green door opposite the Counsellor's house was a Sikh [of the 3rd]. He rushed up to the lawn and then toured the compound: an unforgettable sight, naked to the waist, sweating like a pig, hair tumbling on his shoulders. He kept waving his rifle and shouting: 'Oorah!' There was no doubt his joy at our relief. The next man was Tom Scott (Bengal Lancers), hard on the Sikh's heels; then the ADC, Captain Pell, and in a bunch with officers and men, that old darling General Gaselee, about twenty five yards behind.[14]

Mrs Gamewell, too, was almost caught napping, and, though American, understood the pride expressed:

I was stitching sandbags on Mrs Douw's sewing machine when there came a sound of running and of voices, calling. We ran out and soon saw the turbaned heads of India troops. On they came through the south gate, shouting, glad to be the first, and who can tell how glad we were to see them![15]

And Mrs Galt was definitely caught napping, as she describes:

> About two in the afternoon I was trying to take a nap up in our 'sky parlour',
> for the noise for some nights has been almost unbearable, and the fleas were
> worse. Sleep was out of the question – when suddenly I began to hear a great
> commotion down stairs, running to and fro of people, shouting and

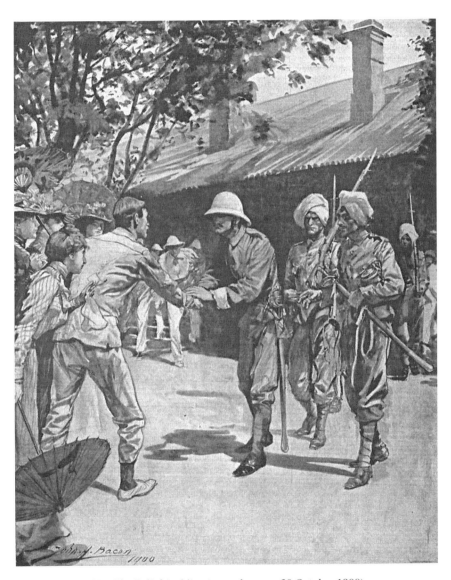

35 The Relief (publication unknown, 20 October 1900)

hurrahing in the other end of the compound. It flashed through my mind 'Have they come?' and with nervous fingers that would scarcely put the buttons and pins in their proper places, I began to dress. In a few minutes Mr Galt came running up to tell me, with tears in his eyes, that they had really arrived, and then he ran away again to see the sights. In a minute or two more I was with the rest of the crowd watching hundred after hundred of soldiers march through the tennis park, when they dropped in the grass under the trees, poor, tired, hot men.[16]

There was still Lady MacDonald to be properly greeted, and Theodora Inglis was there to see it:

A few minutes later, British officers and turbanned Sikhs from India filed through into the British Legation through the little south gate and made their way through the cheering crowd up to Sir Claude's house where they received a royal welcome. I was passing through the hall just as they entered and could not hold back the tears when my eyes fell upon the elderly but gallant General Gaselee bending low before Lady MacDonald's hand. Officers and men were tired and warm, their bronzed faces streaked with dust and sweat and lined with fatigue. General Gaselee's Aide, his frank young face aglow with sympathy, grasped my hand in welcome; at this dramatic moment all I could say hesitatingly was, 'We are so glad you are here,' and all that he uttered with tears standing thick in his clear blue eys, was this,

'We are very glad to see you. If we had not heard the fierce attack upon you last night, we should not have been here today but we heard the Chinese guns miles away and our generals rushed us on.'

After helping serve the refreshments which Lady MacDonald provided, I passed on out into the compound and found it was a moving mass of color.[17]

When it comes to Lady MacDonald, the final focus of the formal arrival, to describe what happened, she wrote disconcertingly for publication

I am not clever enough to describe the scene that ensued. [The] little batch of men was followed by others, all in a terrible state of heat and exhaustion, and in a few minutes the lawn was crowded with besieged and deliverers, shaking hands and asking questions. It was the most impressive moment of my life.[18]

Annie Myers finally joined the throng but had a particular concern:

Mrs Tours rushed in to say that our troops, the British, were the first to be in ... I at once dressed for not having felt well all day I was in a tea-gown, and went into the Hall where the officers were having drinks. Then went into the Tinga when Mr Whittal came up and told me Papa is with the troops and will probably be in shortly. Captain Lee (R.E.) told me Papa had volun-

teered for service and they had been very glad to accept. He had gone back from Yang Tsun to Tientsin with some wounded.[19]

Theodore Inglis then describes the next contingent to arrive:

> Following on the heels of the Sikhs were their comrades, the Royal Rajputs and Bengal Lancers mounted upon their magnificent war steeds. After them came our own [United States] regiments from Manilla, tired and worn out by their fierce battle in the southern city, but with strength enough to return one feeble cheer. There were the besieged in worn summer garb; our faithful Chinese in their brown garments; the Hindoos in British khaki, heads turbanned, and bright hues from Indian looms and our own dear men in United States Army blue. Sobs and tears and laughter akin to tears. Hand clasps, cheers and prayers of thanksgiving and so we welcomed the Allied Relief Force on that day of God's wonderful deliverance.

Mrs Cuillier is Wounded

There was, of course, something special for Theodora Inglis and Emma Martin in the arrival of their own troops, though they lacked the benefit of being first and the verve of the turbanned and mounted Sikhs. Emma Martin catches the moment again:

> Next a column of Amer. came in looking so worn and tired and ready to drop. One poor fellow apologized for himself as he passed along saying, 'We are too tired to holler'. The British troops broke ranks at once and made themselves at home in their compound but the Amer. had to stand in line so we went along with buckets of water and gave them a drink. They had expected to rest a day in Tung Jo for they had had such a hard trip, but they heard the heavy firing at Peking and feared they would be too late so they started. I wish I could remember who it was that said it, but some officer said 'Boys, do you hear that cannonading? Will you go on tonight?' And they started without any breakfast and only a cup of tea and had marched on that since 2am. When we found that out, some body said, 'Oh, let's get them something to eat.' Someone said what would we get, and sure enough our cupboards were bare. They killed a horse but some of them would not touch that. Some of our boys got nothing to eat till 10 that night after they caught some geese and dressed them and boiled them without even salt. An English officer just after they had gotten in said, 'What does all this noise mean?' For the Chinese were firing briskly again. Some of us said, 'Oh, that's the Chinese.'[20]

The insouciance was all very well, but during those festivities, a Frenchwoman, Mme Cuillier, was hit by a sniper, as was a Sikh soldier. It is hard even to be certain of the name of this Frenchwoman (whom at least one account calls

Belgian),[21] nor is she mentioned before or after in siege accounts – M. Pichon does not record her wounding; she simply becomes a statistic in the siege, or an episode in that memorable afternoon. Dr Anna Gloss describes the scene that followed in the hospital:

> The first woman wounded during the siege was brought to the operating table. Then one of the Sikhs, who had rushed to our barricade to help defend us, was brought in badly wounded in the face and shoulder by a bullet. It was while dressing this patient that the surgeon who was known as the Saint of the Hospital, because of his unvarying kindness and patience, for the first time showed some irritation. 'I have but two hands; I will be obliged if some one will hold this bandage for me,' he said to the several assistants who, with thoughts on the tennis court where the American troops were being welcomed, were rendering him very ineffectual assistance. They had worked through days and nights of attack with shells screaming overhead and bullets falling like hail, but this new joy of rescue for the moment unnerved them.[22]

For those women doctors confined that afternoon to the hospital, their own emotion was added to by that of their patients, as Dr Gloss suggests:

> An American officer, wounded while leading a brilliant charge made during the siege, and who had wasted in the hospital ever since, with great anxiety on his face asked what the noise was all about. 'The troops are in,' the nurse replied. 'Impossible,' he answered. She moved the screen and pointed through the window to the black, turbaned soldiers passing by. The sick man looked, tears coursed down his haggard cheeks as he saw for himself that help had come and the terrible siege was ended. 'Are you not glad?' the nurse inquired. 'God knows that I am glad,' he said. Another officer had been quietly watching the excitement from his cot. Though he said nothing, his face told us that God knew that he also was glad.'[23]

For some the emotion had an added dimension; Theodora Inglis, her own feelings rather too raw after taking part in the greeting in the MacDonalds' house, inadvertently witnessed a more private scene:

> The sight of so much emotion laid bare was affecting and I turned back to our own quarters. On the way I passed a young husband greeting his wife [Mr and Mrs Ed Lowry] and, strange to say, the woman bore up and in an instant the man could not speak for the sobs which shook his frame.[24]

As if that was not enough for poor Theodora:

> I went on hastily and did not stop again until I saw the young Baroness von Ketteler. She was lying on her veranda chair and weeping softly. I crossed over to her and asked to give her my sympathy, for that hour of rejoicing for so many, was fraught with its sadness for all those who had lost.[25]

Maud von Ketteler may not have chosen to tell Theodora then that it was not just the loss of her husband amid so much rejoicing that was intolerable, but that the sight of the American troops from Manila reminded her that her brother had been killed there eight months earlier.

Mrs Inglis was not the only person to have brought home to them at that moment Maud von Ketteler's plight. Dr Matignon describes how he was as overcome as everyone else by the occasion:

> We were all profoundly moved and not eloquent. In front of the Minister's house I found one of the nuns from my hospital who, tears in her eyes, said to me, squeezing my hand, 'Well Monsieur le Docteur, we are saved.' I was not even able to say, 'Yes', but I felt the tears spring to my eyes as well.[26]

But, as part of the same memory, he was able to recover his eloquence where Maud was concerned:

> In the middle of that enthusiastic, delirious, and agitated crowd at the English Legation, I saw, passing like a wraith, not taking part in the communal joy, seemingly wrapped up in an idea which cut her off from her surroundings, it was, in fact, tall and thin, in her mourning weeds, the young and lovely Baroness von Ketteler whose husband had been assassinated two months earlier and who must have been suffering more violently in her grief than all the transports of joy that surrounded her.

And then there was poor Bessie Ewing, now several months pregnant, and with the burden of two children, one of whom had been in considerable distress for some days; her 'relief', too, was individual:

> Even through the day I did not get worked up to the situation. When everyone else rushed out at the last to greet the soldiers as they entered, I stayed behind with my sick baby who was trying to go to sleep. But as the 'huzzas' rang out on the air a thrill ran through my heart and I did feel the excitement of the day and the relief from the long strain.[27]

Lady MacDonald's Garden Party

The irony of the welcome by the rescued women is contained in a letter home from Roger Keyes, naval ADC to General Gaselee:

> The scene on coming on the British Legation lawn was extraordinary. It looked like a garden party. All the ladies looked nice in clean white and light-coloured dresses. Strolling about on the lawn ... Lady MacDonald looked very charming and nice and might have been hostess. She said to Pell, one of the ADCs and me, who went up to her, she didn't know who we were but was simply delighted to see us. They all strolled about as casually as ever until a Sikh was hit on the lawn and a French lady was hit – the only woman

touched all through the siege. So they went in under cover, as one would out of a shower of rain.[28]

Somehow that account or impression, perhaps also conveyed to one or more of the journalists who had arrived with the relief force, was picked up and disseminated in the international press, and from that flowed the idea that the siege had been something of a picnic.

The impression given by another ADC, Richard Steel, in a diary entry of 16 August, appears to have been ignored: 'The state of dirt and filth in the Legations could hardly be exaggerated; sanitary arrangements practically nil.'[29]

The woman who is quoted in the last chapter describing how she ironed her dress while feeling indisposed, was asked by an army officer what she would have done differently and replied that the one thing she would *not* do again 'was to take extra trouble to have on clean clothes to welcome the relieving army'.[30]

Surprisingly, perhaps, for a woman who deliberately dissociated herself from her sisters during the siege, it is Paula von Rosthorn who answers the criticism:

> Later one read in the papers that the relief troops had had the impression that there had been a garden party in the English Legation and that the deprivation could not have been very great amongst the besieged. But can this not be explained by the circumstances? For many weeks, everyone had prepared for this big day. Almost everyone had saved a neat, clean piece of clothing, and made themselves as beautiful as they could. On top of that, there was the great joy on all faces; no wonder it gave the impression of a celebration, because there was indeed great cause for celebration.[31]

The American missionaries felt that they came particularly under attack in the press in the months that followed the lifting of the siege, and Luella Miner vented her spleen in her diary for many pages on several issues in mid-October. She has a right to be heard now, and here is her answer to the suggestion that the 'besieged "legationers" greeted the half-dead, bedraggled relief army "in fresh summer suits..."':

> It must be remembered that of the more than two hundred women and children in the British legation, less than a third were missionaries – and that nearly all except missionaries lived in that part of Peking and saved their entire wardrobes. About half of the missionaries saved a trunkful of clothing, and those of us who were not so fortunate had our needs supplied by friends or made garments from ...[?] stuff too frail for sandbags given us by the proprietor of the foreign store for that especial purpose. The American woman who will not try to make herself look presentable under any circumstances is considered a disgrace to the sisterhood. Then every woman who had a decent shirt waist or a clean collar had been saving it up for weeks – 'to wear when we welcome the relief army'. It is sad that our effort to do

honour to the occasion was so misconstrued. Still, we were not all so elegant as the reporters made out, as I could prove by sending a few fragments of the much abused black skirt which I wore on that great occasion.[32]

For all that Luella Miner struggles against unjust, and even malicious, perception, it is the observer again who has the better answer. The writer and traveller Henry Savage Landor, who also came in with the relief force, received a similar impression, but it was the 'speckless linen' on the non-fighting men being relieved that caused him the most offence, and their 'starched shirts, with extra high glazed collars, fancy flannel suits, and vari-coloured ties'.[33] The relieving force were all 'dirty creatures' and found these 'particular fellows silly and objectionable', together with their 'patronising airs'. I have not come across such men, except perhaps the Marchese Salvago Raggi, in first-hand accounts and it is, anyway, beyond my scope, but at least Savage Landor was able to look more closely at the women and observe:

Piteous beyond words was the sight of the women and children. They were, one and all, charming in manner, and pathetically reserved. They seemed hardly yet to realise that they had come out of a great calamity.

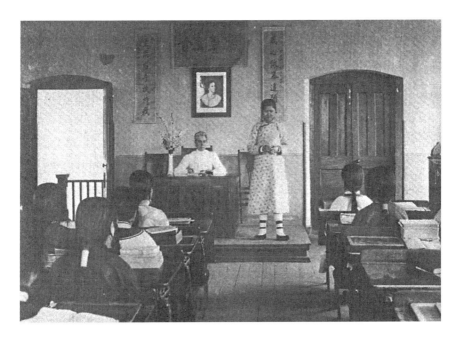

36 Luella Miner teaching at North China Union Women's College, founded 1905
(courtesy of United Church Board of World Missionaries)

They looked clean, it is true, but their poor little faces were so pale and worn, and their eyes so sunken and discoloured, their lips and ears so colourless, that it made one feel quite sad to look at them and think what they had gone through. And, mind you, one should add 'gone through silently,' without the excitement of fighting that the men constantly had – a form of endurance which requires much greater pluck and determination than that of the fighting man. The women, old and young, were all extraordinarily brave and helpful in every way. To their pluck and coolness it is due that no serious panic ever took place within the Legation defences. When the women behaved with such fortitude, what could the men do but be brave?[34]

Another criticism of the American missionaries was that during that first evening and in the following days they were 'feasting on better fare than their rescuers'; Sara Goodrich reveals their unworldliness in her account of the 14th: 'Three paper correspondents lingered about, and we invited them to a supper of brown bread, horse meat, soup, and cakes made of … brown flour. I hardly think they knew what the meat was. We gave them cocoa, which they haven't had for many a day.'[35] When the American newspapers arrived in China some weeks later, it was left to Luella Miner to answer in her diary:

> … As for our menu, I remember that a hungry looking reporter whom some of us missionaries saw at the bell tower and invited to share our siege rations, remarked that the brown bread and yellow rice 'weren't so bad'. If his throat had been scraped with that same coarse bread for two months, and the sickening taste of that half-fermented rice had become a little more familiar, he might not have eaten such a hearty meal. I noticed that he turned a cold shoulder to the meat, and those of us who never partook of horseflesh did not explain what a deadly nausea often came over us when it was served up at every meal. Of course the lady who remarked on the lack of butter didn't get any sympathy from the soldier who was not accustomed to that luxury.[36]

In many ways a better answer comes from Lady MacDonald who, following her 'garden party', had to gather from somewhere the energy and supplies to entertain the British general and his staff to dinner that evening – about forty-six people. We should remember too, the state of her dining room, which she no doubt apologised for in her inimitable way; after a bombardment during the first week of July, it was left thus (according to Polly Condit Smith):

> This room is something of a wreck, denuded of all draperies for sandbags, walls riddled with large and small bullet-holes, a life-sized painting of Queen Victoria occupying the entire wall at one end of the room, hung quite crooked and peppered with shot. A great beam from the ceiling protruded some 4 or 5 feet down into the room, where it had been forced by a spent cannon-ball crashing into the side of the house, and over all this ruin was

the unmistakable atmosphere which clings to a room where many people eat three times a day, and where the staff of servants is not equal to the work.[37]

That evening, however, everything seemed to sparkle and the women were in evening dress. But this is how, in 1931, Ethel MacDonald was to remember it, and how the story was passed on to Peter Fleming over thirty years later, after the publication of his book:

As you know the ponies were all killed for food ... Lady MacDonald had hoped to save her white state mule, but when General Gaselee arrived with the relieving troops, the mule was killed in his honour. The General remarked that he thought they had no meat, to which Lady MacDonald replied that it was her white mule. General Gaselee put down his knife and fork and would not eat. She said she was so hungry she could have taken the food off his plate.[38]

Ironically, given the stories about food that appeared, there were more important things going on in the missionaries' chapel that first evening. During supper, Ed Lowry came in and they clapped him with enthusiasm, but some of them, such as Ada Haven, clustered round Frederick Brown of the Methodist Mission who had also arrived with the relief force; they were eager and fearful for news of their comrades in Paotingfu; lacking in specifics, though it was, Brown had the worst possible answer:

A shudder passed through us as he told how, on examining the records in the viceroy's yamen [in Tientsin] after its capture by the foreign soldiers, a document had been found from the head official in Paotingfu stating how he had beheaded the foreigners in Paotingfu, and how the next day copious showers of much-needed rain had fallen. The letter closed by advising the Tientsin official to do the same, that the sacrifice might be followed by a like good result, and that they might hope for a good harvest.[39]

These meagre details meant a great deal to Dr Maud Mackey and Janet McKillican who had worked in Paotingfu until April and had planned to return in the Autumn. For Luella Miner, it had been her first posting. Soon they would learn the details, that the missionaries whose names Theodora Inglis had mentioned following the arrival of Ed Lowry's letter had been burnt alive or beheaded at Paotingfu, seventy-five miles south of Peking, on 30 June, and ten days later, in Tai Yuan-fu, the capital of Shansi Province, forty-five foreign men, women and children (thirty-three Protestants, twelve Roman Catholics) were beheaded. In all, 242 foreigners are said to have been killed that summer. That is not to ignore thousands of often nameless Christian converts also massacred in cold blood and most brutally outside Peking and Tientsin, nor the non-Christians who were to die as a result of the Allied military intervention.[40]

Some potentially tragic stories had a happy ending that evening; Mrs Conger was to write:

> Our servants have all returned, and we have moved back to our dilapidated Legation home, cleaned it, and gathered up the fragments. Never were people more thankful for a mansion than are we for this shelter. Our house is full to overflowing, and we give most grateful thanks that it can be so. Our first boy, Wang, is a general in helping us. He has a wife and four children, two boys and two girls. ... His wife and three children were out in the city during the siege, he knew not where. Their house was looted, then burned, and for seven weeks they have been wandering beggars. He could not hear one word of them. On the fourteenth, after the allied forces had come in, he came to me and said, 'Madame, I go find my family.' After a few hours, he came back happy, wife and children safe with him. The children were naked and the wife poorly covered. Their story is a sorrowful one.[41]

After all that had happened over the previous weeks, and all that had happened that day, Polly Condit Smith provides an intimate, enduring, and inevitable word on the ending of the siege:

> The night of the 14th was the last night that our siege mess dined together on our little eight-sided Chinese table, which was generously stocked with the remaining tins which we had been hoarding for such a long time. Somebody has said, 'There is a sadness about the last time of everything,' and truly it was so with us. I felt exactly as children feel when they have been having a wild game of make-believe all day, when the grown-ups break in and say, 'Come, children, there has been enough of this.' And so it was with us: these terrible times are over, and there is nothing for us to do but remain passive, and try and get some sort of equilibrium into our lives again; and as we dined together last night there was a strong feeling, although we did not speak of it, that nobody but ourselves, who went through this incredible eight weeks of horror, were ever going to know really what the siege in Peking has been, and that we might all talk until doomsday, but the world would never understand.[42]

Not only were newspaper attacks on the besieged to continue but, soon, Western historians were referring to the siege of the legations as 'unduly famous', and 'a small incident in the vast history of China'.[43] The Boxer uprising itself, and its ramifications for the Manchu dynasty and China's progress, were to become much more interesting and worthy of exploration. And Polly Condit Smith and her sisters, and what they went through, together, and individually, were to leave not even a ripple.

15
Sister Hélène and the Relief of Pei-t'ang (15 August–7 September)

Flight of the Empress Dowager

'Old Buddha, the foreign devils have come!' said Duke Lan bursting into the Palace unannounced. 'Perhaps they are our Mahommedan braves from Kansuh', replied the Empress Dowager.[1] It was 4pm on Tuesday 14 August, and this is the story (said to be based on the diary of a Court insider) told in the now discredited *China Under the Dowager Empress* (1910) by the British Sinologists J.O.P. Bland and E. Backhouse.

In this account, at 3am the following morning, Tz'u-hsi, dressed as a peasant, prepared to flee her palace and her capital. At 3.30am, the concubines were summoned to appear before her. 'The Pearl Concubine, who has always been insubordinate to the Old Buddha, came with the rest and actually dared to suggest that the the Emperor should remain in Peking.'[2] Infuriated, the Empress Dowager shouted to the eunuchs on duty, 'Throw this wretched minion down the well.'

Tz'u-hsi's Italian biographer, the diplomat Daniele Varè (in Peking from 1912), gives another version, based on *The Unofficial History of the Ch'ing Dynasty* – 'a work compiled by different Chinese authors'.[3] In this one, the Pearl Concubine begs to accompany the fleeing party. Once again the Empress Dowager loses patience: 'I can do nothing for you. If you are not satisfied, throw yourself down a well!'[4] The eunuchs took these words as an order, approached Chen-fei and 'wrapped her in a carpet. They threw her down the large well just outside the Ning Shou Palace.'

And so it has always been told, with later added embroideries. One of the oddest of these occurs in the highly respected account of the siege *China in Convulsion* (1901) by Emma Smith's husband Arthur (both of whom were at the siege). He quotes Luella Miner (another besieged) who is quoting 'a Chinese gentleman' who had it from a 'friend who accompanied the Empress Dowager

in her flight'.[5] While Luella Miner writes (in quotation marks) 'None of the concubines could accompany them', Smith omits that, and inserts instead, 'The Chinese report that the favourite concubine,[66] "Pearl", was *strangled* [my italics] and thrown in a well.'[6]

Tz'u-hsi seemed unaware that foreign-written history was to see her not only as the instigator of the Boxer Uprising and Siege of the Foreign Legations, but also as the murderer of the twenty-six-year-old Pearl Concubine – beloved of her poor downtrodden nephew.

The 1998 *Biographical Dictionary of Chinese Women* entry for Chen-fei, based mainly on Chinese sources, suggests, 'Some say Zhenfei committed suicide in the palace, some say she was thrown down a well by eunuchs.'[7] Certainly, when the Forbidden City was eventually entered by the Allies, many concubines of several generations were found still there – and left unharmed.[8] And certainly there is evidence that women in Peking did throw themselves down wells to avoid being raped by foreign troops. Sometimes they were encouraged by their families who would also be dishonoured.

Marina Warner, another biographer of Tz'u-hsi, leans away from the voluntary suicide theory, and describes how, when she was writing her biography, she met in Hong Kong a Miss Tang, niece of the Pearl Concubine and her sister the Lustrous Concubine; Miss Tang joined the latter in the Palace from 1911–24 (after the Empress Dowager's death). After Miss Tang had praised Tz'u-hsi, Marina Warner interrupted her to ask, 'But didn't you believe that your aunt had been thrown down the well at Tz'u-hsi's command?'[9]

Miss Tang replied, 'But there was such confusion ... soldiers everywhere. It was done in the heat of the moment, and afterwards she was very, very sorry.'

If you visit the Forbidden City today, you are likely to be shown the well down which the Pearl Concubine was thrown. Sterling Seagrave, who seeks largely to rehabilitate Tz'u-hsi, suggests that 'the well in question is too narrow to take even the body of a six year old'.[10]

The Biographical Dictionary entry for Chen-fei ends:

> Her body was placed in a gold casket and buried the following year at Enjizhuang. The empress dowager issued an imperial decreee in 1902 praising Zhenfei for dying gallantly and loyally during a time when the capital was under siege. In memory of her deeds she was honored as an imperial consort. In 1913 her gold casket was moved to an eastern court of Lianggezhuang. Two years later her body was formally interred in the western grounds of Ling Yuan Mausoleum and the title Imperial Honored Consort Keshun was posthumously conferred on her in 1921.[11]

The Empress Dowager did not, apparently, discuss her nephew's concubine with Der Ling, appointed a lady-in-waiting in 1903. But she was anxious to put right the impression that she fled humiliated and dressed as a peasant:

I am an old woman, and did not care whether I died or not, but Prince Tuang and Duke Lan suggested that we should go at once. They also suggested that we should go in disguise, which made me very angry, and I refused. After the return of the Court to Peking, I was told that many people believed that I did go in disguise, and said that I was dressed in one of my servant's clothes, and rode in a broken cart drawn by a mule, and that this old woman servant of mine was dressed as the Dowager Empress, and rode in my sedan chair. I wonder who made that story up? Of course everyone believed it, and such a story would get to the foreigners in Peking without any trouble.[12]

Be that as it may, Georgina Smith of the LMS – whose post-siege activities will emerge in the next chapter – had occasion that autumn to become friendly with Prince Su whose palace (fu) had been commandeered for the Christian converts during the siege. He had just returned to Peking from escorting his relative, the Empress Dowager, away from the capital and, as a result of his information, Miss Smith described Tz'u-hsi's departure in a letter to London:

The Royal party left the city the day after the foreign troops arrived. They left on foot dressed in the blue cotton garb of the working class. Their carts, which were following them, were seized by the foreign troops, who of course did not know that they belonged to the Royal party, or that the old lady who pressed through the Hsi Chih Men with her hair tied up in a black cloth like one of Tung Fu Hsiang's soldiers, was the Empress Dowager fleeing for her life.[13]

The headgear described seems so unlikely – so likely to lead to discovery – that it somehow adds authenticity to the story. Luella Miner's informant has it thus:

From the 14th of June [two months earlier], when the empress dowager returned to the city palaces, she had simply twisted her hair in a knot and worn the common dress of the people. The morning when she took her flight it was in this guise. The empress dowager, the emperor, the empress, and the heir apparent each rode in a separate cart, the empress dowager having Prince Lan's private cart, from which she had the red side awnings removed. They left the city by the Te Sheng Gate.[14]

Whether it will ever be possible to recreate an accurate account of that morning, in view of the destruction of documents and a hundred years of false trails, is unlikely. In any case, whenever, and however, Tz'u-hsi left the Forbidden City, she seems to have done so in a hurry and taken little with her – although her treasure was buried and remained undiscovered by the foreign intruders. Lucy Ker visited her bedroom on 25 August as part of post-siege tourism and wrote:

Tzu-hsi's room was just as she had left it. On the rich coverlet of the bed, lay an embroidered coat of black satin; beneath a pair of Manchu shoes. Near by were two large boxes of silk handkerchiefs, overturned: one box of pale

yellow handkerchiefs and one of pale blue. A handful had been hurriedly snatched from each.

In the adjoining rooms, along the walls, were huge camphorwood boxes, filled to the top with coats and trousers of every colour, embroidered with gold and with pearls; all were new, all were neatly piled. In other boxes were rich sable coats, and silk coats lined with white fox fur; untailored sable skins and fur of every kind, stored and ready for the winter.[15]

It was not only signs of haste that were discovered in Tz'u-hsi's quarters. At a diplomatic outing in her abandoned Summer Palace on 20 September, Morrison reports how the Russian diplomat Basil Kroupensky sought to defend the Empress Dowager but Mrs Squiers 'blazed up':

You can tell me this when you know that Popoff [his colleague] discovered on the Empress's table a full report of all that was going on of the murder of foreigners etc. It is puerile to pretend that she, the mover and organiser, was ignorant.

Sir Claude MacDonald, after hanging behind in the Forbidden City on 28 August to question Chinese officials, reported that evening to at least one diary keeper:

It seems that both the Emperor and Empress Dowager's lives were in jeopardy several times. The War party got so strong that neither of them were listened to. It seems that the Empress Dowager was strongly averse to such stringent measures being taken, as she realized their weakness vis à vis the Foreigners, but she was over-ruled by the party afore-mentioned. She was simply furious when the chien men outer bastion got burnt by the Boxers, and when Tientsin was taken she was forced to side with the war-party.'[16]

Whatever her role, one still disputed, Tz'u-hsi fled Peking, as she had done forty years earlier, in advance of Allied troops. She cannot have failed to remember the earlier occasion and, indeed, to have been influenced by it in her actions of the previous months. In its turn, the new Allied intervention would inevitably bear upon future relations.

The Empress Dowager now travelled westward through her empire for two months under some hardship; she was euphemistically on an 'autumn tour of inspection'. She was to stay in exile, eventually in the old imperial capital of Sian, for nearly eighteen months.

Sister Hélène de Jaurias Meets her Maker

Talk of capturing the Empress Dowager is largely absent from accounts, though Putnam Weale expresses disgust that she was allowed, through bungling, to

escape retribution.[17] Jessie Ransome suggests, though, that 'It is generally thought she will commit suicide rather than be taken prisoner.'[18]

Tz'u-hsi's ability to leave Peking so easily on the 15th is no more strange than the lack of effort that same morning to relieve the Pei-t'ang (North Cathedral). And Tz'u-hsi had almost as narrow an escape on 29 June when she appeared to come into the line of fire from the Pei-t'ang. 'We wondered at the meaning of the sight that met our eyes', wrote Bishop Favier; from the more elevated Pei-t'ang, up against the western wall of the Forbidden City, they could see more detail and further than the besieged in the legations to the south-east. He explained what they saw:

> On the white Tower Mountain, which is situated in the middle of the lakes of the Palace, twelve hundred yards from us, there appeared about twenty persons, magnificently dressed. The Empress, Prince Tuang, and others high in the official world had evidently come to make a spectacle of our agony. Our sailors felt like firing a volley on this group. I thought it right to forbid them in order not to increase their already too violent hatred.[19]

Nearly a month earlier, on 3 June, Bishop Favier had gone to the Imperial Palace, hoping to see the Empress Dowager, but she was still at the Summer Palace and he had seen Prince Tuan instead. He had asked for protection for the Christians and punishment for the Boxers and Tuan had courteously taken his petition and promised to pass it on. Two days later, the Governor of Peking visited Favier and ended the meeting with the promise: 'You have nothing to fear, the Pe-tang will not be attacked.'[20]

The first Boxer attack came, however, on 15 June – five days before the German Minister's assassination. By then, the Bishop, 30 French and 11 Italian marines, 20 French, 2 Italian, and 8 Chinese nuns, about 13 French (and some Chinese) missionaries, seminarists and brothers, 900 Chinese male Roman Catholic converts, 1800 women and children, 450 girls – schoolchildren or orphans – and 51 infants in a crèche were barricaded in the Pei-t'ang complex; there was plenty of food for a few days, at least until Seymour's relief column arrived, and perhaps enough ammunition.

The bravery and suffering in the siege of the foreign legations were more than matched by what went on in the Pei-t'ang at the same time. Such were the privations, such the responsibility of those who somehow got the vast throngs of converts through the experience, that Sister Hélène de Jaurias, the seventy-six-year-old Frenchwoman in charge of the women there suffered a stroke a few days before the relief and died a week after it.

And, if any impression is conveyed from the accounts that the French and Italians who took part in the siege of the legations were in some way less worthy of admiration than some other nationalities, their bravery and commitment at the Pei-t'ang must expunge it.

One obvious factor was undoubtedly at work: there was no one else in charge, no one else to turn to; it was give all or die. But there was more to it than that. Lieutenant Mario Valli explains that the mostly Breton marines were all committed Roman Catholics; for the Italians there was also another element. The ten of them under a sub-lieutenant were put in charge of the defence of the Jen-tse-t'ang, the quarters of the thirty sisters and their nearly two and a half thousand charges, women and children. Valli writes:

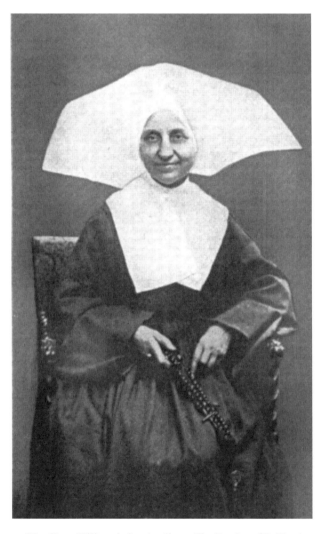

37 Sister Hélène de Jaurias (from *The Heroine of Pe-Tang*)

The Italians, without being so [religiously] fervent as their Latin brothers, all felt the magnitude of the task entrusted to them, and religious fascination also played upon their souls, the potent suggestion of things mystical. But there was another idea, just as full of love and poetry, above our morality, reaching towards the most noble human self-denial; it was to do with the defending of a throng of defenceless women, rendered even weaker through fear; it was to do with defending a little troop of Sisters, who had consecrated their lives to the welfare of others, and who now placed every hope of salvation in their bravery.[21]

Sister Hélène de Jaurias had entered the Sisters of Charity of St Vincent de Paul in 1844, aged twenty; in 1855, she was sent to China, first to Ningpo, which she had to leave for eight months during the Taiping Rebellion. In 1863, she was set the task of organising the Municipal General Hospital in Shanghai and, in due course, she arrived in Peking to run the orphanage at the Jen-tse-t'ang. One of the two Italian nuns was Sister Vincenza who had been running the dispensary in the French Hospital for over thirty years (and she was still there in 1912).

Sister Hélène's Jen-tse-t'ang consisted of a novitiate, foundling asylum, school, a dispensary and a chapel. It was housed in completely separate buildings the other side of a road from the Cathedral and the rest of the Pei-t'ang establishment; it was here that the women and children had come to seek asylum. Sister Hélène described how:

> Every hour we see fugitive Christians arriving. Their villages are destroyed by fire, their fields laid waste; they are without home and bread. All are mourning over some member of their families. A poor wife saw her husband cut to pieces. ... The bandits forgot or disdained her. She is wonderful in her resignation as her husband in his fortitude.[22]

Somehow, these thirty nuns in their wimples spread an aura of calm over crowds of terrified women and children under almost constant bombardment (there was no truce as at the legations), suffering, increased malnutrition, and then death from starvation and disease (including smallpox). Eight children died on average a day; one day there were fifteen deaths. At least thirty babies were born. There was no doctor in the whole Pei-t'ang and no medicine to speak of.

It had been decided in the event of an attack on the Pei-t'ang that all should take sanctuary in the Cathedral itself, and the ends of the street separating the Jen-tse-t'ang from it, had been secured. Somehow, the nuns had to get everyone over, carrying the infants as they went – many of the women were in panic. Sister Hélène wrote of that first night:

> Our beautiful church is crowded with bags of rice, food, ammunition, and goods of every kind. We are huddled together with a crowd of Christian

women and children, the whole household of Jen-tse-tang. Only the children can lie down; they lie on the floor. It is impossible to fall asleep for all these babies are making music.[23]

On 21 June, when communication between the Pei-t'ang and the legations ceased, M. Pichon sent a last note ending, 'Prepared for our last journey, but let us still hope.'[24] They prepared themselves to join the 21 June 1870 martyrs of Tientsin, when anti-Christian resentment and the bungling of the French authorities led to the massacre of ten French nuns, two priests and several other foreigners and converts and the firing of the Cathedral and orphanage.

Typical of the days that followed, is this diary entry by Sister Hélène:

Last evening we were going to the refectory, when we were told that the Boxers were about to attack us. In haste, we gathered our twelve hundred women and girls, carried our babies, who were crying with fear, in our arms, and went to the church. The dreaded attack did not take place, but we had to spend the night without sleep as usual.

On the next day, Mass had just been said when a storm of cannon-shot suddenly burst upon us. A ball penetrated the church through a stained-glass window. A shower of broken glass fell upon the congregation. For one moment they were blinded by dust and [rubble]. Then a panic arose. The women and children were crushed at the doors. When the people grew calm, we saw that there were many victims lying on the ground. One of the refugee women was shot in the stomach. She died behind the altar.[25]

The strain began to tell, as Sister Hélène explained at the end of June:

An awful night. Around us fire, the howling of the mob, and the noise of the guns. A poor refugee woman was shot while crossing the yard. During the night we got thousands of projectiles. It is impossible to sleep. If Almighty God does not come to our assistance soon, our bodies cannot stand much longer such fatigue, intensified by the privations imposed upon us by the siege.[26]

On 7 July she wrote:

From six o'clock in the morning to seven in the evening our house was bombarded by large cannon. The Sisters, children, refugees were crowded into one room less exposed than the other apartments. A gunner was killed beside his cannon; a woman cut in two by a shell; bombs and torches fell on every side. The roof was broken, the ceilings fell in, windows were shattered into pieces. We were very near death.[27]

As a result, Sister Hélène transferred the women to the Pei-t'ang, explaining on the 8th, 'They are not safe in our house any longer. Sister Fraisse and three of her companions went to take care of them. The food is cooked here. Our

stores are diminishing rapidly.'[28] In the midst of all this, her thoughts strayed elsewhere:

> No news from the Legation. We think of our own Sisters who are shut up over there and share their sorrows. They must suffer more than we do. We have two masses daily, and we are all together. Our holy Bishop and Missionaries watch over us. Alas! I fear our dear Sisters have not the same consolation.

But the physical suffering continued; she wrote on 10 July:

> During the afternoon the cannonade became awful. Projectiles came from every side, and especially poured into our chapel, which had not yet fallen. A large hole was made in the roof and ceiling of our dormitory. We spent the afternoon crowded into our laundry with our five hundred children.[29]

In the legations, the threat of mines constantly hung over them – and two French marines died in an explosion on 13 July. In the Pei-t'ang, the first mine hit them two days earlier, on 11 July; Sister Hélène wrote:

> At one o'clock a dreadful explosion terrified us almost to death; the Chinese had filled with powder a large hole which was dug under the ground near the walls, and then caused it to explode. Earth and stone were thrown up ninety feet high. Pe-tang and Jen-Tse-Tang were terribly shaken. We all thought that it was the end. Signs of havoc are visible everywhere, roofs have fallen in, gates and ceilings have crumbled, walls have been shattered. The remains of our roofs are giving way under the heavy weight of earth and bricks. One man was killed, another man, with three women and a child, were wounded.[30]

She had no time to think of Bastille day when she wrote on 14 July:

> With our five hundred children we keep on moving, now north, now east, now south, now west, guided by the direction from which the firing comes. We try to flee from the shells and balls which are pouring on Pe-tang and Jen-tse-Tang. Light is visible through the holes in the walls of our houses. It is a miracle that they are standing. The roofs and gables are all much damaged. Our dear little girls are very good. They are obedient and orderly while being moved, which happens almost every moment. They are well trained. At noon a grave accident occurred that grieved us deeply. One of our Italian sailors was killed by a ball which pierced his head. The dear boy exposed himself without thinking. He was cleaning his gun at a dangerous post. One moment after a Chinaman was killed on the same spot.[31]

In tandem with the attacks and resulting deaths, Sister Hélène noted on the 16th, 'We have scarcely any of our stores left; our provision of rice diminishes rapidly.'[32] It was thanks to her forward planning that there was anything at

all left by now – several months' supply of grain for her establishment had been delivered not long before the siege.

Digging underneath them was a constant background noise and mines were continually being discovered and disconnected but on 18 July there was another fearsome explosion; twenty Chinese Christians and a Marist brother were killed and twenty-five wounded. Bishop Favier wrote, 'The explosion terrified our dear Christian women. Women and children, demented, ran in every direction.'[33]

On 23 July, Sister Hélène wrote:

Torrents of rain last night. Our houses are roofless, the ceilings have fallen in. It rained in our rooms just as if we were in the open air. We could not find a corner in which to sleep; there was water flowing everywhere. ... at about four [o'clock] several thousands of soldiers and Boxers rushed towards the Pe-Tang and Jen-Tse-Tang. All our men ran to arms; the firing began with terrific noise. ... Twice the Boxers attempted to enter our convent, twice they were repulsed.[34]

By 28 July the Italians had only 180 cartridges left between them.[35] But it was the night of 30 July that the end seemed to have come for it was then that Paul Henry, the French sub-lieutenant upon whose shoulders the whole defence had hitherto rested, came to join the Italians to repulse a full-scale attack on the Jen-tse-t'ang and was mortally wounded. His death stupefied the whole community. A French quartermaster was now head of the French detachment; the more senior Italian sub-lieutenant in the Jen-tse-t'ang was in overall command from there but, in fact, it was Bishop Favier who took the major decisions and held everything together.

The following day, not realising how vulnerable the besieged had really become, streams of arrows were launched into the Pei-t'ang tagged with a message to persuade the Christian converts to leave its safety and return to their true ways, or else. For once Sister Hélène had something to rejoice about; as she wrote, 'Not a single one fell away. They had no more courage to resist, but they were resigned to die, spurning the idea of apostasy and betrayal.'[36]

On 2 August Sister Hélène recorded, 'We are giving our children and refugees only two small bowls of rice a day. After this week we shall not have any more to give.'[37] A day later, the daily ration was reduced to a thousand pounds for three thousand people and Sister Hélène explained,

We can distribute only one bowl of very light rice each day. This is enough to prevent starvation. Everyone looks dreadful. We feel sorry for our poor children. Half of them will die. Dear little ones! They do not complain, they are very good, but they are suffering.[38]

Bishop Favier noticed that the moans of the children decreased daily, 'for we buried one hundred and seventy of these innocent creatures'.[39] The women's

ration was so low that they could not suckle their babies; The Bishop tells how one morning a woman who had given birth during the night threw herself at his feet, begging for a bowl of millet 'in order that I may suckle my child'. He had to tell her he had none to give. Now, indeed, all babies dependent on their mothers' milk were dead or dying.[40] There were no more leaves on the trees – the man climbing to pluck the last was picked off by a sniper. By 10 August, there was virtually nothing left, and the Bishop again had to explain:

> We state with dread that after two days we shall have no more food. We saved four hundred pounds of rice and one mule in order that our defenders might live ten more days. We put the question whether or not we should keep something for ourselves and Sisters. Unanimously it was answered 'No! We shall die with our Christians.'[41]

Only water was not lacking. But there was another blow still to fall – the Bishop describes it on 12 August:

> At a quarter-past six, a formidable explosion was heard. A mine, more terrible than the others, exploded at the Sisters' Convent. We all ran. Happily most of the Sisters and children were at Mass in the chapel, otherwise half of the people would have been killed. The damage was awful. The whole eastern part of Jen-Tse-Tang was reduced to a heap of [rubble]. An opening, twenty-one feet deep by twelve long, marked the place of the explosion. Five Italian sailors and their officer disappeared. More than eighty-five Christians, including fifty children of the Infant School are buried for ever in this immense chaos. In spite of a shower of bullets we ran to rescue the wounded. If the Boxers had courageously attacked us then we were lost.[42]

After several hours digging, led by Sister Vincenza whose little charges were buried, they found Olivieri, the leader of the Italian detachment, alive and relatively unharmed; two of his colleagues were retrieved but they later died of their injuries.

It was all beginning to be too much for the elderly nun who had given forty-five years of her life to the Chinese people. The following day, there was another, less devastating, mine explosion underneath the Jen-tse-t'ang. Later that evening, amid a hail of bullets, the Sisters heard Sister Hélène moaning; approaching her, they heard her say, 'I am not wounded, but I think I am going to have a paralytic stroke.'[43] Their prompt care averted it but later she did have a stroke and she was anointed by Bishop Favier.

It was clear by now that the relief forces were approaching – they could see more from the elevation of the Pei-t'ang – but in the early hours of the morning more sounds of mining were heard and the Sisters reverently carried their patient to the Pei-t'ang – to Bishop Favier's own room – for safety. As she was brought in, it was pierced by several shells and she was moved again.

Meanwhile, the legations had been relieved, the French contingent of 800 not finding their way into Peking until early on the 15th. That morning, General Frey, their commander, was provided with breakfast by Mme Pichon and the other French Legation women from the luxuries they had been conserving, including pâté de foie gras. From then on, the force was victualled by Auguste and Annie Chamot.[44] Although Frey was told of a less hazardous route to the Pei-t'ang than the one he had planned, he persisted with it and had, therefore, to wait upon the heavy artillery promised by the Americans before he could set out to relieve his compatriots. The Americans, however, already had other plans for the day. Left temporarily kicking his heels, Frey devised an alternative diversion, witnessed by Paula von Rosthorn; she later wrote of how he declared,

> 'Since we have started out, we want to show the ladies a little bombardment.' He offered Mme Pichon his arm and led her, followed by many ladies and gentlemen, onto the city wall. After he had had the cannon brought up, they started to bombard the Forbidden City, without notifying any of the other commanders. With each shot that hit the walls or the beautiful yellow roofs, the ladies clapped their hands to show their appreciation and exclaimed, 'Oh, que cela fait du bien' [that certainly does one good].
>
> This game, however did not last long because soon the Japanese Minister appeared and asked Frey to stop his fire because his own men were in the Forbidden City. Almost at the same time, the American general came by and, as his horse reared up, he shouted, 'Will you immediately stop your senseless shooting, can't you see that there are Americans inside.'
>
> This was an example of the unity, purposefulness and determination of the generals of the relief troops.[45]

Into this day of farce beyond the walls of the Pei-t'ang, intruded a moment of purest tragedy. Father Addosio, who had been rescued against his will from the South Cathedral minutes before it went up in flames, decided to act independently; he wanted to make sure that Sister Vincenza and his other colleagues were all right and he set off for the Pei-t'ang on a donkey; he should obviously have been noticed and stopped, for Polly Condit Smith had written on 16 July:

> I talked with him from day to day, and from being at first *comblé* with grief at the ruin of his life's work in the destruction of his cathedral and hospital, he gradually has become full of hallucinations. His loss of mind has been a gentle affair compared with the violence shown by the Swedish missionary [Nestegard]...[46]

Now the gentle priest was to meet the most violent end as he ran into a troop of General Tung Fu-hsiang's men, was beheaded and his head stuck up on a pike by the roadside.

By the 16th, everyone, French and American, was ready to relieve the Pei-t'ang where Sister Hélène was in a state which might have been reversed by a doctor's treatment and where the 3000 besieged were dying from starvation – more than twenty-four hours would have made a considerable difference. When General Frey and M. Pichon arrived, they found the Japanese had got there before them and lifted the siege.[47] Neither mentions Sister Hélène.

Sister Hélène dragged herself up to supervise the return to the shattered Jen-tse-t'ang. On 19 August, she presided at prayers at 4.30am in the chapel then went to her desk to work. There she had another stroke. For two days, she remained immobile, attended by the Bishops and Sisters from three houses in Peking. She died on 21 August.

Goodbye to Peking

The lifting of the siege of the legations raised new problems for those relieved and highlighted or exacerbated others. Dr Emma Martin wrote in her usual frank and unaffected way of 15 August – which she noted was 'bright and clear':

> Just before I came off duty, Mitchell, who should have been in bed but would not, came in to the operating room and said, 'The maggots are in my arm, I wish you would get them off.' And I looked and said, 'I guess not.' And he said, 'Well, see here.' And he put his well hand under his wounded arm and brought out a lot of little wriggling ones, sure enough. It just about made me sick but I did not let on and called Fuller and took off the outside bandage; we nurses were never allowed to do any dressings except when a surgeon was present, even when the dressings were neglected for days because the surgeons were too busy.
>
> Fuller scraped them off and put on a creolin rag and did him up again. I told Dr Saville when I went off duty so it would be dressed at once, when the surgeons came. They decided two days after I think that the Belgian Count, who had a scalp wound, had the Typhus fever and the Hospital would be abandoned at once and the men taken to the various field hospitals before any one else took it. Several of the Chinese had died with it. Lippett and Meyer were taken over to the American Legation and Mitchell and Schroeder to the Field hospital. ... I [later] saw Mitchell [in Tientsin] and he said, 'I just got here in time to save my arm'. And I said, 'How long was it after that morning we fixed you up in the hospital?' He said, 'Till we got here 10 days.'[48]

Whether or not Emma Martin is getting at the British doctor Lillie Saville for not making sure the dressing was changed it is hard to tell; it is unlikely that Dr Saville was neglectful. But, as we have seen, in spite of her willingness to work as a nurse, rather than a doctor, Emma Martin disapproved of some aspects

of how the hospital was run under its German and British military surgeons and British matron (Marian Lambert). For her part, Lillie Saville was to end her published medical account:

> The unity which was a striking feature of the siege in Peking was nowhere more manifest than in the International Hospital. Differences of nationality, creed and professional status were laid aside, and all worked with much happiness together.[49]

If she is ignoring some differences, it was certainly not all public relations and wishful thinking for, when Deaconess Jessie Ransome was dying in 1905, Dr Saville was beside her, and those writing Jessie's obituary noted that the two were 'dear friends' (as a result of their work together during the siege) and that it was possible for 'strong women of strong religious convictions of greatly differing creeds to be indeed as sisters'.[50] Dr Velde's mostly military account particularly praises Dr Saville. Dr Poole's has proved untraceable.

Mrs Conger notes how the devotion to duty shown by the women doctors and the diplomatic women was continued after the siege:

> Just as soon as possible after the siege was raised, the hospital in the British Legation was removed, and each nationality took its own sick and wounded. Then Mr and Mrs Bainbridge, of the American Legation, gave up their bright, airy drawing-room to Captain Myers and Dr Lippet, as a hospital, and crowded themselves into very small quarters, as much of their building was badly shattered by shot and shell. This was quietly done, without one word in regard to discomfort; they never tell of their sacrifices, nor of their good deeds. Two lady physicians, Dr [Eliza] Leonard and Dr [Maud] Mackey, turned nurses and devotedly cared for Captain Myers and Dr Lippet.[51]

Mary Bainbridge may have been self-sacrificing and silent in public, but not in private; she wrote in her diary on 17 August:

> We were asked to give up our front room this morning as a hospital. There are only ten rooms in the Minister's house, and thirteen which the 1st Secretary [Herbert Squiers] occupies [while] we only had two. The one we are in has no window lights, and the outside blinds hang in all directions, bullet holes everywhere and just over my head is where a shell came through the roof and when it rains, we usually know that it is damp inside as well as out.

These accounts by the American diplomatic wives make interesting reading beside the press reports in the newspapers at home which Luella Miner attempted to answer in her diary in October:

> For some reason our American soldiers *no others* seem to be especially bitter against missionaries. It is said that when they came in to Peking on the 14th

August utterly worn out from their forced march in the intense heat, the missionaries neither helped them to find quarters nor to care for the sick and wounded. The missionaries who had rendered such efficient aid in our 'International Hospital' during the siege that a well informed surgeon said he did not think there was a better regulated hospital in the world, fully expected to continue their services when the allies arrived – the Americans having their own separate hospital. At least one made an offer of assistance – perhaps not to the proper person – and the reply was made that the army had its own doctors and field hospital outfit, and that such services were not needed. This reply circulated among the company of weary missionaries and no more offers of help were made.

As to finding quarters for the army, no missionary would have dreamed of being so ostentatious as to go to the officers and make such an offer, for all civilians were in blissful ignorance as to what the plans were, and what part of the city each country was to occupy. If asked, they would most gladly have accepted.

Another criticism was that the American missionaries did not give up any of their rooms that first night to the officers who had rescued them. Luella justifies that, too, but the only quotation from her diary that is needed is 'rooms!!!'

Polly Condit Smith describes on 16 August the more general subject of accommodation for those who had been besieged:

All of us, now we have no longer any right to continue living in the British Legation, feel that we should leave as soon as possible. The diplomatic people have houses to go to, and those who have no houses to go to are usually taken in by their colleagues, but the great majority are houseless and homeless.

It is like hunting a needle in a haystack to find a habitable house anywhere near the Legations, because, for blocks and blocks, almost everything is burnt. To find any decent Chinese houses one has to go too far from our lines to be really safe, as even now there are plenty of snipers still in Peking. Some wretched, dirty, and filthy temples have partially escaped burning, owing to the fact that almost up to the time that our troops arrived they were used by the Chinese as strongholds for themselves and Boxers. Into these holes people must go for lack of anything better.[52]

And on 18 August Dr Emma Martin describes how,

We had a mission meeting down near our old place. Dr [Anna] Gloss and I walked around over the ruins and there was nothing left but a pile of broken bricks. Not even a stick or a piece of glass was to be seen. We were a little surprised to find that the buildings had all been looted and carried off instead of being burned. They had even dug up the foundations of our beautiful Church and dug up the well curbing to get the foreign bricks. The 'children's

giant tree' was still standing and Dr Gloss and I sat down on a stone to rest and we were both speechless, stunned. We could hardly realize that this was once, only such a short time ago, our happy homes. Mr King and Miss [Alice] Terrill came along and we walked back. Mr King spoke to several of the neighbours whom we saw and told them to bring back any foreign things that they had, and they did bring back 3 trunks and some chairs and other things, and left many near by, but nothing of ours.[53]

Charlotte Brent was among the lucky ones where immediate accommodation was concerned; she noted:

On Monday 20th *exactly 2 months* since I arrived I left the Legation and went back to the [Hongkong and Shanghai] bank where a room in the Chinese part had been prepared for me. Three shells had been through the ceiling and much damage been done by bullets but it was a great comfort to get a room to oneself again.

But it was a temporary expedient; it was not just a lack of accommodation that made life difficult but people's health also deteriorated after the siege as, with today's knowledge of the effect of post-traumatic stress, one would expect. Arthur Brent wrote to his father, 'I am more afraid of the Mother's health now than during the siege as the nerves are all relaxed and she is generally much run down.'[54] In a letter to a friend, Brent added, 'My mother kept very well during the siege but now that the tension is over I rather fear a breakdown and it is the same with a lot of the other women.'[55]

Howard Smith of the LMS wrote on 15 August:

My wife and baby have stood the siege fairly well on the whole, but are now showing signs of sickening, so that I feel very anxious to get them away to a place of rest and quiet for an entire change. I have several times during the siege feared a nervous breakdown in my wife's health and now it is this that threatens again. We also feared we should lose baby, but are glad to say she picked up again though is now sick with malaria.

Lucy Ker lost her baby, Murray (two years, four months), on 21 August, the sixth siege death among foreign babies. He had had scarlet fever which kept him and his mother in stifling quarantine, and then dysentery; he died of septic poisoning with Dr Lillie Saville at his side. And Polly Condit Smith recorded:

Mrs Squiers is busy nursing little Bard; he has gone down with typhoid fever within the last few days, and we are all dreadfully worried about him. He is now at our Legation, in an isolated building. It is hard to nurse typhoid without fresh milk and ice, but we hope to get them before long. Mrs Squiers is also nursing Captain Myers (who has developed a case of typhoid) and Dr Lipitt, thus making two cases of typhoid in our little compound.[56]

And the effects of the siege were to be long-lasting; a friend of Helen Brazier was to write, when she died in childbirth in Scotland in 1902, aged twenty-eight, that she 'ultimately died as a result of the hardships and privation ... endured'.[57] It should be said, however, that her daughter Helen Hope, six months old at the beginning of the siege, whom it must have exhausted the mother to provide for, and who must have lacked the proper diet at a crucial stage of development, lived to be a hundred – probably the last Western siege survivor.[58]

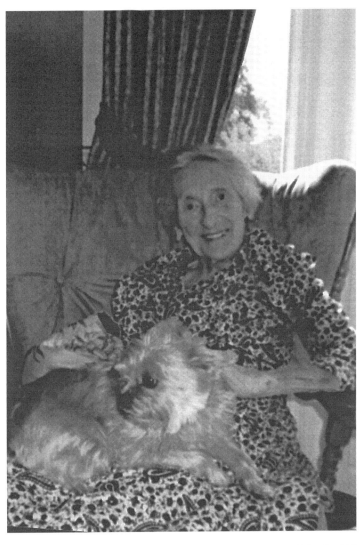

38 Helen Hope Brazier Steedman, August 1999 (courtesy of the family)

Charlotte Brent's husband later wrote that 'the privations and dangers she passed through must have affected her health'.[59] Sara Goodrich dedicates her unpublished 'Journal of 1900' to two of her children but 'to the memory of Mary Dorothea' – her eight-year-old daughter so lively during the siege. She died of diabetes in China in 1904. Mrs Wyon appears to have died immediately after the siege.

It was by no means only the women and children who suffered after-effects: George Morrison noted in his diary on 24 August, 'Tours ill, baby dying.' And, on the 27th, 'Tours dying meningitis' (Ada Tours' diary had stopped by this time). Happily, on 3 September, Morrison was to write, 'Tours safe'. In a letter of 4 November, though, he observed, 'My health has been bad since the siege and I have aged considerably.'[60] And on 20 December, Lady Blake wrote to Morrison, 'I thought Mr Bredon looked as if 20 years passed since I had seen him in May.'[61] Bessie Ewing told how her husband Charles 'was taken sick with fever as soon as the strain of the summer was over and was barely able to sit up'.[62] Charles's fever refused to abate and later she was to write 'Oh! I think those days when Charles was so sick were worse to me than the two months of siege.'[63] The Reverend Roland Allen, back in England by November, wrote, 'I am rather distraught and I really do not know what I shall be able to do just yet.'[64]

There was more obvious reason for the marines to be in bad physical shape; nevertheless, Dr Emma Martin's remarks on it, and the psychological ill-effects that went with it, are noteworthy:

> The American surgeon Dr Lang said when he was examining the marines, (physically) after the siege, he found many of them with rheumatism, kidney trouble and all sorts of things from their long hard exposure. He is such a kind hearted man and as he talked to the boys, some of whom had not slept with their boots off for a month at a time, they just broke down and cried. Some of them are physical wrecks.[65]

Ethel MacDonald who was looking after Dr Poole, down with fever, in her bedroom, summed it up: '... almost everyone broke down in some form or other when the tension and strain relaxed'.[66]

Some women had their own ways of dealing with the siege and, now, with the after-effects. On 20 September, Morrison confided to his diary that it was a 'Glorious day's outing to Summer Palace. Mrs Squiers turning up an hour late as usual. ... Mrs Squiers as usual drinking too much.' Mrs Houston's son observed that, following the siege, his mother could never touch champagne again.[67] Polly Condit Smith noted during the siege the reliance on another drug to calm the nerves and cope with the unsupportable air pollution caused by animal carcasses and Chinese corpses: 'Even the women, principally Italians and Russians, find relief in the constant smoking of cigarettes.'[68] Since there

seemed to be only one Italian woman, she meant the elegant Marchesa Salvago Raggi. Polly does not make it clear that she, too, smoked heavily.[69] After the siege, American missionaries were constantly having to make the point that none of them had let liquor pass their lips, in spite of reports of much resorting to champagne and other alcohol.

Poorly, homeless, hungry and destitute as so many foreigners were, it was clear within a few days of the relief that the best option was for as many of them as possible, especially women and families, to leave. Arrangements were put in hand for them to do so and a great cavalcade of seventy or so carts with baggage mules and some chairs finally set out for T'ung-chou on the first stage of the journey to Tientsin at 8am on Thursday 23 August escorted by Sikhs and Bengal Lancers. Most people's diaries start to dribble away now, but we know that it was a difficult, unpleasant, and dangerous journey.

Sara Goodrich, who had fled T'ung-chou with her three children two months earlier, noted of their arrival there, 'The Boxers cut our Christian babies in pieces and now the Japanese and Russians have returned double, quadruple, for all they gave. The stories the soldiers tell us are too horrible to put on paper.'[70]

Dr Emma Martin observed that when they changed to boats at T'ung-chou, 'the lieutenant in charge of the expedition was drunk'[71] and also that 'It was 'much more dangerous than we "women folks" knew about for a small force of Chinese could have gotten us all if they had tried at the time. The boats did not keep together at all.'

But it was not only their own discomfort that she was conscious of; she also wrote,

> We saw so many dreadful sights along the way. Scores of dead Chinese had been shot along the way and their bodies left to rot in the sun or be eaten by dogs and worms. Many of the bodies were in the water and sometimes the stench was dreadful. We had to use this river water for cooking and I had to drink it once.

Bessie Ewing and her family were on the same boat, as were Alice Fenn and her family, and Mr and Mrs Walker; there were forty-one passengers altogether on three boats, not counting their guards whom Emma Martin had occasion to nurse. The group of Americans rested in Tientsin for a week before leaving for Japan and then the United States.[72]

Jessie Ransome was travelling in a party with her sister Edith, their medical assistant Miss Hung, the two Chinese orphans she had been looking after, and the Reverend Roland Allen, and she noted that T'ung-chou itself was a 'most painful sight, a mass of ruins for the most part, in some places still smoking, and the sights and smells anything but agreeable'.[73] But Jessie's diary did not carry her as far as Tientsin or she would have noted what awaited them there.

Frances Scott, the Bishop's wife, who had gone from the siege of Tientsin to the comparative safety and comfort of Weihaiwei, arrived back in Tientsin to rejoin her husband on 28 August, seven weeks later. It was a joyful reunion for she had left out of duty, much missed her husband and been constantly anxious about him. But the day after the arrival of the party from Peking, Frances Scott fell ill with dysentery. Three or four days later she was so much worse that the doctor sent her, together with Edith Ransome who was also unwell, to Taku to catch a transport to Nagasaki; the Bishop, Roland Allen, and Jessie Ransome acting as nurse accompanied them and, by the time they reached Japan, Frances Scott seemed slightly better. But by 7 September she was dead.[74]

16
Miss Georgina Smith and the Loot
(15 August 1900–60)

The Violation of Peking

'Then the Russians demanded the rooms which we occupied for barracks', explained the schoolgirl informant whose story Luella Miner made sure was published.[1]

Most of the foreign women had a choice about whether or not they left Peking in August 1900; some stayed for their own or their husband's work – most of the diplomatic wives did so – and Miss Smith and Dr Saville of the LMS and Luella Miner stayed too. For the Chinese women, either Christian converts or ordinary or privileged citizens of Peking, such options were not so available.

The schoolgirl recounted her immediate fate, that of her fellows, and of those who had been left outside the magic circle of the legations and the Fu when she continued:

> The missionaries must find a new home for us. So six days after the siege was relieved, the homeless ones had found new abiding-places. We twenty-two girls of the Bridgman School were back close by the desolate ruins of our former schoolhouse, in the forsaken residence of a Mongol [Manchu] prince. Before our school broke up last June, his place had been a Boxer camp. We saw the great kettles in which their food was cooked. We saw great piles of swords, some of them bloodstained. ...
>
> During those weeks after we left our prison-house, joy and grief came to us hand in hand. One day there would be a touching meeting between parents and daughters who had given one another up as lost; the next a friend would come to tell some one of our number that she was an orphan. We heard of the martyrdom of our beloved Ruth, valedictorian of our last class, who died with our missionaries in Shansi, where she was teaching, far away from home and friends. About twenty of our schoolmates are among those who 'out of the great tribulation' have passed to their place beside the

309

great White Throne. We did not hear of one who denied Jesus. Three have come back to us after months of hiding in deserts and mountains and caves.[2]

The schoolgirls were merely frightened by the Russians; there is barely a hint of the more extreme problem facing the women of Peking – the depredations of the invading foreign soliders. Putnam Weale gives a fairly low-key introduction to what was to become a savage and shameful interlude of some months caused by lack of military discipline, nationalistic division, greed, lust, and the demand for retribution when he wrote of 18 August:

> I came back into broken Legation Street to find that a whole company of savage-looking Indian troops – Baluchis they were – had found their way in the dark into a compound filled with woman-converts who had gone through the siege with us, and that these black soldiery were engaged, amidst cries and protests, in plucking from their victims' heads any small silver hair-pins and ornaments which the women possessed. Trying to shield them as best she could was a lady missionary. She wielded at intervals a thick stick, and tried to beat the marauders away. But these rough Indian soldiers, immense fellows, with great heads of hair which escaped beneath their turbans, merely laughed, and carelessly warding off this rain of impotent blows, went calmly on with their trifling plundering. Some also tried to caress the women and drag them away Then the lady missionary began to weep in a quiet and hopeless way, because she was really courageous and only entirely over-strung. At this a curious spasm of rage suddenly seized me ...[3]

Weale pushed his revolver into the man's face and ordered him to desist; there were some moments of standoff, and even of fear on the part of Weale, but he prevailed. Who the missionary woman was is impossible to be certain; in my mind's eye I see Miss Georgina Smith, because of later developments, though I cannot quite see her weeping, unless she hoped it might achieve something. But Weale was to witness and hear about much worse.

He himself was begged to take up protective residence in a household where the men – officials – had fled leaving the women to fend for themselves and had to fight off marauding soldiers. But some of the worst stories were told to him with relish possibly by Polly Condit Smith's erstwhile admirer Merghelynck, Secretary at the Belgian Legation, or at least a man with a 'thick Brussels accent' who, during the siege had 'volunteered to play the part of executioner' to captured Chinese. In a long, rambling speech, he asked Weale,

> Have you seen them?' he said, not pausing for a reply. 'It is the sight of all others – the best of all. Hsu Tung, you remember, the Imperial Tutor, who wished to make covers for his sedan chair with our hides, and who was allowed to escape when we had him tight? Well, he is swinging high now from his own rafters, he and his whole household – wives, children, concubines, attendants, every one. There are sixteen of them in all – sixteen,

all swinging from ropes tied on with their own hands, and with the chairs on which they stood kicked from under them. That they did in their death struggles ...

'And the wells near the Eastern Gates, have you seen them, where all the women and girls have been jumping in? They are full of women and young girls – quite full, because they were afraid of the troops, especially of the black troops. The black troops become insane, the people say, when they see women. So the women killed themselves wherever they heard the guns. Now they are hauling up the dead bodies so that the wells will not be poisoned. I have seen them take six and seven bodies from the same well, all clinging together ...'

Then he came up to me and whispered how soldiers were behaving after they had outraged women. It was impossible to listen. He said that our own inhuman soldiery had invited him to stay and see. ...[4]

Once again, it is impossible to tell where the line between truth and fantasy should be drawn in either the Belgian or Putnam Weale's account but, even with the cuts I have made for reasons of length, the reader cannot avoid a sense of some reality, and Weale also wrote in September of how previous Chinese friends, members of the *bourgeoisie*, came to see him and how 'Each one had had women of their house violated. One with many hideous details, told me how ... soldiers came in and violated all his womenkind, young and old.'[5] He could tell the man was telling the truth.

Journalists who came with the relief force made it their business to report such incidents taking place in Tientsin and T'ung-chou, as well as Peking, in their books, and Morrison had more than one entry in his diary; on 22 September, for example, he wrote:

To a house with an opium smoking teacher who tells me that his sister was ravished by Russian soldiers and that in consequence every member of her family living in the house – seven persons in all – then committed suicide by opium having first buried their treasures and then burnt the house to the ground. This is a common story.[6]

The foreign women were not unaware of what was going on; Luella Miner wrote in her diary on 15 August:

The conduct of the Russian soldiers is *atrocious*, the French are not much better, and the Japanese are looting and burning without mercy. ... The Russians all the way up from Tientsin butchered women and children without mercy, and women and girls by hundreds have committed suicide to escape a worse fate at the hands of Russian and Japanese brutes. Our American soldiers saw them jumping into the river and into wells, in T'ungchow twelve girls in one well, and one mother was drowning two of her children in a large water jar. ... It is easy to say that China has brought

this calamity on herself – that this is not war but punishment – but when we *can* distinguish the innocent from the guilty why stain the last pages of the century's history by records which would disgrace the annals of the dark ages? Sweet lessons in 'western civilization' we are giving to the Chinese.[7]

Polly Condit Smith wrote, apparently on 16 August – I suspect added later:

> When the rich Chinese inhabitants left Peking in such a hurry they in many cases took their treasure, their favourite wives and themselves out of the capital with the greatest expedition possible, while the young girls and women of their households thus left in countless instances promptly committed suicide, usually by hanging themselves, or drowning themselves in the wells of their courtyards. The men who are throughout Peking now looting, constantly run into these silent testimonials, showing how these people all preferred self-inflicted death to what they knew they could expect when the civilized and Christian soldiers of the West should be turned loose.[8]

It is worth remembering that suicide was a distinctive feature of Chinese society, particularly among women, not only involving the question of personal or family honour but also as an opportunity for revenge (as a spirit) from beyond the grave.[9]

One cannot ignore, though it is hard to accept, Henry Savage Landor's contention that most of the atrocity stories – particularly about the Russians – were fabricated. So prevalent were the accounts that Landor made a determined effort to track down the truth, including questioning an American correspondent who had been responsible for some, and satisfying himself that they all stemmed from one unsubstantiated incident.[10]

Whatever motives male journalists, writers, and informants had for their accounts, one cannot ignore, either, Miss Smith's letter of 8 September in which she writes, 'The Russian troops were the terror of the neighbourhood. They robbed and looted and did many other shameful things, so that the people trembled for their lives, their virtue and their property.'[11] Georgina Smith was not writing from hearsay; she had, as we shall see, become part of that neighbourhood – in the Russian sphere of control.

Lady MacDonald Accused

Whatever the reality, the perception of uncontrolled savagery has taken so strong a hold that the suffering of foreigners and Christian converts during the Boxer uprising is seen as nothing to what the Chinese subsequently experienced. This has particular bearing on how the foreigners who had been besieged have been regarded in respect of the portmanteau concept of looting – a subject that needs to be explored because women have been implicated.

As so often, Polly Condit Smith's account gets neatly to the heart of at least one aspect of the question:

> This morning Baron von Rahden [commander of the Russian siege detachment] came for breakfast... He told me he had procured for me a good sable coat – and when a Russian speaks of good sables they are good ... I wanted to accept the coat in the spirit it was offered, as a testimonial of a charming friendship, formed under extraordinary circumstances, but owing to the intrinsic value of the garment I had to decline it. I don't think he understood very well my refusing it, and I had within an hour the pleasure of seeing him present it to another woman, who accepted it without a qualm, and without giving him, I thought, very many thanks. My soul was torn with conflicting emotions all day, and in the afternoon a Belgian, of whom I had seen a good deal during the siege, brought me a tortoise-shell bracelet, set with handsome pearls, which he had taken from the arm of a Chinese officer whom he had killed. I surprised myself by promptly accepting it. My nerves could not have stood it, and I took it rather than have a repetition of the sequel to the sable-coat episode.[12]

That extract suggests that Polly was unaware of any broader picture – even the fact that one sable coat and one bracelet from two admirers would mean that those individuals (only two of thousands of other foreigners) had a hoard of loot, possessions of the Chinese citizens of Peking. That is not so; she was aware that each of the Allied powers had its own formal attitude to 'loot'; and then there were the informal attitudes held by its military (officers and men), its diplomats, its ordinary citizens, and its missionaries. She gives a useful and nicely cynical thumbnail sketch, dated 18 August:

> Yesterday a very animated generals' conference was held, the great question being whether there should be a unanimous effort to stop all looting and sacking, or whether it should be continued. The Japanese, French, and Russians were absolutely *pro*; English and Americans, *con*, the latter having the strictest orders from President McKinley against any looting. The English, although giving their vote for no looting, added they should continue to place 'in safe-keeping all valuable things' found in the district given them to police. This, of course, gives them practically the right to loot although whatever is brought in has to be placed in one place, where there is an auction later, and the officially prescribed amount *pro rata* is given to the officers and men, so that they are really doing just what the other nations are doing, only in a somewhat more legalized way. They say that these Indian troops, the Sikhs and the Rajputs, are something horrible when they get started, and occasionally the British officer who is supposed to always be on these parties sent out to procure 'the valuable things for safe-keeping' has to shoot a man to keep them in discipline.[13]

> The rumours come in now the whole of Peking is being looted, and worse, and each Legation, closed up in its little compound, feels like a little question-mark of respectability, surrounded by a whole page of wicked, leering horrors.[14]

The international looting of Peking was to raise much criticism in the international press at the time, but there was no particular focus on women; only Putnam Weale in his rather subversive book made the generalised, and therefore unsubstantiated, remark at the end of August: '... some of the biggest people in the Legations are so mean and so bent on covering up their tracks that they are using their wives to do the dirty work'.[15]

Then Peter Fleming published his reconstruction of the siege in 1959, and his correspondence file and a newspaper's letters column show the mine on which he had trodden when he penned the lines,

> In October a British officer wrote home: 'Lady MacDonald was out with a small force left behind in Peking [during a punitive expedition in Chihli] and devoted herself most earnestly to looting.' Everyone was in it.[16]

No one could believe that he could so casually besmirch the name of such a gracious and brave 'lady'. Fleming's most hurt and irate critics were Ethel MacDonald's daughter Stella and F.S.G. Piggott, a diplomat who served under Claude MacDonald in Japan. One of Fleming's problems was the square brackets he inserted about a 'punitive expedition', which could be misconstrued; then, it was an anonymous accuser – in fact, it emerges in Fleming's correspondence with Stella MacDonald, that he was thirty-two-year-old Sapper, later Colonel, Charles Henry Ryder of the Royal Engineers who arrived with the relief forces, and wrote his letter in October.[17]

In answer to this public shaming, emphasised in a review, Sergeant Murphy, then aged ninety-two, who had been senior NCO in the Royal Marine Guard at the siege wrote to Fleming, 'As for looting by Sir Claude and his wife it is unthinkable.'[18] Stella MacDonald quoted a letter to her from William MacKinnon, also at the siege,

> We who had the happiness of knowing Sir Claude and Lady MacDonald know how impossible it was to even suggest such a thing. One can only imagine that an anonymous officer had never actually met them and so took someone else to be Lady MacDonald.[19]

While Sir Lionel Gaunt, in a rather convoluted letter full of Latin tags, in which he mentioned that his wife was a clanswoman of Sir Claude, ended, 'I have moreover a recollection of having read somewhere that the MacDonalds' summer bungalow ... was completely looted and destroyed by the Boxers ...'[20]

All Fleming was prepared to concede, by means of a clarification in a letter to the *Sunday Times*, was the possible misreading caused by the square brackets

– Lady MacDonald was not involved in a punitive expedition. That Lady MacDonald's reputation suffered is obvious from a less protective letter to Fleming, in which a woman reader informed him that her uncle brought home a 'Eunuch coat' that he looted from the Summer Palace and commented:

> What a Eunuch was I did not know, but 'loot' was a word I did understand and I was scandalised that an uncle of mine, commanding a distinguished regiment, and a very religious man – that he should stoop to so sordid an occupation! However, I gather from your book that everybody did it 'from the Governor's Lady to Judy O'Grady', they all partook joyously in this pursuit.[21]

Without wishing to stir up any further controversy about an obviously admirable woman, I shall quote from two other primary sources on the subject – both already in the public domain – one before and one after Fleming's publication. The Dutch diplomat William Oudendyk was away from Peking when the trouble started and made his way back in September; in his 1939 memoirs of diplomatic life he writes of his return, elaborating on what Polly Condit Smith has touched upon – a well-known feature of post-siege Peking:

> When I entered the gate of the British Legation a busy scene presented itself. An auction was in full swing in the first *ting'rh*, or open pavilion, in front of

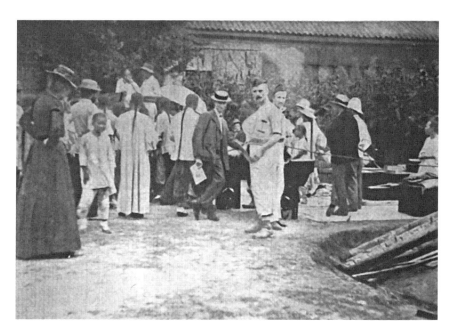

39 Auction of Chinese silks and curios, British Legation (from *Black and White*, supplement, 20 October 1900)

the Minister's house. A collection of Chinese things lay spread out on the tiled floor, from silks and furs to blackwood furniture and antique bronzes. All the legation people, amongst them Lady MacDonald sitting on a chair, and a number of other English men and women thronged around this display of valuable articles, taking them up and examining them and discussing their age and merits. There was an atmosphere of happiness and enjoyment. A sergeant held up each article in turn, and the bidding was lively, but the prices were low, there was evidently a glut in the market. An officer noted down all the sums in a register, the proceeds going to his regiment's prize fund. While this was going on two Chinese mule carts drove in escorted by some Indian soldiers under an officer. They were heavily loaded with more Chinese valuables destined for auction. This had a bad influence on the bidding.[22]

There, Ethel MacDonald is part of a system which is open to criticism then and now but which was also overt, regulated and acceptable (even moral) to the British military and diplomats then.[23] Annie Myers notes, 'Our poor men find it very hard that the commands against looting are so strict, as all the other nationalties are looting left and right.'[24]

That the morals of the situation appeared different, even to civilians, if you were there in Peking, particularly if you had been through the siege, is obvious from the letter that Arthur Brent wrote home to his father: 'Looting was in full swing before we left and I managed to get a few silks etc which the Mother will take home and distribute.'[25] George Morrison, who heaped up his own cache of loot, has a somewhat cryptic diary entry on 3 October which reads: 'Experience with fur and Mrs Tours. My boy accidentally put a beautiful white fox skin among my white furs. I gave her the choice and she took the best worth 100 taels.' Lucy Ker received so many requests to bid at auction that she gave herself a crash course in Chinese porcelain.

Rather more difficult is an entry in Morrison's diary for 5 November (in the public sphere from 1967): 'Dined with General [Sir Norman Robert] Stewart and First Brigade Mess. The son of Sir Donald. Palace of Prince Chun. All condemned the way Sir Claude and Lady looted since the siege – 185 boxes at least.'[26] But, whatever Chinese 'loot' the MacDonalds had, not all those boxes contained it, for Annie Myers wrote on 29 August, 'packed a box for Lady MacDonald, containing her Chinese and Benin City bronzes'. The Benin artefacts, it perhaps needs to be said, had been presents (though perhaps originally looted!).[27]

The MacDonalds left Peking for Tokyo on 25 October. There Sir Claude was Minister, then Ambassador, for twelve years. Ethel MacDonald was prominent in the Japanese Red Cross, particularly during the Russo-Japanese War of 1905. In an obituary of her, Francis Piggott was to write: 'Her unique place in Japanese and diplomatic society ... remains unchallenged to this day – it can, indeed,

never be equalled ...'[28] She was widowed in 1915 and moved, at the request of George V, to Royal Cottage, Kew, where she lived for the next twenty-five years, much revered and deeply involved, when health allowed, in the Overseas Nursing Association. She was created a Dame (D.B.E.) in 1935, and died six years later aged eighty-four.

Polly Condit Smith suggests that the French were pro-looting, and certainly their troops did their share.[29] But Paula von Rosthorn gives a different impression. She is clear, for a start, about the savagery of the behaviour of the Allied troops – the brutalising effects of war, the blurring of the division between right and wrong. Then she goes on to recount how,

> Persons of the highest society, who would condemn a poor devil who stole a piece of bread out of hunger, they started to rob on a grand scale. ...
>
> M. Pichon was there one evening when an Italian volunteer [during the siege] from a very aristocratic family came back from his looting expedition. Three carts were piled high with silk fabrics, precious furs and baskets full of silver shoes [taels, Chinese currency]. This gentleman had, in order to pass the guard unhindered, draped French flags over his carts.
>
> When Pichon saw this, he stepped up to the cart, ripped the flags off and yelled at the man, 'If you want to rob and steal in the first place, don't dare again do this under the protection of the French flag. ...'
>
> There were very few people who thought as honestly as Pichon. And Arthur, as well, had daily the most vehement discussions about this because he aired his views about such acts very openly. One day he exclaimed to a Belgian volunteer at our dining table who also brought back daily whole cart loads full of precious curios, furs and such like, 'So, what have you plundered today?'
>
> The man turned pale with anger, jumped up, and shouted, 'How can you accuse me of plundering? The Chinese have taken all my possessions; everything that I owned is destroyed. Is it not fair and reasonable that I should take a few little things, to keep them as a souvenir of this terrible time?'
>
> Arthur was not exactly in sympathy with this view ...[30]

At that stage, Captain Darcy and the Austrian officers had to intervene. Having extolled the virtue of M. Pichon, Paula von Rosthorn does then suggest that the French Bishop [Favier?] was of a different bent.[31] She also explains, without apparent irony (though with much humour, for it was quite a tale), how, following the arrival of the Austrian detachment on 17 August, she and Arthur commandeered the mansion (and all its possessions) of Ch'ung-li, the Military Governor of Peking, under suspicion of being a powerful Boxer protector, as a replacement Austrian Legation. She was fascinated to have the opportunity of

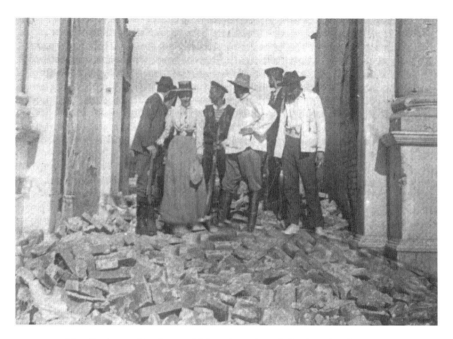

40 Paula von Rosthorn visiting the ruins of the Austrian Legation
(from *Ware Ich Chinese, so Ware Ich Boxer*)

seeing such a grand Chinese establishment for the first time so close-to and describes it in detail.[32]

Arthur Smith suggests that when the late owner 'sent over to ask for a fur garment as the winter was coming on, they genially replied that they had none to spare'.[33] The implication is that it was the von Rosthorns who gave this reply but, as in due course they were to leave Peking, I cannot be certain. Paula had had enough of China for a while, even though she wrote home, 'It was a very interesting time and I was glad I was there.' Again, there is no hint of her pregnancy.

When the von Rosthorns returned temporarily to Vienna, they were treated as heroes, Paula not only receiving the Order of Elizabeth, but also, during an audience with the Emperor, Franz Joseph's own special medal; she was the only woman to be so honoured. She also received the French Legion of Honour. They were soon to return to Peking and stay there until 1906, as we shall see in the Epilogue. In 1911, Arthur was Minister to Persia, but later that year he was back in Peking as Minister until 1917 when the Austro-Hungarian Legation had to close because of the First World War and the downfall of the Habsburgs. Paula died in Vienna in 1967, twenty-two years after Arthur, aged ninety-four.[34]

Mrs Conger seems, too, to have been a woman of honour though, perhaps, as far as the Forbidden City was concerned, also a little naive. She noted on 4 September, after being taken round, that, 'The Japanese and Americans are protecting these treasures from vandalism' and 'Not a thing was molested in these halls, private buildings or grounds.'[35] But Annie Myers describes looting in the Forbidden City at every level. She, together with the Kers and her sister Helen and 'Russ' Brazier and Daisy visited it on 25 August and she frankly observes:

> The eighth commandment was very difficult to keep, but, as Captain Norris did and Captain Wingate had told the guard at the gate they were both officers on the staff … we felt in honour bound to keep our hands from picking and stealing though it was evident others had not.[36]

The party proceeds through the Empress Dowager's palace and Annie continues, 'We were taken into her bedroom and each given a yellow silk handkerchief from her own wardrobe.'

But even more telling is her account of the day, 28 August, when the Allies formally entered the Forbidden City, processing through it with much fanfare. Lady MacDonald was allowed on the periphery and she took Annie Myers and Daisy Brazier with her. Afterwards, they once again explored the palaces. In one pavilion:

> There were some Japanese standing in front of me simply cramming things into their haversacks. It was more than I could stand to see those lovely things going to the common Japanese soldiers, so, being the nearest of our party to the kang, I handed Daisy a lovely round of Jade, got on the kang and got the pair to it for Mr Dering and was just beginning to think nothing remained for myself, when Daisy spied an oblong one on the opposite side. I hustled a Jap out of the way and got it just before him. He doubtless got a great deal more, for they systematically set to and looted from the moment they set foot in the Palace until after we had left it.[37]

From there, they went to what Annie describes as a throne room and she writes:

> The sceptre, inlaid with Jade was lying on the throne and was nearly being taken by a German officer, who, however was stopped by M. von Below, through Sir Claude's intervention. As we were standing there the Japanese General came up to Lady MacDonald and, with a deep bow, presented her with a beautiful clock inlaid with stones … [later] while Sir Claude was talking to this man two German officers came out of the Palace simply laden with loot so Sir Claude asked them in German if they did not know that it was strictly forbidden as we were in the Palace to-day as guests, but of course he could not say anything to them as they were German officers and he was the British Minister, but if they had been British officers he would order them

to leave the things – which they did. The next people to come out were Messrs Porter and Hewlett with their pockets bulging. Sir Claude said to them 'Now young men, no looting you know, I am afraid I must ask you to turn out your pockets', and to his relief and great pleasure they had only some of the Empress Dowager's gourds. He was greatly pleased at how well they came out of it and especially before the Germans, who were still standing there. ... Captain Wingate told Helen this afternoon that after we had all left the palace the Foreign Troops, Russian, French and Japanese, stationed round the walls, placed ladders against them and looted everything.

Luckily for her credibility, by November Mrs Conger knew that other looting at least was going on for she wrote on the 4th:

There is no Chinese government here to hold the Chinese or the foreigner to law and order ... One of the most heartrending acts to me is the removing and carrying away of the exquisite bronze instruments at the Peking obser-vatory. These old historic treasures were more than valuable and beautiful. They have stood on their sentinel watch between four and five hundred years. They belong to China and can never act as honorable and beautiful a part elsewhere. The venerable Examination Halls are in complete ruin. Our Government has given strict orders against looting; it recognises no spoils of war.'[38]

For all Mrs Conger's certainty and President McKinley's strictures about looting, and Polly Condit Smith's suggestion of British diplomatic hypocrisy, George Morrison's diary keeps tabs on the activities of Herbert and Harriet Squiers – Polly's host and hostess. On 31 August Morrison noted, 'To the American Legation Squiers buying for a drink of gin carved ivories worth 200 taels and for 4 dollars a lacquer table worth 400'. A few days later, in an undated note:

Smith's [Arthur?] story of Mrs Squiers and the box full of silk which two men could carry. [Elwood] Tewksbury cheerfully hoping to sell it for untold treasure. Mrs Squiers after glancing at the contents 'I'll give you $20 for it. I don't want to see it. I buy it in the interests of the poor Christians. Take it away.'[39]

And 4 September: 'Squiers had purchased all best things at Tewksbury's 1/5 value.' These diary entries are formalised by a *New York Times* article – perhaps even via Morrison – of 3 September 1901 which notes that:

H.G. Squiers, Secretary of the United States Legation, started for home to-day on leave of absence. He takes with him a collection of Chinese art, filling several railway cars, which experts pronounce one of the most complete in existence. Mr Squiers intends to present the collection, which consists largely of porcelains, bronzes and carving from palaces, bought

from missionaries and at auctions of military loot, to the New York Metropolitan Museum of Art.[40]

A reporter asking the museum how they justified accepting a looted donation was informed:

> The Metropolitan Museum of Art does not accept loot. I think it an outrage, however, that such a suggestion should be made in connection with anything which Mr Squiers has to give. He is a gentleman and has one of the finest porcelain collections in the country ... Now a man who engages in that kind of work – the collecting of Chinese art – is not apt to be a man who accepts or presents loot ... It would be presumed by the Museum that Mr Squiers' collection has been honestly got, he being a gentleman without question.'[41]

Nevertheless, Herbert Squiers' career did, apparently, suffer from such reports.[42]

Miss Smith Takes Charge

Under the greatest attack for civilian looting in the international press were missionaries such as Elwood Tewksbury, originally of the T'ung-chou mission (now completely destroyed). Missionary 'looting' took three forms, two of them described innocently by Dr Emma Martin – who has already written of the looting and destruction of her own mission.[43]

On 20 August, which started with a stress-relieving horse-ride through Peking, she ended up at the palace taken over by Tewksbury for his mission with the permission of its owners, a duke and duchess who attended the church services now held there and knew that such an arrangement was probably their only protection. She was much amazed by the treasures that surrounded her as she walked through – even though the Russians had already been there looting anything portable. Then, as she noted:

> Mr T[ewksbury] had said if anyone needed any of the things there, it would be all right to take it, so I suddenly decided I need a silk waist but all the colors were so gay I could not find one that I could wear at first and then Mr Lewis found a garment of tafata silk of a quiet green shade which I liked very much and took. We rummaged around some, he explaining some, and I took a Manchu stilted embroidered shoe and a pair of little ones and two sandalwood fans, the odor of which was so delicate you could only catch it the first whiff then I found a little piece of jade and a hair ornament, which we brought away as souvenirs. I just had the best time. I was so sorry Lizzie was not there too, it was such fine sport. I could hardly believe it was me. It was surely the gayest 'lark' I ever had. ...
>
> ... The P.M. Lizzie and I took our indemnity list over and put it on file at the American Legation. It amounted to $652.00 ...

... Mrs Jewell was very busy getting the girls moved out of the place where they had been for some weeks for the Russians were going to move in as it was near their Legation. ... [It had] belonged to a wealthy man and there were dozens of chests full of silk and fur garments and nice bedding. He was anxious to save as much of it as possible but he knew if he tried to move it the soldiers would take it away from him. So Mrs J told him if he would get carts and help her move the schoolgirls she would help him move his things, all she did not need. She told him she would have to keep the bedding as the girls had lost all theirs and some of the clothing. So they turned out all the chests, the man's servants, and they looked it over and kept what they wanted which was a very small part of it. I happened to be there when the things were spread out and Mrs J said to the man, 'This lady has lost all her winter clothes because of your people and it might be nice for you to give her one.' And he said, 'All right, which one?' And I said, 'This.' He gave me a fox skin, I think.[44]

Two days earlier, Sara Goodrich had noted,

We all went over to the Yu Wang Fu, the place taken by Mr Tewksbury for our Christians. It was a very large place, a palace, with beautiful large rooms finely furnished. It had been looted by the English, the Russians and two French women (What looters the French are!) ... It seemed like the irony of fate for our T'ungchow Christians to go and occupy it as their own, a place which had been a nest for 600 Boxers.[45]

Emma Martin gives a strong flavour of 'souvenir looting' and 'looting to replace destroyed or looted possessions'; now Sara Goodrich begins to cast light on what Elwood Tewksbury was up to when he sold 'loot' to Herbert and Harriet Squiers. This third form of missionary looting – 'looting to enable converts to survive' while justified in the press in the United States by returned missionaries such as Alice Fenn's husband, Courtenay, is best revealed through the activities of the British missionary Miss Georgina Smith.[46]

We meet post-siege Miss Smith first in George Morrison's diary and are rather taken aback – somehow what is revealed does not seem to fit either Miss Smith, or a dedicated missionary. On 27 August he wrote, 'Wonderful treasures in Miss Smith's.' On 5 September: 'Called on Miss Smith with the object of purchasing things but all things far too high in price.' On 11 September he noted with disgust, 'I have bought at Miss Smith's LMS a fur "the silver fox" for 18 tls which I find is German rabbit skin imported by Carolwitz.' 17 November: 'Saw Miss Smith and bought some curios.'

But then there are other Morrison entries about Miss Smith which vie with the selling of 'loot': 6 September: 'Miss Smith had arrested boxer who burned the mission and thrown two children into the flames. Sir Claude had him shot.

Squiers said our govt. won't permit anything of the sort.' 23 September: 'Miss Georgina Smith is our Boxer catcher. General Staff dreads the name of Miss Smith.' 8 October: 'Miss Smith has hunted down several boxers and had them executed. She has blackmailed a respectable Chinese who fed the Boxers Tls5000 to be devoted to the Mission. Money well spent.' 3 November:

> Miss Smith has been enacting punishment on her own account levying compensation contributions on villages where her Christians murdered. Chapels have been refurbished for her; public funeral given gentry themselves leading procession of great humiliation. Men guilty of complicity in murder have given best sites in the village and land for the mission and honoured graves.

17 November: 'In [Miss Smith's] quarters 2000 German soldiers and 30 officers are to be billeted. She has done much to help them.' 12 December: 'Called on

41 Georgina Smith
(courtesy of Council for World Mission)

Miss Smith – the "Extortioner" ... said Dr [Eliza] Leonard.' 19 December: 'Sir Ernest [Satow, new British Minister] is in favour of Miss Smith's view that the line should not be constructed to Tientsin.'

The picture of Miss Smith thus conveyed shows a woman both in charge and slightly out of control in a situation that was on many levels totally out of control. The American missionary Arthur Smith (no relation), in his thorough two-volume study *China in Convulsion* speaks highly of Georgina Smith's activities, but her own unpublished letters to the London Missionary Society headquarters of 8 September (supplemented in October and November) are more fascinating. Only the dozens of pages of difficult to decipher handwriting on dark, differently coloured paper, in a somewhat feverish style, betray the strain under which she was running a complex humanitarian operation.[47]

She had managed to bring through the siege and now, from 20 August, look after, 180 LMS converts – both from Peking and country stations. As she says, they left only six graves behind in the legation quarter. She had taken over a mansion rather than a palace, the owner of which was Mrs Sung, sister of the Duchess Kuang, sister-in-law of the Empress Dowager. Unfortunately, owing to the short-sightedness of her male colleagues in not putting up the British flag before she moved in, the servants had removed the bulk of their mistress's treasure but, fortunately, they had left behind much wearing apparel – furs and dresses – and lots of valuable china and curios.

When Miss Smith and her people first arrived, every shop in the quarter was closed and empty (looted) and the streets deserted – mainly because of the activities of the Russians which she has already described. The first thing she did was to get her converts comfortably housed in the neighbourhood by 'promising protection to the people who received them'. She then proceeded to offer protection to the shops and encourage them to renew their stock. She describes how she did this:

> I fought the Russian soldiers tooth and nail when we first came. I have a letter from the Russian general which General Gaselee procured for me ... in which he ... says I am to receive protection and my Christians. I cannot read this precious document, which is framed, but I wave it frantically in the face of the soldier I am bent on arresting. *He* can read it even less than I can but he looks solemnly at the Russian writing says 'Russe' in an awestruck voice, drops his loot and bolts. Sometimes he pulls some article such as soap etc out of his pocket and a dollar to prove to me he is not stealing from my shops but only browsing[?]. Everything is ... (Miss Smith's) in this neighbourhood now. The Chinese explain politely to the would-be Russian looter that the articles and shop and even the shop keeper are all [Miss Smith's] and not to be touched. The Russian, who of course doesn't understand a word he says, pokes him with his rifle and while he helps himself the troubled shopkeeper flies here and fetches me to the rescue. We have [made] a friend of two

soldiers, the Welsh Fusiliers, and they are extremely useful in a thousand ways.

There was much else to be done in the community and, to this end, Miss Smith divided her people into gangs, the men with a foreman, and the women, a forewoman – the women taking on sewing for 'various gentlemen in Peking'. She started a laundry too. There was a roll-call every morning and you had to have a good reason for not being there; after that there was a service, and then she was available for 'audiences'. The workers were paid at 4.30, as long as there were no complaints – each man and woman receiving 1000 (?) a day, and those with children an extra allowance. She explained how this worked:

> We had no money when we came here and the Hong Kong Bank could not supply me with any. I therefore decided on the following plan. I issue my own 'homemade' cheques to the Christians, which are only payable on the date of issue. These cheques can only be cashed at *one shop* which takes the cheque and gives copper cash in exchange which the Christians use to spend at the other shops. This shopman comes here every night and reckons the cheques with me, but as he is afraid of the Russian looters he prefers not receiving any silver! At present it costs just 300 taels a month to pay all our Christians. They receive absolutely nothing but this small sum they earn for food, coal etc. and any old clothes and ...[?] I can find to bestow. ... I have sold about 300 taels worth of furs which were here. I have also bought a lot of cash which the Russians were selling at the rate of one hundred[?] for one dollar!! But later they only sold 40 ...[?] for a dollar. I still made a good bargain with the dollars I sold! Then I bought 600 taels for 600 dollars from an officer in the B. Army. ... I gave this officer, Captain Whitcombe, a cheque on the Hong Kong Bank at Hong Kong as he said he had an a/c there and would not need to draw the money for some months. I should be much obliged if the Society would pay this sum into the Hong Kong Bank at Hong Kong for me. I have no money of my own in the bank here and have not received any for 3 months! There is none of the Society's and Mr Stonehouse is away, so I have really to manage to feed all these people by such contrivances as I have stated here. I now have money to go on with but I am anxious to buy a large quantity of wheat as I quite anticipate a particular famine later in the year.

Then Miss Smith justifies, at some length – detailing his crimes – the arrest (and subsequent execution) of the petty local official about whom Morrison wrote. To this she added, 'We have found many interesting proofs that this was a boxer place and we have also found Eluh-E-Yuan [her mission] property here too! So I feel quite justified in taking possession of their property for our *present* needs.' After this, she describes her out-of-town activities also touched upon by Morrison. 'I am treating them roughly,' she explains, 'because I think

they need a severe lesson. But I am going down to see General Gaselee and ask him to give them *time* as I know many of the Shi-pa-li-tuen folk had little real sympathy with the boxers.' She concluded her twenty-fourth page, 'I am *very glad* to be alive once more!'

By November, her converts numbered between two and three hundred and there were thirty girls in the school. What is more, the Russians had gone, to be replaced by the Germans who had arrived with Field Marshal von Waldersee appointed commander-in-chief of the Allied forces. She approved of the major in charge and explained in her letter how,

> I told him the people had been oppressed, looted and ill-treated by the Russians and how bitterly the neighbourhood had suffered in consequence and I assured him if he would forbid his men from going into any house on any pretense whatsoever I would undertake to see that all his places were provided with what was needed. He agreed and I then called upon some leading men here and laid my scheme before them. They entered into it with joy and great heartiness, got others to join and soon we had the *whole locality* at work producing whatever furniture was asked for free of cost.
>
> But I have arranged with the Major that all the furniture is to be returned to the owners when the troops leave. The consequence is four immense places have been furnished rapidly and with comparative ease as so many have been employed on the work. The Germans are exceedingly pleased and most grateful to us and the neighbourhood is at rest and beginning to revive. We, the Major and I, are now organising a much larger scheme, namely the better sanitation of this especial district.[48]

As a result of her contribution to the local community, she was presented with six pairs of gorgeous 'Myriad People Canopy' – as Arthur Smith explains, 'The highest popular honour in China. It is not often bestowed.'[49]

The locals and the troops were not Miss Smith's only contacts – she was a person to keep in with. 'A great many Chinese gentlemen leave their cards here', she wrote in October.[50] Among her frequent visitors was Prince Su whose palace had been used for the converts during the siege. He was now, apparently, a committed anti-Boxer and men such as him were useful in providing information.

In September, she had suddenly remembered that she was not completely alone; there was an important PS to her letter:

> Dr Saville is at present living here in the East [of the City]. It has been a great pleasure and help to have her here. She has taken her full share of the burden and also has had a dispensary daily for the converts. As she has hardly any drugs it is not very satisfactory work for a doctor. I regret to say for my sake that she leaves tomorrow for a much-needed and well-earned change. She is most unwilling to leave me alone but we have both decided it is the sensible

thing to do, for when she returns rested and strengthened I may perhaps go for a holiday and leave her to hold the fort. Dr Saville is in fairly good health considering the strain and hard work she had during the siege.[51]

In her October letter, Miss Smith wrote, 'I have been given *most remarkable* physical health. I am doing three persons' work without any apparent fatigue.'[52] Their colleague Thomas Biggin was also around – in the west of the City – running a resurrected boys' school. He wrote of Miss Smith on 24 September:

> Her work there [in the East] is the wonder and admiration of other societies here in Peking. She has gone about it in her own way, and obtained I think one may safely say the only really organised and efficient mission station in Peking, besides doing work of the greatest value to the Legation (and appreciated by them as such).[53]

Miss Smith was to marry Thomas Biggin in Shanghai in February 1903 (aged forty-five) and, thereafter, Mr and Mrs Biggin took charge of three country stations between Peking and T'ing-chou. She had been in China since 1884, he since 1899. As for Dr Lillie Saville, she was awarded the Royal Red Cross by the King and stayed in Peking until 1906 when she left because of serious ill health.[54] She severed links with the LMS in 1908 but returned to Tientsin for medical service under the Chinese government, dying there in 1911.

The Baroness Buries her Husband

When Ada Tours' husband was reported to have meningitis on 24 August, his was not the only case; Winterhalder tells us that his brother officer Baron Boyneburg had it too and that, as the siege hospital had been closed down, the patient found himself in the German Legation receiving the 'most careful attention' of Baroness von Ketteler and Frau von Rosthorn. For a few days all hope vanished but, fortunately, his youthful constitution – and presumably the care of the two women – pulled him through.[55] This is the only first-hand evidence I have found of Maud's nursing.

Such a demand on her capacity to give came at a particularly difficult time for the widow: however clear it was that her husband had been assassinated on 20 June, Maud apparently still hoped that when the siege was lifted she would find him alive (but imprisoned).[56] Polly Condit Smith almost brutally recounts how any such hopes were dashed when she writes on 18 August:

> Baron von Ketteler's body was accidentally discovered on the 16th by Russian troops who were passing near the Tsung-li Yamen, very near the spot where he had been murdered. The body had been thrown into an old wooden box and left. The polite communication which had been sent to Baroness von Ketteler during the semi-armistice days of the siege that her husband's body was lying in state at the Tsung-li Yamen was thus proved to be an utter

fabrication on their part. To-day his formal obsequies took place in the German Legation, the doyen of the Corps, the Spanish Minister, reading a short address, which was as well put as it was as hard for Baroness von Ketteler to hear. I did not go to the ceremony, however, for I felt as if I had attended more than enough to last me the rest of a long life.[57]

While accounts agree that the body was mercifully unmutilated, they differ about the number of bullet wounds, Morrison firmly announcing 'There was one bullet wound to the head, the wound described by Cordes.'[58] The British student interpreter, Hewlett, writes that it was 'riddled with bullets'.[59]

Savage Landor wrote of the ceremony, 'The poor Baroness broke down altogether. Seldom in my experience have I seen a more touching case of nervous collapse.'[60] A memorial service was held on 6 September on the spot where the German Minister had been shot, and Arthur Smith noted, 'The chair of the Baroness, in deep mourning, stood beside the coffin; the streets lined with interested European spectators, and with impassive Chinese, perhaps dimly wondering what it was all about.'[61]

Morrison who, in his diary, never evades his own or other people's lack of charity, wrote on 23 August: 'Von Below [German Chargé] said how sad and depressed he was – in need of a change after his experiences here especially now as he had the Baroness von Ketteler to sadden his house.' By 30 August, Maud was dining at the Squiers with Morrison who noted, 'She was very sad, talking all the time of her husband ...' It was then that she was prepared to talk about the role of her husband and others on 19–20 June. By 5 September she was obviously able to discuss with Morrison and William Pethick the possibility of being properly debriefed about those last days.

Morrison asked himself on 6 September when the Baroness was leaving and neither then nor later did he answer his question. On 7 September, von Ketteler's alleged murderer was captured – he was recognised because he tried to sell the Baron's watch to a Japanese who handed it in and the initials CK were recognised. Later that month, on the 26th, the man was brought face to face with Cordes and, according to Morrison, they recognised each other. The accused – scapegoat or assassin – was executed on 1 January 1901, the event, according to von Waldersee's journal, evoking little interest in passersby.[62]

But von Waldersee does not mention Maud von Ketteler once, perhaps partly because she had left Peking by the time he arrived. At a certain stage, about 3 September, Maud apparently cabled her father, 'Come to Yokohama for me.'[63] The appeal was answered by her brother Henry who, on 5 September, married his fiancée and incorporated Yokohama into their honeymoon. Maud's father, Henry B. Ledyard, the railway magnate, arranged for a train to take his son and new daughter-in-law to meet the *Empress of China* sailing for Japan on 10 September; the passenger list of the *Empress of Japan* sailing from Yokohama on

5 October contained the names Mr and Mrs Henry Ledyard and Baroness von Ketteler and maid – leaving us only with the supposition that Maud left Peking sometime between, say, 15 September and 1 October. Waldersee arrived in Tientsin on 27 September and stayed there until 14 October when he left for Peking.[64] Why are these details of timing important?

There is a long and well-established story, written about in poems, novels and non-fiction, that the Chinese courtesan Sai Chin-hua (Sai Jinhua) played a large part in Sino-German relations at this time, including being the mistress of von Waldersee, and having a crucial meeting with Maud von Ketteler.[65] I fear it may be, at least partly, a myth.

The Romance of Sai Chin-hua

The story is that Sai Chin-hua became a courtesan on the flower boats in Suchow when she was nearly thirteen (in 1886). There she met and became the concubine of the mandarin Hung-ch'un and with him she went on a diplomatic mission to Europe lasting three years (1887–90). During that time, she was not only presented to the Empress of Germany but, apparently, met, or had a liaison with, von Waldersee. Not long after their return to China, Hung-ch'un died and Sai Chin-hua became once more a courtesan, so much admired and in demand that she was acquainted even with such officials as Li Hung-chang.

During the worst days of the foreign depredations after the siege, so the story continues, a group of German soldiers broke into the house where Sai Chin-hua was sheltering. She realised their nationality, talked to them in German, and stopped them in their tracks. She explained her stay in Germany, it was reported to von Waldersee, he sent for her, recognised her, and installed her as his mistress in the Forbidden City. Through her relationship, she managed to stop German atrocities and destruction in Peking and create a climate where the citizens, at least in the German quarter, could live in peace and restart economic life which also benefited the Germans.

Meanwhile, negotiations were going on between the Allies and the Chinese under Li Hung-chang (who had carefully kept his head down during the siege of the legations) and Prince Ch'ing to secure a peace, including reparations from the Chinese government. The most obdurate of the Allies, not surprisingly, were the Germans and, among them, the influence of greatest intransigence was that of the widow of their Minister who demanded nothing less than the head of the Empress Dowager.

The arch-manipulator Li Hung-chang, knowing Sai Chin-hua's background and position, suggested through an intermediary that she call upon Baroness von Ketteler and, with her fluent German, talk her round. This she did, finally persuading the Baroness that, instead of either the Empress Dowager's head,

42 Sai Chin-hua (from *That Chinese Woman*)

or public humiliation for her or the Emperor, a grand memorial arch should be erected in honour of the assassinated Baron. That is how the story has been told.

Certainly Sai Chin-hua existed, a peace protocol was eventually signed (in September 1901), and a white marble memorial arch, with an explanatory inscription in Latin, German and Chinese, was erected in 1902 to von Ketteler on the site of his assassination. But, even if we accept that Sai Chin-hua's fluent German was the key to speaking to the American widow of the German Minister – a woman whose French was probably better than her German (her husband's English was entirely idiomatic) – Maud von Ketteler does not appear to have been still in Peking when the Chinese woman took up with the German Field Marshal.

Without wishing totally to debunk a brave and moving story, I cannot also help noticing that the details of Sai Chin-hua's improvements in German behaviour and the well-being of Peking's citizens bear a striking resemblance to the activities and results of Miss Georgina Smith!

Maud Ledyard von Ketteler's Hospital

As for Maud von Ketteler, she returned to Detroit and was based there until her father died in 1921. In 1901, she was summoned to Berlin to be appointed to the Imperial household. It is not clear that she took up such an appointment, even short term; she was still under medical supervision for a 'severe ... nervous malady' and travelled with a trained nurse.[66] She was certainly presented at Court and spent time with her mother-in-law in Munster, Westphalia.

Clemens von Ketteler's body had been returned on a German warship to his homeland and buried with pomp and honour in Munster. According to von Ketteler's manservant, Heinrich Biege, when Prince Ch'un, the Emperor's brother, called to offer the Chinese Government's apologies and condolences to the bereaved mother, she refused to see him, and announced to the manservant, 'If the Chinese have put a wreath on the grave of my son, kindly throw it out today.'[67]

Prince Ch'un, whose son was to become the last Emperor of China, may have made some effort to regain face when he was deputed, too, to perform the opening ceremony for the memorial arch, by 'performing his duty in so slipshod and careless a manner that [it] was robbed of all dignity and impressiveness'.[68] Lady Susan Townley, new at the British Legation, felt that his 'fulfilment of his penance turned out to be rather an added insult than an atonement for a crime'.

What is more, Dr Mariam Headland was to write, 'I have heard the Chinese refer to this arch as the monument erected by the Chinese Government in memory of the man who murdered Baron von Ketteler.'[69] And it was demolished and reconstructed elsewhere when the Republic of China joined the Allies against Germany in 1917.[70] Maud von Ketteler may well have read these accounts, and they will not have helped, whatever her role in the erection of the arch.

Maud remained a widow for sixty years. She divided her time between her family properties in the United States and Europe, and the Villa Gamberaia outside Florence – which belonged to the German Government.[71] In 1919, during the influenza epidemic that killed millions, she and some women friends set up the Cottage Hospital at Grosse Point, Michigan (where she had grown up on her father's summer estate, Cloverleigh); it is her memorial and perhaps owes its founding to the dedication displayed in the siege hospital.

Maud made another bequest in 1942 when the *Detroit Free Press* reported that the Maud Ledyard von Ketteler Collection recently given to the University of Michigan was to go on display. Interestingly, among *objets* from around the world, only 'two Chinese throne mats and a velvet hanging, eighteenth century' are itemised. Maud was not, perhaps a 'looter' but she was described as a

'fastidious and intelligent collector'.[72] She died on 30 November 1960, aged eighty-nine, at Falls Village, Connecticut.[73]

Aftershock and Annie Chamot

Perhaps only one couple were unashamed, acknowledged looters for personal gain. Although all the available evidence concerns Auguste Chamot, rather than Annie, as they did everything during the siege as a couple, and as she did not leave him out of moral scruple following their departure from Peking, it is reasonable to assume that they were partners in that endeavour too.

George Morrison sets the scene when he writes on 14 November, 'Met Chamot with tls128,000 going to the Russian Bank, profit, he said, secured by buying silver from the Bishop Favier and the French General [Frey].' Chamot later told his doctor about other activities – how he would see drunken soldiers or sailors leaving the imperial palaces with precious objects, an empresses's headpiece, golden or jade jewels, antique furniture and fans, ivory carvings. Outside the palace as they left, he would stop them saying, 'What are you carrying? You'll never manage to get that trinket back to Europe. It'll be stolen from you, or you'll lose it. I'll give you ten (or twenty) dollars, here, it's gold in your hand.'[74]

But by no means all the Chamots' new wealth came from loot or clever dealing. It is said that Chamot was decorated by Pope Leo XIII who also gave him 100,000 francs and a signed miniature of himself. He was knighted by the Mikado and given the French Legion of Honour, together with $US200,000 which the French government obtained for him as indemnity for the damage done to his hotel. The Italian government made him a Chevalier, and the grateful governments together gave him $US450,000 in cash. Again, this information excludes Annie, though it is known that she, too, received the Legion of Honour.

The Chamots left China, on a ship provided by the Russians, in 1902, to visit his relatives in Switzerland where he, at least, flaunted their new wealth (in tips and property for his family) and Annie won several medals for sharpshooting. In Paris, M. Pichon, then Minister for Foreign Affairs, entertained them to a banquet at the Quay d'Orsay attended by ambassadors. They returned to Peking to tidy up their affairs, then went to settle, in 1903, in Annie's home town of San Francisco. There they bought a mansion in Stockton Street and built another in the country, in Inverness (Marin County), beside Tomales Bay.

In Inverness they, Auguste at least, led the life to go with their wealth. Exhibited there was a $5000 dollar headpiece that had belonged to the Empress Dowager, and panels and an imperial screen that had belonged to the Ch'ienlung Emperor in the eighteenth century. They had two chefs, one for themselves and their guests, one for the animals in Auguste's menagerie

(pythons, monkeys, bears and panthers). The main reception room of the house could accommodate fifty armchairs in front of a podium big enough to take ten dancers. A case of champagne would be carried onto Auguste's sailing boat, and his neighbours would watch as, on his return, he failed safely to dock and had to be carried ashore. He regularly hired a train to take him gambling in Sausalito.

Annie does not appear in any of these memoirs – that may or may not be significant. But on 18 April 1906, she and Auguste awoke to find themselves on top of the kitchen range instead of in their bedroom above. In the great earthquake and fire, they lost nearly everything: the house in Inverness, the one in Stockton Street, Annie's San Francisco investment properties, their Chinese treasures – and Annie's brother, who was a frequent drinking guest at Inverness, had neglected the insurance.[75]

By 1907, they had rebuilt the house at Inverness, but apparently never lived there. The newer house still stands, in tree-shaded grounds, giving off a faint whiff of the past.[76] Auguste, gathering what treasures there were left, set off for New York to sell them. He realised $35,000 but, instead of returning to Annie, he met a manicurist in his Fifth Avenue hotel – Miss Betsy Dollar – and took up with her. When Annie came looking for him, she was introduced to his new friend who, coincidentally, was also travelling westwards to San Francisco. Eventually, Annie divined what was going on and divorced him in 1908.

Auguste's finances continued to decline and, living in poverty with Betsy, he developed tuberculosis. He married her on his deathbed in January 1910, aged forty-three.

Annie, who lived comfortably enough with her mother following her divorce, learnt how to drive, taking lessons from Gus Renstrom, a chauffeur. She married him in 1909; she was thirty-eight, he twenty-five. The article in the *San Francisco Call* announcing this event started:

> Annie Elizabeth McCarthy, the 'Angel of the Peking Legations' whose bravery during the Boxer rebellion won her the cross of the Legion of Honor from the French Republic and formerly the wife of August Chamot, created a sensation among her circle of friends yesterday ...[77]

Epilogue
Meeting the Empress Dowager (1902)

'On January seventh [1902] the Emperor, Empress Dowager, Empress and their court returned to their forsaken capital', wrote Mrs Conger, and added in her usual sanguine way, 'This was a wonderful day. The future will detect more in it than the present understands.'[1]

Sarah Conger had been ready to forgive and look to the future almost from the moment of the Relief; she wrote to a niece on 23 September:

> Some people feel very revengeful and cry out against showing mercy to the Chinese. They say, 'Burn every town and village!' This seems like an 'eye for an eye and a tooth for a tooth.' We should not sting ourselves with our own malice; we should pluck it out and cast it away. It is true, the cruelty of the Chinese toward the foreigners has been extreme, but the Chinese wish to be alone in their own land. When will this dark cloud scatter and let in the bright sunshine, so that we may see the outcome?[2]

She followed that up a week later:

> Poor China! Why cannot foreigners let her alone with her own? China has been wronged, and in her desperation she has striven as best she could to stop the inroads, and to blot out those already made. My sympathy is with China. A very unpopular thing to say, but it is an honest conviction, honestly uttered.[3]

Her generosity of spirit has, indeed, been much disparaged, particularly where the Empress Dowager is concerned, and it is easy enough to mock her and emphasise her naivety. But, as this story draws to its natural close, it is worth bearing in mind that the views expressed about both women may owe something to the fact that they were just that – women, and of a certain age. And it may even be possible to suggest that their gender was, indeed, a unifying factor, one that ultimately brought benefit rather than otherwise.

334

As for the Empress Dowager, she was ready to woo and be wooed. Even her arrival in Peking that day was an exercise in public relations. A special stand had been prepared for diplomats and, as Paula von Rosthorn noted, the Court stopped just before the gate below; Tz'u-hsi and the Emperor descended from their sedan chairs and entered a small temple to make the prescribed sacrifice. Then, before she stepped back into her chair, the returning exile 'looked up and waved to us Europeans in a friendly way'.[4] It was as if she really had just been away on a 'tour of inspection'.

A few days later, the Ministers presented their credentials, officially entering the Forbidden City – which many of them had entered eighteen months previously uninvited – for the first time by the front gate, and being received for the first time by the Empress Dowager.

Even before her return, Tz'u-hsi had expressed her wish to see the diplomatic wives as well. The new British Minister, Sir Ernest Satow, suggested to Lucy Ker, who had been acting as his hostess and redecorating the Legation, that she represent Britain; she demurred. When the invitation arrived, as on previous occasions, the unspecific language set the cat among the legation pigeons. Who exactly was invited? Should they be going anyway? Paula von Rosthorn tells us that male diplomats, who would be making the decisions, were worked on by their wives, and unmarried ones were invited to dinner to be influenced.

Arthur von Rosthorn disliked the Empress Dowager whom he considered cruel and reactionary; Paula's feelings were more ambivalent – she still harboured a certain respect and admiration; she certainly wanted to meet her. In any case, as Paula was to write to Fleming in 1960, 'I can assure you that we have felt the Chinese had been deeply wronged by the European powers.' In the end, Ministers' and First Secretaries' wives were invited, and their children. Lucy Ker, by accident or design, was away.

Among the accounts kept of the occasion are those of Sarah Conger – since Ethel MacDonald's departure doyenne of diplomatic wives – and Mary Bainbridge, her new number two, Paula von Rosthorn, and Lady Susan Townley whose husband had very recently arrived in the British Legation. George Morrison wrote of Lady Susan that she was 'A pattern of indiscretion and communicativeness, most charming.'[5] That is, she took pleasure in amusing the powerful and beguiling *Times* correspondent with gossip and a certain diplomatic outrageousness. She even entitled her memoirs *'Indiscretions' of Lady Susan*. But, in his diary a few months later, Morrison also called her 'The cold-blooded Lady Susan'.[6] We should not, therefore, be surprised that Susan Townley was to write:

Before the approach of the great day Mrs Conger ... called together in her capacity of 'Doyenne' all the ladies of the *corps diplomatique* who were privileged to attend the Imperial Audience, and put us through a sort of dress rehearsal of the ceremonial to be pursued. She was a funny old lady, a

Christian Scientist, spoken of as a possible successor to 'Mother Eddy', and great was her excitement at the prospect of the morrow. She made us all curtsy to her Chinese Majesty, and strongly recommended that we should all wear white embroidered under-petticoats, so that, in the event of our tripping over our feet in the performance of these curtsys, no undue display of stockinged leg should offend the susceptibilities of the surrounding Chinese dignatories![7]

Paula von Rosthorn, in her more private account, was no less amused by Sarah Conger. She described how, at this dress rehearsal, 'She sat down in a high-backed chair, played the Empress Dowager and demanded that each of us do a Court curtsy before her which met with outraged refusal by most.'[8]

On the day, 1 February, twelve women and six children set off in the customary picturesque cavalcade and a dust storm, and it was perhaps as well that they were wearing clean petticoats because the wife of the Portuguese Minister – Mme d'Almeida – was tipped out of her sedan chair, ripped her dress, and was herself scratched. This incident delayed proceedings and probably set up in Paula von Rosthorn a mild hysteria from which she failed to recover and which thus makes her account rather different in tone and content from that of Sarah Conger who, not surprisingly, took her position seriously.

Paula's first faux pas was to fail to notice the Emperor's outstretched hand, and thus to slight him, for the first time. Later, after numerous pourings of tea, she became anxious to dispose of the exquisite little cup. She gave it to the nearest young man and then watched horrified as a bevy of eunuchs rushed up and desperately kowtowed to the 'waiter' as they relieved him of his burden.

Perhaps the best example of different perceptions recorded by foreign women – leading one to question either their background informants or their own judgement – is that of the Emperor. The newcomer Lady Susan Townley, undoubtedly briefed by George Morrison, described how 'He sat there with his mouth open, and his glazed eyes had a fixed expression in them which I was afterwards told was due to his opium-sodden condition.'[9] Sarah Conger wrote to her daughter Laura, on the other hand: 'The Emperor was in the banquet hall at times, either sitting or standing. He is rather small, with a young, bright face; his eyes give expression to his smile. He did not impress me as being a frail person.'[10]

Whatever the position now of the Emperor, it was the Empress Dowager who was in charge, and she had made every effort to arrange things to please her foreign guests – care that was not necessarily appreciated, particularly the protecting of the snowy white table cloth with a garish waxed one, and the provision of napkins. After commenting on the cloth, Lady Susan wrote: 'To each of us also was given a napkin (evidently hailing from Manchester) of coarse cotton, mauve in colour and adorned with squares. Neither more nor less than a duster!'[11] While Paula von Rosthorn went further: 'Also napkins were

colourfully printed cotton. On mine was still stuck the label "Made in Germany" and when a woman wiped her mouth carelessly she had green and red blotches on her face.'[12] Sarah Conger wrote of a different aspect of the Audience, 'I never saw its equal in artistic beauty. The Chinese study the effect of color and the multiplied shades of color.'[13]

Paula von Rosthorn suggests that her first faux pas at least was 'probably noticed negatively by all my colleagues'.[14] But, in fact, Mrs Conger and Mrs Bainbridge fail to notice her presence at all in their accounts (and Susan Townley may not yet have known who was who). As Sarah Conger never mentions her once in her book of letters and diary about the siege and thereafter, one can assume that Paula had even earlier blotted her copybook. But the Empress Dowager noticed her, particularly because of her animated conversation in her 'coolie Chinese' with her neighbours at table.

Tz'u-hsi who, unprecedentedly, was eating with her guests, came up and offered her titbits: 'She pulled her own chopsticks through her lips to show me that they were clean and then personally put a few bites into my mouth with them.'[15] And, however non-existent Paula may be in some accounts, Dr Mariam Headland was to write of that occasion:

> The conversation ran upon various topics, and, among others, the Boxer troubles. One of the ladies wore a badge. The Empress Dowager noticing it, asked what it meant.
>
> 'Your Majesty,' was the reply, 'This was presented to me by my Emperor because I was wounded in the Boxer insurrection.'
>
> The Dowager Empress took the hands of this lady in both her own, and as the tears stood in her eyes, she said:
>
> 'I deeply regret all that occurred during those troublous times. The Boxers for a time overpowered the government, and even brought their guns in and placed them on the walls of the palace. Such things shall never occur again.'[16]

The questions of 'emotion', and what the Empress Dowager said about the summer of 1900, and what the diplomatic wives responded, were to form the crux of the matter when the audience came to be analysed diplomatically and politically. It is not clear if Dr Headland heard that conversation herself – she may have acted as interpreter – but Paula writes of it: 'She expressed her regrets about the Boxer uprising, assured me that everything that had happened was against her will and emphasised that she hoped we had not suffered damage through it. I had put on my Order ... which interested her greatly.'[17]

Paula may have kept the details of the exchange to herself; Sarah Conger's role was more public. In her formal speech – which it is fair to assume had been much discussed in advance within the American Legation, at least – she said:

> Your Majesty, the ladies of the Diplomatic Corps have responded with pleasure to your kind invitation for this audience; and we most heartily

congratulate you and all the Imperial Court that the unfortunate situation which led you to abandon your beautiful capital has been so happily resolved, and that you are now permitted to return to it in freedom and peace. Your safe return to Peking and to this undestroyed palace will furnish pages to future history little comprehended at this time.

The events of the past two years must be painful to you as they are to the rest of the world; but the sting of the sad experience may be eliminated, and we sincerely hope that it will be, through the establishment of better, franker, more trustful, and friendlier relations between China and the peoples of the earth. The world is moving forward. The tide of progress cannot be stayed, and it is to be hoped that China will join the great sisterhood of nations in the grand march. May all the nations, united, manifest forbearance, respect, and good will, moving on to the mutual good of all. ...[18]

What perhaps Mrs Conger did not notice, but which seemed clear to Paula von Rosthorn, was that the Empress Dowager was bored by her long speech, not helped by the nervousness of the interpreter who had to get out a primer. Eventually, she told one of the princes to tell the interpreter to stop.[19]

Mrs Conger describes what happened at the more informal part of the audience:

The Empress Dowager was there and as we entered she asked for 'Kang Tai Tai' – my Chinese name – and I was presented to her. She took my hands in both of hers, and her feelings overcame her. When she was able to control her voice, she said, 'I regret, and grieve over the late troubles. It was a grave mistake, and China will hereafter be a friend to foreigners. No such affair will again happen. China will protect the foreigner, and we hope to be friends in the future.'

'We believe that you are sincere,' I replied. 'By knowing each other better we believe we shall become friends.'

The Empress Dowager then asked if there were any other ladies present who were in the siege. Mrs Bainbridge of the American Legation and Mme Saussine of the French Legation were presented. She again turned to me, extending both hands, and took mine with a few uninterpreted Chinese words. And then taking from one of her fingers a heavy, carved golden ring set with an elegant pearl, she placed it upon one of mine; then from her wrists she took choice bracelets and placed them upon my wrists. To each lady she presented gifts of great value.[20]

Who was it who talked to George Morrison so that the *The Times* published on 3 February:

The audience granted to the ladies of the legations at the Palace today was the most revolutionary event which has occurred since the Court's return ...

The ladies then retired to the ante-room and the Dowager Empress entering grasped Mrs Conger's hand for some minutes. Trembling, weeping and sobbing loudly she exclaimed in broken sentences that the attack on the legations was a terrible mistake of which she repented bitterly. Mrs Conger replied that the past would be forgotten.[21]

Mrs Conger was to take exception to Morrison's story. In May that year, Dr Maud Mackey acted as an intermediary between her and an American woman journalist who had had to leave Peking without being able to interview her; in reponse, Sarah Conger wrote to Maud Mackey with a list of answers among which was point (b):

> The Empress Dowager did not weep upon my neck. After a dignified ceremony in the throne building, we were invited to a reception room. Her Majesty asked for Mrs Conger and I was escorted to her. She took both my hands in hers and said with emotion that she deeply regretted the terrible troubles and our great suffering during the siege. She said that it was a great mistake, and that it should never happen again. She declared that foreigners should henceforth be protected in China. There was nothing said by either of us about forgiving and forgetting.[22]

Be that as it may, there is a paragraph in Mrs Bainbridge's unpublished diary which reads:

> Mrs Conger stepped forward and the Empress Dowager took both her hands in her own, saying, 'Kang Tai Tai' and with tears streaming down her thin cheeks, she led her to the other side of the room that she might look into her face and, through her interpreter, tell how very sorry she was for all the trouble and sorrow she (Mrs Conger) had passed through and so on.[23]

The reaction by others to the Audience of the diplomatic women was summed up in a letter which J.O.P. Bland, joint-author of the now discredited *China Under the Dowager Empress*, wrote to Morrison from Shanghai on 12 February:

> I can't say I would go as far as you do in the matter of letting byegones be byegones. *Moderate durant* is a good saying, and there is a happy medium to be found, I think, between vindictiveness and adulation. To me the taking of gifts by the Legation women was as undignified as it was unnecessary. There is no doubt whatever to the DE's complicity in the Boxer business, and however well that business may have turned out for our interests and for the ultimate good (?) of China, there could be no harm in *all* the powers letting her see by a 'more in sorrow than in anger' attitude that the fact is remembered and that only her future good behaviour can obliterate the memory. That is my feeling.
>
> The address which Mrs Conger incongruously read strikes on the mind like a cold douche of imbecile fatuity. There was no reason why the women

should not go to the reception, but there was every reason why they should have there comported themselves as the representatives of that civilisation which the Chinese Court and Govt so lately flouted and bombarded! The Diplomatic Body, however, is not exactly where one expects to find either united action or common sense, and the fact that they are nearly all new and ignorant persons (as far as Chinese affairs are concerned) goes far to explain matters. But there is no excuse for Mother Conger[24]

By the time of the next reception of the diplomatic women, as soon as the end of February, word had been received in the Forbidden City that presents were not appropriate, but the Empress Dowager still managed, with a theatricality which showed that she knew what she was doing, to present Mrs Conger with a carved jade object.[25] And whatever the commentators said, Mrs Conger was, over the coming years, to be received many times in Audience by the Empress Dowager, and to initiate a series of regular interchanges whereby groups of imperial princesses would attend luncheons at the American Legation; and she would visit them and the wives and families of officials. After the first of the lunches, her servant Wang remarked, 'Might stay hundred year, never see like this.'[26]

Not to be outdone, the initially unimpressed Lady Susan Townley was also, according to her, to enter upon unusually familiar relations with the Empress Dowager, including woman to woman talks seated cross-legged opposite each other on a k'ang.[27] And there is no doubt that a certain rivalry existed between legations concerning the intimacy of their women with the imperial palace.[28]

It would be a mistake to think that the Empress Dowager did not know exactly what she was doing, and sometimes this openness with foreign women palled; her lady-in-waiting Der Ling, who came to court in 1903 and whose father's house had been destroyed by the Boxers, offers some useful asides. One concerns the anti-footbinding campaigner Alicia Little who apparently turned up at a spring garden party

> dressed in a heavy tweed travelling costume, having enormous pockets into which she thrust her hands as though she were extremely cold. She wore a cap of the same material. Her Majesty asked if I had noticed this lady with the clothes made out of 'rice bags', and wasn't it rather unusual to be presented at Court in such a dress. Her Majesty wanted to know who she was and where she came from. ... Her Majesty said that whoever she was she certainly was not accustomed to moving in decent society as she (Her Majesty) was quite certain that it was not the thing to appear at a European Court in such a costume. 'I can tell in a moment,' Her Majesty added, 'whether any of these people are desirous of showing proper respect to me, or whether they consider that I am not entitled to it. These foreigners seem to have the idea that the Chinese are ignorant and that therefore they need not be so particular as in European Society.'[29]

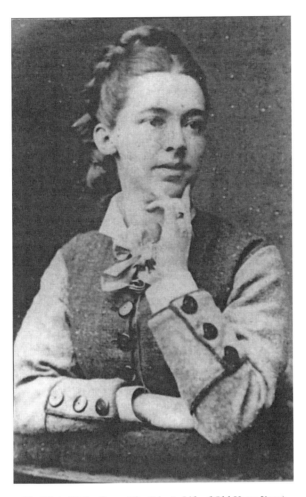

43 Alicia Little (from *The Private Life of Old Hong Kong*)

Tz'u-hsi then issued instructions:

> I think it would be best to let it be understood for the future what dress
> should be worn at different Court Functions, and at the same time use a
> certain amount of discretion in issuing invitations. In that way I can also
> keep the missionary element out, as well as other undesirables. I like to meet
> any distinguished foreigners who may be visiting in China, but I do not want
> any common people at my Court.

Mrs Conger sometimes used missionary women as interpreters, which the
Empress Dowager did not care for, but American Dr Mariam Headland, who

often facilitated her contacts, sums up her achievement and gives a clue about the main reason for her success:

> Who can doubt that the warm friendship which the Empress Dowager conceived for Mrs Conger ... who did more than any other person ever did, or ever can do, towards the opening up of the Chinese court to the people of the West, was because of her appreciation of the fact that Mrs Conger was anxious to show the Empress the honour due to her position.[30]

And Katherine Carl, an American portraitist whom Mrs Conger organised to paint the Empress Dowager, and who lived in the palace for some time in 1904, noted, 'Mrs Conger, by her own individual initiative, has done much to bring about a friendly social feeling between the Chinese and foreign ladies.'[31]

There was, of course, another side to the story for, as anti-Tz'u-hsi commentator, British Alicia Little, was to write,

> The American Minister's wife speaks of 'my friend the Empress Dowager' or 'Her Majesty'. But at each fresh foreign visit to the Old Buddha ... Chinese Christian women weep and protest bitterly, thinking of their murdered relations, whom they esteem *martyrs*.[32]

Tz'u-hsi also complained in private about the lectures she endured, not only from importunate foreign women but also from Chinese women who had lived abroad. But the fact also remains that, as a result of this new openness, a breath of fresh air wafted through the hitherto enclosed imperial palaces, resulting in the setting up, for example, of educational institutions for girls and an edict, in 1902, banning the binding of young girls' feet. Mrs Little may have been dismissed by the petite and elegant Empress Dowager for her frumpishness, and even kept from the presence, and she may herself have bitterly criticised Old Buddha, but she won some sort of victory, at least.[33]

As for Tz'u-hsi, her reputation remained tarnished long after her death in 1908; for all her Western 'friendships', contrived or spontaneous, and public relations initiatives, the sympathetic accounts of Western women made no impact on the Western historical record. George Morrison unflatteringly linked the American Minister's wife and the Empress Dowager when he wrote in 1903 of 'Mrs Conger who is a Christian Scientist on terms of considerable intimacy with that infernal old harridan'.[34]

That remark and the record can partly be explained by a comment in the entry for Tz'u-hsi in the 1998 *Biographical Dictionary of Chinese Women*: 'Much of the hatred she engendered ... was clearly due to her having transgressed the unwritten law that women must not rule but must stay within the boudoir quarters. Empress Dowager Cixi [Tz'u-hsi] braved the world of men, both Chinese and foreign ...'[35]

As for Sarah Conger, she would have been the first to agree that, more important than her own reputation, or that of the Empress Dowager, was China's relations with the rest of the world and they were, more than previously, now fit to be built on. Or, as Mrs Conger would have expressed it, 'The future will detect more in it than the present understands.'[36]

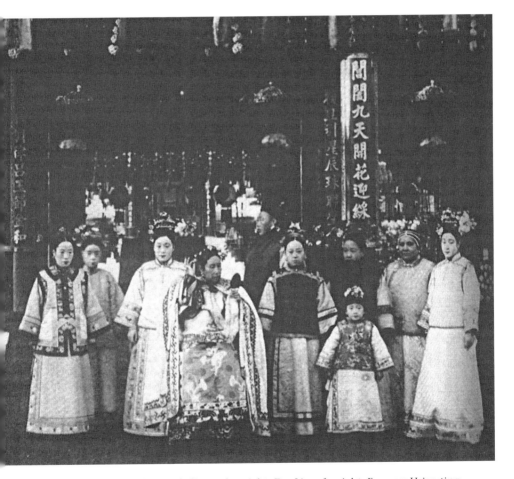

44 Tz'u-hsi and Court ladies; to her right, Der Ling; far right, Empress Hsiao-ting
(courtesy of United Church Board of World Ministries)

Notes

Where unpublished material is in typescript and has an identifying page number, this has been included here in a note; but where there is only an identifying date, which is already clear from the text (with the manuscript in the bibliography), a note would be superfluous. This applies particularly to the diaries of Mary Bainbridge, Charlotte Brent, Luella Miner, George Morrison, Annie Myers, Ada Tours and some LMS letters.

Prologue

1. Sarah Pike Conger, *Letters from China* (1909), p. 39.
2. Eliza Ruhamah Scidmore, *China the Long-Lived Empire* (1900), p. 136. Diplomatic relations were forced upon China at the end of the Second Opium War, following the invasion of Peking by the foreign powers.
3. Tours Cuttings. An undated newspaper account of Lady MacDonald suggests that the Minister's wife was the originator of the idea and that she worked through Prince Henry of Prussia who was received by the Empress Dowager earlier that year; Sir Claude MacDonald's dispatch of 20 December confirms that Tz'u-hsi expressed her willingness to the Prince. Diplomats had received a New Year audience with the Emperor since 1895. Conger, *Letters from China*, p. 369.
4. John King Fairbank et al., *The I.G. in Peking* (1975), Hart to Campbell, 4 December 1898, letter 1124, vol. II.
5. Ethel MacDonald, 'My visits to the Dowager-Empress of China' (1901), p. 247.
6. FO/17/1337, no.250, 20 December 1898, Sir Claude MacDonald to Lord Salisbury, f262.
7. Conger, *Letters from China*, p. 40.
8. Earlier foreign accounts suggest that the Empress Dowager was all-powerful. But for one later secondary account she always had a 'ceremonial position' – 'power' remaining 'exclusively a privilege of the princes, grandees and high mandarins' who continually jockeyed for it. Sterling Seagrave, *Dragon Lady* (1993), p. 209.
9. MacDonald, 'My visits to the Dowager-Empress ...', p. 249.
10. FO17/1337 f266 (included in Sir Claude's dispatch).
11. MacDonald, 'My visits to the Dowager-Empress', p. 251.
12. MacDonald, 'My visits to the Dowager-Empress', p. 252.
13. Conger, *Letters from China*, p. 41.
14. MacDonald, 'My visits to the Dowager-Empress', p. 253.
15. MacDonald, 'My visits to the Dowager-Empress', p. 247.
16. Conger, *Letters from China*, p. 42.
17. Conger, *Letters from China*, p. 43.

Chapter 1

1. Conger, *Letters from China*, p. 23.
2. E.G. Ruoff, *Death Throes of a Dynasty* (1990), p. 34.
3. This account cannot attempt to unravel the intricacies of Chinese Court history; it can only suggest a background to the events that were later to affect its mainly foreign protagonists. Where appropriate, I have drawn on women's accounts.

4. Seagrave, *Dragon Lady*, p. 173; Conger, *Letters from China*, p. 42.
5. Maud von Ketteler, unpublished 'Account of Meeting the Dowager Empress of China', nd, p. 5. Katherine Carl, Tz'u-hsi's American portraitist, wrote of Hsiao-ting in c.1904, 'Her face shines with so sweet an expression, criticism is disarmed and she seems beautiful.'
6. MacDonald, 'My visits to the Dowager-Empress ...', p. 250.
7. J.O.P Bland and E. Backhouse, *China Under the Empress Dowager* (1910), p. 209. This book has been criticised, and the primary source that underpins some of it discredited, by Hugh Trevor-Roper in *A Hidden Life: The Enigma of Sir Edmund Backhouse* (1976). It has, however, much influenced accounts that followed it and muddied the waters perhaps beyond clarification. I have sometimes used it to make such points. See also notes 3, 9 and 22.
8. Mrs Archibald Little, *Intimate China* (1899), p. 415. Alicia Little was not an admirer of the Empress Dowager, but was of K'ang Yu-wei. See Chapter 2, note 40.
9. Der Ling, *Old Buddha* (1928), pp. 202–3. See note 7 above. Trevor-Roper writes, 'There were so many bogus Chinese memoirs in circulation. ... There were the memoirs of the bogus "princess" Der Ling ...' (p. 96). But Bessie Ewing, who was in Peking for the siege, and in 1905, wrote concerning a fellow missionary at a social occasion then, 'The Dowager Empress did not appear herself, but of her ladies-in-waiting whom do you suppose sat next to Mrs Ament? None other than Princess Der Ling a devoted friend and companion to the Dowager Empress' (Ruoff, *Death Throes of a Dynasty*, pp. 147–8). In her autobiography, *Kowtow* (c. 1930), Der Ling asserts that she received from Tz'u-hsi 'the rank and title of princess' (p. 312), and that she kept it until 'the fall of the Dynasty' (p. 316). The *Biographical Dictionary of Chinese Women* (1998) accepts the status of Der Ling (Yu Deling), though it does describe *Old Buddha* (not *Two Years in the Forbidden City* – Der Ling's memoirs) as 'a fictionalised dramatization of the entire life of the Empress Dowager' (pp. 263–6). That same source says that Der Ling 'denied to the Empress Dowager her Catholic faith'. Sue Fawn Chung suggests in *The Much Maligned Dowager Empress* (1975) that Der Ling's later books drew on Backhouse (p. 20). Chung's doctoral thesis and article seek to provide a corrective to much anti-Tz'u-hsi wrtiting.
10. Daniele Varè, *The Last of the Empresses* (1936), p. 161. K'ang Yu-wei was given sanctuary in Hong Kong in the home of Clara Ho Tung – see 'Ho Tung, Clara (Lady)' in Susanna Hoe, *Chinese Footprints* (1996), p. 240.
11. Cyril Pearl, *Morrison of Peking* (1967), p. 90.
12. *Blue Book* (1899), no. 358, Sir Claude MacDonald to Lord Salisbury, 15 October 1898.
13. Conger, *Letters from China*, p. 26.
14. Claude MacDonald 'Some Personal Reminiscences of the Siege' (1914), p. 2. For a full account of 1841, see Susanna Hoe and Derek Roebuck, *The Taking of Hong Kong* (1999).
15. Little, *Intimate China*, pp. 411–12.
16. Isaac Taylor Headland, *Court Life in China* (1909), pp. 155–6. This account is ostensibly by Professor Headland (of Peking University) but he says in the preface that it is to his wife (doctor to the imperial princesses) that he is 'indebted for much of the information contained in [his] book' p. 1; first-hand observations are often obvious. The Headlands were in the USA during the siege. Her name is unusual; I have seen it printed as Marian but Courtenay Fenn, who knew her well as Dr Sinclair, clearly calls her Mariam.
17. Scidmore, *China the Long-Lived Empire*, p. 139.
18. MacDonald, 'My visits to the Dowager-Empress ...' p. 254.
19. MacDonald, 'My visits to the Dowager-Empress ...', p. 252.

20. F017/1337, no. 250, 20 December 1898, Sir Claude MacDonald to Lord Salisbury, f265.
21. Lo Huimin, *The Correspondence of G.E. Morrison 1895–1912* (1976), vol. II, pp. 106–7.
22. *The Times*, 16 December 1898, p. 9, col. 3–4. George Morrison was not above contriving such details, often with the help of Edmund Backhouse who was later to be discredited; see note 7.
23. Lo, *The Correspondence of G.E. Morrison*, vol. II, no. 67 from Charles Beresford to George Morrison, 7 May 1901.
24. Conger, *Letters from China*, p. 24.
25. *Blue Book* (1899), no. 344, Sir Claude MacDonald to Lord Salisbury, 1 October 1898.
26. Mario Valli, *Gli Avvenimenti in Cina* (1905), p. 186.
27. Conger, *Letters from China*, p. 25.
28. Marina Warner, *The Dragon Empress* (1972), p. 217, quoting Commandant Hartfeld *Opinions Chinoises sur les Barbares d'Occident* pp. 234–6.
29. Mrs Archibald Little, *In the Land of the Blue Gown* (1902), p. 159.
30. Little, *Intimate China*, pp. 170–1.
31. Conger, *Letters from China*, 3 June 1899, p. 68.
32. F.S.G. Piggott, 'Ethel MacDonald'(1931–41). This extract from the obituary comes from the memory of C.A.W. (Archibald) Rose.
33. Lady Blake, unpublished 'A Journey to China, Corea and Japan' (1900), p. 85.
34. Little, *In the Land of the Blue Gown*, p. 1. Alicia Little was living in Shanghai at the time of the siege.
35. Ruoff, *Death Throes of a Dynasty*, p. 35.
36. Although Sarah Conger writes of meeting Li Hung-chang's wife, the woman known as Lady Li died in 1892 and, therefore, she probably met a secondary wife.
37. Conger, *Letters from China*, p. 35.
38. Conger, *Letters from China*, p. 34.
39. Conger, *Letters from China*, p. 45.

Chapter 2

1. Emma Martin, unpublished diary, 15 May 1900, p. 29.
2. Martin, unpublished letter, 18 May 1900.
3. Martin, unpublished diary, 16 May, p. 31.
4. Martin, unpublished diary, 18 May, pp. 31–2.
5. Martin, unpublished diary, 20 May, p. 33.
6. Martin, unpublished diary, 26 May, p. 34.
7. Martin, unpublished diary, 26 May, p. 35.
8. Jessie Ransome, letter in *Land of Sinim*, 26 May 1900, p. 30. At some points, her work, and that of her colleagues, was funded by the Society for the Propagation of the Gospel (now United SPG), a voluntary agency of the Church of England.
9. Mary Hooker, *Behind the Scenes in Peking* (1910) 27 May 1900, p. 3.
10. Fleming Correspondence, letter from Mrs Philip Hoge, 19 February 1960.
11. Hooker, *Behind the Scenes in Peking*, p. 4.
12. Hooker, *Behind the Scenes in Peking*, p. 6.
13. Hooker, *Behind the Scenes in Peking*, p. 7.
14. Hooker, *Behind the Scenes in Peking*, p. 8.
15. Seagrave, in *Dragon Lady*, questions Morrison's reporting on several subjects, including his three siege articles in *The Times*, October 1900.
16. George Morrison, unpublished diary, 17 May 1900.
17. Morrison, unpublished diary, 22 May 1900; Fleming Correspondence, letter from Samuel Duff McCoy, 5 July 1959; his sister Bessie described Polly as 'beautiful'. Mrs Hoge in her letter talks of her 'natural beauty'.

18. Lillie Saville, *Siege Life in Peking* (c.1900), p. 2.
19. Saville, *Siege Life in Peking*, p. 3.
20. Saville, *Siege Life in Peking*, p. 4.
21. *Land of Sinim*, Frances Scott, letter of 28 May, p. 31.
22. *Land of Sinim*, Edith Ransome, letter of 29 May, p. 31.
23. Roland Allen, *The Siege of the Peking Legations* (1901), p. 27.
24. *Land of Sinim*, Marian Lambert, letter of 29 May, p. 32.
25. *Land of Sinim*, Edith Ransome, letter of 29 May, p. 31.
26. LMS, Georgina Smith, unpublished letter, 25 and 28 May 1900, folder B2.
27. MacDonald, 'Some Personal Reminiscences', p. 3.
28. MacDonald, 'Some Personal Reminiscences', p. 4.
29. Von Ketteler, unpublished 'Account of Meeting the Dowager Empress of China', p. 4.
30. MacDonald, 'My Visits to the Dowager-Empress of China', p. 254.
31. Von Ketteler, unpublished 'Account of Meeting the Dowager Empress of China', p. 5; MacDonald, 'My Visits to the Dowager-Empress of China', p. 253.
32. MacDonald, 'My Visits to the Dowager-Empress of China' p. 254.
33. MacDonald, 'My Visits to the Dowager-Empress of China', pp. 254–5.
34. Mrs A.H. Mateer, *Siege Days* (1903), p. 27.
35. Mateer, *Siege Days*, p. 29.
36. Theodora Inglis, unpublished 'Siege Diary 1900', p. 2.
37. W.A.P Martin, *The Siege in Peking* (1972), p. 59.
38. Princess Der Ling, *Two Years in the Forbidden City* (1929), p. 357.
39. Blake, unpublished 'A Journey in China, Corea and Japan', pp. 80–1.
40. Little, *In the Land of the Blue Gown*, p. 319. See note 33 of Epilogue. Alicia Little was a supporter of K'ang Yu-wei who, in 1898, memorialised the Throne for a prohibition on footbinding and in support of the Anti-Footbinding Society founded by her. See Chapter 1, note 8.
41. Jonathan Spence, *The Search for Modern China* (1990), p. 232.
42. Piggott, 'Ethel MacDonald', p. iv. Student interpreter W.E. Townsend describes her as 'most awfully nice' – *In Memoriam* (1901), p. 39.
43. Charlotte Brent quoted in *Japan Herald*, 23 October 1900.
44. E.g., Morrison, unpublished diary, 8 April and 15 May 1900.
45. Morrison, unpublished diary, 1 May 1900.
46. Morrison, unpublished diary, 23 April, 29 April, 1900. A third child had died in infancy.
47. Weale, *Indiscreet Letters from Peking*, p. 45.
48. MacDonald, 'Some Personal Reminiscences', p. 7.
49. E.g., Arthur H. Smith, *China in Convulsion* (1972), vol. I, p. 309; Brent, 'The Siege of Peking'; Robert Hart, *These from the Land of Sinim* (1903), p. 27; Nigel Oliphant, *A Diary of the Siege of the Legations* (1901), p. 106.
50. Millie Robbins, 'Millie's Column', 13 March 1960.
51. P. Campiche, 'Notes sur la Carrière d'Auguste Chamot' (1955), pp. 26–7.
52. Mateer, *Siege Days*, p. 35.

Chapter 3

1. Conger, *Letters from China*, p. 19.
2. Oliphant, *A Diary of the Siege of the Legations in Peking*, pp. 1–2.
3. Weale, *Indiscreet Letters from Peking*, p. 18.
4. Hooker, *Behind the Scenes in Peking*, p. 14.

5. It would be invidious not to exclude Paul A. Cohen from this criticism of neglect; indeed, the bibliography of *History in Three Keys* (1997) has been invaluable for locating American missionary women's manuscripts. But he is not telling the women's story (although alert to relevant women's issues). Just as this manuscript was going to press, Diana Preston published *Besieged at Peking* (1999); she has used some women's accounts and not ignored what they experienced, but she is concerned to tell a broad story.

6. Many contemporary accounts tend to reflect prejudices; later ones also follow agendas, as, often, do those who deconstruct them. My own position is suggested in the preface. See also Chapter 4, note 4 and, for example, impressions of 13 June and Annie Myers' comments.

7. Allen, *The Siege of the Peking Legations*, p. 49.

8. MacDonald, 'Some Personal Reminiscences', p. 8.

9. Hooker, *Behind the Scenes in Peking*, p. 15.

10. Conger, *Letters from China*, p. 92.

11. Eugène Darcy, *La Défense de la Légation de France à Pékin* (1901), p. 12.

12. A.D. Brent, in 'The Siege of Peking', says this is an exaggeration.

13. MacDonald, 'Some Personal Reminiscences', p. 8.

14. Weale, *Indiscreet Letters from Peking*, p. 22.

15. Darcy, *La Défense de la Légation*, p. 26.

16. Jessie Ransome, *The Story of the Siege Hospital in Peking* (1901), p. 34.

17. After the lifting of the siege, these pawn shops were ransacked by everyone, Chinese and foreign alike, as Putnam Weale describes.

18. Conger, *Letters from China*, p. 93.

19. *Land of Sinim*, Frances Scott, letter of 3 June, p. 35.

20. Ransome, *The Story of the Siege Hospital*, p. 35.

21. Annie Myers, unpublished 'The Siege of Peking', 2 and 3 June, and Smith, *China in Convulsion*, vol. II, p. 575.

22. Smith, *China in Convulsion*, vol. I, p. 211.

23. Hooker, *Behind the Scenes in Peking*, p. 16.

24. Martin, unpublished diary, 4 June, p. 38.

25. Conger, *Letters from China*, p. 95.

26. Martin, unpublished diary, 5 June, pp. 39–49.

27. Fenn Cuttings, *San Francisco Chronicle*, 2 October 1900.

28. Cecile Payen, 'Besieged in Peking' (1901), p. 455.

29. Hooker, *Behind the Scenes in Peking*, p. 17.

30. Arthur Brent, unpublished 'My Life Story', p. 23.

31. Hooker, *Behind the Scenes in Peking*, p. 18.

32. Hooker, *Behind the Scenes in Peking*, p. 20.

33. Peter Fleming, *The Siege at Peking* (1959), p. 129.

34. Sara Goodrich, unpublished 'Journal of 1900', p. 2.

35. Jane Hunter, 'Luella Miner' (1999).

36. Ruoff, *Death Throes of a Dynasty*, p. 73.

37. Goodrich, unpublished 'Journal of 1900', p. 8.

38. Conger, *Letters from China*, p. 95.

39. Goodrich, unpublished 'Journal of 1900', p. 8.

40. Goodrich, unpublished 'Journal of 1900', pp. 8–9.

41. Jane Hunter, *The Gospel of Gentility* (1984), p. 283, note 2.

42. Martin, unpublished diary, 8 June, p. 41.

43. Mateer, *Siege Days*, p. 68. Most sources suggest there were 20 Congregational school-girls, but Ada Haven, who should know, says quite clearly on p. 66 of *Siege Days* that

there were 'some thirty', but she does also say, 80–90 Methodist schoolgirls (p. 69), whereas Charlotte Jewell, their principal, says 100 (and 20 Congregational) (p. 349).

44. Luella Miner, *China's Book of Martyrs* (1903), pp. 47–8. She says 20 Congregational schoolgirls – see note above.
45. Theodora Inglis, unpublished 'Siege Diary 1900' p. 13.
46. Inglis, unpublished 'Siege Diary 1900', p. 14.
47. Inglis, unpublished 'Siege Diary 1900', p. 15.
48. Inglis, unpublished 'Siege Diary 1900', p. 17.
49. Inglis, unpublished 'Siege Diary 1900', p. 21.
50. Ruoff, *Death Throes of a Dynasty*, p. 74.
51. Saville, *Siege Life in Peking*, p. 7.
52. Martin, unpublished diary, p. 43.
53. Goodrich, unpublished 'Journal of 1900', p. 9.
54. Inglis, unpublished 'Siege Diary 1900', p. 25.
55. LMS, Lillie Saville, unpublished letter, 9 September 1900, folder 3D; quotations that follow, unless otherwise stated, come from this letter.
56. LMS, Howard Smith, unpublished letter, 29 August 1900, folder 3B.
57. Ruoff, *Death Throes of a Dynasty*, p. 76.
58. Conger, *Letters from China*, p. 96.
59. LMS, Georgina Smith, unpublished letter, 18 June 1900, folder C2.

Chapter 4

1. Conger, *Letters from China*, p. 97.
2. Ransome, *The Story of the Siege Hospital* p. 46.
3. Oliphant, *A Diary of the Siege of the Legations*, p. 6. Captain F.G. Poole, staying with his doctor brother to learn Chinese, was even less restrained, first calling Robert Hart an 'old footlar' then adding that he was 'rushing around frightening our [British Legation] ladies ... what an old woman [he] is'. – unpublished diary, 9 June.
4. Lucy Ker tells how not only the Bredon women turned up but also Lauru (later Juliet's husband) and Putnam Weale (according to Morrison, Lily Bredon's lover). Claude MacDonald packed the two men back to the Customs compound to do their duty which, Lucy suggests, accounts for the poor figure the British Minister cuts, by way of revenge, in *Indiscreet Letters from Peking*. Lucy Ker's later autobiography and contemporary letters are in the possession of her granddaughter, Kate Ker, who is preparing them for publication. I met Kate, by chance, just as I had finished this manuscript, after a ten-year search for Lucy's account. I thank her for allowing me to read the autobiography and to use it to clarify some points, but fuller details of the content must await her publication.
5. Townsend, *In Memoriam*, 10 June. On 11 June he wrote, 'Oh, what a glorious time we're having!' He was to be badly wounded, recover, then, sent to Japan to recuperate, to die of typhoid in September.
6. Ransome, *The Story of the Siege Hospital*, pp. 46–7.
7. Tours, unpublished diary, 9 June. Annie Myers called it a 'towering temper'.
8. Allen, *The Siege of the Peking Legations*, p. 70.
9. George Morrison, *The Times*, 13 October 1900, p. 6. General Tung Fu-hsiang and his men had been responsible for the anti-foreign incidents in Peking in the autumn of 1898.
10. Ransome, *Story of the Siege Hospital*, p. 47.
11. *Land of Sinim*, Edith Ransome, letter of 11 June, p. 43.

12. Ransome, *The Story of the Siege Hospital*, pp. 49–50. While Jessie Ransome gives these details of her party, her colleague Roland Allen at this time, and post-siege, speaks of 'Chinese women'; perhaps Jessie continued to maintain a subterfuge because she had been given preferential treatment for her converts.
13. LMS, Joseph Stonehouse, unpublished letter, 25 July 1900, folder D2.
14. Saville, *Siege Life in Peking*, p. 8.
15. Conger, *Letters from China*, p. 97.
16. Morrison, *The Times*, 13 October; the diary entry for 9 June of Paul Henry in the Pei-t'ang (Bazin p. 201) suggests that the Ministers went to see Prince Ch'ing and received this impression which had the same effect on them.
17. W. Meyrick Hewlett, *The Siege of the Peking Legations* (1900), p. 2; Leslie R.Marchant, *The Siege of the Peking Legations* (1970), p. 109.
18. Ransome, *The Story of the Siege Hospital*, p. 51.
19. Conger, *Letters from China*, p. 98.
20. Hooker, *Behind the Scenes in Peking*, p. 22.
21. Conger, *Letters from China*, pp. 98–9.
22. Ransome, *Story of the Siege Hospital*, p. 51.
23. *Land of Sinim*, Edith Ransome, letter of ll June, p. 43.
24. Hewlett, *The Siege of the Peking Legations*, p. 2.
25. Conger, *Letters from China*, p. 100.
26. René Bazin, *L'Enseigne de Vaisseau Paul Henry* (1905), Henry's diary, 12 June, p. 202.
27. *Land of Sinim*, Bishop George Scott, letter of 13 June, p. 46.
28. Saville, *Siege Life in Peking*, p. 8.
29. Mateer, *Siege Days*, contribution by LaRhue Mateer, p. 71. Her husband John had died on 23 April, and she was, thus, in the American Legation at this time, rather than the Methodist Mission. It was learned formally on 3 September (previously rumoured – see Inglis, unpublished 'Siege Diary 1900', p. 29) that the cemetery where he was buried had been destroyed, and the bodies desecrated on 12 June. She is not to be confused with Ada Haven, later Mrs Calvin Mateer, editor of the book to which she contributed.
30. Mateer, *Siege Days*, Bessie McCoy, p. 85.
31. Mateer, *Siege Days*, p. 85.
32. Mateer, *Siege Days*, p. 77.
33. Mateer, *Siege Days*, p. 78.
34. Inglis, unpublished 'Siege Diary 1900', p. 26.
35. Martin, unpublished diary, pp. 43–4.
36. Martin, unpublished diary, p. 42.
37. Inglis, unpublished 'Siege Diary 1900', p. 26.
38. Mateer, *Siege Days*, p. 80.
39. Mateer, *Siege Days*, p. 82.
40. Inglis, unpublished 'Siege Diary 1900', pp. 32–3.
41. Ruoff, *Death Throes of a Dynasty*, p. 77.
42. Ruoff does not understand Martha's status but Jane Hunter in *The Gospel of Gentility* suggests that Bessie had adopted her (p. 192), and the passage that follows supports that.
43. Ruoff, *Death Throes of a Dynasty*, p. 77.
44. Mateer, *Siege Days*, p. 82.
45. A.H. Tuttle, *Mary Porter Gamewell* (1907), p. 199.
46. Tuttle, *Mary Porter Gamewell*, p. 200.
47. Mateer, *Siege Days*, p. 81.
48. Martin, unpublished letter, 19 June.

49. Tuttle, *Mary Porter Gamewell*, p. 200.
50. Inglis, unpublished 'Siege Diary 1900', p. 25.
51. LMS, Georgina Smith, unpublished letter, 18 June, folder C2.
52. Martin, unpublished diary, pp. 44–5.
53. Ruoff, *Death Throes of a Dynasty*, p. 78.
54. Tuttle, *Mary Porter Gamewell*, pp. 203–4.
55. Tuttle, *Mary Porter Gamewell*, p. 205.
56. Martin, unpublished diary, p. 44.
57. Those details come from Inglis, unpublished 'Siege Diary 1900', p. 35; details vary slightly in other accounts.

Chapter 5

1. Hooker, *Behind the Scenes in Peking*, pp. 24–5.
2. S.M. Russell, *The Story of the Siege in Peking* (1901), p. 7.
3. Anon, 'The Siege of Peking' (1900) – 'An Englishman's Diary' (A.D. Brent?) p. 4. Dr Velde also says that there was a woman there, though he does not mention her being bound (p. 161).
4. Ransome, *The Story of the Siege Hospital*, p. 55.
5. Allen, *The Siege of the Peking Legations*, p. 78.
6. Oliphant, *A Diary of the Siege of the Legations*, p. 10.
7. Myers, unpublished 'The Siege of Peking', 16 June.
8. Mrs W.E. Bainbridge, unpublished diary 'A Siege in Peking of the Legations', 14 June, 10am.
9. Payen, 'Besieged in Peking', p. 455.
10. Robert Coltman, *Beleaguered in Peking* (1901), p. 65.
11. Payen, 'Besieged in Peking', p. 455.
12. Blake, unpublished 'A Journey in China ...', p. 89.
13. Egbert Kieser, *Als China Erwachte* (1984), p. 40.
14. Von Ketteler, unpublished 'Account of Meeting the Dowager Empress of China' pp. 1–2.
15. Ledyard Papers, Maud von Ketteler, unpublished letter from Peking to her future sister-in-law, Maude Hendrie, 7 March 1900.
16. Hooker, *Behind the Scenes in Peking*, p. 25.
17. Ransome, *The Story of the Siege Hospital*, p. 55.
18. Darcy, *La Défense de la Légation*, p. 36.
19. Darcy, *La Défense de la Légation*, p. 38.
20. Weale, *Indiscreet Letters from Peking*, p. 60.
21. Oliphant, *A Diary of the Siege of the Legations*, is clear about that – he went to see it with Houston on 14 June, p. 11 – but it was certainly destroyed at some stage; Smith, *China in Convulsion*, vol. 1, p. 238; and Houston's son, in a letter in Fleming Correspondence of 18 February 1958, tells the story of their destroyed house.
22. Anon, 'An Englishman's Diary', p. 4
23. Morrison, *The Times*, 13 October 1900, col. 3.
24. Oliphant, *A Diary of the Siege of the Legations*, p. 10.
25. Morrison said that it was telegraph wires that were cut, 13 October, col. 3; both men were present on that occasion. Certainly there was an 'electric light plant' there – Mateer, *Siege Days* p. 87.
26. Hooker, *Behind the Scenes in Peking*, p. 24.
27. Hewlett, for example, writes, p. 4, *Diary of the Siege of the Legations*, 'The Austrians used their Maxim on the Boxers, and tried to save a woman, who was burnt by

torches put on her body.' De Courcy of the Customs, who recounted his story to the journalist George Lynch, noted: 'We found the remains of an old woman, burnt to death with joss sticks, but riddled with our bullets!' *The War of the Civilizations*, p. 124.
28. Ransome, *The Story of the Siege Hospital*, p. 56.
29. Weale, *Indiscreet Letters from Peking*, p. 61.
30. Weale, *Indiscreet Letters from Peking*, p. 64.
31. Saville, *Siege Life in Peking*, p. 8.
32. Saville, *Siege Life in Peking*, pp. 9–10.
33. Goodrich, unpublished 'Journal of 1900', p. 13.
34. Martin, unpublished diary, p. 45.
35. Miner, *China's Book of Martyrs*, p. 49.
36. Martin, unpublished diary, p. 46.
37. Inglis, unpublished 'Siege Diary 1900', pp. 38–9.
38. Inglis, unpublished 'Siege Diary 1900', p. 40.
39. Ruoff, *Death Throes of a Dynasty*, pp. 77–8.
40. Miner, *China's Book of Martyrs*, p. 61.
41. Mateer, *Siege Days*, Mrs Ed Lowry, p. 90.
42. Russell, *The Story of the Siege in Peking*, p. 14.
43. W.E. Bainbridge, unpublished 'Besieged in Peking', p. 16.
44. Anon, 'An Englishman's Diary', p. 4.
45. Weale, *Indiscreet Letters from Peking*, p. 80.
46. Martin, unpublished diary, p. 48.
47. Russell, *The Story of the Siege in Peking*, p. 8.
48. Hewlett, *Diary of the Siege of the Legations*, p. 7.
49. Ransome, *The Story of the Siege Hospital*, p. 59.
50. Bainbridge, unpublished 'A Siege in Peking'; she says 14 June.
51. Coltman, *Beleaguered in Peking*, pp. 57–8.
52. Hooker, *Behind the Scenes in Peking*, p. 31.
53. Hooker, *Behind the Scenes in Peking*, pp. 31–3.
54. Hooker, *Behind the Scenes in Peking*, pp. 38–9.
55. Payen, 'Besieged in Peking', p. 455.
56. Paul A. Cohen *History in Three Keys* (1997), pp. 193–4, quoting Tang Yan, a visitor to Peking.
57. Martin, *The Siege in Peking*, pp. 98–9.
58. Henry Savage Landor, *China and the Allies* (1901), vol. II, p. 47.
59. Hewlett, *Diary of the Siege of the Legations*, p. 7.
60. Martin, *The Siege in Peking*, pp. 62–3.
61. Joseph W. Esherick, *The Origins of the Boxer Uprising*, (1987), p. 297.
62. F. Laur, *Le Siège de Pékin* (1904), p. 295.
63. Allen, *The Siege of the Peking Legations*, p. 60.
64. Smith, *China in Convulsion*, vol. II, p. 663
65. Cohen, *History in Three Keys*, p. 39. But Cohen says that the evidence is undependable.
66. Purcell, *The Boxer Uprising*, p. 235, and Ono Kazuko *Chinese Women in a Century of Revolution* (1978), p. 49. Kazuko also mentions the Blue Lanterns (middle-aged women) and the Black Lanterns (elderly women), p. 49, and tells the story of Lotus Huang of Tientsin, pp. 51–2. The attacks on her purity (so important for Red Lantern magic) may have been contrived – Cohen pp. 143–4.
67. Esherick, *The Origins of the Boxer Uprising*, p. 298.

68. Cohen, *History in Three Keys*, p. 293. This is his conclusion, in spite of the 1950s testimony (perhaps party-line-influenced) of Zhao Qing that she joined 'partly as an act of rebelliousness against her parents,' p. 343, n. 110.
69. Kazuko, *Chinese Women in a Century of Revolution*, p. 49; Ida Pruitt, *A Daughter of Han* (1967), p. 152.
70. Weale, *Indiscreet Letters from Peking*, pp. 71–2.
71. Hooker, *Behind the Scenes in Peking* p. 41.
72. It has been difficult to establish satisfactorily details of this family – accounts are inconsistent: W.A.P. Martin, p. 99; Michael Hunt, pp. 511–12; Hart, *These from the Land of Sinim*, p. 26; Fairbank, Hart Letters, 273, 1003; Wu Yung, p. 45; Lucy Ker.
73. Ransome, *The Story of the Siege Hospital*, pp. 60–1.
74. Cecile Payen, quoted in 'The Homecoming of Baroness von Ketteler' (not sufficiently dated) in Ledyard papers. The entry is not in Payen's 'Besieged in Peking'.
75. Mateer, *Siege Days*, p. 87.
76. Mateer, *Siege Days*, Mrs Tewksbury, 16 June, p. 94.
77. Mateer, *Siege Days*, p. 87.
78. Inglis, unpublished 'Siege Diary 1900', p. 39.
79. Bland, *China Under the Dowager Empress* p. 263; said to be from the diary of Ching Shan, claimed to have been found by co-author Backhouse. See Chapter 1, note 7.
80. Headland, *Court Life in China*, pp. 161–2.
81. As Tz'u-hsi loved theatricals, the Boxer troupe would appeal to her on that level as well as on those of superstition and realpolitik.
82. Der Ling, *Two Years in the Forbidden City*, p. 361.
83. Seagrave, *Dragon Lady*, p. 325, suggests that it was in Li Hung-chang's interests to provoke an Allied attack.
84. Hart, *These from the Land of Sinim*, p. 21.
85. Mateer, *Siege Days*, Mrs Tewksbury, 18 June, pp. 96–7.
86. Seagrave, *Dragon Lady*, p. 324; Apparently Morrison discussed this privately with Sir Henry Blake; see Lady Blake's letter to Morrison 7 December 1900, and page 113 here. Juliet Bredon, in an otherwise over-generalised article, 'A Lady in Besieged Peking' (1901), talks of two men being taken on 13 June and adds matter-of-factly – 'They were shot' (p. 453).
87. Laur, *Le Siège de Pékin* p. 288. This is the same informant as note 62.
88. Seagrave, *Dragon Lady*, p. 325, quoting *Blue Book*.

Chapter 6

1. Mateer, *Siege Days*, Mrs Tewksbury, 18 June, p. 97.
2. Martin, unpublished diary, p. 49.
3. MacDonald, 'Some Personal Reminiscences', p. 11.
4. MacDonald, 'My Visits to the Dowager-Empress of China', pp. 253–4.
5. Von Ketteler, unpublished 'Account of Meeting the Dowager Empress of China', p. 5.
6. MacDonald, 'My Visits to the Dowager-Empress of China', pp. 253–4.
7. MacDonald, 'Some Personal Reminiscences', p. 11.
8. Conger, *Letters from China*, pp. 106–7.
9. Martin, unpublished diary, p. 50.
10. Saville, 'Siege Life in Peking', p. 9.
11. Ransome, *The Story of the Siege Hospital*, pp. 63–4.
12. Allen, *The Siege of the Peking Legations*, p. 100.

13. Conger, *Letters from China*, p. 108. The following countries had representatives then in Peking: Austria-Hungary, Belgium, Britain, France, Holland, Germany, Italy, Japan, Russia, Spain, United States.
14. *Japan Herald Mail*, Yokohama, 4 October 1900.
15. George Morrison, in his retrospective *Times* article of 13 October writes, 'On the morning of June 19, Mr Cordes, the Chinese Secretary of the German legation, was at the Yamen, when the Secretaries told him that the allied fleets had taken the Taku forts on June 17.' The anonymous and also retrospective account of an English gentleman (which I have attributed to A.D. Brent) makes a link with Charlotte Brent's interview when he writes, 'Native report says that the Taku forts have been taken by the French, and an ultimatum has been received by the Foreign Ministers from the Tsungli Yamen declaring that on account of the forts being taken war is now declared.' If a 'native report' and Tsungli gossip in the morning were not believed – because how could they be true? – it is not surprising that the translation Sarah Conger records of the 4pm ultimatum is ambiguous.
16. Ransome, *The Story of the Siege Hospital*, p. 62.
17. *Land of Sinim*, Frances Scott, letter of p. 47.
18. Saville, *Siege Life in Peking*, p. 19.
19. Ransome, *The Story of the Siege Hospital*, pp. 64–5.
20. Lucy Ker, unpublished 'Lest We Forget', p. 184.
21. Anon, 'Experiences of ... a Lady', p. 18. By a process of elimination, I had attributed this article to Annie Myers before her unpublished diary was found. Authorship is confirmed now by internal evidence; see chapter 9, note 16.
22. Conger, *Letters from China*, p. 108.
23. Allen, *The Siege of the Peking Legations*, p. 102.
24. Hooker, *Behind the Scenes in Peking*, pp. 44–5.
25. Darcy, *La Défense de la Légation* , p. 55.
26. Weale, *Indiscreet Letters from Peking*, p. 84. See pp. 310–11 for Hsu T'ung's end.
27. Darcy, *La Défense de la Légation*, p. 53.
28. Shiba Gorou, *Peking roujou nikki* (1965), p. 152.
29. Weale, *Indiscreet Letters from Peking*, p. 89.
30. Weale, *Indiscreet Letters from Peking*, p. 99.
31. Goodrich, unpublished 'Journal of 1900', 19 June, p. 20.
32. Inglis, unpublished 'Siege Diary 1900', p. 54.
33. Hooker, *Behind the Scenes in Peking*, p. 45. Putnam Weale says that von Ketteler had earlier requested an 11am meeting about quite other matters.
34. Morrison, unpublished diary, 20 August 1900.
35. MacDonald, 'Some Personal Reminiscences', p. 12.
36. Gerd Kaminski and Else Unterrieder, *Ware Ich Chinese, so Ware Ich Boxer* (1989), p. 63.
37. MacDonald to Bertie, Foreign Office, 4 September, quoted in Fleming, *The Siege at Peking*, p. 106.
38. MacDonald, 'Some Personal Reminiscences', p. 13.
39. Morrison, unpublished diary, 30 August 1900; 5 September.
40. See bibliography, unpublished works, von Ketteler, Ledyard Papers and Archives Munster.
41. Weale, *Indiscreet Letters from Peking*, p. 99.
42. Morrison, unpublished diary, 30 August.
43. Weale, *Indiscreet Letters from Peking*, p. 100.
44. Morrison, *The Times*, 13 October, col. 5, quoting from Cordes's statement to him.
45. Miner, *China's Book of Martyrs*, p. 51.
46. Inglis, unpublished 'Siege Diary 1900', p. 55.

47. Martin, unpublished diary, p. 51.
48. Goodrich, unpublished 'Journal of 1900', 19 June, p. 20.
49. Inglis, unpublished 'Siege Diary of 1900', p. 58.
50. Morrison, *The Times*, 13 October, col. 6.
51. Hooker, *Behind the Scenes in Peking*, pp. 46–7.
52. Inglis, unpublished 'Siege Diary 1900', p. 58.
53. Conger, *Letters from China*, p. 109.
54. Payen, 'Besieged in Peking,' p. 456.
55. Conger, *Letters from Peking*, p. 109.
56. Landor, *China and the Allies*, vol. II, p.50.
57. Conger, *Letters from Peking*, p. 60.
58. Saville, *Siege Life in Peking*, p. 11.
59. Morrison, unpublished diary 20 June, f409.
60. Morrison, *The Times*, 13 October, col. 6.
61. Ledyard Papers.
62. Lo, *The Correspondence of G.E. Morrison*, vol. I, p. 153.
63. Myers, unpublished 'The Siege of Peking', 20 June.
64. Russell, *The Story of the Siege in Peking*, 20 June, p. 10.
65. Biege, unpublished transcript, p. 4.
66. Archives Munster, obituary of Baroness von Ketteler, 9 March 1961, and notice of her death, 11 March 1961. Unfortunately, most of the articles in this collection are neither dated nor sourced. The material quoted from would have been inaccessible to me without the generous translation help of Miss Irma Steinitz.
67. Archives Munster, obituary of Baroness von Ketteler, 9 March 1961. This obituary is more about the Baron than the Baroness.
68. Tuttle, *Mary Porter Gamewell*, p. 237.
69. Von Ketteler, unpublished 'Account of Meeting the Dowager Empress of China', p. 8.

Chapter 7

1. Martin, unpublished diary, p. 52.
2. Conger, *Letters from China*, p. 109.
3. Ruoff, *Death Throes of a Dynasty*, pp. 82–3.
4. Inglis, unpublished 'Siege Diary 1900', p. 59.
5. Martin, unpublished diary, p. 52.
6. Ruoff, *Death Throes of a Dynasty*, p. 83.
7. Inglis, unpublished 'Siege Diary 1900', p. 60.
8. Miner, *China's Book of Martyrs*, pp. 52–3.
9. Martin, unpublished diary, p. 52.
10. Tuttle, *Mary Porter Gamewell*, p. 214.
11. Mrs Bryson, *Cross and Crown* (1904), p. 92.
12. Mateer, *Siege Days*, pp. 181–2.
13. Miner, *China's Book of Martyrs*, p. 54.
14. Saville, *Siege Life in Peking*, pp. 13–14.
15. Inglis, unpublished 'Siege Diary 1900', p. 61.
16. Goodrich, unpublished 'Journal of 1900', p. 21.
17. Hooker, *Behind the Scenes in Peking* pp. 49–50.
18. Lady MacDonald, 'Besieged in Pekin' (1901), p. 247.
19. Inglis, unpublished 'Siege Diary 1900', p. 66.

20. Martin, unpublished diary, p. 44. Emma Martin wrote Miss Terril (who was also besieged), but she obviously means Dr Terry.
21. Goodrich, unpublished 'Journal of 1900', p. 22.
22. Ransome, *The Story of the Siege Hospital*, p. 66.
23. Inglis, unpublished 'Siege Diary 1900', pp. 63–4.
24. Ransome, *The Story of the Siege Hospital*, pp. 66–7.
25. Hooker, *Behind the Scenes in Peking*, p. 50.
26. See also p. 229 and p. 257.
27. Conger, *Letters from Peking*, p. 109.
28. Ruoff, *Death Throes of a Dynasty*, p. 85.
29. Martin, unpublished diary, p. 53.
30. Coltman, *Beleaguered in Peking*, p. 210.
31. Robert Hart, 'The Peking Legations' (1900), p. 15.
32. Ransome, *The Story of the Siege Hospital*, pp. 67–8.
33. Darcy, *La Défense de la Légation*, pp. 59–60.
34. For example, Allen, *The Siege of the Legations*, p. 112.
35. Coltman, *Beleaguered in Peking*, p. 211.
36. MacDonald, 'Some Personal Reminiscences', p. 16.
37. General H.N. Frey, *Français et Alliés au Pechili* (1904), p. 281.
38. Fleming Correspondence, letter from Paula von Rosthorn to Peter Fleming, 24 November 1960.
39. Kaminski, *Ware ich Chinese*, p. 60. This book, and thus the von Rosthorns' own story, would have been inaccessible to me without the generous and highly competent translation help of Yongmi Schibel. The unpublished 'Memoirs' are in the archives of the Boltzman Institute, Vienna.
40. Fairbank, *The I.G. In Peking*, Hart to Campbell, November 1883, letter 445, vol. I.
41. Kaminski, *Ware ich Chinese*, p. 10. Matthaeus Rosthorn left Preston in Lancashire for Austria and was created 'Edler von Rosthorn' in 1790. Arthur was descended from his second wife, Mary Morton, and Paula from his third, Elisabeth See.
42. Biographical information is from Anna Farthing whose father was the brother of Karl Pinschoff, husband of Paula's niece Susanne Leitmaier (daughter of Helene Pichler).
43. Kaminski, *Ware ich Chinese*, pp. 51–2.
44. Kaminski, *Ware ich Chinese*, p. 46.
45. Isaac Headland, 'Heroes of the Peking Siege' (1901), pp. 577–8. According to a family genealogical table, Paula had no children. She may never have been pregnant. There is no clue to a miscarriage and her behaviour during the siege does not suggest pregnancy. Although the Headlands were absent, both were doctors so one cannot dismiss the claim out of hand. See also Chapter 16, note 34.
46. Kaminski, *Ware ich Chinese*, p. 64.
47. Morrison, unpublished diary, 26 July.
48. Kaminski, *Ware ich Chinese*, p. 64.
49. Miner, *China's Book of Martyrs*, p. 56.
50. Mateer, *Siege Days*, p. 189. See Chapter 4, note 29 for distinction between Mrs Calvin Mateer (Ada Haven), and Mrs John Mateer.
51. Saville, *Siege Life in Peking*, p. 14.
52. Inglis, unpublished 'Siege Diary 1900', p. 65.
53. Lo, *Correspondence of G.E. Morrison*, Timothy Richards to Morrison, from Shanghai, 27 October 1901.
54. Martin, unpublished diary, p. 54.
55. Mateer, *Siege Days*, p. 129.

56. Tuttle, *Mary Porter Gamewell*, p. 235.
57. Martin, unpublished diary, p. 54.
58. Inglis, unpublished 'Siege Diary 1900', pp. 66–7.
59. I cannot claim complete accuracy for the distribution of nationalities.
60. Mateer, *Siege Days*, pp. 271–2.
61. Hooker, *Behind the Scenes in Peking*, pp. 53–4.
62. Bainbridge, unpublished 'A Siege in Peking', 20 July; Mrs Goodrich gives the date as the 5th which seems to fit better.
63. Tuttle, *Mary Porter Gamewell*, p. 236.
64. Hooker, *Behind the Scenes in Peking*, p. 59.
65. Hooker, *Behind the Scenes in Peking*, p. 52.
66. Ransome, *The Story of the Siege Hospital*, p. 68.
67. Ransome, *The Story of the Siege Hospital*, p. 70.
68. Payen, 'Besieged in Peking', 12 July, p. 462.

Chapter 8

1. Goodrich, unpublished 'Journal of 1900', 21 June, p. 23.
2. Ransome, *The Story of the Siege Hospital*, p. 7.
3. Martin, unpublished diary, p. 57.
4. Lillie Saville 'The Siege of Peking' (1901), p. 1.
5. Saville, 'The Siege of Peking', p. 2.
6. Martin, unpublished diary, p. 57.
7. Saville, 'The Siege of Peking', pp. 2–3.
8. Martin, unpublished diary, 24 June, p. 58.
9. Saville, 'The Siege of Peking', p. 2.
10. Ransome, *The Story of the Siege Hospital*, pp. 10–11.
11. Hooker, *Behind the Scenes in Peking*, p. 143. According to American missionary accounts, Mme de Giers' son Constantine also helped in the hospital. Lieutenant Winterhalder notes that Mlle de Giers did too. Morrison wrote on 4 July, 'M de Giers is a divorcé married to a divorcée. His first wife treated their daughter with the utmost cruelty, battering her head out of shape, thence derives her present ugliness.' Lucy Ker noted that Mlle de Giers was a 'demoiselle d'honneur' at the Russian Court but in Peking 'She is not attractive or popular.'
12. Mateer, *Siege Days*, pp. 241–2.
13. Saville, 'The Siege of Peking', p. 2.
14. Ransome, *The Story of the Siege Hospital*, p. 13.
15. Mateer, *Siege Days*, p. 279.
16. Ransome, *The Story of the Siege Hospital*, p. 13.
17. Saville, 'The Siege of Peking', p. 2.
18. Ransome, *The Story of the Siege Hospital*, p. 17,
19. Saville, 'The Siege of Peking', p. 1.
20. Quoted in Fleming, *The Siege at Peking*, p. 152. Dr Poole's diary was available to Fleming through the widow of his brother, Captain F.G. Poole, who was also at the siege and also kept a diary. The second diary, at least, was later lodged with the British Library, but they apparently have no record even of its receipt. After my manuscript was completed, I saw it on microfilm at the National Army Museum, but not the doctor's.
21. Hooker, *Behind the Scenes in Peking*, 25 June, p. 74.
22. Kaminski, *Ware ich Chinese*, p. 65.

23. Don Lochbiler, 'Maude and the Empress Dowager' (1973). The only resemblance between Maud von Ketteler and Natasha Ivanova (in *55 Days in Peking*) is their title. There is more resemblance to Mme de Giers who was Russian and worked indefatigably in the hospital, and Mme Pokotilova who possibly had a 'past'. However, see page 327 for one example of Maud nursing in the German Legation after the siege. Lochbiler, like several writers, erroneously adds an 'e' to her first name.

24. Mateer, *Siege Days*, p. 282 (Ada Haven); Conger, *Letters from China*, letter of 15 July to her sister, pp.120–1.

25. Martin, unpublished diary, 25 June, p. 61.

26. Tuttle, *Mary Porter Gamewell*, p. 252.

27. Ruoff, *Death Throes of a Dynasty*, p. 90.

28. Mateer, *Siege Days*, p. 177. Some of the American women missionaries who kept unpublished diaries, such as Theodora Inglis, also wrote separate pieces for publication in Ada Haven Mateer's book.

29. Mateer, *Siege Days*, pp. 176–9.

30. Payen, 'Besieged in Peking', 25 June, pp. 457–8.

31. Mateer, *Siege Days* (Ada Haven), p. 282.

32. MacDonald, 'Besieged in Pekin', p. 252. Perhaps some rolls were then or later used but Annie Myers wrote in her diary on 3 August, 'This morning Miss Armstrong came into our room with her arms full of rolls of silk, which she said the Emperor of Corea had given Lady MacDonald on her visit there, and which they were going to cut into sandbags. Daisy and I both exclaimed at the idea of cutting them and suggested that they should be kept for the very last thing, so she took the curtains from our room instead. Daisy met her shortly afterwards in the Hall when she said Lady MacDonald gave them to be divided between [us] as we had thought so much of them.' This may be a touching example of the public face and the private reality; Lady MacDonald was obviously glad to have some way of thanking the two, particulary Daisy who had taken the burden of catering from her.

33. Inglis, unpublished 'Siege Diary 1900', pp. 80–1.

34. Christein, Heidi 'A Detroit Baroness in Peking' (1997), p. 15.

35. Conger, *Letters from China*, p. 124.

36. Hooker, *Behind the Scenes in Peking*, p. 62.

37. Bainbridge, unpublished 'A Siege in Peking', 1 July.

38. Mateer, *Siege Days*, p. 151.

39. Goodrich, unpublished 'Journal of 1900', pp. 22–3.

40. Ruoff, *Death Throes of a Dynasty*, pp. 88–9.

41. Tuttle, *Mary Porter Gamewell*, p. 244.

42. Tuttle, *Mary Porter Gamewell*, p. 232.

43. Tours Cuttings.

44. Hooker, *Behind the Scenes in Peking*, 29 June, p. 85.

45. Anon (an English 'Lady'), p. 19.

46. MacDonald, 'Besieged in Pekin', p. 250.

47. Hooker, *Behind the Scenes in Peking*, 29 June, p. 86.

48. Darcy, *La Défense de la Légation*, p. 58.

49. Theodor Winterhalder, *Kampfe in China* (1902), p. 227. While my husband, Derek Roebuck, ascertained which passages merited copying, Miss Steinitz's translations made more complete sense.

50. Winterhalder, *Kampfe in China*, p. 228.

51. Hooker, *Behind the Scenes in Peking*, p. 115.

52. Mateer, *Siege Days*, p. 280.

53. Martin, *The Siege in Peking*, p. 98.

54. Inglis, unpublished 'Siege Diary 1900', p. 92.
55. Coltman, *Beleaguered in Peking*, p. 220.
56. Anon (an English 'Lady'), p. 18.
57. Mateer, *Siege Days*, p. 175.
58. Ruoff, *Death Throes of a Dynasty*, p. 175.
59. Mateer, *Siege Days*, p. 174.
60. Hooker, *Behind the Scenes at Peking*, p. 79.
61. Fleming Correspondence, letter of 19 February 1960 from Mrs Philip Hoge, née Anderson; story probably told to her by Captain Myers.
62. Hooker, *Behind the Scenes in Peking*, 21 June, pp. 55–6.
63. Mateer, *Siege Days*, p. 182.
64. Marchant, *The Siege of the Peking Legations*, p. 121.
65. Mateer, *Siege Days*, p. 180.
66. Tuttle, *Mary Porter Gamewell*, p. 244.

Chapter 9

1. Kaminski, *Ware ich Chinese*, p. 66.
2. Kaminski, *Ware ich Chinese*, p. 51.
3. Morrison, *The Times*, 15 October, p. 3, col. 2.
4. Weale, *Indiscreet Letters from Peking*, p. 121.
5. MacDonald, 'Some Personal Reminiscences', p. 19.
6. Martin, unpublished diary, pp. 55–6.
7. Inglis, unpublished 'Siege Diary 1900', p. 69.
8. Ada Tours does not tell this story; Annie Myers does, unpublished 'The Siege of Peking', 7 July.
9. Ransome, *The Story of the Siege Hospital*, pp. 70–1.
10. Lucy Ker, unpublished letter of 8 October, 'Mrs Cockburn had a little daughter two weeks after we left [3 September].' – i.e. c.17 September.
11. Oliphant, *A Diary of a Siege of the Legations*, p. 37.
12. B.G. Tours, unpublished lecture 1, p. 10.
13. Ransome, *The Story of the Siege Hospital*, p. 71.
14. Mateer, *Siege Days*, pp. 164–4.
15. Mateer, *Siege Days*, pp. 164–5.
16. Anon (an English 'Lady') pp. 18–19. There is a line in Annie Myers' unpublished diary about 'inflammable stuff' that directly connects the two writings (23 June).
17. Weale, *Indiscreet Letters from Peking*, p. 140.
18. Hooker, *Behind the Scenes at Peking*, p. 68.
19. Smith, *China in Convulsion*, vol. II, p. 486; A.D. Brent confirms this in his article under the date of 25 June.
20. Goodrich, unpublished 'Journal of 1900', 26 June, p. 27.
21. Martin, unpublished diary, 24 June, p. 57.
22. Martin, unpublished diary, p. 58.
23. Mateer, *Siege Days*, p. 141.
24. Miner, *China's Book of Martyrs*, pp. 56–7.
25. MacDonald, 'Some Personal Reminiscences', p. 22.
26. Morrison, unpublished diary, 25 June.
27. Fleming Correspondence, Peter Fleming to Paula von Rosthorn, 10 January 1961.
28. Hooker, *Behind the Scenes in Peking*, 9 July, pp. 121–2.
29. Baron A.F. d'Anthouard, *La Chine Contre l'Etranger* (1902), pp. 209–10.
30. Kaminski, *Ware ich Chinese*, p. 66.

31. Darcy, *La Défense de la Légation*, p. 96.
32. Winterhalder, *Kampfe in China*, pp. 251–2.
33. Jean Mabire, *L'Eté Rouge de Pékin* (1978), p. 113; Coltman conveys first-hand the same erroneous message (p. 218).
34. Kaminski, *Ware ich Chinese*, p. 68.
35. Kaminski, *Ware ich Chinese*, p. 66.
36. Darcy, *La Défense de la Légation*, p. 90.
37. J.J. Matignon, *Dix Ans au Pays du Dragon* (1910), p. 45.
38. Darcy, *La Défense de la Légation*, p. 90.
39. Darcy, *La Défense de la Légation*, pp. 101–2.
40. Kaminski, *Ware ich Chinese*, p. 66.
41. Matignon, *Dix Ans au Pays du Dragon*, p. 70.
42. Kaminski, *Ware ich Chinese*, p. 67.
43. Kaminski, *Ware ich Chinese*, p. 66.
44. Darcy, *La Défense de la Légation*, p. 113.
45. Darcy, *La Défense de la Légation*, p. 116 and Colonel de Pelacot, *Expédition de Chine de 1900* (1901), p. 212.
46. Darcy, *La Défense de la Légation*, p. 144.
47. Goodrich, unpublished 'Journal of 1900', 29 June, p. 31.
48. Quoted in Fleming, *The Siege at Peking*, p. 120.
49. Quoted in Fleming, *The Siege at Peking*, p. 120.
50. Oliphant, *A Diary of the Siege*, 10 July, pp. 108–9.
51. Ransome, *Story of the Siege Hospital*, 27 June, p.77.
52. Hewlett, *The Siege of the Peking Legations*, p. 18.
53. LMS, Lillie Saville, unpublished letter, 9 September 1900, folder 3D.
54. J.J. Matignon, *La Défense de la Légation de France* (1902), pp. 26–7. This booklet is very similar in content to the relevant part of his *Dix Ans*, with one or two additions, such as that quoted here. Darcy was known as Captain; his rank in the French Navy was *Lieutenant de Vaisseau*.
55. Campiche, 'Notes sur la Carrière d'Auguste Chamot', p. 28.
56. Winterhalder, *Kampfe in China*, p 227; see also Coltman, p. 218 and Goodrich, unpublished 'Journal of 1900', p. 54.
57. Darcy, *La Défense de la Légation*, p. 106.
58. Kaminski, *Ware ich Chinese*, p. 53.
59. Darcy, *La Défense de la Légation*, p. 110.
60. Darcy, *La Défense de la Légation*, p. 111.
61. Pierre Loti, *Les Derniers Jours de Pékin* (1902), p. 102.
62. Matignon, *Dix Ans au Pays du Dragon*, p. 43. He uses 'fée' without an adjective which I have added hoping to make it more idiomatic. See Chapter 16, note 34.

Chapter 10

1. Tours, unpublished diary, 29 June.
2. Ransome, *The Story of the Siege Hospital*, p. 76.
3. Arthur D. Brent, unpublished letter to his father, Arthur Brent, 3 September 1900.
4. Martin, unpublished diary, p. 60.
5. Miner, unpublished 'Siege Journal 1900–1901', 28 June. The handwritten pages of Luella Miner's microfilmed diary are only numbered later and the pages have not always been filmed sequentially, making reference unreliable; most of the other American diaries are typescripts.
6. Mateer, *Siege Days*, p. 230.

7. Mateer, *Siege Days*, p. 149.
8. Martin, unpublished diary, p. 66. Emma wrote to Miss Smith; I suspect she did not mean Miss Georgina but, rather, Mrs Emma. Mrs Smith was one of the American missionary family; Miss Smith, although she had been the only British woman with the Americans during the semi-siege, returned, in the Legation, to her British colleagues such as Lillie Saville. Of course, Georgina Smith may have been visiting and it is certainly the sort of remark she might have made.
9. Tuttle, *Mary Porter Gamewell*, pp. 247–9.
10. Coltman, *Beleaguered in Peking*, p. 200.
11. Hooker, *Behind the Scenes in Peking*, p. 87.
12. Allen, *The Siege of the Peking Legations*, p. 144.
13. Conger, *Letters from China*, 7 July, pp. 117–18.
14. Conger, *Letters from China*, 15 July, p. 119.
15. Martin, *The Siege at Peking*, p. 94.
16. Hooker, *Behind the Scenes in Peking*, pp. 61–3.
17. Martin, *The Siege at Peking*, pp. 87–8.
18. Hooker, *Behind the Scenes in Peking*, 80–2.
19. Martin, *The Siege at Peking*, p. 116.
20. Fleming Correspondence, unpublished letter from Samuel Duff McCoy to Peter Fleming, 5 July 1959.
21. Fleming Correspondence, unpublished letter from Mrs Philip Hoge to Peter Fleming, 19 February 1960.
22. Hooker, *Behind the Scenes in Peking*, pp. 110–12.
23. Hooker, *Behind the Scenes in Peking*, 16 July, pp. 127–8.
24. Hooker, *Behind the Scenes in Peking*, pp. 117–8.
25. Martin, *The Siege at Peking*, pp. 95–6.
26. Martin, *The Siege at Peking*, p. 96.
27. Martin, *The Siege at Peking*, p. 95.
28. Inglis, unpublished 'Siege Diary 1900', p. 95.
29. Goodrich, unpublished 'Journal of 1900', p. 36.
30. Hewlett, *The Siege of the Peking Legations*, 30 August, p. 67.
31. Marchant, *The Siege of the Peking Legations*, p. 141.
32. Hewlett, *The Siege of the Peking Legations*, 16 June, p. 97.
33. Inglis, unpublished 'Siege Diary 1900', p. 116.
34. Weale, *Indiscreet Letters from Peking*, pp. 175–6.
35. Miner, *China's Book of Martyrs*, p. 63.
36. Weale, *Indiscreet Letters from Peking*, pp. 176–7.
37. Martin, unpublished diary, p. 70.
38. Weale, *Indiscreet Letters from Peking*, p. 216.
39. Having berated Putnam Weale, it has to be admitted that Alicia Little writes in *Round My Peking Garden*, 'The Manchu women are for the most part buxom and well grown, with fine, rosy cheeks. Chinese women [who bind their feet, unlike Manchu] unable to move, are generally pasty-faced' (p. 65). Alicia, with her anti-footbinding campaign in mind, had a vested interest in talking up the healthy appearance of Manchu women.
40. Martin, *The Siege at Peking*, p. 87.
41. Mateer, *Siege Days*, Annie Gowans, p. 294.
42. Inglis, unpublished 'Siege Diary 1900', p. 117.
43. Hooker, *Behind the Scenes at Peking*, p. 130.
44. Hooker, *Behind the Scenes at Peking*, p. 130.
45. *Japanese Herald*, 23 October 1900.

46. Tuttle, *Mary Porter Gamewell*, pp. 233–4.
47. Fenn Cuttings. Neither a name of publication nor a date is clear from the cutting; it may have been the *San Francisco Call* of 2 October 1900, or the *San Francisco Chronicle*. Cecile Payen was less specific in her diary.
48. A.D. Brent, unpublished letter to William Pitcher, 2 September 1900.
49. A.D. Brent, unpublished letter to his father, Arthur Brent, 3 September 1900.
50. MacDonald, 'Besieged in Pekin', p. 252.
51. Hooker, *Behind the Scenes in Peking*, 9 July, p. 120.
52. Hewlett mentions having to talk to Salvago in French on official business, 25 June, p. 18.
53. Blake, unpublished 'A Journey in China etc.', pp. 96–7.
54. Inglis, unpublished 'Siege Diary 1900', p. 121.
55. Valli, *Gli Avvenimenti in Cina*, p. 462. Hewlett, for example, writes of Pichon, 'a piece of shell fell in the Legation, causing an absurd little panic, especially to the French Minister, who has shown himself a horrible coward all through' (24 June, p. 16).
56. Ransome, *The Story of the Siege Hospital*, p. 94.
57. Goodrich, unpublished 'Journal of 1900', p. 46.
58. I have translated the Italian deliberately into the same general term 'projectile' because it was not only bullets and shells that came over; I recently handled a weighty little cannon ball brought back from the siege by Helen and Russell Brazier.
59. Valli, *Gli Avvenimenti in Cina*, p. 472. The marine was killed by a sniper on the way back.
60. Hooker, *Behind the Scenes in Peking*, pp. 83–4.
61. Hooker, *Behind the Scenes in Peking*, p. 79.
62. Goodrich, unpublished 'Journal of 1900', p. 40.
63. Fenn Cuttings.
64. Payen, 'Beseiged in Peking', 6 July p. 460.
65. Pearl, *Morrison of Peking*, p. 121.
66. Hooker, *Behind the Scenes in Peking*, p. 130.
67. Ransome, *The Story of the Siege Hospital*, 27 June, p. 76.
68. Ransome, *The Story of the Siege Hospital*, 29 June, p. 80.
69. Hooker, *Behind the Scenes in Peking*, pp. 93–4.
70. W.E. Bainbridge, unpublished 'Besieged in Peking', p. 36.
71. Morrison, unpublished diary, 25 July.
72. Coltman, *Beleaguered in Peking*, pp. 86–7.
73. Coltman, *Beleaguered in Peking*, p. 143.
74. MacDonald, 'Besieged in Pekin', p. 254.
75. Hooker, *Behind the Scenes in Peking*, pp. 100–1.
76. Hooker, *Behind the Scenes in Peking*, 1 July, p. 89.
77. Morrison, unpublished diary, 4 July.
78. Pruitt, *A Daughter of Han*, p. 147. Ning Lao T'ai-t'ai's criticism is even fiercer than those words suggest and she is speaking as the non-Christian *amah* who has to wash the menstrual cloths of a missionary.
79. Martin, unpublished diary, p. 62.
80. Martin, unpublished diary, p. 63. This touchiness may have something to do with Emma Martin's general defensiveness *vis-à-vis* the British. A letter of 1905, quoted in Hunter (p. 154), ends ' ... and I was born in the land of the free ... and I am proud to be an American and a lot more I would like to tell them'.
81. Ransome, *The Story of the Siege Hospital*, p. 83.
82. Goodrich, unpublished 'Journal of 1900', p. 41.
83. Goodrich, unpublished 'Journal of 1900', p. 43.

84. Goodrich, unpublished 'Journal of 1900', p. 57.
85. Hooker, *Behind the Scenes in Peking*, pp. 90–1.
86. Ruoff, *Death Throes of a Dynasty*, p. 91.
87. Inglis, unpublished 'Siege Diary 1900', p. 85.
88. Martin, unpublished diary, pp. 68–9.
89. Fleming Correspondence, unpublished letter from Amy M. Russell to Peter Fleming, 1 June 1963.
90. Hooker, *Behind the Scenes in Peking*, p. 128.
91. Stéphen Pichon, *Dans La Bataille* (1908), p. 304.
92. Inglis, unpublished 'Siege Diary 1900', p. 104.
93. Allen, *The Siege of the Peking Legations*, p. 193.
94. Inglis, unpublished 'Siege Diary 1900', p. 104.
95. Lo, *The Correspondence of G.E. Morrison*, vol. I, p. 140.
96. Tours, unpublished diary, 12 July 1900.

Chapter 11

1. Kaminski, *Ware ich Chinese*, p. 67.
2. In 1999 an article in the American *Journal of Circulation* suggested that 'Cocaine increases the risk of heart attack by 24 times during the hour after using it.' Quoted from the *Guardian* (London), report by Science Editor Tim Radford, 1 June.
3. Oliphant, *A Diary of the Siege of the Legations*, 8 July, p. 102.
4. Darcy, *La Défense de la Légation*, pp. 165–6. My translation 'bread and milk' might be questioned; 'pap' is more literal.
5. Kaminski, *Ware ich Chinese*, p. 68.
6. Ransome, *The Story of the Siege Hospital*, 13 July, pp. 94–5.
7. Martin, unpublished diary, 14 July, p. 72.
8. Darcy, *La Défense de la Légation*, p. 172.
9. Morrison, unpublished diary, 14 July. Chamot's later doctor, P. Campiche, suggests that Mesdames Brandt-Chamot and Jeanrenaud, Swiss wives of storekeepers, also remained in the hotel throughout (p. 24).
10. Oliphant, *A Diary of the Siege of the Legations*, 10 July, p. 106.
11. Pichon, *Dans la Battaille*, 13 July, p. 264.
12. Bainbridge, unpublished 'A Siege in Peking', p. 8.
13. Kaminski, *Ware ich Chinese*, p. 69.
14. Darcy, *La Défense de la Légation*, p. 182.
15. Matignon, *Dix Ans au Pays du Dragon*, p. 69.
16. Hewlett, *The Siege of the Peking Legations*, 14 July, p. 45.
17. Kaminsky, *Ware ich Chinese*, p. 69.
18. Kaminsky, *Ware ich Chinese*, pp. 69–70.
19. Conger, *Letters from China*, p. 115.
20. Hooker, *Behind the Scenes in Peking*, p. 109.
21. Goodrich, unpublished, 'Journal of 1900', p. 37.
22. Hooker, *Behind the Scenes in Peking*, p. 109.
23. Martin, unpublished diary, p. 66.
24. Oliphant, *A Diary of the Siege of the Legations*, 10 July, p. 106.
25. Goodrich, unpublished 'Journal of 1900', p. 40
26. Goodrich, unpublished 'Journal of 1900', p. 41.
27. Goodrich, unpublished 'Journal of 1900', p. 44.
28. Goodrich, unpublished 'Journal of 1900', p. 46.
29. Ransome, *The Story of the Siege Hospital*, pp. 91–2.

30. Oliphant, *A Diary of the Siege of the Legations*, 8 July, p. 100.
31. Allen, *The Siege of the Peking Legations*, p. 190. Annie Myers had written on 28 June, 'The other night a bullet had entered the Cockburns' bedroom door' and subsided harmlessly beside the bed.
32. Morrison, unpublished diary, 15 July, quoted in Pearl, p. 125. The Bredon women were sleeping in Hewlett's former bedroom; he recorded the event on 14 July, p. 46.
33. Tours, unpublished diary, 16 July. Sir Claude MacDonald's post-siege dispatch suggests that Daisy was hit while delivering water which she had distilled to the hospital but her co-distiller, Annie Myers, makes clear this was not so, though Annie, at least, and probably Daisy as well, had many near-misses while going about their hospital duties. Both young women received the Royal Red Cross for this work.
34. Morrison, unpublished diary, 14 July.
35. Goodrich, unpublished 'Journal of 1900', p. 50.
36. Martin, unpublished diary, p. 68.
37. Goodrich, unpublished 'Journal of 1900', 10 July, p. 44.
38. Goodrich, unpublished 'Journal of 1900', p. 48.
39. Mateer, *Siege Days*, Mrs Galt, pp. 224–5.
40. Ransome, *The Story of the Siege Hospital*, 8 July, p. 91.
41. Myers, unpublished 'The Siege of Peking', 29 July.
42. Martin, unpublished diary, 10 July, pp. 69–70.
43. Bainbridge, unpublished 'A Siege in Peking'. She gives the date as 15th, but she must mean 16th.
44. Hooker, *Behind the Scenes in Peking*, p. 125.
45. Hooker, *Behind the Scenes in Peking*, pp. 125–6.
46. Martin, unpublished diary, pp. 74–5.
47. Martin, unpublished diary, p. 71.
48. Martin, unpublished diary, pp. 72–3.
49. Kaminski, *Ware ich Chinese*, p. 51.
50. Inglis, unpublished 'Siege Diary 1900', p. 108.
51. Mateer, *Siege Days*, p. 284.
52. Inglis, unpublished 'Siege Diary 1900', p. 110.
53. Bainbridge, unpublished 'A Siege in Peking'. The bullets may have been imagined on 22 July – the truce was not to break until 6 August. But Cecile Payen says that firing began again on 23 July 'to prevent the building of barricades' (p. 465), and firing was particularly noticeable during funerals.
54. Mateer, *Siege Days*, p. 284.
55. Inglis, unpublished 'Siege Diary 1900', p. 110.
56. Morrison, unpublished diary, 22 October.
57. Saville, 'The Siege of Peking', pp. 4–5.
58. Martin, unpublished diary, pp. 78–9.
59. Inglis, unpublished 'Siege Diary 1900', pp. 114–15.
60. *Japan Herald*, 4 October.
61. Inglis, unpublished 'Siege Diary 1900', pp. 115–16. The obituary of Edward Wyon in the *Birmingham Daily Post* of 24 August 1906, transcribed into James O. Sweeny's *A Numismatic History of the Birmingham Mint* (1981), pp. 227–9, suggests that 'He and his wife were locked up in the city through-out the siege and Mrs Wyon died during that time.' If she had died during the siege, not only would Theodora Inglis have mentioned it, but so would other diarists; it must have been immediately after and, probably as a result. I thank Philip Attwood of the British Museum for providing the first name and details of Edward Wyon.
62. Brent, *Daily News*, p. 4. col. 6.

63. Goodrich, unpublished 'Journal of 1900', p. 63.
64. Saville, *Siege Life in Peking*, pp. 15–16.
65. Goodrich, unpublished 'Journal of 1900', p. 37.
66. Martin, unpublished diary, p. 66.
67. Goodrich, unpublished 'Journal of 1900', p. 40.
68. Conger, *Letters from China*, p. 155.
69. Conger, *Letters from China*, p. 122.
70. Oliphant, *A Diary of the Siege of the Legations*, pp. 100–1.
71. Miner, *China's Book of Martyrs*, pp. 61–2.
72. Mateer, *Siege Days*, p. 229.
73. Goodrich, unpublished 'Journal of 1900', 10 July, p. 45.
74. Mateer, *Siege Days*, pp. 227–8.
75. E.g., Goodrich, unpublished 'Journal of 1900', 28 July, p. 63.
76. Martin, unpublished diary, pp. 92–3.
77. Martin, unpublished diary, pp. 89–90.
78. Martin, unpublished diary, pp. 93–4.
79. Miner, *China's Book of Martyrs*, p. 62.
80. Bryson, *Cross and Crown*, pp. 96–7.

Chapter 12

1. Oliphant, *A Diary of a Siege of the Legations*, p. 128.
2. Bainbridge, unpublished 'A Siege in Peking', chronology. Hoover's memoirs say June, but he is mistaken.
3. Herbert Hoover, unpublished 'History from 28th May to 17th June', p. 16.
4. Fairbank, *The I.G. in Peking*, vol. I, letter 717, Hart to Campbell, 15 September 1889.
5. Mrs E.B. (Anna) Drew, unpublished siege diary, p. 7.
6. *Land of Sinim*, Frances Scott, letter of 24 June, p. 52.
7. Matignon, *Dix Ans au Pays du Dragon*, p. 55.
8. Varè, *The Last of the Empresses*, p. 194. See also Chapter 13, notes 21 and 23.
9. Drew, unpublished siege diary, pp. 6–7.
10. Drew, unpublished siege diary, p. 22.
11. Hoover, unpublished 'History from 28th May to 11th June', last page of draft. He is mistaken in saying that Miss Burgignone was the only trained nurse in North China – Nurse Marian Lambert, besieged in Peking, was also trained.
12. Herbert Hoover, *Memoirs* (1952), p. 50.
13. Drew, unpublished siege diary, pp. 23–4.
14. Drew, unpublished siege diary, p. 30.
15. Drew, unpublished siege diary, p. 31.
16. Drew, unpublished siege diary, p. 32.
17. Drew, unpublished siege diary, p. 33.
18. *Land of Sinim*, Frances Scott, letter of 27 June, p. 53.
19. *Land of Sinim*, Bishop Scott, letter of 27 June, p. 53.
20. *Land of Sinim*, Miss Critall, letter of 27 June, p. 54.
21. Drew, unpublished siege diary, p. 39.
22. *Land of Sinim*, Frances Scott, letter of 1 July, pp. 56–7.
23. Drew, unpublished siege diary, p. 39.
24. *Land of Sinim*, Frances Scott, letter from Weihaiwei of 9 July, p. 64.
25. *Land of Sinim*, Miss Critall, letter from Nagasaki of 12 July, pp. 72–3.
26. W. McLeish, *Tientsin Besieged* (1901), p. 34.

27. Hoover, *Memoirs*, pp. 51–2. Many years later in Washington, Hoover met the young girl he had carried that night at a diplomatic function; she was then married to the Chinese Minister to Washington, Wellington Koo, and was to die in the 'flu epidemic of 1918–19. For further links, see 'Of Palaces and Jade' in Hoe, *Chinese Footprints*, pp. 82–91. I am grateful to my friend Dr Linda Koo and her aunt for additional family details in the biographical entry.
28. McLeish, *Tientsin Besieged*, 16 July, p. 43. *Who's Who in the Far East 1906–7*.
29. Drew, unpublished siege diary, pp. 41–2.
30. Winterhalder, *Kampfe in China*, pp. 339–40.
31. Matignon, *Dix Ans au Pays du Dragon*, p. 76.
32. Pichon, *Dans la Bataille*, p. 273.
33. Darcy, *La Défense de la Légation*, p. 198.
34. Kaminski, *Ware ich Chinese*, p. 70.
35. Darcy, *La Défense de la Légation*, p. 200.
36. Kaminski, *Ware ich Chinese*, p. 70.
37. Darcy, *La Défense de la Légation*, p. 197.
38. Darcy, *La Défense de la Légation*, p. 198.
39. Darcy, *La Défense de la Légation*, p. 204.
40. Darcy, *La Défense de la Légation*, p. 213.
41. Oliphant, *A Diary of the Siege of the Legations*, p. 129.
42. Darcy, *La Défense de la Légation*, p. 202.
43. Hooker, *Behind the Scenes in Peking*, 21 July, p. 138.
44. Oliphant, *A Diary of the Siege of the Legations*, 20 July, p. 130.
45. Weale, *Indiscreet Letters from Peking*, p. 230.
46. Hewlett, *The Siege of the Peking Legations*, p. 51.
47. Russell, *The Story of the Siege in Peking*, p. 17.
48. Russell, *The Story of the Siege in Peking*, p. 21.
49. Mateer, *Siege Days*, p. 309.
50. Martin, unpublished diary, p. 81.
51. Hooker, *Behind the Scenes in Peking*, 21 July, p. 139.
52. Mateer, *Siege Days*, Miss N.N. Russell, p. 311.
53. Mateer, *Siege Days*, p. 332.
54. Anon, 'An Englishman's Diary', col. 2., p. 12.
55. Pichon, *Dans la Bataille*, p. 283.
56. Hooker, *Behind the Scenes in Peking*, p. 146.
57. Hooker, *Behind the Scenes in Peking*, p. 160.
58. MacDonald, 'Besieged in Pekin', p. 250.
59. Hooker, *Behind the Scenes in Peking*, p. 138.
60. Winterhalder, *Kampfe in China*, p. 323.
61. Ruoff, *Death Throes of a Dynasty*, p. 99. Many Chinese soldiers also went to Colonel Shiba to sell their rifles and ammunition, e.g. Annie Myers' diary, 6 August.
62. Inglis, unpublished, 'Siege Diary 1900', pp. 127–8. Some diaries say 6th but there was obviously an increase in firing on the 9th; 'it was really like a recommencement of the siege', wrote Annie Myers.
63. Weale, *Indiscreet Letters from Peking*, p. 252.
64. Mateer, *Siege Days*, pp. 203–4. Helen Brazier herself had a daughter of six months, and a son six years old.
65. Ransome, *The Story of the Siege Hospital*, 30 July, p. 104.
66. Allen *The Siege of the Peking Legations*, p. 298.
67. Fleming Correspondence, unpublished letter from Violet Garnons Williams to Peter Fleming, 10 March 1958.

68. Letter from Susan Ballance to the author, 16 December 1998.
69. Hewlett, *The Siege of the Peking Legations*, p. 51.
70. Inglis, unpublished 'Siege Diary 1900', p. 121.
71. Payen, 'Besieged in Peking', 11 August, p. 467.
72. Mateer, *Siege Days*, p. 337.
73. Mateer, *Siege Days*, p. 321.
74. Mateer, *Siege Days*, p. 361.
75. Inglis, unpublished 'Siege Diary 1900', p. 119.
76. LMS, Joseph Stonehouse, unpublished letter 25 July and 15 August, folder D2.
77. LMS Howard Smith, unpublished letter 6 and 15 August, folder A3.
78. Mateer, *Siege Days* p. 323.
79. Ruoff, *Death Throes of a Dynasty*, p. 94.
80. Ruoff, *Death Throes of a Dynasty*, p. 100.
81. Hooker, *Behind the Scenes in Peking*, 8 August, p. 161.
82. Inglis, unpublished 'Siege Diary 1900', p. 123.
83. Oliphant, *A Diary of the Siege of the Legations*, p. 158.
84. Marchant, *The Siege of the Peking Legations*, p. 175.
85. Ruoff, *Death Throes of a Dynasty*, 15 August, p. 100.
86. Ruoff, *Death Throes of a Dynasty*, 23 July, p. 99
87. Ruoff, *Death Throes of a Dynasty*, 20 August, p. 103.
88. Payen, 'Besieged in Peking', p. 466.
89. Martin, unpublished diary, p. 79.
90. Ransome, *The Story of the Siege Hospital*, p. 99.
91. Ransome, *The Story of the Siege Hospital*, p. 114.
92. Ransome, *The Story of the Siege Hospital*, p. 114.
93. Allen, *The Siege of the Peking Legations*, p. 257. Allen wrote from first-hand experience; during his convalescence, he acted as a steward in the hospital.
94. MacDonald, 'Besieged in Pekin', p. 248. She also established a convalescent ward in his study. There was such competion for the six beds that she sometimes had to evict contented long-stayers. An Italian civilian 'never forgave me for telling him plainly he was well enough to leave'. See also Chapter 14, note 38.
95. MacDonald, 'Some Personal Reminiscences', p. 40.

Chapter 13

1. Ruoff, *Death Throes of a Dynasty*, 17 July, p. 98.
2. Ruoff, *Death Throes of a Dynasty*, 17 July, p. 98.
3. Hooker, *Behind the Scenes in Peking*, 28 July, p. 159.
4. Hooker, *Behind the Scenes in Peking*, p. 149.
5. Goodrich, unpublished 'Journal of 1900', 28 July, p. 62.
6. Hooker, *Behind the Scenes in Peking*, 3 August, p. 158.
7. Drew, unpublished siege diary, p. 37.
8. Goodrich, unpublished 'Journal of 1900', p. 64.
9. Mateer, *Siege Days*, Mrs Galt, p. 331.
10. Mateer, *Siege Days*, p. 330.
11. Inglis, unpublished 'Siege Diary 1900', p. 127.
12. Hooker, *Behind the Scenes in Peking*, p. 139.
13. Pichon, *Dans la Bataille*, 19 July, p. 271.
14. Goodrich, unpublished 'Journal of 1900', p, 61. Morrison says Jeanrenaud maltreated his wife, unpublished diary, 24 June 1900, and, according to that entry and one on 29 June from Annie Myers, he was also suspected of being a Boxer spy.

15. Payen, 'Besieged in Peking', p. 465.
16. Mateer, *Siege Days*, pp. 346–7. .
17. *Japan Herald Mail*, Mrs Brent in interview, Roland Allen, p. 263, and Luella Miner who did not see the design as positive: 'I do not at all approve of the design on one side, Europe, America, Japan trampling on the Dragon ... I object to this first because it isn't true to fact, as the dragon came out on the top side, and second because it isn't polite' quoted in Hunter, *The Gospel of Gentility*, p. 172. Their contemporary interpretation differs from the identity of the figures in Laurence Brown, *British Historical Medals* (1987): 'Britannia and Germania standing facing each other ... A Chinese female standing behind ...' No. 3672, p. 467. Unfortunately, there is no evidence there, or in diaries, of who designed the medal – perhaps Edward Wyon the medallist?
18. Martin, unpublished diary, p. 83.
19. Tuttle, *Mary Porter Gamewell*, p. 263.
20. Martin, unpublished diary, p. 85.
21. Hooker, *Behind the Scenes in Peking*, pp. 14–41. Sino-Russian conflict in Manchuria started in June, gathered pace in July, and reached a climax with the entry, on 1 October, of Russian troops into Mukden. Cohen describes Russian atrocities in Manchuria; Tan gives a detailed account of developments.
22. Weale, *Indiscreet Letters from Peking*, p. 214.
23. Lo, *Correspondence of G.E. Morrison*, J.O.P. Bland to Morrison, 19 December 1897, vol. I, p. 55. While Witte does not mention any family connection to Pokotilov in his memoirs, he does, subsequent to the rifle incident, describe a telling link to the Boxer uprising: 'Kuropatkin's [Minister for War] face was radiant. When I told him that the rebellion was a direct result of our taking Kwantung territory, he replied joyfully that he was very pleased with this result, for it gave us "grounds for taking Manchuria" ...'(p. 279). Witte also admits bribing Li Hung-chang to get a lease granted and Pokotilov was his agent (p. 277).
24. Morrison, unpublished diary, 12 April 1900.
25. Lo, *Correspondence of G.E. Morrison*, diary of 5 May 1905, p. 299.
26. Lo, *Correspondence of G.E. Morrison*, Morrison to Chirol, 8 September 1906, p. 378.
27. Ruoff, *Death Throes of a Dynasty*, Charles Ewing to Judson Smith, Peking, 17 February 1899, p. 61.
28. Hooker, *Behind the Scenes in Peking*, p. 107.
29. Goodrich, unpublished 'Journal of 1900', p. 65.
30. William J. Oudendyk *Ways and By-Ways of Diplomacy* (1939), p. 129, describes Pokotilov's final philandering in Peking.
31. Bainbridge, unpublished 'Besieged in Peking', p. 36.
32. Payen, 'Besieged in Peking', p. 465.
33. Goodrich, unpublished 'Journal of 1900', pp. 56–7.
34. Conger, *Letters from China*, p. 148.
35. Inglis, unpublished 'Siege Diary 1900', p. 126.
36. Goodrich, unpublished 'Journal of 1900', p. 66.
37. Mateer, *Siege Days*, pp. 367–8.
38. Martin, unpublished diary, p. 78.
39. Mateer, *Siege Days*, p. 377.
40. Mateer, *Siege Days*, p. 377.
41. Russell, *The Story of the Siege in Peking*, p. 23.
42. Hooker, *Behind the Scenes in Peking*, p. 165.
43. Mateer, *Siege Days*, pp. 361–4.
44. Hooker, *Behind the Scenes in Peking*, pp 161–3.

45. Conger, *Letters from China*, p. 153.
46. Russell, *The Story of the Siege in Peking*, p. 24.
47. Ransome, *The Story of the Siege Hospital*, pp. 112–13.
48. Martin, unpublished diary, pp. 91–2.
49. Hooker, *Behind the Scenes in Peking*, pp. 168–9.
50. Goodrich, unpublished 'Journal of 1900', pp. 66–7.
51. Martin, unpublished diary, p. 93.
52. Mateer, *Siege Days*, pp. 370–1. After the siege, Lucy Ker taught Constantine de Giers (16) English. Edith Miller must have gone home.
53. Mateer, *Siege Days*, pp. 373–4.
54. Martin, unpublished diary, p. 94.
55. Tuttle, *Mary Porter Gamewell*, p. 274.
56. Hooker, *Behind the Scenes at Peking*, p. 170.
57. Inglis, unpublished 'Siege Diary 1900', pp. 128–30.
58. Mateer, *Siege Days*, pp. 397–8.
59. Conger, *Letters from China*, pp. 156–7.
60. Martin, unpublished diary, pp. 94–5.
61. Ruoff, *Death Throes of a Dynasty*, pp. 99–100.
62. MacDonald, 'Besieged in Pekin', p. 254.
63. Kaminski, *Ware ich Chinese*, p. 71.
64. Russell, *The Story of the Siege in Peking*, p. 25.

Chapter 14

1. Inglis, unpublished 'Siege Diary 1900', p. 130.
2. Mateer, *Siege Days*, p. 385.
3. Inglis, unpublished 'Siege Diary 1900', p. 130.
4. Martin, unpublished diary, pp. 97–8. Putnam Weale helps explain the Anglo-Japanese connection: '... a transport corps, composed of Japanese coolies ... belonging to some British regiment ...' (p. 328). The Japanese had less distance to travel to China and thus could come more quickly in greater numbers.
5. Hooker, *Behind the Scenes in Peking*, 15 August, p. 182.
6. Martin, unpublished diary, pp. 97–8.
7. Russell, *The Story of the Siege in Peking*, 15 August, p. 26.
8. Varè, *The Last of the Empresses* (1936), p. 199. It is also quoted in Lucy Ker's unpublished autobiography. See Chapter 15, note 15.
9. H.B. Vaughan, *St George and the Chinese Dragon* (1902), p. 101.
10. Hooker, *Behind the Scenes in Peking*, pp. 173–6.
11. Mateer, *Siege Days*, p. 396.
12. Martin, unpublished diary, p. 96.
13. Ransome, *The Story of the Siege Hospital*, 15 August, pp. 117–18.
14. Varè, *The Last of the Empresses*, p. 199. See also note 8.
15. Tuttle, *Mary Porter Gamewell*, p. 277.
16. Mateer, *Siege Days*, p. 387.
17. Inglis, unpublished 'Siege Diary 1900', pp. 130–1.
18. MacDonald, 'Besieged in Pekin', p. 255.
19. Myers, unpublished 'The Siege of Peking', 14 August. Her father arrived on the 16th.
20. Martin, unpublished diary, pp. 96–7.
21. *The Times*, 21 August 1900; Fleming, *The Siege at Peking*, p. 207. And Cecile Payen says she was Russian!
22. Mateer, *Siege Days*, pp. 399–400.

23. Mateer, *Siege Days*, p. 399.
24. Inglis, unpublished 'Siege Diary 1900', p. 131.
25. Inglis, unpublished 'Siege Diary 1900', p. 132.
26. Matignon, *Dix Ans au Pays du Dragon*, p. 93.
27. Ruoff, *Death Throes of a Dynasty*, p. 100.
28. Cecil Aspinall Oglander, *Roger Keyes* (1951), p. 64.
29. Richard A. Steel, *Through Peking's Sewer Gate* (1985), p. 55.
30. Mateer, *Siege Days*, p. 377.
31. Kaminski, *Ware ich Chinese*, p. 71.
32. Miner, unpublished diary, mid-October, f287 etc. (See chapter 10, note 5.) Miner's apparent lack of interest in fashion should be read in conjunction with letters of 1888 and 1913 quoted in Hunter, *The Gospel of Gentility* p. 137, which show that she was surprisingly interested.
33. Landor, *China and the Allies*, vol. II, p. 190.
34. Landor, *China and the Allies*, vol. II, pp. 191–2. Cecile Payen, in an interview, gave another slant on the so called 'garden party' when she elaborates on how the American women responded to the 'worn out' troops: 'So we gave them a lawn party. That's what they called it. We were all about the yard when somebody said tea. Mrs Conger went to have the water put on, and we brought out what cups there were and bowls and whatever we could find and from 3 o'clock in the afternoon until 7 in the evening we made the soldiers tea.' Fenn papers, no source or date accessible.
35. Goodrich, unpublished 'Journal of 1900', pp. 69–70.
36. Miner, unpublished diary, mid-October, f287 etc. see note 32.
37. Hooker, *Behind the Scenes in Peking*, 9 July, pp. 118–19.
38. Fleming Correspondence, unpublished letter from Amy M. Russell to Peter Fleming, 1 June 1963. For all Ethel MacDonald's graciousness and self-deprecation, another side was noted by one of her guests that night. General Barrow described her as 'a very alert and managing woman'. Quoted in Diana Preston, *Besieged in Peking* (1999), p. 186.
39. Mateer, *Siege Days*, pp. 395–6.
40. Witold Rodzinky, *The Walled Kingdom* (1984), pp. 242 and 245; see also Nat Brandt, *Massacre in Shansi* (1994), and Luella Miner's unpublished diary, ff305–6.
41. Conger, *Letters from China* 19 August, pp. 160–1.
42. Hooker, *Behind the Scenes in Peking*, 15 August, pp. 182–3.
43. Rodzinsky, *The Walled Kingdom*, p. 244; Purcell, *The Boxer Uprising*, p. 252.

Chapter 15

1. Bland, *China under the Dowager Empress*, pp. 287–8.
2. Bland, *China under the Dowager Empress*, p. 300.
3. Varè, *The Last of the Empresses*, p. 188.
4. Varè, *The Last of the Empresses*, p. 188.
5. Luella Miner 'The Flight of the Empress Dowager' (1900–01), p. 777. Luella Miner's unpublished diary (October, ff308 and 312) makes it clear that her informant was a Mr Lieu who also briefed or debriefed Li Hung-chang. She also writes of having translated Lieu's 'siege' diary, but I am not aware that her translation is available either published or unpublished.
6. Miner, 'Flight of the Empress Dowager', p. 778; Smith, *China in Convulsion*, vol. II, p. 552. The second sister was a member of the imperial party in exile. The two, the Pearl Concubine (Chen-fei/Zhenfei) and the Lustrous Concubine (Chin-fei/Jinfei) are easily confused in their early transliterations.

7. Clara Wing-chung Ho, *Biographical Dictionary of Chinese Women* (1998), p. 372 (entry by Yu Shanpu).
8. Weale, *Indiscreet Letters from Peking*, pp. 384 and 390–3.
9. Warner, *The Dragon Empress*, p. 267, note 20, chapter 13.
10. Seagrave, *Dragon Lady*, p. 386. But Diana Preston, who visited it with the same question in mind, is not so sure, partly because its current sealed condition does not allow certainty, (telephone conversation 15 January 2000).
11. Ho, *Biographical Dictionary of Chinese Women*, p. 372 (entry by Yu Shanpu).
12. Der Ling, *Two Years in the Forbidden City*, pp. 180–1.
13. LMS, Georgina Smith, unpublished letter, 25 November 1900, folder 3C.
14. Miner, 'Flight of the Empress Dowager', p. 778; Varè also has her leaving by the Shen Wu Gate, Gate of Victory, p. 188; Mrs Ker has her leaving by the Sheng Wu Men, Gate of Military Prowess, on the Western Road, Varè, p. 189.
15. Varè, *The Last of the Empresses*. p. 189. Mysteriously, the second of these paragraphs is in Lucy Ker's unpublished autobiography, the first is not. Perhaps she wrote the account specially for Varè when they were in Peking together from 1912; his book was published in 1936; her account was written up in the 1960s; the passage does not appear to come from a contemporary letter. See also Annie Myers' account of each member of the party being given a handkerchief, p. 319.
16. Myers, unpublished 'The Siege of Peking', 28 August.
17. Weale, *Indiscreet Letters from Peking*, p. 323.
18. Ransome, *The Story of the Siege Hospital*, p. 119.
19. Henry Mazeau, *The Heroine of Pe-Tang* (1928), p. 219.
20. Mazeau, *The Heroine of Pe-Tang*, p. 194. According to Theodora Inglis' unpublished 'Siege Diary 1900', p. 34, 'One canon [at the Pei-t'ang] was mounted facing towards the roof of the Imperial Palace and Father Favier sent word to the Empress that if the Chinese soldiers attacked them, they would fire upon Her Majesty's residence.'
21. Valli, *Gli Avvenimenti in Cina*, p. 558.
22. Mazeau, *The Heroine of Pe-Tang*, p. 191.
23. Mazeau, *The Heroine of Pe-Tang*, p. 202.
24. Mazeau, *The Heroine of Pe-Tang*, p. 208.
25. Mazeau, *The Heroine of Pe-Tang*, pp. 208–9. The translator has consistently used the word 'rubbish' instead of 'rubble'; I have made the switch in square brackets.
26. Mazeau, *The Heroine of Pe-Tang*, p. 218.
27. Mazeau, *The Heroine of Pe-Tang*, p. 221.
28. Mazeau, *The Heroine of Pe-Tang*, p. 222.
29. Mazeau, *The Heroine of Pe-Tang*, p. 222.
30. Mazeau, *The Heroine of Pe-Tang*, p. 223.
31. Mazeau, *The Heroine of Pe-Tang*, p. 225.
32. Mazeau, *The Heroine of Pe-Tang*, p. 225.
33. Mazeau, *The Heroine of Pe-Tang*, pp. 227–8.
34. Mazeau, *The Heroine of Pe-Tang*, p. 229.
35. Valli, *Gli Avvenimenti in Cina*, p. 572.
36. Mazeau, *The Heroine of Pe-Tang*, p. 236.
37. Mazeau, *The Heroine of Pe-Tang*, p. 237.
38. Mazeau, *The Heroine of Pe-Tang*, p. 237.
39. Mazeau, *The Heroine of Pe-Tang*, p. 237.
40. Valli, *Gli Avvenimenti in Cina*, p. 575.
41. Mazeau, *The Heroine of Pe-Tang*, p. 238.
42. Mazeau, *The Heroine of Pe-Tang*, p. 239.
43. Mazeau, *The Heroine of Pe-Tang*, p. 242.

44. Frey, *Français et Alliés au Petchili*, pp. 285 and 477.
45. Kaminski, *Ware Ich Chinese*.
46. Hooker, *Behind the Scenes in Peking*, p. 131. There is no unanimity about his nationality or the spelling of his name.
47. Frey's account claims most convolutedly that the French force relieved the Pei-t'ang but it is generally accepted that the Japanese did so and that this was the contemporary impression is confirmed by Annie Myers who wrote on 16 August, 'We heard just before we started out on our walk that the Peitang had been relieved by the Japanese today.'
48. Martin, unpublished diary, pp. 98–9.
49. Saville, 'The Siege of Peking', p. 5.
50. *North China and Shantung Mission Quarterly Paper*, 'Memorial to Deaconess Jessie Molyneux Ransome', January 1906, pp. 6–7.
51. Conger, *Letters from China*, p. 184.
52. Hooker, *Behind the Scenes in Peking*, p. 185.
53. Martin, unpublished diary, p. 102.
54. Brent, unpublished letter from A.D. to his father, 3 September 1900.
55. Brent, unpublished letter from A.D. to William Pitcher, 3 September 1900.
56. Hooker, *Behind the Scenes*, 16 August, p. 186.
57. Lucy Soothill, *A Passage to China* (1931), p. 308. Lucy Soothill knew the Brazier–Myers family well and, without naming names, writes engagingly of the three Myers girls – Helen Brazier, Annie, and Charlotte (who was not at the siege) – and their mother.
58. I went to see Helen Brazier Steedman on 23 July 1999, one of the greatest thrills in the research for this book. Her father rarely mentioned the siege when she was old enough to take in what she and her family had been through; their suffering, and his wife's untimely death, were no doubt as much factors as traditional cultural reticence. Helen Steedman died on her hundredth birthday, 17 December 1999. She knew this book was to be dedicated to her and was pleased.
59. Brent, unpublished 'My Life Story', p. 24.
60. Lo, *The Correspondence of G.E. Morrison*, letter from Morrison to J.O.P. Bland, 4 November 1900, vol. I, p. 150.
61. Lo, *The Correspondence of G.E. Morrison*, Lady Blake from Hong Kong to Morrison, 7 December 1900, p. 153.
62. Ruoff, *Death Throes of a Dynasty*, 7 September, p. 104.
63. Ruoff, *Death Throes of a Dynasty*, 7 October, p. 107. There was at least one good post-siege moment for Bessie Ewing: she learnt that little Ellen's nanny had, after all, survived. Charles died in a car crash in 1927; Bessie lived to ninety-six. Courtenay Fenn had typhoid during the Pacific crossing (Fenn papers); he remained 'haggard and worn out' for some time after.
64. USPG/D/133a, China No. 68, Roland Allen, November 1900, from Cheltenham.
65. Martin, unpublished diary, 15 August, p. 99.
66. MacDonald, 'Besieged in Pekin', p. 251.
67. Fleming Correspondence, unpublished letter from C. Derek Houston to Peter Fleming, 18 February 1958.
68. Hooker, *Behind the Scenes in Peking*, 9 July, p. 91.
69. Fleming Correspondence, unpublished letter from Mrs Philip Hoge to Peter Fleming, 19 February 1960. She wrote, 'Some years later Captain Jack Myers told us how she had taken care of his wounded leg, had often given up her share of the hoarded rice and practically lived on cigarettes (of which the Russians had a good supply) ...'
70. Goodrich, unpublished 'Journal of 1900', p. 78.
71. Martin, unpublished diary, p. 107.

72. Annie Myers notes that the following also left the same morning: Miss Armstrong with Ivy and Stella MacDonald, Mme Salvago and Paris, the Bredons and Brewitt-Taylors.
73. Ransome, *Story of the Siege at Peking*, 24 August, p. 123.
74. Frances Scott's obituary includes the following: 'Her first summer in China, that of 1890, was spent at Chefoo, where she underwent a very serious attack of typho-malarial fever. ... she recovered entirely ... and was never again attacked in a similar way until just ten years later, when in her fatal illness at Nagasakai, there appeared symptoms of the same disease.' *Land of Sinim*, vol. viii, no. 4, October 1900, p. 15.

Chapter 16

1. Miner, *China's Book of Martyrs*, p. 64.
2. Miner, *China's Book of Martyrs*, p. 64.
3. Weale, *Indiscreet Letters from Peking*, pp. 327–8.
4. Weale, *Indiscreet Letters from Peking*, pp. 361–3. See also p. 106 concerning Hsu-t'ung.
5. Weale, *Indiscreet Letters from Peking*, p. 422.
6. Morrison, unpublished diary, 22 September; see also, 19 August; 31 August; 4 September.
7. Miner, unpublished diary, 15 August, quoted Cohen p. 184.
8. Hooker, *Behind the Scenes in Peking*, p. 191.
9. Margery Wolf, 'Women and Suicide in China' (1975), pp. 111–14.
10. Landor, *China and the Allies*, vol. II, p. 244. But see also George Lynch, an Irish journalist writing for several British publications; in his two books, more concisely in *The War of Civilisations* (1901), he gives details of crimes against women, the results of which he witnessed himself, e.g. pp. 46–9, 140–2. He also quotes a French General's excuse: 'It is impossible to restrain the gallantry of the French soldier', (p. 140).
11. LMS, Georgina Smith, unpublished letter 8 September, folder 3C.
12. Hooker, *Behind the Scenes in Peking*, 18 August, p. 190.
13. Sir Claude MacDonald regretted that the British forces were tied up in South Africa – letter to Morrison of 22 August 1900. Lo, *Correspondence of G.E. Morrison*, p. 144.
14. Hooker, *Behind the Scenes in Peking*, pp. 191–2.
15. Weale, *Indiscreet Letters from Peking*, p. 398.
16. Fleming, *The Siege at Peking*, p. 243.
17. Fleming had an access to Ryder's correspondence which has eluded me, in spite of appealing to the Ryder family archives of the Earl of Harrowby. He wrote of Ryder to Stella MacDonald on 16 July 1959: 'I have read all the letters he wrote home from China, and also a larger batch which he wrote home from Tibet in 1904, and I am bound to say that he impressed me as a witness whose integrity and powers of observation can hardly be called in question' (Fleming Correspondence).
18. Fleming Correspondence, unpublished letter from Sergeant Murphy to Peter Fleming, 6 July 1959.
19. Fleming Correspondence, unpublished letter from Stella MacDonald to Peter Fleming, 15 July 1959.
20. Fleming Correspondence, unpublished letter from Sir Lionel Gaunt to Peter Fleming, 3 August 1959. Luella Miner writes in her unpublished diary on 26 September, 'The repairing of the railroad now fallen into English hands – also the Imperial Palace at the Western Hills which Lady MacDonald went out yesterday to occupy.'
21. Fleming Correspondence, unpublished letter from A.M.D. Rathbone to Peter Fleming, March 1961.

22. Oudendyk, *Ways and Byways in Diplomacy*, pp. 107–8. Three diary entries from Annie Myers are also relevant: 16 August: 'numerous packing mules under the window of the convalescent ward (Sir Claude's study) laden with furs, which, with a whole heap of embroideries and silks are to be sold by auction, for the benefit of the soldiers, and marines'; 24 August: 'En route we stopped off at some of the curio shops. Such a sight everything tumbled on to the floors, trampled underfoot, torn from their cases or left on the upper shelves to the mercy of the next comer. Some of our soldiers were there collecting the things to take back to be sold at the auctions'; 27 August: This afternoon we went to the auction but did not get anything, as the prices ran fearfully high, sometimes higher than they would in ordinary times. These auctions are great fun.'

23. The British officer Henry Vaughan writes, for example, 'It should be remembered that it is one of the unwritten laws of war that a city which does not surrender at the last and is taken by storm is looted' (p. 121). But, even more than fifty years earlier, not everyone was in agreement with this general precept; see, for example, Hoe, *The Taking of Hong Kong* for Captain Charles Elliot's attitude to looting and the repercussions he faced. More personally, and at the highest level of society, one of General Gaselee's ADCs, Lieutenant Richard Steel, who had previously been ADC to Lord Curzon, Viceroy of India, wrote on 4 September, 'I bought several things at auction in the evening for Lord Curzon, cloisonné and bronze.' H.C. Thomson, a contemporary observer, reminds his readers that article XLVI of the 1899 Hague Convention (on War) talks of 'Family honour and rights, individual lives and private property ... must be respected. Private property cannot be confiscated.' Article XLVII reads, 'Pillage is formally prohibited' *China and the Powers* (1902), p. 130. George Lynch also gives article XXVIII 'It is forbidden to loot a town or place even if taken by storm' *The War of the Civilizations*, p. 303.

24. Myers, unpublished 'The Siege of Peking', 16 August.

25. Brent unpublished letter from A.D. to his father, 3 September. Captain Poole wrote on 7th, 'I sent a fur-lined coat to the mater by Mrs Brazier who is going home.

26. Morrison, unpublished diary, 5 November, f338; published in Pearl *Morrison of Peking*, p. 131.

27. The Benin bronzes may have been bona fide presents; when Ethel Robertson married Major MacDonald in 1892, he was consul-general, Oil Rivers (later Niger Coast) Protectorate, a job he left to go to Peking in 1896. But in 1897, a British military punitive expedition 'took' the Benin bronzes which are now in the British Museum and the subject of international dispute (*Guardian*, 30 October 1999).

28. Piggott, 'Ethel, Lady MacDonald', p. vi.

29. See also Weale, *Indiscreet Letters from Peking*, pp. 325–6.

30. Kaminski, *Ware Ich Chinese*.

31. Favier was not the only French Bishop in Peking, but later details of Auguste Chamot's financial transactions suggest he is the more likely.

32. Kaminski, *Ware Ich Chinese*, p. 73.

33. Smith, *China in Convulsion*, vol. II, p. 535.

34. Kaminski, *Ware Ich Chinese*, p. 75. It is clear that Paula never had children. Arthur apparently did. Wilfred Lefford, b.c.1922, is said to be his. Love poems to the mother (the wife of a friend) and an essay on life from Arthur to his son on his 18th birthday are lodged at the Boltzmann Institute in Vienna and the boy partly grew up on the von Rosthorn estate. It has been said of turn-of-the-century Vienna that 'Duplicity was a duty in a society where men were ashamed not to betray their partners and women were shameless if they did' (Frederic Raphael, introduction to Arthur Schnitzler's *Dream Story*). It is not surprising, therefore, that there should have been

aspersions cast on Paula whose outgoing nature and bravery inspired great admiration among men. The suggestion was to be made by vice-consul Cach, a man of dissimilar disposition serving at some stage under her husband, that she was a 'nymphomaniac'. His remark, also recorded at the Institute, is nowhere substantiated. It brings to mind the various aspersions used to diminish Lily Bredon, Sarah Conger, Ethel MacDonald and Mme Pokotilova. I am grateful to Professor Gerd Kaminski of the Institute, and author of publications about the von Rosthorns and Sino-Austrian relations, for his help to me through Yongmi Schibel and in a telephone conversation of 10 January 2000.

35. Conger, *Letters from China*, p. 171.
36. Myers, unpublished 'The Siege of Peking', 25 August. Putnam Weale (pp. 377–96) also describes looting in the Forbidden City.
37. Myers, unpublished 'The Siege of Peking', 28 August. Journalist George Lynch also describes looting that day (pp. 159–60).
38. Conger, *Letters from China*, p. 171.
39. Morrison, unpublished diary, f. 424.
40. Quoted in Seagrave, *Dragon Lady*, p. 369.
41. Quoted in Seagrave, *Dragon Lady*, pp. 368–9.
42. Harriet Squiers had some connection with the post-siege naval court of enquiry into the conduct of Captain Newt Hall, against whom Mary Gamewell brushed up in the American Methodist compound, and whom Dr Emma Martin disparaged in her diary. Prompted by Fleming's footnote on p. 142 of *The Siege at Peking*, R.D. Heinl jr wrote to him on 12 December 1959 of the court's findings: 'The court feels called upon to remark that there will be found in the record a great deal of incidental or collateral evidence going to show the prevalence of a feeling adverse to Captain Hall, officially and socially, at the United States Legation, which naturally would not tend to minimise any mistake or unpopular act on his part. Femininity figures on certain pages, and it is plainly indicated that some of the severest criticisms of Captain Hall are traceable to the same residence which extols into heroic importance a civilian (Mr Squiers) who is incidentally condemned by evidence adduced by the defense.' But Mary Gamewell's biographer records meeting Hall at a wedding reception in 1902. He remembered 'that white faced little heroine [who] never faltered. It seemed as if she was omni-present, and her bright, ready smile and cheery words helped us more than she ever knew.' Ethel Hubbard, *Under Marching Orders* (1909), pp. 199–200.
43. Arthur Smith, in *China in Convulsion*, vol. II, p. 498, itemises Protestant property destroyed: 34 dwelling houses, 18 chapels, 11 boys' schools, 1 university, 11 girls' schools, 4 training schools, 11 dispensaries, 8 hospitals, + 30 summer houses.
44. Martin, unpublished diary, pp. 104–6.
45. Goodrich, unpublished 'Journal of 1900', p. 73.
46. Courtenay and Alice Fenn accumulated a quantity of potentially invaluable newspaper cuttings now lodged with the Yale Divinity School Library; unfortunately, in spite of the library's courtesy and efficiency, the need to use photocopies impedes establishing sources and dates, and even following articles from one page to another.
47. LMS, Georgina Smith, unpublished letter, 8 September 1900, folder 3C; information and quotations that follow are from this letter.
48. LMS, Georgina Smith, unpublished letter, 25 November 1900, folder 4C.
49. Smith, *China in Convulsion*, vol. II, p. 539.
50. LMS, Georgina Smith, unpublished letter, 21 October 1900, folder 4A.
51. LMS, Georgina Smith, unpublished letter, 8 September, folder 3C.
52. LMS, Georgina Smith, unpublished letter, 21 October, folder 4A.

53. LMS, Thomas Biggin, unpublished letter, 24 September 1900, folder 3D.
54. This award by the British sovereign, dating from 1883, is given for 'special exertions in providing for the nursing, or for attending to, sick and wounded soldiers and sailors'. P.E. Abbott, *British Gallantry Awards* (1981), p. 259. It also went to Jessie Ransome, Marian Lambert, Daisy Brazier, Annie Myers and the American Abbie Chapin.
55. Winterhalder, *Kampfe in China*, p. 424.
56. Winterhalder, *Kampfe in China*, p. 341; Landor, *China and the Allies*, vol. II, p. 250.
57. Hooker, *Behind the Scenes in Peking*, p. 194. The abandonment of von Ketteler's body may have been caused by the execution in early August of Hsu Yung-i, one of those who visited Claude MacDonald on 18 June. Chester Tan suggests he took charge of the body after the assassination (p. 108).
58. Morrison, unpublished diary, 18 August.
59. Hewlett, *The Siege of the Peking Legations*, 17 August, p. 75.
60. Landor, *China and the Allies*, vol. II, p. 251.
61. Smith, *China in Convulsion*, vol. II, p. 499. It is not clear how the coffin was available on both occasions, unless it was not buried on 18 August. Certainly any burial was only temporary.
62. Graf von Waldersee, *A Field Marshal's Memoirs* (1924), p. 246. The executed man appears to have been a soldier of no standing, whereas Cordes's statement to Morrison describes the assassin as 'a banner soldier ... with a mandarin's hat with a button and blue feather'. But Morrison says that the alleged murderer and Cordes, when brought face to face, recognised each other.
63. Heidi Christein, 'A Detroit Baroness in Peking' (1997), p. 15. In correspondence (24/8/99) Christein says the cable, according to press reports, arrived in Detroit 3 September.
64. Valli, *Gli Avvenimenti in Cina*, p. 617.
65. Most of the details are taken from Henry McAleavy, *That Chinese Woman* (1959) translated from the Chinese. The novel *The Fabulous Concubine*, using different names, and the 1936 play *Sai Jinua* by Xia Yan are examples of the mythologising.
66. Ledyard Papers, *Detroit Free Press*, 9 February 1901.
67. Biege, unpublished transcript, p. 5.
68. Lady Susan Townley, *'Indiscretions' of Lady Susan* (1922), p. 104.
69. Headland, *Court Life in China*, p. 179.
70. Varè, *The Last of the Empresses*, p. 208.
71. Cass Ledyard Shaw, *The Ledyard Family in America* (nd), says (p. 284) that the villa, a national monument, was taken over by the Germans as their headquarters during the war; Maud seems to have been in the United States, at least in 1941–42, see below.
72. Ledyard Papers, *Detroit Free Press*, 19 April 1942.
73. As with Paula von Rosthorn, Peter Fleming neither mentions Maud von Ketteler in his book nor, unfortunately, knew that she was still alive when he was doing his research. Bessie Ewing was also alive, until 1966, and Lucy Ker, until 1969. An irony about Maud's deep and lasting grief over her husband's death is thrown up by the suggestion: 'although he was married to an attractive American wife, rumours circulated that he was involved in several love affairs in the Peking diplomatic community' – William J. Duiker, *Cultures in Collision* (1978), p. 55. Unfortunately, 22 years later, Professor Duiker has been unable to substantiate this. I thank him for trying. The von Kettelers had only been in Peking since July 1899.
74. Campiche, 'Notes sur la Carrière d'Auguste Chamot', p. 30. Much of the following information comes from Paul Campiche, Chamot's doctor in San Francisco during

the last six months of his life; he later supplemented what Chamot had told him with research of his own, particularly in Switzerland. I have failed to discover any unpublished Annie McCarthy Chamot papers. She must have written home to her mother, Harriet McCarthy, in San Francisco, both before and after the siege but the letters may have been lost in the earthquake of 1906.

75. According to Tz'u-hsi's biographer Philip Sergeant, she offered the earthquake sufferers £15,000 from her privy purse; when the US government declined outside assistance, she gave £6,000 'for the relief of the Chinese left destitute by the earthquake', *The Great Empress Dowager of China*, p. 318.

76. I visited the house in February 1999. Tomales Bay appeared comparatively unchanged and delightful, and I was much helped in finding the house and later being provided with supplementary material by local people; see acknowledgements.

77. *San Francisco Call*, 2 July 1909.

Epilogue

1. Conger, *Letters from China*, p. 215.
2. Conger, *Letters from China*, p. 175.
3. Conger, *Letters from China*, p. 176.
4. Kaminski, *Ware Ich Chinese*, p. 104. The von Rosthorns appear to have watched from the city wall, rather than from the diplomatic stand.
5. Lo, *The Correspondence of G.E. Morrison*, 7 July 1902, vol. I, p. 194.
6. 25 November 1902, quoted Seagrave, *Dragon Lady*, p. 546.
7. Townley, *'Indiscretions' of Lady Susan*, pp. 86–7.
8. Kaminski, *Ware Ich Chinese*, pp. 104–7.
9. Townley, *'Indiscretions' of Lady Susan*, p. 89.
10. Conger, *Letters from China*, 14 March, 1902, p. 222. There was a second visit to the Empress Dowager by diplomatic women on 27th February but these accounts seem to concern the first.
11. Townley, *'Indiscretions' of Lady Susan*, p. 92.
12. Kaminski, *Ware Ich Chinese*, pp. 104–7.
13. Conger, *Letters from China*, p. 218.
14. Kaminski, *Ware Ich Chinese*, pp. 104–7.
15. Kaminski, *Ware Ich Chinese*, pp. 104–7.
16. Headland, *Court Life in China*, p. 98.
17. Kaminski, *Ware Ich Chinese*, pp. 104–7
18. Conger, *Letters from China*, p. 219.
19. Kaminski, *Ware Ich Chinese*, pp. 104–7
20. Conger, *Letters from China*, p. 220.
21. *The Times*, London, dateline Peking 1 February 1902.
22. Conger, *Letters from China*, 10 May 1902, pp. 235–6.
23. Bainbridge, unpublished 'A Siege in Peking', 1 February 1902.
24. Lo, *Correspondence of G.E. Morrison*, letter from J.O.P. Bland to George Morrison, 12 February 1902, vol. 1, p. 178.
25. Conger, *Letters from China*, p. 224.
26. Conger, *Letters from China*, 16 March, p. 229. After Tz'u-hsi's death in 1908, the 'Manchu princesses maintained this atmosphere of cordiality and were often to be seen at Legation parties' – C.A.V. Bowra, unpublished 'Memoirs', 1874–1932, p. 212.
27. Susan Townley tells (p. 100) how she and Tz'u-hsi became so friendly that she was given, among other presents, 'a set of the imperial yellow dishes which she used for her meals'. This may equate with Dr Mariam Headland's explanation of why

Tz'u-hsi stopped eating with foreign women. At a lunch a woman guest had the temerity to ask for a bowl, as a souvenir, from which her hostess was eating. Tz'u-hsi hid her consternation and asked a eunuch to prepare two, as it was the custom to give in pairs; but she ended by explaining apologetically that 'I should be glad to give bowls to each of you, but the Foreign Office has requested me not to give presents at this audience' (Headland, pp. 99–100).

28. Katherine Carl wrote: 'In spite of Her Majesty's cordiality ... there seemed an absolute lack of harmony among the ladies of the Legation. Each seemed to watch the other with a jealous eye, in constant fear that someone might overstep her place' – Katherine Carl, *With the Empress Dowager of China* (1986), p. 169. In 1905, a Morrison informant relayed a story from the German Minister, Baron Mumm: 'When the Lister Kaye's [sic] were here, Lady LK got an audience of the Empress Dowager just at the time the concession was hanging fire. She went there with a fine diamond tiara which the old Empress did not fail to admire which gave Lady K the opportunity she wanted to "spontaneously" take it off and present it to her. It was a bit of a gamble as she stood to lose her tiara in addition to the concession – but it paid in the end' – Lo, *The Correspondence of G.E. Morrison* vol. I, from G.D. Gray, 3 August.

29. Der Ling, *Two Years in the Forbidden City*, pp. 366–7; Seagrave, *The Dragon Lady*, p. 409, deduces that the woman was Alicia Little (e-mail, 31 October 1999). Alicia does not tell her side of this story in *Round My Peking Garden* (1905); indeed, she writes very much as if her only view of Tz'u-hsi was on her return to Peking in 1902 when foreigners caught a glimpse of her, while noting that other foreign women had seen her with 'eyes raised', 'her smile', and 'conversed with her', p. 52.

30. Headland, *Court Life in China*, pp. 101–2.

31. Carl, *With the Empress Dowager of China*, p. 91.

32. Mrs Archibald Little, *Round My Peking Garden* (1905), p. 57.

33. In spite of the edict, the provisional government which followed the fall of the Manchu Dynasty had to abolish footbinding in 1912. For more details of Alicia Little's anti-footbinding campaign and her life, see 'Mrs Little and Big Feet' in Susanna Hoe, *The Private Life of Old Hong Kong* (1991), pp. 226–31.

34. Lo, *The Correspondence of G.E. Morrison*, letter from Morrison to Chirol, 7 September 1903, vol. 1, p. 230. Suggestions about good relations can only be carried so far. Der Ling tells of a debriefing with the Empress Dowager following an audience with foreign women which included Mrs Conger. After criticising their large feet and white hairy faces, Tz'u-hsi added '... they have ugly eyes. I can't bear that blue color, they remind me of a cat.' (*Two Years in the Forbidden City*, p. 144).

35. Ho, *Biographical Dictionary of Chinese Women*, p. 366 (entry by Yu Shanpu and Susan Wiles).

36. Conger, *Letters from China*, letter to her daughter Laura, 14 March 1902, p. 215.

Biographical Details
(alphabetical)

If you have any further information about any of these women, please let the author know

key

ABCFM American Board of Commissioners for Foreign Missions (Congregational)
dau. daughter, or daughter of
IG Inspector General (of Imperial Maritime Customs)
IMC Imperial Maritime Customs
LMS London Missionary Society (Methodist)
m. married, or married to
MEM Methodist Episcopal Mission (American)
MO medical officer

Siege of the Legations

ANDREWS, Mary E., of Cleveland; ABCFM boys' boarding school, T'ung-chou, from 1868 and, from at least 1880, teaching women and girls. In Peking 1922.

ARC, Mme d', m. George d'Arc, assistant manager Peking Hotel. Stayed there during siege.

ARMSTRONG, 'Arkie', dau. Major William Cairns Armstrong; sister of Lady MacDonald (q.v.). Lived with MacDonalds, Peking, and looked after their daus. Ivy and Stella, and household.

BAILIE, Mrs, m. Joseph Bailie (professor of English, Imperial University; former Baptist minister). In Peking from at least 1898. Served LMS hospital pre-siege, and siege hospital. Mother of Victoria.

BAINBRIDGE, Mary, m. William E. Bainbridge, 2nd Secretary, American Legation. Unpublished diary 'Besieged in Peking'.

BARBIER, Olga (?), m. R.T. (or J.) Barbier of Russo-Chinese Bank and secretary board of directors Chinese Eastern Railway. In Peking 1922.

BERGAUER, Mlle, elderly, long-serving retainer of Baroness d'Anthouard (m. French Secretary of Legation; both in siege of Tientsin). Supervised running of French Legation house in British Legation.

BERTEAUX, Mme, m. F. Berteaux, 1st Interpreter and Chancellor, French Legation.

BOK, Mme, of Swedish Mission, N. China. Lost one infant, 6 August; had at least one other child (dau.); heavily pregnant.

BRANDT, Mme, née Chamot (?), m. A. Brandt of Tallieu & Co. (storekeepers, commission agents, manufacturers of Peking cloisonnées, and silk factors). In Peking Hotel during siege.

BRAZIER, (Marian) Daisy, 1871–1913; dau. Professor James S. Brazier (1825–1889), Aberdeen University, and Emma Russell (1832–1898); sister of (James) Russell Brazier, of IMC. With sister-in-law Annie Myers (q.v.), filtered water for siege hospital; awarded Royal Red Cross. Post-siege, trained as nurse. d. Leipzig. 29 at siege.

BRAZIER, Helen Elizabeth, 1874–1902; dau. William Wykeham Myers of IMC (b.1846) and Alice Jones (1848–1920); sister of Annie Myers (q.v.); b. Chefoo and brought up

379

in China; educated by her mother; m., Formosa 1893, (James) Russell Brazier (Chief Secretary IMC from 1899; 1st appointed 1878). Treasurer Women's Winter Refuge. Mother of Willie (6) and Helen Hope (6 months); 2nd child d. 1899 and she d. in Scotland just after birth of 4th. 26 at siege.

BREDON, Juliet, b. c.1881, China; dau. Robert Bredon (British Deputy IG IMC; 1846–1918) and American Lily Banks (q.v.); niece of Sir Robert Hart (IG IMC); m. 1911 Frenchman Charles H. Lauru (IMC from 1898; deputy commissioner 1910; d. 1930). Away from Peking 6 years post-siege. 1922, Board of Managers, Peking Institute of Fine Arts. Author of several books on China; still lived Peking 1930s. Published 'A Lady in Besieged Peking'. c.19 at siege.

BREDON, Lily, dau. Thomas Crane Banks of San Francisco; m. 1879 Robert Bredon (1846–1918; Deputy IG ICM 1898–1908 (joined service 1873) and brother-in-law of Sir Robert Hart, IG; 1900–04 he was in charge Shanghai; knighted 1904; acting IG, Peking, 1908–10; d. Peking). Post-siege, lived Shanghai until at least 1906. Still in Peking 1922. Mother of Juliet (q.v.).

BRENT, Charlotte Louisa, 1840–1926; dau. Thomas J. Ditchburn, shipbuilder; m. 1872 Arthur Brent, banker, and left with him for Japan. From 1874–83, 4 children b. Yokohama, including, 1874, Arthur Ditchburn. After family's return to England, travelled, November 1899, for health to Japan and Peking where her son ADB worked for Hongkong and Shanghai Bank (started 1897 Shanghai). 60 at siege.

BREWITT-TAYLOR, Ann Amy Jane, d. 1947; dau. Alexander Michie (1833–1902; he worked China 1853–95?). m. 1894 as 2nd wife Charles Henry Brewitt-Taylor (1857–1938; in China from 1880 as professor of mathematics, Foochow; IMC from 1891; 1900, assistant Chinese Secretary, already appointed Commissioner, Swatow) Their child d. 1896.

BROWN, Amy; American (?) Presbyterian of Christian and Missionary Alliance, Peking from at least 1897.

CHAMOT, Annie-Elizabeth, b. c. 1871, San Francisco; dau. Eugene McCarthy, property developer, and Harriet. 1893–94, passed through Peking with her mother; met Auguste F. Chamot (1867–1910) of Lausanne then working in family-run Peking Hotel; married him in San F. 1895 (aged 24); returned with him to hotel of which, by 1900, he was proprietor (also partner (?) in Tallieu & Co). Dubbed 'Angel of the Peking Legations'; awarded Legion of Honour for outstanding siege bravery and activities. They retired to San F. 1903 rich from government honours and post-siege looting; lost much property and wealth in 1906 earthquake. Divorced 1908; she lived with her mother until 1909 when she m. Gus Renstrom, chauffeur who had taught her to drive. 29 at siege.

CHAPIN, Abbie G., brought up in China; relative of Frank Chapin (see below), From at least 1884 with ABCFM at Bridgman Girls' School Peking; from 1893, T'ung-chou working with women and girls; experienced in nursing. In charge siege hospital diet; awarded Royal Red Cross (only American).

CHAPIN, Mrs Frank M.; guest from ABCFM Tientsin during siege. T'ung-chou from at least 1880; 1886 moved to Linch'ingchou; formerly in Kalgan. Mother of Ralph and Ernest.

CLARA, German governess to children of Harriet and Herbert Squiers, Secretary American Legation.

COCKBURN, Elizabeth, dau. Colonel Stevenson Gordon; m. 1899 Henry Cockburn (1859–1927; Chinese Secretary British Legation 1896–1906; entered consular service China 1880; in Peking from 1891; Consul-General Korea 1906–09; retired to England 1910). Newly married at start of siege; pregnant during siege; dau. b. c. 17 September 1900. 1 son, Claud (b. 1904).

COLTMAN, Mrs, m. Dr Robert Coltman jnr (physician to American Legation; arrived China c. 1883 with Presbyterian Mission; left over his 'business methods'; from 1896, professor of anatomy and physiology Imperial College; professor of surgery and medicine, Imperial University; sent dispatches to Chicago *Record*). 6 children; some or all b. China. Spoke Chinese. In Peking 1922.

CONDIT SMITH, Polly (Mary) b. c.1877; niece of Chief Justice Field of US Supreme Court. On round-the-world tour staying with Harriet Squiers (q.v.), American Legation. As Mary Hooker, wrote *Behind the Scenes in Peking*. 23 at siege.

CONGER, Laura, dau. Sarah Pike Conger (q.v.) and American Minister. Retrieved her health during siege. 1st child b. 1903; 1904, received many presents, including from Empress Dowager – tribute to Sarah Conger.

CONGER, Sarah, née Pike, b. c.1843; m. 1866 lawyer Edward Hurd Conger (1843–1907; Congressman 1884–90; Minister to Brazil 1890–97; Minister Plenipotentiary China 1898–1905). Arrived Peking Summer 1898. Sometimes mocked as Christian Scientist but also known during siege as 'the Fairy God-Mother'. Mother of Laura (q.v.) and 1 other child; aunt of Mary Pierce (q.v.). Doyenne of diplomatic wives for audience of 1902 and developed friendly relations with Empress Dowager, imperial princesses and mandarin women. 1905, he was briefly Minister to Mexico but retired. Published *Letters from China*. 57 at siege.

CUILLIER, Mme, Frenchwoman (or Belgian?) shot by sniper day of Relief (14 August).

DOUW, D. Matilda, 1891, with her own funds, set up (American Presbyterian) Christian and Missionary Alliance, Peking, sometimes called Douw Mission – independent ministry for women and girls. Left China post-siege and her work in Peking discontinued.

DUDGEON, Miss, one of 5 daus. Dr John Dudgeon (to China 1864, LMS Hospital). Her sister Nellie was 1st wife, d. 1893, of Professor Charles Henry Oliver, President Imperial College from 1899. His 2nd wife, Alice, née Mitchell, was not at siege, but Miss D. was, apparently looking after 2 Oliver sons.

EVANS, Jane G., ABCFM missionary T'ung-chou.

EWING, Bessie, b. c.1870–1966; dau. George Walstein Smith and Mary Hough; m. 1894 Charles Ewing (c.1869–1927). With ABCFM China 1894–1911, Peking and Tientsin. Mother of Marion (5) and Ellen (20 months); pregnant during siege (Edward, b. 26 December 1900); 2nd son, 4th child, b. 1902. Also adopted Chinese, Martha, who d. during siege. Charles stayed in China until 1913; family settled New Haven; Charles returned to China 1920; Bessie followed. Charles killed in car crash back in New Haven; Bessie unhurt. Siege letters published in *Death Throes of a Dynasty*. 30 at siege.

FENN, Alice, 1865–1938; b. Corning New York; moved to Washington DC with foster parents Dr and Mrs Henry May; graduated Vassar College 1889. m. USA, 1892, Courtenay H. Fenn (b. 1866; 1893, boys' boarding school, American Presbyterian Mission Peking; principal, 1899). 1898, involved in establishment of Women's Winter Refuge. Mother of Henry (b. Peking 1894), Martha (b. November 1898), Billy (b. 1903). From 1912, more time to work for women and girls; still in Peking 1922, Martha teaching North China American school, T'ung-chou. 35 at siege.

FILIPPINI, Mme, m. 1st interpreter, French Legation.

GALT, Mrs, m. Howard S. Galt (b. 1878). With ABCFM, T'ung-chou from 1889, teacher. In Peking 1922.

GAMEWELL, Mary Q., 1848–1906, née Porter. 1871, sent by MEM to new school for girls, Peking, dedicated to unbinding feet. Frank D. Gamewell, civil engineer, arrived at school 1881; they m. 1882. He was appointed Chungking 1884; she was injured and imprisoned in riot of 1886. She was appointed to training school for Bible women, Peking, when he became professor of chemistry and physics, Peking University.

Methodist Mission and British Legation relied on his engineering skills during siege. 1906, she fell ill in harness in New Jersey and d. Mary Porter Gamewell school established Peking, pupils including great-great-niece of Li Hung-chang. Her sister Mrs A.H. Tuttle published her siege and other notes. 52 at siege.

GIERS, Mlle de, dau. Russian Minister Michel N. de Giers (Peking 1897–1901) and step-dau. Mme de Giers (q.v.). Helped in siege hospital.

GIERS, Mme de; 2nd wife of Michel N. de Giers, Russian Minister, Peking 1897–1901; she was also previously m. Step-mother of Mlle de Giers (q.v.); 1 son, Constantine (16). She was invaluable in siege hospital.

GILMAN, Gertrude, Women's Foreign Missionary Society, MEM.

GLOSS, Dr Anna, Women's Foreign Missionary Society, MEM; arrived Tientsin 1885. Nurse in siege hospital.

GOODRICH, Sara (Sarah), 1855–1923; dau. Rev. Luther Clapp and Harriet Boardman of Wauwatosa. Attended Rockford Seminary for Women, Illinois, 1873–77, then taught there. With Women's Missionary Board, ABCFM, in China from 1879; at first Kalgan. 1880, m. twice widowed Chauncey G. Goodrich (1836–1925; in China from 1865). Stationed T'ung-chou. 1st child, b. USA, d. T'ung-chou 1888; 3 others at siege, Grace (11), Dorothea (8; d. diabetes China 1904) and Carrington (5). Founded girls' school T'ung-chou in memory of Dorothea. Spoke and read Chinese; strong co-worker with him; later prominent mission lecturer and campaigned for more support for married women missionaries and for Chinese women (unbinding feet) and Women's Winter Refuge, Peking; 1912, Secretary Women's Christian Temperance Union (opium), with Grace her secretary. d. Peking. Unpublished diary, 'Journal of 1900'. 45 at siege.

GOWANS, Annie H., British citizen from Toronto; with (American Presbyterian) Christian and Missionary Alliance. One of 3 'American' missionary women working on diet in siege hospital. Post-siege and closure of Douw (q.v.) Mission, joined American Presbyterian Mission, Paotingfu; left China 1925.

HAVEN, Ada, b. c.1850, Brookline, Mass. 1879–1900, in charge ABCFM Bridgman Girls' School, Peking. Missionary since 1875; expert on Greek and Mandarin. In charge of 30 or so schoolgirls during siege. m. 20 or 25 September 1900, Chefoo, as 2nd wife, missionary Calvin Mateer (1836–1908; in China from 1863) Joined Presbyterian Mission; became assistant Testament translator to him, and chief reviser and abridger of his Mandarin lessons. Returned Peking 1913; still there 1922. As Mrs A.H. Mateer, ed. *Siege Days*. 50 at siege.

HOUSTON, Mrs; m. Hong Kong April 1900 M.H. Houston, British manager of Chinese Imperial Bank, Peking. Helped in siege hospital.

IMBECK, Frau, m. Carl Imbeck, German storekeeper, wine and spirit merchant, commission agent. Their only 2 children d. during siege, 20/21 June; 5 July, aged 2 years.

INGLIS, Theodora, née Marshall of Chicago; m. Dr John Inglis, American Presbyterian Mission; arrived Peking 1898. Their dau., Elizabeth, d. enteritis 22 July. Elizabeth's Nanny was Wang Nai Nai. Unpublished 'Siege Diary 1900'.

INGRAM, Mrs, m. 1895 in USA as 2nd wife Dr James H. Ingram (b. 1858; ABCFM missionary, T'ung-chou from 1888). Stepmother of Ruth, mother of Miriam. She and daus. in Peking 1922; Ruth nursing Union Medical College Hospital and Supt. Nurses Training School.

ISHII, Mme, m. Ishii Kikujiro (1866–1945; Secretary Japanese Legation; later Ambassador to Washington).

JEANRENAUD, Mme, German m. Swiss Charles Jeanrenaud (dealer in curios, carpets, etc.; suspected of being Boxer spy). Spent siege in Peking Hotel.

JEWELL, Mrs Charlotte M.; in China from 1883, Women's Foreign Missionary Society, MEM; 1885, joined Dr Anna Gloss (q.v.) Tientsin, training classes for women. Principal girls' school and in charge of 100 or so during siege. By 1906, principal Mary Gamewell (q.v.) school; 1910, principal Haung Lu-yin Peking school; in Peking 1922.

KER, Lucy, 1868–1969; b. Saskatoon, Canada, dau. Dr Charles Murray and Elizabeth Mackenzie. Educated Halifax Ladies College and taught English there under her future husband's sister. m. 1897 William Pollock Ker (1864–1945, British consular service China from 1888, then Seoul; Peking 1892; 1899, Assistant Chinese Secretary, British Legation; 1902, consul Wuhu, 1905, Nanking; called to the Bar, Middle Temple, 1903; 1909–17, commercial attaché Peking; 1917–26, consul general Peking). She arrived China 1897, Soochow, then Shanghai. Murray Ker d. aged 2 years, 4 months, a week after siege (21 August); 2nd son, 1902–1904; last of 5 sons d. Nanking aged 10. Post-siege, in charge of redecorating British Legation and hostess for new Minister; taught Russian boy Constantine de Giers English; during World War I, helped Russian refugees in Britain. Unpublished autobiography written in her eighties, and contemporary letters about siege. 32 at siege.

KETTELER, Maud (Matilda Cass) von, 1871–1960; eldest child, only dau. Henry Brockholst Ledyard (engineer, from 1883 President Michigan Central Railroad) and Mary R. L'Hommedieu (American railroad family; m. 1867; d. 1895); paternal grandfather and great-grandfather were American diplomats in Paris. Travelled widely in Europe. m. 1897, Detroit, Baron Clemens von Ketteler (1853–1900; then Secretary German Legation, Washington; thereafter, Minister Mexico; appointed Minister, Peking, July 1899; earlier, 1880–90, Interpreter, Legation, Peking; distinguished himself when foreign settlement attacked in Canton 1888). His murder, 20 June 1900, may have saved diplomatic community from similar fate and marks beginning of siege. Brother killed in action, Philippines, 6 December 1899. Much pitied during siege. Post-siege, lived with father, Detroit, until he d. 1921; in 1935 she lived Villa Gamberaia, near Florence. Established Cottage Hospital, Grosse Point, Michigan, 1919, and donated art collection to University of Michigan, 1942. Widow 60 years. Some unpublished papers. 29 at siege.

KILLIE, Louisa Scott, b. 1856, Iowa; m. Charles A. Killie; with him to China 1889 with American Presbyterian Mission, starting Ichow-fu; then Peking, country work.

KORSAKOVA, Mme, m. V.V. Korsokov (surgeon, Russian Legation and volunteer during siege). 1 dau.

KRUGER, Frau, m. J. Kruger (German manager of Danish Kierulffs, commission agents, dealers in curios and manufacturers of Peking enamels). Only child d. during siege.

LAMBERT, Marian, d. 1942; trained nurse with Church of England Mission from 1898; matron, siege hospital; awarded Royal Red Cross. Opened women's dispensary with Miss Hung (q.v.), 1902; resigned through ill-health 1922.

LEONARD, Dr Eliza Ellen, 1866–1842; b. Kossuth, Iowa; from Tacoma Washington. Graduated Parson's College 1888; University of Michigan, Medical Faculty, grad. 1895, then to China with American Presbyterian Mission, replacing Dr Mariam Headland (q.v.). Nurse in siege hospital. By 1908, Dean North China Union Medical College for Women; d. Peking. 34 at siege.

LOWRY, Mrs, m. Edward K. Lowry, MEM, director of Industrial Department, Peking University. He was in Tientsin until relief column set out for Peking where she was besieged. Sister-in-law of Mrs George Lowry (q.v.).

McCOY, Bessie Campbell, 1871–1940; dau. (1 of 8 children) Daniel Charles McCoy and H. Pollock, missionaries in Peking until 1889. Educated Parson's College and Lake Forest; Chicago kindergarton training school under Jane Addams; taught 4 years. 1896 sent by American Presbyterian Mission to join Grace Newton (q.v.) at girls' boarding

school Peking; kindergarten classes. Spoke Chinese. In Peking 1922, technician Peking Union Medical College Hospital. 26 at siege.

MACDONALD, Ethel (Lady, later Dame), 1857–1941; dau. Major William Cairns Armstrong of Roscommon; widow of Craigie Robertson of Indian Civil Service (d. cholera with their children); m. 1892 Major Claude Maxwell MacDonald (1852–1915; Consul-General, Oil Rivers (later Niger Coast) Protectorate; on retirement from British Army, appointed Envoy-Extraordinary and Minister Plenipotentiary, Peking, 1896–1900; KCB 1898; GCMG 1900; military KCB 1901; appointed Minister Tokyo 1900; 1st British Ambassador there, 1905–12; GCVO 1905; Privy Councillor 1906). Mother of Ivy (5) and Stella (3, b. Peking); Doyenne of diplomatic corps wives; suggested and led meetings with Empress Dowager December 1898 and March 1900. In 1915, on his death, lived Royal Cottage, Kew; continued involvement with Overseas Nursing Association (started Japan); chair, Nursing Committee; retired through ill-health 1934; Dame, 1935; d. Sidmouth. Published 'My Visits to the Dowager-Empress of China' and 'Besieged in Pekin'. 43 at siege.

MACKEY, Dr Maud Aura, b. 1872, Evanston, Illinois; educated Occidental College and State Normal School, California; full course Medical School, Los Angeles, plus 1 year in Children's Hospital. In China from 1899 with American Presbyterian Mission; left Paotingfu April 1900, thus escaping certain death. Nurse in siege hospital. 28 at siege.

McKILLICAN, Janet (Jennie), b. 1855 Vankleet Hill, Ontario, Canada. In China from 1880 with American Presbyterian Mission. Left Paotingfu April 1900, thus escaping certain death. In Peking 1922. 45 at siege.

MADEMOISELLE, French governess to children of Harriet (q.v.) and Herbert Squiers, American Legation.

MARIE, Sister, with Sisters of Charity; rescued, with 10 other foreign nuns, 13 June from South Cathedral; nursed in siege hospital.

MARTIN, Elizabeth (Lizzie), b. c.1873, Otterbein, Indiana; sister of Dr Emma (q.v.). Graduated de Pauw University and Chicago Training School (missionary preparation). Arrived Peking May 1900 with MEM. 27 at siege.

MARTIN, Dr Emma E., b. c.1870, Otterbein, Indiana; sister of Lizzie (q.v.). Graduated de Pauw University; 4 years Chicago Women's Medical College, plus 1 year internship in Hospital for Women and Children; Chicago Training School (missionary preparation). Arrived China May 1900; physician with MEM Peking. Nurse in siege hospital. 1922, teaching at North China Union Medical College for Women; practising Sleeper-Davis Memorial Hospital. Unpublished diary. 30 at siege.

MATEER, LaRhue, m. John Mateer, ABCFM missionary from 1894; he d. 23 April 1900; body desecrated in Foreign Cemetery, Peking, 12 June; discovered 3 September.

MEARS, Mrs; m. Christopher B. Mears (handyman IMC; gas engineer from 1880). Their dau. Kitty d. 1984. Organised, with Mrs S.M. Russell, Inspectorate Mess during siege.

MILLER, Elizabeth, governess to family of Mme and M. de Giers, Russian Minister.

MINER, Luella, 1861–1935, of Oberlin, Ohio; dau. missionaries Daniel Irenaeus and Lydia Jane Cooley; 2nd of 7 children. Entered Oberlin College class of 1884. Taught black students, Lexington, Ky., and Fisk University, Nashville Tenn. for 3 years. 1887, appointed N. China by ABCFM, starting Paotingfu, moving, 1889, to teach, in Chinese, mathematics, geology, physiology, history at Boys' High School, T'ung-chou. Wrote standard geology text in Chinese. 1903, appointed Principal Bridgman Girls School, Peking, and 1905, organised North China Women's College – 1st for girls; President until 1920 when it merged with Yenching University and she became Dean. Gained entry to Peking reform circles and provided lecture series and support for Manchu women newly emerging in public. Post-Revolution, helped form committee for protection of women and children; post-1919, involved in 4 May Movement. 1923

moved to Cheeloo for 12 years and d. there. Author of *China's Book of Martyrs*, 'A Prisoner in Peking' and unpublished diary. 39 at siege.

MOORE, Mrs, m. J.M. Moore (book-keeper, Peking Hotel and Tallieu and Co.). Son b. 24 June 1900 'of Chinese and French parentage', nicknamed 'Siege Moore'.

MORISSE, Mme, m. 2nd Interpreter, French Legation.

MYERS, Annie, 1875–1967, b. and brought up in China; dau. Dr William Wykeham Myers (b. 1846) and Alice Jones (1848–1920). Parents in China from 1869, he attached IMC and British Consular Service, MO at Foochow until 1895, then political adviser to Japanese Government, Formosa, based Takow; attached to force relieving Peking at Tientsin (base hospital). Educated by her mother; staying with sister Helen Brazier (q.v.) at siege. She and sister-in-law, Daisy Brazier (q.v.), served siege hospital and awarded Royal Red Cross. m. Euan Mackinnon of consular service; 2 children. May have published anonymous siege account; unpublished diary 'The Siege of Peking'. 25 at siege.

NAKAGAWA, Mme, m. Nakagawa Jiuzen (surgeon, trained Berlin and Tokyo, Japanese Legation).

NARAHARA, Mme, dau. Marquis Saigo, Japanese Home Minister; m. Narahara Nobumasa (2nd Secretary Japanese Legation who also studied Edinburgh and Chinese scholar; in China 6 years; formerly private secretary of Marquis Ito and present at peace negotiations, Shimonoseki, 1895; Buddhist). He was wounded 11 July; d. 24 July in siege hospital of tetanus; she helped nurse him. 2 children.

NEWTON, Grace, 1860–1915, South Orange, New Jersey. Peking from at least 1893 with American Presbyterian Mission in charge of girls' boarding school; dispatched girls to their homes pre-siege; only 6 of 50 survived, some in siege. Proficient in Chinese. Post-siege, in charge of girls' boarding school Paotingfu. 40 at siege.

NISHI, Baroness, m. Nishi Tokujiro (b. 1847; Japanese Minister to Peking from 1899; studied in Russia 1871–76; 2 years legation Paris, then Russian to 1880; 1886–96 Minister St Petersburg; 1895 cr. baron; 1897 Foreign Minister).

OGAWA, Mme, m. Ogawa Ryouhei of Japan, working for Peking Power Company.

PARROT, Mme m. Belgian engineer on Peking–Hankow railway line. Rescued 29 May from Ch'ang-hsien-tien, with 8 other women, 7 children, 13 men by Auguste and Annie Chamot.

PAYEN, Cecile E., b. Dubuque, Iowa, French descent. Painter of miniature portraits and watercolours; studied New York and Paris; exhibited Art Institute of Chicago 1892–98. Guest of Mrs Conger (q.v.), American Legation, from April 1900. Published 'Besieged in Peking'.

PICHON, Mme, m. Stéphen-Jean-Marie Pichon (1857–1933; French Minister to Peking; previously French parliamentarian, 1889–94; Minister to Haiti, 1894; to Italy, 1894–96; to Brazil, 1896; arrived Peking early 1898; resident-general, Tunisia, 1901–06; Foreign Minister, French Government, 1906–11; and 1917–20; Senator, 1906–24).

PIERCE, Mary, niece of Mrs Conger (q.v.).

PIRY, Mme, m. A. Theophile Piry (d. 1918; French Secretary of Chinese Postal Service, IMC; Commissioner at Lappa (Macao) 1896–1900; 1st appointed IMC 1874). 3 daus. 1 son.

POKOTILOVA, Mme, m. Dmitri D. Pokotilov (d. 1908; Director, Russo-Chinese Bank from 1896; arrived Russian Legation, Peking, 1888; later entered Russian finance administration; returned Peking to Bank and Director-General, Manchurian Railway (Chinese Eastern Railway); Russian Minister, Peking, 1905–08; d. *en poste*). Former opera singer St Petersburg, and teacher; her voice inspirational during siege.

PONS, Mme, governess to 4 children of Mme Piry (q.v.).

POPOVA, Mme, m. P.S. Popov, Interpreter, Russian Legation. 5 daus.

POZDNEEVA, Mme, m. D.M. Pozdneev of Russo-Chinese Bank and assistant director of Chinese Eastern Railway. 1 child.

RANSOME, Edith, c. 1856–1930; appointed Peking, 1898, Church of England Mission to assist younger sister Jessie (q.v.) and ordained Deaconess. Facility for languages enabled her to learn Chinese and teach both languages and translate; she also conveyed her love of botany and natural history. Ill-health during siege confined her to advising on nutrition in siege hospital. On Jessie's death, just before her own return to Peking in 1905, became head of women's work in Church of England diocese, Peking. In his later years in retirement in Peking, supported Bishop Scott (see Mrs Scott, siege of Tientsin). d. Peking. 44 at siege.

RANSOME, Jessie Molyneux, 1857–1905; b. Lancaster; sister of Edith (q.v.). Deaconess Church of England Mission; head of St Faith's Home for Women Workers, Peking, from November 1896 until her death. Aspired to missionary work from 18; partly trained in nursing (curtailed through ill-health) and experienced in teaching in England; nurse in siege hospital; awarded Royal Red Cross. Published *The Story of the Siege Hospital in Peking*. 43 at siege.

REID, Mrs, m. Gilbert Reid (Presbyterian active in Mission Among the Higher Classes in China 1894- ; arrived China 1882). He was wounded 5 July. 1 child.

ROSTHORN, Paula von, 1873–1967, b. Vienna; dau. Dr Johann Pichler (1834–1904, dentist) and Josia Kner (1843–1919). m. Vienna 1895 Dr Arthur von Rosthorn (1862–1945; in China since 1883, at first with IMC; entered Austro-Hungarian Consular Service 1895; Peking early 1896). Paula joined him November from Shanghai. He was Chargé d'Affaires during siege, based French Legation where she joined him from British. Nursed and fed defenders; known as 'Good Fairy of the Defence'. Said to be pregnant pre-siege but no children. Post-siege, Vienna, awarded Order of Elizabeth, and Emperor Franz Joseph's personal medal – only woman – and Legion of Honour. At Peking Legation again 1902–06; he was Minister to Tehran 1911 and, 1911–17, Minister to Peking. Siege account published Vienna 1989. 27 at siege.

RUSSELL, Nellie, with ABCFM, city work, Chicago; 1890, to China; became Chinese speaker, primarily concerned with Chinese women in their homes; travelled extensively in Chihli Province. One of 3 American women missionaries in charge of diet in siege hospital. 1910, opened centre in Peking, with classes, for women of official and literary families.

RUSSELL, Mrs, m. S. Marcus Russell (professor of mathematics and astronomy Imperial College, from 1879). She organised, with Mrs Mears (q.v.), Inspectorate Mess. Post-siege, he became IMC Commissioner, Foochow. Her siege diary published in *The Story of the Siege of Peking*.

RUTHERFORD, Hattie E, British subject attached to (American Presbyterian) Christian and Missionary Alliance in Peking under Miss D.M. Douw (q.v.).

SALVAGO RAGGI, Camilla, née Pallavicinio (Marchesa), d. pre-1918; m. 1890, Genoa, Marchese Guiseppe Salvago Raggi (1866–1946, b. Genoa; entered diplomatic service 1889; title recognised 1890; served Madrid, St Petersburg, Constantinople, Cairo; 2nd Secretary, Peking, 1897–98; returned as Italian Minister 1899–1901; later served Cairo, Zanzibar, Eritrea). Attacked by mob 1898. Noted for toilette during siege. Mother of Paris.

SAUSSINE, Mme, m. student interpreter, French Legation.

SAVILLE, Dr Lillie Emma Valimeetua, 1869–1911; b. Huahine, Society Islands; dau. Rev. A.T. Saville. Studied London School of Medicine for Women; appointed missionary doctor West City Peking by LMS 1895. Nurse in siege hospital; awarded Royal Red Cross. Left Peking 1905 through ill-health and left LMS 1908; returned to Tientsin to

practise under Chinese Government; d. there. Published *Siege Life in Peking* and 'The Siege of Peking'; unpublished letters. 31 at siege.

SHEFFIELD, Miss M.E., 1899, ABCFM missionary Bridgman Girls' School. Responsible, with Ada Haven (q.v), for schoolgirls during siege; also helped in siege hospital. Post-siege, she restarted school with Grace Wyckoff (q.v.). m. 1903.

SHILSTON, Ethel, b. 1874, Stoke Newington; LMS missionary, Peking, September 1899. Post-siege, moved to Tientsin; 1902, m. Rev. E. Box Shanghai Mission. 26 at siege.

SMITH, Emma, née Dickinson, d. 1926; m. 1871 Arthur Henderson Smith (1845–1932). 1872, to China with ABCFM; at first Tientsin; from 1880 Shantung for nearly 25 years (until 1905). Helped with schoolgirls and foreign children during siege. d. Peking. 1910, he wrote *China in Convulsion* dedicated to her and their 29 years in China.

SMITH, Georgina, b. 1857, Bristol. Arrived Peking with LMS 1884. Took charge of girls' boarding school in East City. Only British woman among Americans in Methodist Mission during semi-siege. Post-siege, reorganised East City Mission; protected local community from foreign troops; awarded 6 pairs of 'Myriad People Canopy'. 1903, m. colleague Thomas Biggin in Shanghai and they took charge of 3 country stations between Peking and T'ing-chou; then joined North China Union College. Unpublished letters. 43 at siege.

SMITH, Mary, née Burton of Sydney, d. 1917; appointed LMS 1897 and m. in Shanghai, Thomas Howard Smith (b. 1864; LMS appointed 1896 from Sydney). Ran girls' school, Peking; disbanded pre-semi-siege. 1 baby. All 3 Tunghsien 1922; d. Pei-ta-ho.

SQUIERS, Harriet Bard, d. 1935; dau. of Dr William P. Woodcock and Mary Bard of New York; granddaughter of John Jacob Astor; m. as 2nd wife 1889, Herbert Godsmith Squiers (1859–1911; teacher of military science; 1891, active service; 1894–97, 2nd Secretary Berlin Embassy; 1899, Secretary Legation, Peking). He was chosen chief of staff to Sir Claude MacDonald, 16 July; her generosity with food supplies appreciated. 3 sons at siege (also had 4 stepchildren, at least 1 at siege). 1902–05, he was Minister to Cuba. She was active in work for the wounded in World War I.

STEPHANIE, Sister, of Sisters of Charity; rescued 13 June with 10 other foreign nuns from South Cathedral; nursed siege hospital.

STONEHOUSE, Gertrude Eliza, née Randall. Arrived China with LMS 1884; m. 1884, Shanghai, Joseph Stonehouse (1854–1901; arrived China with LMS 1882). They moved to Peking 1886 and worked East City. She returned to England 1891, and 1895; in Peking during siege with 7-year-old son and baby. He was killed by robbers, T'ung-chou, 1901; she returned to England.

TERRILL, Alice, MA; MEM missionary; professor of mathematics, Peking University; still there 1918.

TERRY, Dr Edna G. of Women's Foreign Mission (MEM), stationed Tsun-hua from 1887; guest in Peking pre-siege. Nurse in siege hospital.

TEWKSBURY, Grace, m. ABCFM missionary Elwood Gardner Tewksbury (b. c.1865; Harvard graduate). Arrived North China College T'ung-chou 1890. Mother of Donald (5) and Gardner.

TITOVA, Mlle C. of Russo-Chinese Bank. Sister (?) or dau. (?) of C.W. Titov of Ratouieff & Co., merchants, Tientsin or Titov, engineer-in-chief Chinese Eastern Railway, Newchang, Manchuria.

TOURS, Ada Theophila, 1869–1956; dau. Samuel Harwood and Theophila Frances Cruttenden. 1897, to Peking to marry childhood friend Berthold George Tours (1871–1944; student interpreter from 1893; accountant, Peking Legation, May 1899–1900). 1st child, Violet, to be known as 'Siege Baby' and later Mrs Garnons Williams, b. February 1899; 2 children b. 1902 and 1908. 1902, he was assistant in shipping, Shanghai; 1906, Consul, Chinkiang; 1922, Consul-General; retired 1930.

She did not accompany him when children were of school age. After his death, she lived and d. at Abercamlais, Powys. Unpublished diary. 31 at siege.

WALKER, Mrs W.F., MEM missionary, Tientsin; arrived back in China May 1900. Chinese speaker. Guest in Peking pre-siege. Mother of Esther.

WOODWARD, Ione, dau. Mrs M.S. Woodward of Evanston, Chicago (q.v.); guest of Mrs Conger (q.v.), American Legation since April.

WOODWARD Mrs M.S., of Evanston, Chicago; guest of Mrs Conger (q.v.), American Legation, since April. Took photographs and helped in siege hospital – known as 'Mamma'; formed singing quartet to entertain in hospital and at bell tower. Mother of Ione (q.v.).

WYCKOFF, Gertrude, b. c.1864; ABCFM missionary Pangchuang from 1887. 36 at siege.

WYCKOFF, Grace, b. c. 1864; ABCFM missionary Pangchuang from 1887. Post-siege, reopened Bridgman Girls' School with Miss Sheffield (q.v.); 1912, reopened girls' boarding school Tientsin closed by revolution scares of 1911. 36 at siege.

WYON, Mrs, d. 1900. m. Edward Wyon (1837–1906; member of engraving and medal family of several generations employed by Ralph Heaton and Sons of Birmingham. Having previously set up mints in Cairo, Japan, Brazil, Burma, Colombia and Canton (1887) where he stayed to supervise, invited by Chinese government to do the same in Peking). Although a complete stranger within foreign community, befriended widowed Mrs Narahara (q.v.) and bereaved Theodora Inglis (q.v.). d. as result of siege.

Siege of the Pei-t'ang

FRAISSE, Sister, Superior of Cha-la-eul.

JAURIAS, Sister Hélène Anaïs Marguérite de, 1824–1900; dau. Count de Jaurias (Chateau Jaurias, Bordeaux). Entered French order Sisters of Charity of St Vincent de Paul 1844; sent to China 1855, 1st Ningpo; 1863, organiser Municipal Hospital, Shanghai; then to Peking and, by 1871, set up House of Immaculate Conception (Jen-tse-t'ang) with almshouse and dispensary; later a school and, elsewhere in Peking, a hospital. During siege in charge of 30 sisters and two and a half thousand women, children and infants. d. a week after relief (21 August). Her siege diary translated and published in *The Heroine of the Pe-Tang*. 76 at siege.

VINCENZA, Sister, Italian. Ran dispensary in French Hospital for over 30 years; there 1912.

Siege of Tientsin

ANTHOUARD, Baroness d'; m. Secretary of French Legation. Detained in Tientsin during siege but their house and possessions appreciated by defenders of their Peking legation.

DREW, (Abbie) Anna, née Davis; m. 1874 Connecticut, Edward Bangs Drew (1843–1924; graduated Harvard 1863; IMC since 1865; Commissioner 1868; Chief Secretary 1889–93; Commissioner Tientsin from 1898). Full household during siege, including Herbert and Lou Hoover (q.v.), Mrs George Lowry (q.v.) and Edward Lowry, but excluding Drew daus. Elsa, Kathleen and Lucy, and son Lionel, sent away 15 June. Eventually had 6 children b. China. Unpublished siege diary.

HOOVER, Lou, 1874–1944, b. Waterloo, Iowa; dau. Charles Delano Henry and Florence Weed. Grew up Monterey, California; through interest in geology, enrolled Stanford University 1894; met there Henry Hoover; m. him, now mining engineer, British co., 10 February 1899 and left next day for Peking, later Tientsin; stayed 2 years. During siege distinguished herself by active bravery and hospital work. 2 sons b. London, 1903 and 1907. Active in war work 1914–17; post-war, they lived Stanford. Together translated *De Re Metallica* (1556). He was US President 1919–33. She d. New York, buried Palo Alto. 26 at siege.

LOWRY, Mrs; m. 1894 Dr George Davis Lowry (b. 1867 Foochow; s. of Hiram Harrison, Superintendent N. China MEM. From 1894 physician MEM Hospital Peking; 1896–1906 professor histology and pathology Medical College Peking University). Though Peking resident, caught visiting Tsun-hua June and took refuge Tientsin with Anna Drew (q.v.) and brother-in-law Edward Lowry also stranded. 1922, taught Peking American School.

SCOTT, Frances Emily, 1853–1900; dau. Professor Montagu Burrows (1819–1905; retired Royal Navy, Chichele Professor of History, Oxford University, 1862) and Mary Anna Gardiner (Brocas family, m. 1849, d. 1906). Educated at home and Isle of Wight school. Missionary interest first in Africa; 1887–89, joined a brother in Ceylon. m. 1889 Charles Perry Scott (1847–1927; C of E Bishop of North China at Peking 1880–1913 and chaplain British Legation; in China from 1874). In China from 1889; Chefoo 1890; Peking thereafter. Treasurer native girls' school; started working party for missionary women and Christian Chinese girls; secretary Women's Winter Refuge; provided support and comforts for C of E missionaries; Scotts bought and furnished for them St Hilary's in Western hills. Stranded Tientsin June 1900 and in Gordon Hall for siege; nursed wounded cousin then evacuated to Weihaiwei. d. Nagasaki days after rejoining him in Tientsin.

Miscellaneous Foreign Women

BLAKE, Edith (Lady), dau. Ralph Bernal M.P. and Catherine Isabella Osborne; m. 1874, as 2nd wife, Sir Henry Blake (1840–1918, Governor Hong Kong 1898–1903). Set up Natural Foot Society Hong Kong; March 1900, held anti-foot-binding meeting Government House, inviting Chinese women for 1st time and addressed by Alicia Little (q.v.). Thereafter, travelled China, Korea and Japan; in Shanghai, President 4-day women's conference, including footbinding; Peking in May, 1 week. Correspondent of George Morrison. 1901, set up Hong Kong Nursing Institution. 2 sons, 1 dau., Olive, Secretary Natural Foot Society. Unpublished diary of Asian tour.

HEADLAND, Dr Mariam, née Sinclair, in Peking as physician with American Presbyterian Mission at Women's Hospital from at least 1893; later physician to imperial princesses and mandarin women. 1894 m. Isaac Taylor Headland (MEM missionary; professor of mental and moral science and of practice of medicine, Peking University). On leave in United States at siege. Post-siege, her contacts useful to Mrs Conger (q.v.) and facilitated visits. Her experience of Court life informs his book.

LITTLE, Alicia, 1845–1926; b. Madeira, youngest dau. Calverley Bewick of Leicestershire and Mary Hollingsworth; educated by her father; became a novelist (1st pub. 1885) and served philanthropic committees. m. 1886 Archibald Little (1838–1908; in China since 1855; commercial career leading to formation of Upper Yangtse Steam Navigation Co., and Kiangpeiting Mining Co. of Szechwan). She arrived China 1887; his work allowed her to travel, observe and write. 1895, founded Natural Foot Society, Shanghai, and travelled campaigning against bound feet. 1900, vice-president Women's Conference, Shanghai. Widowed soon after return to England (1908); continued work for women and travelling almost until death at 81. In Shanghai during siege.

Chinese Women

CHEN-fei (Zhenfei) Pearl Concubine, 1876–1900; dau. Ch'ang Hsu, Governor of Canton; 1889, secondary consort, with her sister Lustrous Concubine (Chin-fei; Jinfei), to Kuang-hsu Emperor (1871–1908); promoted imperial consort 1894; favourite and perhaps only friend of Emperor. d. (murdered ?; by orders of Empress Dowager ?) 15 August 1900 as imperial party left Forbidden City; later honoured. Lustrous Concubine

accompanied imperial party into exile and back and remained in Forbidden City after deaths of Emperor and Empress Dowager and Revolution.

CH'ING (Tching, Tseng), Mme; mother of Ch'ing Ch'ang, Minister to France 1896–99 (?); long-established Manchu R.C. family. Relatives and dependents killed and injured, palaces looted and burnt, pre-siege and took refuge, destitute, Fu. Relative of Marquis Tseng Kuang-luan. Post-siege, he moved dependents into American sector and helped Americans until November 1900 when party moved, under US army escort, to family home, Hunan.

DER LING (Yu Deling), 'Princess', 1885 (?)-1944 (?); dau. Yu-keng (?-1905; member of Manchu imperial family; Minister to France 1899–1903). Spent 6 years in Europe and was Western-educated. With her sister, appointed lady-in-waiting to Empress Dowager and became interpreter 1903–04; hoped to influence Tz'u-hsi for reform. 1907, m. Thaddeus C. White, American Deputy-Consul Shanghai. 1st book about Court life – *Two Years in the Forbidden City* – pub. US 1911. Some question her existence, title, veracity.

HUNG Mary, medical assistant Church of England Mission; accompanied Deaconess Jessie Ransome (q.v.) to British Legation, semi-siege. Post-siege, left with C of E party; 1902, opened women's dispensary, Peking, with Nurse Lambert (q.v.).

LIN Hei-erh, Holy Mother of Yellow Lotus (Huanglien sheng-mu) b. c.1880; leader of Red Lanterns Shining Society, Tientsin. m. Li-you (boatman); became anti-foreign when husband jailed over dispute with foreigner. Organised young girls and said to cure sick at altar on Grand Canal. Liaised with Boxer leaders on battle plans near Tientsin. Executed on fall of city to Allies.

SAI Chin-hua (Sai Jinhua) 1874–1936, courtesan on flower boat from 1886, and concubine to mandarin Hung-ch'un from 1887; travelled with him on diplomatic mission to Europe 1887–90; learnt German. On his death, resumed her career. Following Field-Marshal von Waldersee's arrival in Peking as Commander-in-Chief of relief forces, October 1900, said to have become his mistress, met Baroness von Ketteler, and improved relations between foreign troops and Chinese and conditions of latter. d. in poverty and obscurity but became dramatic and legendary figure.

TONG Pao Yue, also May Tong, d. 1918; dau. Tong Shao (or Shoa) Yi (T'ang Shao-i) (Director of Railways Tientsin 1900, later Chief Minister Manchu Dynasty and First Premier Republican Government) and his second wife, née Tan, killed during siege of Tientsin. Rescued from shell-hit house by Herbert Hoover. 1913, m. Shanghai, Wellington Koo (graduate Columbia University; 1918, Minister to United States). d. Washington D.C. in Spanish influenza epidemic.

TZ'U-HSI, Empress Dowager, 1835–1908, of Yehe Nara Clan; member of Manchu Trimmed Blue Banner; dau. Hui-cheng, minor military official; secondary consort, 1851, Hsien-feng Emperor (r.1850–61); mother of his only surviving son. On his death in exile from foreign incursion, became, with consort Tz'u-an (d. 1881), co-regent, 1861–72, and Empress Dowager. 1862, elevated to member of Manchu Trimmed Yellow Banner. When her son, the Emperor, d. 1875, responsible for choice of her nephew as Kuang-hsu Emperor (1871–1908). Relinquished new regency on his marriage to her niece (Empress Hsiao-ting; Lung-yu) 1889. 100 days of reform (11 June-21 September 1898) initiated by Emperor, and apparent threats to her safety, led to her *coup d'état*. Ascendancy of anti-foreign advisers surrounding family of heir-apparent to her childless nephew led also to influence of anti-foreign, anti-Christian Boxers and so to Siege of the Legations (20 June–14 August). Exact role still debated. Exile 15 August 1900–7 January 1902; returned following Peace Protocol September 1901. 1 February 1902, resumed contact with foreign diplomatic women initiated 13 December 1898. d. 1 day after her nephew and 3 years before creation of Republic.

Bibliography

Published Works

Abbott, P.E. and Tamplin, J.M.A., *British Gallantry Awards* (London, Nimrod Dix, 1981).

Ahern, Emily M., 'The Power and Pollution of Chinese Women' in Margery Wolf and Roxane Witke eds, *Women in Chinese Society* (Stanford, California, Stanford University Press, 1975).

Allen, Reverend Roland, *The Siege of the Peking Legations: Diary* (London, Smith Elder, 1901).

Anon, 'The Siege of Peking, a Narrative from Day to Day: An Englishman's Diary' (A.D. Brent?); 'With the Experiences of an American Missionary, and a Lady' (Annie Myers?) reprinted from the *North China Daily* (Shanghai, 1900).

Anthouard, Baron A.F. d', *La Chine Contre l'Etranger* (Paris, Plon-Nourrit, 1902).

Arlington, L.C., and Lewisohn, William, *In Search of Peking* (Hong Kong, Oxford University Press, 1987; first published 1935).

Baldwin, S.L., *The Chinese Recorder and Missionary Journal*, vols 1–64, 1869–1933, Foochow, Shanghai.

Bazin, René, *L'Enseigne de Vaisseau Paul Henry* (Tours, 1905).

Beals, Reverend Z., *China and the Boxers: A Short History of the Boxer Outbreak* (New York, Munson, 1901)

Beresford, Charles, *The Memoirs of Admiral Lord Charles Beresford*, 2 vols (London, Methuen, 1914).

Bigham, Clive, *A Year in China 1899–1900* (London, Macmillan, 1901).

Bland, J.O.P., and Backhouse, E., *China Under the Empress Dowager* (London, Heinemann, 1910).

Blue Book, 'Parliamentary Papers', *China*, no. 1, 1899; *China*, no. 3, 1900; no. 4. 1900; no. 3, 1901.

Bodin, Lynn E., *The Boxer Rebellion* (London, Osprey, 1979).

Brandt, Nat, *Massacre in Shansi* (Syracuse, Syracuse University Press, 1944).

Bredon, Juliet, 'A Lady in Besieged Peking' in *The World Wide Magazine*, pp. 452–7, August 1901.

Bredon, Juliet, *Sir Robert Hart: The Romance of a Great Career Told by his Niece* (London, Hutchinson, 1909).

Bredon, Juliet, *Peking* (Hong Kong, Oxford University Press, 1982; first published 1919).

Brent, A.D., 'The Siege of Peking: By One Who Went Through It' in the *Daily News*, October, 1900.

Brown, Frederick, *From Tientsin to Peking with the Allied Forces* (London, C.H. Kelly, 1902).

Brown, Frederick, *Boxer and Other China Memories* (London, A.H. Stockwell, 1936).

Bryson, Mrs, *Cross and Crown: Stories of the Chinese Martyrs* (London, London Missionary Society, 1904).

Buck, David, *Recent Chinese Studies of the Boxer Movement* (Amonk, New York, M.E. Sharpe, 1987).

Buck, Pearl, *My Several Worlds: A Personal Record* (London, Methuen, 1955).

Cameron, Nigel, *Barbarians and Mandarins: Thirteen Centuries of Western Travellers in China* (Hong Kong, Oxford University Press, 1989).

Campiche, P., 'Notes sur la Carrière d'Auguste Chamot', in *Revue Historique Vaudoise*, pp. 21–38, March 1955.

Carl, Katherine, *With the Empress Dowager of China* (London, KPI, 1986; first published 1906).

Chamberlain, W.J., *Ordered to China: Letters … Written from China while under Commission from the New York 'Sun' during the Boxer Uprising of 1900 and the International Complications that Followed* (New York, Stokes, 1903).

Chamot, Annie (see Campiche, O'Brien, Robbins, *San Francisco Call*).

Chang Hsin-hai, *The Fabulous Concubine* (Hong Kong, Oxford University Press, 1986; first published 1956).

China (Imperial) Maritime Customs Service List (Shanghai, Inspectorate General of Customs, 1900).

Chow Jen Hwa, *China and Japan: The History of Chinese Diplomatic Missions In Japan 1877–1911* (Singapore, Chapman, 1975).

Christein, Heidi, 'A Detroit Baroness in Peking' in *Michigan History Magazine* vol. 81, no. 1, January/February 1997.

Chronicle and Directory for China etc. for the Year 1900 (Hong Kong, Hong Kong Daily Press, 1900).

Chung, Sue Fawn, 'The Much Maligned Empress Dowager: A Revisionist Study of the Empress Dowager Tz'u-hsi in the Period 1898 to 1900' (unpublished doctorate, University of California, Berkeley, 20 December 1975); and an article in *Modern Asian Studies*, 13, 2 (1979) (Cambridge University Press).

Coates, P.D., *The China Consuls* (Hong Kong, Oxford University Press, 1988).

Cohen, Paul A., *History in Three Keys: The Boxers as Event, Experience, and Myth* (Columbia, Columbia University Press, 1997).

Coltman, Robert, jr, *Beleaguered in Peking: The Boxer's War Against the Foreigner* (Philadelphia, F.A. Davis, 1901).

Condit Smith, Polly (see Hooker).

Conger, Sarah Pike, *Letters from China: With Particular Reference to the Empress Dowager and the Women of China* (Chicago, A.C. McClurg, 1909).

Couling, S., *The Encyclopaedia Sinica* (Hong Kong, Oxford University Press, 1983; first published 1917).

Cranmer-Byng, J.L., 'The Old British Legation at Peking 1860–1959', in *Journal of the Royal Asiatic Society* vol. 3, (Hong Kong, 1963).

Croll, Elisabeth, *Wise Daughters from Foreign Lands: European Women Writers in China* (London, Pandora, 1989).

Darcy, Eugène, *La Défense de la Légation de France à Pékin* (Paris, Augustus Challamel, 1901).

Der Ling, Princess, *Old Buddha* (New York, Dodd, Mead, 1928).

Der Ling, Princess, *Two Years in the Forbidden City* (New York, Dodd, Mead, 1929).

Der Ling, Princess, *Kowtow* (New York, Dodd Mead, c.1930).

Der Ling, *Imperial Incense* (London, Stanley Paul, 1934).

Donnet, Gaston, *En Chine 1900–1901* (Paris, Paul Ollendorf, 1902).

Duiker, William J., *Cultures in Collision: The Boxer Rebellion* (San Rafael, Presidio Press, 1978).

Esherick, Joseph W., *The Origins of the Boxer Uprising* (Berkeley, University of California Press, 1987).

Ewing, Bessie (see Ruoff).

Fairbank, John King et al. ed., *The I.G. in Peking: Letters of Robert Hart Chinese Martime Customs 1868–1907*, 2 vols (Cambridge, Mass., Belknap/Harvard University Press, 1975).

Fan Hong, *Footbinding: The Liberation of Women's Bodies in Modern China* (London, Frank Cass, 1977).

Fleming, Peter, *The Siege at Peking* (London, Rupert Hart-Davis, 1959).

Frey, General Henri Nicolas, *Français et Alliés au Petchili, Compagne de Chine en 1900–1901* (Paris, Hachette, 1904).

Gamewell, Mary (see Tuttle).

Guillot, Lt-Col., *Pékin Pendant l'Occupation Etrangère en 1900–1901* (Paris, Charles-Lavauzelle, 1904).

Haldane, Charlotte, *The Last Great Empress of China* (London, Constable, 1965).

Hart, Robert, 'The Peking Legations: A National Uprising and International Episode' reprinted from *The Fortnightly Review* (Shanghai, 1900).

Hart, Robert, *These from the Land of Sinim: Essays on the Chinese Question* (London, Chapman Hall, 1903).

Headland, Isaac Taylor, 'Heroes of the Peking Siege', in *Munsey's Magazine*, vol. XXIV, no. 5, pp. 577–89, February 1901.

Headland, Isaac Taylor, *Court Life in China: The Capital, its Officials, and People* (New York, Fleming H. Revell, 1909).

Henry, Léon, *Le Siège de Pe't'ang dans Pékin en 1900* (Paris, 1908).

Hewlett, W. Meyrick, *The Siege of the Peking Legations June to August 1900* (Harrow, Editors of the Harrovian, 1900).

Hewlett, W. Meyrick, *Forty Years in China* (London, Macmillan, 1943).

Ho, Clara Wing-chung ed., *Biographical Dictionary of Chinese Women: Qing Period, 1644–1911* (Armonk, New York, M.E. Sharpe, 1998).

Hoe, Susanna, *The Private Life of Old Hong Kong: Western Women in the British Colony 1841–1941* (Hong Kong, Oxford University Press, 1991).

Hoe, Susanna, *Chinese Footprints: Exploring Women's History in China, Hong Kong and Macau* (Hong Kong, Roundhouse (Asia), 1996).

Hoe, Susanna and Roebuck, Derek, *The Taking of Hong Kong: Charles and Clara Elliot in China Waters* (London, Curzon Press, 1999).

Hooker, Mary, *Behind the Scenes in Peking* (London, John Murray, 1910).

Hoover, H.C., *Memoirs* 2 vols (London, Hollis and Carter, 1952).

Hubbard, Ethel Daniels, *Under Marching Orders: A Story of Mary Porter Gamewell* (New York, Young People's Missionary Movement, 1909).

Hummel, Arthur, *Eminent Chinese of the Ch'ing Period* (Taipei, Ch'eng Wen, 1970).

Hunt, Michael H., 'The Forgotten Occupation: Peking 1900–1901' in *Pacific Historical Review* 48.4, pp. 501–29, November 1979.

Hunter, Jane, *The Gospel of Gentility: American Women Missionaries in Turn-of-the-Century China* (New Haven, Yale University Press, 1984).

Hunter, Jane, 'Luella Miner' entry in *American National Biography*, eds John A. Garraty and Mark C. Carnes (New York, Oxford University Press, 1999).

Hyatt, Irwin, *Our Ordered Lives Confess: Three Nineteenth Century American Missionaries* (Cambridge, Mass., Harvard University Press, 1976).

Irwin, Will, *Herbert Hoover: A Reminiscent Biography* (London, Mathews and Marrot, 1929).

James, Edward T. ed., *Notable American Women: A Biographical Dictionary 1607–1950* (Cambridge, Mass., Belknap/Harvard University Press, 1971).

Japan Herald, 'A Lady's Experience of the Peking Siege' (Mrs Brent) 23 October 1900.

Japan Herald Mail, 'More About the Peking Siege' (Mrs Brent) 4 October 1900.

Janvrais, Théophile, 'La Fée de la Défense – Mme de Rosthorn', *Figaro*, 24 June 1901, in Pelacot, Colonel de, *Expédition de Chine* (Paris, Henri Charles-Lavauzelle, 1900).

Jellicoe, George (Earl of), *The Boxer Rebellion* (Southampton, University of Southampton, 1993).

Johnston, Reginald F., *Twilight in the Forbidden City* (Hong Kong, Oxford University Press, 1985; first published, 1934).

Kalyuzhnaya, N.M., *Vostanie Ichetuanei 1898–1901* (Moscow, Academy of Science, 1978).

Kaminski, Gerd, and Unterrieder, Else, *Ware Ich Chinese, so Ware Ich Boxer* (Vienna, Europaverlag, 1989).

Kazuko, Ono, *Chinese Women in a Century of Revolution, 1850–1950* (Stanford, Stanford University Press, 1978).

Ketler, Isaac C., *The Tragedy of Paotingfu* (New York, Fleming H. Revell, 1902).

Keown-Boyd, Henry, *Fists of Righteous Harmony: A History of the Boxer Uprising in China in the Year 1900* (London, Leo Cooper, London 1991).

Kieser, Egbert, *Als China Erwachte: Der Boxeraufstand* (Munich, Bechtle Verlag, 1984).

Land of Sinim, (see Society for the Propagation of the Gospel).

Landor, Henry Savage, *China and the Allies*, 2 vols (London, Heinemann, 1901).

Laur, F., *Le Siège de Pékin: Récits Authentiques des Assiégés* (Paris, Société des Publications Scientifiques et Industrielles, 1904).

Life and Times of the Emperors and Empresses in the Forbidden City (in Chinese) (Beijing, China Travel and Tourism Press, 1983).

Little, Mrs Archibald (Alicia), *Intimate China: The Chinese as I have seen them* (London, Hutchinson, 1899).

Little, Mrs Archibald, *In the Land of the Blue Gown* (London, Everett, 1902).

Little, Mrs Archibald, *Life of Li Hung Chang* (London, Cassell, 1903).

Little, Mrs Archibald, *Round my Peking Garden* (London, Fisher Unwin, 1905).

Lo Huimin, *The Correspondence of G.E. Morrison 1895–1912*, 2 vols (Cambridge, Cambridge University Press, 1976).

Lochbiler, Don, 'Maude and the Empress Dowager' in *The Detroit News*, 30 April 1963.

Lodwick, Kathleen ed., *The Chinese Recorder Index: A Guide to Christian Missions in Asia, 1867–1941*, 2 vols (Wilmington, Del., Scholarly Resources, 1986).

Loti, Pierre, *Les Derniers Jours de Pékin* (Paris, 1902).

Lynch, George, *The War of the Civilizations: Being a Record of a 'Foreign Devil's' Experience with the Allies in China* (London, Longmans, Green, 1901).

Lynch, George, *Impressions of a War Correspondent* (London, George Newnes, 1903).

McAleavy, Henry trans., *That Chinese Woman: The Life of Sai-chin-hua* (London, George Allen & Unwin, 1959).

Mabire, Jean, *L'Été Rouge de Pékin* (Paris, Fayard, 1978).

MacDonald, Claude, 'The Japanese Detachment During the Defence of the Peking Legations 1900' in *Transactions of the Japan Society of London*, vol. XII, Part 1, 1913–14.

MacDonald, Claude, 'Some Personal Reminiscences of the Siege of the Peking Legations in 1900' in *The Journal of the Royal United Service Institution*, vol. LIX, no. 437 (London, August 1914).

MacDonald, Ethel, 'Besieged in Pekin', in *The Lady*, pp. 246–56 (London, March 1901).

MacDonald, Ethel, 'My Visits to the Dowager-Empress of China' in C. Kinloch Cooke ed. *Empire Review* vol. 1, no. 3, (London, Macmillan, April 1901).

MacDonald, Ethel (see Piggott).

MacGuillvray, Donald, ed., *A Century of Protestant Missions in China* (1807–1907) (Shanghai, American Presbyterian Press, 1970).

McLeish, W., *Tientsin Besieged and After the Siege from 15 June to 16 July* (Shanghai, 1901).

Marchant, Leslie R., *The Siege of the Peking Legations: A Diary, Lancelot Giles* (Western Australia, University of Western Australia Press, 1970).

Martin, W.A.P., *The Siege in Peking: China Against the World* (Shannon, Irish University Press, 1972; first published 1900).

Mason, Jack, 'Charlie Mel' in *Summertown* (Point Reyes, California, Northshore Books, 1973).

Mason, Jack, 'In Search of Chamot' in *Point Reyes West* (Point Reyes, California, Northshore Books, 1981).

Mateer, Mrs A.H. (Ada Haven), *Siege Days: Personal Experiences of American Women and Children During the Peking Siege* (New York, Fleming H. Revell, 1903).

Matignon, J.J., *La Défense de la Légation de France* (Bordeaux, Revue Philomatique, 1902).

Matignon, J.J., *Dix Ans au Pays du Dragon* (Paris, A. Maloine, 1910).

Mazeau, Henri, *The Heroine of Pe-Tang: Hélène de Jaurias, Sister of Charity (1824–1900)* translated from the French (London, Burns Oats, 1928).

Miner, Luella, 'A Prisoner in Peking: The Diary of an American Woman During the Siege' in *Outlook*, November 10, pp. 641–9; 17, pp. 697–705; 24, pp. 734–41 (New York, 1900).

Miner, Luella, 'The Flight of the Dowager Empress' in *Century Magazine*, vol. 39, pp. 777–80, (New York, March 1901).

Miner, Luella, *China's Book of Martyrs: A Record of Heroic Martyrdoms and Marvellous Deliverences of Chinese Christians During the Summer of 1900*, (New York, Pilgrim Press, 1903).

Morrison, G.E., articles in *The Times* (London, 13, 14, 15, October 1900).

Morse, H.B., *The International Relations of the Chinese Empire* 3 vols, (London, Longmans Green, 1910–1918).

O'Brien, Robert, 'Riptides' (Chamot) in *San Francisco Chronicle* Editorial page, 26 and 28 February 1947.

O'Brien, Robert, *This San Francisco: A Classic Portrait of the City* (San Francisco, Chronicle Books, 1994).

O'Connor, Richard, *The Boxer Rebellion* (London, Robert Hale, 1973).

Oglander, Cecil Aspinall, *Roger Keyes* (London, Hogarth Press, 1951).

Oliphant, Nigel, *A Diary of the Siege of the Legations in Peking* (London, Longmans Green, 1901).

Oudendyk, William J., *Ways and By-Ways of Diplomacy* (London, Peter Davies, 1939).

Parliamentary Papers (see Blue Book).

Pascoe, C.F., *Two Hundred Years of the S.P.G. 1701–1900* (London, 1901).

Payen, Cecile, 'Besieged in Peking' in *The Century Magazine*, pp. 453–68, (New York, January 1901).

Pearl, Cyril, *Morrison of Peking* (Melbourne, Angus & Robertson, 1967).

Pelacot, Colonel Charles de, *Expédition de Chine de 1900* (Paris, Henri Charles-Lavauzelle, 1903).

Pichon, Stéphen, *Dans la Bataille* (Paris, 1908).

Piggott, F.S.G., 'Ethel, Lady MacDonald, D.B.E. R.R.C.' (obituary) in *Transactions and Proceedings of the Japan Society London* vol. xxxviii, 1931–1941, pp. xx–xxvi.

Pruitt, Ida, *A Daughter of Han: The Autobiography of a Chinese Working Woman* (Stanford, Stanford Univesity Press, 1976; first published 1945).

Purcell, Victor, *The Boxer Uprising: A Background Study* (Cambridge, Cambridge University Press, 1963).

Ramsey, Alex, *Peking Who's Who 1922* (Peking, Ramsey, 1922).

Ransome, Jessie, *The Story of the Siege Hospital in Peking, and Diary of Events from May to August 1900* (London, Society for Promoting Christian Knowledge, 1901).

Rausch, F.V., *Mit Graf Waldersee in China* (Berlin, 1907).

Ricalton, James, *Photographs of China During the Boxer Rebellion* (New York, Underwood, 1902).

Robbins, Millie, 'Millie's Column' (Chamot) in *San Francisco Chronicle* 13 and 14 March 1960.

Robinson, Jane, *Angels of Albion: Women of the Indian Mutiny* (London, Viking, 1996).

Rodzinski, Witold, *The Walled Kingdom: A History of China from 2000 BC to the Present* (London, Flamingo, 1984).

Rosthorn, von (see Kaminski).

Ruoff, E.G. ed., *Death Throes of a Dynasty: Letters and Diaries of Charles and Bessie Ewing, Missionaries to China* (Kent, Ohio, Kent State University Press, 1990).

Russell, S.M., *The Story of the Siege in Peking* (London, Elliot Stock, 1901).

Russell, Wilmot, in *The National Review* (London, May, July 1926).

Saillens, M.M.P., *Campagne de Chine: Mai à Septembre 1900, Journal d'un Officier* (Paris, 1901).

San Francisco Call, 'Angel of Peking Weds Chauffeur' (Annie Chamot) 2 July 1909.

San Francisco Chronicle.

Saville, L.E.V., *Siege Life in Peking* (London, London Missionary Society, c.1900).

Saville, Lillie E.V., 'The Siege of Peking: Its Medical Aspects' in *The China Medical Missionary Journal* (London, January, 1901).

Scidmore, E.R., *China, the Long-Lived Empire* (London, Macmillan, 1900).

Seagrave, Sterling, *Dragon Lady: The Life and Legend of the Last Empress of China* (New York, Vintage, 1993).

Sergeant, Philip, *The Great Dowager Empress of China* (London, Hutchinson, 1910).

Shanghai Mercury, 'The Boxer Rising: A History of the Boxer Trouble in China' (reprinted from the *Shanghai Mercury*, 2nd Edition, August 1901).

Shaw, Cass Ledyard, *The Ledyard Family in America* (West Kennebunk, Maine, Phoenix, nd).

Shiba Gorou, *Pekin in roujou* and *Pekin roujou nikki* (Tokyo, Heibonsha, 1965).

Sibree, James, *A Register of Missionaries* (London, 1923).

Smith, Arthur H., *China in Convulsion*, 2 vols (Shannon, Irish University Press, 1972; first published 1901).

Society for the Propagation of the Gospel, *Land of Sinim* vol. VIII, no. 4, October 1900 and vol. IX, no. 1, January 1901 (North China Mission); vol. XIV no. 1 January 1906 (*North China and Shantung Quarterly Paper*).

Soothill, Lucy, *A Passage to China* (London, Hodder and Stoughton, 1931).

Spence, Jonathan, *The China Helpers: Western Advisers in China 1620–1960* (London, The Bodley Head, 1969).

Spence, Jonathan, *The Search for Modern China* (New York, W.W. Norton, 1990).

Steel, Richard, A., *Through Peking's Sewer Gate: Relief of the Boxer Siege 1900–1901* (New York, Vantage Press, 1985).

Sweeney, James O., *A Numismatic History of the Birmingham Mint* (Birmingham, Birmingham Mint, 1981).

Tan, Chester C., *The Boxer Catastrophe* (New York, Norton, 1967).

Thomson, H.C., *China and the Powers* (London, Longmans, 1902).

Townley, Lady Susan, *My Chinese Notebook* (London, 1904).

Townley, Lady Susan, *'Indiscretions' of Lady Susan* (London, Thornton and Butterworth, 1922).

Townsend, W.E., *In Memoriam* (printed for private circulation, 1901).

Trevor-Roper, Hugh, *The Hermit of Peking: The Hidden Life of Sir Edmund Backhouse* (London, Macmillan, 1976).

Tuttle, A.H., *Mary Porter Gamewell and Her Story of the Siege in Peking* (New York, Easton & Mains, 1907).

Valli, Mario, *Gli Avvenimenti in Cina nel 1900 e l'Azione della R. Marina Italiana* (Milan, Ulrico Hoepli, 1905).

Varè, Daniele, *The Last of the Empresses* (London, John Murray, 1936).

Vaughan, H.B., *St George and the Chinese Dragon: An Account of the Relief of the Peking Legations* (London, C. Arthur Pearson, 1902).

Velde, [Carl], *Ruckblick auf die Ereignisse in Peking im Sommer 1900* (1906) in *Militär Wochenblatt*, supplemantary vols of *Beihefte* (1906) pp. 149–85 (Berlin).

Waldersee, Graf von, *A Field Marshal's Memoirs: From the Diary, Correspondence and Reminiscences* ... cond. and trans. F. Whyte, (London, Grant Richards, 1924).

Warner, Marina, *The Dragon Empress* (London, Weidenfeld and Nicolson, 1972).

Weale, B.L.Putnam (pseud.), *Indiscreet Letters from Peking* (New York, Dodd, Mead, 1909).

Wen Ching (pseud.), *The Chinese Crisis from Within* (London, Grant Richards, 1901).

Who's Who in the Far East 1906–7 (Hong Kong, 1906–07).

Winterhalder, Theodor Ritter von, *Kampfe in China* (Vienna, A. Hartleben, 1902).

Witte, Count Sergius, *Memoirs* trans. & ed. Abraham Yarmolinky, (Armonk, New York, M.E. Sharpe, 1990; first published 1921).

Wolf, Margery, 'Women and Suicide in China', in Margery Wolf and Roxane Witke, *Women in Chinese Society* (Stanford, Stanford University Press, 1975).

Wright, Stanley F., *Hart and the Chinese Customs* (Belfast, W.M. Mullan, 1950).

Wu Yung, *The Flight of an Empress* trans. Ida Pruitt (London, Faber and Faber, 1937).

Unpublished Works

Bainbridge, Mrs W.E. (Mary), 'A Siege in Peking of the Legations' (typescript) in Lou Hoover Papers, Boxer Rebellion: Diaries, Herbert Hoover Presidential Library.

Bainbridge, W.E., 'Besieged in Peking' (typescript) in Lou Hoover Papers, Boxer Rebellion: Diaries, Herbert Hoover Presidential Library.

Biege, Heinrich, 'Mein Erinnerungen aus dem Leben am 20. Juni 1900 in Peking erschossenem Kais. Gesandten Freiherrn Cl. von Ketteler' (transcript) Stadtarchiv, Munster, Westphalia.

Blake, Edith (Lady), 'A Journey in China, Corea and Japan, 1900' (typescript) Cambridge University Library, Add 8423.

Bowra, C.A.V., 'Memoirs 1874–1932' (typescript, 3 vols) in Papers Relating to the Chinese Maritime Customs 1860–1943, Special Collections, School of Oriental and African Studies (SOAS) London.

Brent, Arthur, 'My Life Story' typescript, in the family's possession.

Brent, Arthur D., letters to his father, Arthur Brent, and to his friend William Pitcher, in the family's possession.

Brent, Charlotte (Mrs Arthur), 'British Legation During the Siege' Notebook, in the family's possession (Brent Notebook).

Drew, Mrs E.B., Siege Diary (typescript) in Lou Hoover Papers, Boxer Rebellion: Diaries, Herbert Hoover Presidential Library.

Fenn, Mr and Mrs Courtenay H., assorted press cuttings, in group no. 8, box no. 68 and 69, China Records Project, Yale Divinity School Library, (Fenn Cuttings).

Fenn, Courtenay, 'Diary of Courtenay Hughes Fenn (1866–1953)' (typescript) RG8 box 68–9, China Records Project, Yale Divinity School Library.

Fleming, Peter, Correspondence following publication of *The Siege at Peking* (1959) in Reading University Library (Fleming Correspondence).

FO17/1337 and 1411, Public Record Office, Kew.

Goodrich, Sara Boardman (Mrs Chauncey G.), 'Journal of 1900' (typescript) in Miscellaneous Personal Papers, Manuscript Group no. 8, box no. 90, China Research Project, Yale Divinity School.

Hart, Robert, 'Diary', Queen's College, Belfast.

Hoover, Herbert, 'History of Inside the Circle' (corrected typed draft) in Lou Hoover Papers, Boxer Rebellion: Drafts, box no. 14, Herbert Hoover Presidential Library.

Hoover, Herbert, 'History from 28th May to 17th June 1900' in Lou Hoover Papers, Boxer Rebellion: Drafts, Box no. 14, Herbert Hoover Presidential Library.

Inglis, Theodora, 'Siege Diary 1900' (typescript) in John Inglis Papers, box no. 1, Hoover Institution Archives, Stanford.

Ketteler, Baron and Baroness von, assorted newspaper cuttings, including 'The Homecoming of Baroness von Ketteler', *Detroit News* September ? 1900 (Homecoming) and unpublished letter to Maude Hendrie, Ledyard Family Papers, Burton Collection, Detroit Public Library (Ledyard Papers).

Ketteler, Maud von, 'Account of Meeting the Dowager Empress of China' File Box 6:14, Ms Ledyard Family Papers, Burton Collection, Detroit Public Library (Maud von Ketteler).

Ketteler, Baron and Baroness von, assorted newspaper cuttings, Stadtarchiv, Munster, Westphalia (Archives Munster).London Missionary Society (LMS), letters (Thomas Biggin, Lillie Saville, Georgina Smith, Howard Smith, Joseph Stonehouse) North China, Box 12, Special Collections, School of Oriental and African Studies (SOAS), London.

Martin, Dr Emma, 'Diary' (typescript) and letters, in Miscellaneous Personal Papers, Manuscript Group no. 8, box no. 137, China Records Project, Yale Divinity School Library.

Miner, Luella, 'Siege Journal 1900–1901', American Board of Commissioners for Foreign Missions (ABCFM) Personal Papers: Miner, Luella (1:1–1:4) Houghton Library, Harvard University.

Morrison, George E., 'Diary', 1900, ML MSS312/9 item 2, Morrison Papers, Mitchell Library, State Library of New South Wales.

Myers, Annie, 'The Siege of Peking: From One Point of View' (typescript) in the family's possession.

Poole, Captain F.G., microfilm, National Army Museum, London.

Tours, Ada (Mrs B.G. Tours), 'Siege Diary 1900' and assorted newspaper cuttings, in the family's possession (Tours Diary and Tours Cuttings).

Tours, B.G., Lectures (typescripts) in the family's possession.

United Society for the Propagation of the Gospel (USPG)/D/133a China No. 68, Rhodes House, Oxford.

Index

Page number in **bold** denotes entry in Biographical Details

205–6, 229, 237–9, 244, 254, 261, 281, 293–6, 301, 311, 317, 322, 332, 333, 338
Frey, General N. 128, 300, 332, 372 n47
Fu, the, see Su-wang-fu
Fuller, 199–200, 206, 213, 215, 260–2, 278, 301

Galt, Mrs Howard, 178–80, **381**
Gamewell, Frank, 55, 70–1, 117, 148–9, 190
Gamewell, Mary, 18–21, 55–6, 70–2, 114, 118–19, 122, 134–5, 137, 152, 157, 178, 190, 224, 262–3, 268–9, 278, 375 n42, **381**
Gaselee, General, 237, 253, 265–6, 276–8, 280, 283, 287, 324, 326
Gates (city), Ch'ien-men, 86, 93–4, 102, 251, 268, 292; Ha-ta-men, 22, 77, 79–80, 83, 86, 95, 99, 113
Gender issues (awareness, protection, sexual exploitation, side-lining, stereo-typing), 12, 32, 40–2, 48, 51–2, 58, 61, 71–2, 88–9, 92, 105–6, 128, 133, 140–1, 162, 164, 181, 186–8, 190, 194, 212, 215, 245, 248, 254–5, 301–2, 334, 342, 348 n5, 355 n67, 374–5 n34, 376 n73 (see also footbinding and women)
Germany, Germans, Legation, troops, 2, 8, 10–11, 15, 18, 29, 40, 42, 75–9, 86, 96–7, 107–8, 110–14, 135, 137–8, 141, 143–4, 164–5, 169–70, 196–7, 204, 208–9, 213, 232, 238, 247, 269, 319–20, 323, 326–9, 331, 376 n71
Giers, Constantine de, 267–8, 357 n11, 369 n52
Giers, Mlle de, 30, 357 n11, **382**
Giers, Mme Michel de, 19, 30, 124, 142–3, 145–6, 164, 194, 245, 259, 357 n11, 358 n23, **382**
Giers, Michel N. de, 124, 159, 173, 194, 229, 259, 357 n11
Giles, Lancelot, 64, 156, 186, 248
Gilman, Gertrude, 53, 122, **382**
Gloss, Dr Anna, 20, 22–3, 51, 53, 72, 122, 141, 250, 282, 303–4, **382**
Goodrich, Carrington, Dorothea and Grace, 50, 106, 119, 156, 255, 277–8, 306
Goodrich, Chauncey G., 48, 110
Goodrich, Sara, 47–51, 56, 83, 110, 120, 123, 140, 151, 155, 162–4, 173, 185, 193, 198, 210–12, 221, 223, 254–5, 259–61, 267, 307, 322, **382**
Gordon Hall, 103, 228, 231, 233–4
Gossip and rumour, 12, 35–7, 65, 76–7, 103, 123–4, 154, 189, 194, 215, 218, 243, 251, 254, 258–9, 265, 335, 354

n15, 357 n 11, 367 n14, 374 n34, 376 n73
Gowans, Annie H., 135, 144, 286, **382**
Grand Council, 96–8

Hague Convention (on war), 374 n23
Hall, Captain Newt, 59, 72–3, 117–8, 187, 215
Hanlin Library, 162–3, 260, 267
Hart, Sir Robert, 1–2, 18, 26, 35, 40, 46, 60–1, 97, 102, 124–5, 127–9, 132–3, 185, 194, 228, 230, 241, 265, 349 n3
Hart, Lady, 254
Haven, Ada, 31, 52–3, 66–7, 109, 118, 133, 149, 156–7, 165–7, 178, 198, 223, 240–1, 254–6, 260–1, 263–4, 267–8, 287, 350 n29, **382**
Headland, Dr Isaac, 96, 129–30, 345 n16, 356 n45
Headland, Dr Mariam, 11, 96, 331, 337, 341–2, 345 n16, 356 n45, 377–8 n27, **389**
Health (of foreigners), 16–7, 33–4, 44, 68, 198 ; (of Chinese refugees): 67–9; (see also Children, Deaths, Women)
Henry, Lieutenant Paul, 298
Hewlett, Meyrick, 64–5, 90, 173, 185–6, 193, 208, 239, 245, 320, 328
Heyking, Baroness, 2, 30
History, reconstruction of (process, problems, discrepancies, sources), 8, 41, 76, 89, 92, 95–7, 104–5, 107–8, 111–12, 114, 126–8, 204, 244, 254–5, 258–9, 276, 288–292, 327–30, 336, 338–9, 342, 346 n22, 348 n5, 349 n4, 353 n72, 354 n21, 355 n66, 356 n45, 357 n59, n20, 358 n23, 372 n58, 373 n17, 375 n46, 376 n62, 377 n74, 76
Ho Tung, Clara, 345
Holland, Dutch, Legation, 79, 185, 261, 315–6
Hong Kong, (and New Territories), 11, 80, 113, 140, 325, 245 n10
Hoover, Herbert, 227–237
Hoover, Lou Henry, 227–237, 253, **388**
Houston, Mrs M.H., 60–1, 80–1, 136, 139, 145, **382**
Houston, M.H., 60–1, 351 n21
Hsiao-ting, Empress (later Lung-yu), 3, 8–9, 291, 345 n5
Hsien-feng Emperor, the, 8, 97
Hsu T'ung, 106, 310–11, 354 n26, 373 n4
Hsu Yung-i, 100, 114, 376 n57
Hung, Mary, 60, 62–3, 127, 307, **390**

Iliff, Geoffrey and Florence, 233–4
Imbeck, Frau, 137–8, 247, **382**